THE
77TH
ART DIRECTORS
ANNUAL

Editorial Direction
Myrna Davis

Editor
Laetitia Wolff

Hall of Fame Editor
Jeff Newelt

Copy Editor
Sharon Bodenschatz

Editorial Assistant
Gwendolyn Leung

Design/Production
Jane Dekrone

Jacket Illustration
Adrian Tomine

Jacket, Dividers and Endpaper Design
Gary Koepke

Annual Awards Coordinator
Laetitia Wolff

Published and distributed by
RotoVision SA
7 Rue du Bugnon
1299 Crans
Switzerland

RotoVision SA Sales Office
Sheridan House
112/116A Western Road
Hove, West Sussex BN3 1DD
England
Tel: (44) 1273 72 72 68
Fax: (44) 1273 72 72 69

Production and color separation in Singapore by
Provision Pte Ltd.
Tel: (65) 334-7720
Fax: (65) 334-7721

The Art Directors Club
250 Park Avenue South
New York, NY 10003-1402
United States

RotoVision SA ISBN: 2-88046-398-x

Printed in Singapore

TABLE OF CONTENTS

I first heard the word "fusion" in high school chemistry class. It had something to do with two elements heating up and merging into one. The second time I heard the word was a few years ago, referring to acid-jazz music, the fusion of jazz and hip-hop. It was new, fresh and appealing across a wide range of listeners.

The next time I heard the term used was with the opening of the restaurant "Asia de Cuba," designed by Philippe Stark, for the cross between Cuban and Asian cuisine. Very unexpected and pleasing to the palate.

The truth is, fusion is all around us.

And fusion is the most exciting thing to happen in visual communications since the invention of the camera. The conventional boundaries between art direction and design, between illustration and photography, between typography and film, between music videos and tv commercials, between editorial design and architectural environmental design, between Broadway lighting design and exhibition installation, even between graffiti and fine art—are all being blurred.

Today's creatives are collectors of experiences, moving across disciplines seamlessly. The more eclectic—even contradictory— the experiences, the better: copywriters are directing film, advertising art directors are designing books, account people are doing stand-up comedy. Creatives are bored doing one thing all the time. And with all the sweeping changes in technology, these

creatives are now able to change their endeavors overnight, from far distances.

This is, not by coincidence, exactly where the Art Directors Club is most relevant. The ADC has never been about one thing and one thing only. The ADC is a place where all cross-disciplinary creative work, and the people who made it, have been seen and celebrated. The 77th Art Directors Annual, which you hold in your hands, is your handbook to this newly fused industry.
As deemed by our impressive list of judges across Advertising, Graphic Design, Photography & Illustration, New Media, and everything in between, these pages hold the very best of what's out there in this brave new world.

It's a lot more interesting than a periodic table.

—Bill Oberlander
President, The Art Directors Club

Passionately dedicated to emerging innovation in a visual world.

The Art Directors Club, Inc., founded in New York in 1920, is an international non-profit organization of creatives in advertising, graphic design, interactive media, photography, illustration, broadcast design, typography, and related disciplines. The mission of The Art Directors Club is to promote the hightest standards of excellence in visual communications and to encourage students and young professionals entering the field.

In addition to the Annual Awards program, which includes a traveling show and publication of the Art Directors Annual, the Art Directors Club presents regularly scheduled gallery exhibitions, maintains the Art Directors Hall of Fame, publishes the bi-monthly ADC International Review published in Graphis Magazine, *supports the Art Directors Scholarship Foundation, which administers an annual scholarship award program for New York advertising and graphic design students, and produces other professional and educational projects including speaker events, The Saturday Career Workshop, symposia, and student portfolio reviews.*

ADC Committtees include the Annual Awards, Gallery Exhibits, New Media, Holiday Book Fair, Graphics, Membership, Newsletter, Portfolio Reviews, ADC Publications, Inc., Scholarship Foundation, Speaker Events, Young Professionals, and Video Project.

The Art Directors Club Gallery, located near Union Square, on Park Avenue South, in the Flatiron district, is a convenient meeting place for industry creatives. Facilities include two floors of exhibition space and offices, professional library/ archives, as well as a dining area, bar, and full catering kitchen. The gallery is generally open 10 am to 6 pm Monday through Friday, and is closed in August.

Please peruse our ever-expanding Web site at http://www.adcny.org.

This edition of the Art Directors Annual represents the 77th consecutive judging of the year's best work in visual communications. Of 11,903 entries received, 622 works were chosen, with New Media entries presented in print and on CD-ROM.

The Annual Awards Presentation, held on June 4, 1998, at the Sony Imax Theatre, Lincoln Square, New York, honored 65 medalists — 9 Gold and 9 Silver in Advertising, 1 Gold and 4 Silver in New Media, 6 Gold and 27 Silver in Graphic Design, 1 Gold and 8 Silver in Photography/Illustration — from 12 countries, including the United States, Canada, Brazil, Germany, The Netherlands, Spain, Switzerland, South Africa, England, Japan, China, and Singapore.

The 77th Annual Exhibition opened on June 5, 1998, at the Art Directors Club Gallery in New York, featuring Medalist and Distinctive Merit winners, and will travel throughout the world during 1998-1999. Selected winners are also displayed at www.adcny.org.

On behalf of the Board and the ADC, I extend appreciation and thanks to our outstanding chairs and judges, to our talented and hardworking staff; and to our entrants, whose participation supports this and other inspiring programs.

—Myrna Davis
Executive Director, The Art Directors Club

hall of fame

Rochelle Udell
Chairperson

Meg Crane
Stephen O. Frankfurt
Milton Glaser
Steven Heller
George Lois
Bill Oberlander
B. Martin Pedersen
Richard Wilde
Fred Woodward

The Art Directors Hall of Fame was established in 1971 to recognize and honor those innovators whose lifetime achievements represent the highest standards of creative excellence.

Eligible for this coveted award, in addition to art directors, are designers, typographers, illustrators, and photographers who have made significant contributions to art direction and visual communications.

The Hall of Fame Committee, from time to time, also presents a special Educators Award to those educators, editors, and writers whose lifetime achievements have significantly shaped the future of these fields.

1972
M. F. Agha
Lester Beall
Alexey Brodovitch
A. M. Cassandre
René Clark
Robert Gage
William Golden
Paul Rand

1973
Charles Coiner
Paul Smith
Jack Tinker

1974
Will Burtin
Leo Lionni

1975
Gordon Aymar
Herbert Bayer
Cipes Pineles Burtin
Heyworth Campbell
Alexander Liberman
L. Moholy-Nagy

1976
E. McKnight Kauffer
Herbert Matter

1977
Saul Bass
Herb Lubalin
Bradbury Thompson

1978
Thomas M. Cleland
Lou Dorfsman
Allen Hurlburt
George Lois

1979
W. A. Dwiggins
George Giusti
Milton Glaser
Helmut Krone
Willem Sandberg
Ladislav Sutnar
Jan Tschichold

1980
Gene Federico
Otto Storch
Henry Wolf

1981
Lucian Bernhard
Ivan Chermayeff
Gyorgy Kepes
George Krikorian
William Taubin

1982
Richard Avedon
Amil Gargano
Jerome Snyder
Massimo Vignelli

1983
Aaron Burns
Seymour Chwast
Steve Frankfurt

1984
Charles Eames
Wallace Elton
Sam Scali
Louis Silverstein

1985
Art Kane
Len Sirowitz
Charles Tudor

1986
Walt Disney
Roy Grace
Alvin Lustig
Arthur Paul

1987
Willy Fleckhaus
Shigeo Fukuda
Steve Horn
Tony Palladino

1988
Ben Shahn
Bert Steinhauser
Mike Tesch

1989
Rudolph deHarak
Raymond Loewy

1990
Lee Clow
Reba Sochis
Frank Zachary

1991
Bea Feitler
Bob Gill
Bob Giraldi
Richard Hess

1992
Eiko Ishioka
Rick Levine
Onofrio Paccione
Gordon Parks

1993
Leo Burnett
Yusaku Kamekura
Robert Wilvers
Howard Zieff

1994
Alan Fletcher
Norman Rockwell
Ikko Tanaka
Rochelle Udell
Andy Warhol

1995
Robert Brownjohn
Paul Davis
Roy Kuhlman
Jay Maisel

1996
William McCaffery
Erik Nitsche
Arnold Varga
Fred Woodward

1997
Allan Beaver
Sheila Metzner
B. Martin Pedersen
George Tscherny

1998
Tom Geismar
Chuck Jones
Paula Scher
Alex Steinweiss

Educators Award

1983
Bill Bernbach

1987
Leon Friend

1988
Silas Rhodes

1989
Herschel Levit

1990
Robert Weaver

1991
Jim Henson

1996
Steven Heller

1998
Red Burns

The hours are Dickensian. The markers are toxic. The clients are opinionated. The account group can be tyrannical. The competition for the best assignments is sometimes bloody. The assignment is always the same: to find a visual solution so original that it seems familiar. And the end-result is always the same; the art director or designer makes understanding possible and then disappears. Once a great design exists, it takes on a life of its own, without the designer.

That's the way it should be. The power of a great design is not in who designed it, but in what it does. Great designers, like great designs, are invisible, but their message comes through loud and clear. Therefore, we have the Art Directors Hall of Fame award for lifetime achievement.

Many were considered for this year's award. Five laureates were selected. A lot has changed since our Hall of Famers began their careers. Yet, their work has endured.

Computer animation was science fiction when Chuck Jones created Looney Tunes, a cast of cultural cartoon icons, and launched a flotilla of Warner Brothers products.

Packaging design was still in its infancy when Paula Scher developed a visual signature that works in every communications environment. She has exhibited extraordinary consistency over her long career.

There was no global marketplace when Tom Geismar created his

first logo. He has since designed over 100 familiar corporate identities, and his trademark designs have become international shorthand.

CDs weren't even a concept when Alex Steinweiss looked at a blank record sleeve and saw great visual real estate. He created the album cover as a means to entice, inform, and market.

Most of us had not even heard of the Internet or the Web when Red Burns was working in new media, creating an organization and symbology, and truly dancing in the dark.

The structure and symbologies these designers have created transcend time and mediums, and, at the same time, perfectly articulate the zeitgeist of any particular time.

Chuck Jones, Paula Scher, Tom Geismar, Alex Steinweiss, and Red Burns are great designers in the truest sense. They have changed the way we see and where we look for, and how we accept information. Their work entertains and informs, saves time and builds emotional connections. This is why they are the winners of the 1998 Art Directors Hall of Fame lifetime achievement award. And this is why, to these winners, I say, 'thank you', and ask everyone reading this book to stand and give these five great designers the recognition they have earned, a thunderous round of applause.

—Rochelle Udell
Chairperson, Hall of Fame Committee

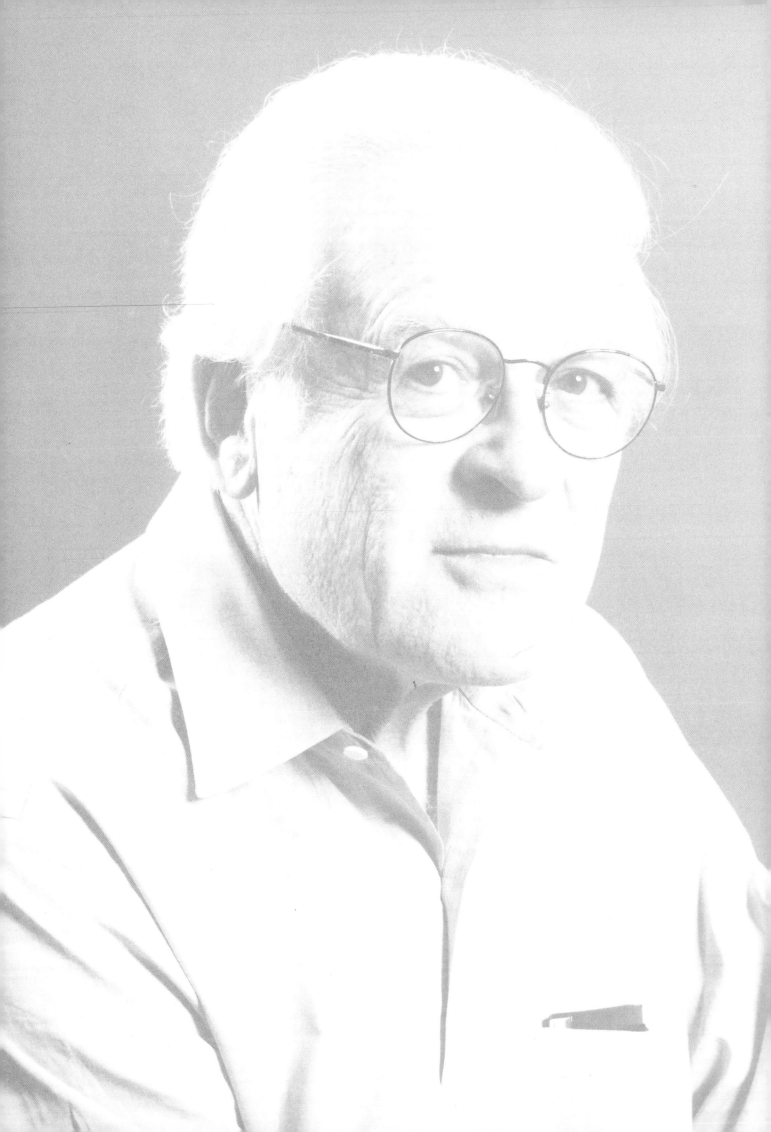

For 40 years, Tom Geismar has quietly and steadily punctuated the designscape with symbols for many of the world's major corporations, institutions, and thoroughfares. Among the most familiar, of the more than 100 trademarks and corporate identities for which he is singlehandedly responsible, are those for Mobil Oil Corporation, The Chase Bank, New York University, Public Broadcasting Service (PBS), Xerox, Rockefeller Center, Screen Gems, Univision, and a series of aquariums around the world.

Raised in New Jersey, Geismar concurrently attended the Rhode Island School of Design and Brown University, graduating cum laude and Phi Beta Kappa from Brown. After a two-year stint designing exhibits in the U.S. Army in Washington D.C., he was invited into a fledgling New York partnership with Ivan Chermayeff and Robert Brownjohn. They became world-famous for their fresh creative approach for such clients as Pepsi-Cola and Ciba Pharmaceuticals. When Brownjohn moved to London, the firm, which patterned itself after an architectural partnership, changed its name to Chermayeff & Geismar. Tom's partnership with Ivan has subsequently thrived for four decades.

If one relationship might stand as an emblem of Geismar's career, it would have to be Mobil. Since the mid-1960s, he has continued to evolve and update the look of Mobil, both nationally and internationally, from logotype and product packaging to gas stations, helicopter landing pads, signage, cultural sponsorships, and corporate projects. "He provided us with 'branding' long before the term became fashionable," said Earle Layman, Mobil's brand communications manager. "Ego was never an issue," Layman adds, "He has this ability to unite people with conflicting disciplines and points of view, and treats everyone the same regardless of their level in an organization."

Client David Teiger, to whom Tom was recommended by designer Elliot Noyes, has also remained steadfast for 35 years. Teiger observes, "In a typical meeting with architects, marketing people and top executives, everybody talks and Tom doesn't say a word. When, at the end of the meeting, Tom is asked for his opinion, he says the most insightful, clear and convincing things, and transforms everybody's thoughts into a winning solution."

Even with an acceptable solution at hand, Geismar's penchant for exploring dozens of alternative concepts and directions, each with subtle variations and details, has been noted more than once. "It is not unusual for Tom to come into the office Monday morning with a briefcase full of hand-drawn sketches, and I mean worked out renderings, resolved and ready for scanning or final cleanup," says Swiss-trained partner Steff Geissbuhler. "Then he starts with his favorite process—working with marker, scissors, tape, and copy machine—mutating, altering, modifying, and exponentially multiplying his sketches and solutions. Often it is hard to decide which is the best."

Geismar has done memorable work in print, packaging, and environmental graphics throughout his career. The annual reports he designed for Xerox in the 1960s and 1970s helped establish a new standard for design and the use of color photography in corporate communications. In the early 1990s he reinvigorated the graphics for Knoll furniture, establishing a memorable range of graphic materials that refocused the company's position in the marketplace. His work in the 1980's and 1990's for Gemini Consulting ranged from award-winning graphics to advertisements, wall murals, unique furniture, and architectural consultation.

Geismar is especially attracted to content-driven museum

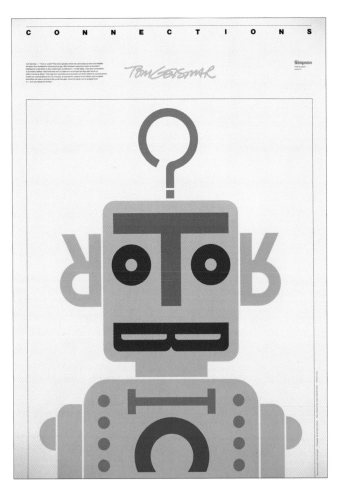

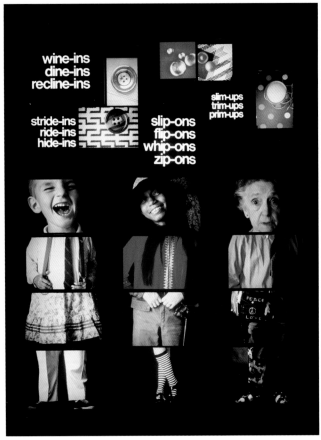

exhibitions, where he may function equally as curator and designer. The complexity, and the need to combine architecture, industrial design, graphic design, research, and writing skills, give these assignments a singularly appealing challenge. He was instrumental and responsible for developing the concepts and designs for The Statue of Liberty Museum, The Ellis Island Museum, The Hall of the Sun at the Hayden Planetarium in New York, The Burlington Mill, and the United States Pavilion for the World's Fair at Expo '70 in Osaka, Japan. He is currently involved in creating entirely new exhibits for The Harry S. Truman Library and Museum, and an exhibition on Sigmund Freud at the Library of Congress. Also, he is the author of the recently published Spiritually Moving: A Collection of Folk Art Sculpture.

Geissbuhler, after 23 years of working with Geismar, offers this assessment, "Tom Geismar is a great influence and inspiration to me, both professionally and personally. Highly intelligent, very creative, a very sure eye and taste, charming and humble, yet with a strong character, and, more than the other three of us partners combined, has management and business skills. He personifies to me an ideal designer."

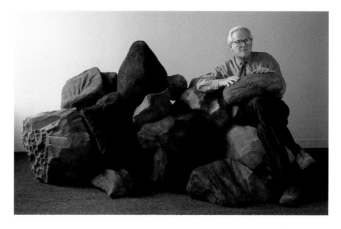

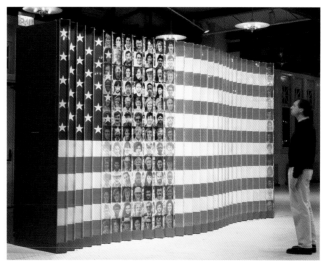

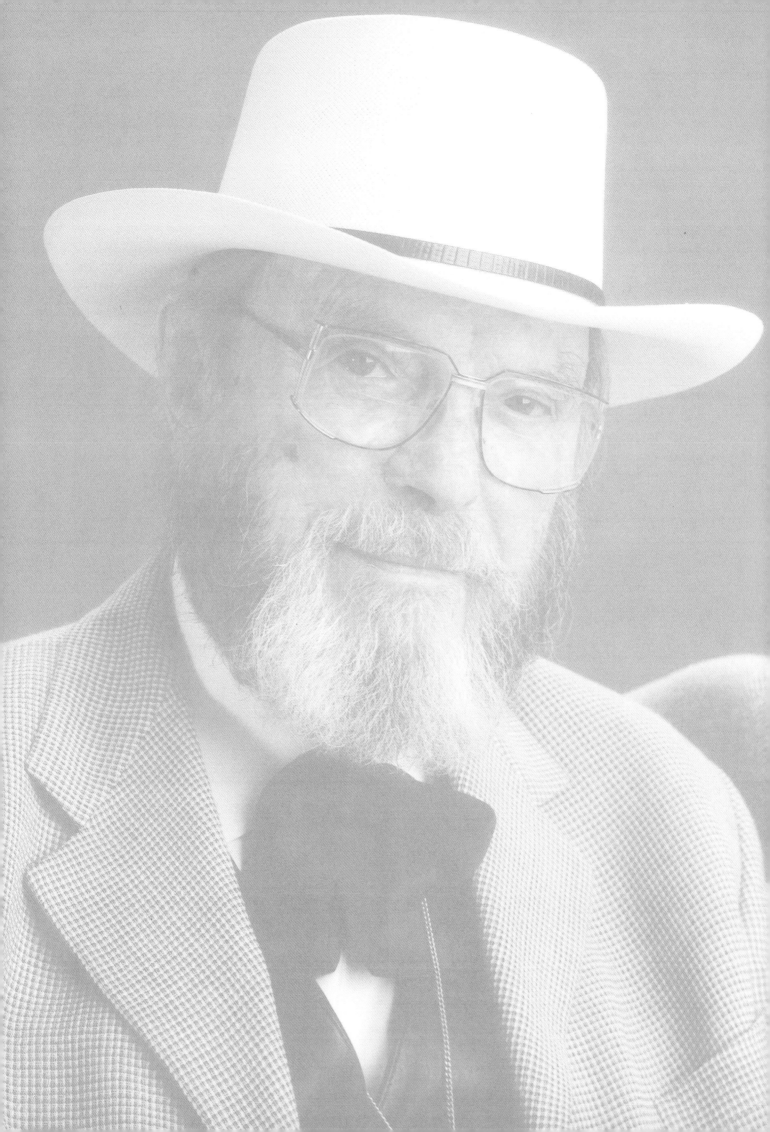

"You don't draw Bugs Bunny, you draw pictures of Bugs Bunny," a child once explained to animation director Chuck Jones. *"That's a very profound observation because it means he thinks the characters are alive, which, as far as I'm concerned, is true,"* says Jones who believes, *"Animation isn't the illusion of life; it is life."*

In a career spanning over 60 years, Jones has made more than 300 animated films and has earned two Academy Awards: For Scent-imental Reasons *(1950)* and The Dot and the Line *(1965).* He received an Honorary Oscar in 1996, three Honorary Doctorates, most recently by the American Film Institute in 1997, and the Directors Guild of America Life Membership Award.

Jones is a master of full *"character"* animation, breathing heart, soul, and life into design. His arrival at Warner Brothers Animation, in 1936, resulted in a retooling of the *"Looney Tunes"* characters. Under Jones's direction, Bugs Bunny, Daffy Duck, Elmer Fudd and Porky Pig developed their definitive plucky personas. His own creations include Road Runner, Wile E. Coyote, Marvin Martian, Pepe Le Pew, Michigan J. Frog, and Charlie the Tuna.

Jones respects the intelligence and humanity of children, *"We must first maintain, nurture, and insure the ability to recognize and communicate the characteristics we, ruefully, recognize in ourselves. We must never write down to children. We should take our work, but not ourselves, seriously."*

Born September 21, 1912, in Spokane, Washington, Jones grew up in Hollywood, California. Living a few blocks away from Charlie Chaplin's house, he spent his time as a child extra in Mack Sennett comedies.

At the Chouinard Art Institute in Los Angeles (now the California Institute of the Arts), Jones studied with Donald Graham, who trained the early Disney animators. After graduating, Jones drew pencil portraits for a dollar apiece on the street. In 1932, he got his first job in the fledgling animation industry as a cel washer for former Disney animator, Ubbe Iwerks.

In 1936, Jones was hired by the Leon Schlessinger Studio (later sold to Warner Brothers) and was assigned to Tex Avery's animation unit. The team produced *"Looney Tunes"* and *"Merrie Melodies"* in a back lot building nicknamed Termite Terrace. Here he learned, *"An animator must have only three things—a pencil, a number of sheets of paper, and a light source; with these he can animate, without them he cannot."*

At 25, Jones directed his first animated film, The Night Watchman, released in 1938. Approximately 5000 animation drawings were used for the six-minute cartoon. As director, he timed the picture, finalized all the writing, produced over 300 layouts, and directed the art design, music, sound effects, and animation. Today he remains the same uncompromising craftsman, *"In all the years I've done Bugs, I've never done the same run, because each time Bugs runs, he runs for a different reason."*

During World War II, he directed Army training films featuring Private SNAFU, a popular 1940s character, and he directed a reelection film for President Franklin Delano Roosevelt. Heading his own unit, Jones remained at Warner Brothers Animation until it closed in 1962, except for his brief stint at Disney Studios in 1955 during a hiatus. He then moved to MGM Studios where he created new episodes for the Tom & Jerry cartoon series, and also co-wrote, co-directed, and produced a full-length feature, The Phantom Tollbooth.

In 1966, Jones directed one of the most beloved holiday specials ever produced—How the Grinch Stole Christmas by Dr. Seuss.

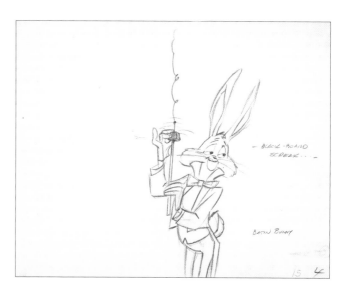

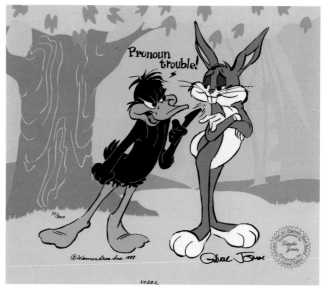

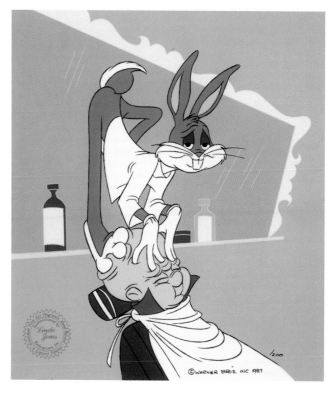

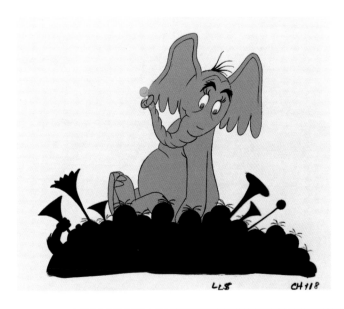

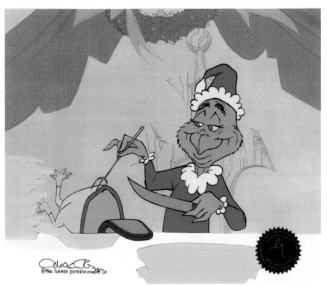

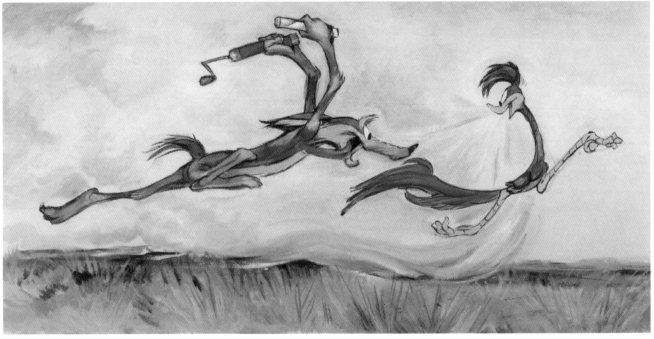

The special earned him a Peabody Award for Television Program Excellence, an accolade also bestowed upon him for Horton Hears a Who by Dr. Seuss (1971). In 1972, Jones served as a vice president of ABC where he made several animated films for television including The Cricket in Times Square (1973). He then moved to CBS where he wrote, directed, and produced animated adaptations of Rudyard Kipling's Rikki-Tikki-Tavi (1975) and Mowgli's Brothers (1976).

In 1992, Jones's mini epic, What's Opera, Doc?,(1957), which featured a Viking Elmer Fudd singing "Kill the Wabbit" to the tune of Wagner, was inducted into the National Film Registry as, "…among the most culturally, historically or aesthetically significant films of our time."

In the late 1970s, Jones began to create limited edition images depicting scenes from his most enduring cartoons. His art has been exhibited at more than 250 galleries and museums worldwide, including a one-man film retrospective at The Museum of Modern Art in New York.

Today, at 85, Jones has a contract with Warner Brothers, as Chuck Jones Productions, and is producing several new animated short films including: Chariots of Fur with Wile E. Coyote and Road Runner, Another Froggy Evening with Michigan J. Frog, and From Hare to Eternity with Bugs Bunny. He continues to produce original fine art drawings. His 1989 autobiography, Chuck Amuck, is in its fifth printing, and Chuck Reducks, its follow-up, was published in 1996.

Jones's work is still a huge influence on creators. Steven Spielberg says, "Chuck's originality, pacing, and humor have no peer. He's the top toon in town." Ringling Brothers, Barnum and Bailey Circus Clown College uses Road Runner cartoons in its gag-development class. Film historian and critic Peter Bogdanovich explains the unwavering appeal of Jones's work, "It remains, like all good fables and only the best of art, both timeless and universal."

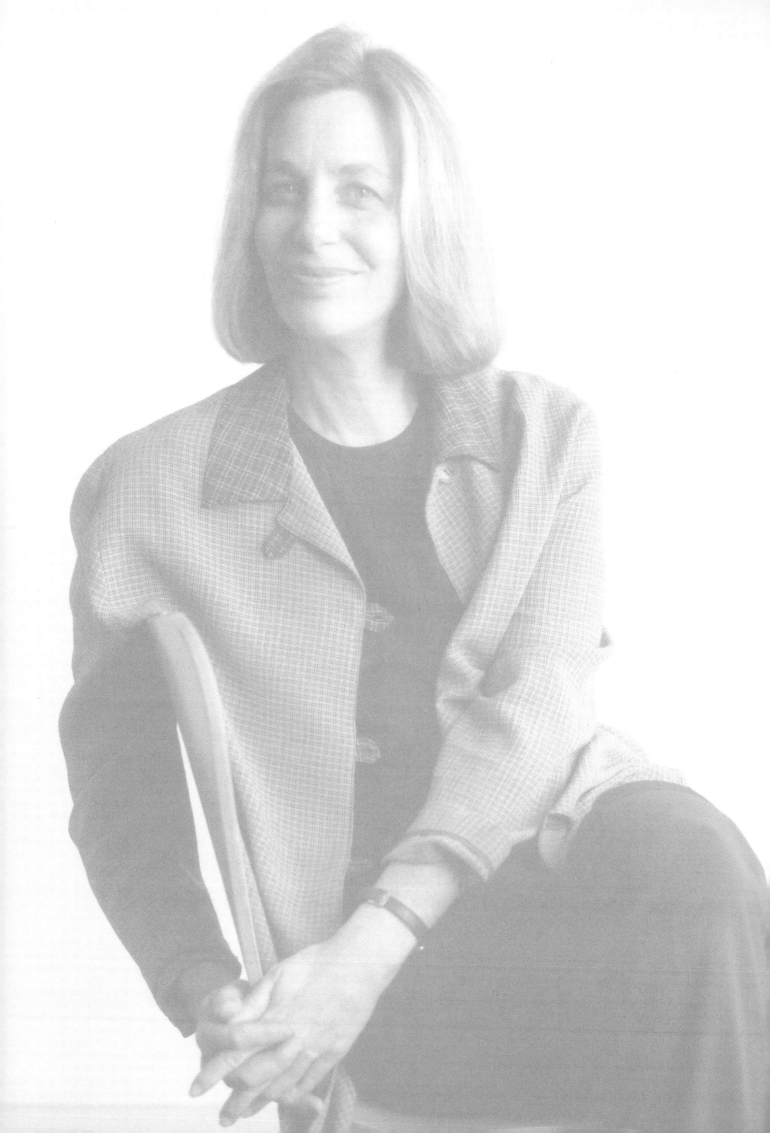

Paula Scher plunged into the New York design world in the early 1970s, a moment when progressive art directors, illustrators, and graphic designers, as well as architects and product designers, were drawing energy and ideas from the parking lots of Las Vegas, the Factory of Andy Warhol, the creative boutiques of Madison Avenue, and the tragi-comedy of the Nixon Administration. This was the nadir of the Pop movement, a period when American design, music, fashion, and fast-food had become a global vocabulary—more profoundly international than the "International Style." From New York to London to Tokyo to LA, Helvetica was outpaced by the lascivious swashes of Herb Lubalin's lettering and the exuberant curves, serifs, in-lines, and outlines of a veritable harem of decorative typefaces revived from the dustbins of an ornamental past.

It was in this culture that Paula Scher came of age. She majored in illustration at the Tyler School of Art in Philadelphia, finishing her BFA in 1970. As a student, Scher avoided graphic design because she lacked the necessary "neatness skills" and didn't like arranging Helvetica on a grid. She didn't draw well either (a modest liability for an illustrator), but she discovered what she could do; come up with concepts and illustrate them with type.

In 1972, Scher jumped into the belly of popular culture; as art director for CBS Records in New York City, she designed approximately 150 album covers a year, and produced innumerable ads and posters. During her decade in the record industry (one year with Atlantic Records, the rest with CBS), Scher made work that was accessible but smart. She collaborated with illustrators and photographers to interpret music in suggestive, poetic ways—she preferred to invoke a mood or stage a mysterious scenario than provide literal depictions of bands and performers. Scher often drew on typographic styles from the past to complement the imagery she had commissioned. The economic crash that gripped the late 1970s pushed Scher to rely increasingly on letterforms over illustrations; the impulse to convey content and identity through typography became the hallmark of her mature work.

An enormous influence on Scher was designer Seymour Chwast, whose clever blending of image and type inspired countless students and young designers in the 1960s and 1970s. But Scher didn't just admire Chwast, she married him. At age 22, she embarked on what would prove to be a long and complicated relationship with this towering hero of popular design, a man 17 years her senior. They later divorced, and Scher built a life and career on her own, pushing ahead in the competitive design world of New York to construct a distinct identity for herself—a difficult achievement for any designer, and a feat especially rare among women. She married Chwast again when she was 40, and today each enjoys the other's hard-earned stature and independence, alongside their shared love and company.

Scher left CBS Records in 1982. She formed the studio Koppel & Scher with Terry Koppel in 1984, where she embraced the pressures of working on her own. The experience taught her the challenge of keeping her own clients and, "paying my own phone bill,"—a situation distant from that of a corporation like CBS. In 1991, Scher became a partner in the New York office of Pentagram. This unique business environment makes each partner responsible for maintaining his or her own clients and design teams while sharing accounting services, overhead, and profits with the other partners. The sole woman among 15 partners, Scher describes herself as, "the only girl on the football team." That doesn't make her a cheerleader or a trophy date, but an equal player in a pack of heavy-hitters. The Pentagram

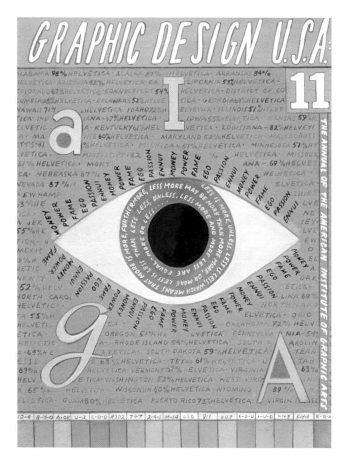

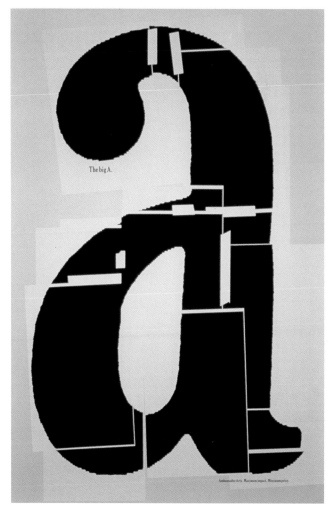

The big A.

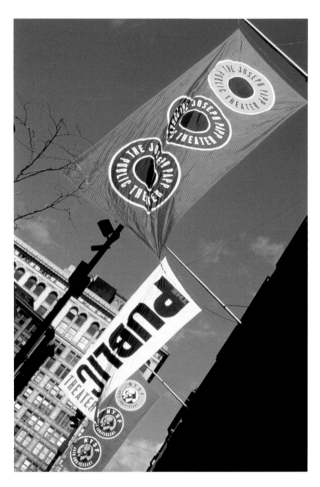

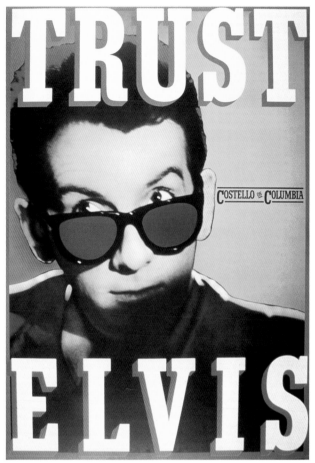

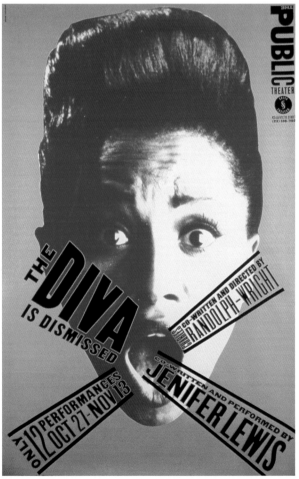

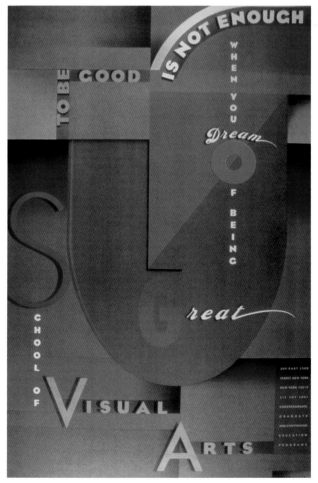

environment continually forces her to hold her own and stay on top, both creatively and economically.

The move to Pentagram marked a major shift in Scher's career. This world-class, large-scale studio brought Scher a new level of visibility, and cultural and economic clout. She now had access to clients and projects that would not have ordinarily come to a smaller studio, especially not to one run by a woman. The years at Pentagram have allowed Scher to sharpen her typographic wit and her knack for conceptual solutions into a powerful approach to identity and branding. Whereas Scher's earlier work often centered around the creation of a neatly contained package for a specific cultural product, she now confronts the much broader challenge of conveying a visual personality across a range of media, from posters, advertisements, and packages to physical spaces.

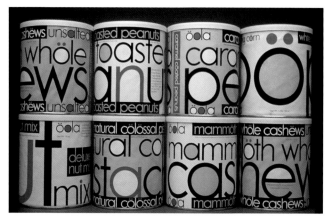

Among her most spectacular achievements has been the institutional identity she generated for the New York Public Theater in 1994. From large-scale billboards, down to the logo and stationery, Scher used a rhythmic mix of sans serif letterforms to construct a visual vocabulary that is both diverse and coherent—like the theater's programming. Other clients include The New York Times Magazine, *Champion International Corporation, Philips Van Heusen, and The American Museum of Natural History.*

Assessing her work, Scher says, "I've always been what you would call a 'pop' designer. I wanted to make things that the public could relate to and understand, while raising expectations about what the 'mainstream' can be. My goal is not to be so above my audience that they can't reach it. If I'm doing a cover for a record, I want to sell the record. I would rather be the Beatles than Philip Glass."

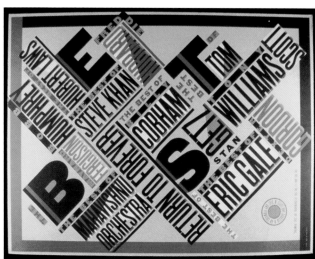

Paula Scher is among the best designers of her generation. She cut a path for herself through the billboard-jungle of Pop, creating an approach to design that is articulate yet unpretentious, open to influences yet decisively individualistic. Through her astonishing visual work as well as her generous efforts within our profession as a teacher, advocate, and agitator, Scher has helped put an intelligent face on the field of graphic design.

—Ellen Lupton

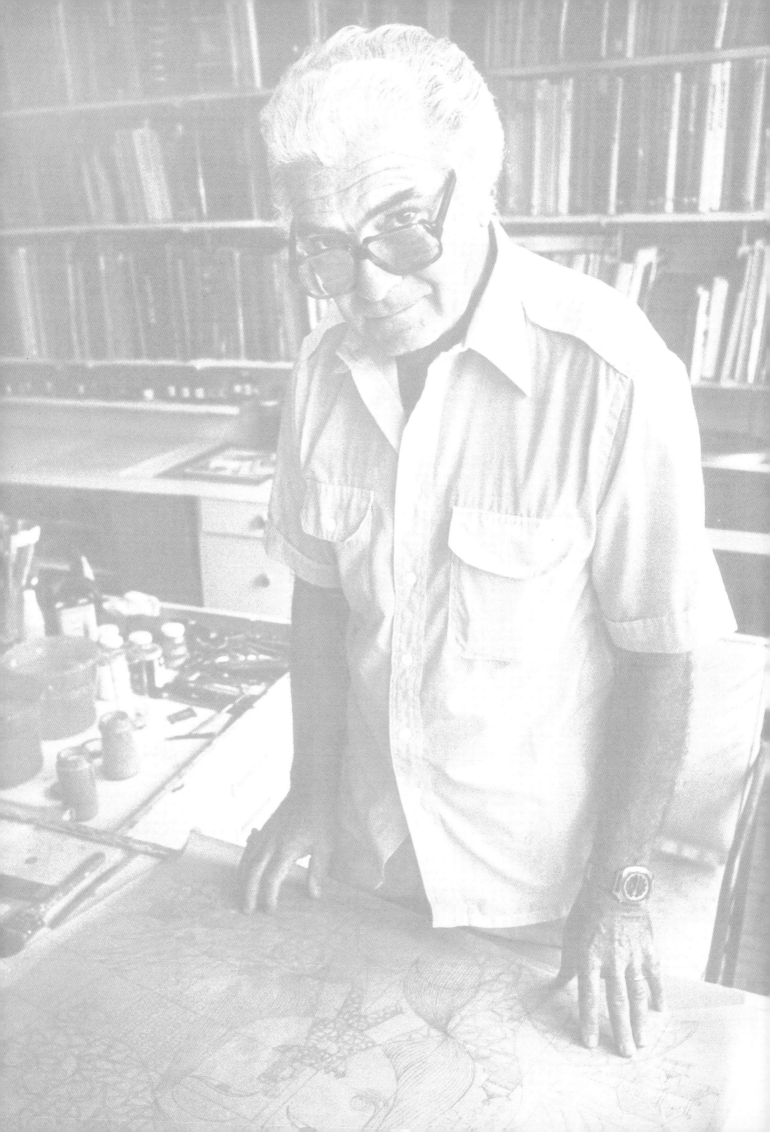

In 1939, at the age of 23, Alex Steinweiss revolutionized the way records were packaged and marketed. As the first art director for the recently formed Columbia Records, Steinweiss saw a creative opportunity in the company's packaging for its 78 rpm shellac records. The plain cardboard covers traditionally displayed only the title of the work and the artist. "They were so drab, so unattractive," says Steinweiss, "I convinced the executives to let me design a few." For what he saw as 12-inch by 12-inch canvasses inspired by French and German poster styles, he envisioned original works of art to project the beauty of the music inside. In 1947, for the first LP, Steinweiss invented a paperboard jacket which has become the standard for the industry for nearly 50 years.

Alex Steinweiss was born in 1917 in Brooklyn, New York. His father loved music and instilled the passion in him. In 1930, Steinweiss entered Abraham Lincoln High School. His first artistic endeavors resulted in beautifully articulated marionettes. These brought him to the attention of the art department chair, Leon Friend, co-author of Graphic Design (1936), the first comprehensive American book on the subject.

Steinweiss's first day in Friend's class was a magical experience. "To see these young men painting letters with flat-tipped brushes was one of the great inspirations of my life," he says, "I had to get involved with that!" He learned the principles of design and how to apply them through daily contact with the endless array of beautiful examples of poster design, typography, drawing, and calligraphy. Friend exposed Steinweiss to the the works of the great graphic designers of the time, including Lucian Bernhard, A.M. Cassandre, and Joseph Binder.

Upon graduation from high school, the School Art League awarded Steinweiss a one-year scholarship to Parsons School of Design in New York. He almost left after the first year, convinced, in spite of the depression, that he would be able to get a job. Before quitting school, however, he wrote to illustrator Boris Artzybasheff, who, instead of offering employment, advised Steinweiss to finish school.

Steinweiss followed his advice. Afterward he presented himself, unannounced, to the New York studio of Lucian Bernhard, the German master of poster and type design. Bernhard's son, Carl, answered the door with a rankled, "Don't you know you're supposed to call for an appointment?" But Steinweiss confidently handed him his portfolio and requested that the master peruse it. Carl glanced at the work, was impressed, and brought it to his father. A half an hour later, Bernhard came out of his office and informed Steinweiss that he had already phoned Joseph Binder, the Viennese poster maker who was looking for an assistant. Steinweiss worked for Binder for almost three years until he quit to form his own studio. Six months later he got a call from Robert L. Leslie, who recommended him as an art director to Columbia Records.

At Columbia, Steinweiss evolved a unique cover art style using musical and cultural symbols. His first cover, for a collection of Rodgers and Hart music, featured a theater marquee with the album's title appearing in lights. He designed images for jazz recordings by Louis Armstrong and Earl Hines, and numerous classical, folk and pop recordings. Newsweek reported that sales of Bruno Walter's recording of Beethoven's "Eroica" Symphony "increased 895%" with its new Steinweiss cover. His signature, the "Steinweiss scrawl," became ubiquitous on album covers in the 1940s.

"I tried to get into the subject," he explains, "either through the music, or the life and times of the composer. For example, with a Bartok piano concerto, I took the elements of the piano—the hammers,

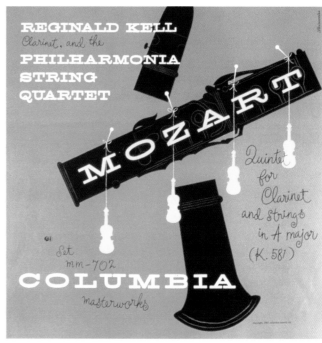

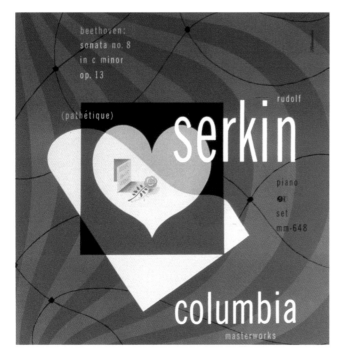

keys, and strings—and composed them in a contemporary setting using appropriate color and rendering. Since Bartok is Hungarian, I also put in the suggestion of a peasant figure." For the album, La Conga, he painted a huge pair of hands playing a stylized conga drum. For the original recording of Gershwin's Rhapsody in Blue, he placed a piano on a dark blue background lit up only by the yellow glow of a lone street lamp. His cover for Songs of Free Men by Paul Robeson, depicting a slave's chained hand holding a knife, had great emotional impact. He experimented with various styles (cubism for Stravinsky's Firebird Suite) and typography (an ornamental circus-like typeface for La Bohème).

Cristobal Diaz, a musicologist who originally collected only Latin American music, wrote, "After viewing these covers for awhile, I felt that the music within these albums had to be worthwhile to inspire this art. So it is by means of my appreciation of (Steinweiss's) covers that I was introduced to classical music." Many performing artists developed a love for and loyalty to Steinweiss. Leopold Stokowski requested that only Steinweiss do his covers, and Steinweiss often received letters of praise from artists such as Eddy Duchin and Rise Stevens for so exquisitely interpreting their work.

Steinweiss also designed movie posters (Casino Royale and The Love Machine), DeKuyper Liquor bottles, and graphics for countless other products. But at age 55, noting the rise of Swiss Modernism and minimalism, and the increasing preference for photography in the field, Steinweiss decided to retire from graphic design and start a new career as a painter under the pseudonym, Piedra Blanca.

In 1974 he began "Homage to Music," an open-ended series of paintings. "Many great works came into existence because a composer was moved to create a masterwork of music as his emotional response to a painting," says Steinweiss. "Since I've loved and listened to great music all my life, it has always been a desire of mine to reverse this process and create paintings directly inspired by the masterpieces of the great composers." These paintings include: "Petrouchka" (Igor Stravinsky), "Salome" (Richard Strauss), and "Don Giovanni" (Mozart).

Still active in his 80s, Steinweiss recently designed a home page for the Internet, "to interest people in the opera and ballet fields," who might commission his work for their companies. And he is proud that his family is following in his creative footsteps. His son Leslie is a composer and conductor, daughter-in-law Marjory is a filmmaker, and granddaughter Shoshannah is a graphic designer.

Red Burns is considered by many to be the godmother of Silicon Alley, New York's downtown multimedia hub. Her former students have gone on to launch Internet start-ups, create interactive units at traditional media companies and pioneer new communications technologies worldwide.

Burns is the chair of the Interactive Telecommunications Program (ITP) at New York University's Tisch School of the Arts where she holds the Tokyo Broadcasting Chair in Interactive Communications and New Media. Since its inception in 1979, the ITP has pioneered the field of new media experimentation.

An Ottawa, Canada native, Burns has been exploring the social benefits of technology since she received a black-and-white portable video camera nearly 30 years ago. She was trained as a documentary filmmaker at the Film Board of Canada.

In 1971, Burns co-founded the Alternate Media Center, a research and implementation center for new technologies at NYU's Tisch School of the Arts. There she designed and directed a series of telecommunications projects, including a two-way cable system in Reading, Pennsylvania, that allowed elderly people to get information about social services through interactive television. She also developed telecommunications applications to serve people with developmental disabilities and initiated one of the first field trials of teletext in the United States.

This innovative research led to her co-creation of ITP. It was important to Burns that ITP be housed in NYU's art school in order to draw students from a wide variety of academic and artistic backgrounds. "People who come from other disciplines, not just computer scientists, can now create their own forms of communication," says Burns. "Doctors and architects and educators can use more than words — they can use pictures and sound."

The program, utilizing a unique interdisciplinary approach is, according to Burns, "An experimental environment in which students can think and create in concert with one another." Her students create web sites, build interactive museums, and even build computer mice out of such unlikely objects as tea strainers. Some ITP classes currently being offered: "Digital Journalism," "New Media and Interpersonal Behavior," and "Developing the Interactive Idea."

Burns urges her students to take advantage of all the new multimedia design tools now available: smaller cameras, inexpensive computers and more powerful software, as a means to change the world. "We're a school that's focused on looking at how new technology can be used to express ideas." To emphasize the limits of technology, she says, "The best hardware and software can't calculate a fraction of the relationships in the ecosystem of a pond."

Under Burns's leadership, the two-year program has grown more than ten-fold since it began, to 225 students from 21 countries. It has produced some of New York's best and brightest new media stars and is so popular it can accept only one in five applicants. But Burns doesn't envision ITP expanding much beyond its current size. "It's not a factory," she says, "it's a graduate program." She wants to keep the program small enough so she can stay on a first-name basis with the students.

Burns's new media influence is all-pervasive. She serves on the boards of the New York New Media Association, the Web-development fund of PBS On-line, and Echo Communications, and is principal investigator of the on-going Interval Research Fellows Program at ITP.

She was selected as one of the "Top 25 Influential People on the Net," by Interactive Week, *named one of* Newsweek's *"50 For the Future," and is among* New York Magazine's *"NY 97 Innovators." In 1997, she was honored with the first Matrix Award in the New Media Category, by New York Women in Communications. She also received* Crain's New York Business' *All-Stars Award in education, and the Mayor of New York's Award for Excellence in Science and Technology.*

The New Media industry looks to Burns for visions of our technological future. "People keep asking me what's the next thing on the horizon and I keep saying it's not there yet."

advertising

The judging criteria were simple.
One. Is it a great idea?
Two. Is it stunningly executed?

That is the basic difference between the Art Directors Club Awards and the plethora of other industry contests. Half the judges were art directors this year, the other half copywriters, to ensure that the show would reward breakthrough advertising thinking as well as technique. It was a pretty eclectic bunch, and the judging was organized so that every piece was seen by every judge.

At the end of the day, you want to feel good about what was picked, and it made for a real small show. Only 131 entries made it into the book in the Advertising section, out of more than 6,000 submissions, with just 9 Golds, 9 Silvers, and 35 Distinctive Merit winners.

On the print side, so much of the work was public service stuff, it seems a shame that we don't try to put that same kind of thinking into our other clients. But hey, check out the TV. Oh my gawd.

A veritable potpourri of wonderfulness indeed. In fact, when we tried to vote a Best of Show, so many TV campaigns got nominated, nobody could win. Apple got a lot of support, particularly for the brilliant "Think Different" campaign. Weather Channel, Sprite, Fox Hockey and Sony Playstation got all the laughs. And it was inspiring to see so many great agencies from all over the world entering the show, from Australia's Campaign Palace to London's BBDP-GGT and Leo Burnett, to Japan's Dentsu.

Take a long hard look at the work. Most of the work is fresh, original, and quite sparkly. Not the same old stuff.

—Nick Cohen
Mad Dogs & Englishmen
United States

(top row)
Joe Alexander
The Martin Agency
United States

Trevor Beattie
BDDP GGT Ltd.
England

Bryan Black
Deutsch Inc.
United States

Graham Clifford
United States

(second row)
Brendan Donovan
Kirshenbaum Bond & Partners
United States

David Dye
BMP DDB Ltd.
England

John Fisher
Saatchi & Saatchi
New Zealand

Paul Grubb
Duckworth Finn Grubb Waters
England

(third row)
Al Kelly
Goodby, Silverstein & Partners
United States

Rachel Manganiello
Wieden & Kennedy
United States

Michael Mazza
Hal Riney & Partners
United States

Gary McKendry
Margeotes, Fertitta & Partners Inc.
United States

(fourth row)
Steve Mitchell
Hunt Atkins
United States

Emily Oberman
Number Seventeen
United States

Patrick O'Neill
United States

Hank Perlman
hungry man
United States

(fifth row)
David Ruiz
David Ruiz + Marina Company
Spain

Shelley Stout
Borders Perrin & Norrander
United States

Clay Williams
TBWA/Chiat Day, Inc.
United States

advertising

gold and silver

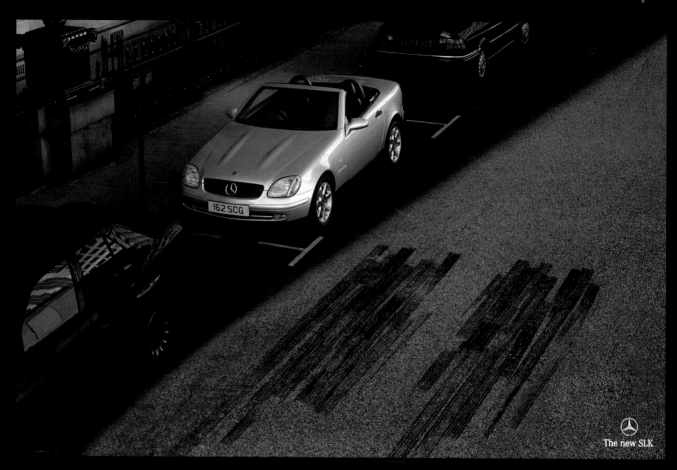

MULTIPLE AWARDS

Gold
MAGAZINE, CONSUMER, FULL PAGE OR SPREAD

and Gold
ADVERTISING POSTERS & BILLBOARDS, OUTDOOR:
BILLBOARD, DIORAMA, OR PAINTED SPECTACULAR
Skidmarks

ART DIRECTOR *Mark Tutssel*
CREATIVE DIRECTOR *Gerard Stamp*
COPYWRITER *Nick Bell*
PHOTOGRAPHER *Russell Porcas*
AGENCY *Leo Burnett*
CLIENT *Mercedes-Benz*
COUNTRY *England*

DEAF AWARENESS WEEK
21-29 September 1997

Isn't it time we started listening to South Africa's four million deaf people? Tel: (021)683-4665. TTY: (021)683-0664. DEAFSA

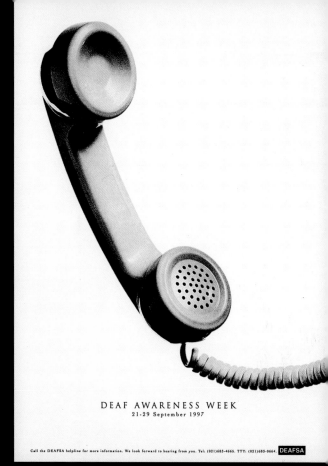

DEAF AWARENESS WEEK
21-29 September 1997

Call the DEAFSA helpline for more information. We look forward to hearing from you. Tel: (021)683-4665. TTY: (021)683-0664. DEAFSA

DEAF AWARENESS WEEK
21-29 September 1997

1.5 million South Africans have sign as their first language, it's time we started making a noise about it. Tel: (021)683-4665. TTY: (021)683-0664. DEAFSA

Silver
NEWSPAPER, CONSUMER, FULL PAGE OR SPREAD, CAMPAIGN
Wham • Receiver • Music Sheet

ART DIRECTOR *Michael Ipp*
CREATIVE DIRECTORS *Marc Lineveldt, Kristian Sumners*
COPYWRITER *Paige Nick*
DESIGNER *Michael Ipp*
PHOTOGRAPHER *Jan Verboom*
ILLUSTRATOR *Michael Ipp*
AGENCY *TBWA Hunt Lascaris Cape*
CLIENT *DEAFSA (Deaf South Africa)*
COUNTRY *South Africa*

Silver
**MAGAZINE, CONSUMER, FULL PAGE OR SPREAD,
CAMPAIGN**
Not Included

ART DIRECTOR *Erik Kessels*
COPYWRITERS *Tyler Whisnand, Johan Kramer*
PRODUCER *Pieter Leendertse*
AGENCY *KesselsKramer*
CLIENT *Rob Penris (The Hans Brinker
Budget Hotel)*
COUNTRY *The Netherlands*

(facing page)
Gold
**ADVERTISING POSTERS AND BILLBOARDS,
TRANSIT**
Rosa Parks Bus Wrap

ART DIRECTOR *Margaret Midgett*
CREATIVE DIRECTOR *Lee Clow*
COPYWRITERS *Craig Tanimoto, Eric Grunbaum*
PRODUCERS *Christine Callejas, Laura Heller*
AGENCY *TBWA Chiat/Day, Inc.*
CLIENT *Apple Computer, Inc.*
COUNTRY *United States*

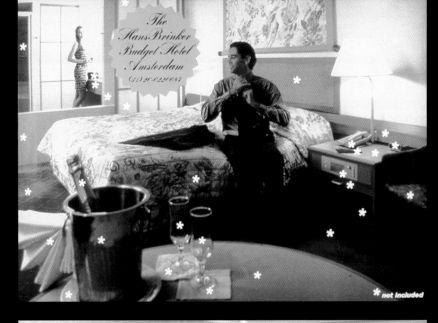

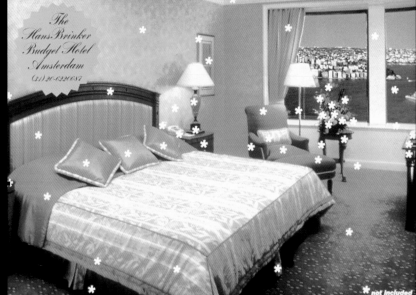

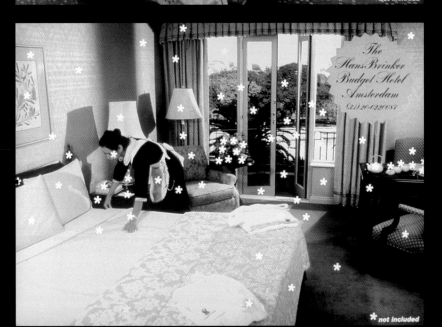

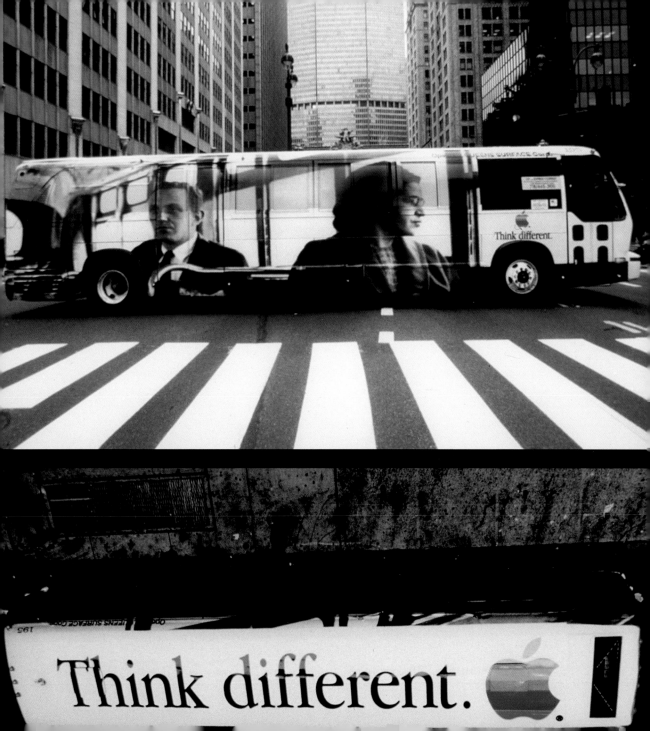

STOP ANTISEMITISM IN SWITZERLAND BEFORE IT'S TOO LATE.

Gold
ADVERTISING POSTERS AND BILLBOARDS,
PUBLIC SERVICE OR NON-PROFIT/EDUCATIONAL
The Swastika Brochure against Antisemitism
in Switzerland

ART DIRECTORS *Martin Bettler, Ernst Bächtold*
CREATIVE DIRECTOR *Edi Andrist*
COPYWRITER *Claude Catsky*
AGENCY *McCann-Erickson, Zürich*

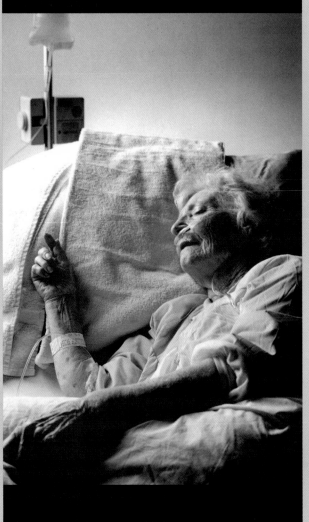

END A PET'S

SUFFERING AND IT'S "HUMANE."

END A HUMAN'S

SUFFERING AND IT'S "HOMICIDE."

America has a special place for people who practice mercy and compassion. It's called jail. For the terminally ill and their families, that's unfortunately the price to pay for stopping the suffering. So, hands tied, thousands of terminally ill patients opt to slowly wither and deteriorate at the hand of a hypocritical system. A system which says euthanasia is okay for your pet, but illegal for a person. Ultimately, they become the victims of outdated laws and antiquated thinking.

We are the Hemlock Society, a grass-roots organization that believes people should have the right, and more important- ly the choice, to die. Our mission is to advance a patient's rights through laws that allow compe- tent, terminally ill adults the legal choice of physi- cian aid in dying. With safe, legalized laws protecting physician assisted suicide, doctors could prescribe humane, lethal doses to consenting patients, which would either be given directly, or self-administered depending on the patient's wishes.

The benefits are threefold: First, patients suffering from strokes, cancer, neurological diseases, AIDS or other chronic diseases can choose to stop their misery, without fear of legal repercussions to them or their family and friends. Secondly, suicide can be achieved safely and humanely because an experienced, caring doctor is involved. In

some disturbing cases, friends and family have been asked to help a terminally ill person commit suicide, often without the proper knowledge or means to do it correct- ly. Clearly, with legalized physician aid in dying, that risk would be eliminated. And thirdly, by legalizing physician assisted suicide, we can accurately monitor and regulate it. This is crucial if we intend on making sure the acts are completely volun- tary and competent. Without laws, the abuses will continue.

It's time to change the laws governing the Right to Die. Patients deserve to choose how they die. So they can die gently. They can die non-violently. They can die painlessly. And more importantly, they can choose to die in the company of loved ones, whose support and love is imperative for a peaceful death.

Please, contact your state representa- tives and tell them to vote in support of bills favoring legalized aid in dying. And educate yourself on the realities facing the Right to Die debate. For general or membership information, please call (415) 923-8559. Or visit our website at hemlock@privatei.com. Because some- thing's wrong when a society treats its dogs and cats more humanely than its family and friends.

THE
HEMLOCK SOCIETY
SUPPORT THE RIGHT TO DIE WITH DIGNITY.

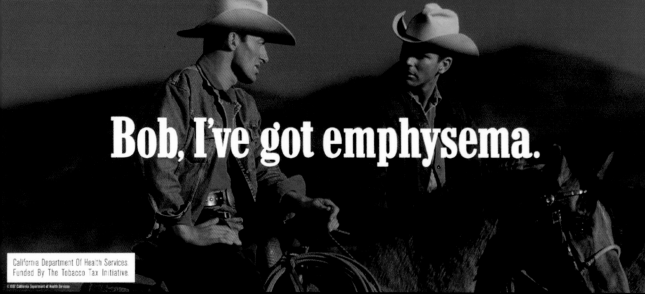

Bob, I've got emphysema.

California Department Of Health Services.
Funded By The Tobacco Tax Initiative.

© 1991 California Department of Health Services

Silver
ADVERTISING POSTERS AND BILLBOARDS,
PUBLIC SERVICE OR NON-PROFIT/EDUCATIONAL
Bob, I've Got Emphysema

ART DIRECTOR *Nancy Steinman*
CREATIVE DIRECTOR *Bruce Dundore*
COPYWRITER *Jeff Bossin*
PHOTOGRAPHER *Myron Beck*
TYPOGRAPHER *Nels Dielman*
AGENCY *Asher & Partners*
CLIENT *California Department of
Health Services*
COUNTRY *United States*

my parents went to the
Mururoa Atoll and all
I got was this T-shirt.

Boycott all French products now. Coalition for Nuclear Disarmament

MULTIPLE AWARDS

Gold
TELEVISION COMMERCIAL, SPOTS OF VARYING
LENGTHS, CAMPAIGN
Jack's Visit • Spicy Crispy Chicks • Driving Test

Distinctive Merit
TELEVISION COMMERCIAL, 30 SECONDS OR LESS
Driving Test

ART DIRECTOR *Dick Sittig*
DIRECTOR *Dick Sittig*
CREATIVE DIRECTOR *Dick Sittig*
COPYWRITER *Dick Sittig*
PHOTOGRAPHERS *Scott Buttfield, Larry Fong,*
Stefan Czapsky
PRODUCERS *Frank Scherma, Jon Kamen,*
Robert Fernandez
MUSIC *Wojahn Brothers*
PRODUCTION COMPANY *@radical.media, inc.*
AGENCY *Kowloon Wholesale Seafood Co.*
CLIENT *Jack In The Box*
COUNTRY *United States*

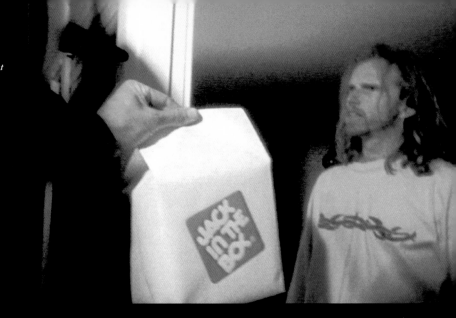

SCRIPT: *Jack's Visit*
OPEN ON THE EXTERIOR OF AN OLD HOUSE. THE
CAMERA MOVES TOWARDS THE FRONT DOOR WITH
THE FEEL OF A REALITY-BASED POLICE CHASE. A MAN'S
HAND LOUDLY KNOCKS ON THE DOOR.
MAN (VO): *Mr. Brad Haley?!*
BRAD: *Relax!* (THE DOOR OPENS AND WE SEE BRAD, A
BIT RUMPLED AND CONFUSED BY THE SIGHT OF JACK.)
BRAD: *Did I win something?*
JACK: *My sources tell me you've been calling Jack
in the Box "Junk in the Box."*
BRAD (INSOLENT): *So?*
JACK: *I take these things personally, Brad.*
BRAD: *Get lost!*
BRAD TRIES TO SLAM THE DOOR IN JACK'S FACE, BUT
JACK FORCES IT OPEN.
JACK: *Sure, just try my food, apologize, and I'll go.*
BRAD (SHOVES JACK): *I said beat it, clown!*
JACK SHOVES BRAD BACK.
JACK: *Listen punk, my employees have been
working their buns off to make the best burgers,
shakes and fries around.*
BRAD: *You're psycho!*
BRAD RUNS INTO THE DARK BACKYARD. JACK AND
THE CAMERA ARE IN HOT PURSUIT. JACK BRINGS BRAD
DOWN. MAN, WOMAN AND DOG BEHIND WIRE FENCE,
WITH FACES BLURRED, LOOK ON.
MAN: *Oh yeah, looking good Jack!*
JACK: *Try a thick and frosty milkshake made
with real ice cream! Yummy, isn't it??!!*
BRAD: *Very yummy!*
JACK: *Thanks, try a fry. Better than Mac's, right?*
BRAD: *Yeah.*

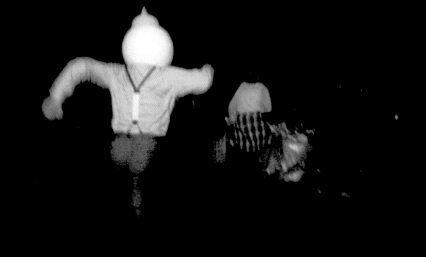

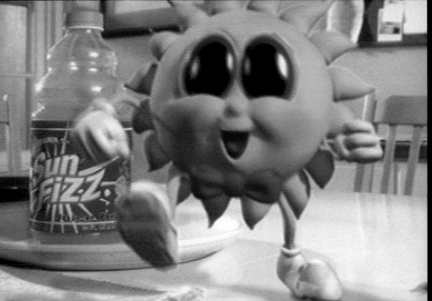

Gold

TELEVISION COMMERCIAL, 30 SECONDS OR LESS
Sun Fizz

ART DIRECTOR *Jason Gaboriau*
CREATIVE DIRECTORS *Lee Garfinkel,*
Todd Godwin, C.J. Waldman
COPYWRITER *Steve Doppelt*
DIRECTOR *Spike Jonze*
AGENCY PRODUCER *Liz Hodge*
PRODUCTION COMPANY *Satellite Productions*
MUSIC *Andy Newell (Earwax)*
EDITOR *Eric Zumbrennan (Spot Welders)*
ANIMATION COMPANY *Olive Jar*
AGENCY *Lowe & Partners/SMS*
CLIENT *The Coca-Cola Company/Sprite*
COUNTRY *United States*

SCRIPT: *Sun Fizz*

OPEN ON MIDDLE CLASS MOM IN THE KITCHEN OF
HER SUBURBAN HOME. HER TWO LOVABLE CHILDREN
RUSH IN.
KIDS: *Mom, we're thirsty.*
MOM: *Well, I've got two glasses of Sun Fizz*
coming right up.
MOM BRINGS TWO GLASSES OF SUN FIZZ TO THE
KITCHEN TABLE.
KIDS: *Sun Fizz. That's our favorite.*
"SUNNY," THE SUN FIZZ [LOGO], JUMPS OFF THE LABEL
AND BECOMES A 3-D CHARACTER.
SUNNY: *That's because there's a delicious ray of*
sunshine in every drop!
SOUND: *KIDS SCREAM.*
MOM PUSHES KIDS THROUGH DOORWAY TO GET THEM
AWAY FROM THIS FRIGHTENING CREATURE.
SUNNY: *I'm filled with nature's goodness!*
SUNNY RUNS AFTER THEM SPOUTING OUT BAD
ADVERTISING CLICHES.
SUNNY: *Hey, what's with you people, I've got*
vitamins and minerals!
MOM TRIPS OVER VACUUM.
GIRL: *Mom!*
AS SUNNY CLOSES IN ON MOM, WE ZOOM IN ON HER
HORROR STRICKEN FACE.
MOM: *Run!*
SUPER: *IMAGE IS NOTHING. THIRST IS EVERYTHING.*
OBEY YOUR THIRST.
VO: *Trust your gut, not some cartoon character.*

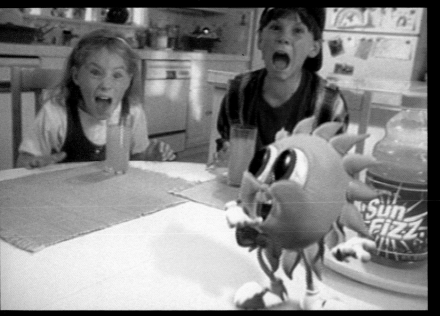

MULTIPLE AWARDS

Gold
**TELEVISION COMMERCIAL, PUBLIC SERVICE/
NON-PROFIT**

and Merit
CINEMA, PUBLIC SERVICE/NON-PROFIT
Talking Heads (TTA)

ART DIRECTOR *Tim Peckett*
CREATIVE DIRECTORS *Barry Delaney,
Greg Delaney, Brian Stewart*
COPYWRITER *Richard Warren*
PRODUCER *Helen Chattwell*
DIRECTOR *Mike Stephenson*
MUSIC *Michael Tippett "The Suite for the
Birthday of Prince Charles"*
AGENCY *Delaney Fletcher Bozell*
CLIENT *Teacher Training Agency*
COUNTRY *England*

SCRIPT: *Talking Heads*
*IN A SERIES OF PORTRAIT SHOTS, WE SEE A VARIETY OF
SUCCESSFUL PEOPLE FROM ALL WALKS OF LIFE. WITH A
SMILE OF AFFECTION, EACH ONE SPEAKS DIRECTLY TO
THE CAMERA.*
SOUND: *MUSIC THROUGHOUT.*
JOHN CLEESE: *Geoffrey Bartlett.*
ANITA RODDICK: *Betty Springham.*
STEVE MCMANAMAN: *Noel O'Neill.*
JEREMY PAXMAN: *George Sayer.*
EDDIE IZZARD: *Andy Boxer.*
MICHAEL GRADE: *Dennis Gale.*
BOB HOSKINS: *Dai Jones.*
BRUCE OLDFIELD: *Ethel Allison.*
TERENCE CONRAN: *Don Potter.*
BEN ELTON: *Gordon Vallins.*
DAVID PUTTNAM: *Cleo Kirkpatrick.*
SEBASTIAN COE: *David Jackson.*
JOANNA LUMLEY: *Sister Dilys Dodd.*
STEPHEN HAWKING: *Mr. Tahta.*
DAVID SEAMAN: *Bob Cox.*
TONY BLAIR: *Eric Anderson.*
SKIN: *Miss Webb.*
FADE TO A BLACK SCREEN.
SUPER: *No-one forgets a good teacher.*
[LOGO] TEACHER TRAINING AGENCY

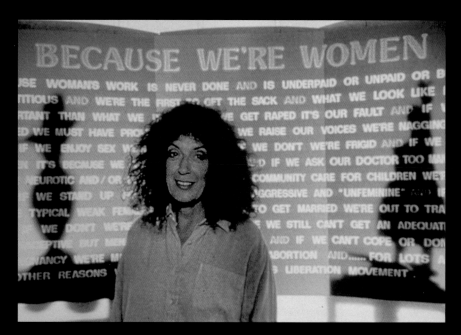

SCRIPT: *Bowling*

OPEN ON BOWLING TOURNAMENT. BOWLER PREPARES FOR FIRST ROLL.
ANNOUNCER A: *Yes—we're here in the Pavilion at Manhattan Beach and you're looking at Christy Ellison. She's up now in the tenth frame.*
ANNOUNCER B: *She needs two strikes to win the match.*
BOWLER RELEASES FIRST BALL AND STRIKES.
ANNOUNCER A: *Just like that. She got a great break—a crossover. But she'd like to have a second strike.*
BOWLER LEAVES APPROACH FOR SECOND SHOT.
ANNOUNCER B: *And she was striking a bunch in practice.*
JUST AS SHE RELEASES THE BALL, HER OPPONENT CHECKS HER ONTO THE FLOOR. THEY BOTH GO FLYING INTO THE NEXT LANE.
SUPER: *Bowling would be better* (FADE UP) *if it were hockey.* [LOGO] NHL ON FOX
ANNOUNCER A: *Well…she has to be disappointed. Did not throw a good shot. And she's left with a*

Silver
TELEVISION COMMERCIAL, 30 SECONDS OR LESS
Billiards

ART DIRECTOR *Roger Camp*
CREATIVE DIRECTOR *Cliff Freeman*
COPYWRITERS *Eric Silver, Jeff Bitsack*
PRODUCER *Liz Graves*
DIRECTOR *Christopher Guest*
STUDIO *Moxie Pictures*
AGENCY *Cliff Freeman and Partners*
CLIENT *Fox Sports*
COUNTRY *United States*

SCRIPT: *Billiards*
OPEN ON A POOL TOURNAMENT. BILLIARDS PLAYER
SETS UP FOR SHOT.
ANNOUNCER A: *Well he's sweating over there,
but not because he's losing. Dan Malloy is
leading 5–3.*
ANNOUNCER B: *He's got to come back up and,
hopefully, shoot the five in the same pocket.*
BILLIARDS PLAYER SETS UP FOR SECOND SHOT.
ANNOUNCER A: *Well, that shouldn't be a problem.
I think that was the toughest thing. It would
appear now…uh…the rack is his for the taking.*
OPPONENT APPEARS OUT OF NOWHERE AND STRIKES
BILLIARDS PLAYER ACROSS CHEST WITH CUE STICK. HE
DROPS TO THE FLOOR.
ANNOUNCER A: *And there it is.*
ANNOUNCER B: *Notice the cue ball, center of
the table.*
SUPER: *Billiards would be better* (FADE UP) *if it
were hockey.* [LOGO] NHL ON FOX
ANNOUNCER B: *Bing.*
ANNOUNCER A: *Roddy's lucky to avoid a slashing
call. And, as you can see, there's some action on
table number one.*

BILLIARDS WOULD BE BETTER
IF IT WERE HOCKEY.

Weather fans you're not alone.

MULTIPLE AWARDS

Silver
TELEVISION COMMERCIAL, 30 SECONDS OR LESS
Painted Faces

Merit
TELEVISION COMMERCIAL, OVER 30 SECONDS
I Hate the Rain

Merit
**TELEVISION COMMERCIAL, SPOTS OF VARYING
LENGTHS, CAMPAIGN**
Painted Faces • I Hate the Rain • Blender

ART DIRECTORS *Deb Hagan, Chris Graves*
CREATIVE DIRECTORS *Steve Robosky,
Jerry Gentile*
COPYWRITERS *Mickey Taylor, Erik Moe*
PRODUCER *Cheryl Childers*
DIRECTOR *David Ramser*
AGENCY *TBWA Chiat/Day, Inc.*
CLIENT *The Weather Channel*
COUNTRY *United States*

SCRIPT: *Painted Faces*
*OPEN OUTSIDE "THE FRONT." CUT INSIDE TO THE BIG
SCREEN. THERE IS AN OCM GETTING READY TO
PRESENT THE WEEKEND OUTLOOK.*
SOUND: *TELEVISION NOISE. CUT TO CROWD IN THE
BAR WATCHING THE BIG SCREEN. THEY ALL ERUPT
IN CHEERS.*
CROWD/SOUND: *CHEERING AS IF SOMEONE SCORED A
TOUCHDOWN. CUT TO A WAITRESS GETTING DRINKS
AT THE BAR, TALKING TO THE BARTENDER.*
WAITRESS: *Are Fridays always like this? This
place is nuts.*
BARTENDER: *Oh, yeah.*
WAITRESS: *Who are the guys over there?*
*BARTENDER LEANS BACK TO LOOK IN THAT
DIRECTION.*
BARTENDER: *Ah, they're here every Friday.
They're huge Weekend Outlook fans.*
*CUT TO THE TWO GUYS THEY'RE TALKING ABOUT.
THEIR FACES ARE PAINTED TO RESEMBLE A
TEMPERATURE MAP. ONE GUY HAS WARMER COLORS,
THE OTHER GUY HAS COOLER COLORS.*
GUYS: *It's on! It's on! Here we go.*
*CUT TO THE BIG SCREEN. CANTORI IS STANDING IN
FRONT OF A TEMPERATURE MAP THAT INDICATES IT'S
GOING TO BE WARM THIS WEEKEND.*
CANTORI: *Let's take a look at what's on tap for
your weekend.*
*CUT BACK TO THE GUYS WITH THE PAINTED FACES.
THE WARM-COLORED GUY JUMPS UP FROM HIS CHAIR
AND CELEBRATES, TAUNTING HIS FRIEND WHO HAS A
COOL-COLORED FACE.*
COOL GUY: *Stay cool. Stay cool. Stay cool.*
WARM GUY: *Warm weather. Warm! Yes! Hello,
warm weather, right there!*
*CUT BACK TO THE BARTENDER AND WAITRESS
WATCHING THIS SPECTACLE. THE WAITRESS JUST
SHAKES HER HEAD. DISSOLVE TO LOGO.*
SUPER: *[LOGO] THE WEATHER CHANNEL.®
Weather fans you're not alone.*
WARM GUY (VO): *Oooh. Who looks ridiculous now?*

MULTIPLE AWARDS

Silver
TELEVISION COMMERCIAL, 30 SECONDS OR LESS
Old Lady

Distinctive Merit
**TELEVISION COMMERCIAL, 30 SECONDS OR LESS,
CAMPAIGN**
Old Lady • Klutz • Sound Check

ART DIRECTORS *John Payne, Doug Mukai,
Deb Hagan*
CREATIVE DIRECTOR *Jerry Gentile*
COPYWRITERS *Gary Pascoe, Bill Paul,
Mickey Taylor*
PRODUCERS *Kencia Benvenuto, Kara O'Neil,
Phillip Lopez*
DIRECTORS *Richard Sears, Peter Darley Miller,
Mark Gustafson*
MUSIC *Primal Scream*
AGENCY *TBWA Chiat/Day, Inc.*
CLIENT *Sony Computer Entertainment*
COUNTRY *United States*

SCRIPT: *Old Lady*

*OPEN ON GAME FOOTAGE OF THE CANYON TRACK. WE
SEE ALL THE RACERS TAKE OFF. ONE RACER IS MOVING
EXTREMELY SLOW, JUST BARELY PUTTERING ALONG.
CUT TO QUICK SHOTS OF THE OTHER RACERS DOING
INCREDIBLE FLIPS, ETC. CUT BACK TO THE SLOW-
MOVING RACER MOVING AT A SNAIL'S PACE. CUT BACK
TO THE OTHER RACERS DOING AWESOME JUMPS, ETC.
CUT BACK TO THE SLOW-MOVING RACER — HE'S
FRUSTRATED. THE RACER GETS OFF THE JET MOTO
BIKE, THROWS HIS HELMET DOWN AND WALKS
TOWARD THE CAMERA SO HIS FACE IS FULL-FRAME.*
RACER: Hey, lady, come on, hit the gas. You're
killing me out here.
*OUR PERSPECTIVE CHANGES SO THAT WE CAN SEE
THAT THE RACER IS INSIDE THE TELEVISION AND HE'S
TALKING TO A REAL-LIFE LITTLE OLD LADY WHO'S
HOLDING A PLAYSTATION CONTROLLER.*
ANNOUNCER (VO): *Introducing Jet Moto 2.
More tracks, more control, more speed. Take
advantage of it.*
*CUT BACK TO JET MOTO RACER WALKING BACK TO HIS
BIKE. THE TURN SIGNAL IS BLINKING.*
RACER (LOOKING BACK AT THE OLD LADY):
And turn off the blinker!
SUPER: [LOGO] *Jet Moto 2*
SUPER: [LOGO] *PLAYSTATION*™

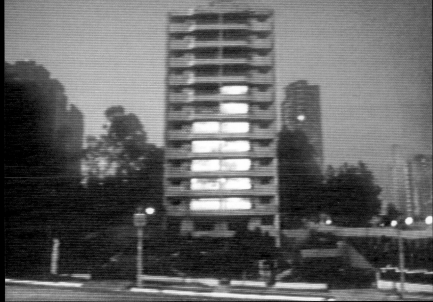

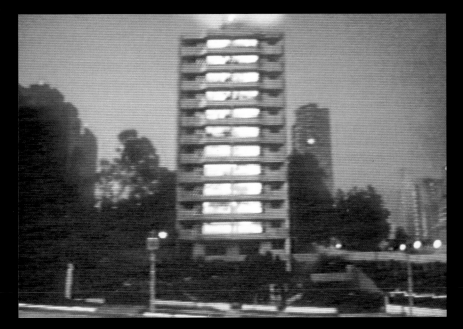

Silver
TELEVISION COMMERCIAL, 30 SECONDS OR LESS
LEDs (Light Emitting Diodes)

ART DIRECTOR *Rogerio Lima*
CREATIVE DIRECTOR *Alexandre Gama*
COPYWRITER *Atila Francucci*
PHOTOGRAPHER *Pepe Moli*
PRODUCER *Luiza Jatobá*
DIRECTOR *Joào Daniel Tikhomiroff*
MUSIC *Sax So Funny*
COMPUTER GRAPHICS *Vetor Zero*
STUDIO *Jodaf*
AGENCY *Young & Rubicam, Brazil*
CLIENT *Gradiente*
COUNTRY *Brazil*

SCRIPT: *LEDs*
*A WIDE SHOT SHOWS THE FACADE OF AN APARTMENT
BUILDING. IT'S LATE AT NIGHT. ALL THE LIGHTS IN
THE BUILDING ARE OFF, EXCEPT FOR A LIGHT ON THE
FIRST FLOOR. ALL IS CALM AND QUIET. WE HEAR THE
NOISES MADE BY CRICKETS AND CICADAS.
CUT TO THE INTERIOR OF THE FIRST FLOOR OF THE
BUILDING. A PERSON IS INSERTING A CD INTO A
GRADIENTE CD PLAYER.
CUT TO WIDE SHOT OF THE BUILDING–AS IN THE
BEGINNING OF THE FILM. THE MUSIC STARTS TO PLAY
LOUDLY. IMMEDIATELY, THE LIGHTS IN THE BUILDING
START TO GO ON AND OUT BLINKING JUST LIKE THE
LEDS ON A VU METER.*
VO: *Energy Gradiente. Sorry, neighbors.*
*DURING THE LAST SECONDS OF THE FILM, THE MUSIC
IS SO LOUD THAT THE RED LIGHT OF THE LIGHTNING
ROD ON TOP OF THE BUILDING BLOWS UP.*

distinctive merit

advertising

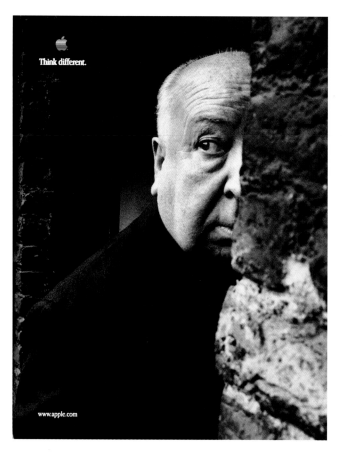

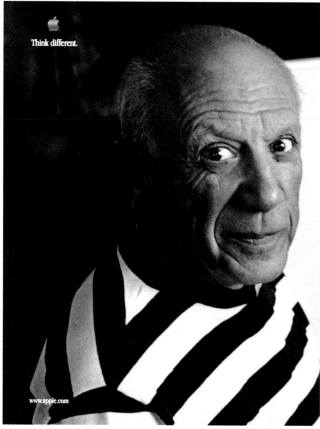

MULTIPLE AWARDS

Distinctive Merit
MAGAZINE, CONSUMER, FULL PAGE OR SPREAD,
CAMPAIGN
Hitchcock • Picasso • Einstein

Distinctive Merit
MAGAZINE, CONSUMER, FULL PAGE OR SPREAD
Hitchcock

Merit
MAGAZINE, CONSUMER, FULL PAGE OR SPREAD
Picasso

ART DIRECTORS *Susan Alinsangan, Ken Younglieb,*
Jessica Schulman, Margaret Midgett
CREATIVE DIRECTOR *Lee Clow*
COPYWRITERS *Craig Tanimoto, Eric Grunbaum*
PHOTOGRAPHY *Corbis*
PRODUCERS *Christine Callejas, Laura Heller*
AGENCY *TBWA Chiat/Day, Inc.*
CLIENT *Apple Computer, Inc.*
COUNTRY *United States*

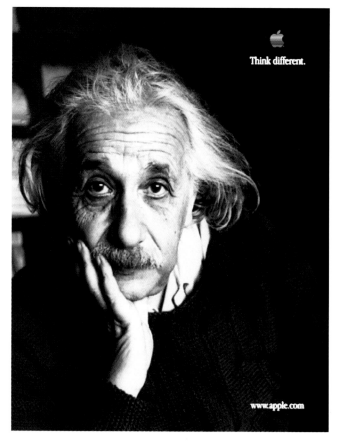

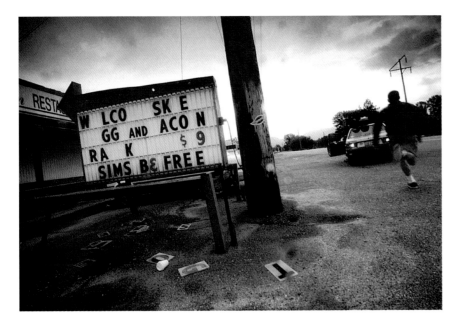

Distinctive Merit
MAGAZINE, CONSUMER, FULL PAGE OR SPREAD, CAMPAIGN
Teaser • Mantra • Tiananmen Square

ART DIRECTORS *Matt Peterson, Mike Proctor*
CREATIVE DIRECTORS *Hugh Saffel,*
Fred Hammerquist
COPYWRITERS *Ian Cohen, Grant Holland*
PHOTOGRAPHER *Bob Peterson*
AGENCY *Hammerquist & Saffel*
CLIENT *Sims Sports*
COUNTRY *United States*

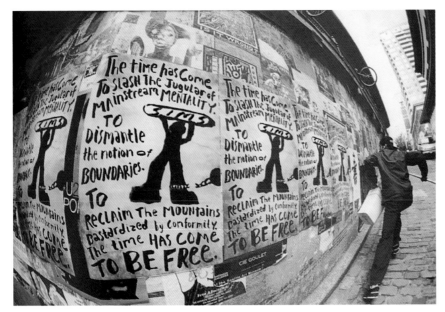

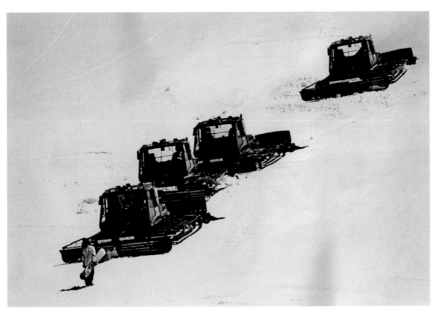

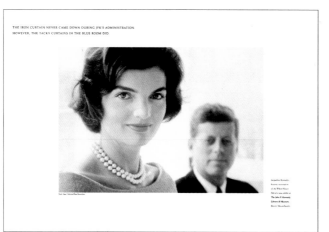

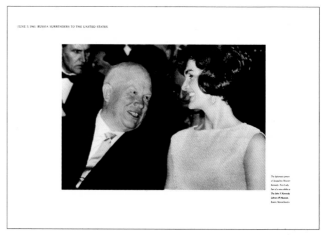

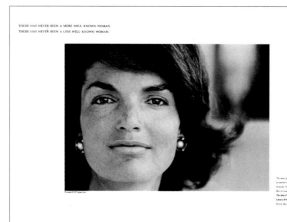

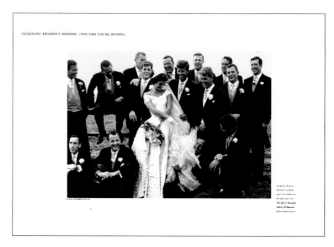

MULTIPLE AWARDS

Distinctive Merit
MAGAZINE, CONSUMER, FULL PAGE OR SPREAD, CAMPAIGN
The Iron Curtain Never Came down during JFK's Administration • Russia Surrenders to the United States • There Has Never Been a More Well-known Woman • Jacqueline Kennedy's Wedding (This Time You're Invited)

Distinctive Merit
MAGAZINE, CONSUMER, FULL PAGE OR SPREAD

and Merit
NEWSPAPER, CONSUMER, LESS THAN A FULL PAGE

and Merit
ADVERTISING POSTERS AND BILLBOARDS, TRANSIT
Russia Surrenders to the United States

Distinctive Merit
MAGAZINE, CONSUMER, FULL PAGE OR SPREAD

and Merit
NEWSPAPER, CONSUMER, LESS THAN A FULL PAGE
There Has Never Been a More Well-known Woman

ART DIRECTOR *Cliff Sorah*
CREATIVE DIRECTOR *Hal Tench*
COPYWRITER *Joe Alexander*
PHOTOGRAPHY *AP/World Wide Photos (Russia Surrenders to the United States), Jacques Lowe (There Has Never Been a More Well-known Woman), Mark Shaw/Photo Researchers (The Iron Curtain), Lisa Larsen/Life Magazine© Time Inc. (Jacqueline Kennedy's Wedding)*
PRINT PRODUCER *Linda Locks*
AGENCY *The Martin Agency*
CLIENT *John F. Kennedy Library Foundation*
COUNTRY *United States*

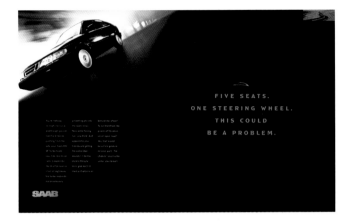

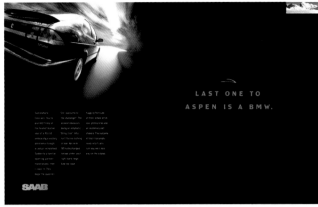

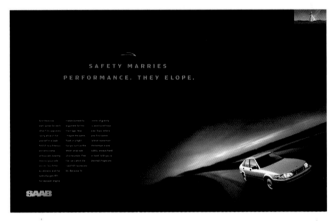

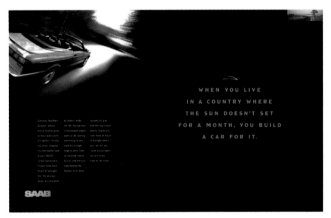

Distinctive Merit

MAGAZINE, CONSUMER, FULL PAGE OR SPREAD, CAMPAIGN

Five Seats. One Steering Wheel. This Could Be a Problem • Last One to Aspen's a BMW • Safety Marries Performance. They Elope • When You Live in a Country…

ART DIRECTORS *Jonathan Mackler, Mark Wenneker*
CREATIVE DIRECTORS *Kerry Feuerman, Rob Schapiro*
COPYWRITERS *Joe Nagy, Jeff Ross, Kerry Feuerman, Tom McElligott*
PHOTOGRAPHER *Clint Clemens*
PRINT PRODUCER *Jenny Schoenherr*
AGENCY *The Martin Agency*
CLIENT *SAAB Cars U.S.A., Inc.*
COUNTRY *United States*

Distinctive Merit

NEWSPAPER, CONSUMER, LESS THAN A FULL PAGE
McCoy

ART DIRECTOR *Michael Cohen*
CREATIVE DIRECTOR *Jim Mountjoy*
COPYWRITER *David Oakley*
PHOTOGRAPHER *Pat Staub*
AGENCY *Loeffler Ketchum Mountjoy*
CLIENT *Richard McCoy, CPA*
COUNTRY *United States*

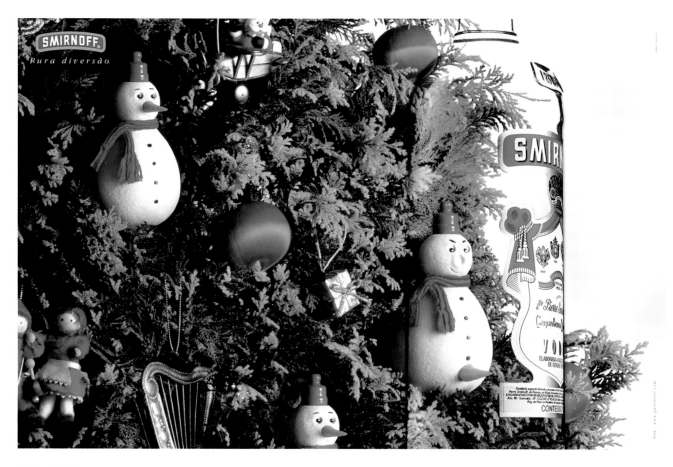

Distinctive Merit
MAGAZINE, CONSUMER, FULL PAGE OR SPREAD
Snowman

ART DIRECTOR *Amaury Terçarolli*
CREATIVE DIRECTORS *Celso Loducca,*
Cristiane Maradei
COPYWRITER *Cristiane Maradei*
PHOTOGRAPHER *Carrieri*
PRODUCER *Alexandre Garcia*
AGENCY *Lowe Loducca Publicidade*
CLIENT *Heublein/Smirnoff*
COUNTRY *Brazil*

Distinctive Merit
MAGAZINE, CONSUMER, FULL PAGE OR SPREAD
Invisible (Bijou Bra)

ART DIRECTOR *Ronnie Brown*
CREATIVE DIRECTORS *Greg Delaney, Brian Stewart*
COPYWRITER *Peter Kew*
TYPOGRAPHER *Ronnie Brown*
AGENCY *Delaney Fletcher Bozell*
CLIENT *Triumph*
COUNTRY *England*

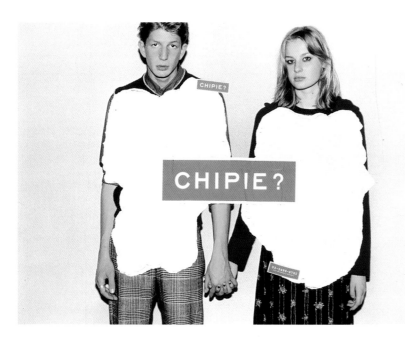

Distinctive Merit
**ADVERTISING POSTERS AND BILLBOARDS,
PRODUCT OR SERVICE, CAMPAIGN**
Coming Soon

ART DIRECTORS *Seijo Kawaguchi, Noritoshi Nishioka*
CREATIVE DIRECTOR *Kenichi Yatani*
COPYWRITERS *Hidetsugu Ishikawa,
Norihisa Dohmen*
DESIGNERS *Noritoshi Nishioka, Toshihiro Hyodo*
PHOTOGRAPHER *Juergen Teller*
AGENCY *DENTSU INC.*
CLIENT *Onward Kashiyama Co., Ltd.*
COUNTRY *Japan*

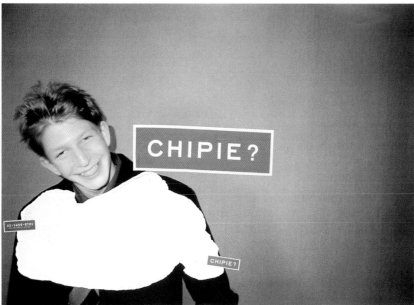

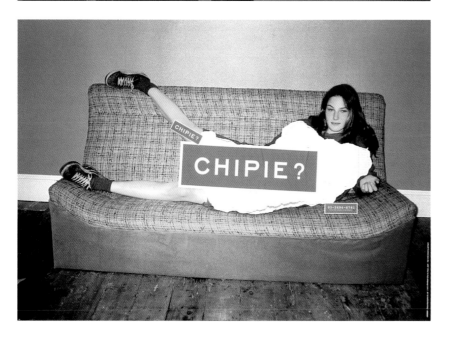

Distinctive Merit

**ADVERTISING POSTERS AND BILLBOARDS,
PRODUCT OR SERVICE**

Groupies

ART DIRECTOR *Jon Wyville*
CREATIVE DIRECTORS *Tom McConnaughy,*
Jim Schmidt
COPYWRITER *Kevin Lynch*
AGENCY *McConnaughy Stein Schmidt Brown*
CLIENT *Pravda Records*
COUNTRY *United States*

(facing page)
Distinctive Merit

**ADVERTISING POSTERS AND BILLBOARDS,
TRANSIT, CAMPAIGN**

The River League Campaign

ART DIRECTOR *Rich Wakefield*
COPYWRITER *Jim Noble*
DESIGNER *Rich Wakefield*
AGENCY *Beige Advertising*
CLIENT *The River League*
COUNTRY *United States*

MULTIPLE AWARDS

Distinctive Merit
**ADVERTISING POSTERS AND BILLBOARDS,
PUBLIC SERVICE OR NON-PROFIT/EDUCATIONAL**
Fly

Merit
**ADVERTISING POSTERS AND BILLBOARDS,
PUBLIC SERVICE OR NON-PROFIT/EDUCATIONAL,
CAMPAIGN**
Fly • Mouse • A-1

ART DIRECTOR *John Boone*
CREATIVE DIRECTOR *Hal Tench*
COPYWRITER *David Oakley*
PHOTOGRAPHERS *Reid Icard, Joe Lampi*
ILLUSTRATOR *Reid Icard (Fly)*
PRINT PRODUCERS *Linda Locks, Kay Franz*
AGENCY *The Martin Agency*
CLIENT *North Carolina Botanical Gardens*
COUNTRY *United States*

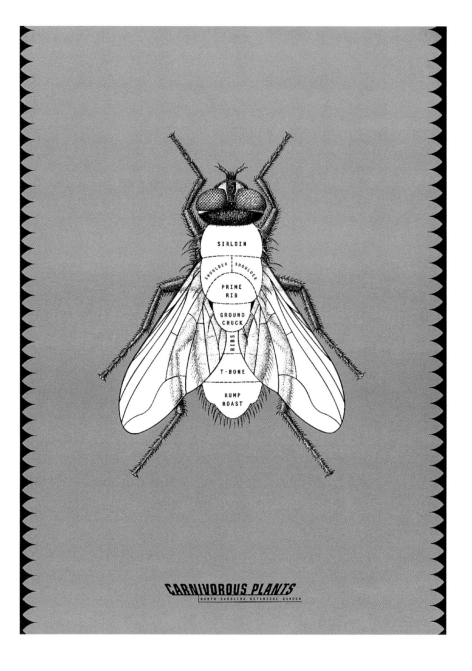

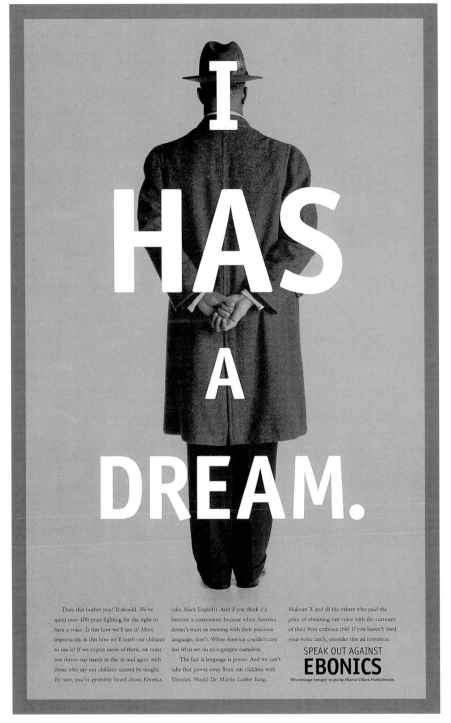

Distinctive Merit
**ADVERTISING POSTERS AND BILLBOARDS,
PUBLIC SERVICE OR NON-PROFIT/EDUCATIONAL**
I Has a Dream

ART DIRECTOR *Lee St. James*
CREATIVE DIRECTORS *Jim Spruell, Mark Robinson*
COPYWRITERS *Mark Robinson, Krystal Falkner*
(Folio Z)
AGENCY *Austin Kelley Advertising*
CLIENT *Atlanta's Black Professionals*
COUNTRY *United States*

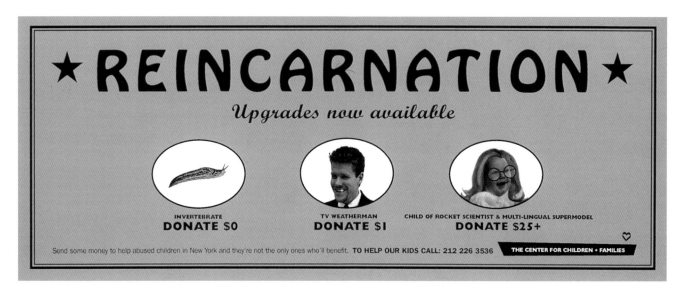

MULTIPLE AWARDS

Distinctive Merit
ADVERTISING POSTERS AND BILLBOARDS,
PUBLIC SERVICE OR NON-PROFIT/EDUCATIONAL
Reincarnation

Distinctive Merit
ADVERTISING POSTERS AND BILLBOARDS,
PUBLIC SERVICE OR NON-PROFIT/EDUCATIONAL
Jerk

Merit
ADVERTISING POSTERS AND BILLBOARDS,
TRANSIT, CAMPAIGN
Reincarnation • Jerk • Instant Gratification •
Self Image

ART DIRECTOR *Judith Grey*
CREATIVE DIRECTOR *Nick Cohen*
COPYWRITER *Neil Riley*
PHOTOGRAPHERS *Judith Grey, Matthew Huber*
PRINT PRODUCER *Valerie Hope*
AGENCY *Mad Dogs & Englishmen*
CLIENT *The Center for Children + Families*
COUNTRY *United States*

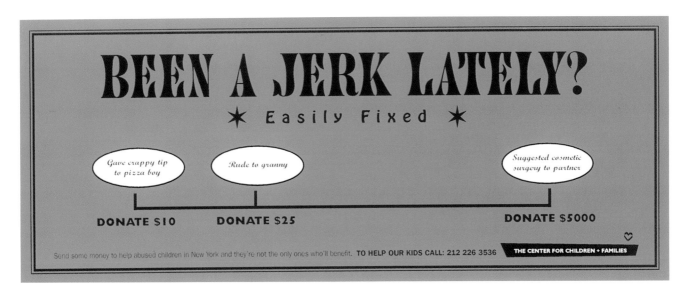

MULTIPLE AWARDS

Distinctive Merit
**ADVERTISING POSTERS AND BILLBOARDS,
PUBLIC SERVICE OR NON-PROFIT/EDUCATIONAL**
Jerk

Distinctive Merit
**ADVERTISING POSTERS AND BILLBOARDS,
PUBLIC SERVICE OR NON-PROFIT/EDUCATIONAL**
Reincarnation

Merit
**ADVERTISING POSTERS AND BILLBOARDS,
TRANSIT, CAMPAIGN**
*Reincarnation • Jerk • Instant Gratification •
Self Image*

ART DIRECTOR *Judith Grey*
CREATIVE DIRECTOR *Nick Cohen*
COPYWRITER *Neil Riley*
PHOTOGRAPHERS *Judith Grey, Matthew Huber*
PRINT PRODUCER *Valerie Hope*
AGENCY *Mad Dogs & Englishmen*
CLIENT *The Center for Children + Families*
COUNTRY *United States*

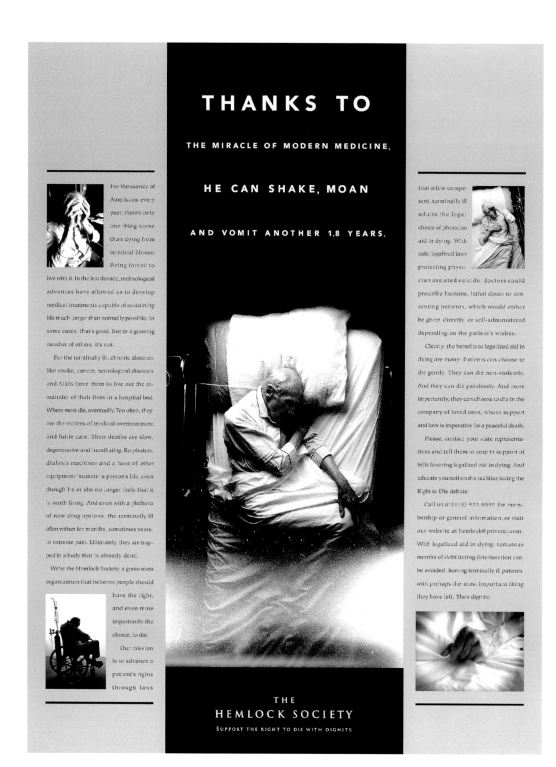

THANKS TO

THE MIRACLE OF MODERN MEDICINE,

HE CAN SHAKE, MOAN

AND VOMIT ANOTHER 1.8 YEARS.

For thousands of Americans every year, there's only one thing worse than dying from terminal illness: Being forced to live with it. In the last decade, technological advances have allowed us to develop medical treatments capable of sustaining life much longer than normally possible. In some cases, that's good. But in a growing number of others, it's not.

For the terminally ill, chronic diseases like stroke, cancer, neurological diseases and AIDS force them to live out the remainder of their lives in a hospital bed. Where most die, eventually. Too often, they are the victims of medical overtreatment and futile care. Their deaths are slow, degenerative and humiliating. Respirators, dialysis machines and a host of other equipment "sustain" a person's life, even though he or she no longer feels that it is worth living. And even with a plethora of new drug options, the terminally ill often wither for months, sometimes years, in extreme pain. Ultimately, they are trapped in a body that is already dead.

We're the Hemlock Society, a grass-roots organization that believes people should have the right, and even more importantly the choice, to die. Our mission is to advance a patient's rights through laws that allow competent, terminally ill adults the legal choice of physician aid in dying. With safe, legalized laws protecting physician assisted suicide, doctors could prescribe humane, lethal doses to consenting patients, which would either be given directly, or self-administered depending on the patient's wishes.

Clearly, the benefits to legalized aid in dying are many. Patients can choose to die gently. They can die non-violently. And they can die painlessly. And more importantly, they can choose to die in the company of loved ones, whose support and love is imperative for a peaceful death.

Please, contact your state representatives and tell them to vote in support of bills favoring legalized aid in dying. And educate yourself on the realities facing the Right to Die debate.

Call us at (415) 923-8559 for membership or general information, or visit our website at hemlock@privatei.com. With legalized aid in dying, torturous months of debilitating deterioration can be avoided, leaving terminally ill patients with perhaps the most important thing they have left. Their dignity.

THE
HEMLOCK SOCIETY
SUPPORT THE RIGHT TO DIE WITH DIGNITY.

Distinctive Merit
ADVERTISING POSTERS AND BILLBOARDS,
PUBLIC SERVICE OR NON-PROFIT/EDUCATIONAL
Modern Medicine

ART DIRECTOR *Heward Jue*
CREATIVE DIRECTORS *John Butler, Mike Shine*
COPYWRITER *Ryan Ebner*
PHOTOGRAPHER *Heward Jue*
PRINT PRODUCTION MANAGER *Deb Mumma*
AGENCY *Butler, Shine & Stern*
CLIENT *The Hemlock Society*
COUNTRY *United States*

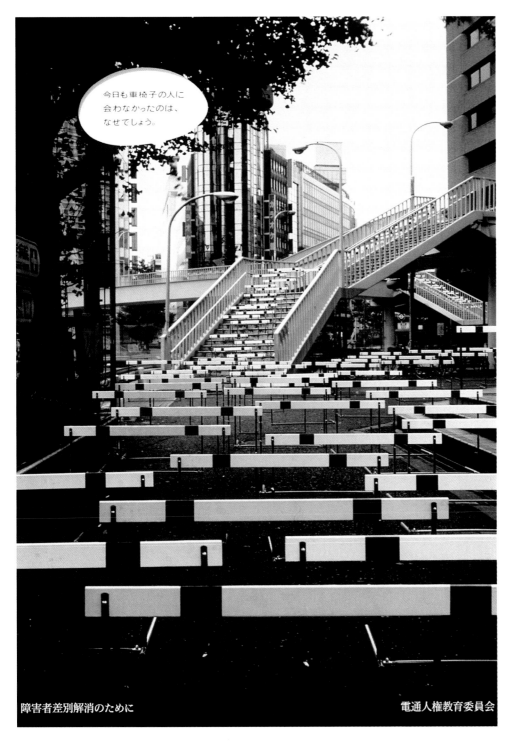

Distinctive Merit
**ADVERTISING POSTERS AND BILLBOARDS,
PUBLIC SERVICE OR NON-PROFIT/EDUCATIONAL**
*Why Didn't I Meet Someone in a Wheelchair
Today Either?*

ART DIRECTOR *Yoshio Okado*
CREATIVE DIRECTOR *Takeomi Takeichi*
COPYWRITER *Saiko Sasaki*
DESIGNERS *Masumi Hayashi, Satoshi Hara*
PHOTOGRAPHER *Hikaru Kobayashi*
STUDIO *Adbrain Inc.*
AGENCY *DENTSU INC.*
CLIENT *Dentsu Human Rights Awareness Committee/
Anti-Defamation Department, DENTSU INC.*
COUNTRY *Japan*

MULTIPLE AWARDS

Distinctive Merit
**ADVERTISING POSTERS AND BILLBOARDS,
PUBLIC SERVICE OR NON-PROFIT/EDUCATIONAL**

and Merit
**NEWSPAPER, PUBLIC SERVICE/NON-PROFIT,
FULL PAGE OR SPREAD**
Babe Ruth & Ty Cobb

Merit
**ADVERTISING POSTERS AND BILLBOARDS,
PUBLIC SERVICE OR NON-PROFIT/EDUCATIONAL,
CAMPAIGN**
*Babe Ruth & Ty Cobb • 420 Feet •
The Black Babe Ruth*

Merit
**NEWSPAPER, PUBLIC SERVICE/NON-PROFIT,
FULL PAGE OR SPREAD**
420 Feet

ART DIRECTOR *Christopher Gyorgy*
CREATIVE DIRECTOR *Hal Tench*
COPYWRITER *Chris Jacobs*
PHOTOGRAPHY *Archives from The Negro Leagues
Baseball Museum*
PRINT PRODUCER *Paul Martin*
AGENCY *The Martin Agency*
CLIENT *The Negro Leagues Baseball Museum*
COUNTRY *United States*

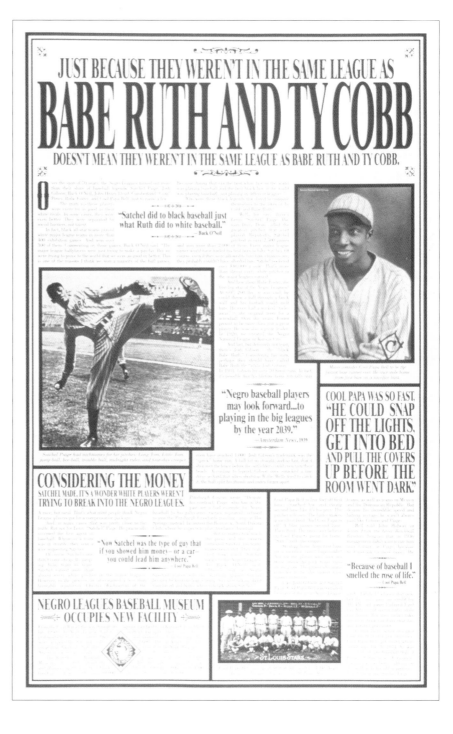

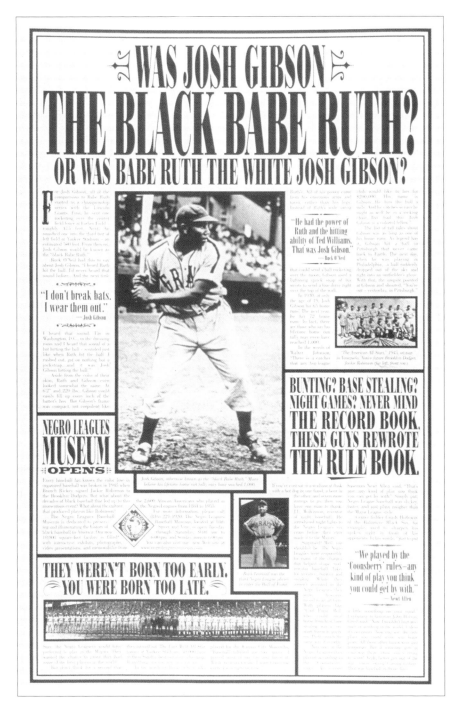

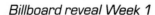

Billboard reveal Week 1

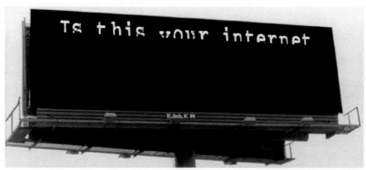

Week 2

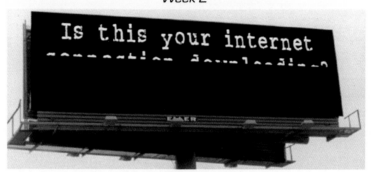

Week 3

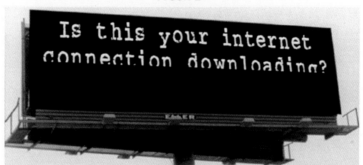

Week 4

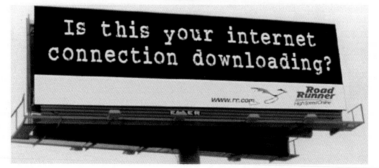

A teaser campaign communicating the experience of other Internet connections.

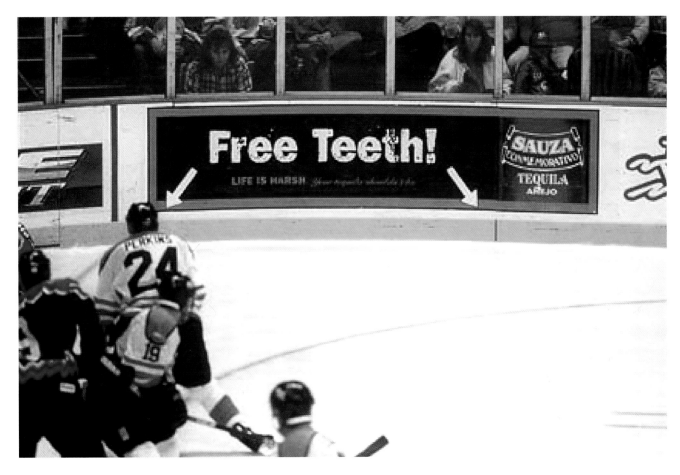

Distinctive Merit
ADVERTISING POSTERS AND BILLBOARDS,
OUTDOOR: BILLBOARD, DIORAMA,
OR PAINTED SPECTACULAR
Free Teeth

ART DIRECTOR *Wayne Best*
CREATIVE DIRECTOR *David Angelo*
COPYWRITER *Ian Reichenthal*
AGENCY *Cliff Freeman and Partners*
CLIENT *Sauza Conmemorativo*
COUNTRY *United States*

(facing page)
Distinctive Merit
ADVERTISING POSTERS AND BILLBOARDS,
OUTDOOR: BILLBOARD, DIORAMA,
OR PAINTED SPECTACULAR
Downloading

ART DIRECTOR *Darren Lim*
CREATIVE DIRECTOR *Dave Cook*
COPYWRITER *Deacon Webster*
PRODUCER *Valerie Hope*
AGENCY *Mad Dogs & Englishmen*
CLIENT *Road Runner High Speed On-line*
COUNTRY *United States*

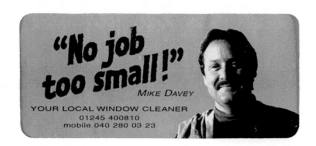

Distinctive Merit
COLLATERAL ADVERTISING, DIRECT MAIL
No Job Too Small

ART DIRECTORS *Suzi Warren, Georg Thesmann*
COPYWRITERS *Suzi Warren, Georg Thesmann*
DESIGNER *Petra Etcetera*
PHOTOGRAPHER *Helmut*
AGENCY *Bates Dorland*
CLIENT *Mike Davey*
COUNTRY *England*

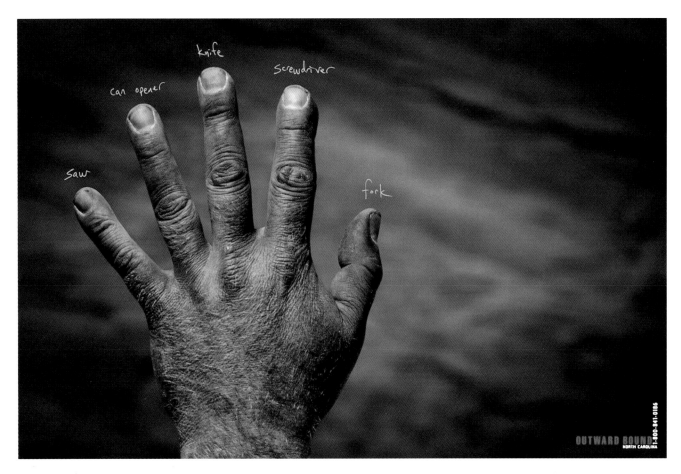

MULTIPLE AWARDS

Distinctive Merit
COLLATERAL ADVERTISING, DIRECT MAIL

and Distinctive Merit
MAGAZINE, PUBLIC SERVICE/NON-PROFIT,
FULL PAGE OR SPREAD
Hand

ART DIRECTOR *Doug Pedersen*
CREATIVE DIRECTORS *Jim Mountjoy, Ed Jones*
COPYWRITERS *Curtis Smith, Mike Duckworth*
PHOTOGRAPHER *Jim Arndt*
AGENCY *Loeffler Ketchum Mountjoy*
CLIENT *Outward Bound*
COUNTRY *United States*

Distinctive Merit
**TELEVISION COMMERCIAL, 30 SECONDS OR LESS,
CAMPAIGN**
Copies • Second Wind • Muzak

ART DIRECTOR *Rick McQuiston*
CREATIVE DIRECTORS *Jerry Cronin, Vince Engel*
COPYWRITER *Canice Neary*
PHOTOGRAPHER *Romeo Tirone*
PRODUCERS *Jon Kamen, Frank Scherma,
Robert Fernandez*
DIRECTORS *Rick Lemoine, Steve Miller*
PRODUCTION COMPANY *@radical.media, inc.*
AGENCY *Wieden & Kennedy*
CLIENT *ESPN*
COUNTRY *United States*

SCRIPT: *Copies*
SUPER: *SPORTSCENTER NEWSROOM October 5, 1997
OPENS ON ROGER CLEMENS AT COPY MACHINE. HE IS
PHOTOCOPYING THE LETTER K, OVER AND OVER AGAIN.
KENNY MAYNE WALKS IN TO DO SOME COPYING.*
ROGER: *Jack*
JACK: *Roger*
ROGER *(TO KENNY): I'm gonna be a while.*
SUPER: *This is SportsCenter.* *[LOGO] ESPN*

Distinctive Merit
TELEVISION COMMERCIAL, 30 SECONDS OR LESS, CAMPAIGN
Kidscenter • Pairings • Around the World

ART DIRECTOR *Rick McQuiston*
CREATIVE DIRECTORS *Jerry Cronin, Vince Engel*
COPYWRITER *Canice Neary*
PHOTOGRAPHER *Romeo Tirone*
PRODUCERS *Jon Kamen, Frank Scherma, Robert Fernandez*
DIRECTORS *Rick Lemoine, Steve Miller*
PRODUCTION COMPANY *@radical.media, inc.*
AGENCY *Wieden & Kennedy*
CLIENT *ESPN*
COUNTRY *United States*

SCRIPT: *Kidscenter/Evander*
OPENS ON LINDA COHN.
LINDA: *What's nice for working mothers here,...*
CUT TO EVANDER HOLYFIELD WITH HULA-HOOP.
LINDA (VO): *...is the Kidscenter,...*
CUT TO KIDS IN CENTER WITH HEADGEAR ON.
LINDA (VO): *...it fosters a family atmosphere.*
CUT TO EVANDER READING A BOOK "RUMBLE IN THE JUNGLE" OUT LOUD TO KIDS.
EVANDER: *Today we are going to read Rumble in the Jungle Book.*
CUT TO EVANDER SHOWING KIDS THE BOOK AND THEM LOOKING ON.
KIDS: *Ohhh.*
EVANDER (VO): *See Mohammed? See George? See Mohammed clobber George?*
LINDA BACK AT DESK BEING INTERVIEWED.
LINDA: *And our children learn skills...*
CUT TO KIDS PRACTICING BOXING WITH EVANDER INSTRUCTING.
LINDA: *...we don't know how to teach.*
CUT TO EVANDER, ONE ON ONE INSTRUCTION TO KIDS.
EVANDER: *No, no, no. You've got to go to the body, you've got to work the left hook. You understand?*
CUT TO EGG BEING CRACKED INTO GLASS.
LINDA (VO): *They get nutritious meals...*
CUT BACK TO BOY WATCHING EGG SLIDE DOWN GLASS.
CUT TO GIRL WALKING AROUND CLASS IN BOXING RING FASHION. SIGN READS "NAP TIME."
LINDA (VO): *...and when your teacher is the reigning WBA champ, you're going to listen. Which is nice.*
CUT TO EVANDER HANDING OUT BOXING GLOVES TO THE KIDS AS THEY LEAVE FOR THE DAY.
EVANDER: *It's cold out, don't forget your gloves.*
STUDENT (LEAVING): *Thank you.*
SUPER: *This is SportsCenter.*

Distinctive Merit
TELEVISION COMMERCIAL, 30 SECONDS OR LESS
Time Warp

ART DIRECTOR *Dick Sittig*
CREATIVE DIRECTOR *Dick Sittig*
COPYWRITER *Dick Sittig*
DIRECTOR *Dick Sittig*
PHOTOGRAPHER *Scott Buttfield*
PRODUCERS *Frank Scherma, Jon Kamen,*
Robert Fernandez
PRODUCTION COMPANY *@radical.media, inc.*
AGENCY *TBWA Chiat/Day, Inc.*
CLIENT *Jack In The Box*
COUNTRY *United States*

SCRIPT: *Time Warp*
OPEN ON THE EXTERIOR OF JACK'S OFFICE DOOR,
A MAN'S HAND KNOCKS.
MAN: *Jack??*
FROM INSIDE THE OFFICE, JACK RESPONDS.
JACK: *It's cool.*
IT IS 1975. TWO MEN ENTER, ONE WHITE, LANCE, ONE
BLACK, JOHNNY. THEY ARE DRESSED AND STYLED LIKE
THE MID 70'S. SAME FOR JACK, HIS OFFICE, AND HIS
FEMALE COMPANION.
JOHNNY: *Hey, check it out, we got the Jumbo Jack*
footage.
LANCE: *It is so boss. Hey Jack, this your foxy lady?*
JACK: *No, Helen's a —*
HELEN: *I work here.*
JOHNNY: *Right on.*
LANCE: *Bummer, a women's libber.*
HELEN: *Chauvinist pig.*
JACK: *Whoa, mellow out, let's fire up the tape.*
THE BETA TAPE IS LOADED INTO ONE OF THOSE HUGE,
EARLY PLAYBACK DECKS. IT'S PART OF JACK'S IMPRESSIVE
ENTERTAINMENT CENTER.
CUT TO FOOD CIRCA 1975, KALEIDOSCOPE EFFECTS.
LANCE: *That Jumbo Jack is primo.*
HELEN: *The fresh lettuce and tomato is blowing*
my mind.
JOHNNY: *Just 99 cents, that's a happening burger.*
SUPER: *Plus tax.*
LANCE AND JOHNNY GIVE EACH OTHER SOME SKIN,
THEN BUTT ELBOWS, THEN DO THE BUMP. CUT TO BAG
DROPS: 1: JUMBO JACK 2: STILL JUST 99¢.

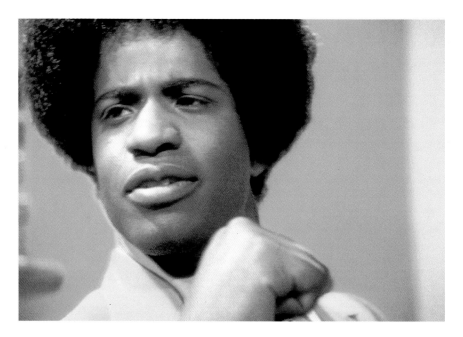

MULTIPLE AWARDS

Distinctive Merit
TELEVISION COMMERCIAL, 30 SECONDS OR LESS
Cologne

Merit
TELEVISION COMMERCIAL, 30 SECONDS OR LESS, CAMPAIGN
Referees • Canadians • Cologne

ART DIRECTORS *David Gray, Gerry Graf*
CREATIVE DIRECTORS *Charlie Miesmer, Gerry Graf, David Gray*
COPYWRITERS *Gerry Graf, David Gray*
PHOTOGRAPHER *Neil Shapiro*
PRODUCERS *Frank Scherma, Jon Kamen, Robert Fernandez*
DIRECTORS *Frank Todaro, Bryan Buckley*
PRODUCTION COMPANY *@radical.media, inc.*
AGENCY *BBDO*
CLIENT *Snickers*
COUNTRY *United States*

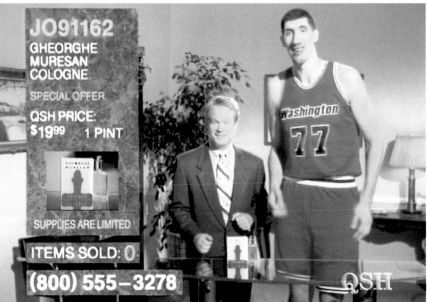

SCRIPT: *Cologne*
ANNOUNCER: *Next up, a very special item for the man.*
GHEORGHE MURESAN: *You want to smell like me?*
ANNOUNCER: *Gheorghe Muresan cologne.*
HOST OF SHOW: *Who wouldn't want to smell like you Gheorghe? I know I would.*
GHEORGHE: *Ahhh*
ANNOUNCER: *Makes a great gift item.*
GHEORGHE: *I'm waiting for your call.*
HOST OF SHOW: *Our operators are standing by.*
VO: *Not going anywhere for awhile?*
HOST OF SHOW: *Is that cabbage Gheorghe?*
GHEORGHE: *Yeah, chicks dig it.*
VO: *Grab a Snickers.*
GHEORGHE: *Call now.*
SUPER: *[LOGO] Snickers. hungry? why wait?*

Distinctive Merit
TELEVISION COMMERCIAL, 30 SECONDS OR LESS
Handy Man

ART DIRECTOR *Mark Gross*
CREATIVE DIRECTOR *Mike Oberman*
COPYWRITER *Bill Cimino*
PRODUCER *Bryan Sweeney*
DIRECTOR *Dave Merhar*
MUSIC *Elias*
STUDIO *Visitor*
AGENCY *DDB Needham Chicago*
CLIENT *Anheuser-Busch*
COUNTRY *United States*

SCRIPT: *Handy Man*
OPEN ON A GROUP OF FRIENDS MEETING AT A BAR.
MAN 1: *Hope my car gets fixed today.*
ALL: *Laughter*
MAN 2: *And my sink*
MAN 3: *And my furnace.*
MAN 4: *And my lawn mower…*
MAN 1: *What? You idiot. You're going to get us caught.*
VO: *For the great taste that won't fill you up and never let's you down.*
WOMAN: *Eddy!*
VO: *Make it a Bud Light.*
SUPER: *Make it a Bud Light. 1997 Anheuser-Busch, Inc. Bud Light Beer. St Louis, Missouri*

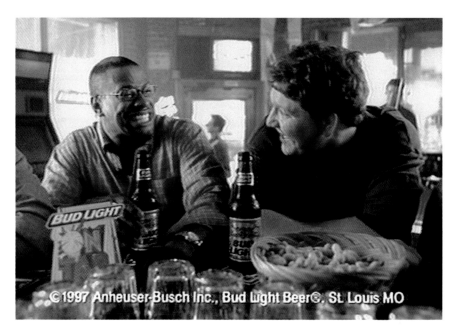

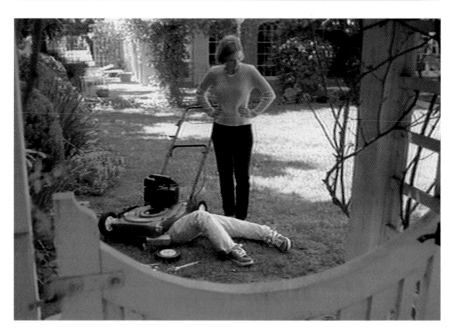

Distinctive Merit
**TELEVISION COMMERCIAL,
LOW BUDGET (UNDER $50,000)**
Star Trek

ART DIRECTORS *John Butler, Mike Shine*
CREATIVE DIRECTORS *John Butler, Mike Shine*
COPYWRITER *Ryan Ebner*
PRODUCERS *Tamsin Prigge, Meredith Norman*
DIRECTOR *Neil Tardio, Jr.*
EDITING *Jonathan Hinman, Kevin Hayenga*
(Phoenix Editorial)
AGENCY *Butler, Shine & Stern*
CLIENT *Borders Books & Music*
COUNTRY *United States*

SCRIPT: *Star Trek*
*OPEN ON A BORDERS CUSTOMER SITTING READING "THE
STAR TREK® ENCYCLOPEDIA." SUDDENLY, ANOTHER
CUSTOMER BY HIM GETS A CALL ON CEL PHONE.*
CEL PHONE GUY *(LOUDLY): Yeah…I don't care what
they're asking for…Look, I said the deal doesn't go
unless I authorize it… (CUT TO THE CUSTOMER WHO IS
READING "THE STAR TREK® ENCYCLOPEDIA." HE SLOWLY
GETS UP, LOOKING AT THE BOOK, AND WALKS OVER TO
THE GUY AND GIVES HIM A VULCAN "STUN GRIP.")
Just have them fax it… (THE CELL PHONE GUY
QUICKLY DROPS TO THE FLOOR. THE CUSTOMER LOOKS
AROUND, SURPRISED THAT IT ACTUALLY WORKED.)*
SUPER: *You can learn a lot from Star Trek.*
SUPER: *"The Star Trek® Encyclopedia."*
SUPER *(TYPEWRITER): Borders. Books. Music. Video.
And a Cafe. Come inside.*
*CUT BACK TO THE BORDERS STORE WHERE EVERYONE
IS CLAPPING.*

MV: *Yeah, Hello, Mega Records.*

RUI: *Mmm great, I'm looking for a song. I saw it on MTV last night.*

MV: *Yeah, okay, sure, what's the name of the band?*

RUI: *Um, I don't know the name...the name of the band. But I know how it goes.*

MV: *Okay, shoot, tell me.*

RUI: *It goes naa, naa, dumph, dumph (INCOHERENT TUNE).*

MV: *No, I don't recognize that one…No, I don't know it, sorry.*

RUI: *Um, hold on I remember now.*

MV: *The name of the band?*

RUI: *No, no I remember how it goes, it's kind of…the guitars sort of quiver a bit.*

VO: *Fortunately, MTN's Pulse Package gives you 120 free weekend minutes every month.*

MV: *I gotta say I've got no idea…no, I don't know it.*

RUI: *Wait, the same band…they had quite a big hit a couple of months ago.*

MV: *Is it?*

RUI: *Yeah, you gotta remember it—it goes naa, naa, dumph, dumph (FADE OFF).*

Distinctive Merit
RADIO ADVERTISING, OVER 30 SECONDS
Record

CREATIVE DIRECTOR *Sandra De Witt*
COPYWRITERS *Richard Bullock, Reed Collins*
PRODUCER *Alison Thame*
DIRECTORS *Richard Bullock, Reed Collins*
VOICES *Rui Alves, Derek Shevel*
STUDIO *Memphis Studio*
AGENCY *TBWA Hunt Lascaris Johannesburg*
CLIENT *Mobile Telephone Network*
COUNTRY *South Africa*

merit

advertising

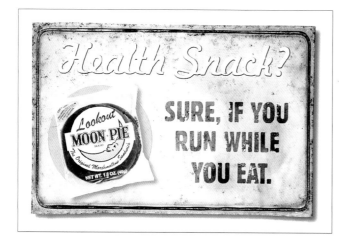

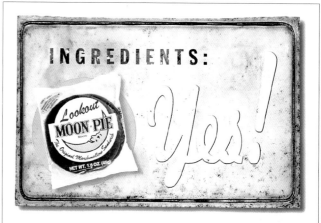

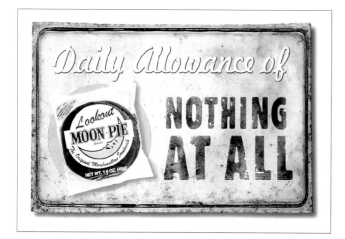

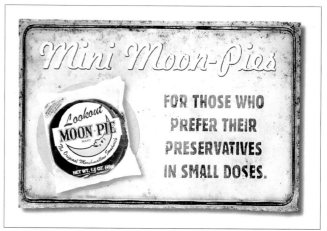

Merit

**NEWSPAPER, CONSUMER, LESS THAN A FULL PAGE,
CAMPAIGN**

*Health Snack • Yes Moon • Daily Allowance •
Mini Moon*

ART DIRECTOR *Michael Cohen*
CREATIVE DIRECTOR *Jim Mountjoy*
COPYWRITERS *Curtis Smith, Mike Duckworth*
PHOTOGRAPHER *Pat Staub*
AGENCY *Loeffler Ketchum Mountjoy*
CLIENT *Moon Pie*
COUNTRY *United States*

Merit

NEWSPAPER, CONSUMER, FULL PAGE OR SPREAD, CAMPAIGN

Restaurants • Plumbers • Locksmiths

ART DIRECTOR *Tony Purnell*
CREATIVE DIRECTOR *Graham Warsop*
COPYWRITER *Brendan Jack*
TYPOGRAPHER *Tony Purnell*
AGENCY *The Jupiter Drawing Room*
CLIENT *Maister Directories*
COUNTRY *South Africa*

Merit

NEWSPAPER, TRADE, FULL PAGE OR SPREAD, CAMPAIGN
Michael Jordan • Economist • Hemorrhoids

ART DIRECTOR *Vanessa Pearson*
CREATIVE DIRECTOR *Graham Warsop*
COPYWRITER *Lawrence Seftel*
AGENCY *The Jupiter Drawing Room*
CLIENT *AAA School of Advertising*
COUNTRY *South Africa*

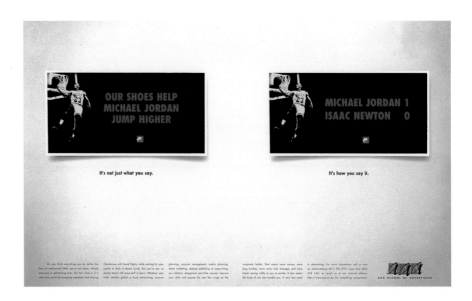

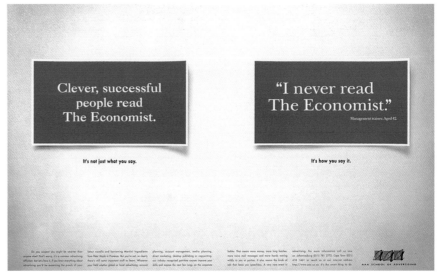

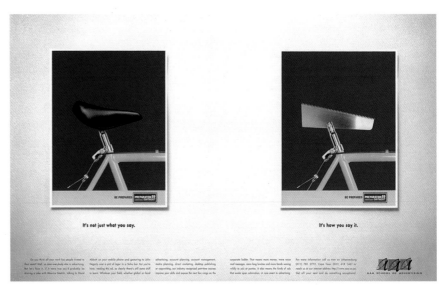

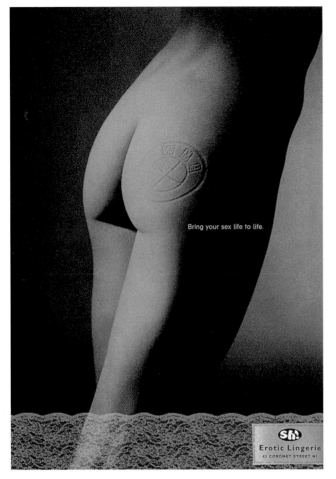

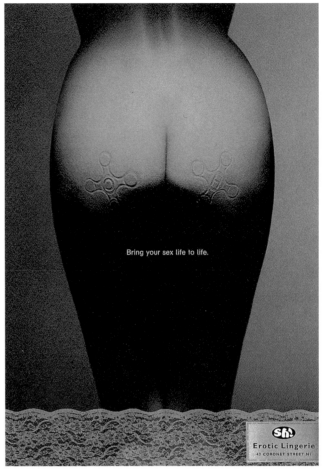

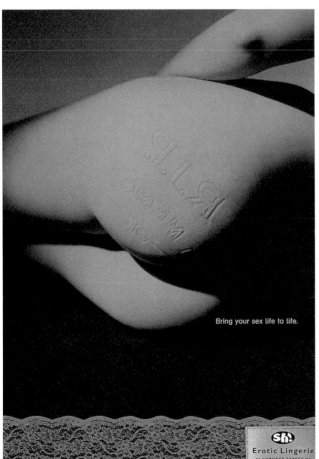

MULTIPLE AWARDS

Merit
MAGAZINE, CONSUMER, LESS THAN A FULL PAGE, CAMPAIGN
BMW • Taps • R.I.P. • Phone Dial

Merit
MAGAZINE, CONSUMER, LESS THAN A FULL PAGE
Taps

Merit
ADVERTISING PHOTOGRAPHY, FASHION
Phone Dial

ART DIRECTORS *Paul Alderman, Pete Ogden*
CREATIVE DIRECTOR *Tim Ashton*
COPYWRITER *Paul Alderman*
MODEL MAKER *Andy Knight*
PHOTOGRAPHER *Tony May*
TYPOGRAPHERS *Kim Le Liboux, Sefton Quest*
AGENCY *Bates Dorland*
CLIENT *Sh! Erotic Lingerie Emporium*
COUNTRY *England*

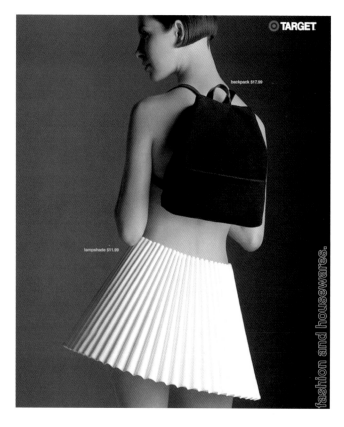

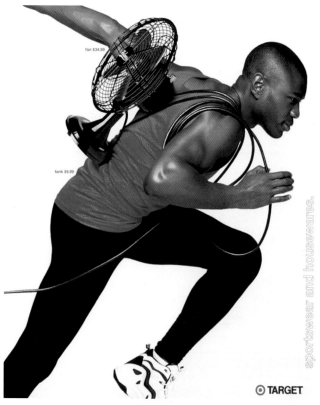

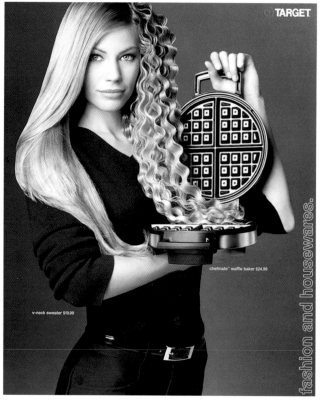

Merit

MAGAZINE, CONSUMER, FULL PAGE OR SPREAD, CAMPAIGN

Target Fashion (Lampshade • Runner • Waffle Iron)

ART DIRECTOR *James Hitchcock*
CREATIVE DIRECTOR *Bill Oberlander*
COPYWRITER *Bob Havlena*
PHOTOGRAPHER *Matthew Rolston*
AGENCY *Kirshenbaum Bond & Partners*
CLIENT *Target*
COUNTRY *United States*

(facing page)
Merit

MAGAZINE, CONSUMER, FULL PAGE OR SPREAD, CAMPAIGN

Apple Corer • Potato Peeler • Ice Cream Scoop • Soufflé Scrubber

ART DIRECTOR *David Fox*
EXECUTIVE CREATIVE DIRECTOR *Marty Cooke*
COPYWRITER *Scott Zacaroli*
PHOTOGRAPHER *Jana Leon*
AGENCY *Merkley Newman Harty*
CLIENT *OXO*
COUNTRY *United States*

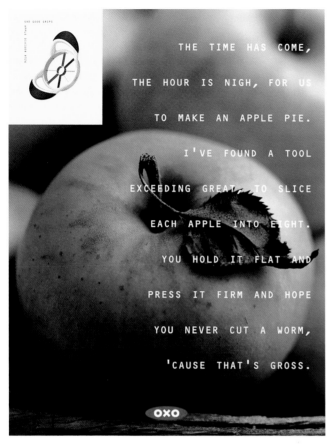

THE TIME HAS COME, THE HOUR IS NIGH, FOR US TO MAKE AN APPLE PIE. I'VE FOUND A TOOL EXCEEDING GREAT, TO SLICE EACH APPLE INTO EIGHT. YOU HOLD IT FLAT AND PRESS IT FIRM AND HOPE YOU NEVER CUT A WORM, 'CAUSE THAT'S GROSS.

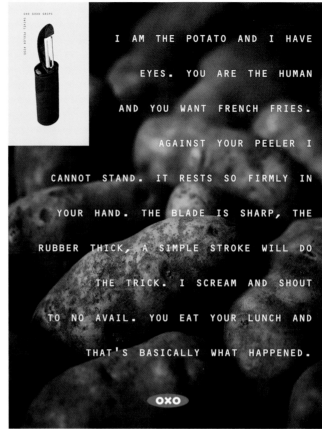

I AM THE POTATO AND I HAVE EYES. YOU ARE THE HUMAN AND YOU WANT FRENCH FRIES. AGAINST YOUR PEELER I CANNOT STAND. IT RESTS SO FIRMLY IN YOUR HAND. THE BLADE IS SHARP, THE RUBBER THICK, A SIMPLE STROKE WILL DO THE TRICK. I SCREAM AND SHOUT TO NO AVAIL. YOU EAT YOUR LUNCH AND THAT'S BASICALLY WHAT HAPPENED.

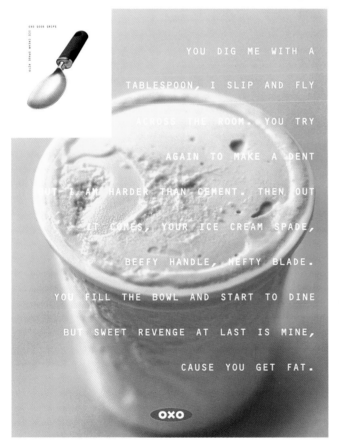

YOU DIG ME WITH A TABLESPOON, I SLIP AND FLY ACROSS THE ROOM. YOU TRY AGAIN TO MAKE A DENT BUT I AM HARDER THAN CEMENT. THEN OUT IT COMES, YOUR ICE CREAM SPADE, BEEFY HANDLE, HEFTY BLADE. YOU FILL THE BOWL AND START TO DINE BUT SWEET REVENGE AT LAST IS MINE, CAUSE YOU GET FAT.

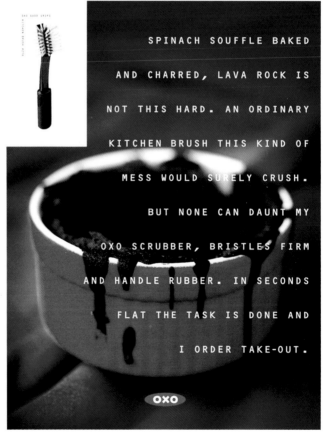

SPINACH SOUFFLE BAKED AND CHARRED, LAVA ROCK IS NOT THIS HARD. AN ORDINARY KITCHEN BRUSH THIS KIND OF MESS WOULD SURELY CRUSH. BUT NONE CAN DAUNT MY OXO SCRUBBER, BRISTLES FIRM AND HANDLE RUBBER. IN SECONDS FLAT THE TASK IS DONE AND I ORDER TAKE-OUT.

Merit

**MAGAZINE, CONSUMER, FULL PAGE OR SPREAD,
CAMPAIGN**
Phonograph • Toy Trucks • Three Girls

ART DIRECTOR *Gary Goldsmith*
CREATIVE DIRECTORS *Lee Garfinkel,
Gary Goldsmith*
COPYWRITER *Dean Hacohen*
PHOTOGRAPHY *Stock*
AGENCY *Lowe & Partners/SMS*
CLIENT *Sony Electronics, Inc.*
COUNTRY *United States*

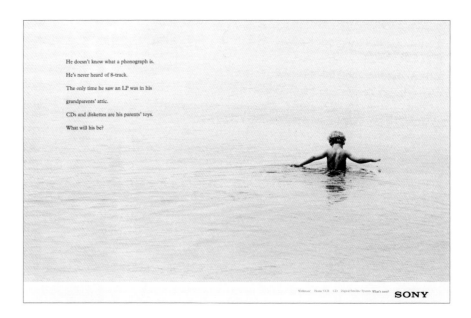

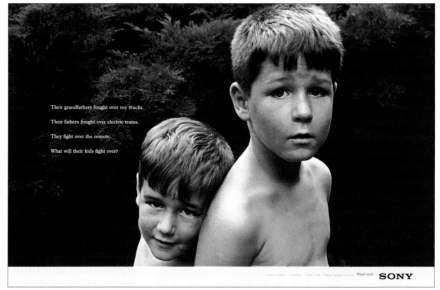

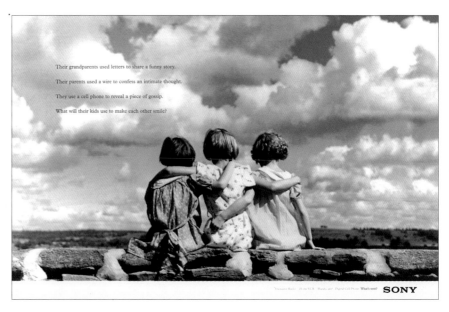

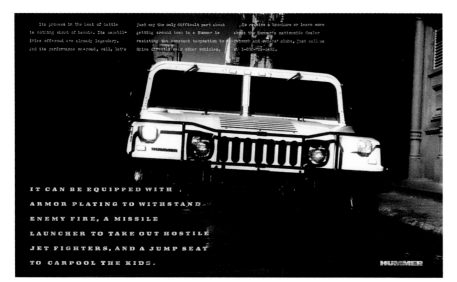

IT CAN BE EQUIPPED WITH
ARMOR PLATING TO WITHSTAND
ENEMY FIRE, A MISSILE
LAUNCHER TO TAKE OUT HOSTILE
JET FIGHTERS, AND A JUMP SEAT
TO CARPOOL THE KIDS.

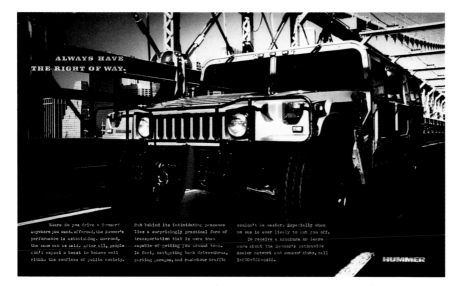

ALWAYS HAVE
THE RIGHT OF WAY.

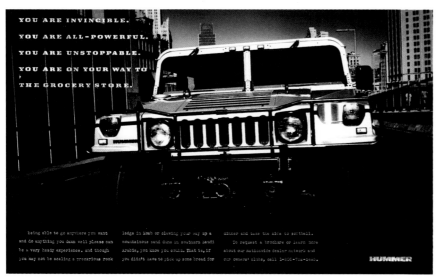

YOU ARE INVINCIBLE.
YOU ARE ALL-POWERFUL.
YOU ARE UNSTOPPABLE.
YOU ARE ON YOUR WAY TO
THE GROCERY STORE.

Merit

MAGAZINE, CONSUMER, FULL PAGE OR SPREAD, CAMPAIGN

Car Pool • Right of Way • Grocery Store

ART DIRECTOR *Terence Reynolds*
CREATIVE DIRECTORS *Todd Tilford, Terence Reynolds*
COPYWRITER *Todd Tilford*
PHOTOGRAPHER *Richard Reens*
AGENCY *Pyro*
CLIENT *AM General*
COUNTRY *United States*

Merit

**MAGAZINE, CONSUMER, FULL PAGE OR SPREAD,
CAMPAIGN**

Emissions • Cat • Shirt

ART DIRECTOR *Gary Marshall*
CREATIVE DIRECTOR *Steve Dunn*
COPYWRITER *Paul Marshall*
DESIGNER *Gary Marshall*
PHOTOGRAPHER *Chris Harrison*
AGENCY *Lowe, Howard-Spink*
CLIENT *British School of Motoring*
COUNTRY *England*

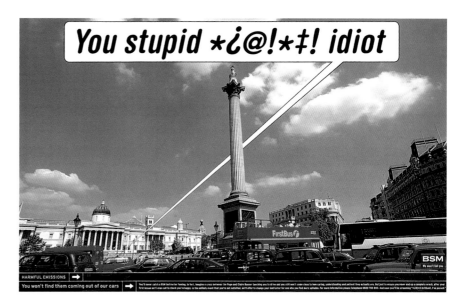

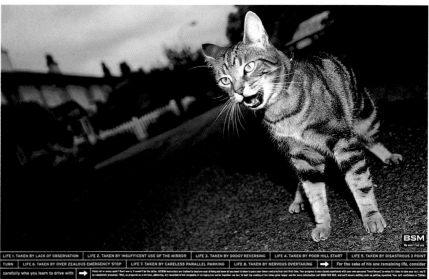

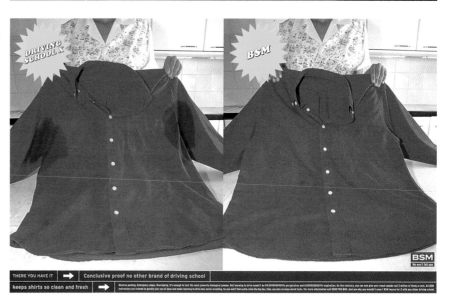

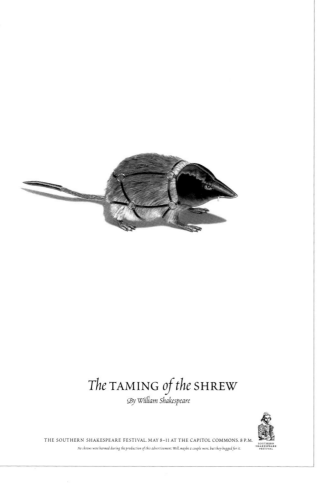

The TAMING *of the* SHREW

By William Shakespeare

THE SOUTHERN SHAKESPEARE FESTIVAL. MAY 8–11 AT THE CAPITOL COMMONS. 8 P.M.

No shrews were harmed during the production of this advertisement. Well, maybe a couple were, but they begged for it.

Why are the ads for IBM created on a Macintosh?

Na hora de fazer anúncios para mostrar o quanto seus computadores são bons, a concorrência prefere usar os nossos: o Power Macintosh é o computador mais usado em publicidade no mundo inteiro. A esmagadora maioria dos anúncios que você vê numa revista é feita num Power Macintosh. Talvez porque o Macintosh seja, na prática, tudo o que a propaganda dos outros computadores afirma: mais simples, mais rápido, mais versátil e mais compatível com outras plataformas. O único que pode dar a uma agência de publicidade a agilidade que ela precisa para satisfazer clientes muito exigentes. Como, por exemplo, uma IBM.

 Apple®

MULTIPLE AWARDS

Merit
NEWSPAPER, CONSUMER, FULL PAGE OR SPREAD

and Merit
ADVERTISING POSTERS & BILLBOARDS, ENTERTAINMENT OR SPECIAL EVENT
Shrew

ART DIRECTOR *Rob Kerr*
CREATIVE DIRECTOR *Doug Engel*
COPYWRITER *Lee Gonzalez*
ILLUSTRATOR *Keith Towler*
PRODUCER *Gwendy Vea*
AGENCY *The Zimmerman Agency*
CLIENT *The Southern Shakespeare Festival*
COUNTRY *United States*

Merit
NEWSPAPER, CONSUMER, FULL PAGE OR SPREAD
Why Are Ads for IBM Created on a Macintosh?

ART DIRECTOR *Marcello Serpa*
CREATIVE DIRECTOR *Marcello Serpa*
COPYWRITER *Eugenio Mohallem*
PHOTOGRAPHY *Apple Archive*
PRODUCER *Jose Roberto Bezerra*
AGENCY *Almap/BBDO Comunicações Ltda.*
CLIENT *Apple Computer Brasil*
COUNTRY *Brazil*

Merit
NEWSPAPER, CONSUMER, FULL PAGE OR SPREAD
Unusually Long Headline

ART DIRECTOR *Joost Hulsbosch*
CREATIVE DIRECTORS *Mark Varder, Joost Hulsbosch*
COPYWRITER *Mark Varder*
AGENCY *Sonnenberg Murphy Leo Burnett*
CLIENT *Reebok S.A.*
COUNTRY *South Africa*

This is an unusually long headline for a print ad. With good reason though. By the time you've read from the first word to the last, including all these words you're trying to hurry past right now - you are, aren't you? - anyway, as we were saying, by the time you get to the last word, you'll have an idea of just how much time Elana Meyer carved off a world record - a <u>world</u> record - not just 0,2 seconds or 2,2 seconds - when she competed in a half marathon in Tokyo on Sunday, running in a pair of Reeboks.

Most people will take just over 20 seconds to read the headline above. Last Sunday Elana Meyer returned to international athletics in Tokyo by slicing an incredible 22 seconds off the woman's world half-marathon record. She covered 21,1 kilometres in 67 minutes 36 seconds. But then she is Elana Meyer. And she was running in the best shoes on earth.

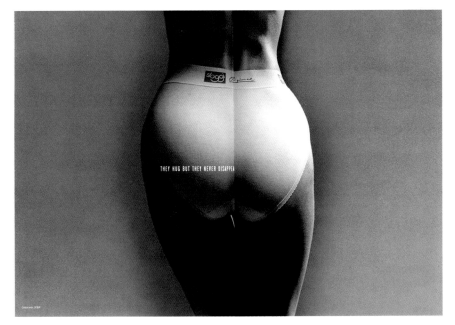

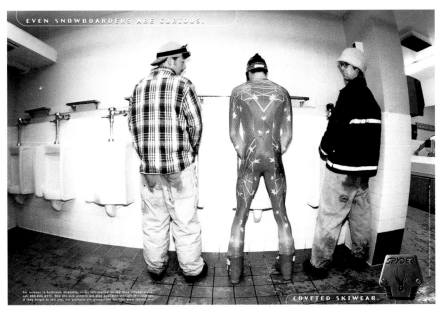

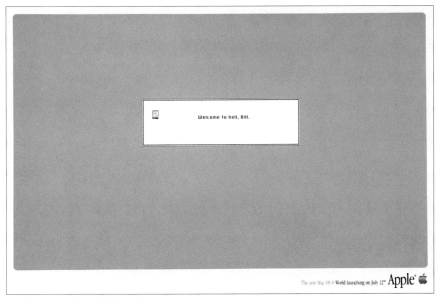

Merit
MAGAZINE, TRADE, FULL PAGE OR SPREAD
Remote Control

ART DIRECTOR *Darren Lim*
CREATIVE DIRECTORS *Dave Cook, Nick Cohen*
COPYWRITER *Alex Lang*
PHOTOGRAPHER *Nora Scarlett*
PRODUCER *Valerie Hope*
AGENCY *Mad Dogs & Englishmen*
CLIENT *Nickelodeon*
COUNTRY *United States*

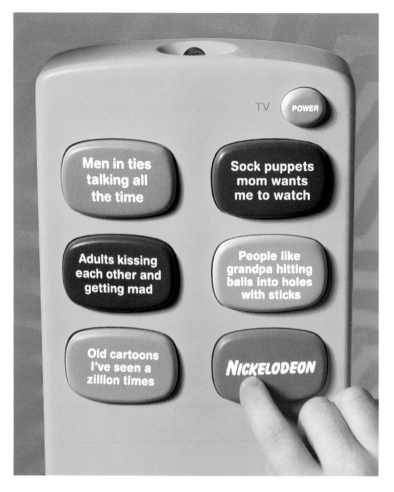

Merit
MAGAZINE, TRADE, FULL PAGE OR SPREAD
Janou Pakter, Inc.

CREATIVE DIRECTOR *Bridget de Socio*
DESIGNERS *Jason Endres, Ninja von Oertzen*
PHOTOGRAPHER *André Thijssen*
AGENCY *Socio X*
STUDIO *Socio X*
CLIENT *Janou Pakter, Inc.*
COUNTRY *United States*

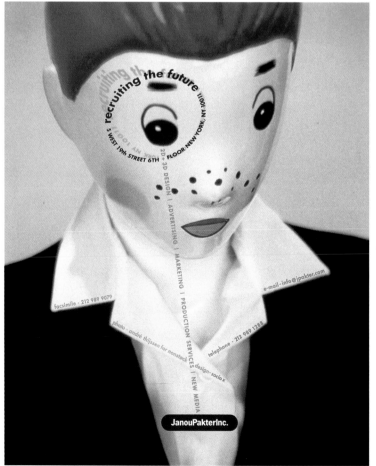

Merit
MAGAZINE, TRADE, FULL PAGE OR SPREAD
Blue-lined Paper

ART DIRECTOR *Shyam Madiraju*
CREATIVE DIRECTOR *Jean Robaire*
COPYWRITER *Peter Blikslager*
ILLUSTRATOR *Graham Jacobs*
PRINT PRODUCER *Renee Carrano*
AGENCY *The Martin Agency*
CLIENT *Art Center College*
COUNTRY *United States*

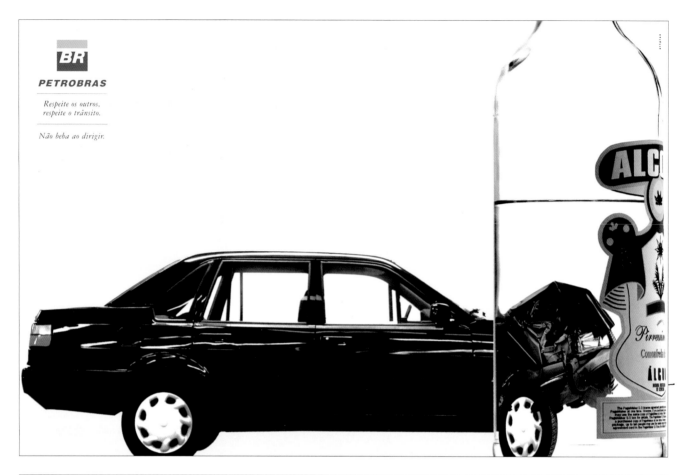

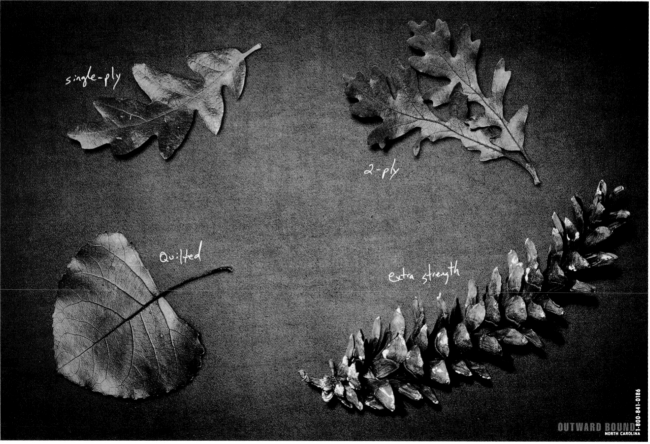

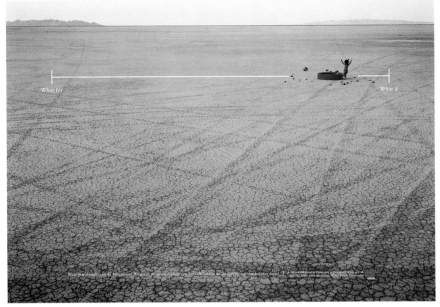

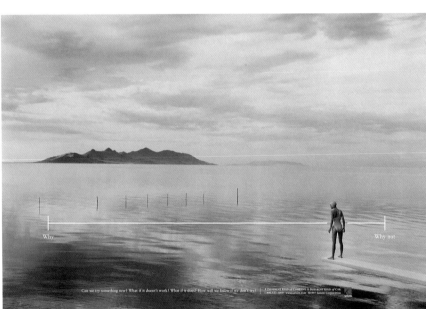

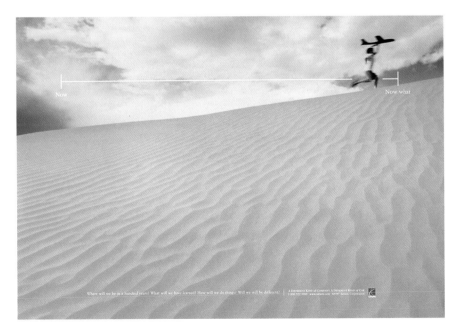

MULTIPLE AWARDS

Merit
ADVERTISING PHOTOGRAPHY, MAGAZINE OR NEWSPAPER, CAMPAIGN
Now, Now what • What for, What if • Why, Why not

Merit
PHOTOGRAPHY, PRODUCT OR SERVICE
Why, Why not

Merit
PHOTOGRAPHY, PRODUCT OR SERVICE
What for, What if

ART DIRECTOR *David Carter*
CREATIVE DIRECTORS *Dave O'Hare, John Doyle*
COPYWRITER *Kurt Dentry*
PHOTOGRAPHER *Nadav Kander*
PRODUCER *Loni Weholt*
AGENCY *Hal Riney & Partners*
CLIENT *The Saturn Corporation*
COUNTRY *England*

(facing page, top)
Merit
MAGAZINE, PUBLIC SERVICE/NON-PROFIT, FULL PAGE OR SPREAD
Vodka

ART DIRECTOR *Guilherme Jahara*
CREATIVE DIRECTORS *Chico Abreia, Marcos Apostolo*
COPYWRITER *André Kassú*
PHOTOGRAPHER *Mauro Risch*
AGENCY *Artplan Comunicações S.A.*
CLIENT *Postos Petrobras*
COUNTRY *Brazil*

(facing page, bottom)
MULTIPLE AWARDS

Merit
MAGAZINE, PUBLIC SERVICE/NON-PROFIT, FULL PAGE OR SPREAD

and Merit
COLLATERAL ADVERTISING, DIRECT MAIL
Leaves

ART DIRECTOR *Doug Pedersen*
CREATIVE DIRECTORS *Jim Mountjoy, Ed Jones*
COPYWRITERS *Curtis Smith, Mike Duckworth*
PHOTOGRAPHER *Jim Arndt*
AGENCY *Loeffler Ketchum Mountjoy*
CLIENT *Outward Bound*
COUNTRY *United States*

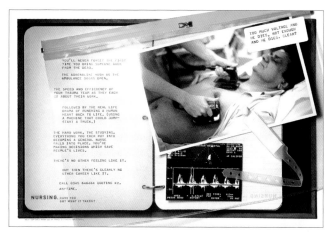

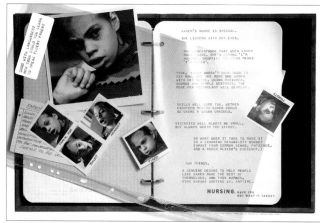

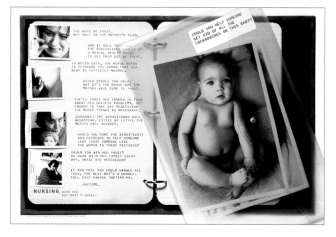

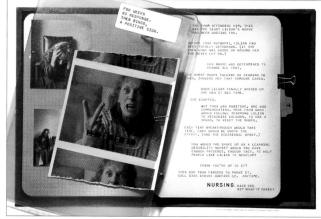

Merit

ADVERTISING PHOTOGRAPHY, MAGAZINE OR NEWSPAPER, CAMPAIGN

Clear • Karen • Cockroaches • Two Fingers

ART DIRECTORS *John Messum, Colin Jones*
CREATIVE DIRECTORS *Adam Kean, Alex Taylor*
COPYWRITER *Mike McKenna*
DESIGNERS *John Messum, Roger Kennedy*
PHOTOGRAPHER *Graham Cornthwaite*
TYPOGRAPHER *Roger Kennedy*
AGENCY *Saatchi & Saatchi*
STUDIO *Actis*
CLIENT *Department of Health (Nursing)*
COUNTRY *England*

(facing page)
MULTIPLE AWARDS

Merit

ADVERTISING POSTERS AND BILLBOARDS, OUTDOOR: BILLBOARD, DIORAMA, OR PAINTED SPECTACULAR, CAMPAIGN

Ali • Henson • Einstein

Merit

ADVERTISING POSTERS AND BILLBOARDS, OUTDOOR: BILLBOARD, DIORAMA, OR PAINTED SPECTACULAR

Ali

ART DIRECTORS *Lee Clow, Jessica Schulman, Craig Tanimoto, Eric Grunbaum*
CREATIVE DIRECTOR *Lee Clow*
COPYWRITERS *Craig Tanimoto, Eric Grunbaum*
PRODUCERS *Christine Callejas, Laura Heller*
AGENCY *TBWA Chiat/Day, Inc.*
CLIENT *Apple Computer, Inc.*
COUNTRY *United States*

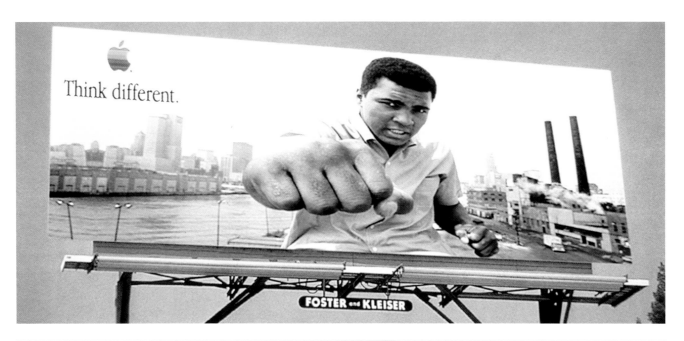

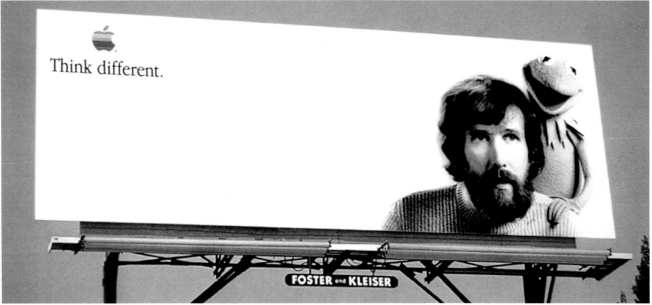

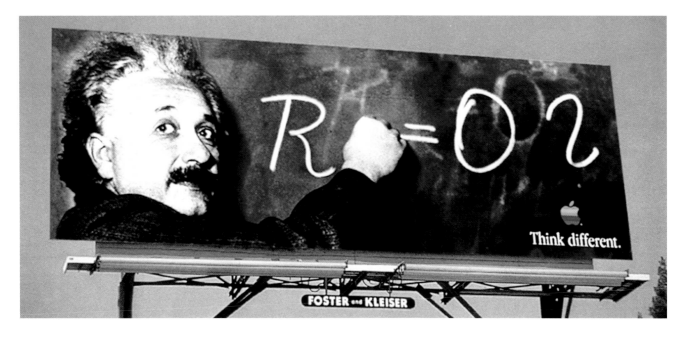

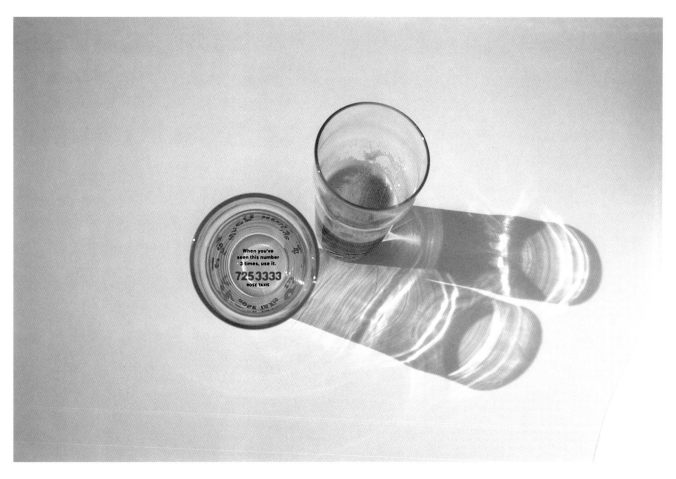

Merit
**ADVERTISING POSTERS AND BILLBOARDS,
POINT-OF-PURCHASE**
Glass

ART DIRECTOR *Guto Bussab*
CREATIVE DIRECTOR *Kady Winetzki*
COPYWRITER *Desiree Brown*
AGENCY *Sonnenberg Murphy Leo Burnett*
CLIENT *Rose Taxis*
COUNTRY *South Africa*

(facing page)
Merit
**ADVERTISING POSTERS AND BILLBOARDS,
PRODUCT OR SERVICE**
Liner Notes

ART DIRECTOR *Jon Wyville*
CREATIVE DIRECTORS *Tom McConnaughy,
Jim Schmidt*
COPYWRITER *Kevin Lynch*
AGENCY *McConnaughy Stein Schmidt Brown*
CLIENT *Pravda Records*
COUNTRY *United States*

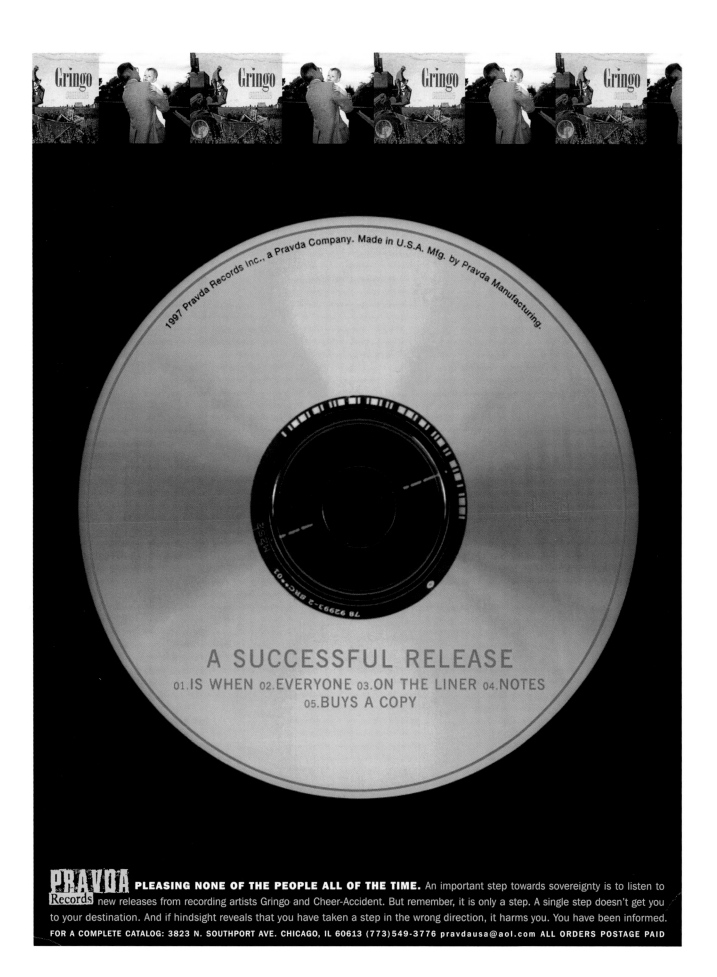

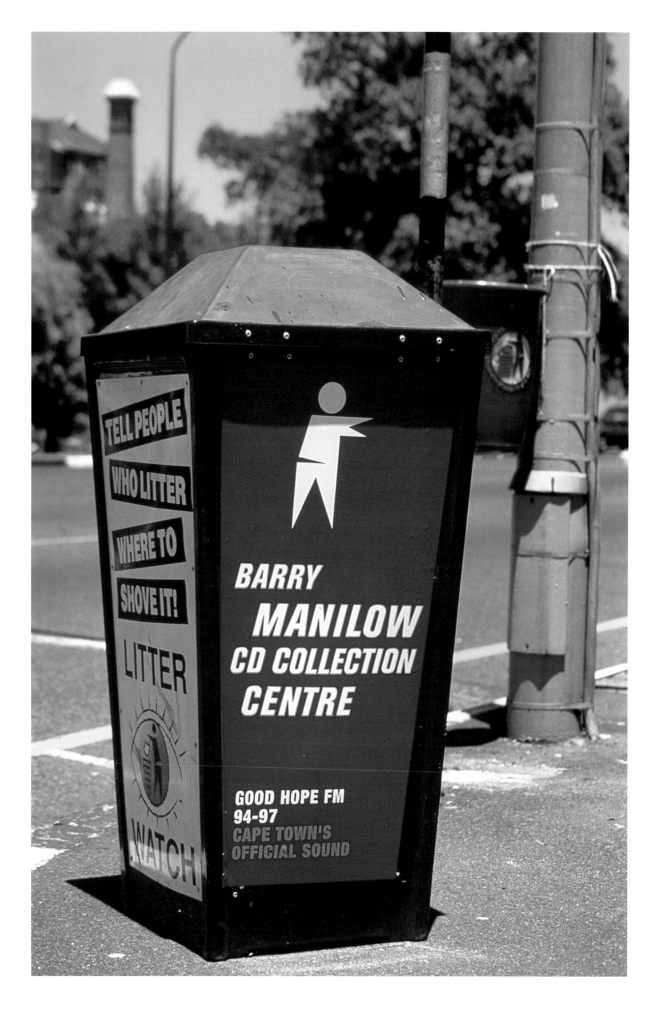

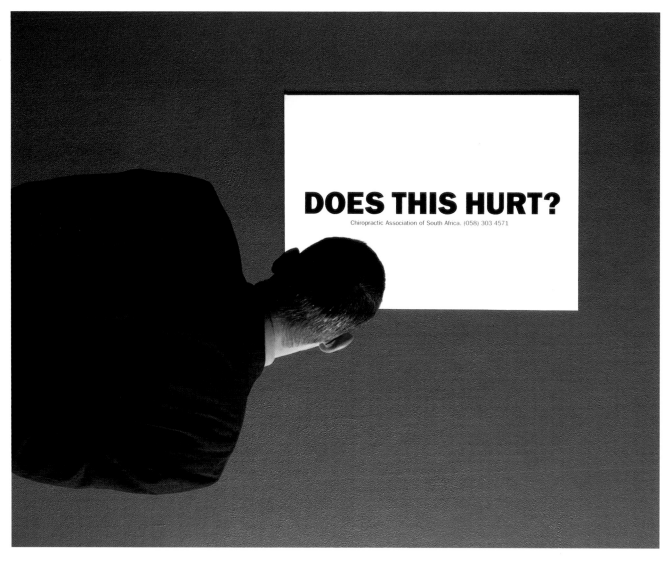

Merit
**ADVERTISING POSTERS AND BILLBOARDS,
PRODUCT OR SERVICE**
Does This Hurt?

ART DIRECTOR *Julian Watt*
CREATIVE DIRECTOR *Kady Winetzki*
COPYWRITER *Jonathan Stilwell*
AGENCY *Sonnenberg Murphy Leo Burnett*
CLIENT *Chiropractic Association of South Africa*
COUNTRY *South Africa*

(facing page)
Merit
**ADVERTISING POSTERS AND BILLBOARDS,
PRODUCT OR SERVICE**
Barry Manilow

ART DIRECTORS *Marc Lineveldt, Kristian Sumners*
CREATIVE DIRECTORS *Marc Lineveldt,*
Kristian Sumners
COPYWRITER *Kristian Sumners*
DESIGNER *Roald Van Wyk*
AGENCY *TBWA Hunt Lascaris Cape*
CLIENT *Good Hope FM*
COUNTRY *South Africa*

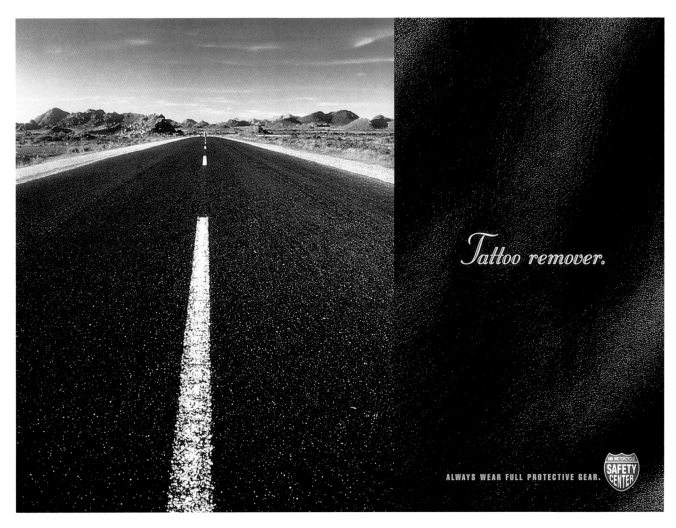

Merit
ADVERTISING POSTERS AND BILLBOARDS,
PUBLIC SERVICE OR NON-PROFIT/EDUCATIONAL
Tattoo Remover

ART DIRECTOR *Randy Hughes*
CREATIVE DIRECTOR *Lyle Wedemeyer*
COPYWRITER *Tom Kelly*
DESIGNER *Randy Hughes*
PHOTOGRAPHER *Rip Saw, Inc.*
DIGITAL ENHANCEMENT *Brad Palm (d'palmz)*
AGENCY *Martin/Williams Advertising*
CLIENT *Minnesota Motorcycle Safety Center*
COUNTRY *United States*

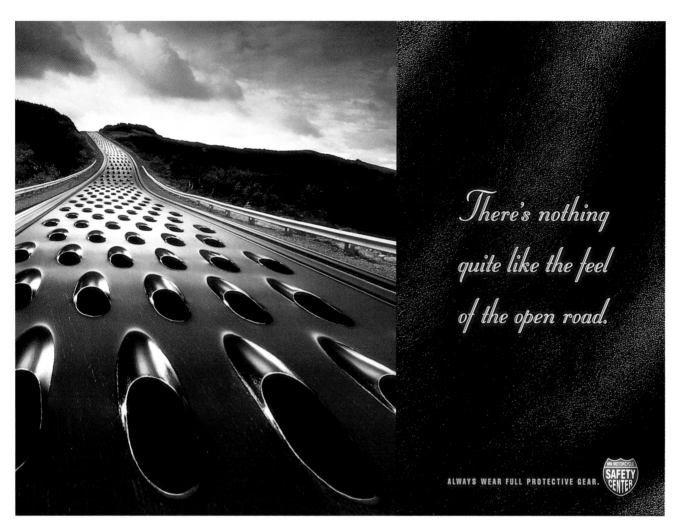

Merit
ADVERTISING POSTERS AND BILLBOARDS,
PUBLIC SERVICE OR NON-PROFIT/EDUCATIONAL
Cheese Grater

ART DIRECTOR *Randy Hughes*
CREATIVE DIRECTOR *Lyle Wedemeyer*
COPYWRITER *Tom Kelly*
DESIGNER *Randy Hughes*
PHOTOGRAPHER *Rip Saw, Inc.*
DIGITAL ENHANCEMENT *Brad Palm (d'palmz)*
AGENCY *Martin/Williams Advertising*
CLIENT *Minnesota Motorcycle Safety Center*
COUNTRY *United States*

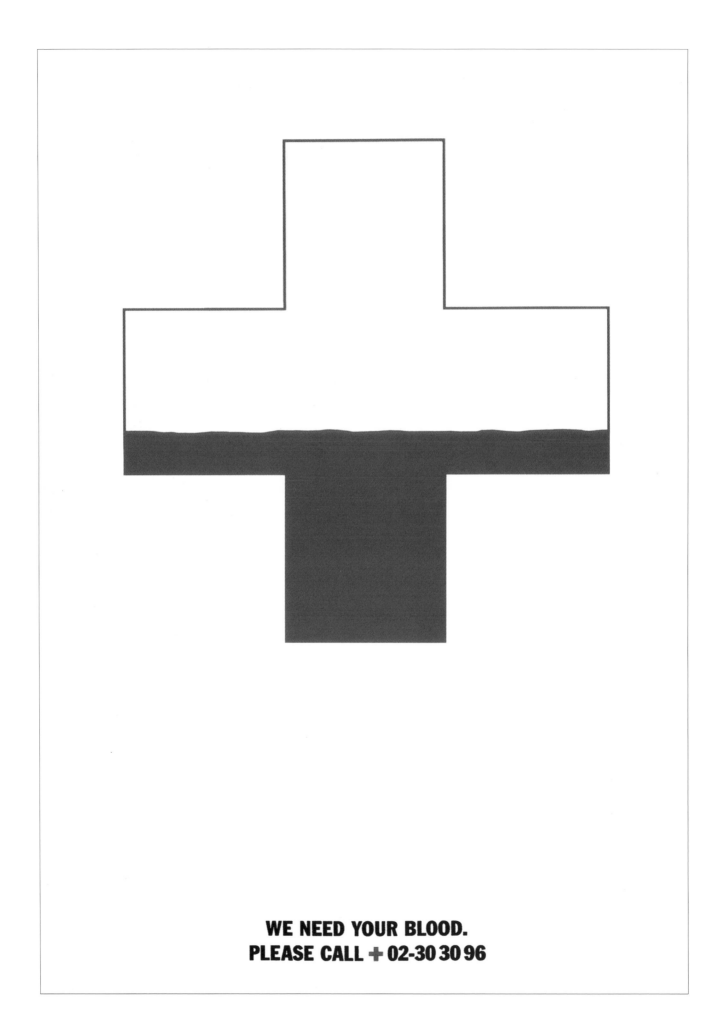

WE NEED YOUR BLOOD.
PLEASE CALL ✚ 02-30 30 96

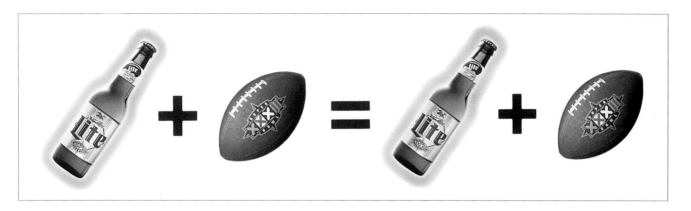

Merit
**ADVERTISING POSTERS AND BILLBOARDS,
TRANSIT**
Beer + Football

ART DIRECTOR *Dan Olson*
CREATIVE DIRECTOR *Joe Duffy*
COPYWRITER *Dave Pullar*
DESIGNER *Dan Olson*
PHOTOGRAPHER *Chris Sheehan*
ILLUSTRATOR *Dan Olson*
STUDIO *Duffy Design*
CLIENT *Miller Brewing Co.*
COUNTRY *United States*

(facing page)
Merit
**ADVERTISING POSTERS AND BILLBOARDS,
PUBLIC SERVICE OR NON-PROFIT/EDUCATIONAL**
Blood

ART DIRECTOR *Jürgen Mandel*
CREATIVE DIRECTOR *Jürgen Mandel*
COPYWRITER *Jürgen Mandel*
ILLUSTRATOR *Jürgen Mandel*
AGENCY *Mandel, Muth, Werbeagentur GmbH*
CLIENT *International Red Cross/*
Cyprus Red Cross Society
COUNTRY *Germany*

Merit
**COLLATERAL ADVERTISING, BROCHURE OR
CATALOG, CAMPAIGN**
*Pequeño Al Manaque Dos Sentidos
(The Small Almanac of the Senses)*

ART DIRECTOR *Rico Lins*
CREATIVE DIRECTOR *Rico Lins*
COPYWRITER *Carlos Nader*
DESIGNERS *Rico Lins, Monique Schenkels*
PHOTOGRAPHERS *Fernando Laszio, Willy Biondani*
ILLUSTRATORS *Various*
PRODUCER *Daniela Santilli*
DIRECTOR *Renato Kerlakian*
STUDIO *Rico Lins Studio*
CLIENT *Zoomp Confecçoès Ltda.*
COUNTRY *Brazil*

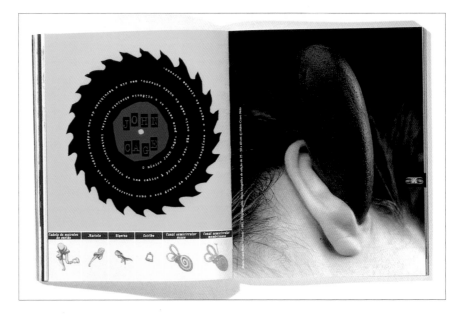

Merit

COLLATERAL ADVERTISING, BROCHURE OR CATALOG, CAMPAIGN

Appleton Utopia Paper Swatchbooks

ART DIRECTORS *Pat Samata, Greg Samata*
CREATIVE DIRECTORS *Pat Samata, Greg Samata*
DESIGNERS *Pat Samata, Greg Samata, Joe Baran*
PHOTOGRAPHER *Sandro*
STUDIO *SamataMason*
CLIENT *Appleton Paper*
COUNTRY *United States*

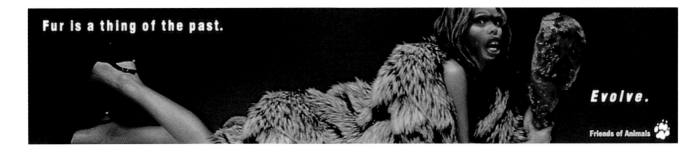

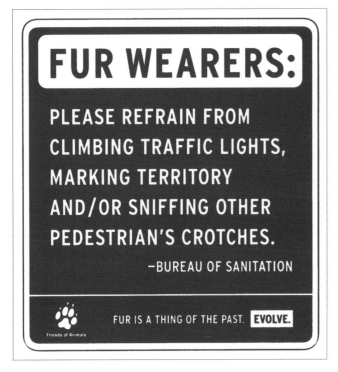

Merit
COLLATERAL ADVERTISING, MIXED MEDIA CAMPAIGN
Evolve (30 second television commercial and bus side) •
Crotches • *Squirrels* • *Awnings (Posters)*

ART DIRECTOR *Darren Lim*
CREATIVE DIRECTORS *Nick Cohen, Dave Cook*
COPYWRITER *Deacon Webster*
PHOTOGRAPHER *Roberto Espinosa*
AGENCY PRODUCERS *Valerie Hope, Sandy Bachom*
DIRECTOR *Roberto Espinosa*
PRINTER *ICP Printing (Bus Side)*
PRODUCTION COMPANY *Tony Kaye Films*
AGENCY *Mad Dogs & Englishmen*
CLIENT *Friends of Animals*
COUNTRY *United States*

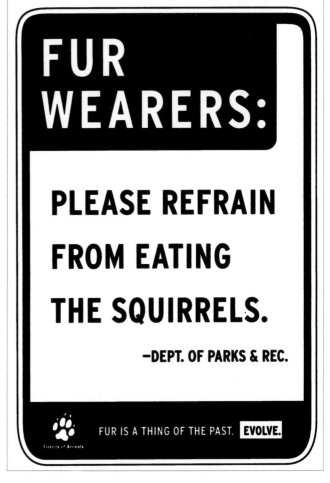

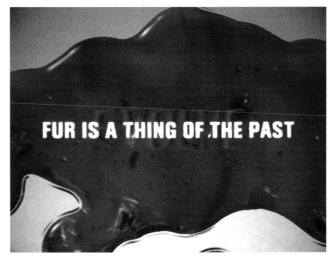

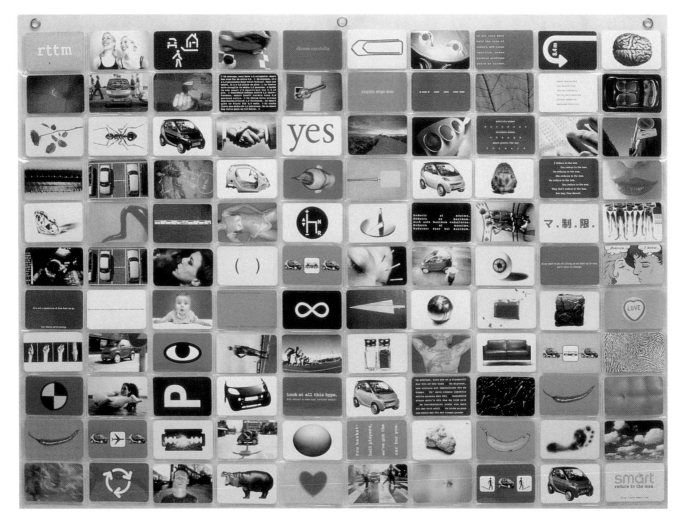

Merit
**COLLATERAL ADVERTISING, MIXED MEDIA,
CAMPAIGN**
Smart

ART DIRECTORS *Thomas von Ah, Juerg Aemmer*
CREATIVE DIRECTOR *Liliane Lerch*
COPYWRITER *Liliane Lerch*
PHOTOGRAPHERS *Various*
ILLUSTRATORS *Various*
AGENCY *Weber, Hodel, Schmid*
CLIENT *MCC Micro Compact Car AG*
COUNTRY *Switzerland*

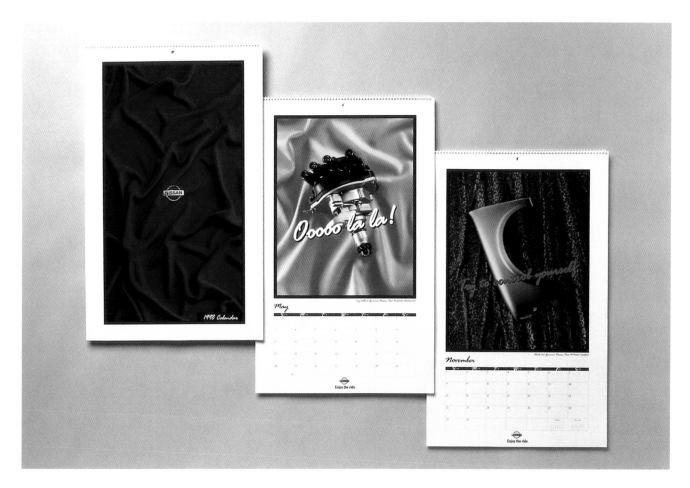

Merit
**COLLATERAL ADVERTISING, BROCHURE
OR CATALOG**
Parts Calendar

ART DIRECTOR *Doug Mukai*
CREATIVE DIRECTOR *Rob Siltanen*
COPYWRITERS *Doug Mukai, David Locascio*
PHOTOGRAPHER *William Hawkes*
PRODUCER *Shanon Espinoso*
AGENCY *TBWA Chiat/Day, Inc.*
CLIENT *Nissan Motor Corp., U.S.A.*
COUNTRY *United States*

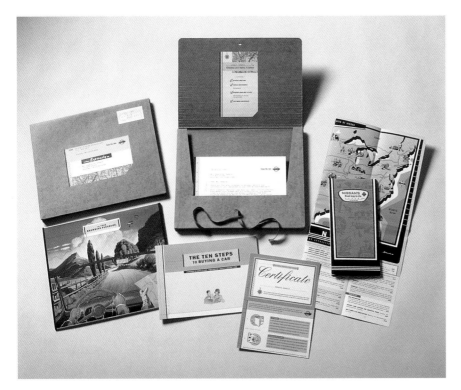

Merit

COLLATERAL ADVERTISING, DIRECT MAIL
Nissan Brand Fulfillment Package

ART DIRECTOR *Jennifer Muranaka*
CREATIVE DIRECTORS *John Avery, David Butler*
COPYWRITER *Maureen Twomey*
ILLUSTRATOR *Doug Jones*
PRODUCER *Diana Johnston*
AGENCY *TBWA Chiat/Day, Inc.*
CLIENT *Nissan Motor Corp., U.S.A.*
COUNTRY *United States*

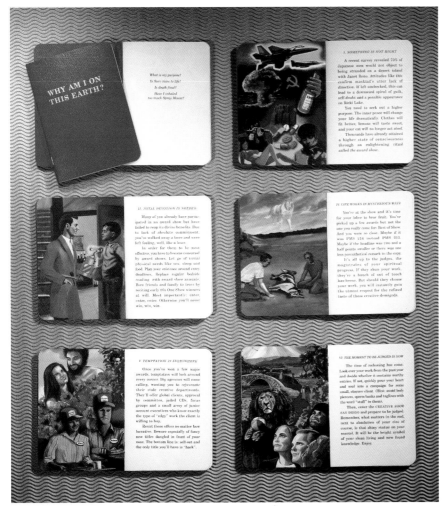

Merit

COLLATERAL ADVERTISING, DIRECT MAIL
Why Am I on Earth

ART DIRECTOR *Wade Koniakowsky*
CREATIVE DIRECTORS *Wade Koniakowsky, Rob Bagot*
COPYWRITER *Oliver Albrecht*
ILLUSTRATORS *Glenn Francis, Dave Blank,*
Wade Koniakowsky, Amy Butzen
AGENCY *Big Bang Idea Engineering*
CLIENT *San Diego Ad Club*
COUNTRY *United States*

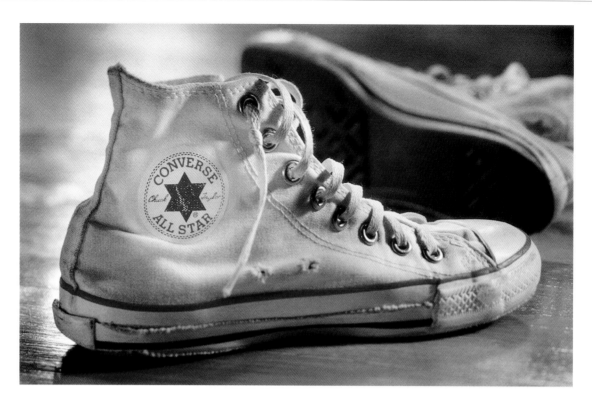

BASKETBALL AT THE JEWISH COMMUNITY CENTER

FOR DETAILS AND LEAGUE SIGN UP CALL 366-5007

Merit
COLLATERAL ADVERTISING, DIRECT MAIL
Basketball

ART DIRECTOR *Michael Cohen*
CREATIVE DIRECTOR *Jim Mountjoy*
COPYWRITER *Curtis Smith*
PHOTOGRAPHER *Pat Staub*
AGENCY *Loeffler Ketchum Mountjoy*
CLIENT *Jewish Community Center*
COUNTRY *United States*

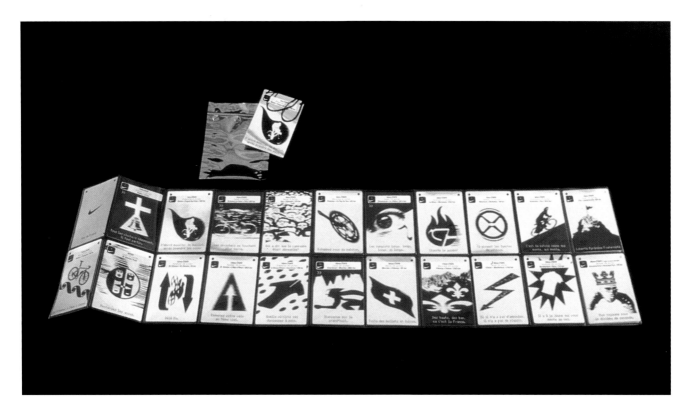

Merit
**COLLATERAL ADVERTISING, POSTCARD,
INVITATION OR ANNOUNCEMENT**
Tour de France Stage Cards

ART DIRECTOR *Erik Kessels*
COPYWRITERS *Tyler Whisnand, Sylviane Louzoun*
ILLUSTRATOR *Leendert Masseling*
PRODUCER *Pieter Leendertse*
AGENCY *KesselsKramer*
CLIENT *René Maas (Nike Europe)*
COUNTRY *The Netherlands*

Merit

TELEVISION COMMERCIAL: 30 SECONDS OR LESS, CAMPAIGN

Competition (Mr. Met) • Yahtzee • Company Counselor

ART DIRECTOR *Rick McQuiston*
CREATIVE DIRECTORS *Jerry Cronin, Vince Engel*
COPYWRITER *Canice Neary*
PHOTOGRAPHER *Romeo Tirone*
PRODUCERS *Jon Kamen, Frank Scherma, Robert Fernandez*
DIRECTORS *Rick Lemoine, Steve Miller*
PRODUCTION COMPANY *@radical.media, inc.*
AGENCY *Wieden & Kennedy*
CLIENT *ESPN*
COUNTRY *United States*

SCRIPT: *Competition (Mr. Met)*

OPEN ON NORBY WILLIAMSON, PRODUCER.
NORBY WILLIAMSON: *It can get competitive here at SportsCenter.*
CUT TO STUART SCOTT TALKING TO EVANDER.
STUART (CONFIDENTIALLY): *Charlie said you were at best the fiftieth best Heavyweight.*
EVANDER (PISSED): *In the world?*
STUART: *In Georgia.*
CUT BACK TO PRODUCER.
PRODUCER: *But when there are differences, we keep it in the family.*
CUT TO MR. MET AND DAN PATRICK.
PATRICK (POINTING): *So, Karl started drinking a little bit. Then he was going on and on about he and Mrs. Met. I mean nasty stuff.*
CUT TO ANGRY EVANDER HOLLIFIELD STORMING THROUGH HALLWAY.
PRODUCER (VO): *And keeping it in the family has made our family stronger.*
EVANDER: *Charlie come on out and get your whoopin. Charlie come on out.*
CUT TO CHARLIE HIDING UNDER DESK.
SUPER: *This is SportsCenter.*

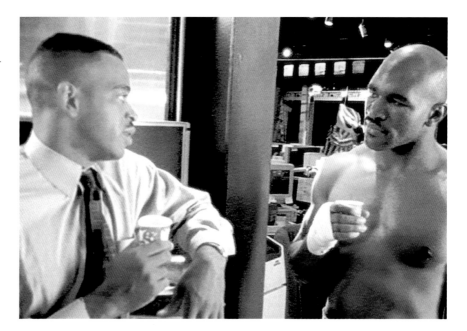

Merit
TELEVISION COMMERCIAL, 30 SECONDS OR LESS, CAMPAIGN
The Commentary • The Away Match • Pete the Eagle

ART DIRECTOR *Ollie Watson*
CREATIVE DIRECTOR *Jon Matthews*
COPYWRITER *Jon Matthews*
PHOTOGRAPHER *Lenard Dorfman*
PRODUCERS *Jon Kamen, Frank Scherma, Robert Fernandez*
DIRECTOR *Lenard Dorfman*
PRODUCTION COMPANY *@radical.media, inc.*
AGENCY *Wieden & Kennedy*
CLIENT *Coca-Cola*
COUNTRY *United States*

SCRIPT: *The Commentary*
OPEN ON FOOTBALL FAN CHEERING FROM STADIUM BLEACHERS.
FAN: *Come on West 'Ham!*
CUT TO FAN IN UNDERGROUND.
FAN: *I don't let anything get in the way of my blindness. If I want to do something or go somewhere, I'll do me damndest, if you like, to get there.*
FAN (VO): *I've got a picture in my mind when James or Scott are commenting to me. I know exactly what's going on.*
JAMES, SCOTT AND MAIN CHARACTER WATCHING GAME.
JAMES: *It's inside to Bowen again. It's inside to Bishop. Bishop back to Bowen. Bowen brings it forward. He's had a pop! Oh!!!!!*
FAN: *BOOH!*
JAMES: *Judson brings it forward on the far side. Kitson gives it to Moncur in the middle. Little shimmy.*
SCOTT: *Intercepted by Dicks. Dimitrescu. He's had a go. It's there.*
ALL THREE CHEER.
SCOTT: *He's got to score.*
FAN: *Tell me what's going on!*
SCOTT: *Dick's got the ball. No one can see. Schmiecel's in goal. It's complete mayhem. Dicks's put in down... YEAH!!!*
FAN *(OUTSIDE): They're not bad commentators actually. They're getting better as every game goes by.*
SUPER: *[LOGO] COCA-COLA*

Merit

TELEVISION COMMERCIAL, 30 SECONDS OR LESS, CAMPAIGN

Big Big Balloon • Cloning • Uncle Ed

ART DIRECTORS *Roger Camp, Michelle Roufa, Cliff Freeman, David Angelo, Arthur Bijur*
CREATIVE DIRECTORS *Cliff Freeman, Arthur Bijur, David Angelo*
COPYWRITERS *Michelle Roufa, Roger Camp, Arthur Bijur, Cliff Freeman, David Angelo*
PRODUCERS *Maresa Wickham, David Verhoef*
DIRECTORS *Jeff Gorman, Mark Story*
MUSIC *Messmer AV Inc.*
STUDIOS *Johns & Gorman Films, Crossroads Films*
AGENCY *Cliff Freeman and Partners*
CLIENT *Little Caesars*
COUNTRY *United States*

SCRIPT: *Big Big Balloon*
OPEN ON LITTLE CAESARS MANAGER SHOWING TWO
EMPLOYEES THE BIG BIG CHEESE AND A 2-LITER BOTTLE
OF COKE.
BOSS: *Crew, this is our Big Big Pizza with 12 big slices, and a free 2-liter bottle of Coke all for 7.99!*
CUT TO TWO EMPLOYEES WITH ONE UNSCREWING
HELIUM TANK KNOB AND THE OTHER HOLDING UP A
HUGE DEFLATED BALLOON.
SOUND: *CRANK. CRANK. CRANK.*
EMPLOYEE: *Boss, let's make everything bigger!*
BOSS: *Like what?*
GIANT BALLOON BEING INFLATED ENTERS AND
FILLS FRAME.
EMPLOYEE: *Balloons!* CUT TO BOSS BEING CRUSHED BY
GIANT BALLOON.
SOUND: *RUBBER SQUEAKING.*
CUT TO TWO EMPLOYEES IN OVERSIZED HATS THAT READ
"BIG BIG DEAL."
EMPLOYEES: *Hats!*
BOSS (HIS FACE IMPRESSED INTO BALLOON): *I like it!*
SOUND: *RUBBER STRETCHING AND SQUEAKING.*
CUT TO TWO EMPLOYEES IN HATS BEING PUSHED
AGAINST COUNTER BY BALLOON.
EMPLOYEE: *Show him the button!*
CUT TO ANOTHER EMPLOYEE SQUEEZING INTO ROOM
WITH GIANT BUTTON.
CUT TO WIDE SHOT OF GLASS STOREFRONT WITH GIANT
BALLOON NOW FILLING ENTIRE STORE AND PINNING
EMPLOYEES AGAINST GLASS AS ELDERLY WOMAN
APPROACHES DOOR. CLOSE-UP ON HUGE PIN OF THE
BUTTON GETTING CLOSER AND CLOSER TO BALLOON.
CUT TO ELDERLY WOMAN OPENING FRONT DOOR.
SOUND: *BOOM!*
BALLOON PIECES FLY AT THE WOMAN AS SHE GRASPS THE
DOOR FRAME TO REMAIN STANDING.
WOMAN: *Ohhhh!*
BOSS (WITH BIG BALLOON FRAGMENT ON HIS HEAD):
What else we got?
CUT TO CLOSE-UP ON SLICER ROLLING THROUGH
PEPPERONI PIZZA.
ANNOUNCER: *Little Caesars Big Big Pizza. Twelve big slices of cheese, and pepperoni, plus a free...*
(CUT TO PIZZA SHOT AND 2-LITER DIET COKE WITH PRICE
AND LOGO) *...2-liter Coke, all for 7.99!*
LITTLE CAESAR: *Bigger! Bigger!*

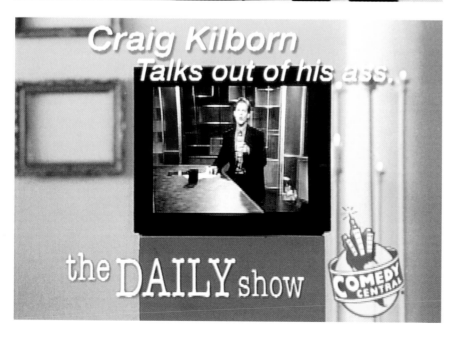

Merit

TELEVISION COMMERCIAL, 30 SECONDS OR LESS, CAMPAIGN

Talks • Causes • Crying

ART DIRECTOR *Mike Rosen*
COPYWRITERS *Craig Kilborn, Chris Kilborn*
DIRECTOR *Hank Perlman*
EXECUTIVE PRODUCER *Stephen Orent*
AGENCY *hungry man*
PRODUCTION COMPANY *hungry man*
CLIENT *Comedy Central*
COUNTRY *United States*

SCRIPT: *Talks*
CRAIG KILBORN (VO): *Sure, I could have gone anywhere: Nickelodeon, BET, and of course, Lifetime. But, I'm hosting the Daily Show, the most important show in the last 25 years of television.*
SUPER: *Craig Kilborn Talks out of his ass.*

Merit

**TELEVISION, SPOTS OF VARYING LENGTHS,
CAMPAIGN**

Trent • Moon • Iggy

ART DIRECTOR *Jarl Olsen*
CREATIVE DIRECTORS *Abby Terkuhle,
Christina Norman, Jarl Olsen*
COPYWRITER *Jarl Olsen*
PRODUCERS *Brian Cooper, Matthew Mapquis,
Mike Engleman, Brian Dilorenzo*
DIRECTOR *Jarl Olsen*
AGENCY *MTV In-House*
STUDIOS *MTV, Dublin Productions*
CLIENT *MTV*
COUNTRY *United States*

SCRIPT: *Trent*

*INTERIOR OF PSYCHIATRIST'S OFFICE. DAY. A WALL OF
DEGREES AND CERTIFICATES. A LEATHER COUCH.*
SOUND: *OFFICE PHONE RINGS THROUGHOUT.*
SUPER: *Trent Reznor's psychiatrist's couch.*
*BOOM DOWN TO REVEAL A MAN IN A SUIT, HIDING
UNDER THE COUCH AND SUCKING HIS THUMB.*
SUPER: *Trent Reznor's psychiatrist.*

MULTIPLE AWARDS

Merit
**TELEVISION COMMERCIAL, SPOTS OF VARYING
LENGTHS, CAMPAIGN**
Picasso • Think Different • Ali

Merit
TELEVISION COMMERCIAL, OVER 30 SECONDS
Think Different

ART DIRECTORS *Lee Clow, Yvonne Smith,
Jennifer Golub*
CREATIVE DIRECTOR *Lee Clow*
COPYWRITERS *Rob Siltanen, Ken Segall, Steve Jobs,
Jennifer Golub, Craig Tanimoto*
PRODUCER *Jennifer Golub*
DIRECTOR *Jennifer Golub*
MUSIC *Jonathan Elias, Issac Albeniz*
AGENCY *TBWA Chiat/Day, Inc.*
CLIENT *Apple Computer, Inc.*
COUNTRY *United States*

SCRIPT: *Picasso*
SOUND: *MUSIC UNDER THROUGHOUT.*
OPEN ON PICASSO PAINTING ON GLASS.
SUPER *(DISSOLVE TO): [LOGO] APPLE® Think different.*™

Merit

TELEVISION COMMERCIAL, SPOTS OF VARYING LENGTHS, CAMPAIGN

Ice Cream Man • Impala Man • Car Chase

ART DIRECTORS *Sean Mullens, Kim Schoen*
CREATIVE DIRECTORS *Brian Bacino,*
Suzanne Finnamore
COPYWRITER *Susan Treacy*
PHOTOGRAPHER *Paul Laufer*
PRODUCERS *Frank Scherma, Jon Kamen,*
Robert Fernandez
DIRECTOR *Tarsem*
PRODUCTION COMPANY *@radical.media, inc.*
AGENCY *Foote, Cone & Belding*
CLIENT *Levi Strauss & Co.*
COUNTRY *United States*

SCRIPT: *Ice Cream Man*

OPEN ON OLD WOMAN AS SHE CONTINUES THROUGH THE CROSSWALK. CAB TEARS OFF IN THE BACKGROUND. SHE HAS A NOSE RING, AND VERY COOL, CONTEMPORARY CLOTHES ON, INCLUDING VINTAGE LEVI'S. SHE WALKS DOWN SOME DINGY STAIRS, GETS TO THE DOOR, AND KNOCKS. WE FOLLOW HER INTO AN UNDERGROUND TECHNO PUB. THE PATRONS ARE OLD, BUT DRESSED IN COOL CLUB CLOTHES.

WE FOLLOW THE OLD WOMAN TO HER BOYFRIEND, WHO IS A GUY IN HIS SEVENTIES, WEARING LEVI'S. SHE KISSES HIM. SHE WHISPERS SOMETHING IN HIS EAR. HE GETS UP AND BEGINS WALKING THROUGH THE CLUB. AT ONE TABLE IS MALCOLM MCCLAREN AND WILLIAM BURROUGHS.

MCCLAREN: *Their last CD was better.*

BURROUGHS: *Yea, they've become way too trance.*

THE DJ IS MARCUS FROM "IMPALA MAN." THE OLD MAN WALKS TO THE BACK. THERE IS A PAY PHONE AND TWO COIN-OPERATED MACHINES: ONE FOR GUM, ONE FOR CONDOMS. THE OLD MAN REACHES INTO HIS POCKET FOR A QUARTER.

SOUND: *BIRDS CHIRPING AND NEIGHBORHOOD SOUNDS.*

CUT TO A LITTLE KID PULLING MONEY FROM HIS LEVI'S. HE'S AT AN ICE CREAM TRUCK. WE SEE A COOL 18-YEAR OLD ICE CREAM MAN WEARING LEVI'S.

ICE CREAM MAN: *Who is Jack Kerouac?*

THE LITTLE KID *(RESPONDS FLATLY): On The Road.*
(HE GETS HIS BOMB POP).

ICE CREAM MAN *(TO THE SECOND KID): Name the godfather of jazz?*

SECOND KID: *Louis Amstrong.*

ICE CREAM MAN: *Nickname?*

KID: *Satchmo. (HE GETS HIS FUDGESICLE).*

ICE CREAM MAN *(TO THE THIRD KID): Charlie Parker had a club named after him.*

THIRD KID: *Birdland, now give up the bomb pop.* THE ICE CREAM MAN HANDS OVER THE FINAL TREAT.

A CAR BEING PUSHED BY TWO 19-YEAR-OLD WOMEN PASSES THE ICE CREAM TRUCK. A THIRD WOMAN STEERS. TIME PASSES AS THEY PUSH THE CAR INTO A GAS STATION.

WOMAN STEERING: *Filler up.*

A 19-YEAR-OLD MAN WEARING LEVI'S SHORTS TALKS ON THE PAY PHONE. HE'S HOLDING A BLOND WIG.

WIG KID: *They want me to wear the wig again.*

SUPER: *[LOGO] LEVI'S. They go on... Http://Levi.Com*

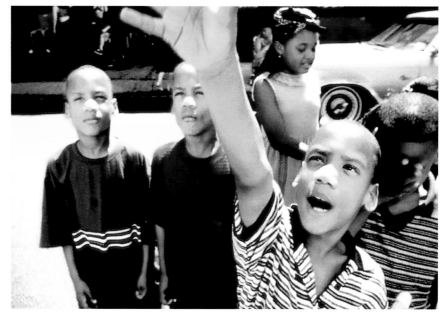

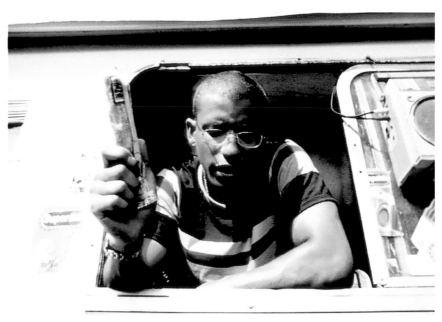

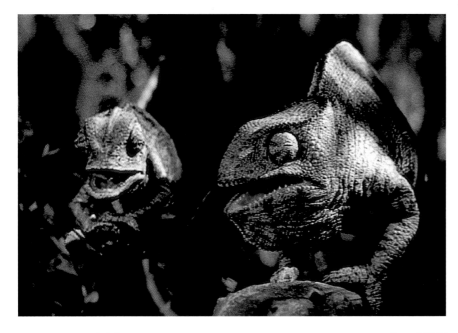

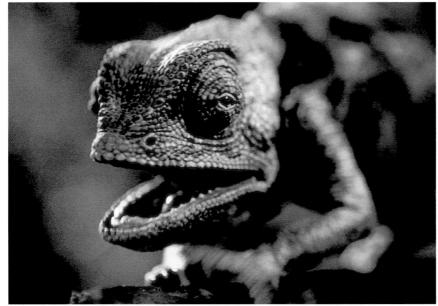

Merit

TELEVISION COMMERCIAL, 30 SECONDS OR LESS
Louie the Lizard

ART DIRECTOR *Todd Grant*
CREATIVE DIRECTORS *Jeffrey Goodby, Sean Ehringer, Harry Cocciolo*
COPYWRITER *Steve Dildarian*
PHOTOGRAPHER *Neil Shapiro*
PRODUCERS *Frank Scherma, Jon Kamen, Robert Fernandez*
DIRECTORS *Frank Todaro, Bryan Buckley*
PRODUCTION COMPANY *@radical.media, inc.*
AGENCY *Goodby, Silverstein & Partners*
CLIENT *Budweiser (Anheuser-Busch)*
COUNTRY *United States*

SCRIPT: *Louie the Lizard*
OPEN ON A MARSHY POND WITH A NEON BUDWEISER
SIGN ON A WOODEN SHACK IN THE BACKGROUND.
SOUND: CRICKETS CHIRPING.
FROG (VO): *Bud. Wise. Er.* (REPEATING THROUGHOUT.)
THE CAMERA MOVES BACKWARD IN BETWEEN TWO
LIZARDS TALKING TO EACH OTHER, LOOKING TOWARD
THE SHACK.
LOUIE: *I can't believe they went with the frogs.*
CUT TO FRONT VIEW OF THE LIZARDS TALKING TO
EACH OTHER.
LIZARD II: *Louie.*
LOUIE: *Our audition was flawless.*
CUT TO PROFILE OF LIZARD II.
LIZARD II: *Louie.*
CLOSE-UP OF LOUIE AS HE ROLLS HIS EYES.
LOUIE: *We did the look. Heh?...*
CUT TO LIZARD II AS HE ROLLS HIS EYES.
LOUIE: *...we did the tongue thing...* (AS HE STICKS HIS
TONGUE OUT TOWARD THE CAMERA).
CUT BACK TO POINT OF VIEW OF THE LIZARDS, THE
CAMERA BETWEEN THEM.
LIZARD II: *Um hum.*
LOUIE: *...that was great.* (CUT TO THE LIZARDS SITTING
ON BRANCHES AS LOUIE GESTURES WITH HIS ARM).
LIZARD II: *Louie, frogs sell beer.*
LOUIE (CLOSE-UP): *Ehh.*
LIZARD II: *That's it man, the number one rule of
marketing.*
CUT TO WIDE SHOT OF LIZARDS UP ON THE BRANCHES AS
A DRAGONFLY FLIES INTO FRAME. CAMERA MOVES IN AS
THE DRAGONFLY FLIES AROUND THEIR HEADS.
LOUIE: *The Budweiser lizards. We could have been huge.*
LIZARD II: *Hey, there will be other auditions.*
LOUIE IS FOLLOWING THE DRAGONFLY WITH HIS EYE AS
HIS TONGUE CATCHES THE INSECT.
LOUIE: *Oh yeah, for what. This was Budweiser, buddy.
This was big.*
SOUND: TONGUE CATCHING BUG.
CUT TO A PROFILE SHOT OF LIZARD II AS HE WATCHES
LOUIE EAT THE DRAGONFLY. CUT TO SHOT OF LOUIE.
LOUIE: *Those frogs are gonna pay.*
CUT TO SHOT BEHIND THE LIZARDS. WE SEE THEIR
SILHOUETTE AGAINST THE BACKGROUND OF THE
BUDWEISER SIGN ON THE SHACK.
LIZARD II: *Let it go Louie, let it go.*

Merit

TELEVISION COMMERCIAL, 30 SECONDS OR LESS
Turkey-Face Santa

ART DIRECTOR *Mike Ferrer*
CREATIVE DIRECTOR *Rob Rosenthal*
COPYWRITER *Tim Sproul*
PRODUCER *Monique Veillette*
DIRECTOR *Vance Malone*
PRODUCTION COMPANY *Food Chain Films*
AGENCY *Moffatt/Rosenthal*
CLIENT *Oregon Lottery*
COUNTRY *United States*

SCRIPT: *Turkey-Face Santa*

*OPEN ON A CHRISTMAS-DECORATED KITCHEN. A WOMAN
IS GIVING A DEMONSTRATION IN FRONT OF A CRAFT
TABLE. IT'S SHOT ON VIDEO.*
WOMAN: *...handmade gifts always add a personal
touch to the holidays. To create a regal door decoration,
all you need is rubber cement, a little imagination and
a turkey carcass... WOMAN HOISTS A LEFTOVER TURKEY.*
WOMAN: *...to add texture, I prefer organic mashed
potatoes...niçoise ("knee-swaaz"). CUT TO WOMAN
ASSEMBLING THE PIECE.*
WOMAN: *...and there he is...Turkey Face Santa...*
CUT TO A CLOSE-UP OF TURKEY FACE SANTA.
ANNOUNCER: *Looking for a truly personal gift? Give
folks a chance to win cash so they can buy what they
really want. Scratch-Its for the holidays.*
*CUT TO THE SCRATCH-IT ON A TABLE TOP SURROUNDED
BY CRAFT SUPPLIES.*
SUPER: *{LOGO} The Oregon Lottery*
*CUT TO THE WOMAN HANGING TURKEY FACE SANTA ON
THE FRONT DOOR.*

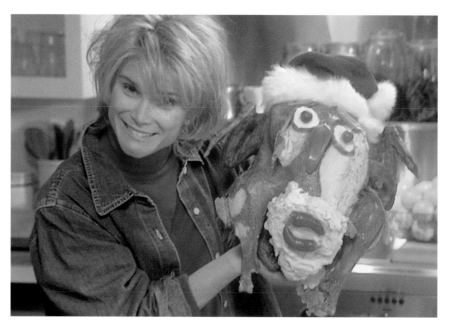

Merit
TELEVISION COMMERCIAL, OVER 30 SECONDS
Little Chef

ART DIRECTORS *Trish Stephenson, Sean Thompson*
AGENCY PRODUCER *Louise Fuller*
COPYWRITER *Ros Sinclair*
PRODUCERS *Kathrin Lausch, Lise Østbirk,*
Paul McNally
DIRECTOR *Dan Nathan*
EDITOR *Steve Gandolfi (Cut & Run)*
PRODUCTION COMPANY *Passport Films/*
Serious Pictures
AGENCY *TBWA/Simons Palmer, London*
CLIENT *Sony Playstation*
COUNTRY *United States*

SCRIPT: *Little Chef*

IN A CLOSE-UP OF THE CLASSY KITCHEN, WE ARE
INTRODUCED TO A WELL-DRESSED CHEF WHO ENGAGES
IN DEEDS WHICH REMIND US WHY IT IS BETTER TO STAY
HOME WITH SONY PLAYSTATION. STARTING WITH "THE
APPETIZER," THE CALM, COOL AND COLLECTED CHEF
PICKS A BOOGER FROM HIS NOSE AND ADDS IT TO A
PLATE OF DESIGNER CAVIER. CUTTING FROM THIS, WE
MOVE ON TO "THE ENTREE," A BEAUTIFUL SAUTEED
STEAK WHICH IS WHISKED AWAY FOR FINISHING
TOUCHES IN THE RESTAURANT'S TOILET BOWL. OUR
FINAL DISPLAY OF A CHEF'S INNER DEMONS COMES WITH
A CUT TO THE FINALE OF THIS GRAND DEBACLE, "THE
DESSERT." THE CAMERA STARES UP AT THE CHEF ONE
LAST TIME, WATCHING AS HE TAKES A SIP OF WINE,
SWILLS IT AROUND IN HIS MOUTH AND SPRAYS IT OUT
OVER THE DISH IN SLOW MOTION.
CUT TO BLACK.
SUPER: *THE SONY PLAYSTATION MOTTO, "P.S. STAY AT*
HOME TONIGHT."

Merit
CINEMA, OVER 30 SECONDS
UFO (Belmondo Shoes)

ART DIRECTOR *Elke Wilhelm*
CREATIVE DIRECTORS *Christine Reich,*
Constantin Kaloff
COPYWRITER *Gordon Hollenga*
PHOTOGRAPHER *Alwin Küchler*
PRODUCER *Giles Lovell-Wilson*
DIRECTOR *David Lodge*
MUSIC *Amber Music*
AGENCY *Springer & Jacoby Werbung GmbH*
CLIENT *Ludwig Görtz GmbH*
COUNTRY *Germany*

SCRIPT: *UFO (Belmondo Shoes)*
VISUAL: *A SPACESHIP SPEEDING TOWARDS EARTH.*
SOUND: *WE HEAR THE DRONING OF A SPACESHIP.*
VISUAL: *THERE ARE THREE GRUESOME ALIENS SITTING*
INSIDE.
SOUND: *THEY ARE SPEAKING ALIEN.*
SUPER: *Preparing to invade blue planet.*
VISUAL: *THE SPACESHIP BEARS DOWN ON ITS TARGET.*
IT CAN'T BE STOPPED. IT LANDS IN THE MIDDLE OF A
BIG CITY.
SOUND: *THE LANDING BEAM DRONES.*
VISUAL: *THE ALIENS CATCH SIGHT OF THEIR FIRST*
VICTIM: A YOUNG WOMAN.
SOUND: *HER FOOTSTEPS ECHO ON THE PAVEMENT.*
VISUAL: *THE ALIENS ARE SUDDENLY FRIGHTENED.*
SOUND: *THEY SCREAM.*
SUPER: *"Oh, **#?->!"*
VISUAL: *THE WOMAN STEPS ON AND CRUSHES THE UFO.*
IT WAS ONLY A FEW CUBIC MILLIMETERS IN SIZE.
SOUND: *THE SHOE FLATTENS IT TO SMITHEREENS WITH*
A CRUNCH.
VISUAL: *WE SEE THE SHOES IN THEIR FULL BEAUTY.*
SUPER: *BELMONDO. Exclusively at GÖRTZ.*
SOUND: *THIS IS ACCOMPANIED BY MUSIC WHICH IS*
REMINISCENT OF A 1960'S SCIENCE-FICTION MOVIE.

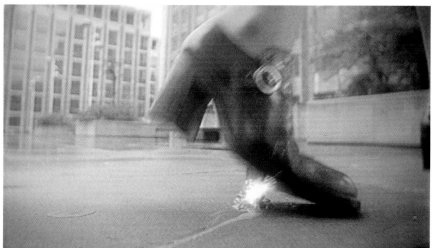

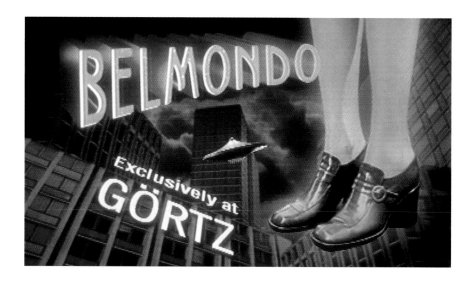

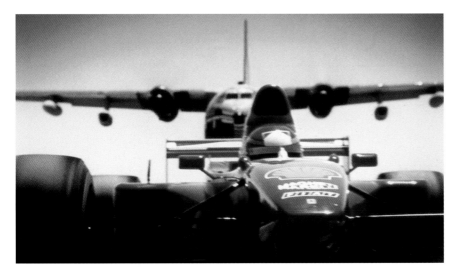

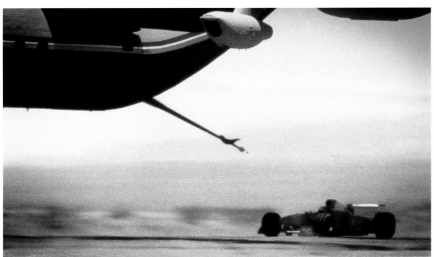

Merit
**TELEVISION AND CINEMA CRAFTS,
CINEMATOGRAPHY**
Refuelling

ART DIRECTOR *Peter Clercx*
CREATIVE DIRECTOR *Peter Hebbing*
COPYWRITER *Victor Silvis*
DESIGNER *Bennedict Schillemans*
PHOTOGRAPHER *John Stanier*
PRODUCER *Vince Oster (RSA)*
DIRECTOR *Allan Van Rÿn (RSA)*
MUSIC *Jaap Eggermond: Soundpush*
STUDIO/EDITING *Kevin Whelan (DGW)*
AGENCY *PPGH/JWT*
CLIENT *Shell International Petroleum Company Ltd.*
COUNTRY *The Netherlands*

SCRIPT: *Refuelling*
*A FORMULA 1 FERRARI APPEARS FROM THE SWELTERING
HEAT ABOVE THE DESERT. A GREY COLOSSUS LOOMS
ABOVE IT. IT TURNS OUT TO BE A C123 PROVIDER
AIRPLANE. THE AIRPLANE DESCENDS UNTIL IT IS FLYING
JUST ABOVE THE FERRARI. THE CAR AND AIRPLANE
ZOOM AHEAD AT EQUAL SPEED. THE RACE-DRIVER AND
THE PILOT HAVE RADIO CONTACT. WE SUDDENLY SEE A
CLOSE SHOT OF A TANK HOSE. WE DISCOVER THAT IT IS A
SHELL TANKER PLANE THAT IS GOING TO REFUEL THE
FERRARI FROM THE AIR. WE SEE A PERFECTLY TIMED
OPERATION. AFTER ALL, SHELL AND SCUDERIA FERRARI
ARE PARTNERS. TOGETHER THEY ROAR RIGHT TOWARDS
A CHASM. BUT THEY DISCONNECT JUST IN TIME, AND
THE FERRARI MAKES A SHARP TURN. THE AIRPLANE
FLIES OVER THE EDGE OF THE CHASM.*
SUPER: *When cars are a passion, the fuel is Shell.*

Merit
TELEVISION AND CINEMA CRAFTS, ANIMATION
Backstage

ART DIRECTOR *Mickey Paxton*
CREATIVE DIRECTOR *Mickey Paxton*
COPYWRITER *John Zissimos*
PRODUCER *Christopher Donovan*
DIRECTOR *Ken Lidster*
MUSIC *Amber Music*
AGENCY *J. Walter Thompson*
CLIENT *Unilever U.S.–Lipton Brisk*
COUNTRY *United States*

SCRIPT: *Backstage*
OPEN ON SINATRA AS HE FINISHES A CONCERT. THE
CROWD IS GOING WILD.
SINATRA: *Good night.*
THE CURTAIN FALLS AND SINATRA GOES BACKSTAGE.
THE CROWD STILL GOING WILD.
SINATRA: *What's with those lights? Who do you think*
I am, Peter Frampton?
AS SINATRA WALKS TO HIS DRESSING ROOM, HIS
HOLLYWOOD TYPE PR GUY SLITHERS IN AND SPEAKS
TO HIM.
SINATRA: *Get the car Louie.*
PR GUY: *Wait, you gotta do an encore, Frank! Those*
da-dames are goin' crazy!
SINATRA REACHES FOR A CAN OF LIPTON BRISK ON ICE.
SINATRA: *…And that's why I'm slippin' out, Jack.*
They were eyein' me up like a leg-o-lamb.
PR GUY: *B-but Frank…*
SINATRA: *You got clay in your ears, Clyde?*
SINATRA OPENS UP THE CAN OF BRISK AND CHUGS IT.
PR GUY: *You heard the man. Get Mr. Sinatra's car.*
CUT TO SINATRA FINISHING HIS BRISK.
SINATRA: *Ahhhhhhhhhhh! That's BRISK, baby!*
SINATRA: *Hold on. Turn up the lights…*
SUPER: *BRISK Lipton Iced Tea. Now that's Brisk.*
with Frank Sinatra (ON MARQUEE).
SINATRA (VO): *…Jack, this gig is just gettin' started.*
SOUND: *CROWD ERUPTS. MUSIC KICKS IN.*

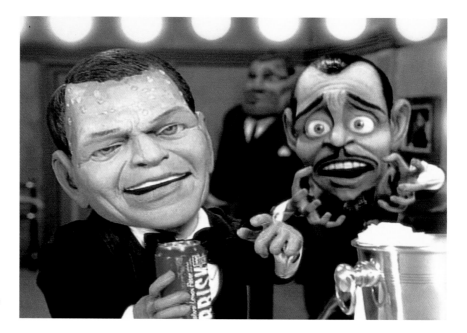

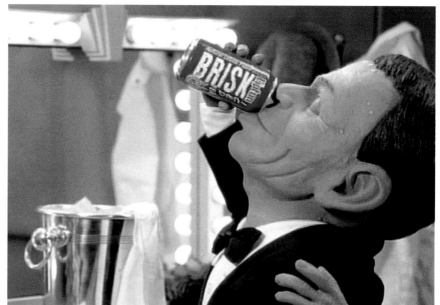

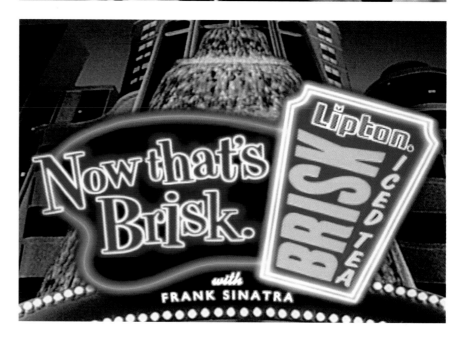

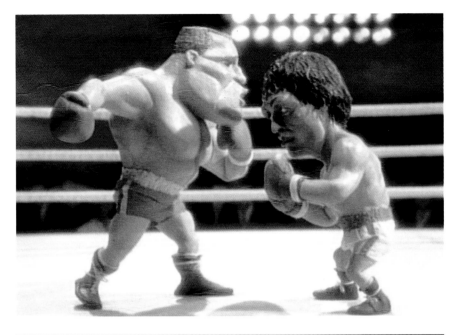

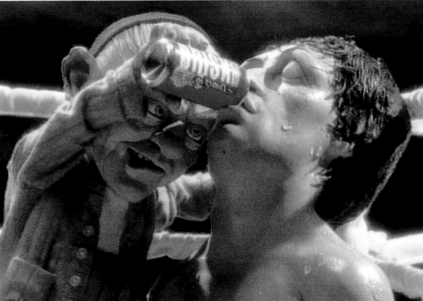

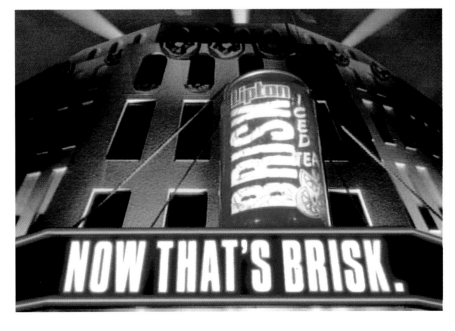

Merit
TELEVISION AND CINEMA CRAFTS, ANIMATION
Rocky

ART DIRECTOR *Mickey Paxton*
CREATIVE DIRECTOR *Mickey Paxton*
COPYWRITER *John Zissimos*
PRODUCER *Vic Palumbo*
DIRECTOR *Ken Lidster*
MUSIC *Amber Music*
AGENCY *J. Walter Thompson*
CLIENT *Unilever U.S.–Lipton Brisk*
COUNTRY *United States*

SCRIPT: *Rocky*
SOUND: *PUNCHING AND A SCREAMING CROWD. OPEN ON ROCKY, WEAK AND WOBBLY.*
ANNOUNCER: *...Ooohh...and Rocky Balboa is taking the beating of his life.*
ROCKY TAKES A COMBO TO THE HEAD...AND THEN ANOTHER...NEWS CAMERA FLASHES...ROCKY TAKES A FEW PUNCHES TO THE STOMACH FOLLOWED BY A FINAL UPPERCUT COMICALLY RATTLING ROCKY'S BRAIN. WE CUT TO "ROUND 15" SIGN IN A HAZE OF SMOKE...THE CAMERA PUSHES IN ON ROCKY'S CORNER.
ROCKY: *Who keeps ringin' dat bell? I can't concentrate.*
MICKEY: *It's over Rock.*
ROCKY: *Nothin' is over, just gimme somethin' to drink.*
MICKEY: *There ain't nothin' on earth that's gonna save ya now!*
VENDOR: *Lipton BRISK Iced Tea here!*
MICKEY: *'Cept maybe this.*
MICKEY GRABS A CAN OF LIPTON BRISK FROM THE VENDOR'S ICE BIN. THE SOUND OF THE CROWD DROPS AWAY AND MUSIC BEGINS AS MICKEY POURS LIPTON BRISK DOWN ROCKY'S THROAT.
ANNOUNCER: *...And Balboa needs a miracle...*
ROCKY FINISHES THE BRISK AND LOOKS REFRESHED AND PUNCHES HIS GLOVES TOGETHER.
ROCKY: *Yo! (BELL RINGS TO START THE NEXT ROUND) That's BRISK baby!*
MICKEY: *Get in there.*
ROCKY WALKS UP TO HIS OPPONENT DUCKS FROM A PUNCH AND THROWS THE OLD ONE TWO AND A COUPLE TO THE BODY. CAMERA BACKS AWAY TO AN AERIAL VIEW.
SUPER: *BRISK Lipton Iced Tea. Now that's Brisk. (ON MARQUEE).*
MICKEY (VO): *Save some of that for the sequel!*
SOUND: *WE HEAR THE CROWD ROAR THE UNSEEN KNOCKOUT.*

Merit
TELEVISION AND CINEMA CRAFTS, ANIMATION
Murphy's Last Orders

ART DIRECTOR *Adam Scholes (BBH)*
CREATIVE DIRECTOR *Dennis Lewis (BBH)*
COPYWRITER *Hugh Todd (BBH)*
DIRECTOR *Oshii Mamoru*
MUSIC *Jake Jackson (Amber Music)*
PRODUCERS *Chris O'Reilly, San Takashima
(Nexus Films)*
AGENCY PRODUCER *Rob Steiner (BBH)*
PRODUCTION COMPANY *Nexus Films*
AGENCY *Bartle Bogle Hegarty*
CLIENT *Whitbred Murphy's Eire*
COUNTRY *England*

SCRIPT: *Murphy's Last Orders*
SOUND: ELECTRONICA MUSIC.
VISUAL: WE OPEN IN A HUGE METROPOLIS, SOMETIME IN THE FUTURE. SKYSCRAPERS AND NEON LIGHT UP THE NIGHT. WE SEE A STREET SELLER WANDERING AMONG THE TRAFFIC-JAMMED STREETS. ROBOTIC BODIES THAT HAVE BECOME REDUNDANT ARE PICKED UP AND TAKEN AWAY BY OVERHEAD CONVEYORS. WE SEE TANKS BEING TRANSPORTED ON TRAINS.
AN OLD MAN WITH A PROSTHETIC LEG IS WALKING AWKWARDLY TOWARDS A LARGE CANNON SET ATOP A BUILDING. HE IS A FUTURISTIC TOWN CRIER. HE FIRES THE CANNON TOWARDS A LARGE BELL ON TOP OF ANOTHER BUILDING. IT RINGS AND THE SOUND ECHOES AROUND THE CITY—IT IS THE CATALYST FOR A SERIES OF EVENTS. WE SEE A BIRD'S EYE VIEW OF THE STREET. CUT TO A SAMURAI RUNNING IN AN UNDERGROUND SEWER. HE STOPS AND LOOKS UP. HE OPENS A MANHOLE COVER AND JUMPS UP INTO THE CONGESTED STREET. THE CAMERA PANS UP TO ANOTHER SAMURAI STANDING ON TOP OF A TRAFFIC SIGNAL. HE LEAPS DOWN ONTO A CAR AND RUNS AWAY OVER THE GRIDLOCKED CARS. A WOMAN IS APPLYING LIPSTICK, USING THE WINDOW PANE AS A MIRROR. SHE IS INSIDE A SKYSCRAPER. A GIANT KITE CARRYING ANOTHER SAMURAI PASSES BY THE WINDOW. WE SEE A CLOSE-UP OF THE WOMAN'S FACE MIRRORED IN THE WINDOW. CUT TO TWO SAMURAI IN A SMALL BOAT. NEXT, WE SEE THE FIRST THREE SAMURAI RUNNING DOWN THE STREET TOGETHER. THEY REACH A BAR WHERE WE SEE THE THREE OTHER SAMURAI STANDING OUTSIDE. THE SIX SAMURAI BURST INTO THE BAR TOGETHER. ASTONISHED FACES ON THE BARMAN, DRINKERS AND CYBORGS.
STANDING IN FRONT OF THE BAR, THE SAMURAI SLOWLY AND OMINOUSLY POINT. THEIR GAZES ARE FIXED ON THE BOTTLES OF MURPHY'S. THE FACES OF THE OTHER DRINKERS IN THE BAR TWITCH IN EXPECTATION. WE VIEW THE SAMURAI THROUGH THE VISION OF A CYBORG. THE SAMURAI PERFORM THEIR UNIQUE PICK-UP SEQUENCE. BEFORE DRINKING FROM THE BOTTLES. THEY SMASH DOWN THE BOTTLES ON THE BAR. THE BARMAN RECOILS SLIGHTLY.
SUPER: THE CANNON BELL ECHOING THROUGHOUT THE CITY.
THE SHUTTERS OF THE BAR SLAM DOWN. A NEON 'MURPHY'S' SIGN FIZZES OFF AS AN OLD MAN GETS TO THE BAR TOO LATE.
SUPER (APPEARS OVER THE OLD MAN): DON'T MISS IT.

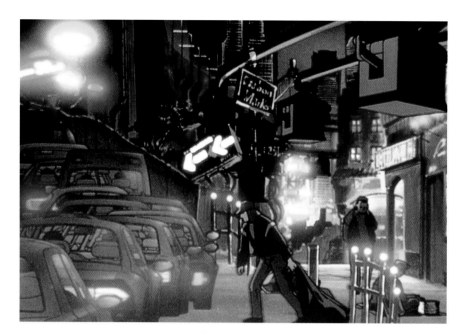

SINGER: *It's hard to mend a broken heart with bobbi pins and glue.*
It's hard to sell ice to people who also sell ice.
It's hard to find keychains with your name already on them if your
name is something weird like Hamlet.
But it's easy to play Little Lotto.
ANNOUNCER: *Want to try something easy? Try Little Lotto from the Illinois*
Lottery. All you gotta do is match 5 balls out of 30 to win as much as $200,000.
Little Lotto — it's as easy as 1-2-3-4-5.
SINGER: *It's hard to climb a mountain when you're wearing women's shoes*
I'm told.
It's hard to get snappy radio jingles (like this) out of your head.
But it's easy to play Little Lotto.
But it's easy to play Little Lotto.

Merit
RADIO ADVERTISING, OVER 30 SECONDS
Keychain

CREATIVE DIRECTOR *Tom O'Keefe*
EXECUTIVE CREATIVE DIRECTOR *Geoff Thompson*
COPYWRITER *Pat Durkin*
PRODUCER *James Mahoney*
MUSIC *Rich Rankin (Mosaic Music)*
STUDIO *Chicago Recording Company–*
Chris Sabold
AGENCY *Foote, Cone & Belding Chicago*
CLIENT *The Illinois Lottery*
COUNTRY *United States*

SOUND: *ROMANTIC BALLAD UP AND UNDER.*

WOMAN: *Everyday it's just the three of us.*

You, me and our Sprite.

MAN: *All those cans and bottles.*

Baby it feels so right.

WOMAN: *Before we drank Sprite, you grossed me out.*

But now I'm ready to tie the knot.

MAN: *Thanks to Sprite you won my heart.*

Despite that mustache problem you've got.

BOTH: *Sprite is why I love your dog breath.*

And the jam between your toes.

WOMAN: *Sprite makes me love all that hair on your back.*

MAN: *And that nasty mole on your nose.*

MAN *(SPEAKING): Wait a second. What are we saying?*

This jingle is full of lies.

WOMAN *(SPEAKING): All Sprite does is quench our thirst.*

It won't make your face easier on my eyes.

MAN: *So our romance is dead.*

WOMAN: *Go sleep on the sofa bed.*

MAN: *Here's a paper bag.*

Put it over your head.

BOTH: *Image is nothing.*

Thirst is everything.

Obey your thirst.

Sprite.

Merit
RADIO ADVERTISING, OVER 30 SECONDS
Sprite Love

CREATIVE DIRECTORS *Lee Garfinkel,*
C.J. Waldman, Todd Godwin
COPYWRITER *Steve Doppelt*
AGENCY PRODUCER *David Gerard*
MUSIC *Fearless Music*
AGENCY *Lowe & Partners/SMS*
CLIENT *The Coca-Cola Company/Sprite*
COUNTRY *United States*

SOUND: *MUSIC UP AND UNDER.*

WOMAN: *I'm a woman and I'm angry.*
I know three chords on the guitar.
That and Sprite are all you need
To become a music star.

Sprite makes me intellectual.
Sprite shapes the way I think.
Sprite improves my self-esteem.
Just go and ask my shrink.

Sprite is more reliable
Than a man who can't commit.
Sprite gives me the strength to forgive
Guys who treated me like…dirt.

This song is just another ad jingle.
Every word is just a crock.
I'd sing about something more important
But I had writer's block.

All Sprite does is quench your thirst.
Don't follow rock stars like sheep.
That's the only message of this song.
I guess I'm not that deep.

Image is nothing.
Thirst is everything.
Obey your thirst.
Sprite.

Merit
RADIO ADVERTISING, OVER 30 SECONDS
Angry Woman

CREATIVE DIRECTORS *Lee Garfinkel,*
C.J. Waldman, Todd Godwin
COPYWRITER *Steve Doppelt*
PRODUCER *David Gerard*
MUSIC *Underground Music*
AGENCY *Lowe & Partners/SMS*
CLIENT *The Coca Cola Company/Sprite*
COUNTRY *United States*

new media

I was lucky enough to have the chance to see the change in a single year of entries for New Media. After being a judge last year, it's quite astonishing to see the rapid development in this category as designers take yet another step forward in pushing a new medium.

Most notably, this year, the work entered shows that designers are learning to understand the audience as well as the technology better. Keeping up with an understanding of what's possible in an environment where the change is constant makes designing something compelling a challenge. More common now is the recognition that a

I'm certain that this dramatic evolution will continue next year as designers continue to push the technology and develop new ways to communicate information.

—Vic Zauderer
NetObjects, Inc.
United States

(top row)
Patricia Greaney
Starchefs
United States

Bill Hill
MetaDesign San Francisco
United States

(second row)
Doris Mitsch
Doris and Clancy, Ltd.
United States

Chee Pearlman
I.D. Magazine
United States

(third row)
Gong Szeto
i/o 360° digital design
United States

gold and silver new media

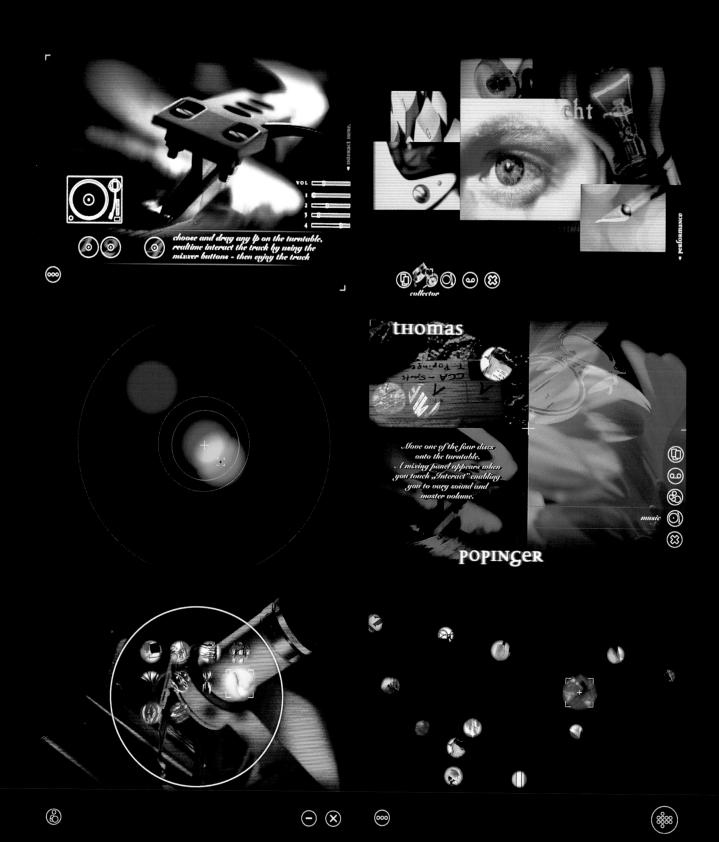

VOL

choose and drag any lp on the turntable,
realtime interact the track by using the
mixxer buttons - then enjoy the track

collector

тномas

CCA - Spot

Move one of the four discs
onto the turntable.
A mixing panel appears when
you touch „Interact" enabling
you to vary sound and
master volume.

music

POPINGER

Silver
CD ROM DESIGN, PROMOTION
A-Klasse. Ein starkes Stück Zukunft
(The A-class, a Powerful Future)

ART DIRECTORS *Anette Scholz, Michael Volkmer*
COPYWRITERS *Isabell Bormann,*
Matthias Faerber
DESIGNERS *Katja Rickert, Nicoletta Gerlach,*
Britta Vogt, Markus Hermanni,
Denise Wasserburger, Cordula Horter
PRODUCER *Irmgard Weigl*
MUSIC *Ralf Wengenmayr*
PROGRAMMERS *Manfred Kraft, Thorsten Kraus*
VIDEO EDITING *Holger Hirth*
STUDIO *Scholz & Volkmer*
CLIENT *Daimler-Benz AG*
COUNTRY *Germany*

(facing page)
Gold
CD ROM DESIGN, PROMOTION
Portfolio no. 1

ART DIRECTOR *Oliver Hinrichs*
CREATIVE DIRECTOR *John Eberstein*
COPYWRITERS *Thomas Lehning,*
Guido Gdowzok
DESIGNERS *John Eberstein, Oliver Hinrichs*
PHOTOGRAPHER *Thomas Popinger*
ILLUSTRATOR *Oliver Hinrichs*
PRODUCER *Jan Becker (Development)*
DIRECTOR *Jan Becker (Development)*
MUSIC *Peter Kruder*
AGENCY *Scholz + Friends N.A.S.A.*
STUDIO *Scholz + Friends N.A.S.A.*
CLIENT *Thomas Popinger*
COUNTRY *Germany*

r

3 SITE DESIGN, PROMOTION
rge (www.xlarge.com)

DIRECTOR *Michael Worthington*
ATIVE DIRECTOR *Michael Worthington*
IGNERS *Michael Worthington, Tracy Hopcus*
TOGRAPHERS *Various*
DIO *Worthington Design*
NT *Adam Silverman (x-large)*
NTRY *United States*

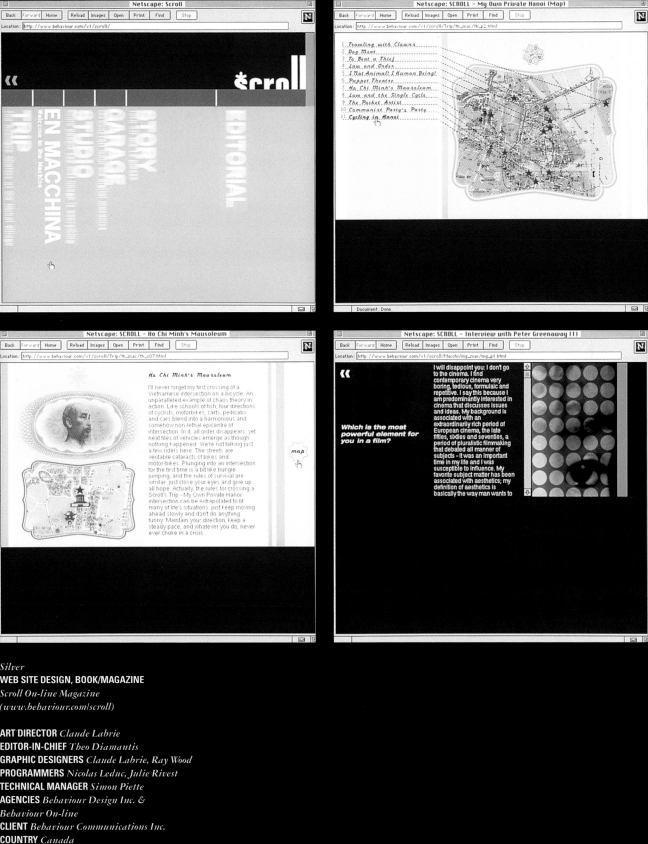

Silver
WEB SITE DESIGN, BOOK/MAGAZINE
Scroll On-line Magazine
(www.behaviour.com/scroll)

ART DIRECTOR *Claude Labrie*
EDITOR-IN-CHIEF *Theo Diamantis*
GRAPHIC DESIGNERS *Claude Labrie, Ray Wood*
PROGRAMMERS *Nicolas Leduc, Julie Rivest*
TECHNICAL MANAGER *Simon Piette*
AGENCIES *Behaviour Design Inc. &*
Behaviour On-line
CLIENT *Behaviour Communications Inc.*
COUNTRY *Canada*

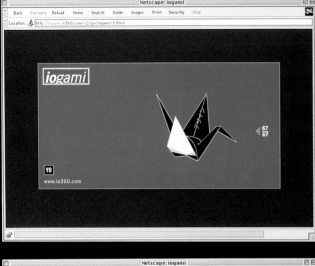

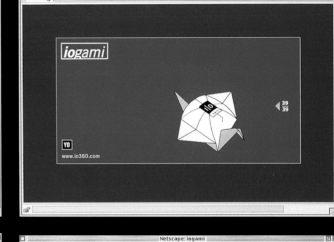

Silver
WEB SITE DESIGN, EDUCATIONAL
iogami interactive origami
(www.io360.com/v2/yo/iogami)

DESIGNER *Casey Reas*
CONCEPT *Ralph Lucci, Casey Reas, Nam Szeto*
TRANSLATION *Naomi Moriyama,*
Jocelyn Hayashi
STUDIO *i/o 360° digital design*
CLIENT *i/o 360° digital design*
COUNTRY *United States*

distinctive merit

new media

STONE ISLAND
AUTUMN/WINTER 97/98

2 | 7 | 1 | 5 | 4 | U | 3 | 3

MATERIAL

DETAILS

LINER

DETAILS LINER

Distinctive Merit
CD ROM DESIGN, ADVERTISING/BRAND CAMPAIGN
Stone Island #2

ART DIRECTORS *Christiane Bördner, Marcus Gaab,*
Matthias Schellenberg
CREATIVE DIRECTORS *Christiane Bördner,*
Marcus Gaab, Matthias Schellenberg
COPYWRITER *Stone Island/Sportswear Company*
COMPANY DESIGNERS *Christiane Bördner,*
Marcus Gaab, Matthias Schellenberg
PHOTOGRAPHERS *Marcus Gaab,*
Matthias Schellenberg
ILLUSTRATOR *Christiane Bördner*
PRODUCERS *Sabina Rivetti, Paul Harvey*
MUSIC *Jonas Grossmann, David Moufang*
MULTIMEDIA AUTHORING *Tilman Hampl*
AGENCY *E*
STUDIO *E*
CLIENT *Stone Island/Sportswear Company*
COUNTRY *Germany*

(facing page)
Distinctive Merit
WEB SITE DESIGN, ADVERTISING/BRAND CAMPAIGN
Zumiez (www.zumiez.com)

ART DIRECTORS *Frank Zepponi, Brian Porterfield*
CREATIVE DIRECTOR *Frank Zepponi*
DESIGNER *Brian Porterfield*
PHOTOGRAPHERS *Various*
ILLUSTRATOR *Brian Porterfield*
PRODUCER *John Beezer*
STUDIO *Frank's Place*
CLIENT *Zumiez*
COUNTRY *United States*

Distinctive Merit
WEB SITE DESIGN, PRODUCT/SERVICE
San Francisco Sidewalk
(www.sanfrancisco.sidewalk.com)

CREATIVE DIRECTOR *Andrea Jenkins*
COPYWRITER *Joseph Lasica*
DESIGNERS *Stephanie Gould, Victoria Guinn,*
Dyna Taylor
PHOTOGRAPHER *Victor Fisher*
EXECUTIVE PRODUCER *Beth Cataldo*
AGENCY *Microsoft Corp.*
CLIENT *Microsoft Corp.*
COUNTRY *United States*

(facing page)
Distinctive Merit
WEB SITE DESIGN, CORPORATE/INSTITUTIONAL
Platinum (www.platinum-design.com)

ART DIRECTOR *Kelly Hogg*
CREATIVE DIRECTOR *Vickie Peslak*
COPYWRITER *Platinum Design, Inc.*
DESIGNER *Kelly Hogg*
PHOTOGRAPHER *Paul Lachenauer*
PROGRAMMER *Alec Cove*
STUDIO *Platinum Design, Inc.*
CLIENT *Platinum Design, Inc.*
COUNTRY *United States*

Distinctive Merit

WEB SITE DESIGN, PRODUCT/SERVICE

Motherhaus Online (www.motherhaus.com)

ART DIRECTORS *Svetlana Raynes, Kevin King*
CREATIVE DIRECTORS *Svetlana Raynes, Kevin King*
COPYWRITERS *Svetlana Raynes, Kevin King*
DESIGNERS *Svetlana Raynes, Kevin King*
PHOTOGRAPHER *Kevin King*
ILLUSTRATOR *Svetlana Raynes*
PRODUCERS *Svetlana Raynes, Kevin King*
DIRECTORS *Svetlana Raynes, Kevin King*
STUDIO *Motherhaus*
CLIENT *Motherhaus*
COUNTRY *United States*

Distinctive Merit
WEB SITE/CD ROM DESIGN, PROMOTION
Spirit Font Promo

ART DIRECTOR *Kevin Wade*
CREATIVE DIRECTOR *Kevin Wade*
DESIGNERS *Ben Hirby, Kevin Wade, Darci Bechen*
FONT DESIGNERS *Darci Bechen, Kevin Wade,*
Ben Hirby
PRODUCER *Planet Design Company*
DIRECTOR *Kevin Wade*
MUSIC *Kevin Wade*
AGENCY *Planet Design Company*
CLIENT *T-26 Digital Type Foundry*
COUNTRY *United States*

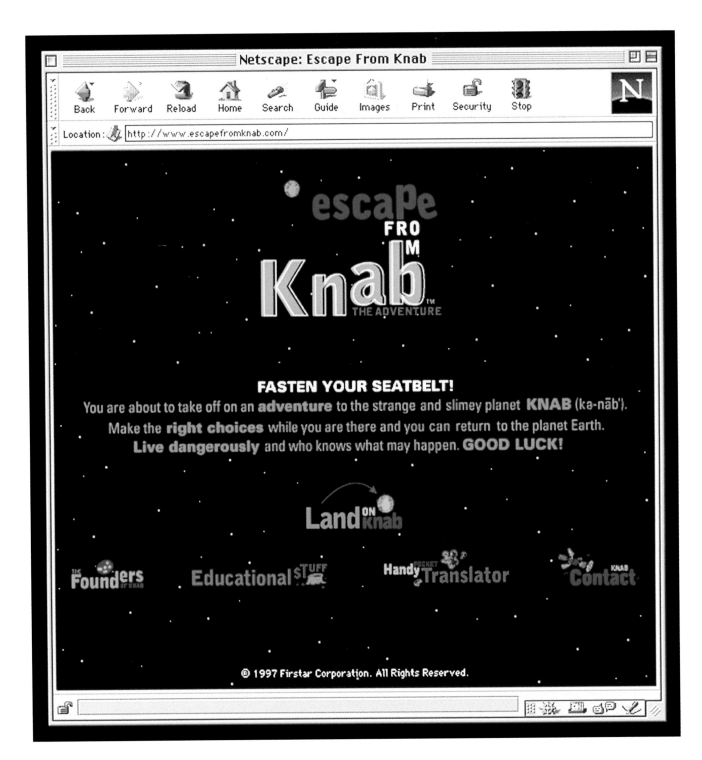

Distinctive Merit
WEB SITE DESIGN, EDUCATIONAL
Escape from Knab - The Adventure
(www.escapefromknab.com)

CREATIVE DIRECTOR *Mark Drewek*
COPYWRITER *John Schaub*
DESIGNER *Amy Fischer*
ILLUSTRATOR *Jim Paillot*
PRODUCER *Scott Kurtz*
AGENCY *Laughlin/Constable*
CLIENT *FIRSTAR Corporation*
COUNTRY *United States*

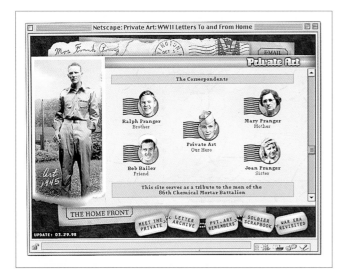

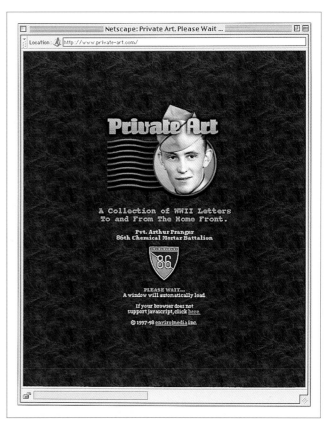

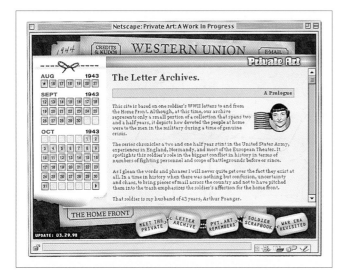

Distinctive Merit
WEB SITE DESIGN, EDUCATIONAL
Private Art: WWII Letters to and from Home
(www.private-art.com)

ART DIRECTOR *Rebecca Pranger*
CREATIVE DIRECTOR *Rebecca Pranger*
COPYWRITERS *Rose Pranger, Art Pranger,*
Rebecca Pranger
DESIGNER *Rebecca Pranger*
PHOTOGRAPHERS *Various*
ILLUSTRATOR *Rebecca Pranger*
MUSIC *RETRO*
PROGRAMMER *Larry Pranger*
AGENCY *enviromedia, inc.*
CLIENT *enviromedia, inc.*
COUNTRY *United States*

Distinctive Merit
WEB SITE DESIGN, GAME/ENTERTAINMENT
PlanetLive (www.planetlive.com)

ART DIRECTOR *Jessie Huang*
CREATIVE DIRECTORS *Chris Do, Marc Lafia*
DESIGNER *Jessie Huang*
PHOTOGRAPHY EDITOR *Charles Girdham*
PHOTOGRAPHERS *various*
ILLUSTRATOR *Jessie Huang*
PRODUCERS *Walter Colsman, Marc Lafia, Ed Rivera*
MUSIC EDITOR *Leiza Richardson*
SOFTWARE ENGINEERS *Fluid, Inc.*
DATABASE & VIDEO ENGINEER *Adam Margulies*
JAVA ENGINEER *Michael Jimenez*
PRODUCT MANAGER *Mark Belanger*
STUDIO *Blind Visual Propaganda, Inc.*
CLIENT *PlanetLive International, Inc.*
COUNTRY *United States*

Distinctive Merit
CD ROM DESIGN, GAME/ENTERTAINMENT
Barbie® Screen Styler ™

ART DIRECTOR *Tim Barber (CircumStance, Inc.)*
CREATIVE DIRECTOR *David Bliss (CircumStance, Inc.)*
DESIGNER *Tim Barber (CircumStance, Inc.)*
ILLUSTRATORS *Chris Howay and Shayne Bingham*
(Big Hand, Inc.), Carol Carpenter (Mattel Media)
PRODUCERS *Roddy McGinnis (Big Hand, Inc.)*
Jesyca Durchin (Mattel Media)
EXECUTIVE PRODUCERS *Steve O'Brien and Jay Wolff*
(Big Hand, Inc.), Nancie S. Martin (Mattel Media)
AGENCY *Big Hand, Inc.*
STUDIO *CircumStance, Inc.*
CLIENT *Mattel Media©*
COUNTRY *United States*

merit

new media

Merit
WEB SITE DESIGN, ADVERTISING/BRAND CAMPAIGN
Nike Promo sitelets
(www.atlasmagazine.com/nike/200M1/index.html)

ART DIRECTORS *Amy Franceschini, Gary Koepke*
CREATIVE DIRECTORS *Amy Franceschini,*
Olivier Laude, John Jay, Kevin Davis
COPYWRITERS *Jimmy Smith, Tina Hall*
DESIGNERS *Amy Franceschini, Terbo Ted*
PHOTOGRAPHER *Dan Winters*
PRODUCER *Katie Raye*
MUSIC *Hellnote*
PROGRAMMING & CODING *Michael Macrone,*
SF Interactive
AGENCY *Wieden & Kennedy*
STUDIO *Atlas Web Design*
CLIENT *Nike*
COUNTRY *United States*

Merit
WEB SITE DESIGN, ADVERTISING/BRAND CAMPAIGN
Dell Computer (www.dell.com)

ART DIRECTORS *Lisa Schiavello, Victoria Goldaracena*
CREATIVE DIRECTORS *Mark Silber, Noel Caban*
COPYWRITERS *David Kosak, Diane Mehta*
DESIGNERS *Jung Park, Pam Savage, David Topper*
ILLUSTRATOR *Pam Savage*
PRODUCERS *Marc Silverstein, Gillian Jackson*
AGENCY *Grey Interactive Worldwide*
CLIENT *Dell Computer*
COUNTRY *United States*

Merit
WEB SITE DESIGN, ADVERTISING/BRAND CAMPAIGN
Nissan (www.nissan-usa.com)
January–March 1997

ART DIRECTOR *John Avery*
COPYWRITERS *David Butler, David Belman,*
Julia Devetski
DESIGNERS *Paul Miller, Helen Yang,*
Christina Kenney
PRODUCERS *Randy Prudhel, Stacy Burgum,*
Tim Langanke
PROGRAMMERS *Mike Rosenberg, Greg Lankford*
MULTIMEDIA STUDIO *Magnet Interactive*
AGENCY *TBWA Chiat/Day, Inc.*
CLIENT *Nissan Motor Corp., USA*
COUNTRY *United States*

Merit

WEB SITE DESIGN, ADVERTISING/BRAND CAMPAIGN
Enjoy the Ride (www.nissan-usa.com)
April 1997 to present

ART DIRECTOR *Paul Miller*
CREATIVE DIRECTORS *Mach Arom, David Belman*
COPYWRITERS *David Belman, Julia Devetski*
DESIGNERS *Helen Yang, Christina Kenney*
PROGRAMMERS *Mike Rosenberg, Greg Lankford*
PHOTOGRAPHER *Nissan Motor Corp., USA*
PRODUCER *Stacy Burgum*
STUDIO *Magnet Interactive*
CLIENT *Nissan Motor Corp., USA*
COUNTRY *United States*

the legacy | cognac tour | tasting rémy | global spirit | our blends | ask the cellar master

when was
the last time
you let
a drink
consume you?

RÉMY MARTIN
FINE CHAMPAGNE COGNAC

Merit
WEB SITE DESIGN, ADVERTISING/BRAND CAMPAIGN
Rémy Martin (www.remy.com)

ART DIRECTOR *Dave Parrish*
CREATIVE DIRECTOR *Dave Parrish*
COPYWRITER *Darrell Kanipe*
DESIGNER *Robbie Wagner*
PRODUCER *Jay Kasberger*
AGENCY *Martin Interactive/The Martin Agency*
CLIENT *Rémy Martin*
COUNTRY *United States*

Merit
CD ROM DESIGN, CORPORATE/INSTITUTIONAL
The Program

ART DIRECTORS *Kevin Kuester, Tim Sauer*
CREATIVE DIRECTORS *Tim Sauer, Eric Kreidler*
COPYWRITER *David Forney*
DESIGNERS *Tim Sauer, Eric Kreidler*
PHOTOGRAPHER *John Casado*
PRODUCERS *Eric Kreidler, Peggy Hufford*
MUSIC *Dick Shopteau*
PROGRAMMERS *Curtis Smith, Eric Kreidler*
AGENCY *Kuester Partners, Inc.*
CLIENT *Potlatch Corporation*
COUNTRY *United States*

Merit
WEB SITE DESIGN, CORPORATE/INSTITUTIONAL
nicolemiller.com

ART DIRECTOR *Bryant Wilms*
CREATIVE DIRECTORS *Nicole Miller, Shannon Carr*
COPYWRITERS *Lynn Butler, Meredith Wollins*
DESIGNER *Theres Wegmann*
ILLUSTRATOR *Kirkpatrick*
PRODUCER *Susan Ahn*
AGENCY *Icon CMT*
CLIENT *Nicole Miller*
COUNTRY *United States*

Merit
WEB SITE DESIGN, CORPORATE/INSTITUTIONAL
Brininstool + Lynch (www.brininstool-lynch.com)

CREATIVE DIRECTOR *Steve Liska*
COPYWRITER *Dawn Bertuca*
DESIGNERS *Matt MacQueen, Matt Leacock,*
Nancy Anderson, John DeVylder
PHOTOGRAPHERS *Various*
STUDIO *Liska + Associates, Inc.*
CLIENT *Brininstool + Lynch, Ltd.*
COUNTRY *United States*

Merit
CD ROM DESIGN, PRODUCT/SERVICE
Webpage Graphics by Ultimate Symbol

ART DIRECTOR *Mies Hora*
CREATIVE DIRECTOR *Mies Hora*
COPYWRITERS *Sabrina Joy, Mies Hora*
DESIGNERS *Ron Meckler, Michael Davis,*
Frances Hora
ILLUSTRATORS *Allison Culbertson, Sabrina Liao,*
Gary Priester
MUSIC *Mies Hora*
STUDIO *Ultimate Symbol Inc.*
CLIENT *Ultimate Symbol Inc.*
COUNTRY *United States*

Merit
CD ROM DESIGN, PRODUCT/SERVICE
FILA In-Line Skate

GRAPHIC DESIGN/INTERFACE *Jason Hemsworth*
MULTIMEDIA PROGRAMMER/INTERFACE
Graham Powell
3D MODELING/RENDERING *Eric Boulden,*
Richard Dirstein
PHOTOGRAPHER *Greg Henderson*
STUDIO *Shikatani Lacroix Design, Inc.*
CLIENT *FILA U.S.A.*
COUNTRY *Canada*

Merit
CD ROM DESIGN, PROMOTION
ABC Fall Season

ART DIRECTOR *Steven Wolfe*
CREATIVE DIRECTOR *Cal Vornberger*
COPYWRITER *Brent Petersen*
DESIGNERS *Curt Middleton, Nora Baker*
PRODUCER *Jane Schneider*
STUDIO *Tumble Interactive Media*
CLIENT *ABC, Inc.*
COUNTRY *United States*

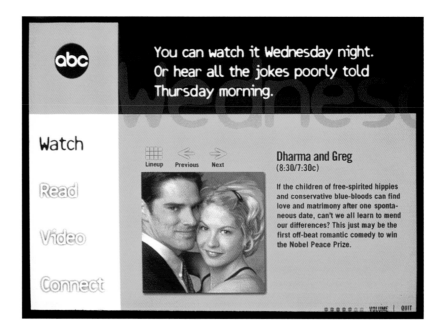

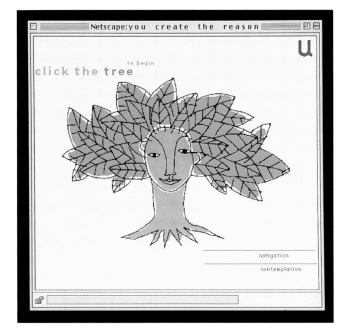

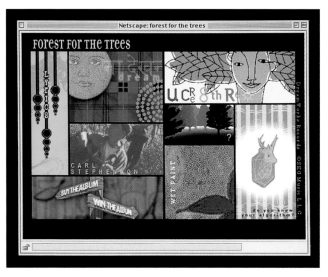

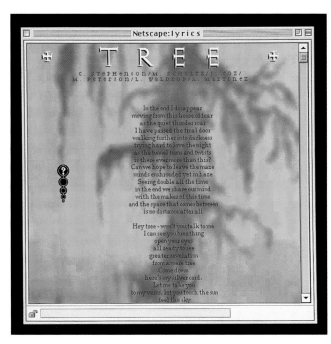

Merit
CD ROM DESIGN, PROMOTION
Forest for the Trees

ART DIRECTOR *Brad Johnson*
DESIGNERS *Bob Aufuldish, Julie Beeler,*
Amy Franceschini, Brad Johnson, Eric Johnson,
Ken Mitsumoto, Kathy Warinner
PRODUCER *Julie Beeler*
MUSIC *Forest for the Trees*
PROGRAMMER *Ken Mitsumoto*
STUDIO *Second Story*
CLIENT *DreamWorks Records*
COUNTRY *United States*

Merit

WEB SITE DESIGN, PROMOTION

JHWD (www.jhwd.com)

ART DIRECTOR *Jeffrey Tyson*
CREATIVE DIRECTORS *Jessica Helfand,*
William Drenttel
COPYWRITER/EDITOR *Timothy McCormick*
JAVASCRIPT PROGRAMMER *Steve Bull*
STUDIO *Jessica Helfand/William Drenttel*
CLIENT *Jessica Helfand/William Drenttel*
COUNTRY *United States*

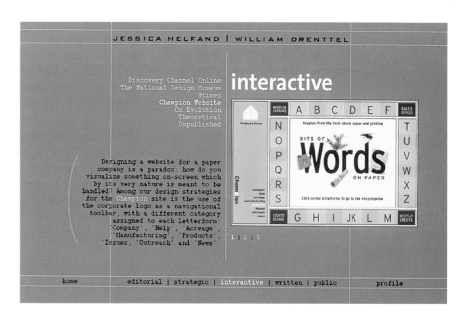

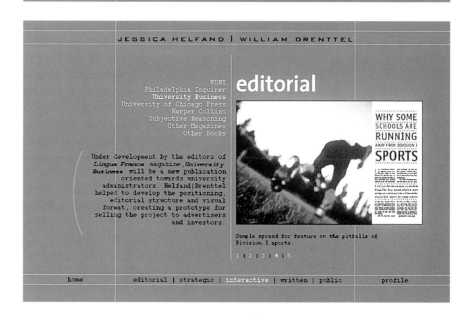

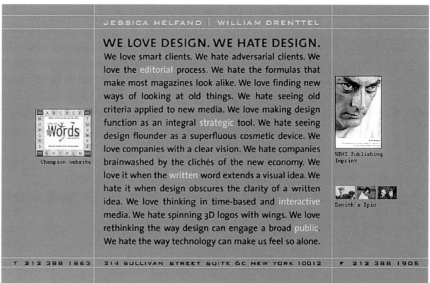

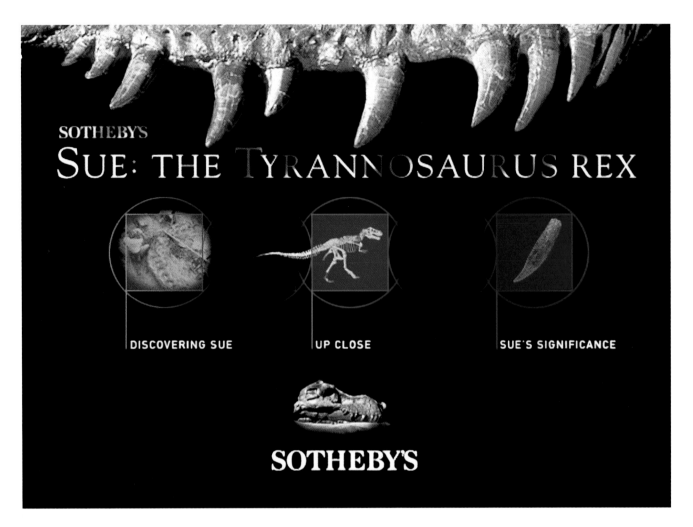

Merit
WEB SITE DESIGN, PROMOTION
Sue: The Tyrannosaurus Rex
(www.sothebys.com/sue-trex)

CREATIVE DIRECTOR *Melissa Tardiff*
DESIGNER *Jonathan Milott*
PHOTOGRAPHER *Bill Milne*
EXECUTIVE PRODUCER *Francis A. Packer (Sotheby's)*
PRODUCER *Benjamin Tolub (Sotheby's)*
EDITORIAL DIRECTOR *Luck Kneebone (Indigo)*
PROGRAMMER *Beau Morley*
STUDIO *Indigo Information Designers*
CLIENT *Sotheby's*
COUNTRY *United States*

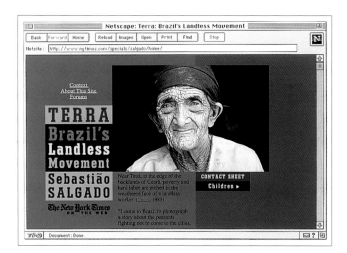

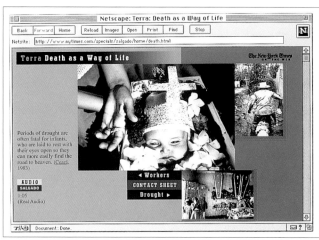

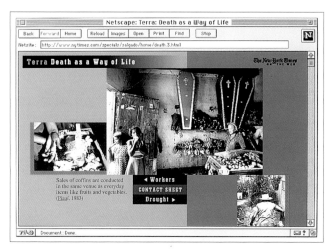

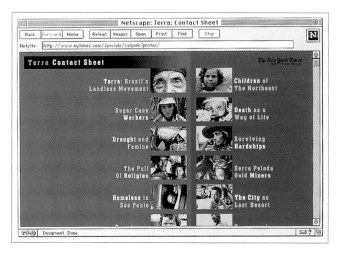

Merit

WEB SITE DESIGN, BOOK/MAGAZINE

Terra: Brazil's Landless Movement
(www.nytimes.com/specials/salgado)

ART DIRECTOR *Ron Louie*
DESIGNER *Ron Louie*
PHOTOGRAPHER *Sebastião Salgado*
EDITORIAL/PROJECT MANAGER *Chris Fowler*
STUDIO *The New York Times Electronic*
Media Company
CLIENT *The New York Times Electronic*
Media Company
COUNTRY *United States*

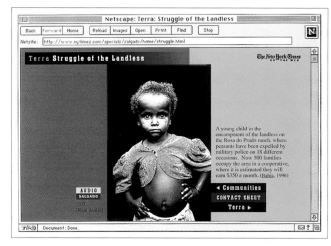

graphic design

When the ADC invited me to chair Graphic Design, I took it upon myself to go forth, like Noah collecting species specimens, on a quest for the combination of individuals who might best represent a broad spectrum of our profession. I was determined to include in the ark even the most uncompromising critics who are too often left out of the judging process.

I aspired to assemble a diversity of minds, cultures, nationalities, sensibilities and eyes in order to appreciate the very specificity of each single entry submitted from the four corners of the globe. Also, I found it crucial to cull judges ranging from the most respected and established figures in Graphic Design to the most alternative and irreverent young talents, and from the solo designer studios to the largest U.S. firms.

An amazing consensus occurred upon electing The Best of Show in Graphic Design: two thirds of the judges voted for the same piece, probably because it encompassed universal values of good design, at the same time gimmicky and sophisticated, modern and classic, and above all a genuine and successful experiment in publication design.

—Mirko Ilić
Mirko Ilić Corporation
United States

(top row)
Tracy Boychuk
MTV Networks
United States

Mark Burdett
Arista Records
United States

Bill Cahan
Cahan & Associates
United States

Ron Dumas
Nike
United States

(second row)
Detlef Fiedler
Cyan Graphisches Büro
Germany

Louise Fili
Louise Fili Ltd.
United States

Milton Glaser
Milton Glaser Inc.
United States

Daniela Haufe
Cyan Graphisches Büro
Germany

(third row)
Alicia Johnson
Johnson & Wolverton
United States

Italo Lupi
Studio Lupi
Italy

Rebeca Mendez
Rebeca Mendez Communication Design
United States

Rick Poynor
writer and editor
England

(fourth row)
Makoto Saito
Makoto Saito Design Studio Inc.
Japan

Irena Wölle
Irena Wölle Studio
Slovenia

Hal Wolverton
Johnson & Wolverton
United States

Tadanori Yokoo
Tadanori Yokoo Studio/
Yokoo's Circus
Japan

graphic design

gold and silver

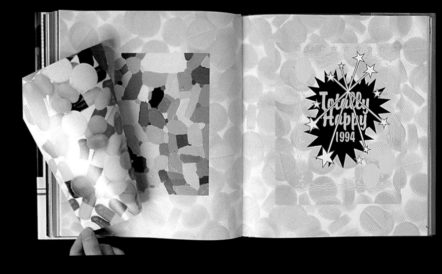

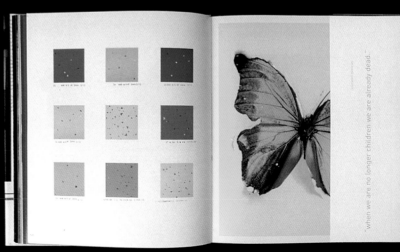

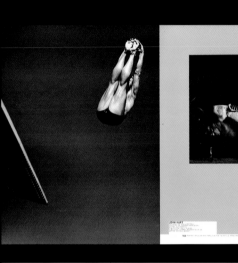

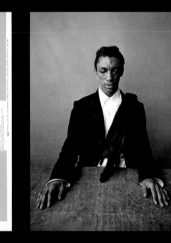

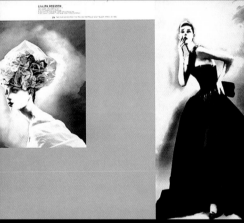

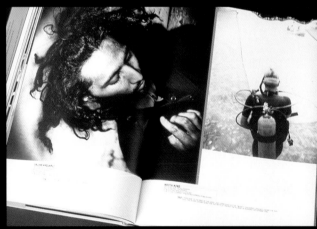

Silver
BOOK DESIGN, GENERAL TRADE BOOKS
American Photography #13

DESIGNERS *Laurie Haycock Makela,*
P. Scott Makela, Liisa Salonen
COPYWRITER *Peggy Roalf (cover)*
PHOTOGRAPHERS *Mimmo Jodice (cover),*
various jury-selected photographers
DIRECTOR *Mark Heflin*
DESIGN FIRM *Words + Pictures for Business +*
Culture at the Cranbrook Academy of Art,
Michigan
CLIENT *Amilus, Inc.*
COUNTRY *United States*

BOOK DESIGN, GENERAL TRADE BOOKS

Der Spiegel–Anzeigentrends: Was bleibt, Was geht, Was kommt (Advertising Trends: What Remains, What Goes, What Comes)

ART DIRECTOR *Régine Thienhaus*
CREATIVE DIRECTOR *Peter Wippermann*
DESIGNER *Régine Thienhaus*
COPYWRITER *Peter Wippermann*
EDITOR *Peter Wippermann*
TEXT DIRECTOR *Andreas Steinle*
ILLUSTRATOR *Birgit Eggers*
PRODUCER *Andrea Junker*
PUBLISHER *Verlag Hermann Schmidt Mainz*
STUDIO *Büro Hamburg*
AGENCY *TrendBüro Hamburg*
CLIENT *Christian Schlottau (Der Spiegel)*
COUNTRY *Germany*

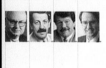

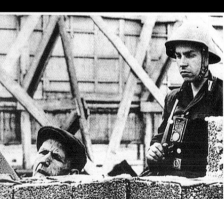

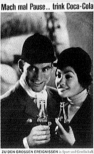

Silver
BOOK DESIGN, GENERAL TRADE BOOKS
Visual Explanations: Image and Quantities
Evidence and Narrative

ART DIRECTOR *Edward R. Tufte*
DESIGNER *Edward R. Tufte*
ILLUSTRATORS *Bonnie Scranton,*
Dmitry Krasny, Weilin Wu
PUBLISHER/STUDIO *Graphics Press*
COUNTRY *United States*

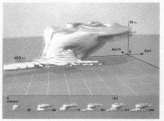

EDWARD R. TUFTE

VISUAL EXPLANATIONS

IMAGES AND QUANTITIES, EVIDENCE AND NARRATIVE

Multiples organize their images by means of a variety of devices: grids, compartments, call-outs, narrative sequence, overlap (opaque or transparent), and integration of multiple elements into a common field. Such organizational apparatus should be visually minimal; better to use the space for information. Ad Reinhardt's multiple above, a witty introductory tour of modern artists, compares 12 versions of a wine glass. Each intriguing and smartly annotated image is surrounded by a noisy border, administrative bloat that consumes an astonishing 42% of space in each framed rectangle. It resembles all too many computer displays, where a cramped window showing the user's work is framed by a bureaucratic debris of scroll bars, buttons, titles, icons, and over-produced drawings. Above, my redesign strips away all the frames (for the edge of each picture defines itself well enough) and also adds each artist's typical palette of colors to the original stylized sketches.

In a paragraph accompanying his illustrated history of 20th-century art, Ad Reinhardt wrote what is probably the single best sentence ever written about the point of images for information design: "As for a picture, if it isn't worth a thousand words, the hell with it."

Ad Reinhardt, "How to Look at Things Through a Wine-Glass," *PM*, July 7, 1946. Rearranged, with collateral material restored.

Design and production by Bonnie Scranton and Edward Tufte.

By sorting through immense stockpiles of text and images, computers can quickly assemble and display one-time confections designed to serve immediate, local, unique purposes. For example, below is my interface for guiding museum-goers to exhibits and facilities. Right from the start, this opening panel shows the scope of information made available. Only a small part of the screen is devoted to computer administration (this is a touch-screen, these are the language options). Free of icons, decorative logotypes, and navigation apparatus, about 90% of the image is substance, a contextual overview describing the reservoir of data. In an architecture of content, the *information becomes the interface.* Rather than sequentially stacking up little bits of data to be unveiled gradually, this *flat interface* surfaces 45 options at once, distributing the information in space rather than in time. Museum-goers then touch the item that they wish to learn about (here, the location of Flemish paintings) and the next confection appears. Shown are a three-dimensional guide-map,

written directions, and a live video image of museum-goers standing at the computer. Users will surely half turn and wave at the camera behind them. Again content dominates, with only two computer commands visible: (1) Return to the original table of contents, or (2) Touch the middle button to generate a sheet of paper reproducing what is on the screen: a map, written directions, *and* a video snapshot of the museum-goer at the computer kiosk! Emerging from a high-resolution printer, this paper serves as a portable and permanent memory, helping visitors navigate through a complex of buildings (shown here is the National Gallery in Washington). Indicating a route down the map, the red pointer on the video-image (linked to red line and footprint on the map) resembles the three-dimensional gesture made by someone giving directions, "Go around and down that way." Only a printed guide will lead people gracefully along a complicated route to Flemish paintings. The personal and entertaining photograph, combined with the map,

Concept and design by Edward Tufte; design and production by Bonnie Scranton, with Dmitry Krasny and Weilin Wu.

Touch any item for more information.

INFORMATION	FACILITIES	PERMANENT WORKS	VISUAL EXHIBITIONS, NOVEMBER 1997
art information	cascade espresso bar	American Painting	
bookstores	checkroom	British Painting	
calendar	concourse buffet	Dutch Painting	
copyrights	elevators	European Sculpture and Decorative Arts, 14th–19th century	Architectural Designs of Humphry Repton / Henri Matisse: Les personnes, 1916
film programs	facility for disabled	Flemish Painting	
gallery talks	first aid	French Painting and Sculpture	
guides	garden cafe	German Painting	
hours	lost and found	Information Design	
photography	restrooms	Italian Painting and Sculpture	Henri Rousseau; French Winged Confections / Susan Rothenberg; Bicycle Paintings
security	stairways	Netherlandish Painting	
slide lectures	telephones	Spanish Painting	
special programs	terrace cafe	Twentieth-century Painting and Sculpture	The Great Age of Tedious British Watercolor: 1750 to 1889 / Information Design of Charles Joseph Minard
Sunday concerts			
tours			
wheelchairs/strollers			

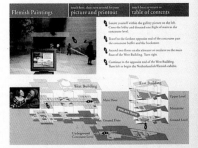

Flemish Paintings — touch here, then turn around for your picture and printout — touch here to return to table of contents

Locate yourself within the gallery picture on the left. Cross the lobby and descend one flight of stairs to the concourse level.

Travel to the farthest opposite end of the concourse past the concourse buffet and the bookstore.

Ascend two floors on the elevator or escalator to the main floor of the West Building. Turn right.

Continue to the opposite end of the West Building. Turn left to begin the Netherlandish/Flemish exhibit.

West Building / East Building
Main Floor / Upper Level / Mezzanine
Ground Floor / Ground Level
Underground Concourse Level

BOOK DESIGN, GENERAL TRADE BOOKS
Synthetic Voice

ART DIRECTORS *Hideki Nakajima,*
Mark Borthwick
EDITORIAL DIRECTOR *Masanobu Sugatsuke*
DESIGNERS *Hideki Nakajima, Mark Borthwick*
PHOTOGRAPHER *Mark Borthwick*
PUBLISHER *Masanori Awata*
STUDIO *Nakajima Design*
CLIENT *Composite Press/Synergy, Inc.*
COUNTRY *Japan*

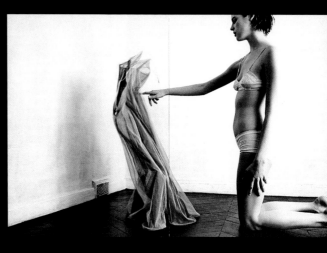

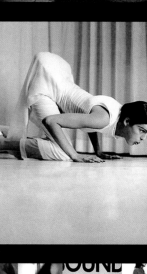

A SBAGLIARE
IF YOU MAKE A MISTAKE BECAUSE OF HASTE
IN FRETTA
YOU'LL THEN HAVE TO CRY SLOWLY.
SI PIANGE ADAGIO

The Region
LA REGIONE

There is something mysterious and paradoxical about this land. The mountains here are relatively young, active, and bubbling with underground springs. Just beneath the surface there is ample evidence of ancient culture. The Etruscans were here long before the Romans, and long before humans settled here, woolly mammoths prowled the area. A typical Sunday outing in spring is herbed around a father showing his young daughter where a fossil sea creature or a creature were found.

Monte Cimone is the highest mountain in these parts, and in winter it is a favorite spot for skiing. In summer it is even more popular, for in summer the upper shoulders of this mountain are covered with wild berries, especially blackberries. People come from miles around to pick and savor these berries. Also in the warmer season, the hills and valleys near Versale erupt in colorful and scented vegetation.

Cherry trees dominate the lower valleys and the countryside is loaded with nuts, chestnuts and berries. Wild mushrooms thrive in these woods, and in the fields a sea of poppies undulates in the easy summer breeze. But a more subtle, and memorable emblem of summer is the aroma of hay drying in the afternoon sun. That's what Rosa, Davide's daughter-in-law, enjoys the most about summer. That, and the perfume of water and earth that lingers in the air after a thunderstorm rolls through the valley and then up over the hills.

It's easy to gaze at this landscape and appreciate its many colors, its complex and layered history, and to lose yourself in musings of all the years that have passed here, all the mystery of ancient lives that unfolded here. In fact, it's not at all difficult to imagine the woolly mammoth still plodding along these hills, or a Roman sentry standing watch over a vital pass. Looking up at the night sky, you can see the moon and the far away stars that reflect the mystery of our own experience, and in such a moment one can sense a very real connection to something that started so long ago and seemingly will go on forever.

Silver
BOOK DESIGN, PROMOTIONAL BOOKS
Luna Bella Luna: A Portrait of Versale, Italy

ART DIRECTOR *James Koval*
CREATIVE DIRECTOR *James Koval*
COPYWRITER *Michael Noble*
DESIGNERS *James Koval, Steven Ryan*
PHOTOGRAPHER *Paul Elledge*
STUDIO *VSA Partners, Inc.*
CLIENT *Mohawk Paper Mills, Inc.*
COUNTRY *United States*

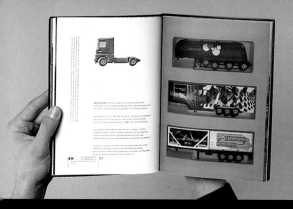

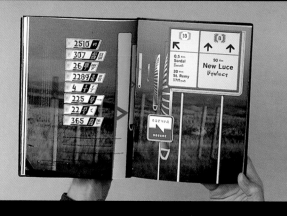

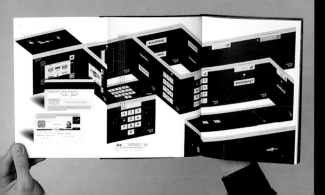

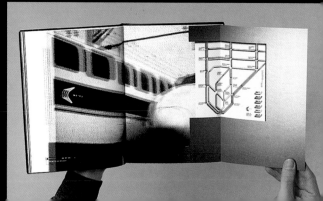

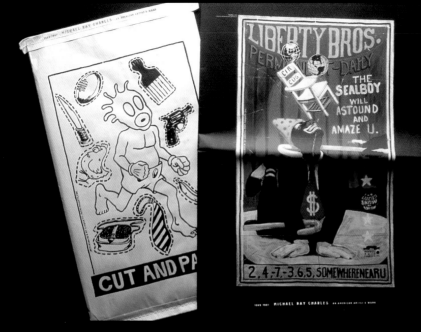

Silver
BOOK DESIGN, MUSEUM, GALLERY, LIBRARY, UNIVERSITY PRESS BOOKS, SERIES
Cut & Paste

ART DIRECTOR *Lana Rigsby*
COPYWRITERS *Spike Lee, Don Bacigalupi, Marilyn Kern-Foxworth*
DESIGNER *Amy Wolpert*
PHOTOGRAPHERS *Patrick Demarchelier, Sharon Seligman*
ILLUSTRATOR *Michael Ray Charles*
STUDIO *Rigsby Design*
CLIENT *Blaffer Gallery, University of Houston*
COUNTRY *United States*

(facing page)
Silver
BOOK DESIGN, LIMITED EDITION, PRIVATE PRESS, SPECIAL FORMAT BOOKS
lahm Ausgabe Nr. 6: Auf Achse
(lahm Issue. No.6: Traveling)

ART DIRECTORS *Lutz Eberle, Andreas Jung, Marcus Wichmann*
DESIGNERS *Lutz Eberle, Andreas Jung, Marcus Wichmann*
STUDIO *lahm*
CLIENT *Staatliche Akademie der Bildenden Künste, Stuttgart*
COUNTRY *Germany*

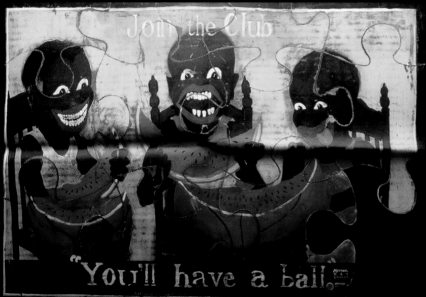

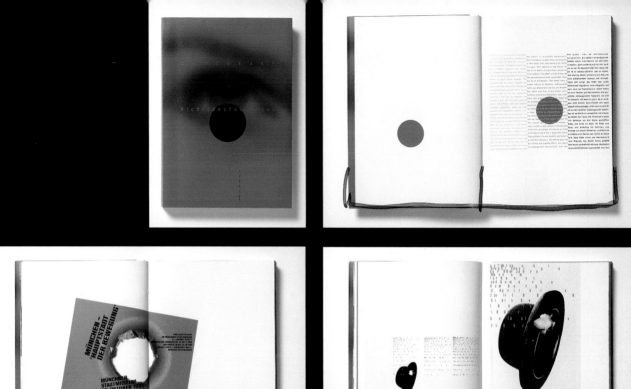
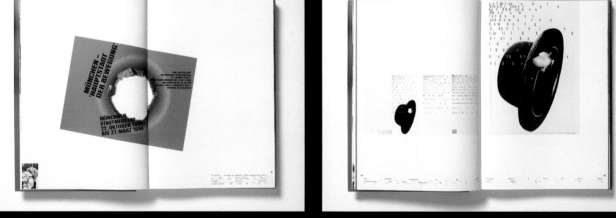
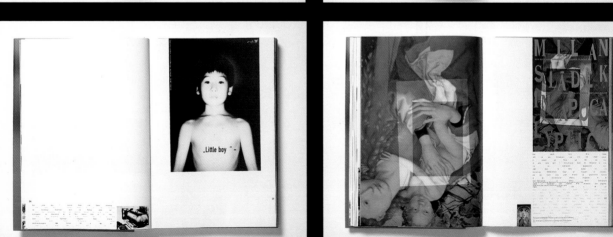

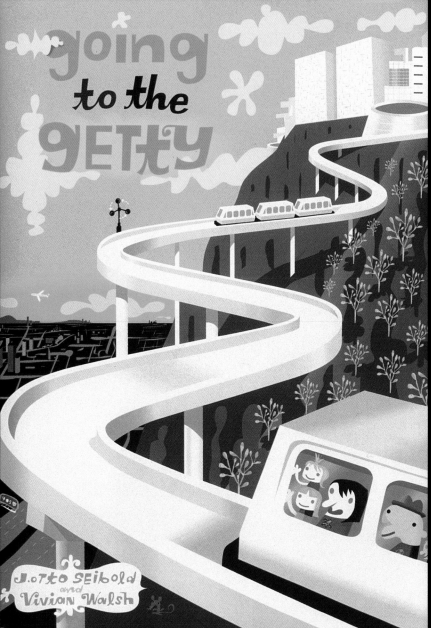

Silver
BOOK DESIGN, JUVENILE BOOKS
Going to the Getty

DESIGNERS *J.otto Seibold, Vivian Walsh*
COPYWRITERS *J.otto Seibold, Vivian Walsh*
ILLUSTRATORS *J.otto Seibold, Vivian Walsh*
STUDIO *J.otto Seibold*
CLIENT *J. Paul Getty Museum*
COUNTRY *United States*

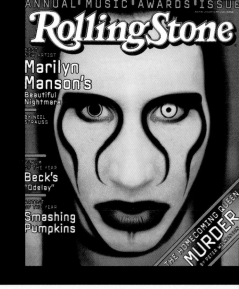

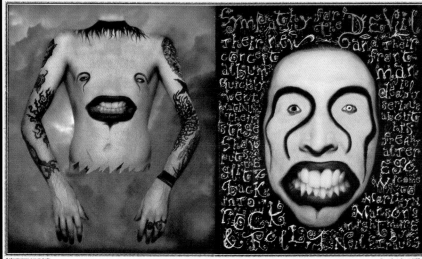

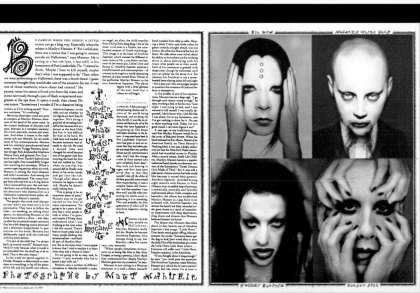

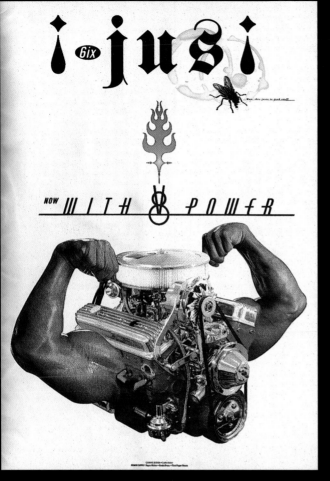

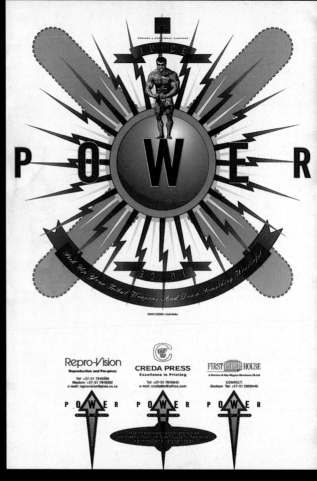

Silver
EDITORIAL DESIGN, MAGAZINE, CONSUMER OR BUSINESS, FULL ISSUE
i-jusi #6

ART DIRECTOR *Garth Walker*
CREATIVE DIRECTOR *Garth Walker*
COPYWRITER *Siobhan Gunning*
DESIGNERS *i-jusi #6 team*
PHOTOGRAPHERS *i-jusi #6 team*
ILLUSTRATORS *i-jusi #6 team*
STUDIO *Orange Juice Design*
CLIENT *Orange Juice Design*
COUNTRY *South Africa*

MULTIPLE AWARDS

Silver
EDITORIAL DESIGN, MAGAZINE, CONSUMER OR
BUSINESS, FULL ISSUE

Distinctive Merit
EDITORIAL DESIGN, MAGAZINE, CONSUMER OR
BUSINESS, SPREAD, SERIES
The New Edition of Design Exchange No.12

ART DIRECTOR *Wang Xu*
CREATIVE DIRECTOR *Wang Xu*
DESIGNER *Wang Xu*
PRODUCER *Wang Xu & Associates Ltd.*
STUDIO *Wang Xu & Associates Ltd.*
CLIENT *China Youth Press*
COUNTRY *China*

no.12

the New Edition
of Design Exchange
no.12

Tokyo-
Warsaw
Line

MUZEUM PLAKATU

The 1994 edition of the Inter-
national Poster Biennale in
Warsaw has presented a larger
number of Japanese graphic
artists compared to their Polish
counterparts. At the same time
the Warsaw Academy of Fine Arts
has granted the honoris causa
doctorate to Yusaku Kamekura
and the National Museum of
Poznan has dedicated an
important retrospective to the
history of the Japanese poster.
Meeting with Yusaku Kamekura
and Lech Majewski, I ask them
the meaning of the encounter
between two visual cultures that
may appear far apart.

Big

Silver

**EDITORIAL DESIGN, MAGAZINE, CONSUMER OR
BUSINESS, FULL ISSUE**
Big Tokyo

ART DIRECTORS *Markus Kiersztan,*
Petra Langhammer
COPYWRITERS *Koji Yoshida, Tim Moss*
DESIGNERS *Markus Kiersztan,*
Petra Langhammer
PHOTOGRAPHERS *Various*
ILLUSTRATORS *Various*
CLIENT *Big Magazine*
COUNTRY *United States*

Tokyo Style

PHOTOGRAPHY AND WORDS BY Kyoichi Tsuzuki

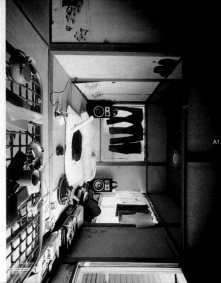

A1

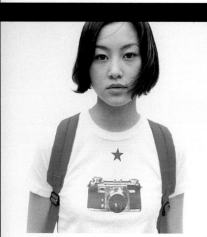

Tokyo Suburbia

PHOTOGRAPHY BY Takashi Homma

CORPORATE & PROMOTIONAL DESIGN,
ANNUAL REPORT
COR Therapeutics, Inc., 1996

ART DIRECTOR *Bill Cahan*
CREATIVE DIRECTOR *Bill Cahan*
COPYWRITERS *Marc Bernstein, Alicia Cimbora*
PHOTOGRAPHERS *Keith Bardin, John Kolesa,*
Tony Stromberg
DESIGNER *Kevin Roberson*
ILLUSTRATOR *Kevin Roberson*
STUDIO *Cahan & Associates*
CLIENT *COR Therapeutics, Inc.*
COUNTRY *United States*

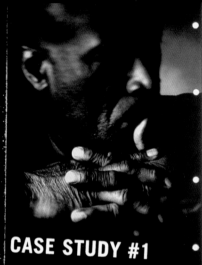

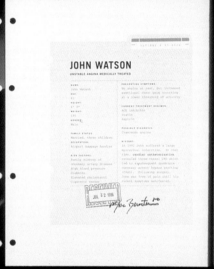

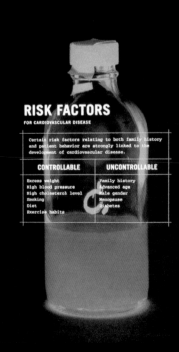

1996 ANNUAL REPORT

Silver
**CORPORATE & PROMOTIONAL DESIGN,
ANNUAL REPORT**
Heartport, 1996

ART DIRECTOR *Bill Cahan*
CREATIVE DIRECTOR *Bill Cahan*
COPYWRITER *Jim Weiss*
DESIGNER *Craig Bailey*
PHOTOGRAPHERS *Ken Schles, Tony Stromberg,
William McLeod*
STUDIO *Cahan & Associates*
CLIENT *Heartport, Inc.*
COUNTRY *United States*

Port-Access CABG and Port-Access MVR Systems

enabling a wide range of minimally invasive cardiac surgery procedures

Silver
CORPORATE & PROMOTIONAL DESIGN,
ANNUAL REPORT
Cracker Barrel, 1997

ART DIRECTOR *Thomas Ryan*
CREATIVE DIRECTOR *Thomas Ryan*
DESIGNER *Thomas Ryan*
COPYWRITER *John Baeder*
PHOTOGRAPHER *McGuire*
ILLUSTRATORS *Various*
AGENCY *Corporate Communications Inc.*
STUDIO *Thomas Ryan Design*
CLIENT *Cracker Barrel Old Country Store, Inc.*
COUNTRY *United States*

NETWORK
GENERAL

We are prepared to guide you!

CORPORATE & PROMOTIONAL DESIGN, ANNUAL REPORT
Network General, 1997

ART DIRECTOR *Bill Caban*
CREATIVE DIRECTOR *Bill Caban*
COPYWRITERS *Tom Hogan, Lisa Jhung*
DESIGNER *Sharrie Brooks*
ILLUSTRATOR *Ross MacDonald*
STUDIO *Caban & Associates*
CLIENT *Network General*
COUNTRY *United States*

TODAY'S NETWORK PROBLEMS ARE
INCREASING IN SIZE AND COMPLEXITY.
THE NEED TO FIND AND
SOLVE THEM QUICKLY IS
BECOMING BUSINESS CRITICAL.

It is important to assess and measure the problem!

The trick is finding the right knot for the right use!

POTLATCH PRESENTS A
SUBTLE BUT MEANINGFUL
CHANGE IN THE LOOK OF
POTLATCH KARMA NATURAL
AND POTLATCH VINTAGE
VELVET CREME. WE'VE
LISTENED CLOSELY TO YOU
AND LIGHTENED THESE TWO
SHADES SO THAT THEY'RE
A LITTLE LESS YELLOW AND
MORE READABLE—BUT
WITHOUT SACRIFICING THE
INHERENT WARMTH AND
DEPTH YOU'VE COME TO
KNOW: KARMA NATURAL.
VINTAGE VELVET CREME. AS
ALWAYS, THE ULTIMATE IN
CONSISTENT REPRODUCTION.

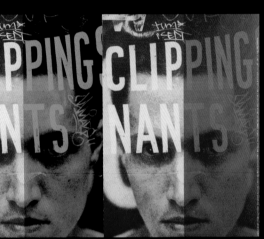

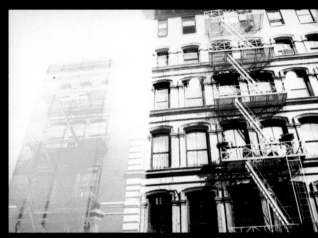

& PROMOTIONAL DESIGN,

's Journal: Volume 1: 1

R Mary Moegenburg
ECTOR Dana Arnett
Andy Blankenburg
son Eplawy
HER Nitin Vadukul
Partners, Inc.
tch Corporation
ited States

(facing page)
MULTIPLE AWARDS

Silver
**CORPORATE & PROMOTIONAL DESIGN,
SPECIAL IDENTITY PROGRAM, SERIES**

Silver
CORPORATE PROMOTIONAL DESIGN, BOOKLET
Tankmal, Exhibition Material and Catalogue

ART DIRECTOR *Margit Tabert*
CREATIVE DIRECTORS *Annchen M. Stiens,
Gereon Sonntag*
COPYWRITER *Marco Füchslin*
PHOTOGRAPHER *Hans-Ruedi Rohrer*
ILLUSTRATOR *Max Grüter*
AGENCY *Grey GmbH & Co. KG*
CLIENT *Max Grüter (Artist)*
COUNTRY *Germany*

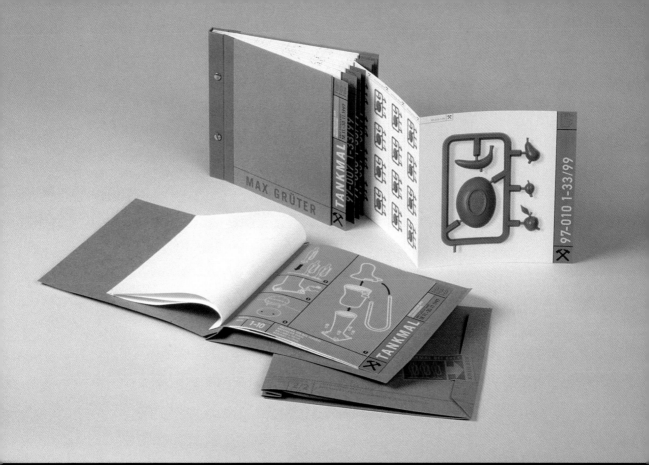
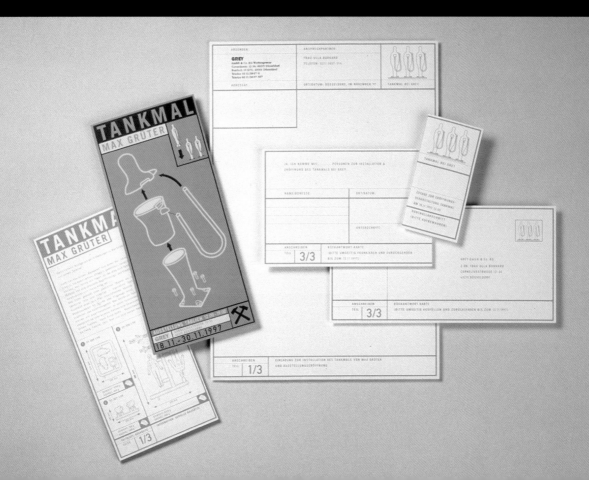

Basin branded product labeling system.

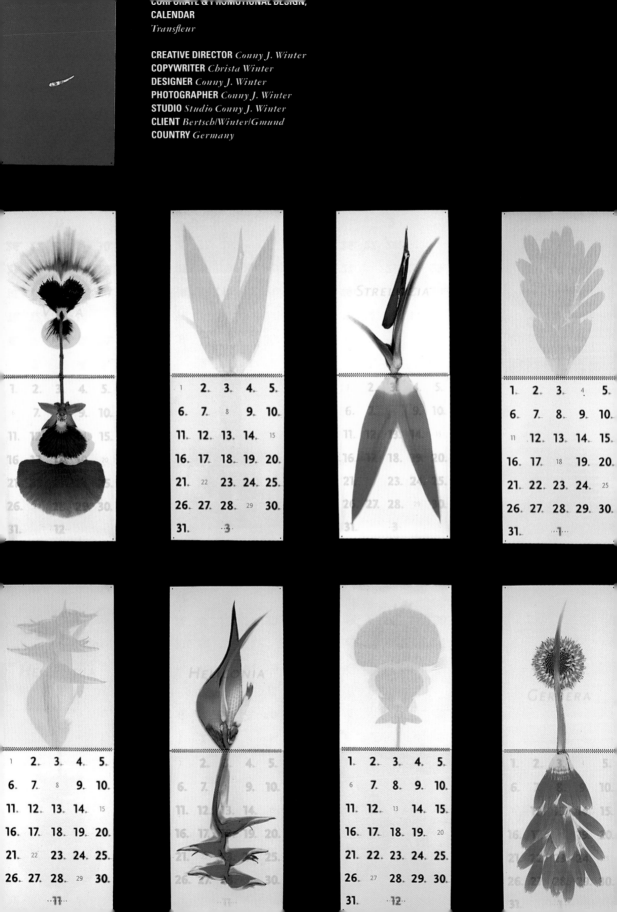

CORPORATE & PROMOTIONAL DESIGN,
CALENDAR
Transfleur

CREATIVE DIRECTOR *Conny J. Winter*
COPYWRITER *Christa Winter*
DESIGNER *Conny J. Winter*
PHOTOGRAPHER *Conny J. Winter*
STUDIO *Studio Conny J. Winter*
CLIENT *Bertsch/Winter/Gmund*
COUNTRY *Germany*

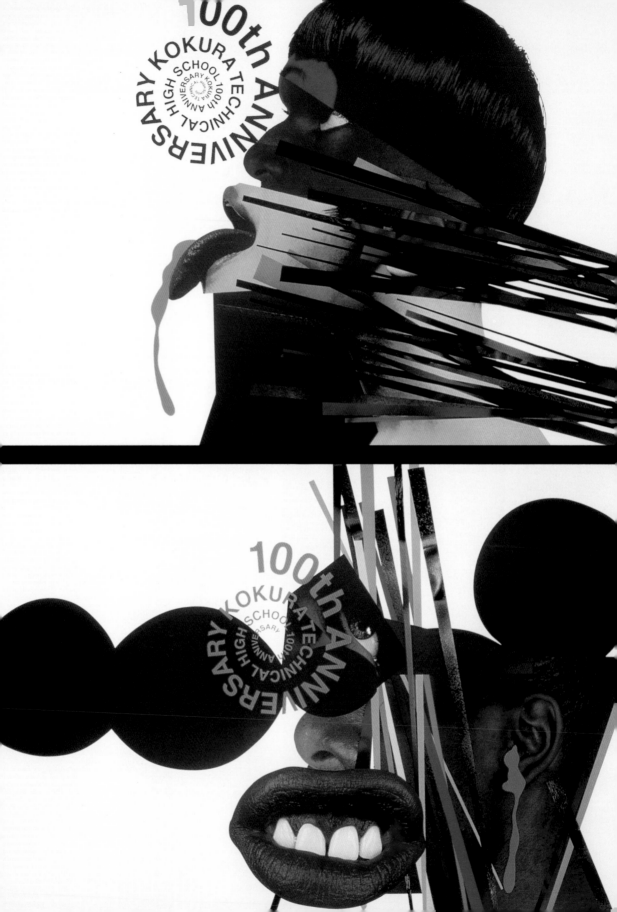

L

n für Gestaltung
e of Design)

el
er
rtner

CE OR
RIES

hnical

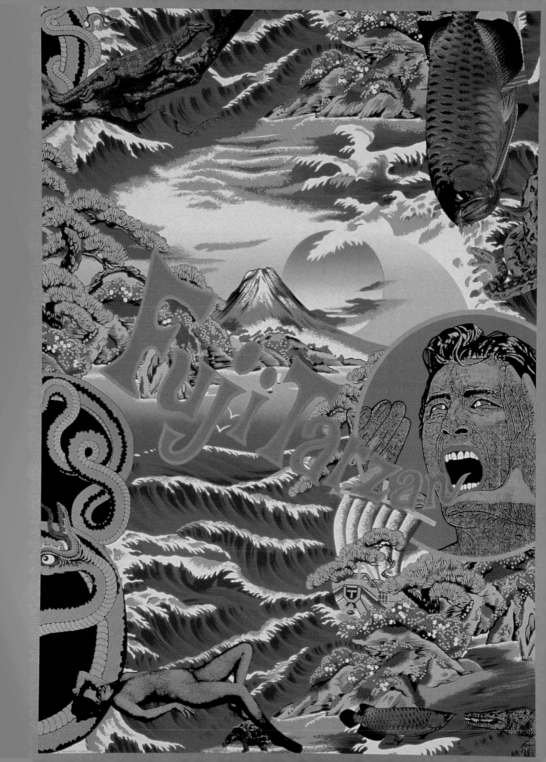

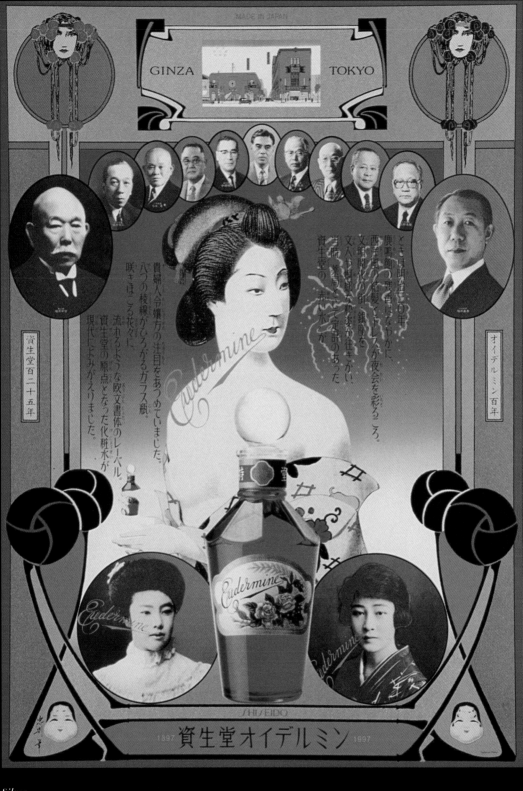

Silver
POSTER DESIGN, PROMOTIONAL
Eudermine

ART DIRECTOR *Tadanori Yokoo*
CREATIVE DIRECTOR *Tadanori Yokoo*
COPYWRITER *Mayumi Kaji*
DESIGNER *Tadanori Yokoo*
PRODUCER *Ikuo Amano*
STUDIO *Yokoo's Circus*
CLIENT *Shiseido Co., Ltd.*

Gold
PACKAGE DESIGN, ENTERTAINMENT, SERIES
Kenji Ozawa "dogs"

ART DIRECTOR *Keiko Hirano*
DESIGNER *Keiko Hirano*
STUDIO *Hirano Studio Inc.*
CLIENT *Toshiba-EMI Limited*
COUNTRY *Japan*

Silver
ENVIRONMENTAL DESIGN, DISPLAY OR
MERCHANDISING EXHIBIT
Eudermine, Shiseido Art House

ART DIRECTOR *Masao Ohta*
CREATIVE DIRECTOR *Masao Ohta*
DESIGNERS *Aoshi Kudo, Taisuke Kikuchi*
PRODUCER *Takao Kakizaki*
AGENCY *Shiseido Co., Ltd.,*
Creation Department
CLIENT *Shiseido Co., Ltd.*
COUNTRY *Japan*

MULTIPLE AWARDS

Gold
**TELEVISION, FILM AND VIDEO DESIGN,
TV BROADCAST GRAPHICS: IDENTITIES,
OPENINGS, TEASERS, CAMPAIGN**
Jello • Bug Zapper • Cow

Gold
**TELEVISION, FILM AND VIDEO DESIGN,
TV BROADCAST GRAPHICS: IDENTITIES,
OPENINGS, TEASERS**
Jello

Silver
**TELEVISION, FILM AND VIDEO DESIGN,
TV BROADCAST GRAPHICS: IDENTITIES,
OPENINGS, TEASERS**
Bug Zapper

Distinctive Merit
**TELEVISION, FILM AND VIDEO DESIGN,
TV BROADCAST GRAPHICS: IDENTITIES,
OPENINGS, TEASERS**
Cow

ART DIRECTOR *Scott Carlson*
CREATIVE DIRECTOR *Eric McClellan*
COPYWRITER *Shalom Auslander*
DIRECTOR *Scott Carlson*
DIRECTOR OF PHOTOGRAPHY *Simeon Soffer*
PRODUCER *Liz Haberman*
SOUND DESIGN *Drew Weir*
EDITOR *Sarah Iben*
AGENCY *TBWA Chiat/Day, Inc.*
CLIENT *ABC, Inc.*
COUNTRY *United States*

TV. What would you
watch without it?

American Broadcasting Company

**TELEVISION, FILM AND VIDEO DESIGN,
PROMOTIONAL VIDEO**
The Hunger

ART DIRECTOR *Tony Castellano (Showtime)*
CREATIVE DIRECTOR *Elaine Brown (Showtime)*
PRODUCERS *David Edelstein, Meridith Brown*
DESIGNERS *John Warwicker, Karl Hyde*
EXECUTIVE PRODUCERS *Richard Winkler,
Meridith Brown*
DIRECTORS *John Warwicker, Karl Hyde
(Tomato)*
MUSIC *Underworld*
PRODUCTION COMPANY *Curious Pictures*
AGENCY *Showtime*
CLIENT *Showtime Networks Inc.*
COUNTRY *United States*

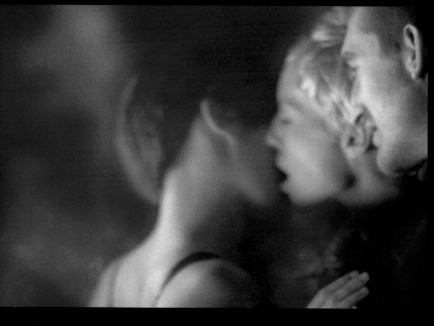

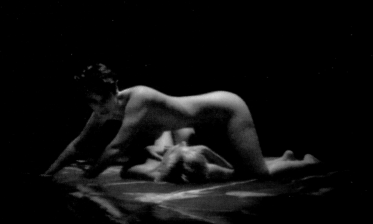

distinctive merit graphic design

Distinctive Merit
BOOK DESIGN, GENERAL TRADE BOOKS
Rock Facts

ART DIRECTOR *John Klotnia*
DESIGNERS *John Klotnia, Seung-il Choi,*
Ivette Montes de Oca, Marni McLoughlin
PHOTOGRAPHERS *Various*
STUDIO *Pentagram Design*
CLIENT *Universe Publishing*
COUNTRY *United States*

Distinctive Merit
BOOK DESIGN, PROMOTIONAL BOOKS
White Paper

DESIGNER *Esther Kit-Lin Liu*
COPYWRITER *Esther Kit-Lin Liu*
STUDIO *The Hong Kong Polytechnic University,*
School of Design
CLIENT *Wiggins Teape (H.K.) Ltd.*
COUNTRY *Hong Kong, China*

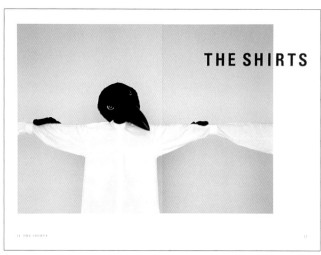

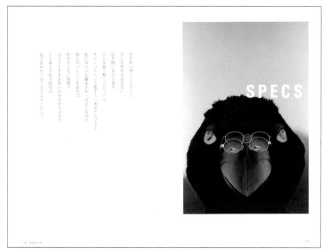

Distinctive Merit
BOOK DESIGN, PROMOTIONAL BOOKS
*Don't Talk about Colors (brand image campaign
for Issey Miyake)*

ART DIRECTOR *Kenya Hara*
COPYWRITER *Munenori Harada*
DESIGNER *Kenya Hara*
PHOTOGRAPHER *Tamotsu Fujii*
AGENCY *Nippon Design Center Inc.*
CLIENT *ON Limits Inc.*
COUNTRY *Japan*

(facing page, top)
Distinctive Merit
**EDITORIAL DESIGN, MAGAZINE, CONSUMER OR
BUSINESS, SPREAD**
Chris Rock

ART DIRECTOR *Fred Woodward*
DESIGNERS *Gail Anderson, Fred Woodward*
PHOTOGRAPHER *Mark Seliger*
PHOTO EDITOR *Jodi Peckman*
PUBLISHER *Wenner Media*
CLIENT *Rolling Stone*
COUNTRY *United States*

(facing page, bottom)
Distinctive Merit
**EDITORIAL DESIGN, MAGAZINE, CONSUMER OR
BUSINESS, SPREAD**
Prodigy

ART DIRECTOR *Fred Woodward*
DESIGNERS *Geraldine Hessler, Fred Woodward*
PHOTOGRAPHER *Peter Robathan*
PHOTO EDITOR *Jodi Peckman*
PUBLISHER *Wenner Media*
CLIENT *Rolling Stone*
COUNTRY *United States*

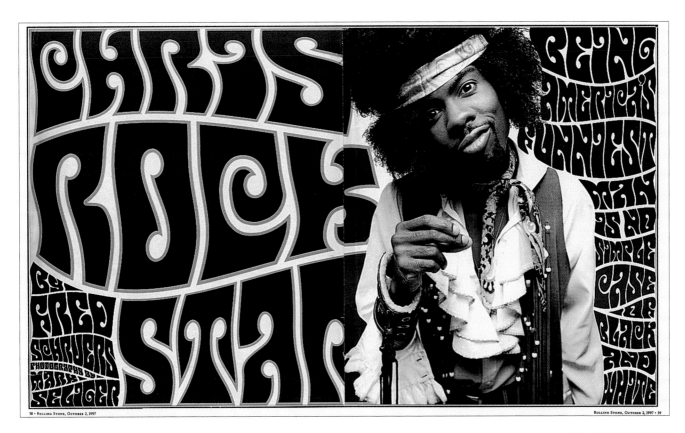

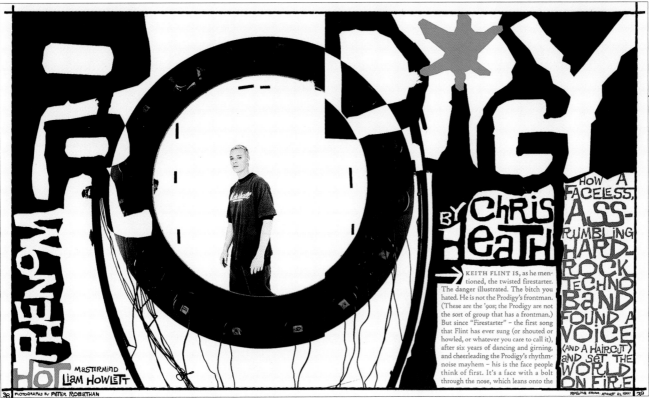

Distinctive Merit

**EDITORIAL DESIGN, MAGAZINE, CONSUMER OR
BUSINESS, MULTIPAGE, SERIES**

Pra que serve a moda (What's Fashion For?)

ART DIRECTOR *Renata Zincone*
CREATIVE DIRECTOR *Paulo Lima*
COPYWRITER *Paulo Lima*
PHOTOGRAPHER *Greg Friedler*
DIRECTORS *Paulo Lima, Carlos Sarli,
Morris Kachani*
VISUAL PROJECT *David Carson*
STUDIO *Trip Magazine*
COUNTRY *Brazil*

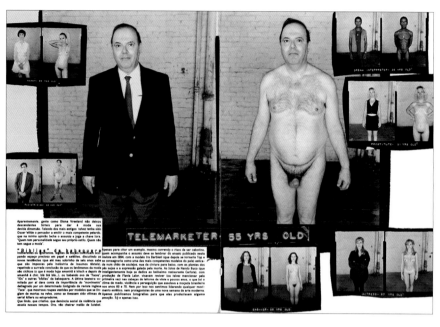

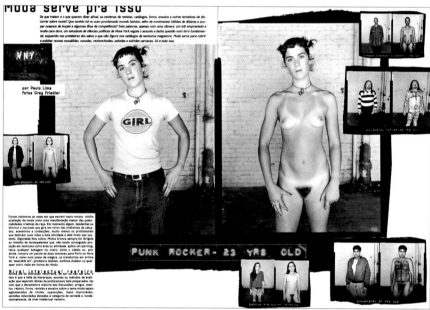

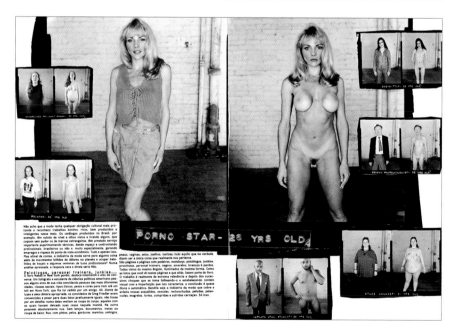

Distinctive Merit
EDITORIAL DESIGN, MAGAZINE, CONSUMER OR
BUSINESS, MULTIPAGE, SERIES
Cut Magazine, July 1997

ART DIRECTORS *Hideki Nakajima, Mark Borthwick*
EDITOR IN CHIEF *Ken Sato*
EDITORS *Hiroshi Inada, Akemi Nakamura*
DESIGNER *Hideki Nakajima*
PHOTOGRAPHERS *Neil Kirk (Brad Pitt spread),*
Nobuyoshi Araki (UA spread)
STUDIO *Nakajima Design*
CLIENT *Rockin' On Inc.*
COUNTRY *Japan*

Distinctive Merit

EDITORIAL DESIGN, MAGAZINE, CONSUMER OR BUSINESS, MULTIPAGE, SERIES

Sum of its Parts

DIRECTOR OF DESIGN *Tom Bentkowski*
DESIGNER *Sam Serebin*
PHOTOGRAPHER *Alexander Tsiaras*
PHOTO EDITOR *David Friend*
CLIENT *LIFE Magazine*
COUNTRY *United States*

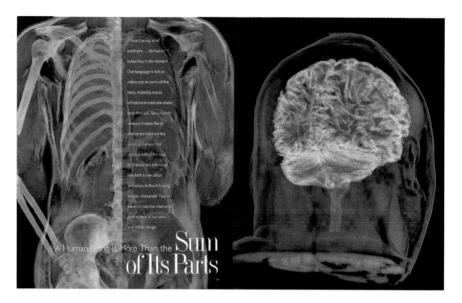

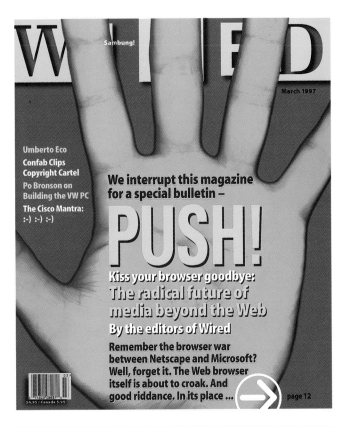

Distinctive Merit
**EDITORIAL DESIGN, MAGAZINE, CONSUMER OR
BUSINESS, MULTIPAGE, SERIES**
Push

ART DIRECTORS *Erik Adigard, Thomas Schneider*
CREATIVE DIRECTOR *John Plunkett*
EDITORS *Louis Rossetto, Kevin Kelly, Gary Wolf, others*
DESIGNERS *Erik Adigard, Eric Courtemanche,
Thomas Schneider*
ILLUSTRATOR *Erik Adigard*
CLIENT *Wired Magazine*
COUNTRY *United States*

glasses. On the map, tiny umbrella icons appear showing stores within a two-block radius that sell rain gear. This carefully tailored mix of instruction and merchandising is environmental push media. Low-intensity networked media. Always-on media.

You are in your study, answering email from the office when you notice something happening on the walls. Ordinarily, the large expanse in front of you features a montage generated by SCI-VIZ - a global news feed of scientific discoveries, plus classic movie scenes and 30-second comedy routines. You picked this service because it doesn't show any of the usual disaster crap, yet the content is very lively, a sort of huge screensaver. Which you usually ignore. But just now you noticed a scene from your hometown, something about an archaeological find. You ask for the full video. This is always-on, mildly in-your-face networked media.

You are driving your car, using the heads-up map display on the windshield to find your way around a strange city. It works wonderfully, helping you get to your appointment on time. Real-time display is expensive, but you're not paying for it. It's "free." You pay by renting a little piece of your brain to the Krakatoa HeadsUp Advertising Corporation, which beams clever poetic messages twice an hour.

Push media are always on. / Push media are mobile. / Push media are customizable.

They are little rhymes, and no matter how hard you try, you cannot get them out of your head. But they beat getting lost, and the maps are detailed beyond belief. Including weather reports. This is ambient, low-intensity push media.

You are skipping through footnote links, researching the diaries of impressionistic painters, when you come across the letters of van Gogh's brother, Theo. The next link holds the documentary film *Vincent*, a feature-length saga about the painter's last years based on his accounts. You click. An hour and half (and US$3) later, you resume surfing. This is intense networked push media - for that 90 minutes, you did not steer at all.

You sit down at your big screen and send your bot out to the DreamWorks server. Give me something 45 minutes long, you tell it. Something funny. You know what I like. Something I can interrupt while I make some phone calls. OK, start. This is in-your-face, immersive, experiential push media.

Revenge of TV?

At first glance all this looks a lot like the revenge of TV. It's back! Just when a billion Web pages are blooming, the sub-

terranean instincts of couch potatoes rise again! After 45 years of addiction to passive media, only a handful of us turn out to be up for the vigorous activity of reaching out to engage the world. Bummer.

True, there's a little couch potato in all of us. The human desire to sit back in the EZ-Lounge and be told a completely ridiculous story is as dependable as the plot of a nighttime soap from Mr. Spelling. But when *The Wall Street Journal* trumpeted the arrival of push media by declaring that the Internet "has been a medium in search of a viable business model. Now it has found one: television," it got the story almost entirely wrong. The new networked media do borrow ideas from television, but the new media landscape will look nothing like TV as we know it. And indeed, it will transform TV in the process.

Start with HTML, the lingua franca of the traditional Web. HTML is an instantiation of SGML, a metalanguage originally developed by IBM to handle in-house documentation for mainframe computers. In other words, it's the language of an archive medium. Archive as in stacks of old books in a library. The Web is a *wonderful* library, but a library nonetheless.

On the other hand the new networked media - part

The look and feel emphasizes tactility and the illusion of three dimensions.

instructional and part entertainment - are not archival, but immersive. The image to hold in mind is an amusement park, full of experiences and information coming at you in many forms, some scripted, some serendipitous. It may be intense, it may be ambient, but it always assumes you are available. Push media arrive automatically - on your desktop, in your email, via your pager. You won't choose whether to turn them on, only whether to turn them off. And there will be many incentives not to.

Foremost is relief from boredom. Push media will penetrate environments that have, in the past, been media-free - work, school, church, the solitude of a country walk. Through cheap wireless technologies, push media are already colonizing the world's last quiet nooks and crannies.

At the same time, networked push media can - and will - bombard you with an intensity that invitational media never muster. After a hard day at work, who wants to come home and face an experience by prospecting for a granule of intelligence or amusement that's buried in 100 billion Web sites? There are times you want the content to steer you. It's worth paying for selections, edits, digests, synthesis, and branded creations. Or you can sit in your chair and become absorbed in a multiplayer game that has been in

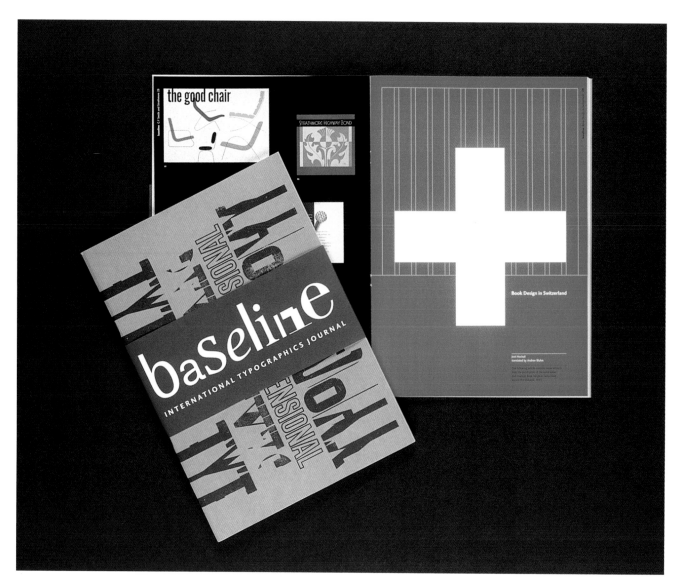

Distinctive Merit
EDITORIAL DESIGN, MAGAZINE, CONSUMER OR
BUSINESS, FULL ISSUE, SERIES
Baseline 22

ART DIRECTOR *Hans Dieter Reichert*
CREATIVE DIRECTOR *Hans Dieter Reichert*
COPYWRITERS *Various*
DESIGNERS *Hans Dieter Reichert, Dean Pavitt,*
Peter Black, Loïc Lévêque, David Scadding
PHOTOGRAPHER *Studio 2*
ILLUSTRATOR *Susanna Edwards*
EDITORIAL BOARD *Alan Fletcher, Misha Anikst,*
Dave Ellis, Colin Brignall, Martin Ashley
STUDIO *HDR Design*
CLIENT *Bradbourne Publishing Ltd.*
COUNTRY *England*

Distinctive Merit

**EDITORIAL DESIGN, MAGAZINE, CONSUMER OR
BUSINESS, FULL ISSUE**

i-jusi #5

ART DIRECTOR *Garth Walker*
CREATIVE DIRECTOR *Garth Walker*
COPYWRITER *Suzy Bell*
DESIGNERS *i-jusi #5 team*
PHOTOGRAPHERS *i-jusi #5 team*
ILLUSTRATORS *i-jusi #5 team and*
M.L. Sultan Technikon students
STUDIO *Orange Juice Design*
CLIENT *Orange Juice Design*
COUNTRY *South Africa*

Distinctive Merit
**CORPORATE & PROMOTIONAL DESIGN,
ANNUAL REPORT**
Geron, 1996

ART DIRECTOR *Bill Cahan*
CREATIVE DIRECTOR *Bill Cahan*
COPYWRITERS *Carole Melis (large book),*
various (small book)
DESIGNER *Bob Dinetz*
PHOTOGRAPHERS *Etta Clark, Geron (large book),*
William McLeod, Geron (small and large books)
ILLUSTRATORS *Lorraine Maschlr, Bob Dinetz*
STUDIO *Cahan & Associates*
CLIENT *Geron Corporation*
COUNTRY *United States*

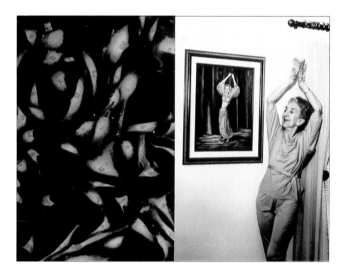

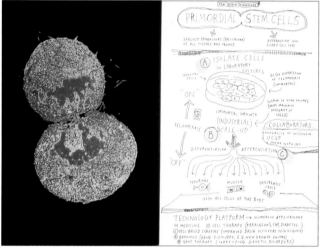

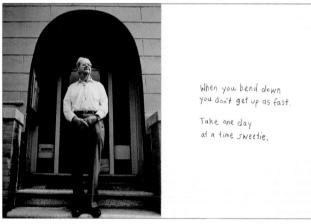

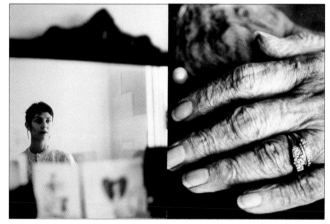

Distinctive Merit
**CORPORATE & PROMOTIONAL DESIGN,
ANNUAL REPORT**
Esterline Technologies, 1997

ART DIRECTOR *Kerry Leimer*
CREATIVE DIRECTOR *Kerry Leimer*
COPYWRITERS *Brian Keogh, Kerry Leimer*
DESIGNERS *Marianne Li, Kerry Leimer*
PHOTOGRAPHER *Jeff Corwin*
ILLUSTRATOR *Paul Bice, Jr.*
STUDIO *Leimer Cross Design*
CLIENT *Esterline Technologies*
COUNTRY *United States*

Distinctive Merit
**CORPORATE & PROMOTIONAL DESIGN,
ANNUAL REPORT**
South Texas College of Law, Dean's Report, 1996

ART DIRECTOR *Mark Geer*
COPYWRITERS *Molly Glentzer, Kim Parker*
DESIGNERS *Mark Geer, Karen Malnar*
PHOTOGRAPHER *Chris Shinn*
ILLUSTRATOR *Mark Geer*
STUDIO *Geer Design, Inc.*
CLIENT *South Texas College of Law*
COUNTRY *United States*

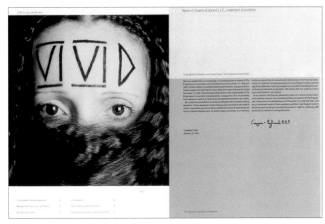

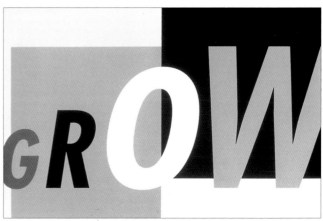

Distinctive Merit
**CORPORATE & PROMOTIONAL DESIGN,
ANNUAL REPORT**
The Progressive Corporation, 1996

ART DIRECTORS *Joyce Nesnadny, Mark Schwartz*
DESIGNERS *Joyce Nesnadny, Michelle Moehler*
PHOTOGRAPHERS *Rimma Gerlovina,*
Valery Gerlovin
PRINTER *Fortran Printing, Inc.*
AGENCY *Nesnadny + Schwartz*
CLIENT *The Progressive Corporation*
COUNTRY *United States*

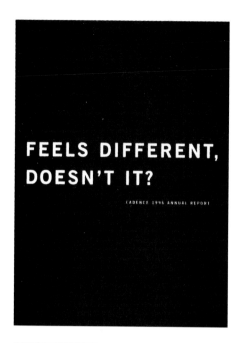

Distinctive Merit
**CORPORATE & PROMOTIONAL DESIGN,
ANNUAL REPORT**
Cadence, 1996

ART DIRECTOR *Bill Cahan*
CREATIVE DIRECTOR *Bill Cahan*
COPYWRITER *John Mannion*
DESIGNER *Bob Dinetz*
PHOTOGRAPHERS *Tony Stromberg, Amy Guip*
ILLUSTRATORS *Mark Todd, Riccardo Vecchio,*
Jason Holley, Bob Dinetz
STUDIO *Cahan & Associates*
CLIENT *Cadence Design Systems*
COUNTRY *United States*

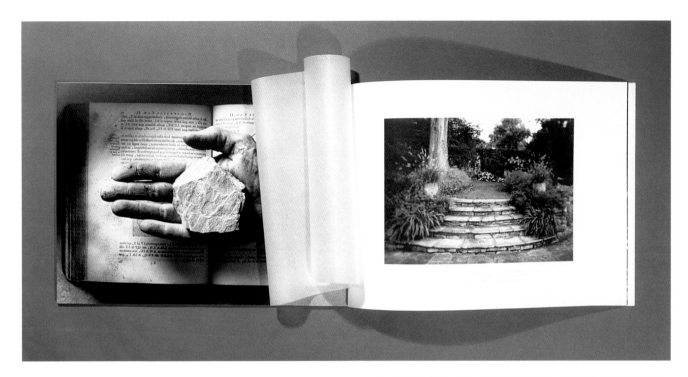

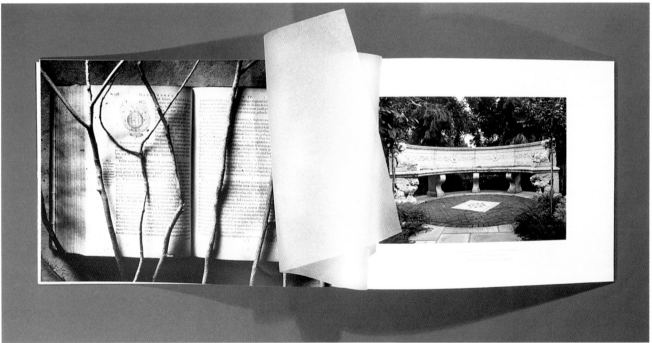

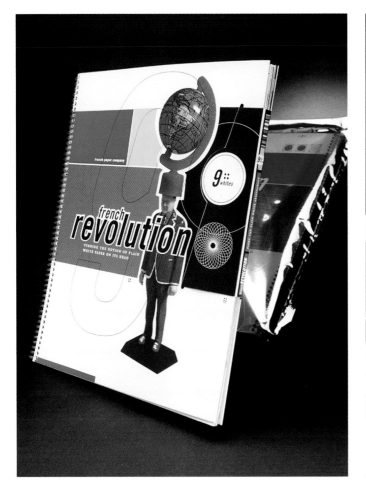

Distinctive Merit
**CORPORATE & PROMOTIONAL DESIGN,
BROCHURE**
French Revolution

ART DIRECTOR *Charles S. Anderson*
COPYWRITER *Lisa Pemrick*
DESIGNERS *Jason Schulte, Charles S. Anderson*
PHOTOGRAPHER *Eric Emmings (CSA Plastock)*
STUDIO *Charles S. Anderson Design Company*
CLIENT *French Paper Company*
COUNTRY *United States*

(facing page)
MULTIPLE AWARDS

Distinctive Merit
**CORPORATE & PROMOTIONAL DESIGN,
BOOKLET**

Merit
BOOK DESIGN, PROMOTIONAL BOOKS, SERIES

Distinctive Merit
**PHOTOGRAHY/ILLUSTRATION,
CORPORATE/INSTITUTIONAL, SERIES**
On Page

ART DIRECTORS *Jennifer Martin, Marion English*
CREATIVE DIRECTOR *Terry Slaughter*
COPYWRITERS *Laura Hambaugh, Terry Slaughter*
DESIGNERS *Jennifer Martin, Marion English*
PHOTOGRAPHER *Sean Kernan*
ILLUSTRATOR *David Webb*
AGENCY *Slaughter Hanson*
STUDIO *Sean Kernan Studio Inc.*
CLIENT *Ben Page Landscape Architects*
COUNTRY *United States*

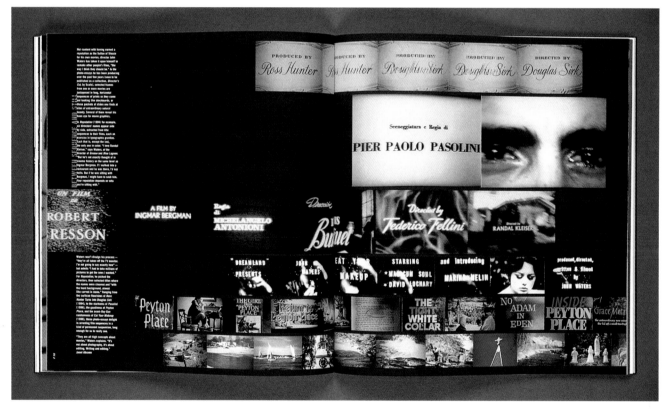

Distinctive Merit
**CORPORATE & PROMOTIONAL DESIGN,
BOOKLET**
Medium: Rethinking Design #4

PARTNER/DESIGNER *Michael Bierut*
DESIGNERS *Michael Bierut, Jacqueline Thaw*
PHOTOGRAPHERS *Various*
STUDIO *Pentagram Design*
CLIENT *Mohawk Paper Mills*
COUNTRY *United States*

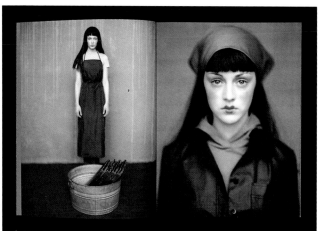

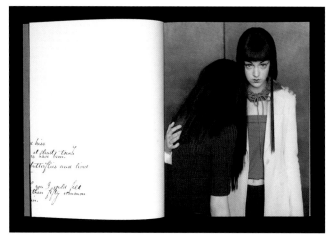

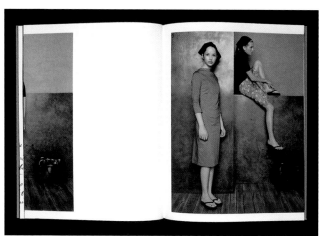

Distinctive Merit
**CORPORATE & PROMOTIONAL DESIGN,
BOOKLET**
EnC Spring Image Book

ART DIRECTORS *J. Phillips Williams,
Allison Muench Williams*
DESIGNERS *Allison Muench Williams,
J. Phillips Williams*
PHOTOGRAPHER *Hans Gissinger*
STUDIO *Design: M/W*
CLIENT *EnC, Dae ha Fashion Co., Ltd.*
COUNTRY *United States*

Distinctive Merit
**CORPORATE & PROMOTIONAL DESIGN,
LEAFLET**
Poster Festo Corporate Design

ART DIRECTOR *Roman Riedmüller*
CREATIVE DIRECTOR *Axel Thallemer*
PRODUCER *Martin Danzer*
STUDIO *Festo Corporate Design*
CLIENT *Festo AG & Co.*
COUNTRY *Germany*

(facing page)
Distinctive Merit
**CORPORATE & PROMOTIONAL DESIGN,
SPECIAL IDENTITY PROGRAM, SERIES**
Abe Survey (II)

ART DIRECTOR *Ken Miki*
DESIGNERS *Ken Miki, Junji Osaki,
Shigeyuki Sakaida*
STUDIO *Ken Miki & Associates*
CLIENT *Abe Survey*
COUNTRY *Japan*

代表取締役会長

阿 部 傳 三

阿部測量株式会社

福島県郡山市
虎丸町21-14〒963

Tel. 0249-33-2585(代表)

Fax.0249-22-5005

President

Renzo Abe

ABE Survey

21-14, Toramaru-cho,
Kouriyama-city
Fukushima, 963 Japan.
Telephone 0249-33-2585
Facsimile 0249-22-5005

Human Scale
ABE Survey

visiting card

ABE Survey
21-14, Toramaru-cho, Kouriyama-city
Fukushima, 963 Japan.
Telephone 0249-33-2585
Facsimile 0249-22-5005

ABE Survey
envelope

ABE Survey
21-14, Toramaru-cho, Kouriyama-city
Fukushima, 963 Japan.
Telephone 0249-33-2585
Facsimile 0249-22-5005

Distinctive Merit
CORPORATE & PROMOTIONAL DESIGN,
LOGO
Viper Boats

ART DIRECTOR *Darcy Magratten*
DESIGNER *Darcy Magratten*
AGENCY *Darcy Magratten Design*
CLIENT *Viper Boats*
COUNTRY *United States*

(facing page)
Distinctive Merit
CORPORATE & PROMOTIONAL DESIGN,
LOGO OR TRADEMARK
Carmichael Lynch Thorburn

CREATIVE DIRECTOR *Bill Thorburn*
DESIGNER *Chad Hagen*
ILLUSTRATORS *Chad Hagen, David Schrimpf*
AGENCY *Carmichael Lynch Thorburn*
CLIENT *Carmichael Lynch Thorburn*
COUNTRY *United States*

Distinctive Merit
**CORPORATE & PROMOTIONAL DESIGN,
PROMOTION**
Fluff Paper

ART DIRECTOR *Dana Lytle*
CREATIVE DIRECTORS *Dana Lytle, John Besmer*
COPYWRITER *John Besmer*
DESIGNERS *Ben Hirby, Dana Lytle*
PHOTOGRAPHERS *Mark Salisbury,
Pier Nicola D'Amico, Michael Furman,
Fredrik Broden*
ILLUSTRATORS *Lin Wilson, David Plunkert,
Mark Fredrickson*
AGENCY *Planet Design Company*
CLIENT *Mohawk Paper Mills, Inc.*
COUNTRY *United States*

Distinctive Merit
**CORPORATE & PROMOTIONAL DESIGN,
CALENDAR**
Reciclate, Amigo (Recycle Yourself, Friend)

ART DIRECTOR *Enric Aguilera*
CREATIVE DIRECTOR *Enric Aguilera*
COPYWRITER *Cuca Canals*
DESIGNER *Enric Aguilera*
PHOTOGRAPHER *Enric Aguilera*
STUDIO *Enric Aguilera, Asociados S.L.*
CLIENT *Errecerre*
COUNTRY *Spain*

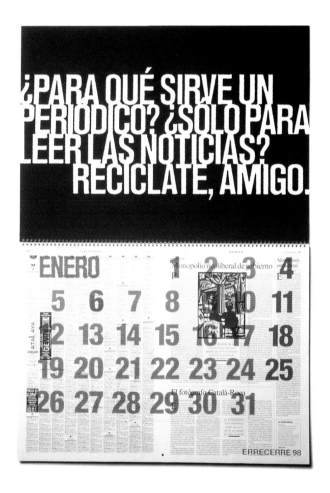

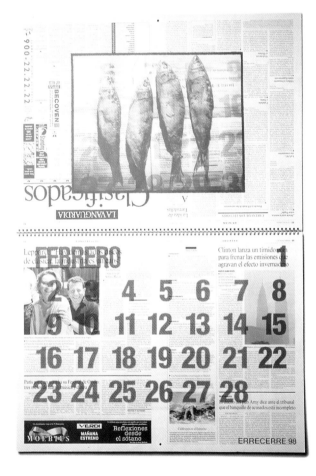

Distinctive Merit
POSTER DESIGN, PROMOTIONAL, SERIES
1997 Ba-Tsu

ART DIRECTOR *Makoto Saito*
CREATIVE DIRECTOR *Ruki Matsumoto*
DESIGNER *Makoto Saito*
COPYWRITER *Makoto Saito*
PHOTOGRAPHER *Yoshihiko Ueda*
PRODUCER *Ruki Matsumoto*
STUDIO *Makoto Saito Design Office Inc.*
CLIENT *Ba-Tsu Co., Ltd.*
COUNTRY *Japan*

(facing page)
Distinctive Merit
POSTER DESIGN, PROMOTIONAL
Morisawa Font

ART DIRECTOR *Shinnoske Sugisaki*
COPYWRITER *Shiho Sugisaki*
DESIGNERS *Shinnoske Sugisaki, Jun Itadani*
PHOTOGRAPHER *Yasunori Saito*
STUDIO *Shinnoske Inc.*
CLIENT *Morisawa & Company, Ltd.*
COUNTRY *Japan*

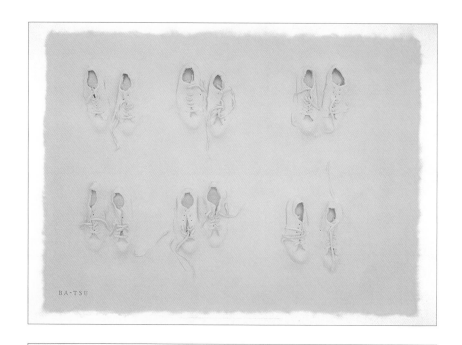

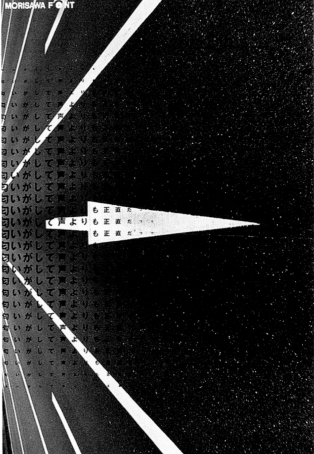

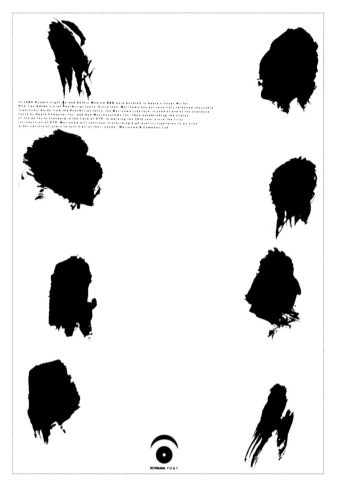

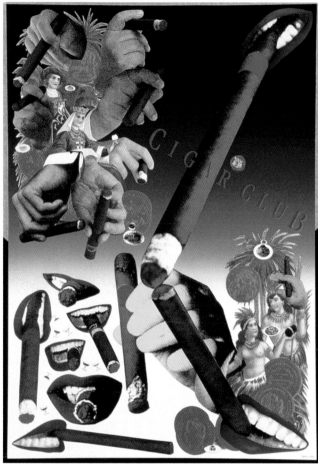

Distinctive Merit
POSTER DESIGN, PROMOTIONAL
Morisawa Font B

ART DIRECTOR *Ikko Tanaka*
DESIGNER *Ikko Tanaka*
STUDIO *Ikko Tanaka Design Studio*
CLIENT *Morisawa & Company, Ltd.*
COUNTRY *Japan*

Distinctive Merit
POSTER DESIGN, PROMOTIONAL
Cigar Club

ART DIRECTOR *Tadanori Yokoo*
CREATIVE DIRECTOR *Tadanori Yokoo*
DESIGNER *Tadanori Yokoo*
STUDIO *Yokoo's Circus*
CLIENT *Intercontinental Trading Corp.*
COUNTRY *Japan*

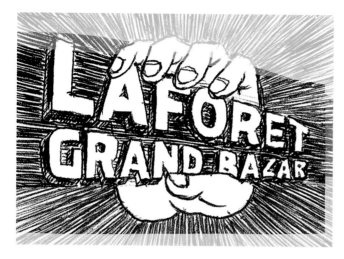

Distinctive Merit
**POSTER DESIGN, ENTERTAINMENT OR
SPECIAL EVENT, SERIES**
Laforet Grand Bazar

ART DIRECTOR *Katsunori Aoki*
CREATIVE DIRECTORS *Katsunori Aoki,
Yasuhiko Sakura, Ichiro Tanida*
COPYWRITER *Yasuhiko Sakura*
DESIGNER *Katsunori Aoki*
ILLUSTRATOR *Ichiro Tanida*
PRODUCERS *Yuko Fujimoto, Ryu Matsumoto*
AGENCY *SUN-AD Co., Ltd.*
CLIENT *Laforet Harajuku*
COUNTRY *Japan*

Niet zenuwachtig zijn.
Het is mijn familie.
Het zijn geen
kannibalen...

Theater van het Oosten speelt
'De Thuiskomst' van Harold Pinter
regie: Jeroen van den Berg

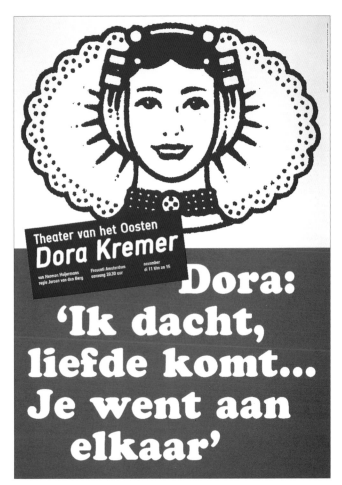

Theater van het Oosten
Dora Kremer

van Herman Heijermans Frascati Amsterdam november
regie Jeroen van den Berg aanvang 20.30 uur di 11 t/m zn 15

Dora:
'Ik dacht,
liefde komt...
Je went aan
elkaar'

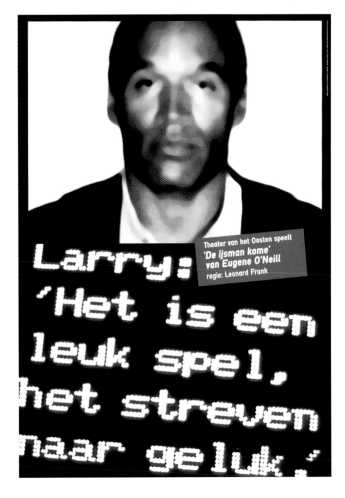

Theater van het Oosten speelt
'De ijsman kome'
van Eugene O'Neill
regie: Leonard Frank

Larry:
'Het is een
leuk spel,
het streven
naar geluk,'

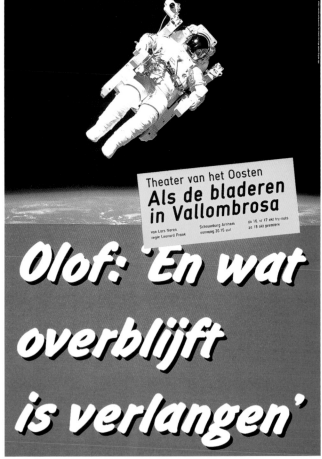

Theater van het Oosten
Als de bladeren
in Vallombrosa

van Lars Noren Schouwburg Arnhem do 16, vr 17 okt try-outs
regie Leonard Fraak aanvang 20.15 uur zn 18 okt premiere

Olof: 'En wat
overblijft
is verlangen'

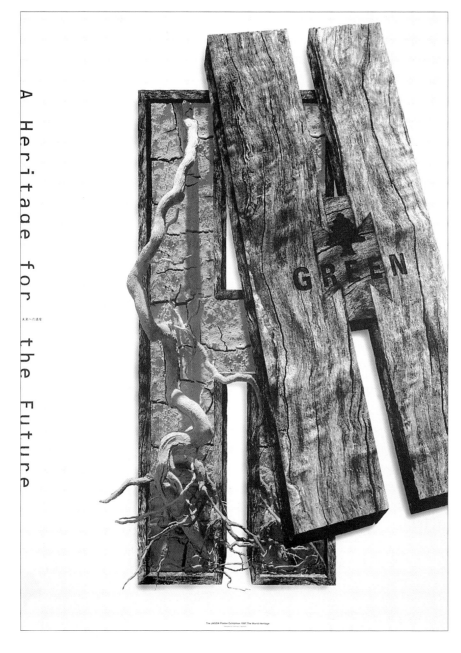

Distinctive Merit
**POSTER DESIGN, PUBLIC SERVICE OR
NON-PROFIT/EDUCATIONAL**
A Heritage for the Future

ART DIRECTOR *Yoshimaru Takahashi*
DESIGNER *Yoshimaru Takahashi*
ILLUSTRATOR *Yoshimaru Takahashi*
STUDIO *Kokokumaru Inc.*
CLIENT *Japan Graphic Designers Association Inc.*
COUNTRY *Japan*

(facing page)
Distinctive Merit
**POSTER DESIGN, PUBLIC SERVICE OR
NON-PROFIT/EDUCATIONAL, SERIES**
*Theater of the East Posters—Homecoming/
Harold Pinter, "Don't be afraid. This is my family.
We're no cannibals." • Dora Kremer/
Herman Heijermans, "I thought love will come…
you get used to each other." • The Iceman Cometh/
Eugene O'Neil, "It's a nice game. The search for luck."
• As The Leaves Vallombrosa/Lars Noren, "And all
which remains is desire."*

ART DIRECTORS *Jacques Koeweiden, Paul Postma*
CREATIVE DIRECTORS *Jacques Koeweiden,
Paul Postma*
COPYWRITERS *Harold Pinter, Eugene O'Neill,
Lars Norèn and others*
DESIGNERS *Jacques Koeweiden, Paul Postma*
PHOTOGRAPHY *Chick Magazine,
L.A. Police Department, Dutch Butter,
Astronaut Stock*
STUDIO *Koeweiden Postma Associates*
CLIENTS *Benjamin Koolstra,
Leonard Frank (Theater van het Oosten)*
COUNTRY *The Netherlands*

Distinctive Merit
**POSTER DESIGN, PUBLIC SERVICE OR
NON-PROFIT/EDUCATIONAL**
Portland 20th Film Festival

ART DIRECTOR *Steve Sandstrom*
CREATIVE DIRECTORS *Steve Sandstrom,
Steve Sandoz*
DESIGNER *Steve Sandstrom*
PHOTOGRAPHER *Mark Hooper*
STUDIO *Sandstrom Design*
CLIENT *Northwest Film Center*
COUNTRY *United States*

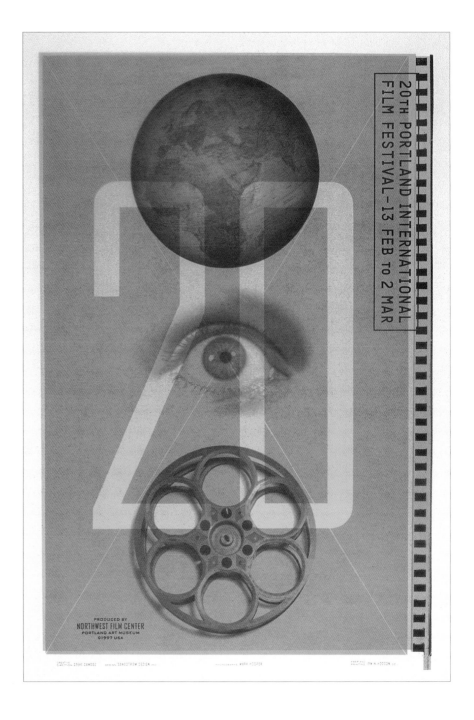

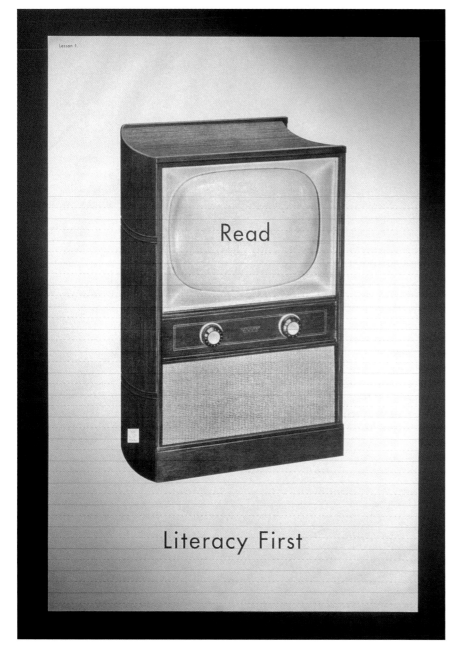

Distinctive Merit
POSTER DESIGN, PUBLIC SERVICE OR NON-PROFIT/EDUCATIONAL
AIGA Colorado Literacy

DESIGNERS *Haley Johnson, Richard Boynton*
STUDIO *Haley Johnson Design*
CLIENT *AIGA (American Institute of Graphic Arts) Colorado*
COUNTRY *United States*

Distinctive Merit

PACKAGE DESIGN, ENTERTAINMENT, SERIES

Jungle Live Mix of Untitled 01 2nd Movement Anger,
Ryuichi Sakamoto

ART DIRECTOR *Hideki Nakajima*
CREATIVE DIRECTOR *Norika Sky-Sora*
DESIGNER *Hideki Nakajima*
STUDIO *Nakajima Design*
CLIENT *For Life Records Inc.*
COUNTRY *Japan*

Distinctive Merit
PACKAGE DESIGN, ENTERTAINMENT, SERIES
Bernstein Century

ART DIRECTOR *Allen Weinberg*
CREATIVE DIRECTOR *Allen Weinberg*
DESIGN *Pentagram Design*
PHOTOGRAPHERS *Various*
PRODUCERS *Various*
MUSIC *Various*
AGENCY *Sony Music Creative Services*
CLIENT *Sony Classical*
COUNTRY *United States*

Distinctive Merit
PACKAGE DESIGN, ENTERTAINMENT
Stupid Fresh, Towa Tei

ART DIRECTORS *Tycoon Graphics, Towa Tei*
DESIGNER *Tycoon Graphics*
ILLUSTRATOR *Gatarò F Man*
STUDIO *Tycoon Graphics*
CLIENTS *Akashic Records, East West Japan,*
Yoshimoto Kogyo, Co., Ltd.
COUNTRY *Japan*

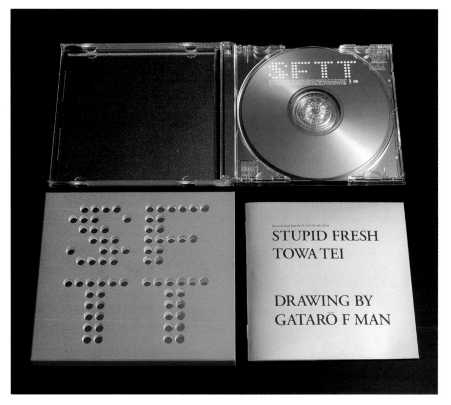

Distinctive Merit
PACKAGE DESIGN, ENTERTAINMENT
Core, Note Your Size

ART DIRECTORS *Stefan Bogner, Boris Simon*
CREATIVE DIRECTOR *Stefan Bogner*
DESIGNER *Stefan Bogner*
PHOTOGRAPHER *Florian Seidel*
PRODUCER *Frandt Niedermayr*
AGENCY *Factor Product*
STUDIO *Factor Product*
CLIENT *Marlboro Music*
COUNTRY *Germany*

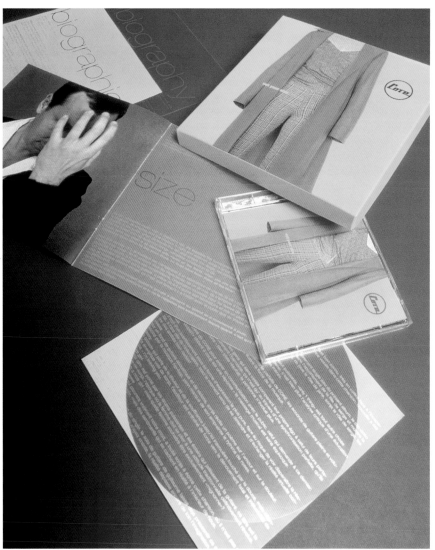

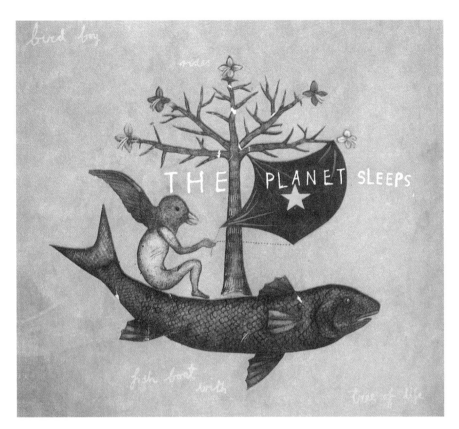

Distinctive Merit
PACKAGE DESIGN, ENTERTAINMENT
The Planet Sleeps

ART DIRECTOR *Julian Peploe*
CREATIVE DIRECTOR *Julian Peploe*
COPYWRITER *David Field*
DESIGNER *Julian Peploe*
ILLUSTRATOR *Jason Holley*
PRODUCER *David Field*
MUSIC *Compilation*
STUDIO *Sony Music Creative Services*
CLIENT *The Work Group*
COUNTRY *United States*

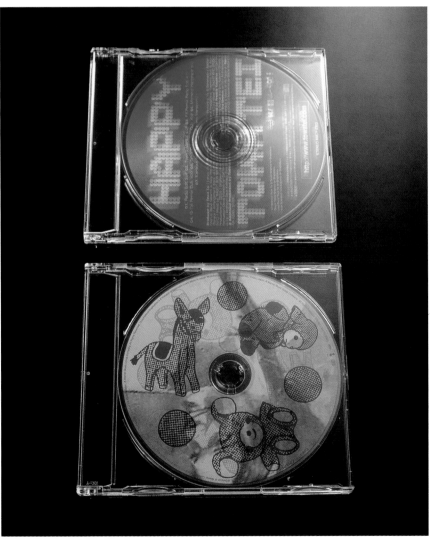

Distinctive Merit
PACKAGE DESIGN, ENTERTAINMENT
Happy, Towa Tei

ART DIRECTORS *Tycoon Graphics, Towa Tei*
DESIGNER *Tycoon Graphics*
ILLUSTRATOR *Hiro Sugiyama*
STUDIO *Tycoon Graphics*
CLIENTS *Akashic Records, East West Japan,*
Yoshimoto Kogyo, Co., Ltd.
COUNTRY *Japan*

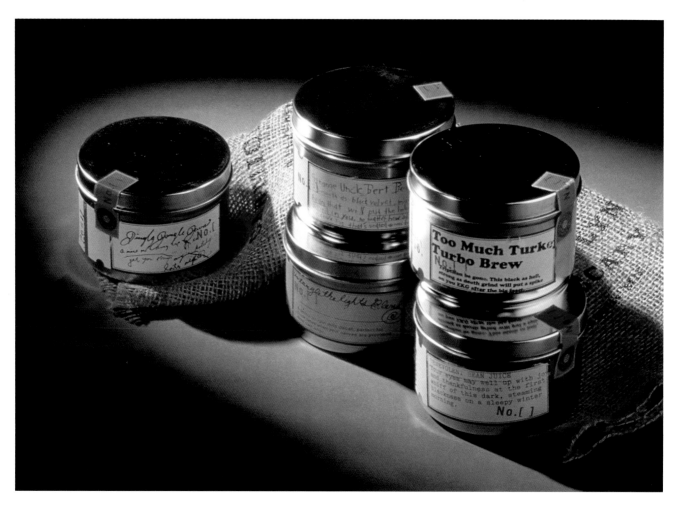

Distinctive Merit
PACKAGE DESIGN, GIFT/SPECIALTY PRODUCT
Carmichael Lynch Holiday Packaging

CREATIVE DIRECTOR *Bill Thorburn*
COPYWRITER *Kathi Skow*
DESIGNER *Chad Hagen*
AGENCY *Carmichael Lynch Thorburn*
CLIENT *Carmichael Lynch Thorburn*
COUNTRY *United States*

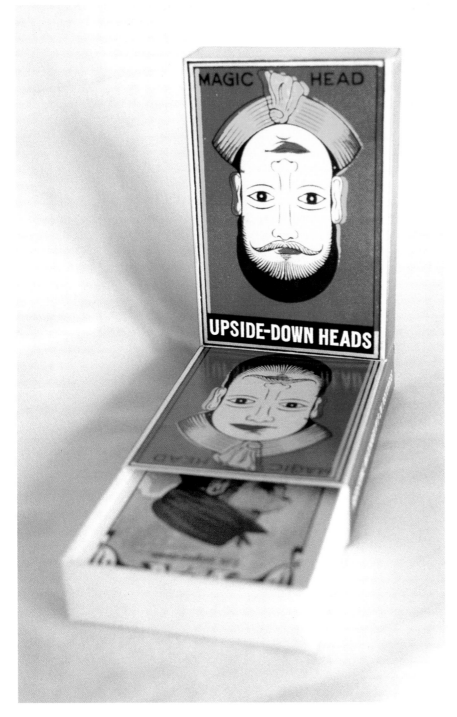

Distinctive Merit
PACKAGE DESIGN, GIFT/SPECIALTY PRODUCT
Upside Down Heads

CREATIVE DIRECTOR *Julian Rothenstein*
PRODUCER *Julian Rothenstein, Chronicle Books*
STUDIO *Chronicle Books*
COUNTRY *United States*

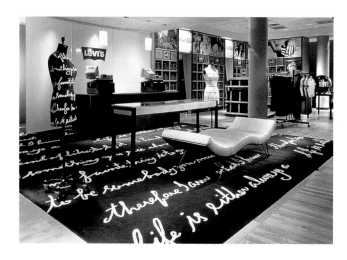

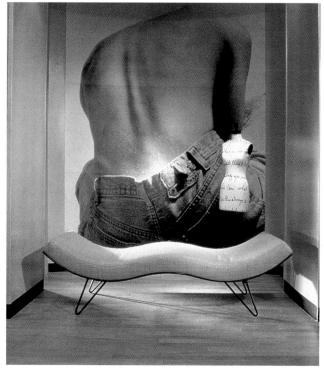

Distinctive Merit
ENVIRONMENTAL DESIGN, INDOOR ENVIRONMENT
*Levi Strauss & Co.: Jeans For Women Ultrashop–
Macy's Herald Square*

ART DIRECTORS *Eric Rindal (Foote, Cone & Belding
San Francisco), Jennifer Morla (Morla Design)*
CREATIVE DIRECTOR *Brian Collins*
COPYWRITER *Suzanne Finnamore*
DESIGNER *Jennifer Morla*
PHOTOGRAPHERS *Sheila Metzner (in-store),
Cesar Rubio (documentation)*
STUDIO *Morla Design*
CLIENTS *Foote, Cone & Belding San Francisco,
Levi Strauss & Co.*
COUNTRY *United States*

Distinctive Merit
BROADCAST DESIGN CRAFTS, ANIMATION
Sally Jessy Raphael

ART DIRECTORS *J. J. Sedelmaier, Robert Smigel*
CREATIVE DIRECTOR *Robert Smigel*
COPYWRITERS *Robert Smigel, Beth Cahill,*
Adam McKay
DESIGNERS *David Wachtenheim, J. J. Sedelmaier*
ILLUSTRATORS *J. J. Sedelmaier, David Wachtenheim*
PRODUCER *J. J. Sedelmaier*
DIRECTOR *J. J. Sedelmaier*
MUSIC *Existing Audio*
AGENCY *Saturday Night Live/NBC*
STUDIO *J. J. Sedelmaier Productions, Inc.*
CLIENT *NBC*
COUNTRY *United States*

merit graphic design

Merit

BOOK DESIGN, GENERAL TRADE BOOKS
David Carson 2nd Sight

ART DIRECTOR *David Carson*
CREATIVE DIRECTOR *David Carson*
COPYWRITER *Lewis Blackwell*
DESIGNER *David Carson*
STUDIO *David Carson Studio*
PUBLISHERS *Calman & King, Universe Publishing*
COUNTRY *United States*

Merit

BOOK DESIGN, GENERAL TRADE BOOKS
Puppies

ART DIRECTOR *Stephen Doyle*
COPYWRITER *William Wegman*
DESIGNER *Gary Tooth*
PHOTOGRAPHER *William Wegman*
STUDIO *Doyle Partners*
CLIENT *Hyperion Books for Children*
COUNTRY *United States*

Merit
BOOK DESIGN, GENERAL TRADE BOOKS
Suffragettes to She-Devils

PRINCIPAL DESIGNER *Paula Scher*
DESIGNERS *Paula Scher, Lisa Mazur,*
Anke Stohlmann, Esther Bridavsky
PHOTOGRAPHERS *Various*
STUDIO *Pentagram Design*
CLIENT *Phaidon*
COUNTRY *United States*

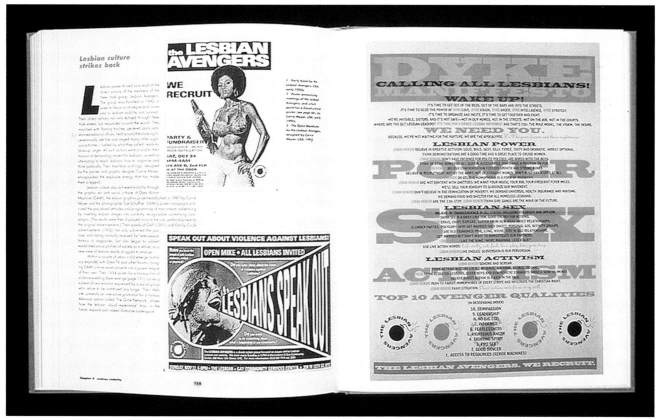

Merit
BOOK DESIGN, GENERAL TRADE BOOKS
hi-fi's & hi-balls

ART DIRECTOR *Susan Hochbaum*
COPYWRITERS *Steven Guarnaccia, Bob Sloan*
DESIGNER *Susan Hochbaum*
PHOTOGRAPHERS *Pete MacArthur, James Worrell*
STUDIO *Susan Hochbaum Design*
CLIENT *Chronicle Books*
COUNTRY *United States*

(top)
Merit
BOOK DESIGN, GENERAL TRADE BOOKS
Essential Energy

ART DIRECTORS *Andrew Hoyne, Jackie Merri Meyer*
CREATIVE DIRECTORS *Andrew Hoyne,*
Jackie Merri Meyer
EDITOR *Jackie Merri Meyer*
DESIGNER *Andrew Hoyne Associates*
PHOTOGRAPHER *Rob Blackburn*
CLIENT *Warner Books/Warner Treasures*
COUNTRY *United States*

(bottom)
Merit
BOOK DESIGN, GENERAL TRADE BOOKS
Popcorn

ART DIRECTOR *Steve Snider*
CREATIVE DIRECTOR *Steve Snider*
DESIGNER *Steve Snider*
COMPANY *St. Martin's Press Inc.*
COUNTRY *United States*

Merit
BOOK DESIGN, GENERAL TRADE BOOKS
The Art of the Bath

ART DIRECTORS *Jennifer Morla, Sara Slavin*
DESIGNERS *Jennifer Morla, Anne Culbertson*
PHOTOGRAPHER *Karl Petzke*
STYLIST *Sara Slavin*
STUDIO *Morla Design*
CLIENT *Chronicle Books*
COUNTRY *United States*

Merit
BOOK DESIGN, GENERAL TRADE BOOKS
Big Book of Big Little Books

ART DIRECTOR *Sharon Werner*
CREATIVE DIRECTOR *Julia Flagg (Chronicle Books)*
COPYWRITERS *Bill Borden, Steve Posner*
DESIGNERS *Sharon Werner, Sarah Nelson*
PHOTOGRAPHERS *Bill Borden, Darrell Eager*
STUDIO *Werner Design Werks, Inc.*
CLIENT *Chronicle Books*
COUNTRY *United States*

Merit

BOOK DESIGN, GENERAL TRADE BOOKS
Fra Angelico

ART DIRECTOR *Patricia Fabricant*
DESIGNER *Barbara Sturman (cover and interior type)*
PHOTOGRAPHERS *Various*
CLIENT *Abbeville Press*
COUNTRY *United States*

Merit

BOOK DESIGN, GENERAL TRADE BOOKS
Italian Frescoes: The Flowering of the Renaissance

ART DIRECTOR *Patricia Fabricant*
DESIGNERS *Molly Shields (cover),*
Barbara Sturman (interior type)
PHOTOGRAPHER *Antonio Quattrone*
CLIENT *Abbeville Press*
COUNTRY *United States*

Merit
BOOK DESIGN, GENERAL TRADE BOOKS
Dick and Jane

ART DIRECTOR *Drew Hodges*
CREATIVE DIRECTORS *Marvin Heiferman,*
Carole Kismaric
COPYWRITERS *Marvin Heiferman, Carole Kismaric*
DESIGNERS *Naomi Mizusaki, Adam Levite,*
Drew Hodges
PHOTOGRAPHY *Stock*
ILLUSTRATOR *Eleanor Campbell*
AGENCY *Spot Design*
CLIENT *Lookout*
COUNTRY *United States*

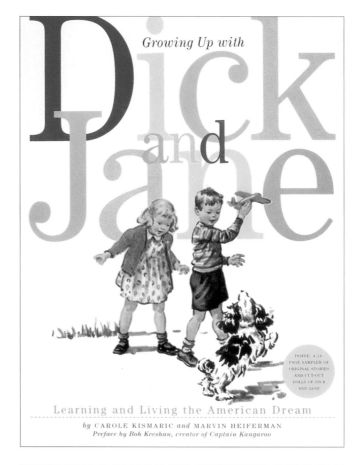

Merit
BOOK DESIGN, GENERAL TRADE BOOKS
My Year of Meats

ART DIRECTOR *Paul Buckley*
DESIGNER *Paul Buckley*
PHOTOGRAPHERS *Paul Buckley, Tom Baril*
ILLUSTRATOR *Ross MacDonald*
STUDIO *Penguin/Putnam, Inc.*
CLIENT *Penguin/Putnam, Inc.*
COUNTRY *United States*

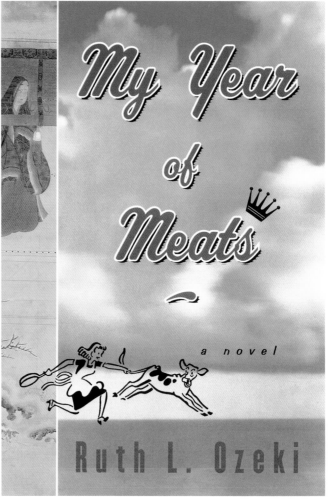

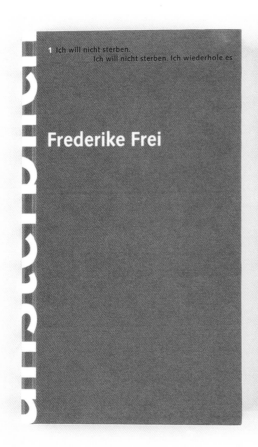

1 Ich will nicht sterben.
Ich will nicht sterben. Ich wiederhole es

Frederike Frei

Merit
BOOK DESIGN, GENERAL TRADE BOOKS
Frederike Frei: Unsterblich (Frederike Frei: Immortal)

ART DIRECTOR *Rainer Groothuis*
CREATIVE DIRECTORS *Florian Fischer,*
Rainer Groothuis, Victor Malsy
DESIGNERS *Ulrich Neutzling, Gilmar Wendt*
AGENCY *Groothuis + Malsy*
CLIENT *Dölling und Galitz Verlag*
COUNTRY *Germany*

Merit
BOOK DESIGN, GENERAL TRADE BOOKS
Soul of the Game

ART DIRECTORS *Joshua Berger, John C. Jay*
CREATIVE DIRECTOR *John C. Jay*
COPYWRITER *Jimmy Smith*
DESIGNERS *Joshua Berger, John C. Jay*
PHOTOGRAPHER *John Huet*
AGENCY *John Jay Design*
CLIENTS *Melcher Media/Workman Publishing*
COUNTRY *United States*

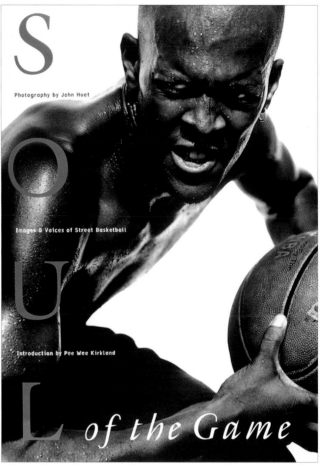

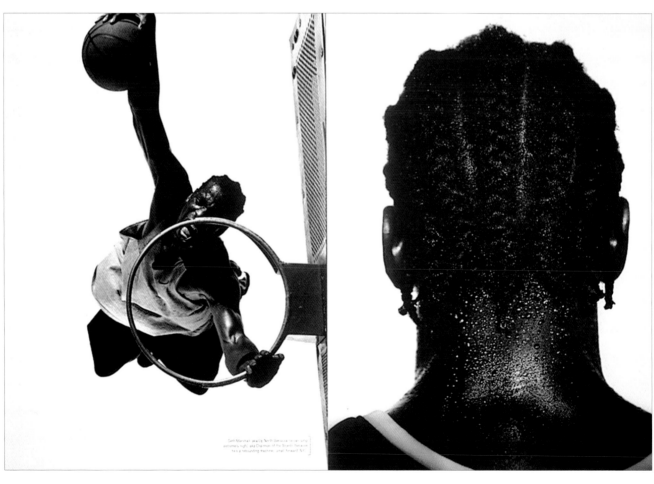

Merit
BOOK DESIGN, GENERAL TRADE BOOKS
Keith Carter Photographs Twenty Five Years

ART DIRECTOR *D.J. Stout*
CREATIVE DIRECTOR *D.J. Stout*
COPYWRITER *A.D. Coleman*
DESIGNERS *D.J. Stout, Nancy McMillen*
PHOTOGRAPHER *Keith Carter*
STUDIO *Texas Monthly*
CLIENT *University of Texas Press*
COUNTRY *United States*

Merit
BOOK DESIGN, GENERAL TRADE BOOKS
Rent Book

ART DIRECTOR *Drew Hodges*
CREATIVE DIRECTOR *Charlie Melcher*
(Melcher Media)
DESIGNERS *Naomi Mizusaki, Rymn Massand*
COPYWRITERS *Evelyn McDonnell,*
Katherine Silberger
PHOTOGRAPHERS *Stuart Ferebee, Larry Fink*
ILLUSTRATOR *McDavid Henderson*
EDITOR *Kate Giel*
STUDIO *Spot Design*
CLIENT *The Producing Office*
COUNTRY *United States*

Merit
BOOK DESIGN, GENERAL TRADE BOOKS
Decode 20

ART DIRECTOR *Hideki Nakajima*
CREATIVE DIRECTOR *Norika Sky-Sora*
EDITORIAL DIRECTOR *Shigeo Goto*
DESIGNER *Hideki Nakajima*
PHOTOGRAPHERS *Ryuichi Sakamoto,*
Hideki Nakajima
ARTIST *Ryuichi Sakamoto*
MUSIC *Ryuichi Sakamoto*
STUDIO *Nakajima Design*
CLIENT *Impress Corporation*
COUNTRY *Japan*

(facing page, top)
Merit
BOOK DESIGN, GENERAL TRADE BOOKS
Leporello Airtecture

ART DIRECTOR *Martin Danzer*
CREATIVE DIRECTOR *Roman Riedmüller*
DIRECTOR *Axel Thallemer*
STUDIO *Festo Corporate Design*
CLIENT *Festo AG & Co.*
COUNTRY *Germany*

(facing page, bottom)
Merit
BOOK DESIGN, GENERAL TRADE BOOKS
Burning Man

ART DIRECTOR *John Plunkett*
CREATIVE DIRECTOR *John Plunkett*
DESIGNER *John Plunkett*
EDITOR *Brad Wieners*
ESSAYISTS *Janelle Brown, Erik Davis,*
Larry Harvey, Kevin Kelly, Bruce Sterling
PHOTOGRAPHERS *Barbara Traub, Stewart Harvey,*
Geoffrey Clifford, Gerry Gropp, Kevin Kelly, others
STUDIO *Plunkett & Kuhr*
CLIENT *Wired Books*
COUNTRY *United States*

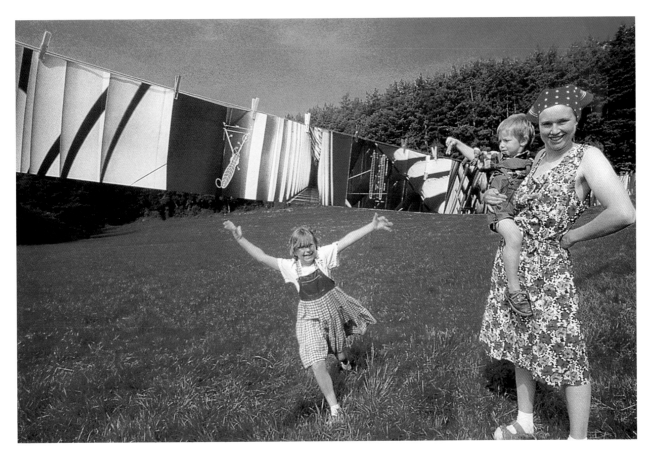

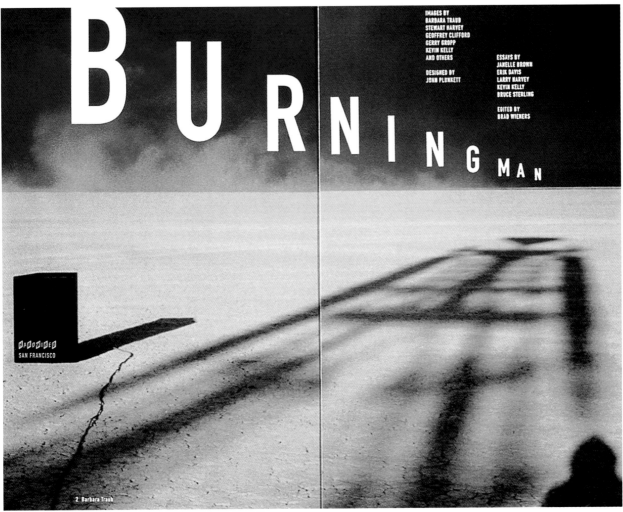

IMAGES BY
BARBARA TRAUB
STEWART HARVEY
GEOFFREY CLIFFORD
GERRY GROPP
KEVIN KELLY
AND OTHERS

DESIGNED BY
JOHN PLUNKETT

ESSAYS BY
JANELLE BROWN
ERIK DAVIS
LARRY HARVEY
KEVIN KELLY
BRUCE STERLING

EDITED BY
BRAD WIENERS

BURNING MAN

HARDWIRED
SAN FRANCISCO

2 Barbara Traub

Merit
BOOK DESIGN, PAPERBACK BOOKS, SERIES
walking A

ART DIRECTOR *Akio Okumura*
COPYWRITER *Miwa Morishita*
DESIGNER *Michiko Eguchi*
TYPOGRAPHERS *Saeko Shintani, Mika Kitaura,*
Toko Murakami, Fumihiko Izutu, Haruyuki Yoshida,
Yoshihiro Yamamoto, U-ichi Tukimori, Kou Shin-Q,
Ryoko Nakamura, Emi Tomita, Kenichirou Kawamura,
Tadaaki Ido, Naoyuki Shibata
STUDIO *Packaging Create Inc.*
CLIENT *Oji Paper Co., Ltd.*
COUNTRY *Japan*

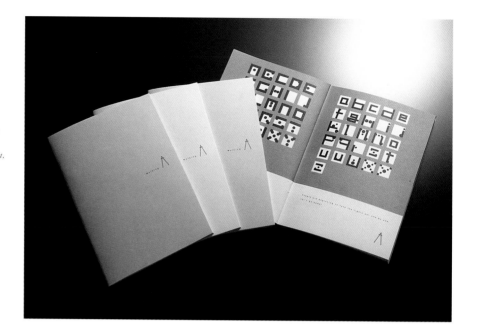

Merit
BOOK DESIGN, PROMOTIONAL BOOKS
Shot Down—60 Ways to Kill a Bad Idea

ART DIRECTOR *Kipling Phillips*
CREATIVE DIRECTORS *Olaf Oldigs,*
Thomas Walmrath
COPYWRITER *Stephanie Krink*
DESIGNER *Kipling Phillips*
PHOTOGRAPHER *Martin Timmermann*
PRODUCER *Stefan Rentzow*
SHARP SHOOTER *André Kemper*
AGENCY *Springer & Jacoby*
CLIENT *Springer & Jacoby*
COUNTRY *Germany*

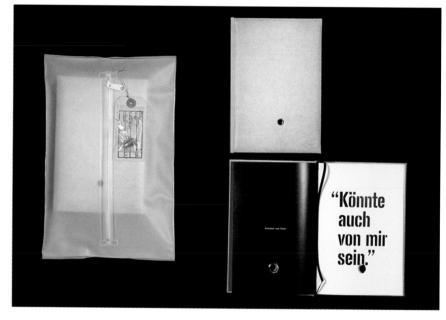

Merit
BOOK DESIGN, PROMOTIONAL BOOKS
L.A. Eyeworks

ART DIRECTOR *Michael Worthington*
COPYWRITER *L.A. Eyeworks*
DESIGNERS *Michael Worthington, Tracy Hopcus*
FONT DESIGNER *Jens Gelhaar (Capricorn font)*
PHOTOGRAPHERS *Greg Gorman,*
Publicworks Productions
STUDIO *Worthington Design*
CLIENT *L.A. Eyeworks*
COUNTRY *United States*

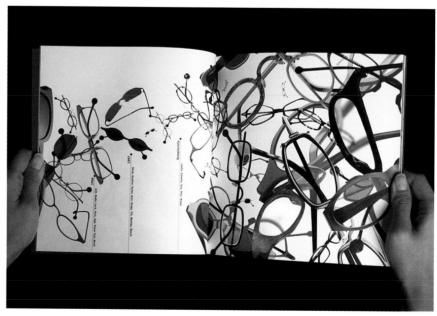

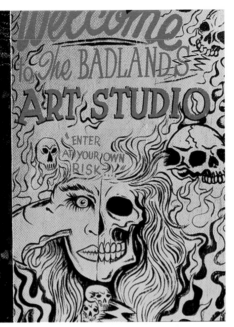

Down the bleak and ravaged stretch of road that lies smack in the middle of gritty, ghoulish Gary, Indiana, "murder capital of the world," there is the Badlands. Lording over it is the maestro of the unrefined. Swallow him whole. Make no mistake. There is no other Roy Boy.

Merit

BOOK DESIGN, PROMOTIONAL BOOKS

IV: Commemorating Four Short Films by Dana Arnett

ART DIRECTOR *Mary Moegenburg*
CREATIVE DIRECTOR *Dana Arnett*
COPYWRITER *Rose Spinelli*
DESIGNER *Jason Eplawy*
PHOTOGRAPHERS *Joanne Rijmes, Dan Morse,
Don Wolf, Terry Maday, Bart Witowski,
Patrick Demarchelier, Sharon Seligman,
Charles Simokaitis*
STUDIO *VSA Partners, Inc.*
CLIENT *Potlatch Corporation*
COUNTRY *United States*

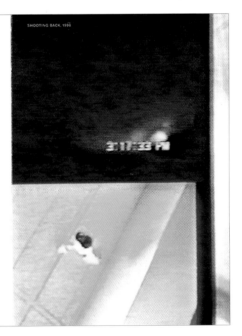

STEVEN MANN LIVES IN A DUAL-ADAPTATION SPACE, A PLACE HE CALLS "COMPUTER-MEDIATED REALITY." BEFORE HE ACCEPTED A PROFESSORSHIP AT THE UNIVERSITY OF TORONTO, HE PROWLED THE HALLWAYS AND WALKWAYS OF MIT, HIS WEARCAM FIRMLY CORDONED TO HEAD AND MIDRIFF, FINGER KEYBOARD IN HAND.

WEARCAM. ONE OF THE MAIN NEOLOGISMS ATTRIBUTABLE TO THIS TECHNO-PRODIGY WHOSE WORK INTERSECTS THE PERIMETERS OF ART, SCIENCE AND TECHNOLOGY.

STEVEN MANN IS THE 26-YEAR OLD AUTHOR OF THE WEARABLE CAMERA, THE "TETHERLESS EXISTENTIAL COMPUTER" THAT IS WORN LIKE CLOTHING. THE CONCEPT IS CALLED PERSONAL IMAGING. THE GOAL? A SEAMLESS EXTENSION OF MIND AND BODY THAT ENHANCES AND DEFINES THE "CORPOREAL ENVELOPE" AND TRANSFORMS IT INTO A SOVEREIGN SPACE.

AS A PERFORMANCE ARTIST HE CHALLENGES AUTHORITY AND SEARCHES FOR SUBJECTIVE TRUTH. AS A SCIENTIST HE EXPLORES FRONTIERS AND SEEKS OBJECTIVE TRUTH. AS A STUDENT OF PHILOSOPHY HIS ASPIRATIONS ARE FANTASTICAL AND ENLIGHTENED. "BY CATEGORIZING ART AND SCIENTIFIC INQUIRY, WE DO SOCIETY A DISSERVICE. I WANT TO BRIDGE THE GAP SO THAT RATHER THAN CREATING EMPIRES WE CAN ADVANCE HUMAN KIND."

Merit
BOOK DESIGN, PROMOTIONAL BOOKS
Website Graphics

ART DIRECTORS *Jacques Koeweiden, Paul Postma*
CREATIVE DIRECTOR *Jacques Koeweiden, Paul Postma*
COPYWRITER *Mediamatic*
DESIGNER *Ralf Schroeder*
PHOTOGRAPHER *Koeweiden Postma Associates*
STUDIO *Koeweiden Postma Associates*
CLIENT *Bis Publishers*
COUNTRY *The Netherlands*

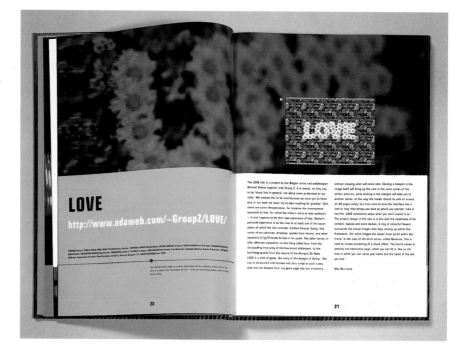

Merit
BOOK DESIGN, PROMOTIONAL BOOKS
The Leg Book

ART DIRECTOR *Hans Dorsinville*
CREATIVE DIRECTOR *Trey Laird*
COPYWRITER *Kathleen Boyes*
PHOTOGRAPHERS *Various*
PRODUCER *Dee Salomon*
AGENCY *The Donna Karan Company*
CLIENT *The Donna Karan Company*
COUNTRY *United States*

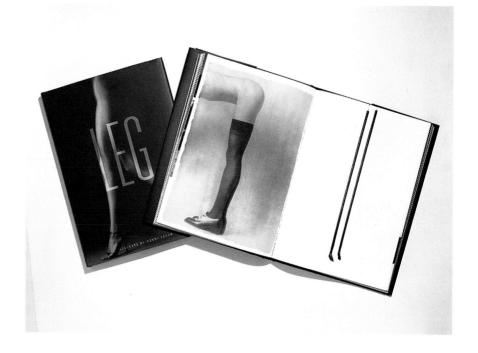

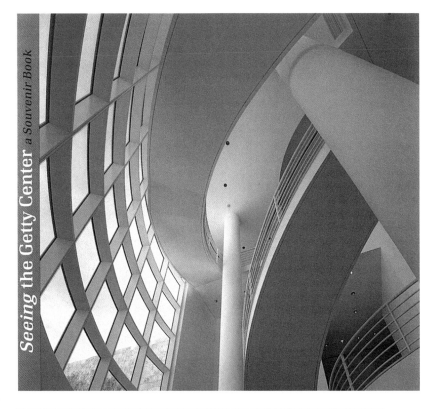

Merit
BOOK DESIGN, PROMOTIONAL BOOKS
Souvenir Book

DESIGNER *Markus Brilling*
PHOTOGRAPHERS *Cindy Anderson, Tom Bonner,*
Scott Frances, Alexander Vertikoff, Vladimir Lange
STUDIO *The J. Paul Getty Trust*
CLIENT *The J. Paul Getty Trust*
COUNTRY *United States*

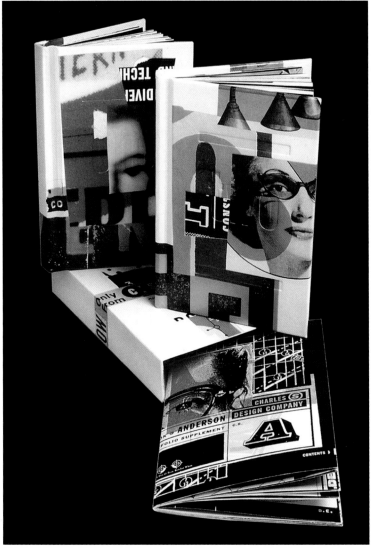

Merit
BOOK DESIGN, PROMOTIONAL BOOKS
Charles S. Anderson Design Company Portfolio Books

ART DIRECTORS *Charles S. Anderson,*
Todd Piper-Hauswirth
DESIGNERS *Todd Piper-Hauswirth, Jason Schulte,*
Charles S. Anderson
AGENCY *Charles S. Anderson Design Company*
CLIENT *Charles S. Anderson Design Company*
COUNTRY *United States*

Merit

BOOK DESIGN, PROMOTIONAL BOOKS
The Zone

ART DIRECTOR *Patrick Giasson*
COPYWRITER *Theo Diamantis*
DESIGNER *Patrick Giasson*
PHOTOGRAPHERS *Diana Shearwood.*
Orazio Fantini. Atelier In Situ
3-D MODELING *Guy Lampron*
AGENCY *Behaviour Design Inc.*
CLIENT *BHVR Communications Inc.*
COUNTRY *Canada*

Merit

BOOK DESIGN, PROMOTIONAL BOOKS
Olmetto's Book

ART DIRECTOR *Titti Fabiani*
CREATIVE DIRECTOR *Titti Fabiani*
DESIGNERS *Titti Fabiani, Maurizio Cinti*
ILLUSTRATOR *Desideria Guicciardini*
AGENCY *B Communications/GGK*
CLIENT *Olmetto*
COUNTRY *Italy*

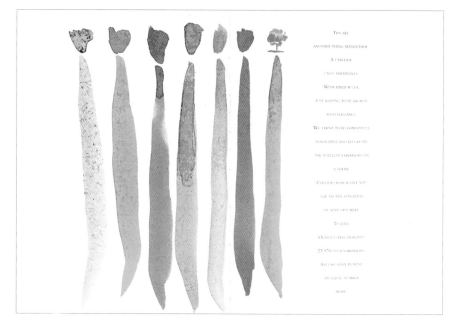

MULTIPLE AWARDS

Merit
BOOK DESIGN, PROMOTIONAL BOOKS

Merit
**CORPORATE & PROMOTIONAL DESIGN,
ENTERTAINMENT/SPECIAL EVENTS PROGRAM**

and Merit
**PHOTOGRAPHY, CORPORATE/INSTITUTIONAL,
SERIES**
1997 Video Music Awards Book

CREATIVE DIRECTORS *Jeffrey Keyton,
Stacy Drummond, Tracy Boychuk*
COPYWRITERS *David Felton, Tara Sutton*
DESIGNERS *Jeffrey Keyton, Stacy Drummond,
Tracy Boychuk*
PHOTOGRAPHER *Jason Stang*
STUDIO *MTV*
CLIENT *MTV*
COUNTRY *United States*

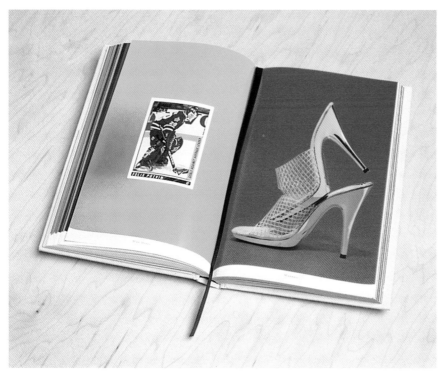

Merit
BOOK DESIGN, LIMITED EDITION, PRIVATE PRESS, SPECIAL FORMAT BOOKS
Winona Ryder

ART DIRECTOR *Richard Baker*
DESIGNERS *Bess Wong, Sha-Mayne Chan, Yoomi Chong, Jennifer Crandall, Robert Festino, Amy Goldfarb, Anke Stohlmann*
PHOTOGRAPHERS *Various*
PHOTO EDITOR *Fiona McDonagh*
CLIENT *US Magazine*
COUNTRY *United States*

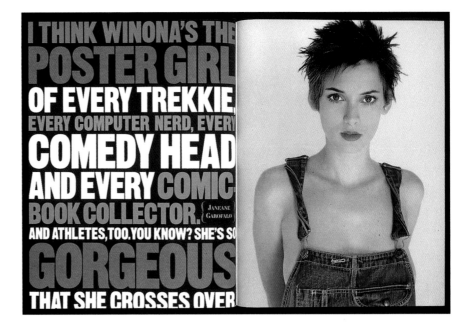

Merit
BOOK DESIGN, LIMITED EDITION, PRIVATE PRESS, SPECIAL FORMAT BOOKS
*abcdefg… Schrift und Typografie
(abcdefg… Type and Typography)*

ART DIRECTOR *Stefan Waidmann*
CREATIVE DIRECTOR *Stefan Waidmann*
COPYWRITER *Stefan Waidmann*
DESIGNER *Stefan Waidmann*
PRODUCER *Stefan Waidmann*
AGENCY *Stefan Waidmann Gestaltung*
CLIENTS *FH Schwäbisch Gmünd, Stefan Waidmann*
COUNTRY *Germany*

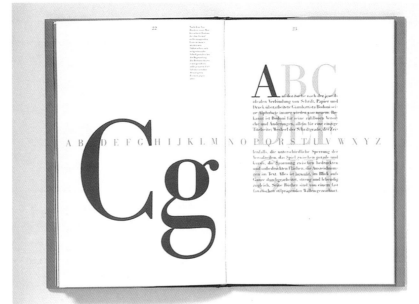

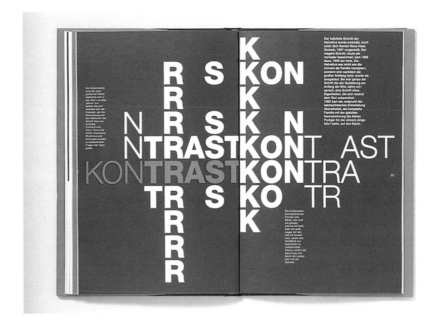

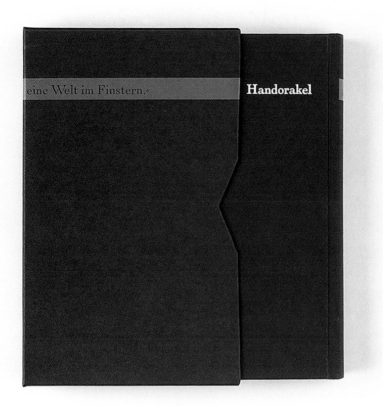

Merit
BOOK DESIGN, LIMITED EDITION, PRIVATE PRESS, SPECIAL FORMAT BOOKS
Baltasar Gracian: Handorakel und Kunst der Weltklugheit (Baltasar Gracian: The Oracle of the Hand and the Art of Worldly Cleverness—A Book of Manners and Etiquette)

ART DIRECTOR *Rainer Groothuis*
DESIGNERS *Rainer Groothuis, Gilmar Wendt*
AGENCY *Groothuis+Malsy*
CLIENT *Bertelsmann Buchclub*
COUNTRY *Germany*

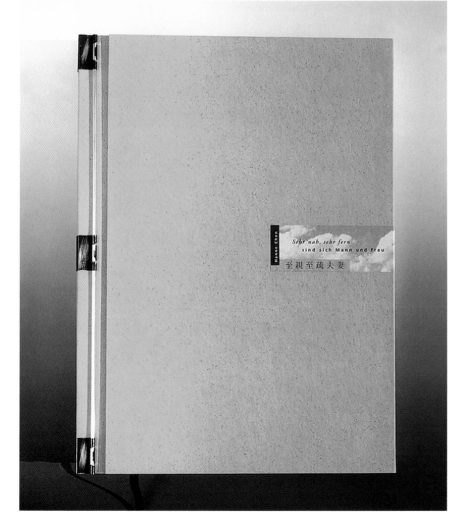

Merit
BOOK DESIGN, LIMITED EDITION, PRIVATE PRESS, SPECIAL FORMAT BOOKS
Sehr Nah, Sehr Fern (Very Close, Very Far)

ART DIRECTORS *Kerstin Weber, Olaf Schmidt*
CREATIVE DIRECTORS *Kerstin Weber, Olaf Schmidt*
DESIGNERS *Kerstin Weber, Olaf Schmidt*
PRODUCER *SchwarzDruck (Print)*
BOOKBINDING *Schmidt & Weber Konzept Design*
STUDIO *Schmidt & Weber Konzept Design*
CLIENT *Edition ZeichenSatz*
COUNTRY *Germany*

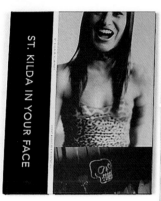

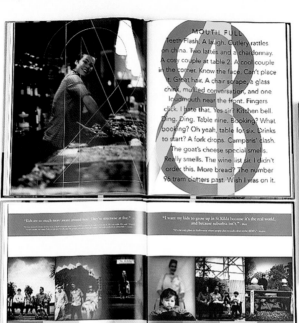

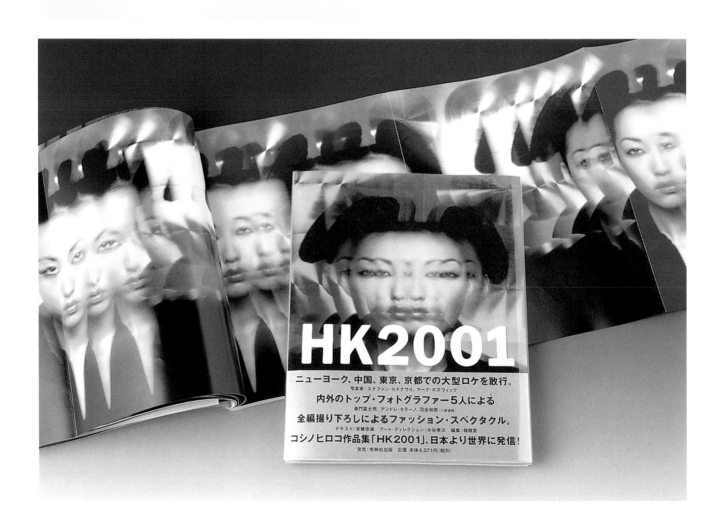

By the Editors of US

BraD

Merit

BOOK DESIGN, LIMITED EDITION, PRIVATE PRESS, SPECIAL FORMAT BOOKS
Brad Pitt

ART DIRECTOR *Richard Baker*
DESIGNERS *Bess Wong, Anke Stohlmann,*
Yoomi Chong, Jennifer Crandall
PHOTOGRAPHER *Mark Seliger*
PHOTO EDITOR *Fiona McDonagh*
CLIENT *US Magazine*
COUNTRY *United States*

(facing page, top)
Merit
BOOK DESIGN, LIMITED EDITION, PRIVATE PRESS, SPECIAL FORMAT BOOKS
St. Kilda in Your Face

ART DIRECTOR *Andrew Hoyne*
CREATIVE DIRECTOR *Andrew Hoyne*
COPYWRITER *Andrew Anastasios*
DESIGNER *Andrew Hoyne*
PHOTOGRAPHER *Jason Loucas*
ILLUSTRATOR *Alex Tyers*
STUDIO *Hoyne Design*
CLIENT *Hoyne Design*
COUNTRY *Australia*

(facing page, bottom)
MULTIPLE AWARDS

Merit
BOOK DESIGN, LIMITED EDITION, PRIVATE PRESS, SPECIAL FORMAT BOOKS
HK2001 (hard cover version)

and Merit
BOOK DESIGN, LIMITED EDITION, PRIVATE PRESS, SPECIAL FORMAT BOOKS
HK2001 (paperback version)

ART DIRECTOR *Koji Mizutani*
CREATIVE DIRECTOR *Koji Mizutani*
DESIGNER *Hiroshi Omizo*
COPYWRITER *Masanobu Sugatsuke*
EDITORIAL DIRECTOR *Masanobu Sugatsuke*
PHOTOGRAPHERS *Stephane Sednaoui,*
Mark Borthwick, Andres Serrano
PRODUCER *Koji Mizutani*
DIRECTOR *Koji Mizutani*
AGENCY *Mizutani Studio*
STUDIO *Mizutani Studio*
CLIENT *Hiroko Koshino Design Office Inc.*
COUNTRY *Japan*

Merit
**BOOK DESIGN, LIMITED EDITION, PRIVATE PRESS,
SPECIAL FORMAT BOOKS**
Sadness after Song

ART DIRECTORS *Bob Faust, Tanya Quick*
CREATIVE DIRECTORS *David Givens, Eric Antonow*
DESIGNERS *Bob Faust, Tanya Quick*
PHOTOGRAPHER *David Givens*
STUDIO *Quick + Faust*
CLIENT *David Givens*
COUNTRY *United States*

Merit
**BOOK DESIGN, LIMITED EDITION, PRIVATE PRESS,
SPECIAL FORMAT BOOKS**
Photograph Collection by Michiko Kon

ART DIRECTOR *Toshio Yamagata*
CREATIVE DIRECTOR *Toshio Yamagata*
DESIGNER *Toshio Yamagata*
PHOTOGRAPHER *Michiko Kon*
PRODUCER *Atsuhide Nakajima*
AGENCY *Shiseido Co., Ltd., Creation Department*
CLIENT *Korinsha Press & Co., Ltd.*
COUNTRY *Japan*

Merit
**BOOK DESIGN, LIMITED EDITION, PRIVATE PRESS,
SPECIAL FORMAT BOOKS**
Smart: The Book

ART DIRECTORS *Markus Bucher, Ercole Troisi,
Jürg Aemmer*
CREATIVE DIRECTORS *Bedq Achermann, Peter Ruch*
COPYWRITERS *Peter Ruch, others*
PHOTOGRAPHERS *Martin Parr, Françoise Caraco,
Daniel Sutter, Nitin Vadukul, Urs Moeckli,
Hans Gissinger, Raymond Meier, Max Vadukul,
Thomas Flechtner, François Halard, Michel Comte,
Glen Luchford, Patricia von Ah*
ILLUSTRATORS *Sandro Fabbri,
Jean-Phillippe Delhomme, Mats Gustafson,
Maurice Vellekoop, Monic Baumann*
PUBLISHERS *Reinhold Weber, Yvonne Hodel,
Liliane Lerch, Thomas von Ah*
AGENCY *Weber, Hodel, Schmid*
CLIENT *Micro Compact Car AG*
COUNTRY *Switzerland*

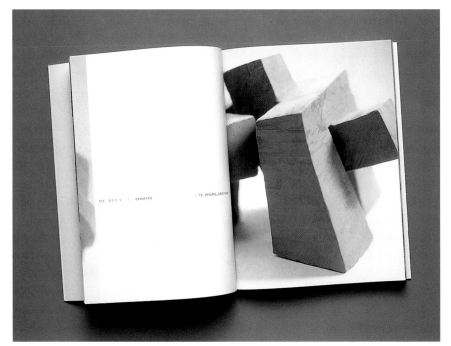

Merit

BOOK DESIGN, MUSEUM, GALLERY, LIBRARY, UNIVERSITY PRESS BOOKS, SERIES
Pierre Lallemand–Le Vide, Le Temps, La Lumière
(Pierre Lallemand–Void, Time, Light)

ART DIRECTORS *Franck Sarfati,*
Joël Van Audenhaege, Olivier Sténuit
CREATIVE DIRECTORS *Franck Sarfati,*
Joël Van Audenhaege, Olivier Sténuit
PHOTOGRAPHER *Jean-François Dewitte*
STUDIO *Sign**
CLIENT *Editions Filigranes*
COUNTRY *Belgium*

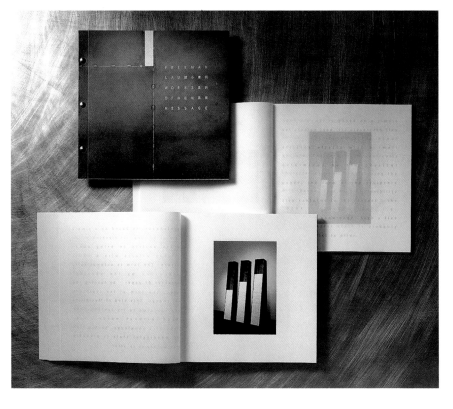

Merit

BOOK DESIGN, MUSEUM, GALLERY, LIBRARY, UNIVERSITY PRESS BOOKS
Freeman Lau Works of Message

ART DIRECTOR *Freeman Lau Siu Hong*
DESIGNER *Freeman Lau Siu Hong*
PHOTOGRAPHER *C.K. Wong, Ken Kan*
STUDIO *Kan & Lau Design Consultants*
CLIENT *Freeman Lau Siu Hong*
COUNTRY *Hong Kong, China*

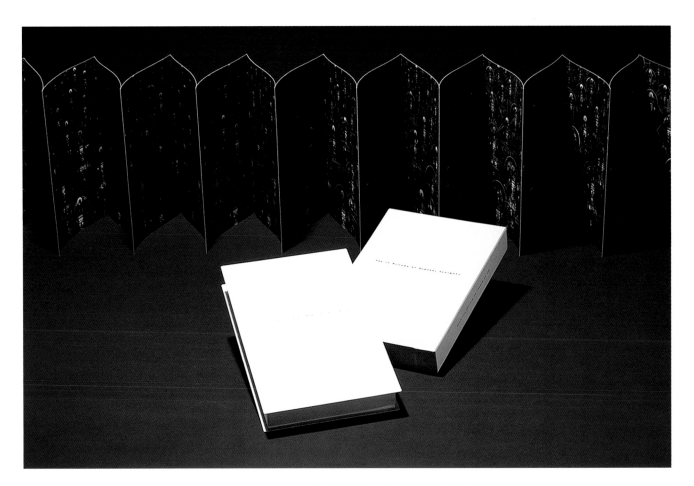

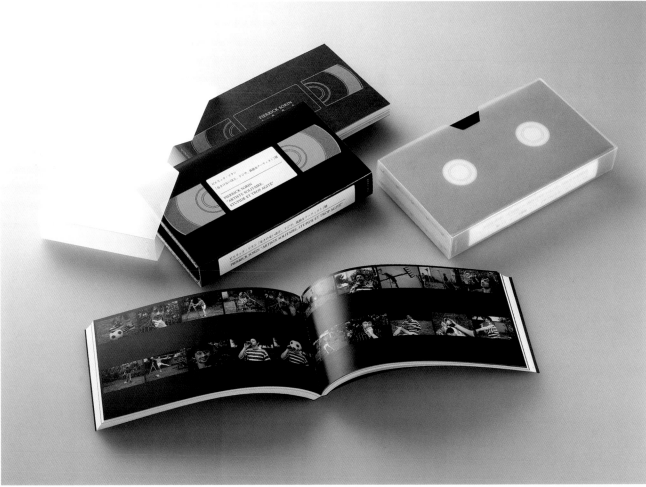

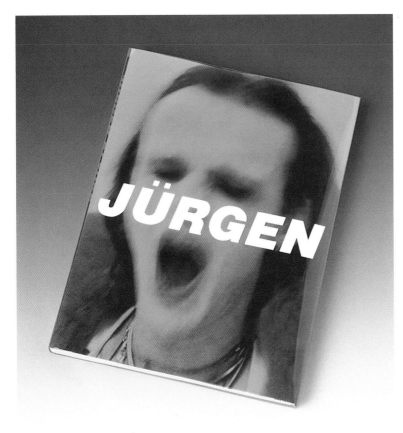

Merit
BOOK DESIGN, MUSEUM, GALLERY, LIBRARY, UNIVERSITY PRESS BOOKS
Jürgen Klauke

ART DIRECTOR *Koji Mizutani*
CREATIVE DIRECTOR *Koji Mizutani*
DESIGNERS *Hiroshi Omizo, Yoshio Saito*
PHOTOGRAPHER *Jürgen Klauke*
ILLUSTRATOR *Jürgen Klauke*
PRODUCER *Koji Mizutani*
AGENCY *Mizutani Studio*
STUDIO *Mizutani Studio*
CLIENT *The Museum of Modern Art, Saitama*
COUNTRY *Japan*

Merit
BOOK DESIGN, MUSEUM, GALLERY, LIBRARY, UNIVERSITY PRESS BOOKS
Flying over Water

ART DIRECTOR *Stephen Coates*
AUTHOR *Peter Greenaway*
DESIGNER *Stephen Coates*
PHOTOGRAPHERS *Various*
STUDIO *Stephen Coates*
PUBLISHER *Merrell Holberton*
CLIENT *Merrell Holberton*
COUNTRY *England*

(facing page, top)
Merit
BOOK DESIGN, MUSEUM, GALLERY, LIBRARY, UNIVERSITY PRESS BOOKS
Sea of Buddha by Hiroshi Sugimoto

ART DIRECTOR *Takaaki Matsumoto*
DESIGNER *Takaaki Matsumoto*
PHOTOGRAPHER *Hiroshi Sugimoto*
EDITOR *Atsuko Koyanagi*
STUDIO *Matsumoto Incorporated*
CLIENT *Sonnabend Gallery*
COUNTRY *United States*

(facing page, bottom)
Merit
BOOK DESIGN, GALLERY BOOKS
Pierrick Sorin–Artiste Solitaire, Stupide et Trop Agité,
Shiseido Gallery Exhibition Catalog
(Pierrick Sorin–Lonely, Stupid, and Too Agitated Artist)

ART DIRECTOR *Aoshi Kudo*
DESIGNERS *Aoshi Kudo, Hikari Nakahashi,*
Seiji Ohta
PHOTOGRAPHERS *Pierrick Sorin, Masato Kanazawa*
ARTIST *Pierrick Sorin*
PRODUCER *Takao Kakizaki*
EDITOR *Motoko Tokuyama*
STUDIO *Shiseido Co., Ltd.*
CLIENT *Shiseido Gallery*
COUNTRY *Japan*

Merit

**BOOK DESIGN, MUSEUM, GALLERY, LIBRARY,
UNIVERSITY PRESS BOOKS**

Front Pages by Nancy Chunn

ART DIRECTOR *Lisa Feldman*
DESIGNER *Lisa Feldman*
EDITOR *Barbara Einzig*
ARTIST *Nancy Chunn*
PRODUCTION DIRECTOR *Elizabeth White*
DESIGN STUDIO *Lisa Feldman Design, Inc.*
CLIENT *Rizzoli International Publications, Inc.*
COUNTRY *United States*

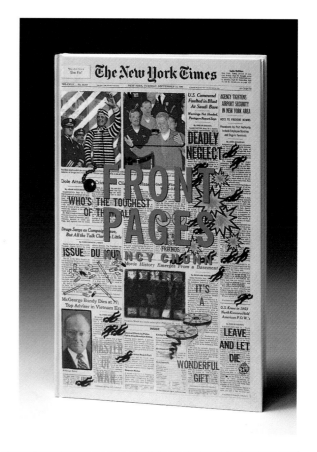

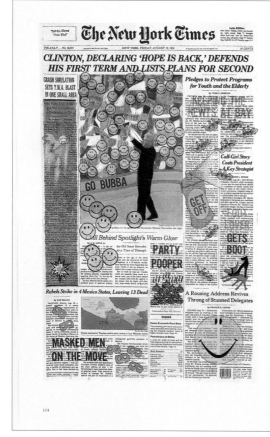

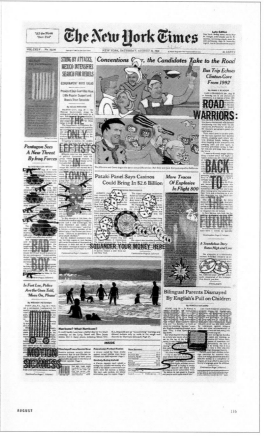

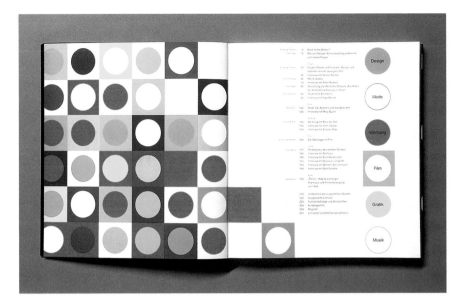

Merit

BOOK DESIGN, MUSEUM, GALLERY, LIBRARY, UNIVERSITY PRESS BOOKS

'68–Design und Alltagskultur zwischen Konsum und Konflikt ('68–Design and Popular Culture between Consumerism and Conflict)

ART DIRECTORS *Helen Hacker, Isabella Til*
CREATIVE DIRECTORS *Helen Hacker, Isabella Til, Professor Vilim Vasata (cover)*
COPYWRITERS *Oskar Negt, Wolfgang Schepers, Günther Beltzig, Hans Höger, Andrea Branzi, Barbara Til, Helmut M. Bien, Hartmut W. Redottée, Klaus Klemp, Uwe Husslein*
DESIGNERS *Helen Hacker, Isabella Til*
PHOTOGRAPHER *Bernd Edgar Wichmann*
PRODUCER *DuMont Verlag*
STUDIO *Helen Hacker, Isabella Til*
CLIENT *Kunstmuseum, Düsseldorf*
COUNTRY *Germany*

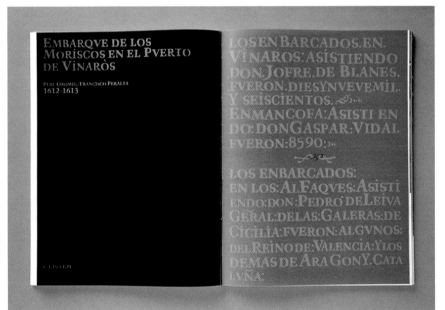

Merit

BOOK DESIGN, MUSEUM, GALLERY, LIBRARY, UNIVERSITY PRESS BOOKS

La Expulsion de los Mariscos del Reino de Valencia (The Expulsion of the Moors from the Kingdom of Valencia)

ART DIRECTOR *Pepe Gimeno*
CREATIVE DIRECTOR *Pepe Gimeno*
DESIGNER *Pepe Gimeno*
PHOTOGRAPHERS *Juan García Rosell, Gil Carles*
STUDIO *Pepe Gimeno, S.L.*
CLIENT *Fundació Bancaixa*
COUNTRY *Spain*

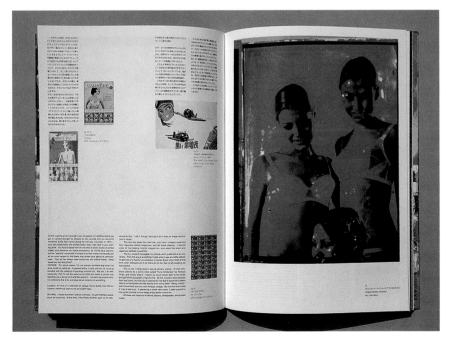

Merit

BOOK DESIGN, MUSEUM, GALLERY, LIBRARY, UNIVERSITY PRESS BOOKS

Shinro Ohtake: Printing/Painting

ART DIRECTOR *Katsuhiro Kinoshita*
CREATIVE DIRECTOR *Katsuhiro Kinoshita*
DESIGNER *Katsuhiro Kinoshita*
PHOTOGRAPHER *Masataka Nakano*
ARTIST *Shinro Ohtake*
STUDIO *Design Club Inc.*
CLIENT *Center for Contemporary Graphic Art and Tyler Graphics Archive Collection (CCGA)*
COUNTRY *Japan*

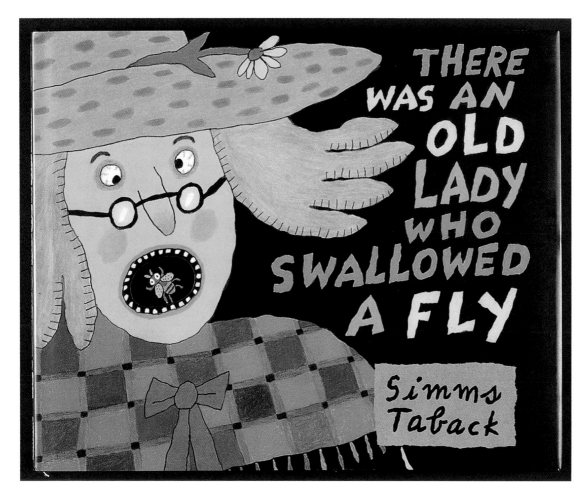

Merit
BOOK DESIGN, JUVENILE BOOKS
There Was an Old Lady Who Swallowed a Fly

ART DIRECTOR *Denise Cronin*
COPYWRITER *Simms Taback*
DESIGNER *Simms Taback*
ILLUSTRATOR *Simms Taback*
PRODUCER *Harriet Ziefert, Inc.*
STUDIO *Simms Taback Studio*
CLIENT *Regina Hayes/Viking Children's Books*
COUNTRY *United States*

(facing page, top)
Merit
BOOK DESIGN, JUVENILE BOOKS
*Alice's Shops in Wonderland, The Nursery Tales
for Young Adults or Over*

ART DIRECTOR *Hitomi Sago*
DESIGNER *Hitomi Sago*
ILLUSTRATOR *Frédéric Clément*
AUTHOR *Frédéric Clément*
TRANSLATOR *Kazunari Suzumura*
EDITOR *Yuko Ota*
STUDIO *Hitomi Sago Design Office, Inc.*
CLIENT *Kinokuniya Co., Ltd.*
COUNTRY *Japan*

(facing page, bottom)
MULTIPLE AWARDS

Merit
BOOK DESIGN, JUVENILE BOOKS

and Merit
BOOK DESIGN, BOOK JACKETS ONLY
Miss Spider's New Car

ART DIRECTOR *Nicholas Callaway*
EDITOR *Antoinette White*
DESIGNER *Toshiya Masuda*
ILLUSTRATOR *David Kirk*
PRODUCTION DIRECTOR *True Sims*
PRODUCER *Callaway & Kirk Company, L.L.C.*
FIRM *Callaway & Kirk Company, L.L.C.*
CLIENT *Scholastic Press*
COUNTRY *United States*

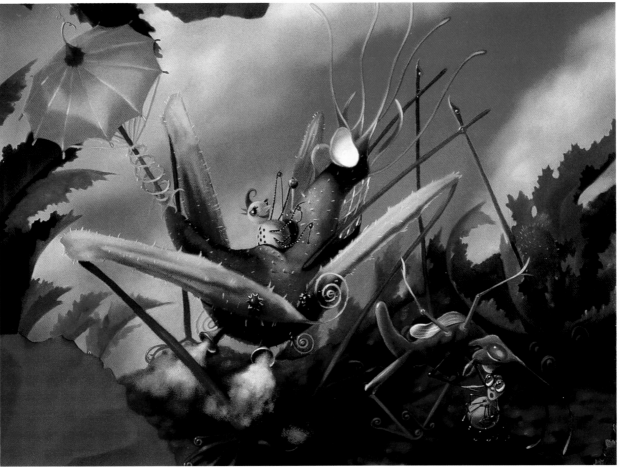

Merit
**BOOK DESIGN, TEXT, REFERENCE,
AND HOW-TO BOOKS**
*Sony Music International Telephone &
Address Directory*

ART DIRECTOR *Erwin Gorostiza*
DESIGNER *Erwin Gorostiza*
STUDIO *Sony Music Creative Services*
CLIENT *Sony Music International*
COUNTRY *United States*

(facing page)
Merit
**BOOK DESIGN, TEXT, REFERENCE,
AND HOW-TO BOOKS**
The Digital Designer

ART DIRECTOR *Mirko Ilić*
DESIGNERS *So Takahashi, Mirko Ilić*
ILLUSTRATOR *Mirko Ilić*
STUDIO *Mirko Ilić Corp.*
CLIENT *Watson-Guptill Publications*
COUNTRY *United States*

Merit
**BOOK DESIGN, TEXT, REFERENCE,
AND HOW-TO BOOKS**
Gemisphere Luminary

ART DIRECTORS *Robin Rickabaugh,
Heidi Rickabaugh*
COPYWRITERS *Michael Katz, Katherine Hall*
DESIGNERS *Robin Rickabaugh, Andrew Reed,
Clint Gorthy, Brian Kerr*
ILLUSTRATOR *Andrew Reed*
STUDIO *Principia Graphica*
CLIENT *Gemisphere*
COUNTRY *United States*

Merit
BOOK DESIGN, BOOK JACKETS ONLY, SERIES
The Wagenbach Paperbacks

ART DIRECTORS *Rainer Groothuis, Gilmar Wendt*
CREATIVE DIRECTOR *Rainer Groothuis*
DESIGNERS *Rainer Groothuis, Gilmar Wendt*
AGENCY *Groothuis+Malsy*
CLIENT *Verlag Klaus Wagenbach*
COUNTRY *Germany*

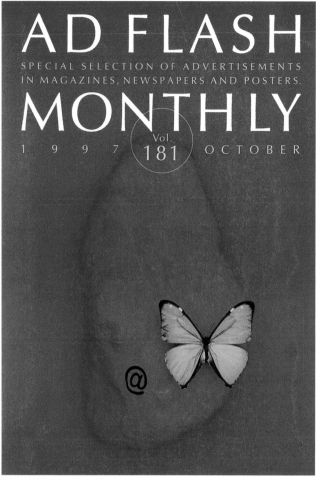

Merit
BOOK DESIGN, BOOK JACKETS ONLY, SERIES
Ad Flash Monthly

ART DIRECTOR *Norio Kudo*
CREATIVE DIRECTOR *Norio Kudo*
DESIGNER *Norio Kudo*
PHOTOGRAPHER *Takahito Sato*
STYLIST *Masato Okamura*
AGENCY *STRIKE Co., Ltd.*
STUDIO *STRIKE Co., Ltd.*
CLIENT *AD PUBLISHING Co., Ltd.*
COUNTRY *Japan*

Merit
BOOK DESIGN, BOOK JACKETS ONLY
The Zig Zag Kid

ART DIRECTOR *Susan Mitchell*
DESIGNER *Susan Mitchell*
PHOTOGRAPHER *David Hughes*
CLIENT *Farrar Straus and Giroux*
COUNTRY *United States*

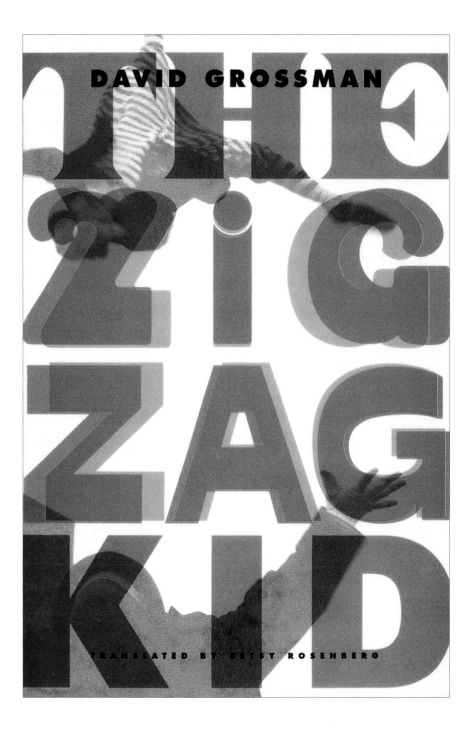

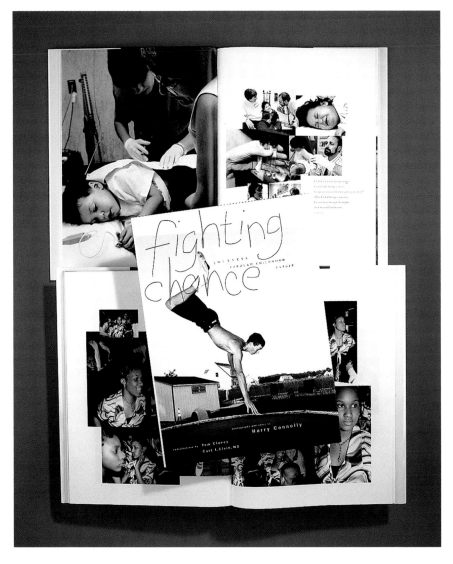

Merit
BOOK DESIGN, BOOK JACKETS ONLY
Fighting Chance

ART DIRECTOR *Gerry Greaney*
COPYWRITERS *Harry Connolly, Tom Clancy,*
Curt I. Civin, M.D.
DESIGNER *Gerry Greaney*
PHOTOGRAPHER *Harry Connolly*
EDITOR *Gregg Wilhelm*
AGENCY *Greaney Design*
CLIENT *Woodholme House Publishers*
COUNTRY *United States*

Merit

**EDITORIAL DESIGN, MAGAZINE, CONSUMER OR
BUSINESS, SPREAD, SERIES**

Awakening to Sleep

ART DIRECTOR *Janet Froelich*
COPYWRITER *The New York Times*
DESIGNER *Catherine Gilmore-Barnes*
PHOTOGRAPHER *Lisa Spindler*
PHOTO EDITOR *Kathy Ryan*
CLIENT *The New York Times Magazine*
COUNTRY *United States*

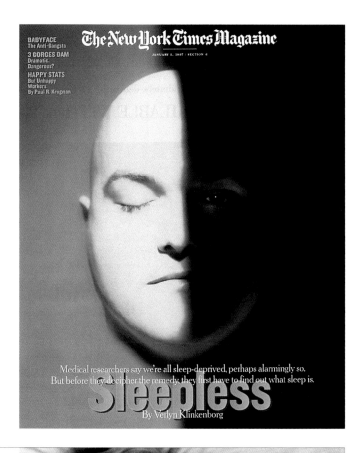

The New York Times Magazine

JANUARY 5, 1997 / SECTION 6

BABYFACE
The Anti-Gangsta
3 GORGES DAM
Dramatic.
Dangerous?
HAPPY STATS
But Unhappy
Workers
By Paul R. Krugman

Medical researchers say we're all sleep-deprived, perhaps alarmingly so.
But before they decipher the remedy, they first have to find out what sleep is.

Sleepless
By Verlyn Klinkenborg

To get a good night's rest you have to learn to spend 14 hours in bed. The payoff? You may discover you've never really been awake.

By Verlyn Klinkenborg

SLEPT BADLY AGAIN last night. Perhaps you did, too. I was in a strange city and in a strange bed filled with the overabundant warmth of a hotel room. At home, I often come awake for an hour or two in the early morning, 3:30, 4. A thread of thought — the merest particle of wakeful-ness — presents itself, and soon the bedside light is on and I'm reading again or lying in the dark, thinking. I often put off going to bed, as I did last night, for no good reason. Like a kid with an 8:30 bedtime in the eternal twilight of summer, I can't quite bear to quit consciousness. The itch of waking won't subside. This is an old and by now not particularly troublesome habit, though its effects are sometimes tedious and grow more pronounced the older I get. Like almost everyone, I borrow more from sleep than I can ever hope

26

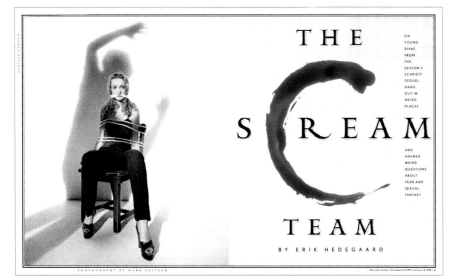

Merit

EDITORIAL DESIGN, MAGAZINE, CONSUMER OR BUSINESS, SPREAD

The Scream Team

ART DIRECTOR *Fred Woodward*
DESIGNER *Fred Woodward*
PHOTOGRAPHER *Mark Seliger*
PHOTO EDITOR *Fiona McDonagh*
PUBLISHER *Wenner Media*
CLIENT *Rolling Stone*
COUNTRY *United States*

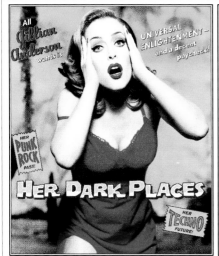

Merit

EDITORIAL DESIGN, MAGAZINE, CONSUMER OR BUSINESS, SPREAD

Gillian Anderson

ART DIRECTOR *Fred Woodward*
DESIGNERS *Fred Woodward, Gail Anderson*
PHOTOGRAPHER *Matthew Rolston*
PHOTO EDITOR *Jodi Peckman*
TYPOGRAPHER *Eric Siry*
PUBLISHER *Wenner Media*
CLIENT *Rolling Stone*
COUNTRY *United States*

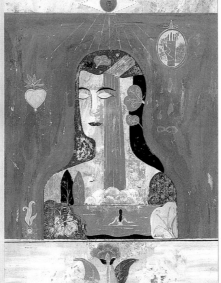

Merit

EDITORIAL DESIGN, MAGAZINE, CONSUMER OR BUSINESS, SPREAD

Caring/Patient Heal Thyself

ART DIRECTOR *Mark Geer*
COPYWRITER *Molly Glentzer*
DESIGNER *Mark Geer*
ILLUSTRATOR *Philippe Lardy*
STUDIO *Geer Design, Inc.*
CLIENT *Memorial Healthcare System*
COUNTRY *United States*

Merit

EDITORIAL DESIGN, MAGAZINE, CONSUMER OR BUSINESS, SPREAD

Phis 1

ART DIRECTOR *Fred Woodward*
DESIGNERS *Fred Woodward, Geraldine Hessler*
PHOTOGRAPHER *Mark Seliger*
PHOTO EDITOR *Jodi Peckman*
PUBLISHER *Wenner Media*
CLIENT *Rolling Stone*
COUNTRY *United States*

Merit

EDITORIAL DESIGN, MAGAZINE, CONSUMER OR BUSINESS, SPREAD

Rza–Zack

ART DIRECTOR *Fred Woodward*
DESIGNERS *Fred Woodward, Geraldine Hessler*
PHOTOGRAPHER *Mark Seliger*
PHOTO EDITOR *Jodi Peckman*
PUBLISHER *Wenner Media*
CLIENT *Rolling Stone*
COUNTRY *United States*

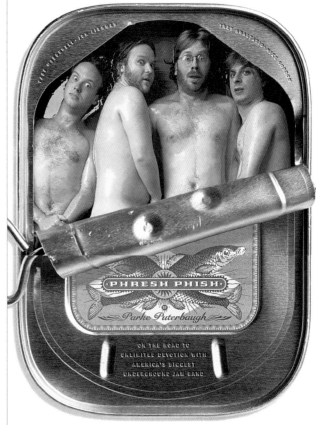

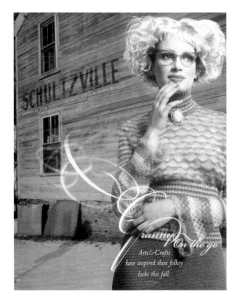

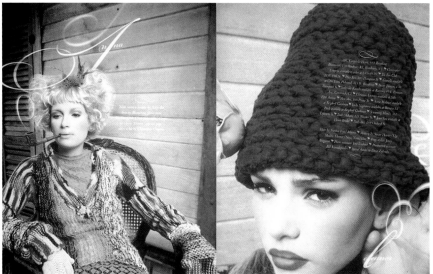

Merit

EDITORIAL DESIGN, MAGAZINE, CONSUMER OR BUSINESS, SPREAD
Granny on the Go

ART DIRECTOR *Bridget de Socio*
DESIGNER *Lara Harris*
PHOTOGRAPHER *Nina Schultz*
STYLIST *Jessica Doyle*
EDITORS *Kim Hastreiter, David Hershkovits*
STUDIO *Socio X*
CLIENT *Paper Magazine*
COUNTRY *United States*

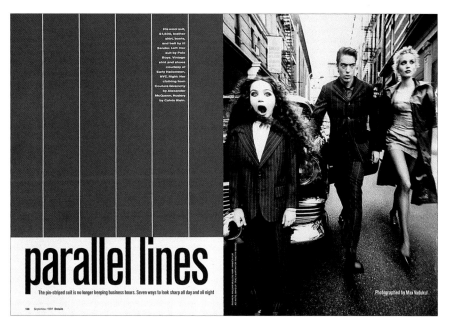

Merit

EDITORIAL DESIGN, MAGAZINE, CONSUMER OR BUSINESS, SPREAD
Parallel Lines

DESIGN DIRECTORS *Mark Michaelson,*
Robert Newman
DESIGNER *Mark Michaelson*
PHOTOGRAPHER *Max Vadukul*
PHOTO EDITOR *Greg Pond*
FASHION EDITOR *William Mullen*
CLIENT *Details*
COUNTRY *United States*

Merit
EDITORIAL DESIGN, MAGAZINE, CONSUMER OR BUSINESS, SPREAD
The Last Ride

ART DIRECTOR *D. J. Stout*
CREATIVE DIRECTOR *D. J. Stout*
DESIGNERS *D. J. Stout, Nancy McMillen*
COPYWRITER *Helen Thorpe*
ILLUSTRATOR *Melinda Beck*
CLIENT *Texas Monthly*
COUNTRY *United States*

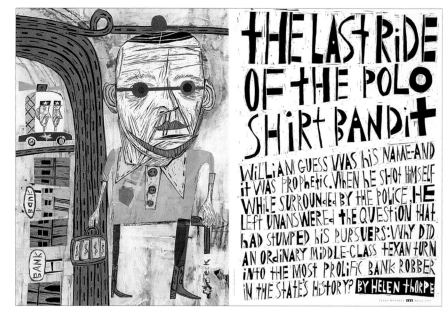

Merit
EDITORIAL DESIGN, MAGAZINE, CONSUMER OR BUSINESS, SPREAD
Blowing in the Wind

ART DIRECTOR *D. J. Stout*
CREATIVE DIRECTOR *D. J. Stout*
DESIGNERS *D. J. Stout, Nancy McMillen*
ILLUSTRATOR *Brad Holland*
CLIENT *Texas Monthly*
COUNTRY *United States*

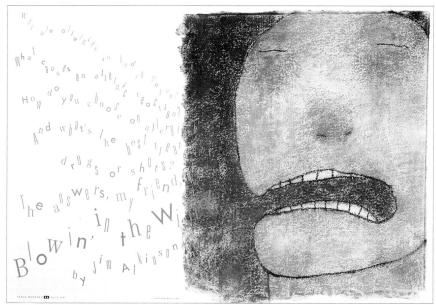

Merit
EDITORIAL DESIGN, MAGAZINE, CONSUMER OR BUSINESS, SPREAD
Merchants of Chaos

ART DIRECTOR *Mark Geer*
DESIGNER *Mark Geer*
COPYWRITER *Neil C. McCabe*
ILLUSTRATOR *Larry McEntire*
STUDIO *Geer Design, Inc.*
CLIENT *South Texas College of Law*
COUNTRY *United States*

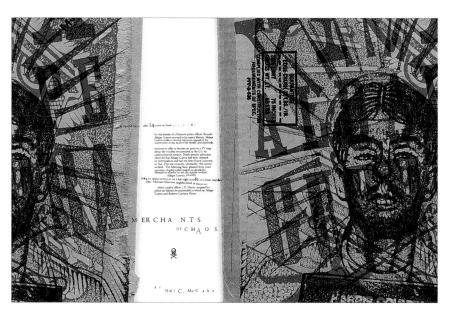

MULTIPLE AWARDS

Merit
EDITORIAL DESIGN, MAGAZINE, CONSUMER OR
BUSINESS, SPREAD

and Merit
EDITORIAL DESIGN, MAGAZINE, CONSUMER OR
BUSINESS, FULL ISSUE
International Gallerie

ART DIRECTOR *Mangesh Rane*
EDITOR *Bina Sarkar Ellias*
DESIGNER *Mangesh Rane*
PHOTOGRAPHERS *Various*
PRODUCTION *Rafeeq Ellias*
PRINTER *Pragati Art Printers*
STUDIO *Paradise Multimedia*
CLIENT *Gallerie Publishers*
COUNTRY *India*

Merit
EDITORIAL DESIGN, MAGAZINE, CONSUMER OR
BUSINESS, PREAD
Chloe Sevigny Personification of Our Times

ART DIRECTOR *Naoki Sato*
EDITOR IN CHIEF *Masanobu Sugatsuke*
DESIGNER *Naoki Sato*
ILLUSTRATOR *Karen Kilimnik*
PUBLISHER *Masanori Awata*
STUDIO *Naoki Sato*
CLIENT *Composite/Synergy Inc.*
COUNTRY *Japan*

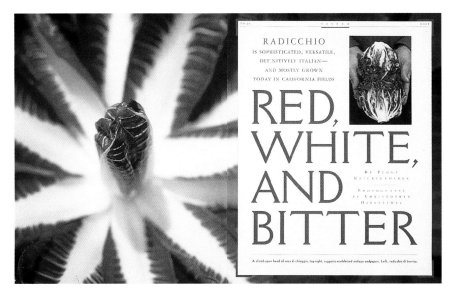

Merit
EDITORIAL DESIGN, NEWSPAPER, CONSUMER OR
BUSINESS, SPREAD
Red, White, and Bitter

ART DIRECTOR *Jill Armus*
CREATIVE DIRECTOR *Michael Grossman*
DESIGNER *Jill Armus*
PHOTOGRAPHER *Christopher Hirsheimer*
STUDIO *Meigher Communications*
CLIENT *Saveur Magazine*
COUNTRY *United States*

311

THE PROUD HIGHWAY
~~THE~~ the LETTERS of
HUNTER S. THOMPSON
1956-1967

* * * * * * * * * * * * * * * * * *

This is a forced march through my per-
sonal history. I don't ~~XXXXXXX~~ think
many people could sit calmly while
boxes of intimate — and in some cases
~~XXXXXX~~ no doubt incriminating — corre-
spondence were ~~DXXX~~ dredged up from
sealed basement vaults. But I did,
Bubba, but always from afar, from the
greatest distance, ~~XXXXXXXXXX~~ trying
not to cause trouble — and because I
wanted to stay in the shadows and act
like I was dead, and others ~~XXIXXXI0~~
tried to act the same way. "Mistah
Thompson, he dead . . . " We all under-
stood ~~UNDERSTOOD~~ that their work and
their lives and their long-range pro-
fessional Fate would be a lot easier if
I went out on a slick Ducati motorcycle
one night and never came back. But that
would be a different road, and this is,
after all, ~~XXXXXXXXXXXXXXX~~ what we've
decided to call "The Proud Highway."
Hunter S. Thompson

80 · Rolling Stone, June 12, 1997

While his boyhood friends from
Louisville, Ky., went off to
college, Thompson began a hitch
in the U.S. Air Force, in 1955.
During his service as an elec-
tronics expert at Eglin Air
Force Base, he managed the
position of sports editor for
the base newspaper, the
"Command Courier." Below,
Thompson writes his childhood
friend Gerald "Ching" Tyrrell
at Yale about life in the Air
Force and his new career plan.

Sept. 22, 1956
Eglin AFB
Fort Walton Beach, Fla.

AALLLLLLOOOOOOOO.......!
Perhaps I'd better
explain my newest and
most successful venture.
In a resounding and
incredible triumph over
regulations and first
sergeants, I managed to
effect a transfer to the
Information Services
career field. More
specifically, I am now
Sports Editor of the
Command Courier, the
official voice of Eglin
AFB. Now you know, and I
know, that I've never
written a word for a
newspaper of any sort.
And you know that it's
ridiculous to even speak
of any experience on my

part, as far as layout or
page arrangement goes. In
short, I'm
no more qualified for a post
like this than I am for the
presidency of a theological
seminary; but there is one
major fact that makes it
possible for me to hold this
job: The people who hired me
didn't bother to check any
too closely on my journalis-
tic background. I've managed
to keep them in safe igno-
rance for about a month now,
by nodding my head knowingly
at any mention of a term
which sounds journalistic,
and using a few simple ones
on occasion, whenever it
seems comparatively safe.
— Hunter

* * * * * * *

Writing Joe Bell, a Louisville
friend, Thompson shares some thoughts
on one of his favorite writer, nov-
elist Ayn Rand. Thompson often lent
copies of her books to friends.

Oct. 24, 1957
Eglin AFB
Fort Walton Beach, Fla.
Dear Joe,
Two reasons for writing this:
one, to let you know that I've
finished "The Fountainhead," and
two, to tell you that Ayn Rand's
new book is called "Atlas
Shrugged." I thought you might
be interested.
To say what I thought of "The
Fountainhead" would take me more
pages than I like to think I'd
stoop to boring someone with. I
think it's enough to say that I
think it's everything you said it
was and more. Naturally, I intend
to read "Atlas Shrugged." If it's
half as good as Rand's first ef-
fort, I won't be disappointed. . . .
Although I don't feel that it's
at all necessary to tell you how I
feel about the principle of
individuality, I know that I'm
going to have to spend the rest of
my life expressing it one way or
another, and I think that I'll
accomplish more by expressing it
on the keys of a typewriter than
by letting it express itself in
sudden outbursts of frustrated
violence. . . . Cheerio. Hunter

THOMPSON, AGE 23, HEADING WEST ON U.S. 50

In late October 1957, Thompson learned that he would be given an honorable dis-
charge from the U.S. Air Force. He was ecstatic at the prospect of beginning his
civilian career as a journalist, as he wrote to Larry Callen, who had been editor
of the "Command Courier" when Thompson arrived at Eglin.

Oct. 30, 1957
Eglin AFB
Fort Walton Beach, Fla.
Dear Larry,
By the time you get this letter, there will be no "H.S.
Thompson" listed on the payroll of the nation's bird
division. Colonel Campbell called me at the "PGN"
[Playground News] office this morning to tell me that the
Comm Sq sergeant had a message for me — to report for my
discharge physical tomorrow at 7:15. And so, after two
years of "arduous service," the walking anomaly that is
H.S.T. has escaped into the jungle of insecurity called
civilian life. Yes . . . it's an honorable. . . . I remain,
your friend . . . Hunty

>>>>>>>>

Merit
**EDITORIAL DESIGN, MAGAZINE, CONSUMER OR
BUSINESS, MULTIPAGE, SERIES**
Hunter S. Thompson

ART DIRECTOR *Fred Woodward*
DESIGNERS *Geraldine Hessler, Fred Woodward*
PHOTOGRAPHY *Courtesy of the
Hunter S. Thompson Collection*
PHOTO EDITOR *Fiona McDonagh*
PUBLISHER *Wenner Media*
CLIENT *Rolling Stone*
COUNTRY *United States*

THOMPSON IN HIS STUDY IN BIG SUR, CALIF.

THOMPSON IN HIS STUDY IN BIG SUR, CALIF.

Continued on Page 126

Merit

**EDITORIAL DESIGN, MAGAZINE, CONSUMER OR
BUSINESS, MULTIPAGE OR INSERT, SERIES**
Tatuagens Na Prisào (Jail's Tattoos)

ART DIRECTOR *David Carson*
COPYWRITER *Giuliano Cedroni*
DESIGNER *David Carson*
PHOTOGRAPHER *Moraes Mello*
DIRECTOR *Paulo Lima*
STUDIO *Walmir Graciano*
CLIENT *Trip Magazine*
COUNTRY *Brazil*

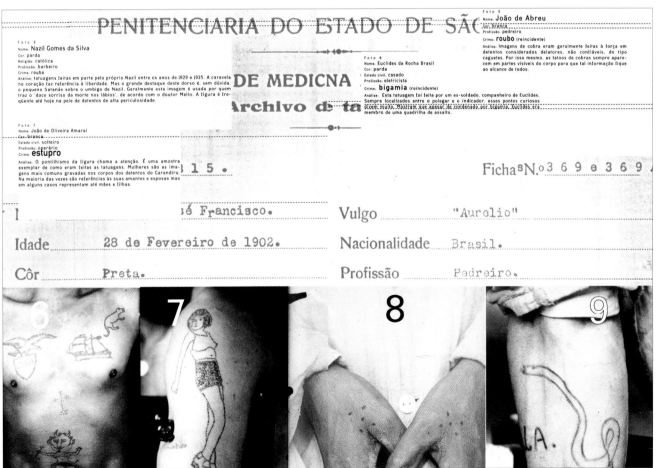

Merit
EDITORIAL DESIGN, MAGAZINE, CONSUMER OR BUSINESS, MULTIPAGE OR INSERT, SERIES
M-Plus

ART DIRECTOR *Naoki Sato*
DESIGNERS *Naoki Sato, Tatsuo Miyamoto*
EDITOR *Eiji Fukasawa*
PUBLISHER *Toru Imada*
STUDIO *Naoki Sato*
CLIENT *DDP digital publishing inc.*
COUNTRY *Japan*

Merit
EDITORIAL DESIGN, MAGAZINE, CONSUMER OR BUSINESS, MULTIPAGE OR INSERT, SERIES
Body Voyage

DESIGN DIRECTOR *Tom Bentkowski*
DESIGNER *Tom Bentkowski*
CLIENT *LIFE Magazine*
COUNTRY *United States*

(facing page, top)
Merit
EDITORIAL DESIGN, MAGAZINE, CONSUMER OR BUSINESS, FULL ISSUE
The Girls of Scream 2

ART DIRECTOR *Fred Woodward*
DESIGNERS *Fred Woodward, Gail Anderson, Eric Siry, Laura Hovanesia, Jesper Sundwall*
PHOTOGRAPHERS *Various*
PHOTO EDITOR *Fiona McDonagh*
ILLUSTRATORS *Various*
PUBLISHER *Wenner Media*
CLIENT *Rolling Stone*
COUNTRY *United States*

(facing page, bottom)
Merit
EDITORIAL DESIGN, MAGAZINE, CONSUMER OR BUSINESS, FULL ISSUE
Alive Magazine

ART DIRECTOR *Rima Sinno*
DESIGNER *Rima Sinno*
COPYWRITERS *Various*
PHOTOGRAPHERS *Various*
STUDIO *Rima Sinno*
CLIENT *Alive Magazine*
COUNTRY *United States*

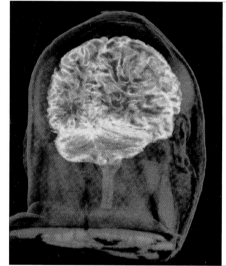

The Brain

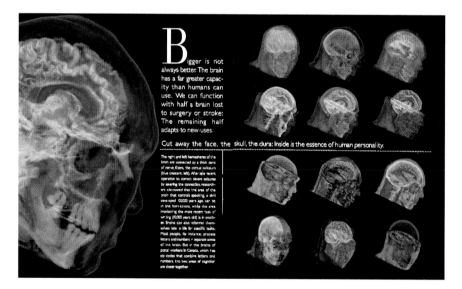

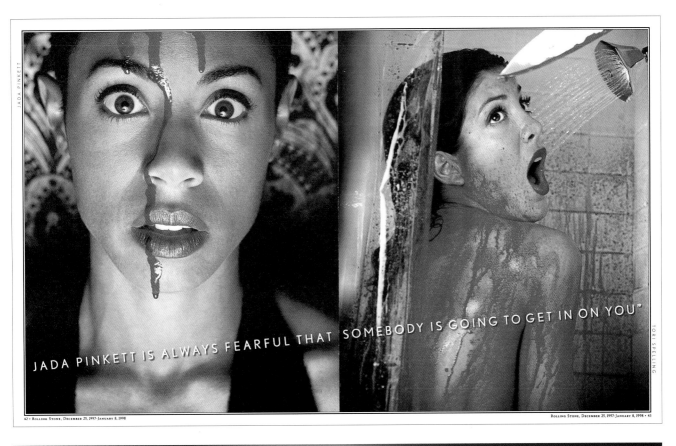

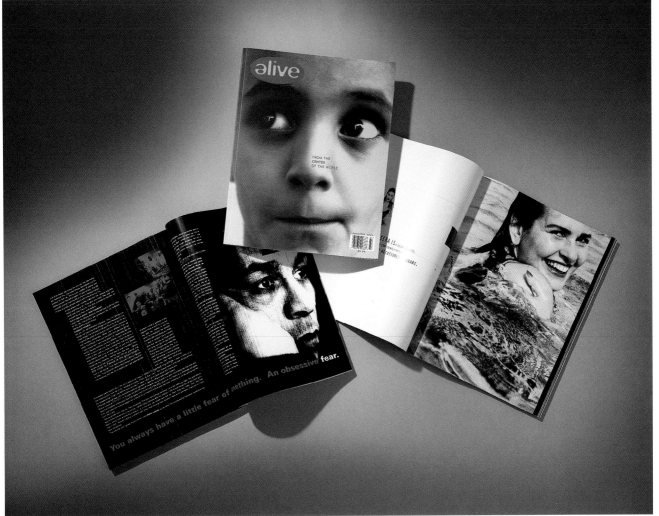

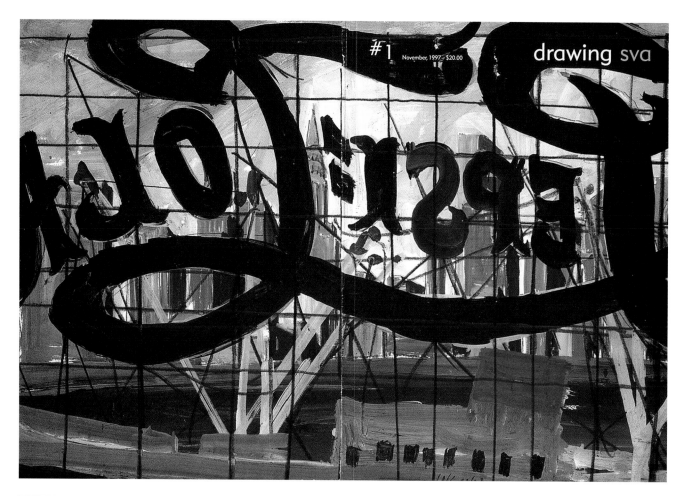

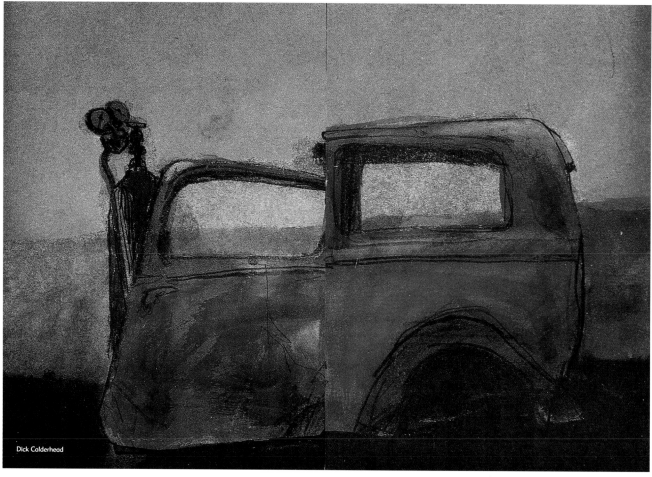

Dick Calderhead

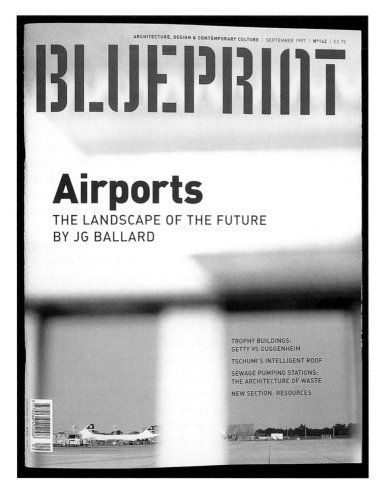

Merit
EDITORIAL DESIGN, MAGAZINE, CONSUMER OR BUSINESS, FULL ISSUE
BLUEPRINT

ART DIRECTOR *Andrew Johnson*
EDITOR *Marcus Field*
PUBLISHER *Gill Hicks*
STUDIO *BLUEPRINT*
CLIENT *Aspen Publishing Ltd.*
COUNTRY *England*

(facing page, top)
Merit
EDITORIAL DESIGN, MAGAZINE, CONSUMER OR BUSINESS, FULL ISSUE
Drawing Magazine #1/SVA

ART DIRECTOR *Paul Davis*
CREATIVE DIRECTOR *Silas Rhodes*
DESIGNERS *Paul Davis, Chalkley Calderwood, Chantal Fredet*
ILLUSTRATOR *Robert Weaver*
STUDIO *Paul Davis Studio*
CLIENT *School of Visual Arts*
COUNTRY *United States*

(facing page, bottom)
Merit
EDITORIAL DESIGN, MAGAZINE, CONSUMER OR BUSINESS, FULL ISSUE
Drawing Magazine #2/SVA

ART DIRECTOR *Paul Davis*
CREATIVE DIRECTOR *Silas Rhodes*
DESIGNERS *Paul Davis, Chalkley Calderwood, Chantal Fredet*
ILLUSTRATORS *Gig Wailgum, Bob Hagel, Valerio Anibaldi, Riccardo Vecchio, Jeffrey Smith, Jonathan Frost, Carol Fabricatore, Patrick Fiore, Beth Bartholomew, Yumi Heo, Gil Ashby, Keunhee Lee, Dick Calderhead, Kelynn Adler, Mark Lang, Marie Lessard, Richard Kelly, Lynn Pauley, Janelle Cromwell, Gayle Hefland, Kevin McCloskey, Julie Lieberman, Tim Purus, John Ferry, Paul Davis, John Gundelfinger, Lli Wilburn, Cynthia Maurice, Philip Stanton, Mickey Paraskevas*
STUDIO *Paul Davis Studio*
CLIENT *School of Visual Arts*
COUNTRY *United States*

EDITORIAL DESIGN, MAGAZINE, CONSUMER OR BUSINESS, FULL ISSUE
Times Square

ART DIRECTOR *Janet Froelich*
COPYWRITER *The New York Times*
DESIGNER *Catherine Gilmore-Barnes*
PHOTOGRAPHERS *Various*
PHOTO EDITOR *Kathy Ryan*
CLIENT *The New York Times Magazine*
COUNTRY *United States*

Merit
**EDITORIAL DESIGN, MAGAZINE, CONSUMER OR
BUSINESS, FULL ISSUE**
The Millennium

DESIGN DIRECTOR *Tom Bentkowski*
ART DIRECTOR *Sharon Okamoto*
DESIGNERS *Melanie de Forest, Sam Serebin,
Sarah Garcea*
CLIENT *LIFE Magazine*
COUNTRY *United States*

THE DISCOVERERS

NICOLAUS COPERNICUS

1473-1543

THE EARTH WAS THE FIXED center of the universe until 16th century Polish astronomer Nicolaus Copernicus ventured the idea that the sun is the center of the solar system, with the earth and the planets revolving around it. Copernicus, a systematic student of mathematics and astronomy, began to amass evidence disputing Aristotle and Ptolemy's geocentric universe. But he was also a cautious man—one might say a wise man—at a time when heretics were put to death. Copernicus didn't publish *On the Revolutions of the Celestial Spheres*, which revolutionized our concept of the world, until 1543, when he was on his deathbed.

GALILEO GALILEI

1564-1642

BY CHALLENGING VIEWS OF the natural world that had prevailed for 1,500 years, Italian astronomer, physicist and mathematician Galileo Galilei changed the way we think. By inventing a mathematical approach to everyday experience, he discovered the laws of inertia, falling bodies and the pendulum. With a telescope he built, he also made astronomical discoveries that convinced him of the heliocentric view of the universe, which Copernicus had formulated earlier but had been hesitant to publish. Galileo took the chance but was forced to recant his findings before a Catholic Church tribunal in 1633. Nonetheless, his beliefs and discoveries lived on, opening the door for modern physics and a new approach to scientific thought.

ISAAC NEWTON

1642-1727

A PASSIONATELY RELIGIOUS man in a time of great scientific discovery, Isaac Newton wanted to know how God's universe worked. His quest for answers gave us the law of universal gravitation, calculus, a new theory of color and light, and the three laws of motion that form the basis of modern mechanics. Brilliant and creative, the English physicist and mathematician synthesized the discoveries of Galileo, Kepler and others, formalizing and transforming physical science. Yet, looking back, Newton said, "I seem to have been only like a boy, playing on the sea-shore, and diverting myself, in now and then finding a smoother pebble or prettier shell than ordinary, whilst the great ocean of truth lay all undiscovered before me."

CAROLUS LINNAEUS

1707-1778

HIS 18TH CENTURY CONTEMPORARIES called Carl von Linné bold, even salacious, when he used sexuality as the starting point for his botanical classification system. He described calyxes as "nuptial beds," corollas as their "curtains," but by using the number and length of stamens to group plants into classes, and pistils to subdivide these into orders, he enabled students in the field to identify a specimen quickly and simply, by counting. The Swedish physician, writing in Latin as Linnaeus, also devised the system of naming the genus and species of plants—and, later, animals. His work was adopted by naturalists worldwide in his time and is evident everywhere in ours.

◄ **CHARLES DARWIN**
1809-1882

A CHILD OF WEALTH AND an undistinguished student, Charles Darwin leapt at the chance to serve as an unpaid naturalist on the H.M.S. *Beagle*. In the course of his five-year adventure, he realized his genius: Though he returned a semi-invalid, he proceeded to father 10 children—and to work out the implications of what he had seen in the Galápagos Islands and atolls of the Pacific. His theories of evolution and natural selection, published in 1859, still excite us today.

137

Merit

**EDITORIAL DESIGN, MAGAZINE, CONSUMER OR
BUSINESS, FULL ISSUE**

Apple

DESIGN DIRECTOR *Thomas Schneider*
CREATIVE DIRECTORS *John Plunkett,*
Barbara Kuhr
DESIGNERS *Thomas Schneider, John Plunkett,*
Eric Courtemanche
PHOTOGRAPHERS *Various*
ILLUSTRATORS *Various*
COVER ILLUSTRATOR *Tony Klassen*
EXECUTIVE EDITOR *Kevin Kelly*
EDITOR *Louis Rossetto*
CLIENT *Wired Magazine*
COUNTRY *United States*

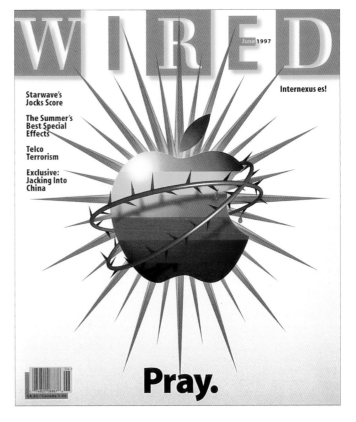

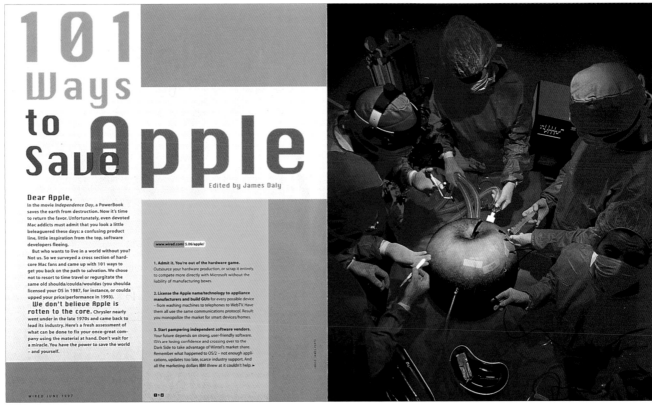

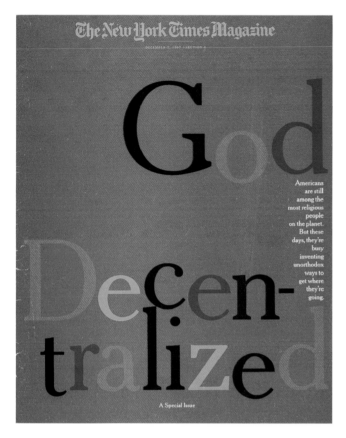

Merit
**EDITORIAL DESIGN, MAGAZINE, CONSUMER OR
BUSINESS, FULL ISSUE**
God

ART DIRECTOR *Janet Froelich*
DESIGNER *Nancy Harris*
COPYWRITER *The New York Times*
PHOTOGRAPHERS *Various*
PHOTOGRAPHY EDITOR *Sarah Harbutt*
CLIENT *The New York Times Magazine*
COUNTRY *United States*

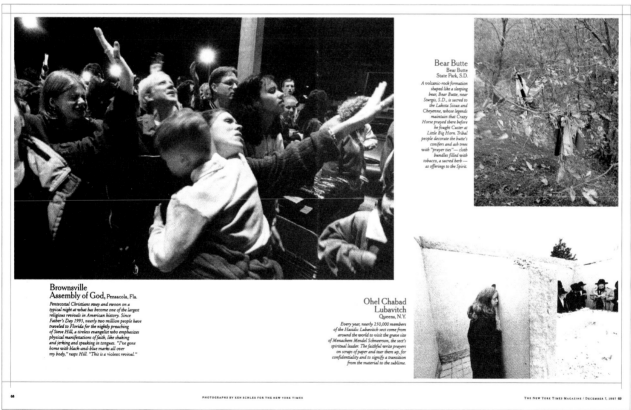

**Brownsville
Assembly of God,** Pensacola, Fla.

Pentecostal Christians sway and swoon on a typical night at what has become one of the largest religious revivals in American history. Since Father's Day 1995, nearly two million people have traveled to Florida for the nightly preaching of Steve Hill, a tireless evangelist who emphasizes physical manifestations of faith, like shaking and jerking and speaking in tongues. "I've gone home with black-and-blue marks all over my body," rasps Hill. "This is a violent revival."

Bear Butte
Bear Butte
State Park, S.D.

A volcanic-rock formation shaped like a sleeping bear, Bear Butte, near Sturgis, S.D., is sacred to the Lakota Sioux and Cheyenne, whose legends maintain that Crazy Horse prayed there before he fought Custer at Little Big Horn. Tribal people decorate the butte's conifers and ash trees with "prayer ties" — cloth bundles filled with tobacco, a sacred herb — as offerings to the Spirit.

**Ohel Chabad
Lubavitch**
Queens, N.Y.

Every year, nearly 250,000 members of the Hasidic Lubavitch sect come from around the world to visit the grave site of Menachem Mendel Schneerson, the sect's spiritual leader. The faithful write prayers on scraps of paper and tear them up, for confidentiality and to signify a transition from the material to the sublime.

Merit

**EDITORIAL DESIGN, MAGAZINE, CONSUMER,
COVER, SERIES**
Das Büro 1 + 2 (The Office)

ART DIRECTOR *Jürgen Mandel*
CREATIVE DIRECTORS *Jürgen Mandel,*
Wilfried Korfmacher
DESIGNERS *Frank Koschembar, Bea Bug,*
Markus Kraus
COPYWRITERS *Wilfried Korfmacher, Jürgen Mandel,*
Wolfgang Laubersheimer, Birgit Mager
PHOTOGRAPHERS *David Hall, Karsten de Riese,*
Marc Joseph, Till Leeser, Frank Koschembar
ILLUSTRATORS *Sibylle Schwarz, Michael Englisch*
AGENCY *Mandel, Muth, Werbeagentur GmbH*
CLIENT *Voko Vertriebstiftung Büroeinrichtungen KG*
COUNTRY *Germany*

Merit

**EDITORIAL DESIGN, MAGAZINE, CONSUMER OR
BUSINESS, COVER**
Prodigy

ART DIRECTOR *Fred Woodward*
DESIGNER *Fred Woodward*
PHOTOGRAPHER *Peter Robathan*
PHOTO EDITOR *Jodi Peckman*
PUBLISHER *Wenner Media*
CLIENT *Rolling Stone*
COUNTRY *United States*

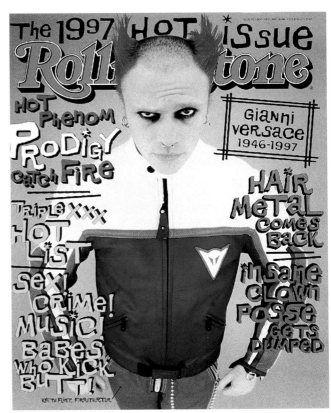

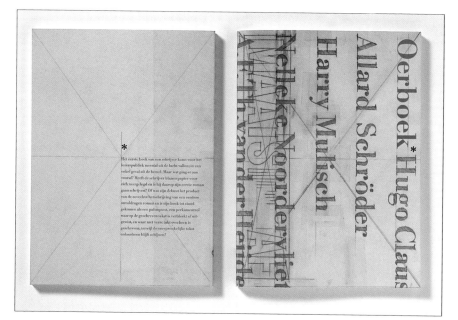

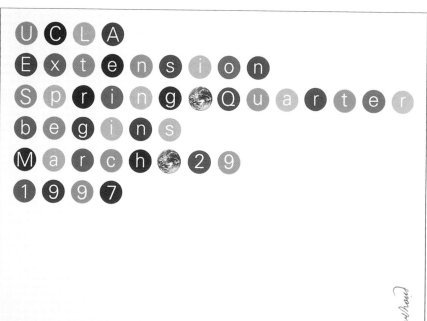

Merit
**CORPORATE & PROMOTIONAL DESIGN,
ANNUAL REPORT**
Sugen, 1996

ART DIRECTOR *Bill Cahan*
CREATIVE DIRECTOR *Bill Cahan*
COPYWRITERS *Carole Melis, Nina Ferrari*
DESIGNER *Sharrie Brooks*
PHOTOGRAPHER *Tony Stromberg*
ILLUSTRATOR *Jeffrey Decoster*
STUDIO *Cahan & Associates*
CLIENT *Sugen*
COUNTRY *United States*

Merit
**CORPORATE & PROMOTIONAL DESIGN,
ANNUAL REPORT**
Swiss Army Brands, Inc., 1996

ART DIRECTOR *Dave Mason*
COPYWRITER *Steven Zousmer*
DESIGNERS *Dave Mason, Pamela Lee*
PHOTOGRAPHER *Victor John Penner*
STUDIO *SamataMason*
CLIENT *Swiss Army Brands, Inc.*
COUNTRY *United States*

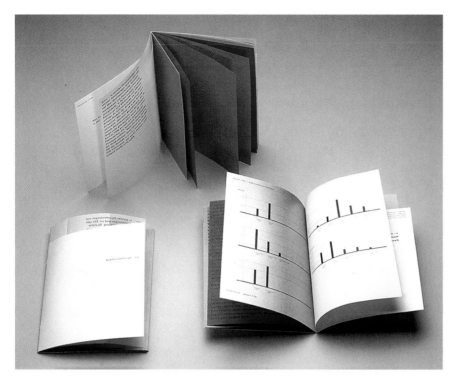

**CORPORATE & PROMOTIONAL DESIGN,
ANNUAL REPORT**

*Telefonseelsorge: "Was heißt Qualität in der TS?", 1996
(What Means Quality in TS: Samaritans
on Telephone?)*

ART DIRECTOR *Peter Felder*
CREATIVE DIRECTOR *Peter Felder*
COPYWRITER *Philip Bohle*
DESIGNERS *Peter Felder, René Dalpra*
PRODUCER *Wenin OHG*
STUDIO *Felder Grafikdesign*
CLIENT *Telefonseelsorge Vorarlberg*
COUNTRY *Austria*

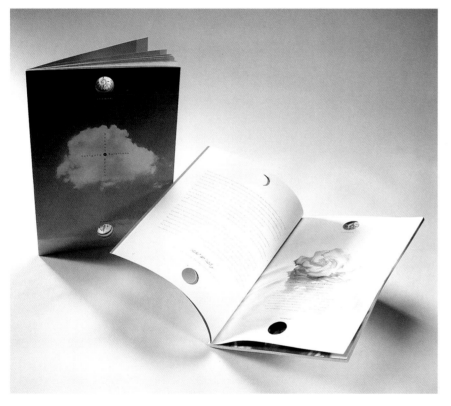

**CORPORATE & PROMOTIONAL DESIGN,
ANNUAL REPORT**

Insignia Solutions, 1996

CREATIVE DIRECTOR *Paul Schulte*
COPYWRITER *Lindsay Beaman*
DESIGNER *Paul Schulte*
PHOTOGRAPHER *Michele Clement*
PRINTER *George Rice & Sons*
STUDIO *Schulte Design*
CLIENT *Insignia Solutions*
COUNTRY *United States*

Merit

**CORPORATE & PROMOTIONAL DESIGN,
ANNUAL REPORT**

PCX, 1996

ART DIRECTOR *Kerry Leimer*
CREATIVE DIRECTOR *Kerry Leimer*
COPYWRITERS *Genie Williams, Mo Shaffroth*
DESIGNER *Kerry Leimer*
PHOTOGRAPHERS *Jeff Corwin, Tyler Boley*
STUDIO *Leimer Cross Design*
CLIENT *Pacific Exchange*
COUNTRY *United States*

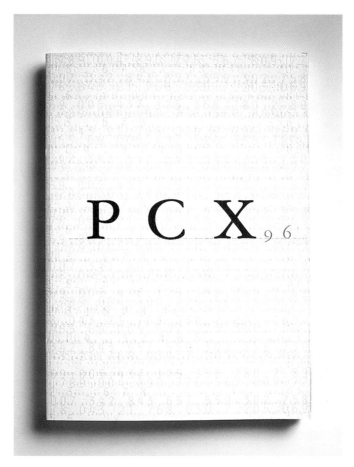

Merit

**CORPORATE & PROMOTIONAL DESIGN,
ANNUAL REPORT**

Universal Connector, Visio Corp., 1997

ART DIRECTOR *Kerry Leimer*
CREATIVE DIRECTOR *Kerry Leimer*
COPYWRITER *Kerry Leimer*
DESIGNER *Kerry Leimer*
PHOTOGRAPHERS *Jeff Corwin, Tyler Boley*
ILLUSTRATOR *Visio Corp.*
STUDIO *Leimer Cross Design*
CLIENT *Visio Corp.*
COUNTRY *United States*

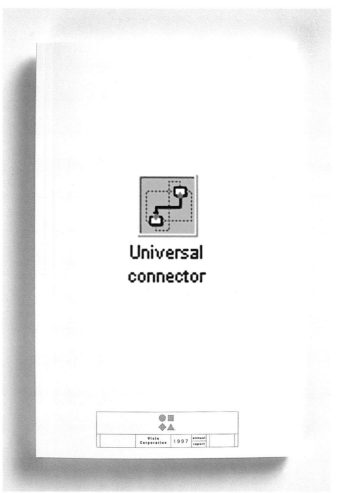

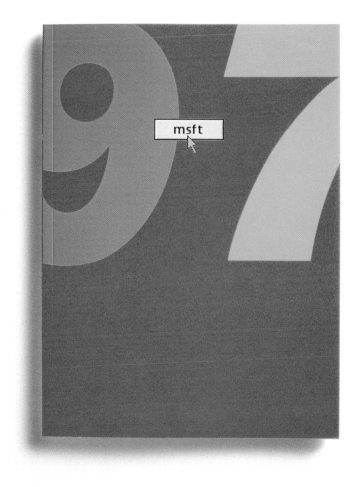

Merit
CORPORATE & PROMOTIONAL DESIGN,
ANNUAL REPORT
msft, 1997

ART DIRECTOR *Kerry Leimer*
CREATIVE DIRECTOR *Kerry Leimer*
COPYWRITER *Kerry Leimer*
DESIGNER *Kerry Leimer*
PHOTOGRAPHER *Jeff Corwin*
STUDIO *Leimer Cross Design*
CLIENT *Microsoft Corp.*
COUNTRY *United States*

Merit
CORPORATE & PROMOTIONAL DESIGN,
ANNUAL REPORT
The Evolution Has just Begun, Nintendo, 1997

ART DIRECTOR *Kerry Leimer*
CREATIVE DIRECTOR *Kerry Leimer*
COPYWRITERS *Kerry Leimer, Don Varyu*
DESIGNER *Kerry Leimer*
PHOTOGRAPHER *Tyler Boley*
ILLUSTRATOR *Nintendo EAD*
STUDIO *Leimer Cross Design*
CLIENT *Nintendo Co., Ltd.*
COUNTRY *United States*

Merit
**CORPORATE & PROMOTIONAL DESIGN,
ANNUAL REPORT**
American National Bank, 1996

ART DIRECTOR *Bart Crosby*
CREATIVE DIRECTOR *Carl Wohlt*
COPYWRITER *Renee McKenna (ANB)*
DESIGNER *Carl Wohlt*
PHOTOGRAPHER *Tom Maday*
AGENCY *Crosby Associates Inc.*
CLIENT *American National Bank*
COUNTRY *United States*

Merit
**CORPORATE & PROMOTIONAL DESIGN,
ANNUAL REPORT**
*AMFAR (American Foundation for AIDS
Research), 1996*

ART DIRECTOR *Martin Perrin*
COPYWRITER *AMFAR*
DESIGNER *Martin Perrin*
PHOTOGRAPHER *Graham Macindoe*
STUDIO *Straightline International*
CLIENT *AMFAR (American Foundation for
AIDS Research)*
COUNTRY *United States*

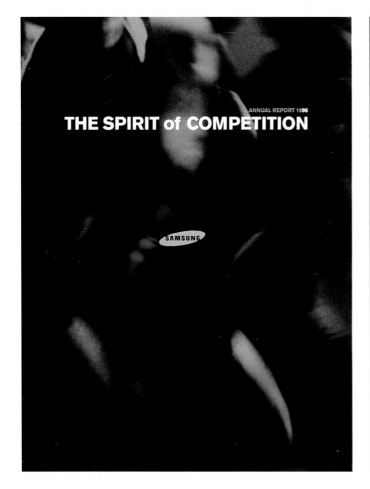

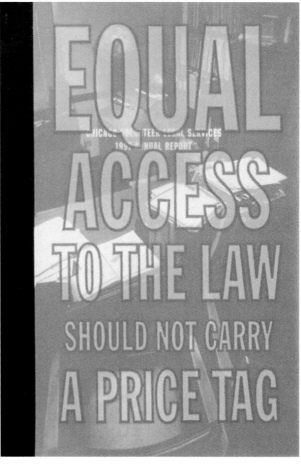

Merit
**CORPORATE & PROMOTIONAL DESIGN,
ANNUAL REPORT**
The Spirit of Competition, Samsung, 1996

ART DIRECTOR *Daniel Koh*
CREATIVE DIRECTORS *Daniel Koh,*
David Stewart
COPYWRITER *Frank J. Oswald*
DESIGNERS *Chris Yun, Christine Wolter,*
Sol Hong, Daniel Koh
PHOTOGRAPHERS *Eric Myer, John Huet*
STUDIO *Addison*
CLIENT *Samsung*
COUNTRY *United States*

Merit
**CORPORATE & PROMOTIONAL DESIGN,
ANNUAL REPORT**
Chicago Volunteer Legal Services, Equal Access
to the Law Should Not Carry a Price Tag, 1997

ART DIRECTOR *Tim Bruce*
COPYWRITERS *M. Lee Witte, Margaret C. Benson*
DESIGNER *Tim Bruce*
PHOTOGRAPHER *Tony Armour*
PRINTER *H. MacDonald*
DESIGN FIRM *Froeter Design Co., Inc.*
CLIENT *Chicago Volunteer Legal Services Foundation*
COUNTRY *United States*

Merit
**CORPORATE & PROMOTIONAL DESIGN,
ANNUAL REPORT**
ICP, 1995 and 1996

ART DIRECTOR *Karinna Hadida*
CREATIVE DIRECTOR *Cheryl Heller*
COPYWRITER *Buzz Hartshorn*
PHOTOGRAPHERS *Various*
PRODUCER *Diana Branski*
PAPER *Warren Strobe*
STUDIO *Siegel & Gale*
CLIENT *International Center of Photography*
COUNTRY *United States*

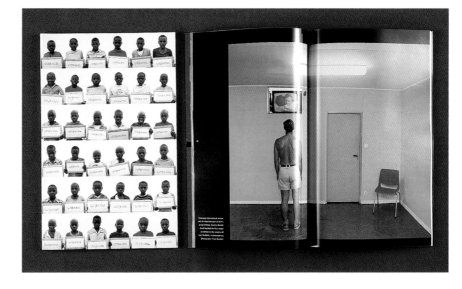

Merit
**CORPORATE & PROMOTIONAL DESIGN,
ANNUAL REPORT**
Picker, 1997

ART DIRECTORS *Mark Murphy, Brian Pristik*
COPYWRITER *Picker International*
DESIGNER *Mark Murphy*
PHOTOGRAPHY *Picker International*
PRINTER *Fortran Printing, Inc.*
AGENCY *Mark Murphy Design*
CLIENT *Picker International, Inc.*
COUNTRY *United States*

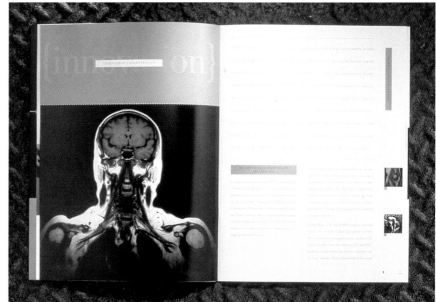

Merit
**CORPORATE & PROMOTIONAL DESIGN,
ANNUAL REPORT**
The Salvation Army, 1997

ART DIRECTOR *Robert Froedge*
CREATIVE DIRECTOR *Cindy Sargent*
COPYWRITER *Cindy Sargent*
DESIGNER *Robert Froedge*
PHOTOGRAPHER *Mark Tucker*
ENGRAVER *GPI*
PRINTER *Lithographics*
STUDIO *Lewis Advertising*
CLIENT *The Salvation Army*
COUNTRY *United States*

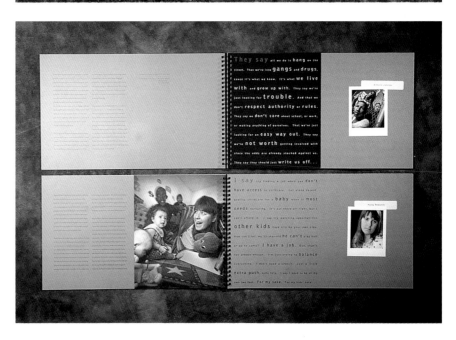

Merit
**CORPORATE & PROMOTIONAL DESIGN,
ANNUAL REPORT**
Penford Corporation, 1997

ART DIRECTOR *Kerry Leimer*
CREATIVE DIRECTOR *Kerry Leimer*
COPYWRITER *Kerry Leimer*
DESIGNER *Kerry Leimer*
PHOTOGRAPHER *Mark Hooper*
PRODUCTION *Rebecca Richards*
STUDIO *Leimer Cross Design*
CLIENT *Penford Corporation*
COUNTRY *United States*

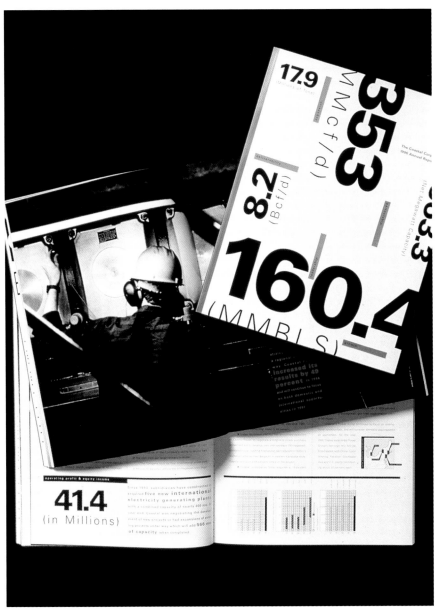

Merit
**CORPORATE & PROMOTIONAL DESIGN,
ANNUAL REPORT**
The Coastal Corporation, 1996

ART DIRECTOR *Mark Geer*
COPYWRITERS *Kim Boetsch, Steve Eames*
DESIGNERS *Mark Geer, Karen Malnar,
Jeffrey W. Savage*
PHOTOGRAPHER *Chris Shinn*
STUDIO *Geer Design, Inc.*
CLIENT *The Coastal Corporation*
COUNTRY *United States*

Merit
**CORPORATE & PROMOTIONAL DESIGN,
ANNUAL REPORT**
Starbucks, 1997

CREATIVE DIRECTORS *Paul Curtin, Rob Price*
COPYWRITERS *Rob Price, Pamela Mason Davey,
Spalding Gray*
DESIGNER *Robert Kastigar*
CALLIGRAPHY *Georgia Deaver*
PHOTOGRAPHY *Karl Petzke, Thomas Heinser,
Francis Wolff, Douglas Christian, Daniel Proctor,
Geof Kern, Scogin Mayo, Michael Baciu,
Hunter Freeman, Holly Stewart, Photonica*
ILLUSTRATION *R. Kenton Nelson, Giselle Potter,
Amy Butler, Ed Fotheringham, Michael Schwab*
PRODUCERS *Jim King, Hilary Bond Read*
AGENCY *Goodby, Silverstein & Partners*
CLIENT *Starbucks*
COUNTRY *United States*

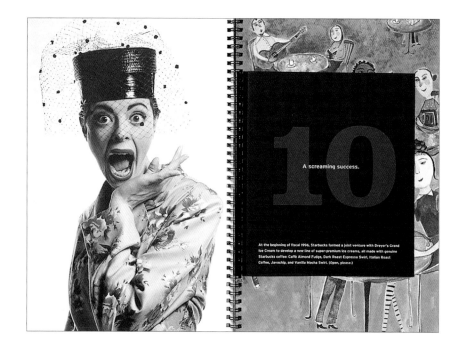

Merit
**CORPORATE & PROMOTIONAL DESIGN,
ANNUAL REPORT**
1997 Was a Great Year. OK. And We're Not Done Yet!

ART DIRECTOR *Stephen Frykholm*
CREATIVE DIRECTOR *Stephen Frykholm*
COPYWRITERS *Clark Malcolm, Jack Schreur*
DESIGNERS *Stephen Frykholm, Yang Kim*
PHOTOGRAPHER *Bill Gallery*
PRODUCTION *Marlene Capotosto*
PRINTER *The Etheridge Company*
CLIENT *Herman Miller Inc.*
COUNTRY *United States*

Merit
**CORPORATE & PROMOTIONAL DESIGN,
ANNUAL REPORT**
The George Gund Foundation, 1996

ART DIRECTOR *Mark Schwartz*
CREATIVE DIRECTOR *Mark Schwartz*
COPYWRITERS *David Bergholz, Deena Epstein*
DESIGNER *Michelle Moehler*
PHOTOGRAPHER *Gregory Conniff*
PRINTER *Fortran Printing, Inc.*
AGENCY *Nesnadny + Schwartz*
CLIENT *The George Gund Foundation*
COUNTRY *United States*

Merit
CORPORATE & PROMOTIONAL DESIGN,
ANNUAL REPORT
These Are the Ground Rules, 1996

ART DIRECTOR *Kerry Leimer*
CREATIVE DIRECTOR *Kerry Leimer*
COPYWRITER *Kerry Leimer*
DESIGNERS *Kerry Leimer, Marianne Li*
PHOTOGRAPHER *Tyler Boley*
STUDIO *Leimer Cross Design*
CLIENT *Expeditors International of Washington, Inc.*
COUNTRY *United States*

Merit
CORPORATE & PROMOTIONAL DESIGN,
ANNUAL REPORT
Interphase Corporation, 1996

ART DIRECTOR *Kevin Bailey*
CREATIVE DIRECTOR *Ron Sullivan*
COPYWRITER *Meltzer & Martin*
DESIGNER *Kevin Bailey*
PHOTOGRAPHER *Gerry Kano*
ILLUSTRATOR *Kevin Bailey*
AGENCY *Sullivan Perkins*
CLIENT *Interphase Corporation*
COUNTRY *United States*

Merit
**CORPORATE & PROMOTIONAL DESIGN,
ANNUAL REPORT**
PMSC, 1996

ART DIRECTOR *Barry Townsend*
CREATIVE DIRECTOR *Barry Townsend*
COPYWRITERS *Tom Poland, Dennis Quick*
DESIGNER *Barry Townsend*
PHOTOGRAPHER *George Fulton*
STUDIO *PMSC*
CLIENT *PMSC*
COUNTRY *United States*

Merit
CORPORATE & PROMOTIONAL DESIGN,
BOOKLET/BROCHURE, SERIES
Mohawk Paper Campaign

ART DIRECTOR *Lana Rigsby*
COPYWRITER *Joann Stone*
DESIGNERS *Thomas Hull, Amy Wolpert, Jerod Dame*
ILLUSTRATORS *Amy Butler, Thomas Hull,*
Andy Dearwater
STUDIO *Rigsby Design*
CLIENT *Mohawk Paper Mills*
COUNTRY *United States*

Merit
CORPORATE & PROMOTIONAL DESIGN,
BOOKLET/BROCHURE
Mine™ Book

ART DIRECTORS *Joshua Berger, Niko Courtelis,*
Pete McCracken
COPYWRITERS *Joshua Berger, Niko Courtelis,*
Yariv Rabinovitch
CONTRIBUTING DESIGNERS *Joshua Berger,*
Niko Courtelis, Pete McCracken, Riq Mosqueda,
Marcus Burlile, Scott Clum, Denise Gonzales Crisp,
Greg Maffei, Carlos Segura, Smokebomb Studios,
Martin Venezky
AGENCY *Plazm Media*
STUDIO *Plazm Design*
CLIENT *Champion International Paper*
COUNTRY *United States*

Merit

**CORPORATE & PROMOTIONAL DESIGN,
BOOKLET/BROCHURE**

Louis Dreyfus Energy

CREATIVE DIRECTOR *Tom Wood*
COPYWRITER *Mary Anne Costello*
DESIGNERS *Tom Wood, Alyssa Weinstein*
PHOTOGRAPHER *Jeff Corwin*
ILLUSTRATOR *Tom Wood*
STUDIO *Wood Design*
CLIENT *Louis Dreyfus Energy*
COUNTRY *United States*

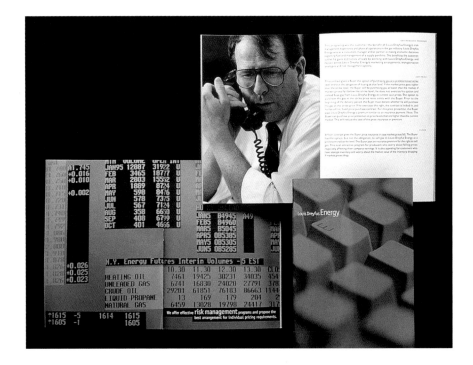

Merit

**CORPORATE & PROMOTIONAL DESIGN,
BOOKLET/BROCHURE**

Portfolio Center Catalog

ART DIRECTOR *Mary Anne Ritter*
CREATIVE DIRECTOR *Gemma Gatti*
COPYWRITER *Sally Hogshead*
DESIGNER *James Victore*
PHOTOGRAPHERS *Tom Schierlitz, Prentiss Theus*
ILLUSTRATOR *James Victore*
STUDIO *James Victore Inc.*
CLIENT *Portfolio Center*
COUNTRY *United States*

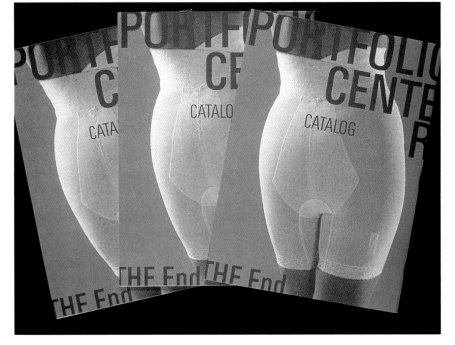

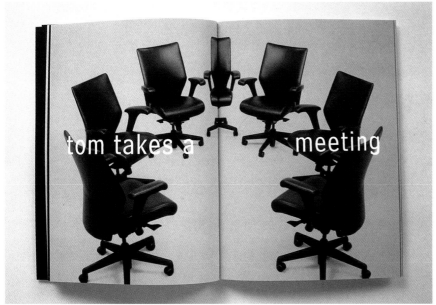

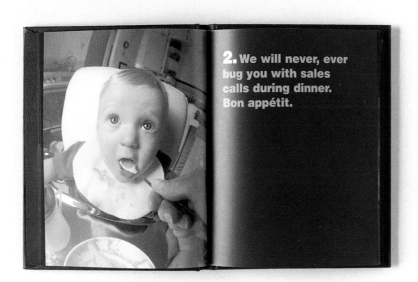

Merit
CORPORATE & PROMOTIONAL DESIGN, BROCHURE
Tom

ART DIRECTORS *John Pylypczak, Diti Katona*
COPYWRITERS *John Pylypczak, Diti Katona*
DESIGNER *John Pylypczak*
PHOTOGRAPHER *Karen Levy*
STUDIO *Concrete Design Communications Inc.*
CLIENT *Keilhauer Industries Ltd.*
COUNTRY *Canada*

Merit
CORPORATE & PROMOTIONAL DESIGN, BOOKLET/BROCHURE
Southwest Bell–Promise Book

CREATIVE DIRECTORS *Paul Curtin, Rob Price*
COPYWRITER *Paul Venebles*
DESIGNER *Peter Locke*
PHOTOGRAPHER *Heimo*
PRODUCER *Michelle Lee*
AGENCY *Goodby Silverstein & Partners*
CLIENT *Southwestern Bell*
COUNTRY *United States*

Merit

**CORPORATE & PROMOTIONAL DESIGN,
BOOKLET/BROCHURE**

*Personal Voice: The Ruth and Robert Vogele Collection
of Self-Taught Art*

ART DIRECTOR *Robert Vogele*
CREATIVE DIRECTOR *Ken Fox*
COPYWRITERS *Ruth & Robert Vogele,
Russel Bowman, Maarten Van De Guchte*
DESIGNERS *Ken Fox, Fletcher Martin*
PHOTOGRAPHERS *Greg Gent, Bart Witowski*
ILLUSTRATOR *William Blackmon (cover)*
STUDIO *VSA Partners, Inc.*
CLIENT *The Ruth & Robert Vogele Collection*
COUNTRY *United States*

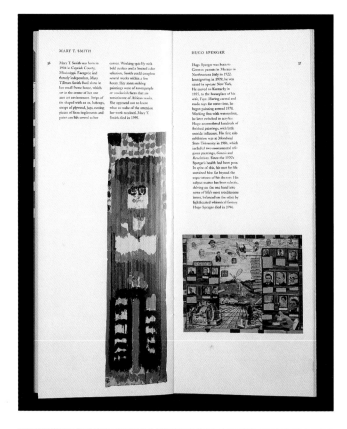

Merit

**CORPORATE & PROMOTIONAL DESIGN,
BOOKLET/BROCHURE**

Takashimaya Volume #5

ART DIRECTOR *Allison Muench Williams*
CREATIVE DIRECTORS *Allison Muench Williams,
J. Phillips Williams*
COPYWRITER *Laura Silverman*
DESIGNERS *Allison Muench Williams, Ariel Apte*
PHOTOGRAPHER *Maria Robledo*
STUDIO *Design: M/W*
CLIENT *Takashimaya New York*
COUNTRY *United States*

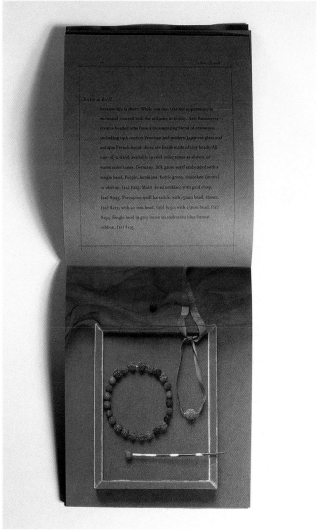

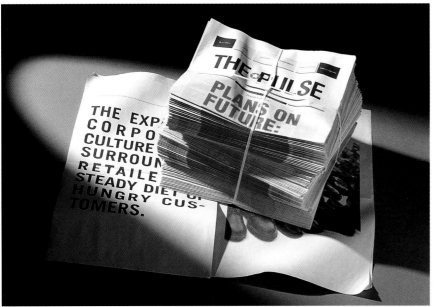

Merit
**CORPORATE & PROMOTIONAL DESIGN,
BOOKLET/BROCHURE**
The Pulse

CREATIVE DIRECTOR *Bill Thorburn*
COPYWRITER *Michael Cronin*
DESIGNER *David Schrimpf*
PHOTOGRAPHY *Chuck Smith Photography*
AGENCY *Carmichael Lynch Thorburn*
CLIENT *Downtown Council of Minneapolis*
COUNTRY *United States*

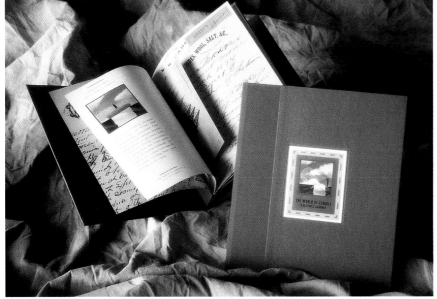

Merit
**CORPORATE & PROMOTIONAL DESIGN,
BOOKLET/BROCHURE**
Cargill Vision Book

ART DIRECTOR *Cyndi Welch*
CREATIVE DIRECTOR *Pat Ludowese Ray*
COPYWRITER *Pat Ludowese Ray*
DESIGNER *Cyndi Welch*
ILLUSTRATOR *Greg Hally*
AGENCY *Miller Meester Advertising*
CLIENT *Cargill Hybrid Seeds*
COUNTRY *United States*

Merit
**CORPORATE & PROMOTIONAL DESIGN,
BOOKLET/BROCHURE**
The Essentials: The Potlatch Annual Report Show, 1997

ART DIRECTOR *Mary Moegenburg*
CREATIVE DIRECTOR *Dana Arnett*
COPYWRITER *Andy Blankenburg*
DESIGNER *Jason Eplawy*
PHOTOGRAPHERS *Bill Phelps, Bart Witowski*
STUDIO *VSA Partners, Inc.*
CLIENT *Potlatch Corporation*
COUNTRY *United States*

Merit
**CORPORATE & PROMOTIONAL DESIGN,
BOOKLET/BROCHURE**
Champion Choices

CREATIVE DIRECTORS *J. Phillips Williams,
Allison Muench Williams*
DESIGNERS *Allison Muench Williams, Ariel Apte*
STUDIO *Design: M/W*
CLIENT *Champion International Paper*
COUNTRY *United States*

Merit
**CORPORATE & PROMOTIONAL DESIGN,
BOOKLET/BROCHURE**
Eagles Eye, A New Perspective

ART DIRECTOR *Bridget de Socio*
CREATIVE DIRECTOR *Deborah Moses*
DESIGNER *Albert Lin*
PHOTOGRAPHER *Ruven Afanador*
DIGITAL IMAGER *Ninja V. Oertzen*
STUDIO *Socio X*
CLIENT *Eagles Eye*
COUNTRY *United States*

Merit
**CORPORATE & PROMOTIONAL DESIGN,
BOOKLET/BROCHURE**
WITS (Working In The Schools)

ART DIRECTOR *Greg Samata*
COPYWRITERS *Fred Krol, Julie Thompson*
DESIGNER *Kevin Krueger*
PHOTOGRAPHERS *Sandro (portraits),
Martha Brock (snapshots)*
ILLUSTRATORS *Kids*
STUDIO *SamataMason*
CLIENT *WITS*
COUNTRY *United States*

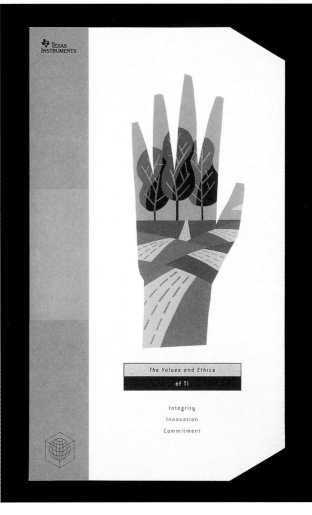

Merit
**CORPORATE & PROMOTIONAL DESIGN,
BOOKLET/BROCHURE**
Crane Business Paper Specifier

ART DIRECTORS *J. Phillips Williams,
Allison Muench Williams*
CREATIVE DIRECTOR *J. Phillips Williams*
DESIGNERS *J. Phillips Williams,
Allison Muench Williams*
ILLUSTRATOR *Peter Phong*
STUDIO *Design: M/W*
CLIENT *Crane Business Papers*
COUNTRY *United States*

Merit
**CORPORATE & PROMOTIONAL DESIGN,
BOOKLET/BROCHURE**
The Values and Ethics of Texas Instruments

ART DIRECTOR *Bryan L. Peterson*
COPYWRITERS *Glenn Coleman, Carl Skooglund*
DESIGNER *Bryan L. Peterson*
ILLUSTRATOR *Craig Frazier*
STUDIO *Peterson & Company*
CLIENT *Texas Instruments*
COUNTRY *United States*

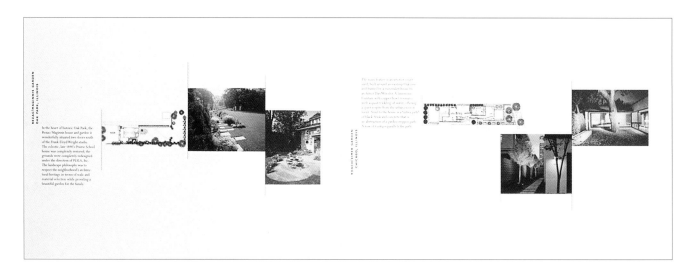

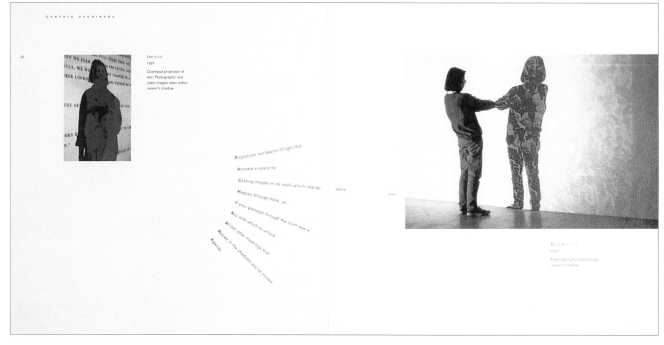

(top)
Merit
**CORPORATE & PROMOTIONAL DESIGN,
BOOKLET/BROCHURE**
Schaudt Landscape Architecture

ART DIRECTOR *Renate Gokl*
COPYWRITER *Peter Lindsay Schaudt*
DESIGNER *Renate Gokl*
PHOTOGRAPHERS *Various*
STUDIO *Renate Gokl*
CLIENT *Peter Lindsay Schaudt Landscape Architecture*
COUNTRY *United States*

(bottom)
Merit
**CORPORATE & PROMOTIONAL DESIGN,
BOOKLET/BROCHURE**
Positions Available

ART DIRECTOR *John V. Clarke*
COPYWRITERS *Mary Antonakos, Jonathan Fineberg,*
Buzz Spector
DESIGNER *John V. Clarke*
PHOTOGRAPHERS *John V. Clarke, various*
STUDIO *Clarke Communication Design*
CLIENT *School of Art and Design/I space Gallery,*
University of Illinois at Urbana-Champaign
COUNTRY *United States*

Merit
**CORPORATE & PROMOTIONAL DESIGN,
BOOKLET/BROCHURE**
Nicolas Africano/Two Sisters

ART DIRECTOR *Kerry Leimer*
CREATIVE DIRECTOR *Kerry Leimer*
COPYWRITER *Lisa Lyons*
DESIGNER *Kerry Leimer*
PHOTOGRAPHERS *Spike Mafford, Arthur Aubrey,
Eduardo Calderon*
STUDIO *Leimer Cross Design*
CLIENT *Myerson & Nowinski*
COUNTRY *United States*

Teens get their spending money in all kinds of ways.
Some of it comes from their parents on an as-needed
basis or a regular allowance. Nearly a third of all
teens earn their own cash from part-time or full-time
jobs. An even larger number do odd jobs like babysit-
ting or mowing lawns. An entrepreneurial fraction
even own their own businesses!
These independent sources of income become
increasingly important as teens move through the
demographic.

HOW TEENS OBTAIN SPENDING MONEY

FROM PARENTS — 55.4% / 46.1%
GIFTS — 50.7% / 49.2%
ODD JOBS — 43.6% / 27.3%
PART-TIME JOB — 10.5% / 34.0%
FULL-TIME JOB — 1.4% / 7.4%
OWN BUSINESS — 1.4% / 1.8%

TEENS 12-14
TEENS 15-17

teen CA$H

Merit
**CORPORATE & PROMOTIONAL DESIGN,
BOOKLET/BROCHURE**
Teen Fact Book

ART DIRECTOR *Cheri Dorr*
CREATIVE DIRECTOR *Sean O'Connor*
COPYWRITER *Sharon Glassman*
ILLUSTRATOR *David High*
STUDIO *Channel One Network*
CLIENT *Channel One Network*
COUNTRY *United States*

Merit
**CORPORATE & PROMOTIONAL DESIGN,
BOOKLET/BROCHURE**
Mohawk Mother Goose

ART DIRECTOR *Sharon Werner*
CREATIVE DIRECTORS *Beth Povie,*
Laura Shore (Mohawk Paper)
COPYWRITERS *Jeff Mueller, various*
DESIGNERS *Sharon Werner, Sarah Nelson*
ILLUSTRATORS *Sharon Werner, Sarah Nelson*
PHOTOGRAPHER *Darrell Eager*
PRINTING *Heartland Graphics*
STUDIO *Werner Design Werks, Inc.*
CLIENT *Mohawk Paper*
COUNTRY *United States*

Merit
**CORPORATE & PROMOTIONAL DESIGN,
BOOKLET/BROCHURE**
Evolution–A Mobile Lifestyle

ART DIRECTOR *Michael Daiminger*
DESIGNER *Michael Daiminger*
COPYWRITER *Stephan Oberacher*
(Arc-en-ciel, Werbeagentur GmbH)
PHOTOGRAPHER *Christoph Hellhacke*
(Studio Hellhacke)
AGENCY *Arc-en-ciel, Werbeagentur GmbH*
STUDIO *Infrarot GmbH*
CLIENT *Dreier Küchen Werk*
COUNTRY *Germany*

Merit
**CORPORATE & PROMOTIONAL DESIGN,
BOOKLET/BROCHURE**
Goldens Bridge

CREATIVE DIRECTOR *Tom Wood*
COPYWRITER *Mary Anne Costello*
DESIGNERS *Tom Wood, Alyssa Weinstein*
PHOTOGRAPHER *Todd Flashner*
ILLUSTRATOR *Clint Bottoni*
STUDIO *Wood Design*
CLIENT *Louis Dreyfus Property Group*
COUNTRY *United States*

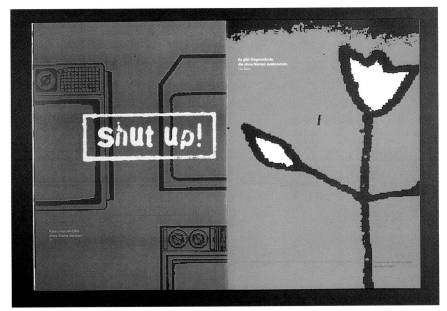

Merit
**CORPORATE & PROMOTIONAL DESIGN,
BOOKLET/BROCHURE**
Speak

ART DIRECTOR *Anna Berkenbusch*
CREATIVE DIRECTOR *Anna Berkenbusch*
COPYWRITERS *Lisa Eidt, Beate Diergardt,
Anna Berkenbusch*
DESIGNERS *Lisa Eidt, Beate Diergardt,
Roberta Hermanns, Gaby Baltha*
AGENCIES *Universität GH Essen, Fb4,
Kommunikationsdesign*
COUNTRY *Germany*

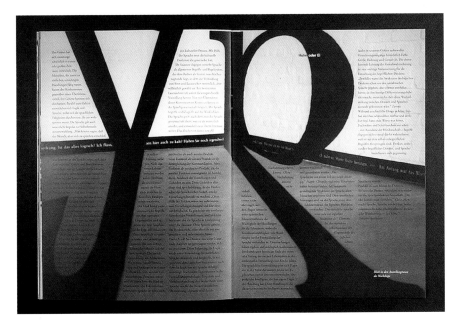

Merit
**CORPORATE & PROMOTIONAL DESIGN,
BOOKLET/BROCHURE**
Klein Catalog

ART DIRECTOR *Bill Cahan*
CREATIVE DIRECTOR *Bill Cahan*
COPYWRITER *Lisa Jhung*
DESIGNER *Bob Dinetz*
PHOTOGRAPHER *Robert Schlatter*
ILLUSTRATOR *Bob Dinetz*
STUDIO *Cahan & Associates*
CLIENT *Trek Bicycle Corporation*
COUNTRY *United States*

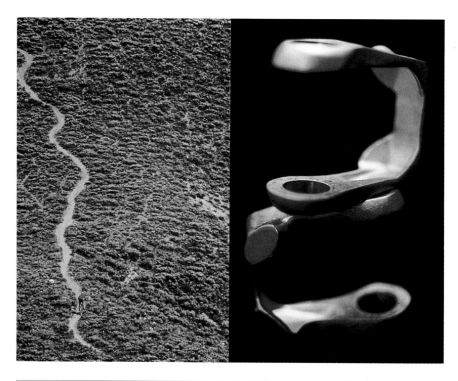

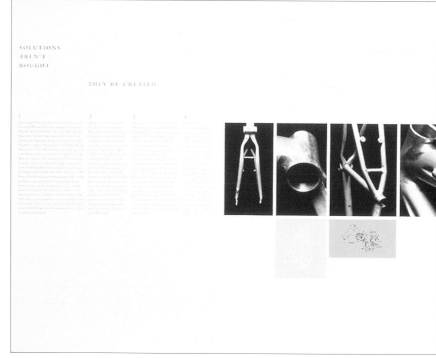

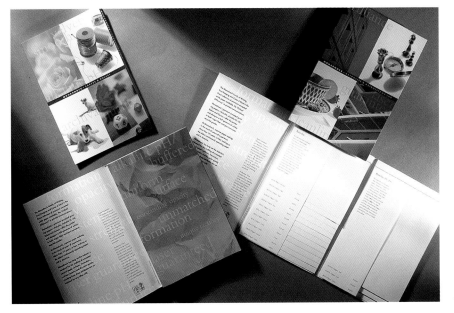

Merit
CORPORATE & PROMOTIONAL DESIGN,
LEAFLET OR FOLDER, SERIES
Monadnock Astrolite • Astrolite PC 100 & Caress •
Ducet Swatch Books

ART DIRECTOR *Tom Geismar*
COPYWRITER *Monadnock Paper Mills*
DESIGNER *Cathy Rediehs Schaefer*
PHOTOGRAPHY *David Arky, Elsa Chabaud,*
various stock
DESIGN FIRM *Chermayeff & Geismar Inc.*
CLIENT *Monadnock Paper Mills*
COUNTRY *United States*

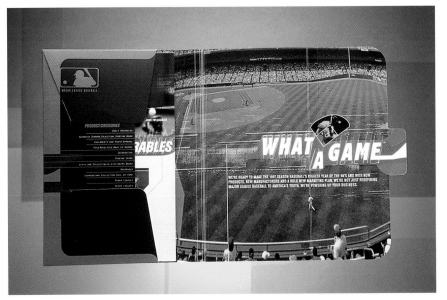

Merit
CORPORATE & PROMOTIONAL DESIGN,
LEAFLET OR FOLDER
Major League Baseball Kit

ART DIRECTOR *Steve Farrar*
CREATIVE DIRECTOR *Michael Jager*
DESIGNERS *Shannon Bradley, Kirk James,*
Jeff Rooney
STUDIO *Jager DiPaola Kemp Design*
CLIENT *Major League Baseball*
COUNTRY *United States*

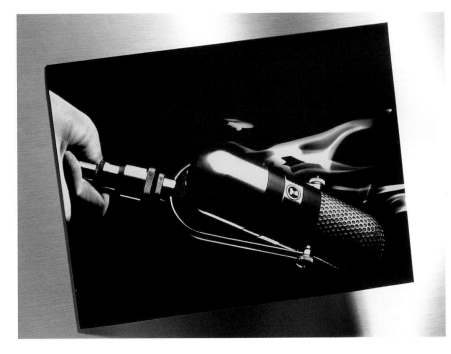

Merit
CORPORATE & PROMOTIONAL DESIGN,
FOLDER
VH1 Press Folder

ART DIRECTOR *Dean Lubensky*
DESIGNER *Kevin Grady (Elastic Design)*
STUDIO *MTV/VH1*
CLIENT *VH1*
COUNTRY *United States*

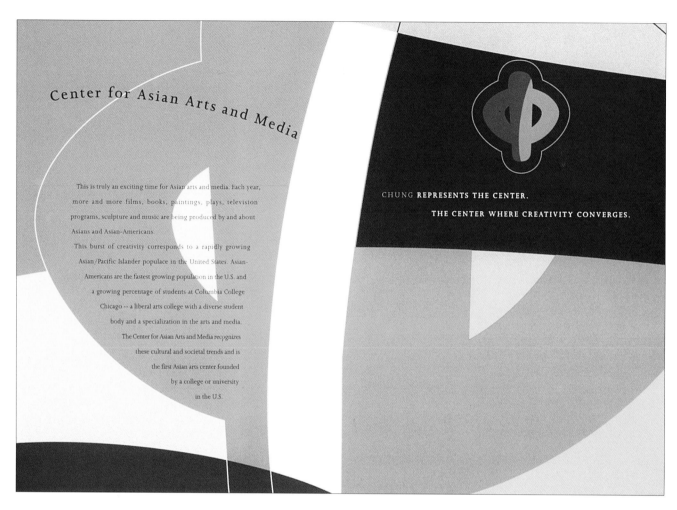

Merit
**CORPORATE & PROMOTIONAL DESIGN,
LEAFLET**
Center for Asian Arts and Media Flyer

ART DIRECTOR *Anthony Ma*
COPYWRITER *Oliver Ramsey*
DESIGNER *Anthony Ma*
ILLUSTRATOR *Anthony Ma*
STUDIO *Tanagram, Inc.*
CLIENT *Center for Asian Arts and Media*
COUNTRY *United States*

Merit
**CORPORATE & PROMOTIONAL DESIGN,
FOLDER**
TAXI Kit Folder

ART DIRECTOR *Nathalie Cusson*
CREATIVE DIRECTOR *Jane Hope*
DESIGNER *Nathalie Cusson*
PHOTOGRAPHER *Colin Faulkner*
PRODUCER *Peter Pigeon*
AGENCY *TAXI*
CLIENT *TAXI*
COUNTRY *Canada*

Merit
**CORPORATE & PROMOTIONAL DESIGN,
FOLDER**
Luminex

ART DIRECTOR *John May*
CREATIVE DIRECTOR *Douglas May*
COPYWRITER *Ann Buser*
DESIGNER *John May*
PHOTOGRAPHERS *Various*
ILLUSTRATOR *John May*
AGENCY *May & Co.*
CLIENT *Luminex Corporation*
COUNTRY *United States*

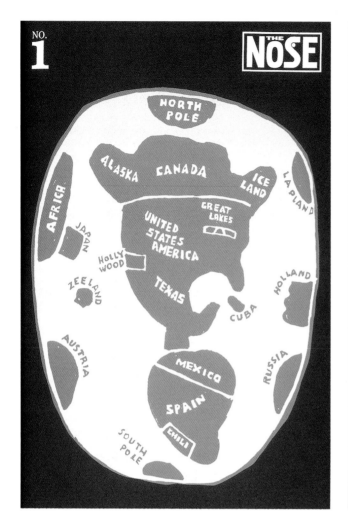

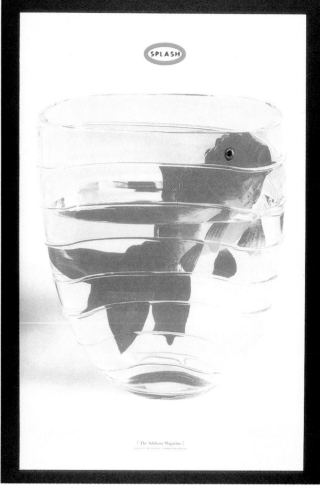

Merit
**CORPORATE & PROMOTIONAL DESIGN,
NEWSLETTER, HOUSE PUBLICATION**
The Nose

DESIGNERS *Seymour Chwast, Steven Brower,
James Victore*
ILLUSTRATOR *Seymour Chwast*
EDITOR *D.K. Holland*
STUDIO *The Pushpin Group*
CLIENT *The Pushpin Group*
COUNTRY *United States*

Merit
**CORPORATE & PROMOTIONAL DESIGN,
NEWSLETTER**
Splash

ART DIRECTOR *David Kohler*
CREATIVE DIRECTOR *Victor Rivera*
COPYWRITER *Judy Kalvin*
DESIGNERS *Anna Tan, Brian Cunningham,
Chris Yun, Christian Luis, Christine Wolter,
Cindy Goldstein, Daniel Koh, David Kohler,
Paul Sternglass, Richard Colbourne, Sol Hong,
Victor Rivera*
PHOTOGRAPHERS *Jody Dole, William Vazquez*
ILLUSTRATOR *Chris Yun*
STUDIO *Addison*
CLIENT *Addison*
COUNTRY *United States*

Merit
**CORPORATE & PROMOTIONAL DESIGN,
NEWSLETTER, JOURNAL**
Letter

ART DIRECTOR *Shinya Nojima*
CREATIVE DIRECTORS *Shinya Nojima, Kyoko Takao*
COPYWRITER *Kyoko Takao*
DESIGNER *Shinya Nojima*
PHOTOGRAPHERS *Noriko Matsunaga, Shigeki Simizu*
AGENCY *ATA Co., Ltd.*
CLIENT *The Hilton Plaza*
COUNTRY *Japan*

Merit
**CORPORATE & PROMOTIONAL DESIGN,
NEWSLETTER, SERIES**
Gallagher Bassett Advantage Newsletter

ART DIRECTOR *Pat Samata*
COPYWRITERS *Tracy Mock, Colleen Saubier*
DESIGNER *Kevin Krueger*
PHOTOGRAPHER *Kevin Krueger*
STUDIO *SamataMason*
CLIENT *Gallagher Bassett Services, Inc.*
COUNTRY *United States*

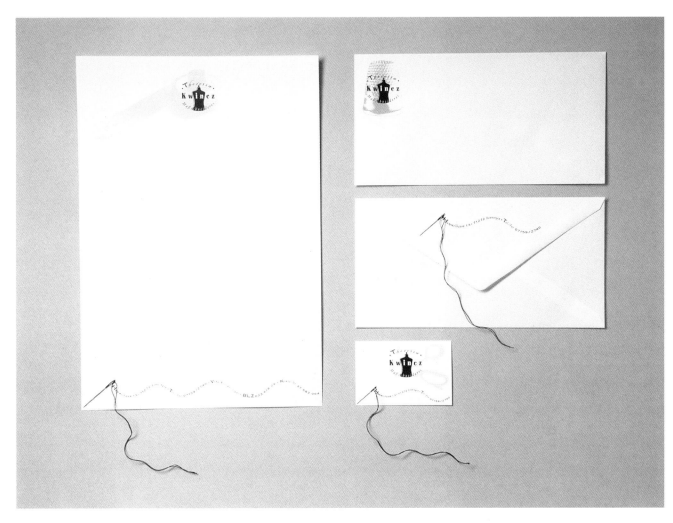

(facing page, top)
Merit
**CORPORATE & PROMOTIONAL DESIGN,
ENTERTAINMENT/SPECIAL EVENTS PROGRAM**
*Council of Fashion Designers of America
Awards Journal, 1996*

PRINCIPAL/DESIGNER *Michael Bierut*
DESIGNERS *Michael Bierut, Lisa Anderson*
STUDIO *Pentagram Design*
CLIENT *Council of Fashion Designers of America*
COUNTRY *United States*

(facing page, bottom)
Merit
**CORPORATE & PROMOTIONAL DESIGN,
ENTERTAINMENT/SPECIAL EVENTS PROGRAM**
Movie Awards Program Guide

ART DIRECTOR *Tracy Boychuk*
CREATIVE DIRECTOR *Jeffrey Keyton*
COPYWRITER *Tara Sutton*
DESIGNER *Tracy Boychuk*
PHOTOGRAPHER *Andrew Moore*
STUDIO *MTV*
CLIENT *MTV*
COUNTRY *United States*

Merit
**CORPORATE & PROMOTIONAL DESIGN,
CORPORATE IDENTITY STANDARDS MANUAL**
Der Faden zieht sich durch (On the Right Track)

ART DIRECTOR *Reiner Hebe*
CREATIVE DIRECTOR *Reiner Hebe*
COPYWRITER *Reiner Hebe*
DESIGNERS *Anda Manea, Britta Moarefi*
PRODUCER *Edith Hebe*
AGENCY *HEBE Werbung & Design*
CLIENT *Theresia Kwincz*
COUNTRY *Germany*

MULTIPLE AWARDS

Merit
**CORPORATE & PROMOTIONAL DESIGN,
CORPORATE IDENTITY PROGRAM, SERIES**

and Merit
**CORPORATE & PROMOTIONAL DESIGN,
STATIONARY: LETTERHEAD, BUSINESS CARD,
ENVELOPE**
Scott Co.

CREATIVE DIRECTOR *Bill Thorburn*
DESIGNER *David Schrimpf*
COMPUTER ARTIST *Phil Kjelland*
AGENCY *Carmichael Lynch Thorburn*
CLIENT *Scott Co.*
COUNTRY *United States*

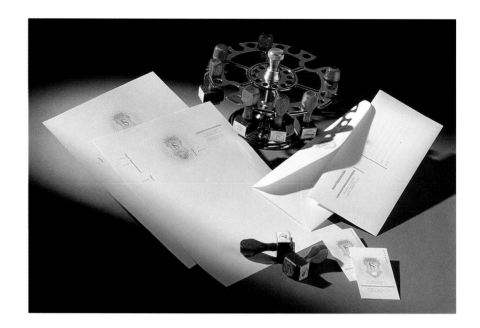

MULTIPLE AWARDS

Merit
**CORPORATE & PROMOTIONAL DESIGN,
CORPORATE IDENTITY PROGRAM, SERIES**

and Merit
**CORPORATE & PROMOTIONAL DESIGN,
STATIONERY: LETTERHEAD, BUSINESS CARD,
ENVELOPE**
Carmichael Lynch Thorburn

CREATIVE DIRECTOR *Bill Thorburn*
DESIGNER *Chad Hagen*
ILLUSTRATORS *Chad Hagen, David Schrimpf*
AGENCY *Carmichael Lynch Thorburn*
CLIENT *Carmichael Lynch Thorburn*
COUNTRY *United States*

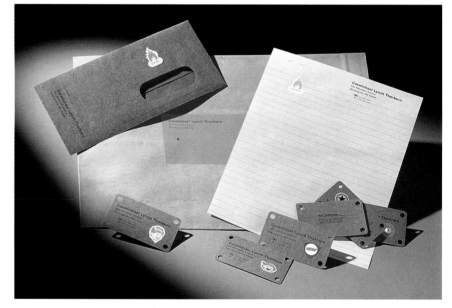

Merit
**CORPORATE & PROMOTIONAL DESIGN,
CORPORATE IDENTITY PROGRAM, SERIES**
Work

ART DIRECTOR *Cabell Harris*
CREATIVE DIRECTOR *Cabell Harris*
COPYWRITERS *Joe Nagy, Tom Gibson*
DESIGNERS *Paul Howalt, Tom Gibson,
Howard Brown, Mike Calkins*
AGENCY *Work*
CLIENT *Work*
COUNTRY *United States*

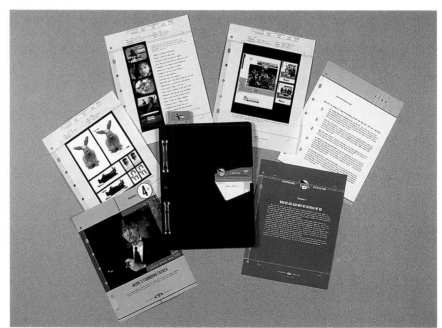

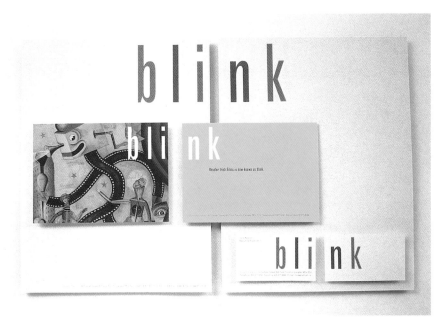

Merit

**CORPORATE & PROMOTIONAL DESIGN,
CORPORATE IDENTITY PROGRAM, SERIES**
Blink Stationery

ART DIRECTORS *John Pylypczak, Diti Katona*
DESIGNERS *John Pylypczak, Diti Katona,
Dana Samuel*
ILLUSTRATOR *Christian Northeast*
STUDIO *Concrete Design Communications Inc.*
CLIENT *Blink Pictures*
COUNTRY *Canada*

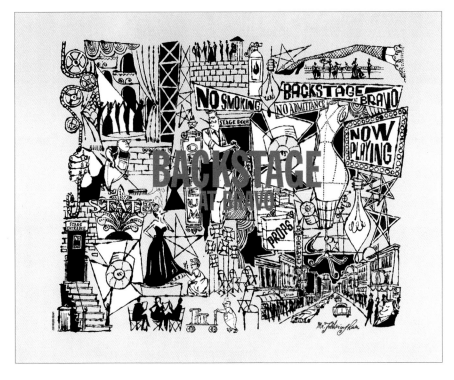

Merit

**CORPORATE & PROMOTIONAL DESIGN,
CORPORATE IDENTITY PROGRAM**
Backstage at Bravo

CREATIVE DIRECTOR *Bill Thorburn*
DESIGNER *David Schrimpf*
ILLUSTRATOR *Ed Fotheringham*
AGENCY *Carmichael Lynch Thorburn*
CLIENT *Backstage at Bravo*
COUNTRY *United States*

Merit
**CORPORATE & PROMOTIONAL DESIGN,
STATIONERY: LETTERHEAD, BUSINESS CARD,
ENVELOPE**
Genesis

ART DIRECTOR *James Wai Mo Leung*
CREATIVE DIRECTOR *James Wai Mo Leung*
DESIGNER *James Wai Mo Leung*
COPYWRITERS *James Wai Mo Leung, Teddy Lam,*
Marcus Yung
STUDIO *Genesis Advertising Company*
CLIENT *Genesis Advertising Company*
COUNTRY *Hong Kong, China*

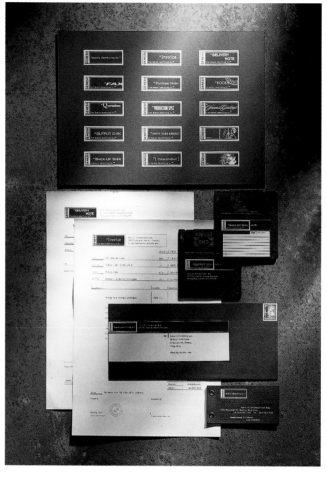

Merit
**CORPORATE & PROMOTIONAL DESIGN,
STATIONERY: LETTERHEAD, BUSINESS CARD,
ENVELOPE**
Nellie's Originals

ART DIRECTOR *Robert Froedge*
DESIGNER *Robert Froedge*
PRINTER/ENGRAVER *Lithographics*
AGENCY *Lewis Advertising*
CLIENT *Nellie Froedge*
COUNTRY *United States*

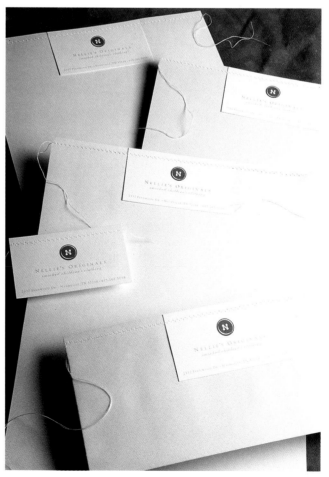

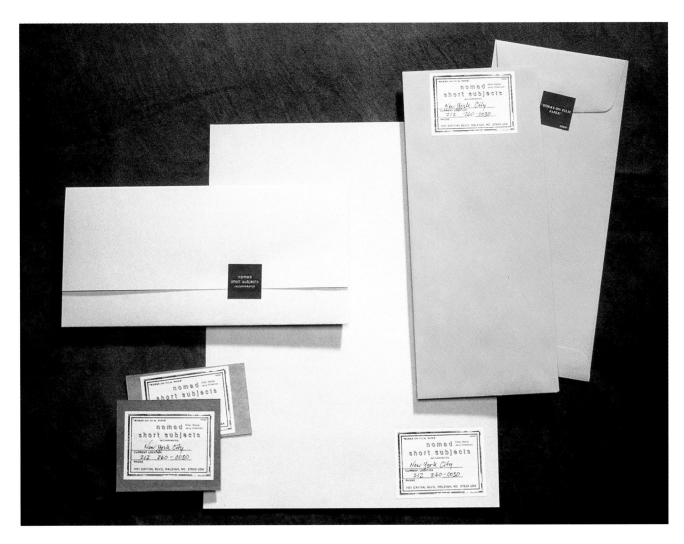

Merit
**CORPORATE & PROMOTIONAL DESIGN,
STATIONERY: LETTERHEAD, BUSINESS CARD,
ENVELOPE**
Nomad Short Subjects

ART DIRECTOR *Patrick Short*
CREATIVE DIRECTOR *Patrick Short*
COPYWRITER *Nomad Short Subjects*
DESIGNERS *Patrick Short, Kristy Beausoleil*
PRODUCER *Joy Crouch*
DESIGN FIRM *BlackBird Creative*
CLIENT *Nomad Short Subjects*
COUNTRY *United States*

Merit
**CORPORATE & PROMOTIONAL DESIGN,
STATIONERY: LETTERHEAD, BUSINESS CARD,
ENVELOPE**
Hairstylist Business Card

CREATIVE DIRECTOR *Pam Patterson*
DESIGNER *Kathleen Sullivan*
PRINTER *Armati Printing*
AGENCY *On Target*
CLIENT *Martina Maina*
COUNTRY *United States*

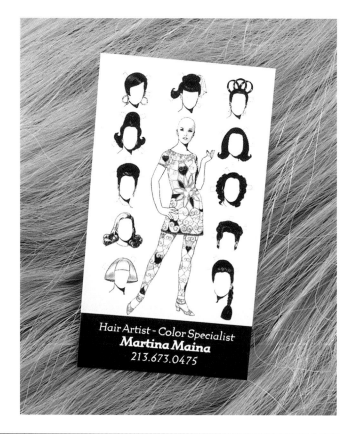

Merit
**CORPORATE & PROMOTIONAL DESIGN,
STATIONERY: LETTERHEAD, BUSINESS CARD,
ENVELOPE**
The Creative Cat Company

ART DIRECTOR *Eric Chan*
CREATIVE DIRECTOR *Eric Chan*
DESIGNERS *Eric Chan, Kelvin Chiu*
ILLUSTRATOR *Kelvin Chiu*
DESIGN FIRM *Eric Chan Design Co. Ltd.*
CLIENT *The Creative Cat Company*
COUNTRY *Hong Kong, China*

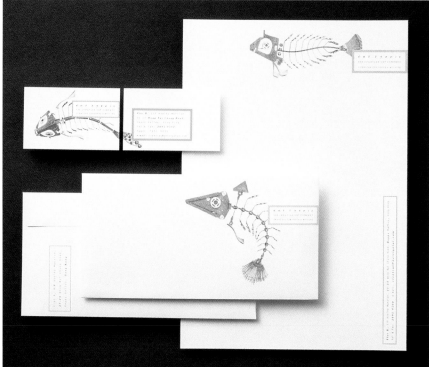

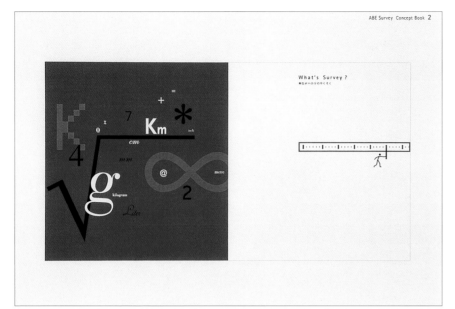

Merit
**CORPORATE & PROMOTIONAL DESIGN,
SPECIAL IDENTITY PROGRAM**
ABE Survey (I)

ART DIRECTOR *Ken Miki*
DIRECTORS *Ken Miki, Junji Osaki,
Shigeyuki Sakaida*
CLIENT *ABE SURVEY*
COUNTRY *Japan*

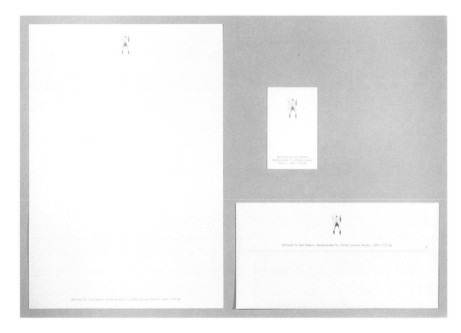

Merit
**CORPORATE & PROMOTIONAL DESIGN,
SPECIAL IDENTITY PROGRAM**
Tooth

ART DIRECTOR *Söhnke Busch*
CREATIVE DIRECTORS *Torsten Rieken, Jan Ritter*
DESIGNER *Heike Saalfrank*
AGENCY *Springer & Jacoby Werbung GmbH*
CLIENT *Dr. Carl Peters, Dentist*
COUNTRY *Germany*

Merit
**CORPORATE & PROMOTIONAL DESIGN,
SPECIAL IDENTITY PROGRAM**
Avant

ART DIRECTOR *Kobe*
CREATIVE DIRECTOR *Joe Duffy*
COPYWRITER *Mark Wirt (brochure)*
DESIGNERS *Kobe, Jason Strong*
ILLUSTRATORS *Kobe, Jason Strong*
PRINTER *Print Craft*
STUDIO *Duffy Design*
CLIENT *Avant*
COUNTRY *United States*

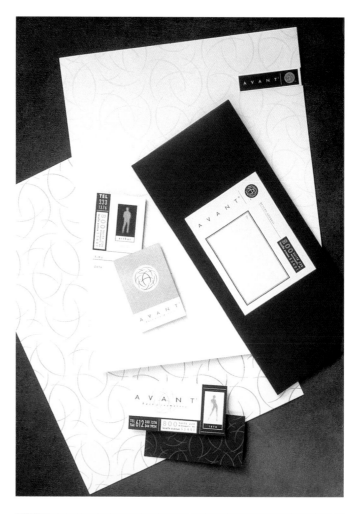

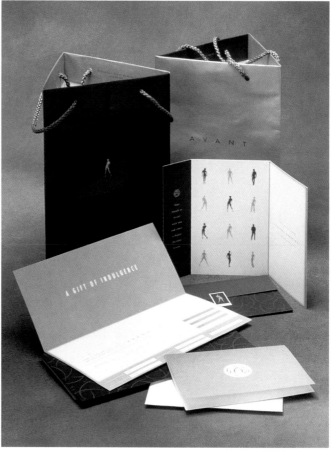

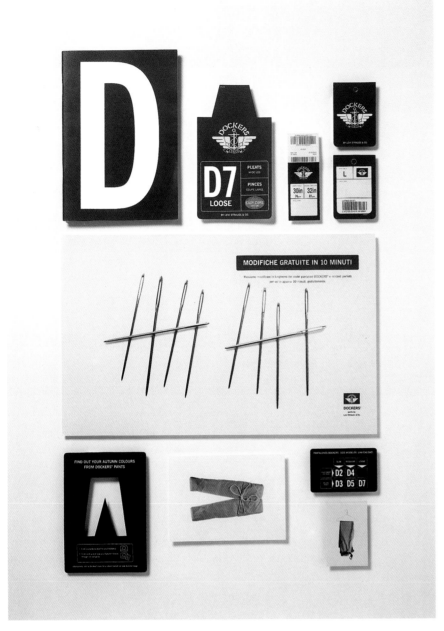

Merit
**CORPORATE & PROMOTIONAL DESIGN,
SPECIAL IDENTITY PROGRAM**
Dockers D-System

ART DIRECTORS *Peter Rae, Roberto D'Andria*
CREATIVE DIRECTOR *Peter Rae*
DESIGNERS *Roberto D'Andria, Mark Lester,
Ian Cockburn*
PHOTOGRAPHER *Mark Mattock*
AGENCY *Tango Design*
CLIENT *Dockers*
COUNTRY *England*

Merit
CORPORATE & PROMOTIONAL DESIGN, LOGO
Showtime

ART DIRECTOR *Ivan Chermayeff*
DESIGNER *Ivan Chermayeff*
DESIGN FIRM *Chermayeff & Geismar Inc.*
CLIENT *Showtime Networks Inc.*
COUNTRY *United States*

Merit
CORPORATE & PROMOTIONAL DESIGN, LOGO
Texas Aerospace

DESIGNER *Patrick Nolan*
ILLUSTRATOR *Patrick Nolan*
AGENCY *GSD&M Advertising*
CLIENT *Texas Department of Economic Development*
COUNTRY *United States*

Merit
CORPORATE & PROMOTIONAL DESIGN, LOGO
Adams Outdoor

ART DIRECTOR *Kevin Wade*
CREATIVE DIRECTOR *Kevin Wade*
DESIGNERS *Martha Graettinger, Kevin Wade*
AGENCY *Planet Design Company*
CLIENT *Adams Outdoor Advertising*
COUNTRY *United States*

Merit
CORPORATE & PROMOTIONAL DESIGN, LOGO
The Perishable Press Limited

ART DIRECTOR *Dana Lytle*
CREATIVE DIRECTOR *Dana Lytle*
DESIGNERS *Jamie Karlin, Dana Lytle*
AGENCY *Planet Design Company*
CLIENT *The Perishable Press Limited*
COUNTRY *United States*

Merit
CORPORATE & PROMOTIONAL DESIGN, LOGO
Junglee

ART DIRECTOR *Gordon Mortensen*
DESIGNERS *Diana Kauzlarich, Gordon Mortensen*
STUDIO *Mortensen Design*
CLIENT *Junglee Corporation*
COUNTRY *United States*

Merit
CORPORATE & PROMOTIONAL DESIGN, LOGO
Talkcity

ART DIRECTORS *Tim Sawyer, Lisa Nielsen*
DESIGNERS *Lisa Nielsen, Tim Sawyer*
ILLUSTRATOR *Lisa Nielsen*
STUDIO *LMN Design/Hogan Communications*
CLIENT *Talkcity*
COUNTRY *United States*

Merit
**CORPORATE & PROMOTIONAL DESIGN,
LOGO OR TRADEMARK**
IndyMac Identity

CREATIVE DIRECTOR *Gary Baker*
DESIGNERS *Michelle Wolins, Louis D'Esposito*
STUDIO *Baker Design Associates*
CLIENT *IndyMac & Affiliates*
COUNTRY *United States*

Merit
CORPORATE & PROMOTIONAL DESIGN, LOGO
GROWS Literacy Council

CREATIVE DIRECTOR *Joe Krawczyk*
DESIGNER *Joe Krawczyk*
STUDIO *Corporate Design Associates*
CLIENT *GROWS (Greater Reading Or Writing Skills)
Literacy Council*
COUNTRY *United States*

LOGO FOR:
GROWS
(Greater Reading
Or Writing Skills)
Literacy
Council

Merit
CORPORATE & PROMOTIONAL DESIGN, LOGO
Pearl Cafe

DESIGNER *Brad Thomas*
STUDIO *Brad Thomas Graphic Design*
CLIENT *Pearl Cafe*
COUNTRY *United States*

Merit
CORPORATE & PROMOTIONAL DESIGN, LOGO
Ton+Bild, Veranstaltungstechnik
(Sound+Picture, Technology for Events)

ART DIRECTOR *Peter Felder*
CREATIVE DIRECTOR *Peter Felder*
COPYWRITER *Martin Beck*
DESIGNERS *Peter Felder, René Dalpra*
PRODUCER *Johannes Thurnher*
STUDIO *Felder Grafikdesign*
CLIENT *Martin Beck*
COUNTRY *Austria*

Merit
CORPORATE & PROMOTIONAL DESIGN, LOGO
Tanofil, Synthetic Fibre Supplier

ART DIRECTOR *Peter Felder*
CREATIVE DIRECTOR *Peter Felder*
COPYWRITER *Robert Amann*
DESIGNERS *Peter Felder, René Dalpra*
PRODUCER *Johannes Thurnher*
STUDIO *Felder Grafikdesign*
CLIENT *Tanofil, Synthetic Fibre Supplier*
COUNTRY *Austria*

Merit

CORPORATE & PROMOTIONAL DESIGN,
PUBLIC SERVICE OR NON-PROFIT/EDUCATIONAL
Journey of the Chickasaw

ART DIRECTOR *David Steinke*
CREATIVE DIRECTOR *Trace Hallowell*
COPYWRITERS *Sheperd Simmons, Cliff Watson*
DESIGNER *David Steinke*
PHOTOGRAPHER *Ben Fink*
AGENCY *Thompson & Company*
CLIENT *Chickasaw Council, B.S.A.*
COUNTRY *United States*

Merit

CORPORATE & PROMOTIONAL DESIGN,
PUBLIC SERVICE OR NON-PROFIT/EDUCATIONAL
Centerspace Brochure

DESIGN *Herman Ellis Dyal, Fuller Dyal & Stamper*
STUDIO *Fuller Dyal & Stamper*
CLIENT *Texas Fine Arts Association*
COUNTRY *United States*

(facing page, top)
Merit

CORPORATE & PROMOTIONAL DESIGN,
PUBLIC SERVICE OR NON-PROFIT/EDUCATIONAL
Points

ART DIRECTOR *Marion English*
CREATIVE DIRECTOR *Marion English*
COPYWRITER *Laura Hambaugh*
DESIGNER *Marion English*
PHOTOGRAPHER *Don Harbor*
AGENCY *Slaughter Hanson*
CLIENT *Boy Scouts–Central Alabama Council*
COUNTRY *United States*

(facing page, bottom)
Merit

CORPORATE & PROMOTIONAL DESIGN,
PUBLIC SERVICE OR NON-PROFIT/EDUCATIONAL
Rickwood Field

ART DIRECTOR *Marion English*
CREATIVE DIRECTOR *Terry Slaughter*
COPYWRITER *Laura Hambaugh*
DESIGNER *Marion English*
PHOTOGRAPHERS *John Huet, Don Harbor*
ILLUSTRATOR *David Webb*
AGENCY *Slaughter Hanson*
CLIENT *Friends of Rickwood Field*
COUNTRY *United States*

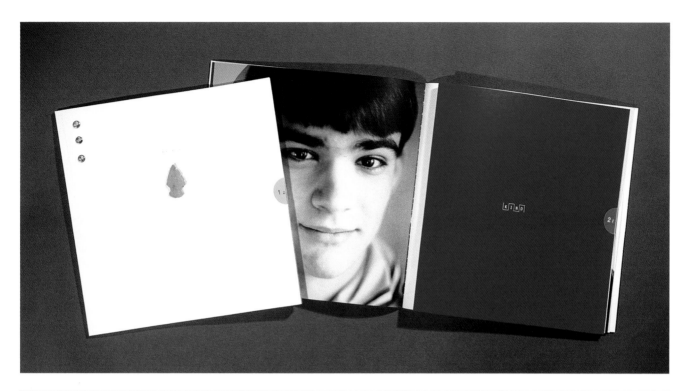

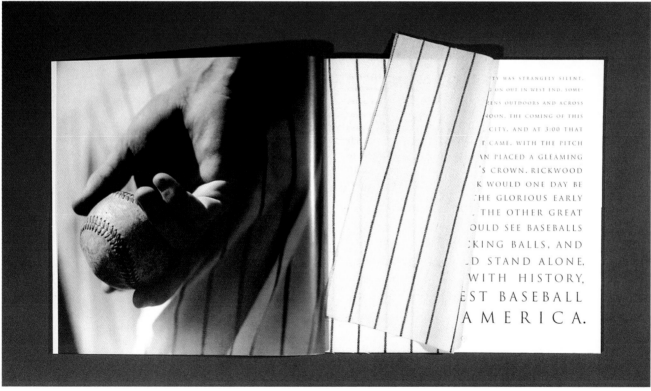

Merit
**CORPORATE & PROMOTIONAL DESIGN,
PUBLIC SERVICE OR NON-PROFIT/EDUCATIONAL**
Documenta

ART DIRECTORS *Sibylle Haase, Fritz Haase*
CREATIVE DIRECTOR *Sibylle Haase*
DESIGNER *Thomas Paschke*
STUDIO *Atelier Haase & Knels*
CLIENT *Bundesministerium für Post und
Telekommunikation*
COUNTRY *Germany*

Merit
**CORPORATE & PROMOTIONAL DESIGN,
PUBLIC SERVICE OR NON-PROFIT/EDUCATIONAL**
Loaves & Fishes Brochure

ART DIRECTORS *Patrick Short, Kristy Beausoleil*
CREATIVE DIRECTOR *Patrick Short*
COPYWRITER *Brad Bray*
DESIGNER *Kristy Beausoleil*
PHOTOGRAPHER *Brad Bridgers*
PRODUCER *Amy Barcelou*
DESIGN FIRM *BlackBird Creative*
CLIENT *Loaves & Fishes*
COUNTRY *United States*

Merit
**CORPORATE & PROMOTIONAL DESIGN,
COMPLETE PRESS OR PROMOTIONAL KIT**
Nick at Nite Media Kit, 1997

ART DIRECTORS *David Slatoff, Tamar Cohen*
CREATIVE DIRECTOR *Kenna Kay (Nickelodeon,
Acme Creative Group)*
COPYWRITER *Robert Leighton*
DESIGNERS *Tamar Cohen, David Slatoff*
ILLUSTRATORS *Chip Wass, Ed Fotheringham*
STUDIO *Slatoff + Cohen Partners, Inc.*
CLIENT *Nick at Nite, Acme Creative Group*
COUNTRY *United States*

Merit
**CORPORATE & PROMOTIONAL DESIGN,
COMPLETE PRESS OR PROMOTIONAL KIT**
TV Land Media Kit, 1997

ART DIRECTORS *Tamar Cohen, David Slatoff*
CREATIVE DIRECTOR *Kenna Kay (Nickelodeon,
Acme Creative Group)*
COPYWRITER *Sharon Lesser*
DESIGNERS *Tamar Cohen, David Slatoff,
Rolyn Barthelman*
PHOTOGRAPHER *Geoff Spear*
STUDIO *Slatoff + Cohen Partners, Inc.*
CLIENT *TV Land, Acme Creative Group*
COUNTRY *United States*

Merit
**CORPORATE & PROMOTIONAL DESIGN,
COMPLETE PRESS OR PROMOTIONAL KIT**
Eudermine Press Kit, Shiseido

ART DIRECTORS *Toshio Yamagata, Serge Lutens*
CREATIVE DIRECTOR *Toshio Yamagata*
COPYWRITERS *Serge Lutens, Shoko Yoshida*
DESIGNERS *Rie Sakai, Takayasu Yamada*
PHOTOGRAPHER *Seiichi Nakamura*
AGENCY *Shiseido Creation Department*
CLIENT *Shiseido Co., Ltd.*
COUNTRY *Japan*

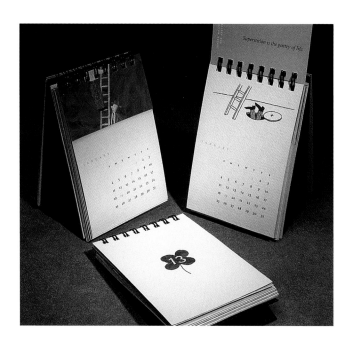

Merit

**CORPORATE & PROMOTIONAL DESIGN,
PROMOTION/SELF-PROMOTION**

Baker's Dozen, 1998

CREATIVE DIRECTORS *Gary Baker, Rexanne White*
COPYWRITER *Bob Bailey*
DESIGNER *Michelle Wolins*
ILLUSTRATOR *Jeffrey Fisher*
PRINTER *Costello Brothers*
STUDIO *Baker Design Associates*
CLIENT *Baker Design Associates*
COUNTRY *United States*

Merit

**CORPORATE & PROMOTIONAL DESIGN,
PROMOTION/SELF-PROMOTION**

Invitation for "Frutta Fresca,"
Graphic Design Exhibition (Fresh Fruit)

ART DIRECTOR *Eduard Cehovin*
CREATIVE DIRECTOR *Eduard Cehovin*
DESIGNER *Eduard Cehovin*
AGENCY *A±B (Art more or less Business) in Exile*
CLIENT *Eduard Cehovin*
COUNTRY *Slovenia*

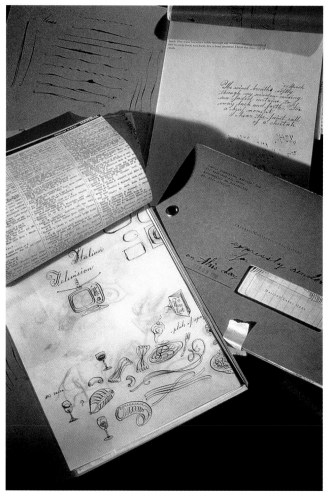

Merit

**CORPORATE & PROMOTIONAL DESIGN,
PROMOTION/SELF-PROMOTION**

Elvis Swift, Illustrator

ART DIRECTOR *Sharon Werner*
DESIGNERS *Sharon Werner, Sarah Nelson*
ILLUSTRATOR *Elvis Swift*
PRINTER *Nomadic Press*
STUDIO *Werner Design Werks, Inc.*
CLIENT *Joanie Bernstein, Art Rep*
COUNTRY *United States*

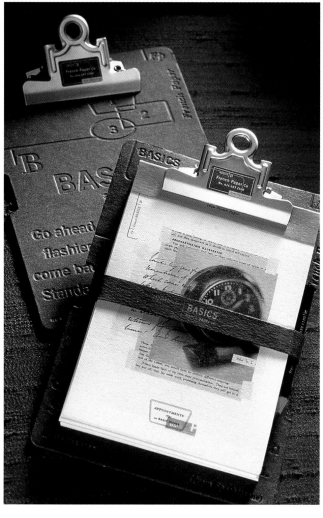

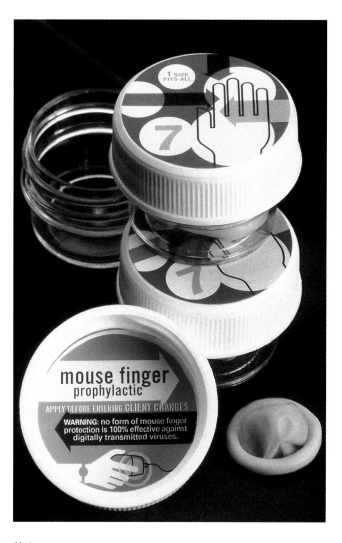

Merit
**CORPORATE & PROMOTIONAL DESIGN,
PROMOTION/SELF-PROMOTION**
Speckletone "Basics" Promotion with Clipboard

ART DIRECTOR *Laurie DeMartino*
COPYWRITER *Lisa Pemrick*
DESIGNER *Laurie DeMartino*
PHOTOGRAPHER *Steve Belkowitz*
PRINTER *The Etheridge Company*
STUDIO *Studio d Design*
CLIENT *French Paper Company*
COUNTRY *United States*

Merit
**CORPORATE & PROMOTIONAL DESIGN,
PROMOTION/SELF-PROMOTION**
Annual Report Survival Kit

ART DIRECTOR *Charles S. Anderson*
COPYWRITER *Lisa Pemrick*
DESIGNER *Jason Schulte*
STUDIO *Charles S. Anderson Design Company*
CLIENT *French Paper Company*
COUNTRY *United States*

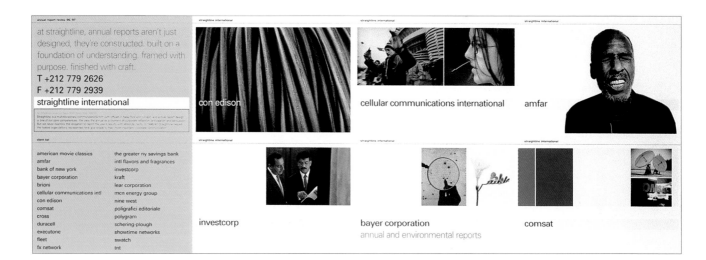

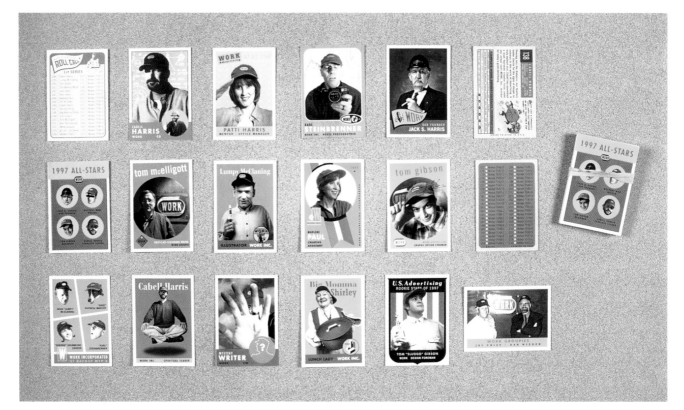

(top)
Merit
**CORPORATE & PROMOTIONAL DESIGN,
PROMOTION/SELF-PROMOTION**
Annual Report Review, 1996/1997

ART DIRECTOR *Martin Perrin*
CREATIVE DIRECTOR *James Hatch*
COPYWRITER *James Hatch*
DESIGNER *Martin Perrin*
PHOTOGRAPHERS *Various*
STUDIO *Straightline International*
CLIENT *Straightline International*
COUNTRY *United States*

(bottom)
Merit
**CORPORATE & PROMOTIONAL DESIGN,
PROMOTION/SELF-PROMOTION**
Work Baseball Cards

ART DIRECTOR *Cabell Harris*
CREATIVE DIRECTOR *Cabell Harris*
COPYWRITER *Tom Gibson*
DESIGNER *Tom Gibson*
PHOTOGRAPHERS *Karl Steinbrenner, Abe Spear*
ILLUSTRATOR *Lumpy McClaning*
AGENCY *Work*
CLIENT *Work*
COUNTRY *United States*

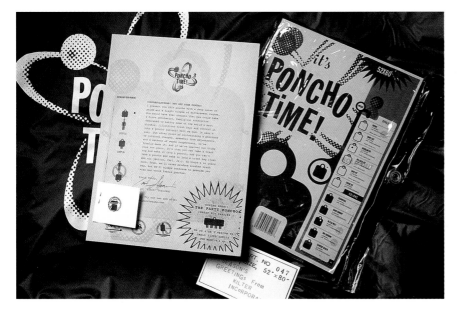

Merit
**CORPORATE & PROMOTIONAL DESIGN,
PROMOTION/SELF-PROMOTION**
Poncho Time

ART DIRECTOR *Travis Olson*
CREATIVE DIRECTOR *Cynthia Knox*
COPYWRITER *Eric Husband*
ILLUSTRATOR *Travis Olson*
AGENCY *Kilter Incorporated*
CLIENT *Kilter Incorporated*
COUNTRY *United States*

Merit
**CORPORATE & PROMOTIONAL DESIGN,
PROMOTION/SELF-PROMOTION**
Paradox Films

ART DIRECTORS *Patrick Short, Brandon Scharr*
CREATIVE DIRECTOR *Patrick Short*
COPYWRITER *Brad Bray*
DESIGNER *Brandon Scharr*
PRODUCER *Julia Winfield*
DESIGN FIRM *BlackBird Creative*
CLIENT *Paradox Films*
COUNTRY *United States*

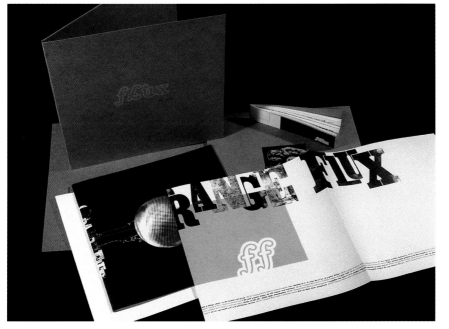

Merit
**CORPORATE & PROMOTIONAL DESIGN,
PROMOTION/SELF-PROMOTION**
Rust Belt-Visual Recordings

ART DIRECTORS *Kristina Meyer, Matt Fey*
CREATIVE DIRECTORS *Kristina Meyer, Matt Fey*
DESIGNERS *Matt Fey, Kristina Meyer*
PHOTOGRAPHERS *Kristina Meyer, Matt Fey*
ILLUSTRATOR *Patrick Dorey*
LYRICS *Kristina Meyer, Matt Fey, Steve Gariepy,
Sam K. Meyer, Allen Parmelee*
GRAPHIC MUSIC *Matt Fey, Kristina Meyer,
Steve Gariepy*
STUDIO *Orangeflux, inc.*
CLIENT *Orangeflux, inc.*
COUNTRY *United States*

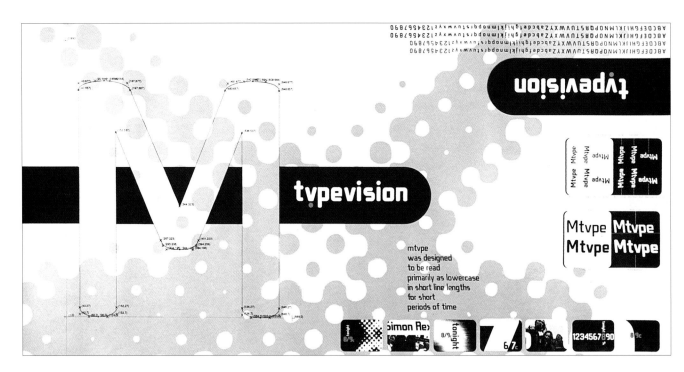

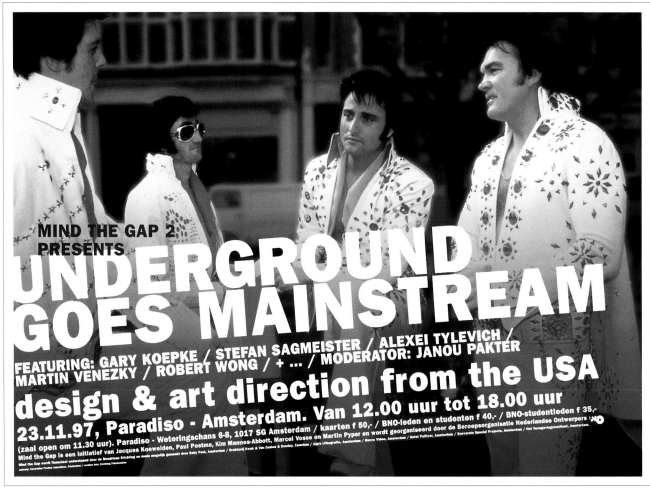

Merit
**CORPORATE & PROMOTIONAL DESIGN,
MIXED-MEDIA PROMOTION**
Mine™ Poster

ART DIRECTORS *Joshua Berger, Niko Courtelis,
Pete McCracken*
DESIGNER *Niko Courtelis*
AGENCY *Plazm Media*
STUDIO *Plazm Design*
CLIENT *Champion International Paper*
COUNTRY *United States*

(facing page, top)
Merit
**CORPORATE & PROMOTIONAL DESIGN,
MIXED-MEDIA PROMOTION, SERIES**
MTVPE

ART DIRECTORS *Joshua Berger, Niko Courtelis,
Pete McCracken*
DESIGNERS *Joshua Berger, Niko Courtelis,
Pete McCracken, Riq Mosqueda*
PRINCIPAL FONT DESIGNER *Pete McCracken*
STUDIO *Plazm Design/Plazm Fonts*
CLIENT *MTV Networks*
COUNTRY *United States*

(facing page, bottom)
Merit
**CORPORATE & PROMOTIONAL DESIGN,
MIXED-MEDIA PROMOTION, SERIES**
Mind the Gap 2 (Poster/Festival Leader)

ART DIRECTORS *Jacques Koeweiden, Paul Postma*
CREATIVE DIRECTORS *Jacques Koeweiden,
Paul Postma*
COPYWRITER *Mind the Gap*
DESIGNERS *Jacques Koeweiden, Paul Postma*
PHOTOGRAPHY *Stock (manipulation: KPA)*
FESTIVAL LEADERS *Jacques Koeweiden, Paul Postma*
PRODUCER *Marcel Vosse*
MUSIC *Elvis*
OPERATOR *Julian de Keijser*
STUDIO *Koeweiden Postma Associates*
CLIENT *the audience*
COUNTRY *The Netherlands*

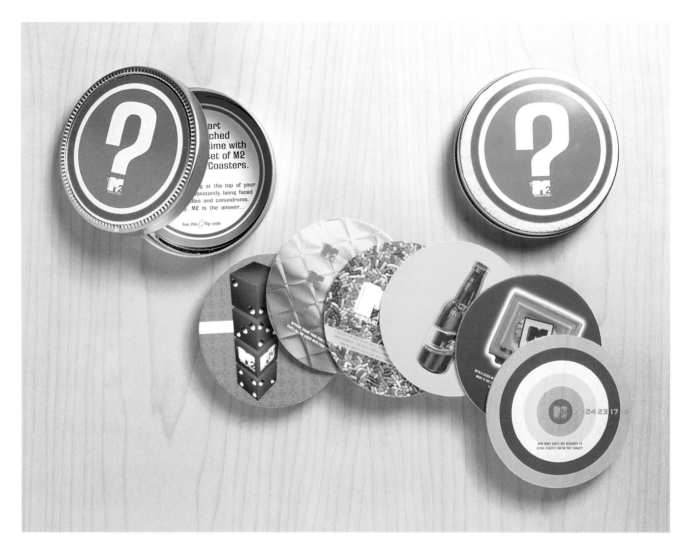

Merit
**CORPORATE & PROMOTIONAL DESIGN,
MIXED-MEDIA PROMOTION**
M2 Coasters

ART DIRECTOR *William Lee*
DESIGNER *William Lee*
STUDIO *MTV*
CLIENT *MTV*
COUNTRY *United States*

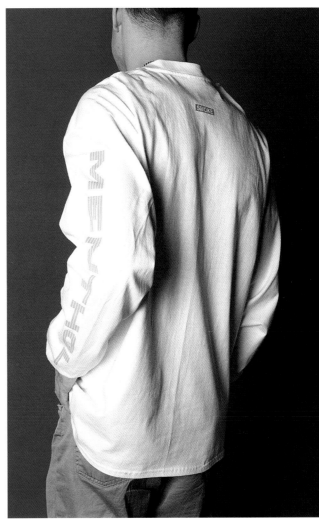

MULTIPLE AWARDS

Merit
**CORPORATE & PROMOTIONAL DESIGN,
PROMOTIONAL APPAREL**
*Trade Show Giveaway for Smoke Software
(black t-shirt)*

and Merit
**CORPORATE & PROMOTIONAL DESIGN,
PROMOTIONAL APPAREL**
*Trade Show Giveaway for Smoke Software
(white t-shirt)*

ART DIRECTORS *Claude Labrie, Patrick Giasson,
Orazio Fantini*
CREATIVE DIRECTOR *Bradford Gorman*
DESIGNER *Patrick Giasson*
AGENCY *Behaviour Design Inc.*
CLIENT *Discreet Logic*
COUNTRY *Canada*

Merit

**CORPORATE & PROMOTIONAL DESIGN,
ANNOUNCEMENT, INVITATION**
WMP

ART DIRECTOR *Jeff Labbé*
COPYWRITER *Chris Cruttenden*
DESIGNER *Jeff Labbé*
PHOTOGRAPHER *Peter Samuels*
PAPER STOCK *French Paper Company*
AGENCY *Labbé Design Co.*
STUDIO *Labbé Design Co.*
CLIENT *Chris & Gwen*
COUNTRY *United States*

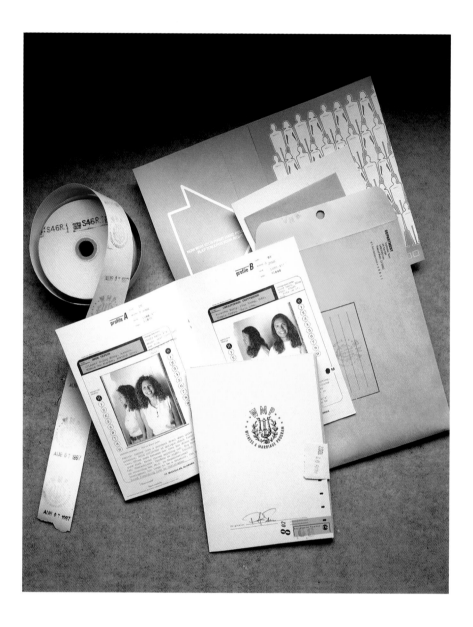

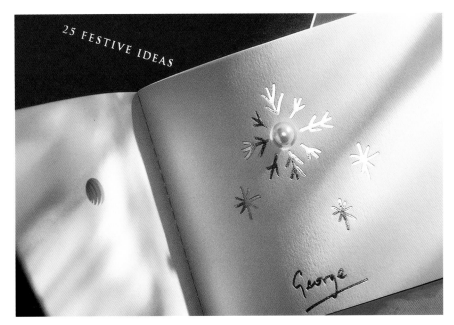

**CORPORATE & PROMOTIONAL DESIGN,
GREETING CARD**
Pearlfisher Christmas Card

ART DIRECTOR *Jonathan Ford*
CREATIVE DIRECTOR *Ashley Carter*
DESIGNER *Sarah Butler*
PRODUCER *Pearlfisher*
AGENCY *Pearlfisher*
CLIENT *Pearlfisher*
COUNTRY *England*

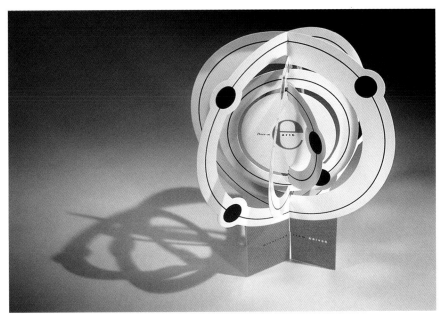

**CORPORATE & PROMOTIONAL DESIGN,
GREETING CARD**
IBM AS/400e Holiday Card

ART DIRECTOR *Billie Harber*
CREATIVE DIRECTOR *Randall Hensley*
DESIGNER *Melissa Mullin*
PRODUCER *Janice Carapellucci*
PRINTER *Structural Graphics*
AGENCY *C3 Incorporated*
CLIENT *IBM Corporation, AS/400 Division*
COUNTRY *United States*

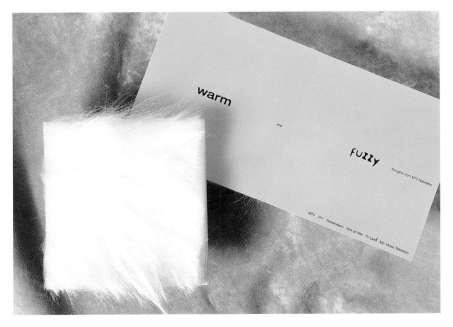

**CORPORATE & PROMOTIONAL DESIGN,
GREETING CARD**
MTV Networks Holiday Card

CREATIVE DIRECTORS *Scott Wadler (design),*
Cheryl Family (editorial)
COPYWRITERS *Ken Saji, Mike Elperin*
DESIGNER *Nok Acharee*
STUDIO *MTV Networks Creative Services*
CLIENT *MTV Networks*
COUNTRY *United States*

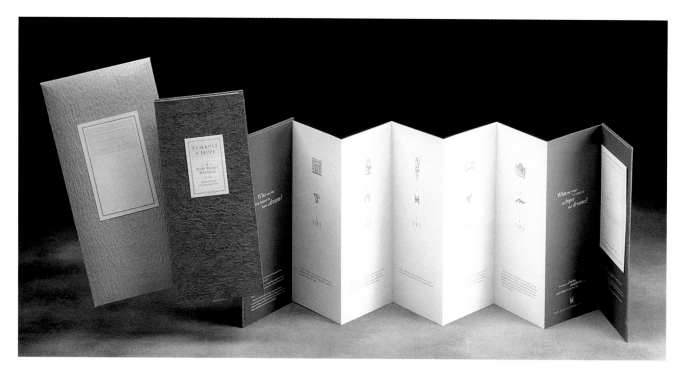

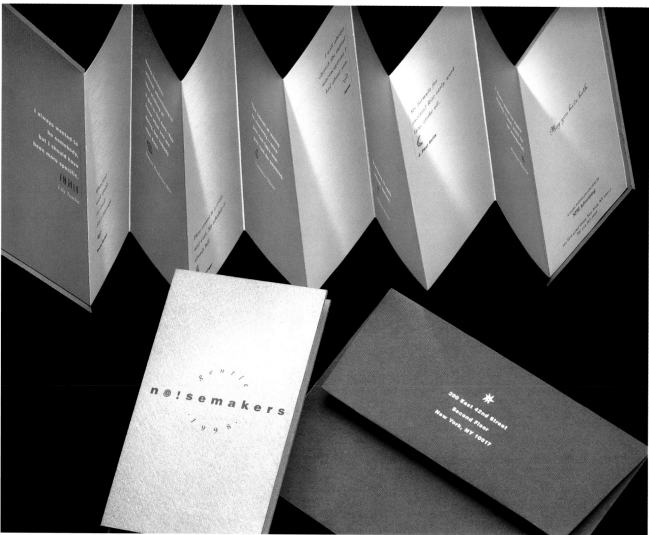

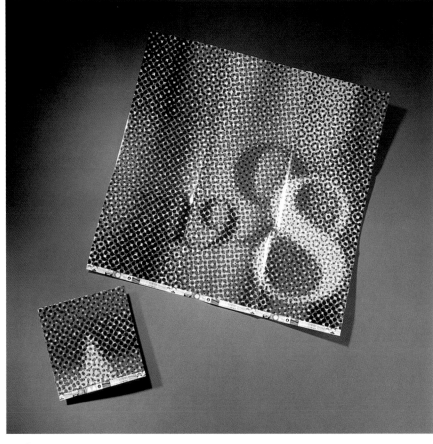

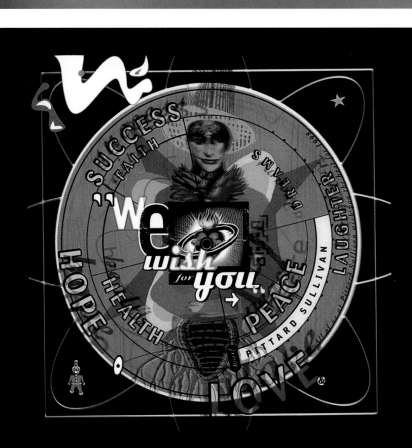

Merit
**CORPORATE & PROMOTIONAL DESIGN,
GREETING CARD**
Hilltop Press Holiday Card

CREATIVE DIRECTOR *Janet Rauscher*
DESIGNERS *Susan D. Morganti, Stephanie Hughes*
ILLUSTRATORS *Susan D. Morganti, Christian Paeth*
PRINTER *Hilltop Press Inc.*
STUDIO *Rauscher Design, Inc.*
CLIENT *Hilltop Press Inc.*
COUNTRY *United States*

Merit
**CORPORATE & PROMOTIONAL DESIGN,
GREETING CARD**
Pittard Sullivan Holiday Card

CREATIVE DIRECTOR *Jennifer Grey*
DESIGNER *Matthieu le Blan*
PRODUCER *Jan Weinberg*
EXECUTIVE PRODUCERS *Billy Pittard, Ed Sullivan*
STUDIO *Pittard Sullivan*
CLIENT *Pittard Sullivan*
COUNTRY *United States*

(facing page, top)
Merit
**CORPORATE & PROMOTIONAL DESIGN,
GREETING CARD**
RCC 1997 Holiday Greeting

ART DIRECTOR *James Rahn*
CREATIVE DIRECTOR *Bruce Edwards*
COPYWRITER *Sherrie Thomas*
ILLUSTRATOR *Kate Thomssen*
ELECTRONIC PRODUCTION ARTIST *Debbie Goetz*
AGENCY *Rapp Collins Communications*
CLIENT *Rapp Collins Communications*
COUNTRY *United States*

(facing page, bottom)
Merit
**CORPORATE & PROMOTIONAL DESIGN,
GREETING CARD**
NPM Holiday Card

ART DIRECTOR *Nancy Merish*
CREATIVE DIRECTOR *Harriet Walley*
DESIGNER *Nancy Merish*
PRODUCER *Philipp Soules*
AGENCY *NPM Advertising*
CLIENT *NPM Advertising*
COUNTRY *United States*

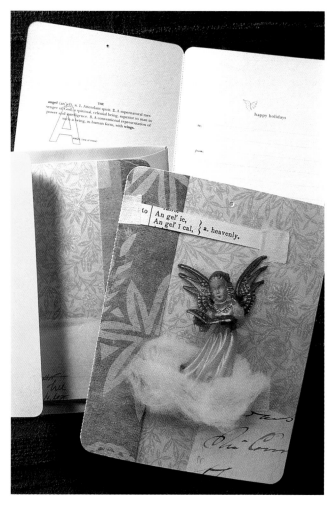

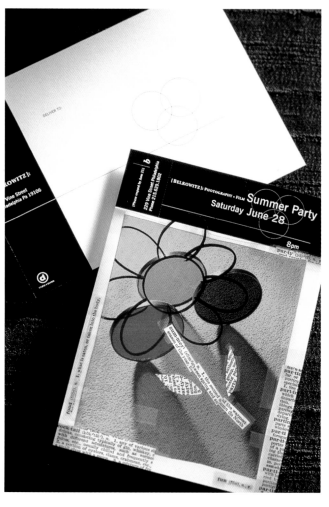

Merit
**CORPORATE & PROMOTIONAL DESIGN,
GREETING CARD**
Studio d Design Holiday Card

ART DIRECTOR *Laurie DeMartino*
DESIGNER *Laurie DeMartino*
PHOTOGRAPHERS *Eric Emmings (CSA Plastock),*
Steve Belkowitz
PAPER *French FrosTone*
PRINTER *Source*
STUDIO *Studio d Design*
CLIENT *Studio d Design*
COUNTRY *United States*

Merit
**CORPORATE & PROMOTIONAL DESIGN,
POSTCARD, GREETING CARD, OR NOTE CARD**
Belkowitz, Summer Party Invitation

ART DIRECTOR *Laurie DeMartino*
DESIGNER *Laurie DeMartino*
PHOTOGRAPHER *Steve Belkowitz*
ILLUSTRATOR *Laurie DeMartino*
STUDIO *Studio d Design*
CLIENT *Belkowitz Photography & Film*
COUNTRY *United States*

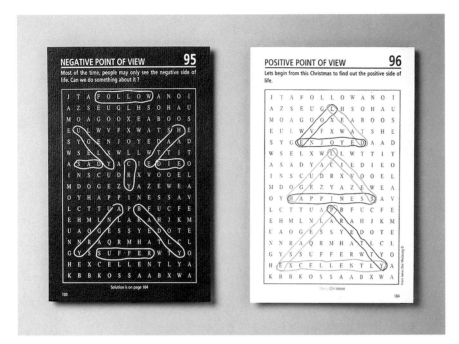

Merit

**CORPORATE & PROMOTIONAL DESIGN,
GREETING CARD**

Genesis Christmas Card

ART DIRECTOR *James Wai Mo Leung*
CREATIVE DIRECTOR *James Wai Mo Leung*
COPYWRITER *James Wai Mo Leung*
DESIGNER *James Wai Mo Leung*
ILLUSTRATOR *James Wai Mo Leung*
STUDIO *Genesis Advertising Company*
CLIENT *Genesis Advertising Company*
COUNTRY *Hong Kong, China*

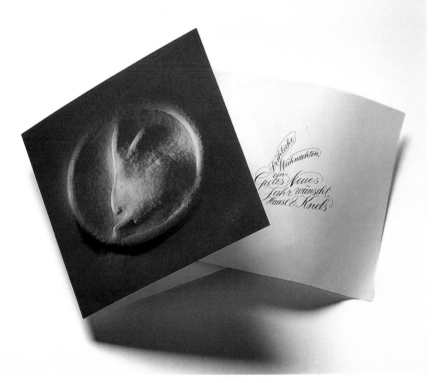

Merit

**CORPORATE & PROMOTIONAL DESIGN,
GREETING CARD**

*Fröhliche Weihnachten Wünscht, Haase & Knels
(Merry Christmas Wishes from Haase & Knels)*

ART DIRECTORS *Sibylle Haase, Fritz Haase*
CREATIVE DIRECTOR *Sibylle Haase*
DESIGNER *Katja Hirschfelder*
PHOTOGRAPHER *Ralf Rühmeier*
STUDIO *Atelier Haase & Knels*
CLIENT *Atelier Haase & Knels*
COUNTRY *Germany*

Merit
**CORPORATE & PROMOTIONAL DESIGN,
POSTCARD**
Parham Sanatana Message Postcards

ART DIRECTOR *John Parham*
CREATIVE DIRECTOR *Maruchi Santana*
DESIGNERS *Annetta Sappenfield, Ron Anderson*
STUDIO *Parham Santana Inc.*
CLIENT *Parham Santana Inc.*
COUNTRY *United States*

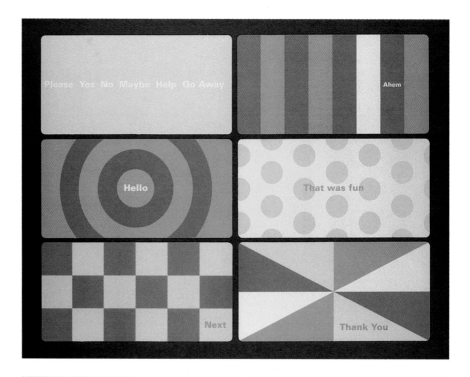

Merit
**CORPORATE & PROMOTIONAL DESIGN,
GREETING CARD**
Silver Belles

ART DIRECTOR *FitzMartin*
CREATIVE DIRECTOR *FitzMartin*
COPYWRITER *FitzMartin*
PHOTOGRAPHER *Geoff Knight*
STUDIO *FitzMartin Design Partners*
CLIENT *FitzMartin Design Partners*
COUNTRY *United States*

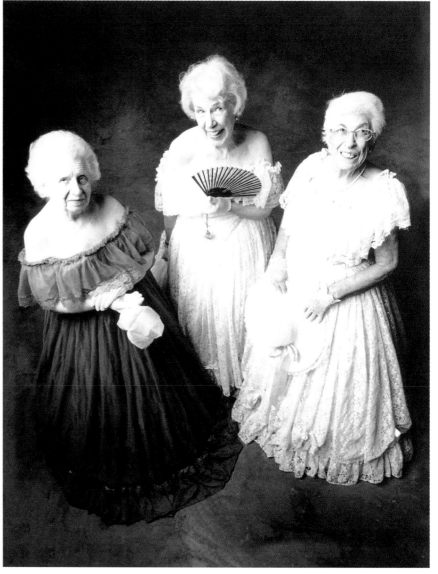

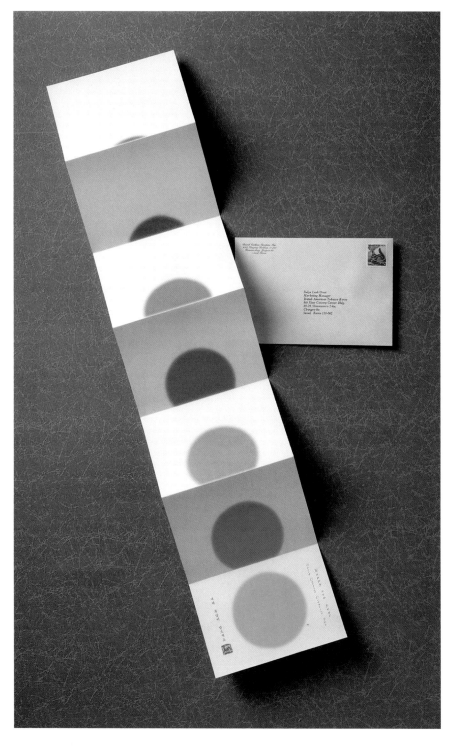

Merit
**CORPORATE & PROMOTIONAL DESIGN,
GREETING CARD**
Lunar New Years

ART DIRECTOR *Nam, Mee-Hyun*
CREATIVE DIRECTOR *David Carlson*
COPYWRITER *Nam, Mee-Hyun*
DESIGNER *Nam, Mee-Hyun*
ILLUSTRATOR *Nam, Mee-Hyun*
PRODUCER *Christine Joung*
PRINTER *Born Printing*
AGENCY *David Carlson Creative, Inc.*
CLIENT *David Carlson Creative, Inc.*
COUNTRY *Korea*

Merit
CORPORATE & PROMOTIONAL DESIGN, CALENDAR
Born Free Recycled Paper Series

ART DIRECTOR *Kan Tai-keung*
CREATIVE DIRECTOR *Kan Tai-keung*
DESIGNERS *Kan Tai-keung, Eddy Yu Chi Kong,*
Leung Wai Yin
PHOTOGRAPHER *C.K. Wong*
COMPUTER ILLUSTRATORS *Benson Kwun Tin Yau,*
Leung Wai Yin, John Tam Mo Fai
CHINESE INK ILLUSTRATOR *Kan Tai-keung*
CALLIGRAPHERS *Chui Tze Hung, Yung Ho Yin*
ENGRAVER *Yip Man Yam*
STUDIO *Kan & Lau Design Consultants*
CLIENT *Tokushu Paper Manufacturing Co., Ltd.*
COUNTRY *Hong Kong, China*

(facing page, top)
Merit
CORPORATE & PROMOTIONAL DESIGN, CALENDAR
1998 (colors, shapes, squares)

ART DIRECTOR *Kenji Nakato*
DESIGNER *Kenji Nakato*
ILLUSTRATOR *Kenji Nakato*
AGENCY *Creators Group MAC*
CLIENT *Creators Group MAC*
COUNTRY *Japan*

(facing page, bottom)
Merit
CORPORATE & PROMOTIONAL DESIGN, CALENDAR
1998 (black & white numbered squares)

ART DIRECTOR *Osamu Takeuchi*
CREATIVE DIRECTOR *Sawako Takeuchi*
DESIGNER *Mootng Toyama*
PHOTOGRAPHER *Toshinobu Kobayashi*
STUDIO *Osamu Takeuchi Design Room*
AGENCY *Creators Group MAC*
CLIENT *Creators Group MAC*
COUNTRY *Japan*

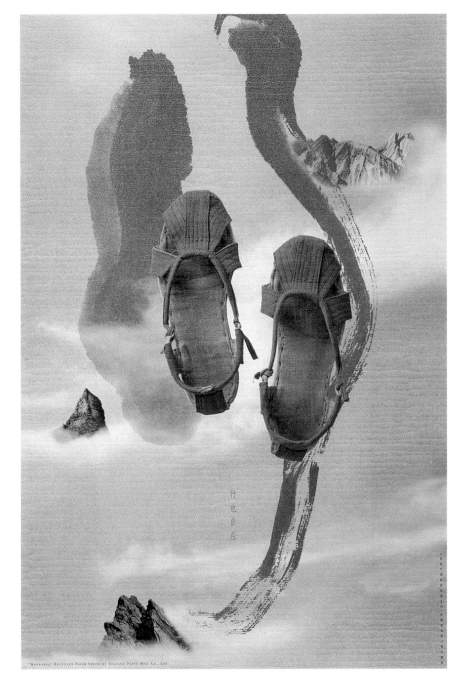

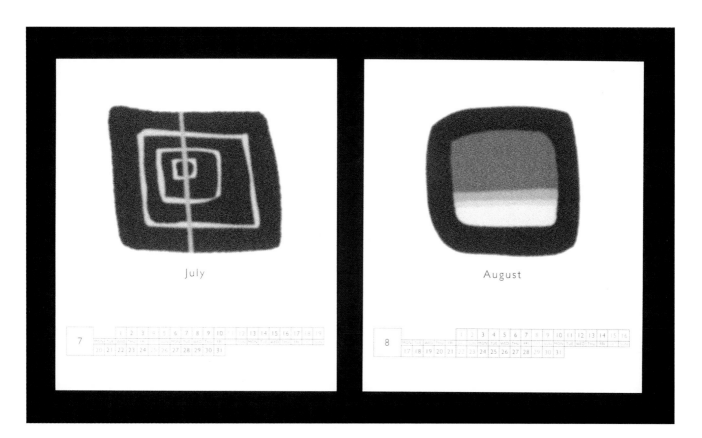

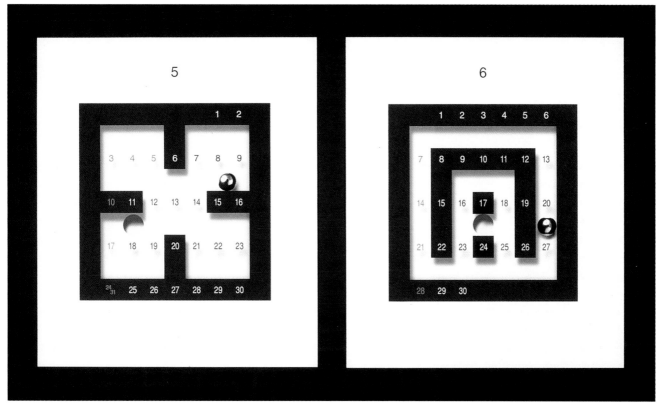

Merit
CORPORATE & PROMOTIONAL DESIGN, CALENDAR, SERIES
Universe, 1998

PRINCIPAL/DESIGNER *Woody Pirtle*
ASSOCIATE DESIGNER *John Klotnia*
DESIGNER *Sha-Mayne Chan*
STUDIO *Pentagram Design*
CLIENT *Universe Publishing*
COUNTRY *United States*

Merit
CORPORATE & PROMOTIONAL DESIGN, CALENDAR
TRI Company Limited, 1998

ART DIRECTOR *Akihiko Tsukamoto*
DESIGNER *Akihiko Tsukamoto*
STUDIO *Zuan Club*
CLIENT *TRI Company Limited*
COUNTRY *Japan*

Merit

**CORPORATE & PROMOTIONAL DESIGN,
APPOINTMENT BOOK**

30th Anniversary Commemorative Appointment Book

ART DIRECTOR *José Luiz Mendieta*
CREATIVE DIRECTOR *Cibar Ruiz*
COPYWRITER *Mauro Thiele*
PHOTOGRAPHERS *Angelo Pastorello, Álvaro Póvoa,
Cássio Vasconcelos, Ella Dürst, Fifi Tong, Gal Oppido,
Giácomo Favretto, Klaus Mitteldorf, Márcio Scavone,
Paulo Fridman, Freitas, Thomas Kremer*
AGENCY *Grottera Comunicação*
CLIENTS *Roberto Casali, Nelson Constanza*
COUNTRY *Brazil*

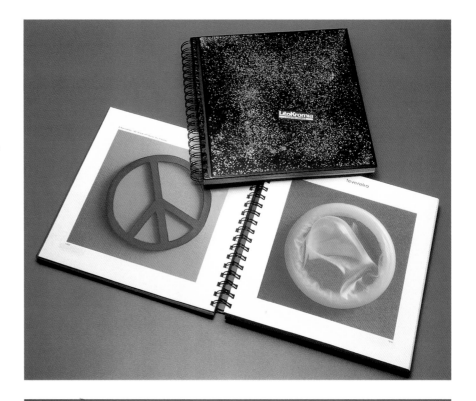

Merit

**CORPORATE & PROMOTIONAL DESIGN,
APPOINTMENT BOOK**

Diary

ART DIRECTOR *David Harris*
CREATIVE DIRECTOR *David Harris*
COPYWRITER *Stephen Pickard*
DESIGNER *David Harris*
PHOTOGRAPHY *Getty Images*
AGENCY *IMP London*
CLIENT *Lauren Munton (Tony Stone Images)*
COUNTRY *England*

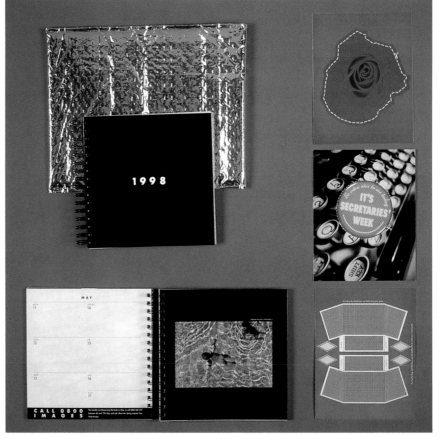

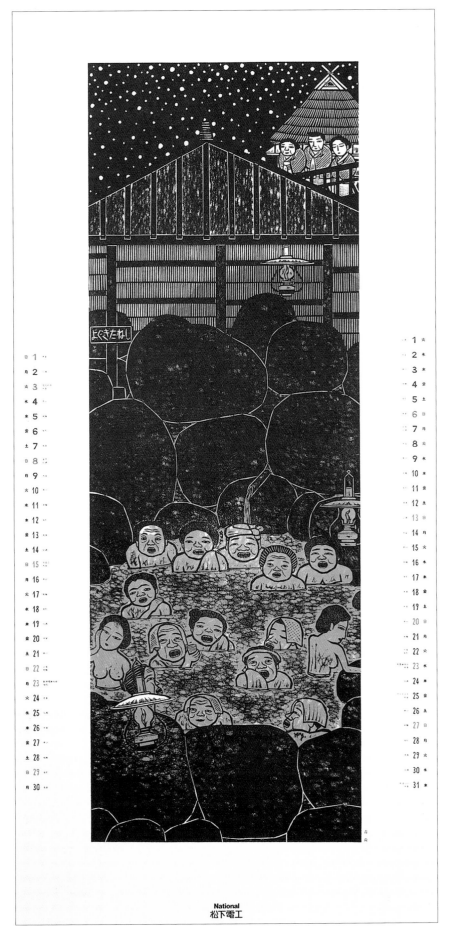

Merit
CORPORATE & PROMOTIONAL DESIGN, CALENDAR
Spas in Japan, 1998

ART DIRECTORS *Yasuhiko Kida, Tsuyoshi Sugino*
CREATIVE DIRECTOR *Yasuhiko Kida*
COPYWRITER *Yasuhiko Kida*
DESIGNER *Kazuhiro Shinzato*
PHOTOGRAPHER *Tadayuki Minamoto*
ILLUSTRATOR *Yasuhiko Kida*
PRODUCER *Tsuyoshi Sugino*
PRINTER *Okamura Printing Co., Ltd.*
STUDIO *Yasuhiko Kida*
CLIENT *Matsushita Electric Works, Ltd.*
COUNTRY *Japan*

Merit
**CORPORATE & PROMOTIONAL DESIGN,
CALENDAR OR APPOINTMENT BOOK**
Domtar Sandpiper Book

ART DIRECTORS *Glenda Rissman, Peter Scott*
COPYWRITER *Ania Szado*
DESIGNER *Nadine Chassé*
PHOTOGRAPHERS *Mary Pocock, Frank Rodick,
Simon Tanenbaum*
PRINTER *C.J. Graphics Inc.*
FINISHER *Ground Zero Packaging Ltd.*
STUDIO *Q30 Design Inc.*
CLIENT *Domtar Papers*
COUNTRY *Canada*

Merit
**CORPORATE & PROMOTIONAL DESIGN,
APPOINTMENT BOOK**
Tom Daytimer

ART DIRECTORS *John Pylypczak, Diti Katona*
DESIGNER *John Pylypczak*
PHOTOGRAPHER *Karen Levy*
STUDIO *Concrete Design Communications Inc.*
CLIENT *Keilhauer Industries Ltd.*
COUNTRY *Canada*

Merit
CORPORATE & PROMOTIONAL DESIGN, CALENDAR
MG Prints, 1998

ART DIRECTOR *Ruba Abu-Nimah*
DESIGNER *Ruba Abu-Nimah*
PHOTOGRAPHERS *Shu Akashi, Anthony Gordon,
Anthony Hamboussi, Henry Leutwyler, Doug Menuez,
Lisa Spindler, Tom Tavee, Eric Zeziola*
ILLUSTRATOR *Gregory Grey*
PRODUCER *Eddie Boginsky*
PAPER CONSULTANT *Karl Lueder, Ris Paper*
AGENCY *Talk to the Hand*
CLIENT *MG Prints*
COUNTRY *United States*

Merit
POSTER DESIGN, PROMOTIONAL, SERIES
Be 10 Again • That Old Feelin' • Raise 'em Right

ART DIRECTOR *Johnny Vitorovich*
COPYWRITER *Johnny Vitorovich*
DESIGNER *Johnny Vitorovich*
PHOTOGRAPHER *Johnny Vitorovich*
ILLUSTRATORS *Various*
PRINTER *Colorcraft of Virginia*
FOIL STAMPING *Artisan II*
SCREEN IMAGE *Archive Films*
CLIENT *Bengies Drive-in Theatre*
COUNTRY *United States*

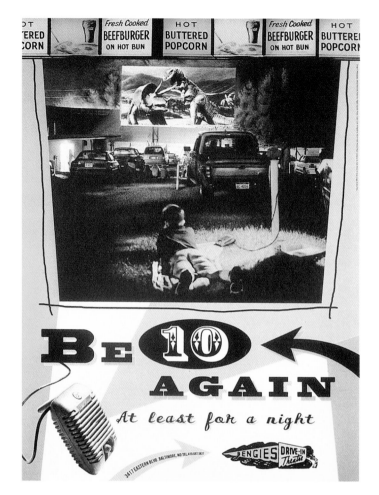

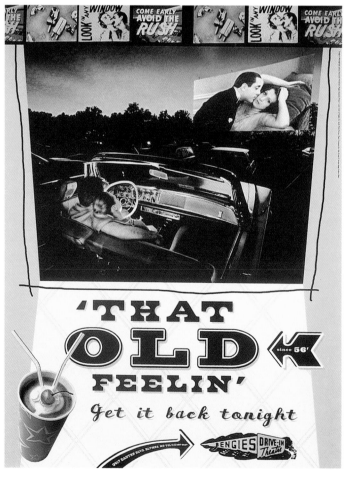

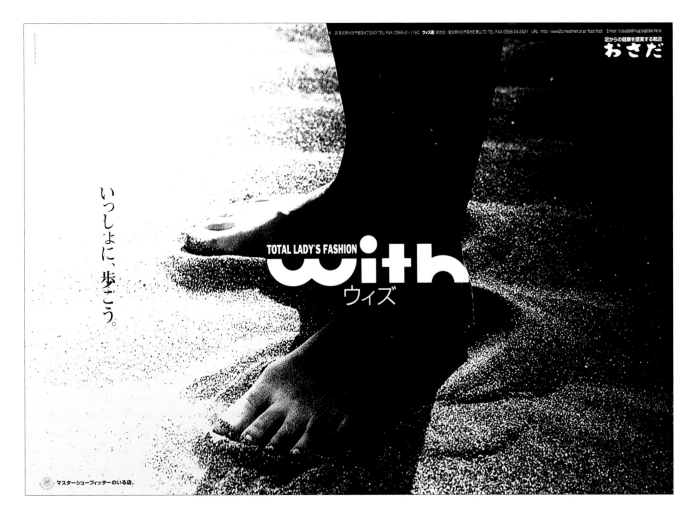

Merit
POSTER DESIGN, PROMOTIONAL, SERIES
With Shoe Shop

ART DIRECTOR *Shigeru Aoyama*
COPYWRITER *Shigeru Aoyama*
DESIGNER *Shigeru Aoyama*
PHOTOGRAPHER *Shigeru Aoyama*
STUDIO *Aoyama Design Office*
CLIENT *Osada Co., Ltd.*
COUNTRY *Japan*

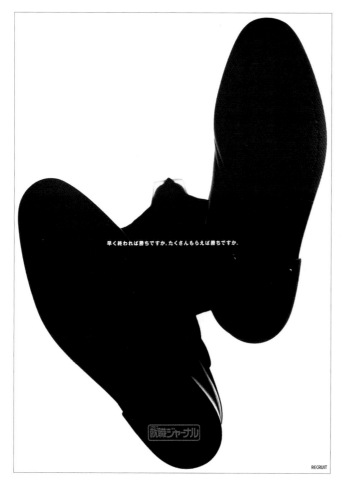

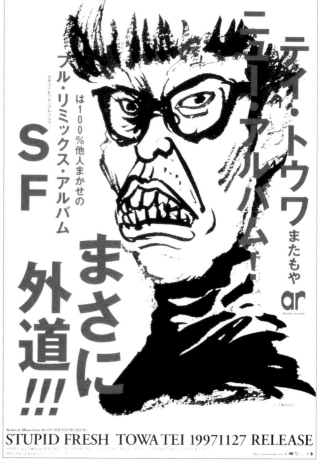

Merit
POSTER DESIGN, PROMOTIONAL, SERIES
*Do Winners always Finish? Do Winners
always Receive Most?*

ART DIRECTOR *Satoji Kashimoto*
CREATIVE DIRECTOR *Toshio Hoshino*
COPYWRITER *Toshio Hoshino*
DESIGNERS *Satoji Kashimoto, Ayana Shiga,
Akihiro Hamabo*
PHOTOGRAPHER *Kenichi Suimoyana*
PRODUCER *Yoshihiro Toyoda*
STUDIO *Recruit Co., Ltd.*
CLIENT *Recruit Co., Ltd.*
COUNTRY *Japan*

Merit
POSTER DESIGN, PROMOTIONAL
Stupid Fresh, Towa Tei

ART DIRECTORS *Tycoon Graphics, Towa Tei*
DESIGNER *Tycoon Graphics*
ILLUSTRATOR *Gatarō F Man*
STUDIO *Tycoon Graphics*
CLIENTS *akashic records/east west japan/
Yoshimoto Kogyo, Co., Ltd.*
COUNTRY *Japan*

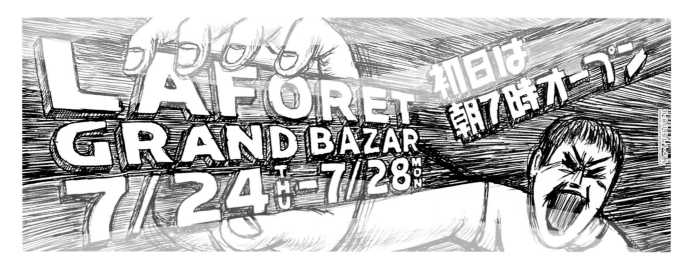

Merit
**POSTER DESIGN, ENTERTAINMENT OR
SPECIAL EVENT**
Laforet Grand Bazar, 7/24–7/28

ART DIRECTOR *Katsunori Aoki*
CREATIVE DIRECTORS *Katsunori Aoki,
Yasuhiko Sakura, Ichiro Tanida*
COPYWRITER *Yasuhiko Sakura*
DESIGNER *Katsunori Aoki*
ILLUSTRATOR *Ichiro Tanida*
PRODUCERS *Ryu Matsumoto, Yuko Fujimoto*
STUDIO *SUN-AD Co., Ltd.*
CLIENT *Laforet Harajuku*
COUNTRY *Japan*

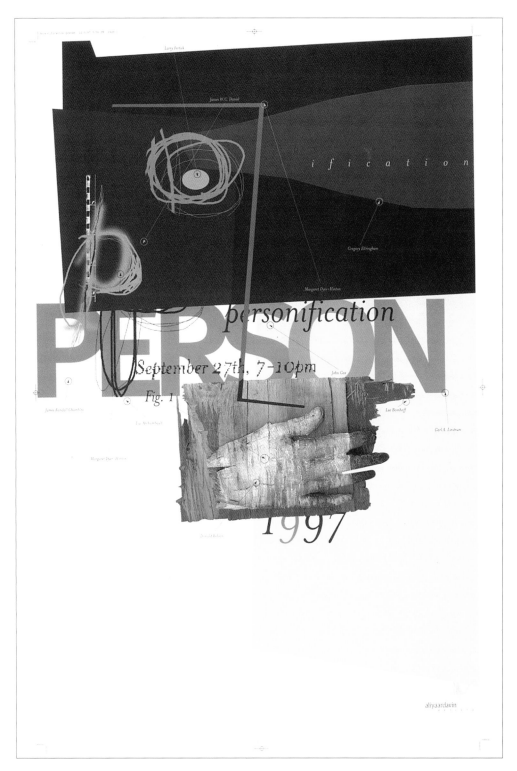

Merit
**POSTER DESIGN, PUBLIC SERVICE OR
NON-PROFIT/EDUCATIONAL, SERIES**
Gallery Opening Reception

ART DIRECTOR *David Arnold*
CREATIVE DIRECTOR *David Arnold*
COPYWRITERS *Anne-Davnes Dusenberry,
David Arnold*
DESIGNER *Anne-Davnes Dusenberry*
ILLUSTRATOR *Anne-Davnes Dusenberry*
AGENCY *The Partnership*
CLIENT *Aliya Ardavin Gallery*
COUNTRY *United States*

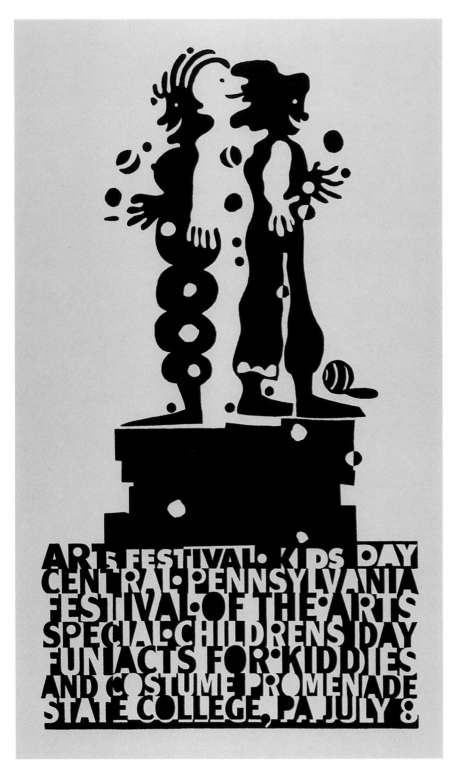

Merit
**POSTER DESIGN, PUBLIC SERVICE OR
NON-PROFIT/EDUCATIONAL, SERIES**
Arts Festival Kids Day

ART DIRECTOR *Lanny Sommese*
CREATIVE DIRECTOR *Lanny Sommese*
DESIGNER *Lanny Sommese*
ILLUSTRATOR *Lanny Sommese*
STUDIO *Sommese Design*
CLIENT *Central Pennsylvania Festival of the Arts*
COUNTRY *United States*

Merit

POSTER DESIGN, PUBLIC SERVICE OR NON-PROFIT/EDUCATIONAL, SERIES

The Golden Age of the Silver Screen

CREATIVE DIRECTOR *Bill Thorburn*
DESIGNER *Chad Hagen*
PHOTOGRAPHER *Bill Phelps*
AGENCY *Carmichael Lynch Thorburn*
CLIENT *Children's Health Care Minneapolis*
COUNTRY *United States*

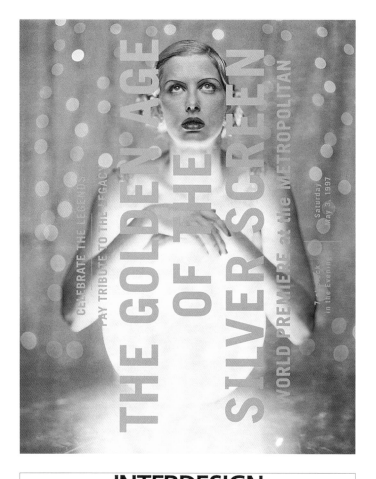

Merit

POSTER DESIGN, PUBLIC SERVICE OR NON-PROFIT/EDUCATIONAL

Inter Design 97

ART DIRECTOR *Shinnoske Sugisaki*
DESIGNER *Shinnoske Sugisaki*
STUDIO *Shinnoske Inc.*
CLIENTS *Inter Design/Japan Typography Association*
COUNTRY *Japan*

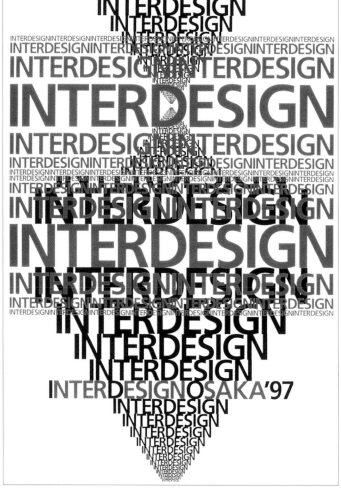

Merit
**POSTER DESIGN, PUBLIC SERVICE OR
NON-PROFIT/EDUCATIONAL**
98

ART DIRECTOR *Shinnoske Sugisaki*
DESIGNER *Shinnoske Sugisaki*
STUDIO *Shinnoske Inc.*
CLIENTS *Ban Gallery, REX Gallery*
COUNTRY *Japan*

Merit
**POSTER DESIGN, PUBLIC SERVICE OR
NON-PROFIT/EDUCATIONAL**
CSD Design Award 1997–Call for Entries

ART DIRECTOR *Esther Kit-Lin Liu*
COPYWRITERS *Esther Kit-Lin Liu, Johnson Chui*
DESIGNERS *Esther Kit-Lin Liu, Nang Wan*
PHOTOGRAPHERS *Edmund Chan, Sam Law*
CLIENT *The Chartered Society of Designers,
Hong Kong Region*
COUNTRY *Hong Kong, China*

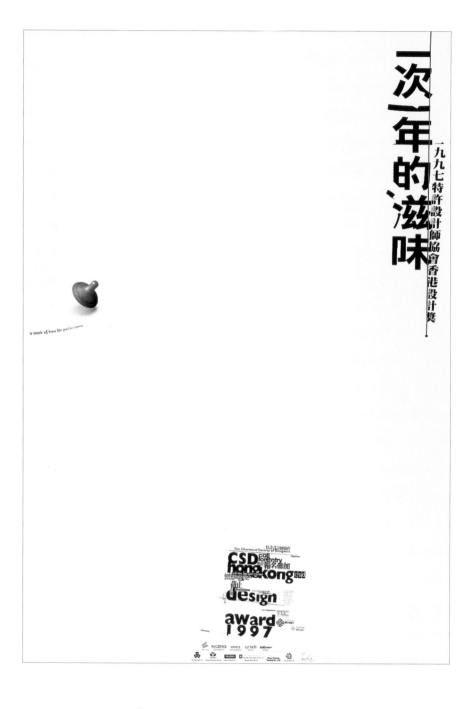

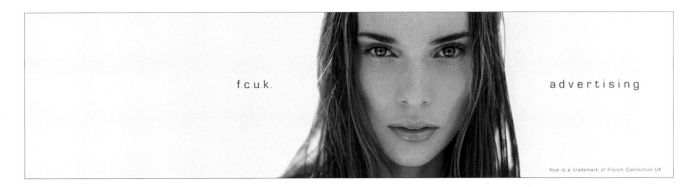

Merit
**POSTER DESIGN, BILLBOARD, DIORAMA,
OR PAINTED SPECTACULAR, SERIES**
f.c.u.k. Advertising

ART DIRECTOR *Bil Bungay*
CREATIVE DIRECTOR *Trevor Beattie*
COPYWRITER *Trevor Beattie*
DESIGNER *Tony Humphrey*
PHOTOGRAPHER *Neil Davenport*
AGENCY *BDDP-GGT Ltd.*
CLIENT *Stephen Marks (f.c.u.k.)*
COUNTRY *England*

Merit
PACKAGE DESIGN, LABELS, SERIES
City of City

ART DIRECTOR *Akio Okumura*
DESIGNER *Mitsuo Ueno*
STUDIO *Packaging Create Inc.*
CLIENT *City of City*
COUNTRY *Japan*

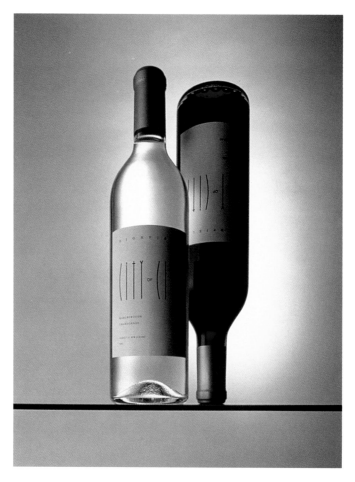

Merit
PACKAGE DESIGN, LABELS OR HANG TAGS
Martha by Mail, Sun Impressions Kit

ART DIRECTOR *Debra Bishop*
COPYWRITER *Jennifer Cegielski*
DESIGNER *Debra Bishop*
ILLUSTRATORS *Shannon Goodson, Harry Bates*
PRODUCT DEVELOPER *Silke Stoddard*
STUDIO *Martha Stewart Living*
CLIENT *Martha by Mail/*
Martha Stewart Living Omnimedia
COUNTRY *United States*

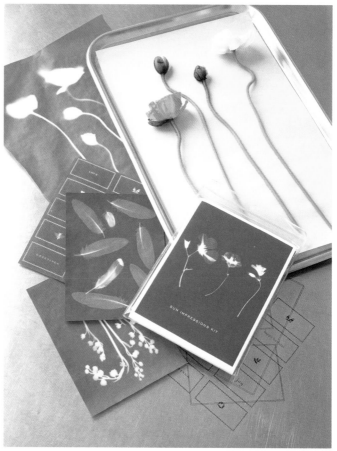

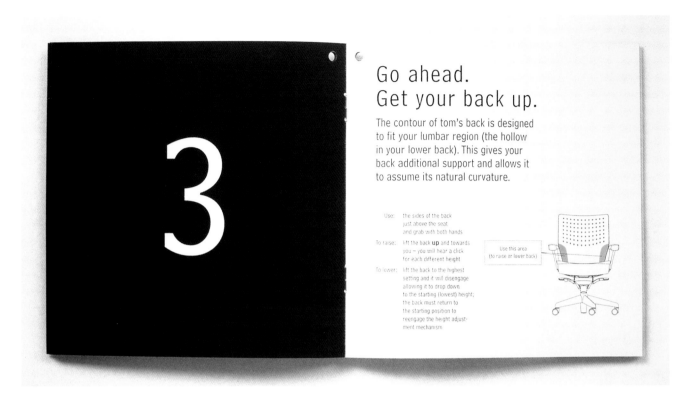

Merit
PACKAGE DESIGN, HANG TAGS
Tom Hangtag

ART DIRECTORS *John Pylypczak, Diti Katona,*
COPYWRITER *John Pylypczak*
DESIGNER *John Pylypczak*
STUDIO *Concrete Design Communications Inc.*
CLIENT *Keilhauer Industries Ltd.*
COUNTRY *Canada*

Merit

PACKAGE DESIGN, ENTERTAINMENT, SERIES

Da Hool CD's

ART DIRECTORS *Stefan Bogner, Boris Simon*
CREATIVE DIRECTOR *Stefan Bogner*
DESIGNER *Stefan Bogner*
AGENCY *Factor Product*
CLIENT *BMG Music/Kosmo Records*
COUNTRY *Germany*

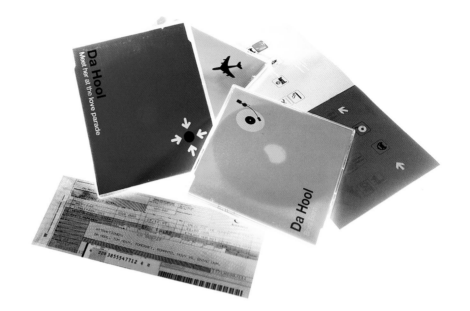

Merit

PACKAGE DESIGN, ENTERTAINMENT

Cuba: I am Time. CD Boxed Set

ART DIRECTOR *Laurie Goldman*
CREATIVE DIRECTOR *Carol Bobolts*
DESIGNERS *Laurie Goldman, Kristina Dimatteo*
PHOTOGRAPHER *Jack O'Neil*
ILLUSTRATOR *Laurie Goldman*
STUDIO *Red Herring Design*
CLIENT *Blue Jackel Entertainment*
COUNTRY *United States*

Merit
PACKAGE DESIGN, ENTERTAINMENT
Imani Coppola

ART DIRECTOR *Kiku Yamaguchi*
PHOTOGRAPHER *Nina Schultz*
STUDIO *Sony Music Creative Services*
CLIENT *Sony Music*
COUNTRY *United States*

Merit
PACKAGE DESIGN, ENTERTAINMENT
Pond "Rock Collection"

ART DIRECTOR *Mary Maurer*
PHOTOGRAPHER *John Clark*
STUDIO *Sony Music Creative Services*
CLIENT *Sony Music*
COUNTRY *United States*

Merit
PACKAGE DESIGN, ENTERTAINMENT
Dogs Eye View–Daisy

ART DIRECTOR *Gail Marowitz*
CREATIVE DIRECTOR *Gail Marowitz*
DESIGNER *Gail Marowitz*
PHOTOGRAPHER *Randall Slavin*
ILLUSTRATOR *Marion Peck*
STUDIO *Sony Music Creative Services*
CLIENT *Columbia Records*
COUNTRY *United States*

Merit
PACKAGE DESIGN, ENTERTAINMENT
The Tango Lesson

ART DIRECTOR *Roxanne Slimak*
EDITORIAL DIRECTOR *Richard Haney-Jardine*
DESIGNER *Roxanne Slimak*
PHOTOGRAPHER *Christopher Porter*
(Adventure Pictures)
DIRECTOR *Sally Potter*
MUSIC *Sony Music*
STUDIO *Sony Music Creative Services*
CLIENT *Sony Classical*
COUNTRY *United States*

Merit
PACKAGE DESIGN, ENTERTAINMENT
King Britt Presents Sylk 130

ART DIRECTOR *Aimee Macauley*
PHOTOGRAPHER *Katrin Thomas*
STUDIO *Sony Music Creative Services*
CLIENT *ovum recordings*
COUNTRY *United States*

Merit

PACKAGE DESIGN, ENTERTAINMENT

Tan Dun/Yo Yo Ma–Symphony

ART DIRECTOR *Roxanne Slimak*
DESIGNER *Roxanne Slimak*
PRODUCER *Steven Epstein*
MUSIC *Sony Music*
STUDIO *Sony Music Creative Services*
CLIENT *Sony Classical*
COUNTRY *United States*

Merit

PACKAGE DESIGN, ENTERTAINMENT

Anthology of American Folk Music

ART DIRECTOR *Scott Stowell*
COPYWRITERS *Various*
DESIGNERS *Scott Stowell, William Morrisey*
PHOTOGRAPHERS *Various*
ILLUSTRATOR *Harry Smith*
STUDIO *Open*
CLIENT *Smithsonian Folkways Recordings*
COUNTRY *United States*

Merit

PACKAGE DESIGN, ENTERTAINMENT

Roy Orbison "Black & White" Pop-up Star Card

ART DIRECTOR *Bill Brunt*
CREATIVE DIRECTORS *Bill Brunt, Tanja Crouch*
DESIGNERS *Bill Brunt, Blake Morgan*
PHOTOGRAPHER *James Schnepe*
STUDIO *Bill Brunt Designs*
CLIENT *Orbison Records*
COUNTRY *United States*

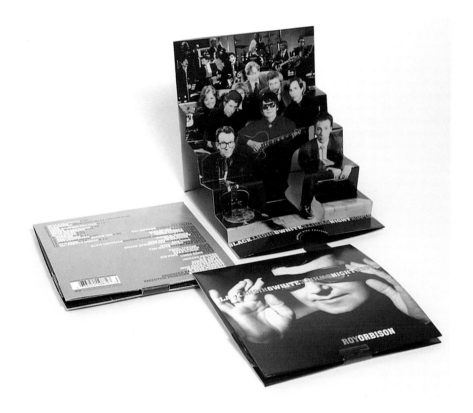

Merit

PACKAGE DESIGN, ENTERTAINMENT

Billy Thompson CD

ART DIRECTOR *Scott Mires*
CREATIVE DIRECTOR *Scott Mires*
DESIGNER *Jeff Samaripa*
PHOTOGRAPHER *Chris Wimpey*
ILLUSTRATOR *John DeMarco*
STUDIO *Mires Design Inc.*
CLIENT *Billy Thompson*
COUNTRY *United States*

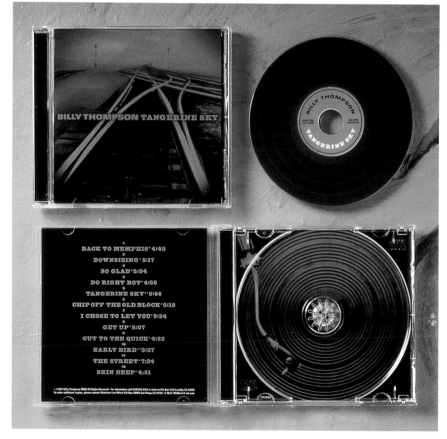

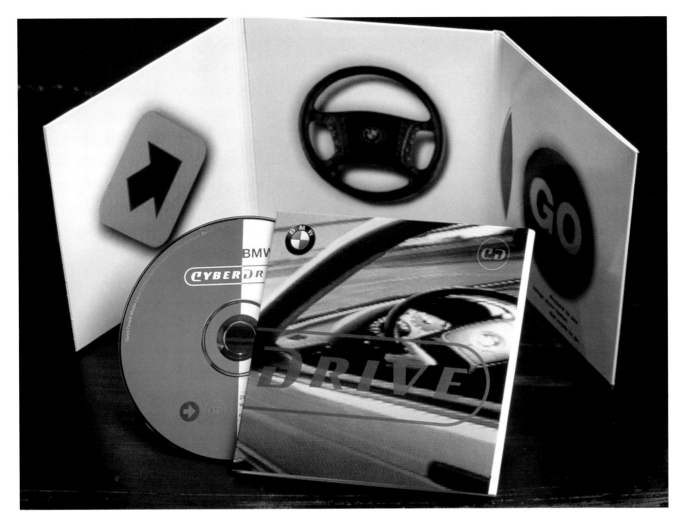

Merit
PACKAGE DESIGN, SOFTWARE/OFFICE
BMW CyberDrive Packaging

ART DIRECTOR *Alan Colvin*
CREATIVE DIRECTOR *Joe Duffy*
COPYWRITER *Chuck Carlson*
DESIGNER *Alan Colvin*
PHOTOGRAPHER *Paul Irmiter (Parallel Productions)*
ILLUSTRATORS *Alan Colvin, Cindy Bennett*
STUDIO *Duffy Design*
CLIENT *BMW of America*
COUNTRY *United States*

Merit
PACKAGE DESIGN, FOOD/BEVERAGE, SERIES
Vinopolis House Wine

ART DIRECTOR *Mary Lewis*
COPYWRITER *Tony Hodges*
DESIGNERS *Mary Lewis, Ann Marshall*
ILLUSTRATOR *Nin Glaister*
AGENCY *Lewis Moberly*
CLIENT *Tony Hodges (Wineworld PLC)*
COUNTRY *England*

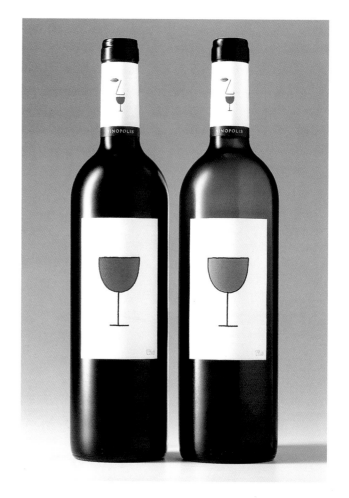

Merit
PACKAGE DESIGN, FOOD/BEVERAGE
Francis Coppola Family Wines

ART DIRECTOR *Jeanne Greco*
CREATIVE DIRECTOR *Francis Ford Coppola*
COPYWRITER *Scott McLeod*
DESIGNER *Jeanne Greco*
CALLIGRAPHER *Jeanne Greco*
STUDIO *Caffe Greco Design*
CLIENT *Niebaum/Coppola Estate/
Vineyards & Winery*
COUNTRY *United States*

Merit
PACKAGE DESIGN, FOOD/BEVERAGE
Columbus Salame: Renaissance 4-Pack

ART DIRECTOR *Kit Hinrichs*
DESIGNERS *Jackie Foshaug, Garth Jordan*
STUDIO *Pentagram Design, Inc.*
CLIENT *Phil Gatto, President (Columbus Salame Co.)*
COUNTRY *United States*

Merit
PACKAGE DESIGN, FOOD/BEVERAGE
President's Choice Chocolatique Deluxe Imported Biscuits

CREATIVE DIRECTOR *Philip Pietrasiak*
COPYWRITER *Sharron Elkouby*
DESIGNERS *Beth Keys, Jennifer McCarrison*
ILLUSTRATOR *François Robert*
STUDIO *Loblaws Brands Limited*
CLIENT *Loblaws Brands Limited*
COUNTRY *Canada*

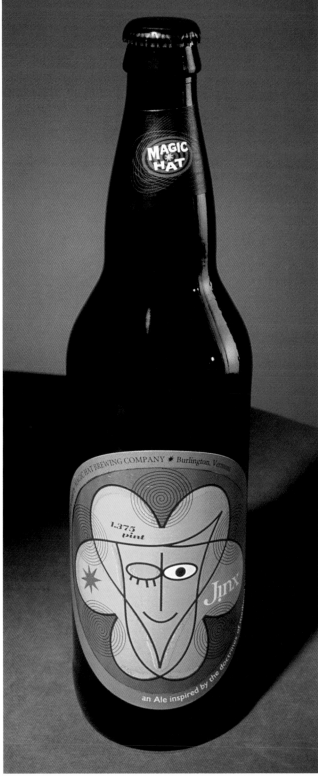

Merit
PACKAGE DESIGN, FOOD/BEVERAGE
DV8

CREATIVE DIRECTOR *Joseph McGlennon*
COPYWRITER *Robert Tsao*
DESIGNER *Dominique Butler*
AGENCY *Dentsu, Young & Rubicam*
CLIENT *Asia Pacific Breweries*
COUNTRY *Singapore*

Merit
PACKAGE DESIGN, FOOD/BEVERAGE
Magic Hat Jinx

ART DIRECTOR *David Covell*
CREATIVE DIRECTOR *Michael Jager*
DESIGNER *David Covell*
STUDIO *Jager DiPaola Kemp Design*
CLIENT *Magic Hat Brewing Co.*
COUNTRY *United States*

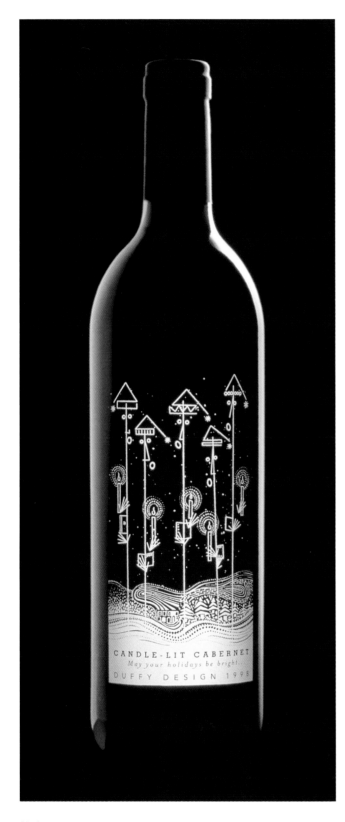

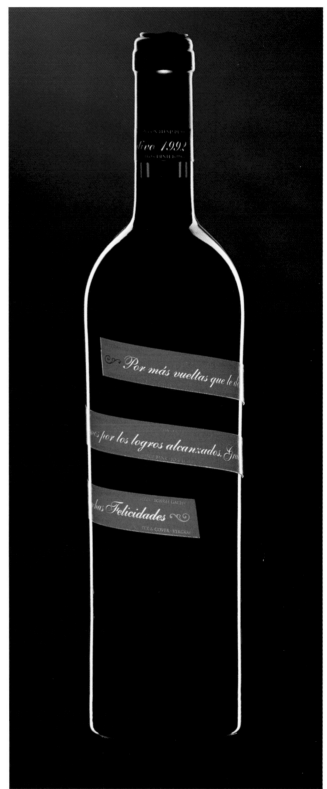

Merit
PACKAGE DESIGN, FOOD/BEVERAGE
Candle-Lit Cabernet–Duffy Design, 1998

ART DIRECTOR *Neil Powell*
CREATIVE DIRECTOR *Joe Duffy*
DESIGNER *Missy Wilson*
ILLUSTRATOR *Missy Wilson*
AGENCY *Duffy Design*
CLIENT *Duffy Design*
COUNTRY *United States*

Merit
PACKAGE DESIGN, FOOD/BEVERAGE
Christmas Gift

CREATIVE DIRECTOR *Gonzalo Berro*
DESIGNERS *Gonzalo Berro, Macarena Ubios*
STUDIO *Cato Berro Diseño*
CLIENT *Cato Berro Diseño*
COUNTRY *Argentina*

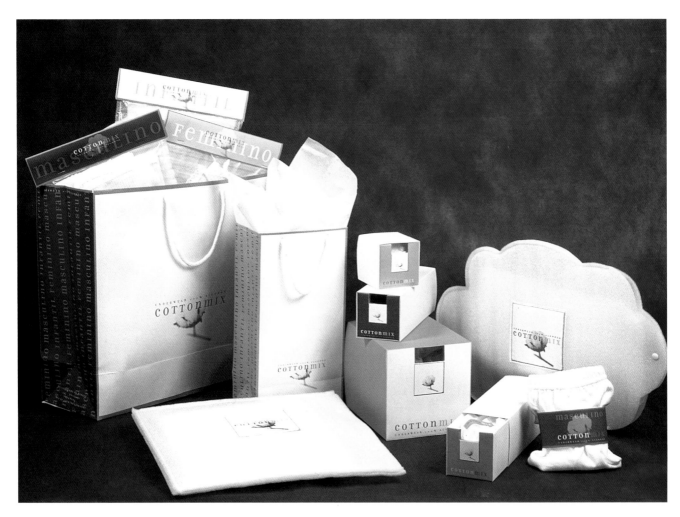

Merit
PACKAGE DESIGN, FASHION/APPAREL, SERIES
*Linha de embalagens para una loja de underwear 100%
algodào (Packaging for a 100% Cotton Underwear Shop)*

CREATIVE DIRECTOR *Ney Valle*
COPYWRITER *Dupla Design*
DESIGNERS *Claudia Gamboa, Ney Valle,
Fernanda Paes*
ILLUSTRATOR/IMAGE MANIPULATION
Rogério Varela
STUDIO *Dupla Design*
CLIENT *Cottonmix*
COUNTRY *Brazil*

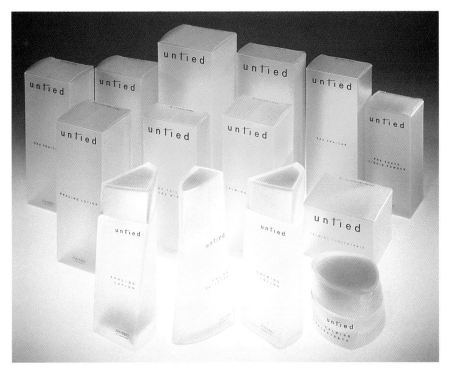

Merit
PACKAGE DESIGN, COSMETICS
Untied

ART DIRECTORS *Syunsaku Sugiura, Tetsuo Hiro*
CREATIVE DIRECTOR *Syunsaku Sugiura*
DESIGNERS *Sergio Calatroni, Taisuke Kikuchi*
LOGOTYPE DESIGNERS *Katsuhiko Shibuya,*
David Habball
AGENCY *Shiseido Creation Department*
CLIENT *Shiseido Co., Ltd.*
COUNTRY *Japan*

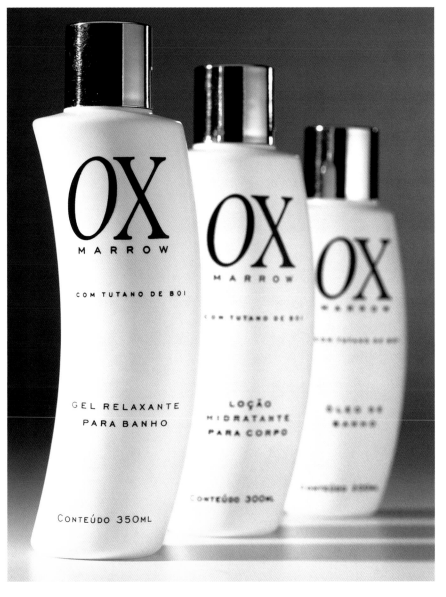

Merit
PACKAGE DESIGN, COSMETICS, SERIES
Ox Marrow

ART DIRECTORS *Margarete Takeda, Renata Melman*
CREATIVE DIRECTORS *Margarete Takeda,*
Renata Melman
DESIGNERS *Margarete Takeda, Renata Melman*
AGENCY *a10 Design Comunicação*
CLIENT *Ox Marrow*
COUNTRY *Brazil*

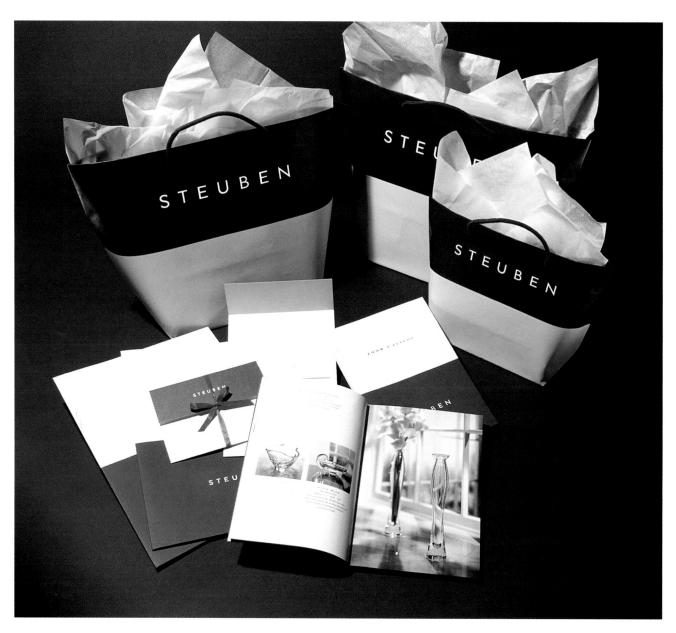

Merit
**PACKAGE DESIGN, GIFT/SPECIALTY PRODUCT,
SERIES**
Steuben Shopping Bag

ART DIRECTOR *Takaaki Matsumoto*
DESIGNERS *Takaaki Matsumoto, Tina Gianesini*
STUDIO *Matsumoto Incorporated*
CLIENT *Steuben*
COUNTRY *United States*

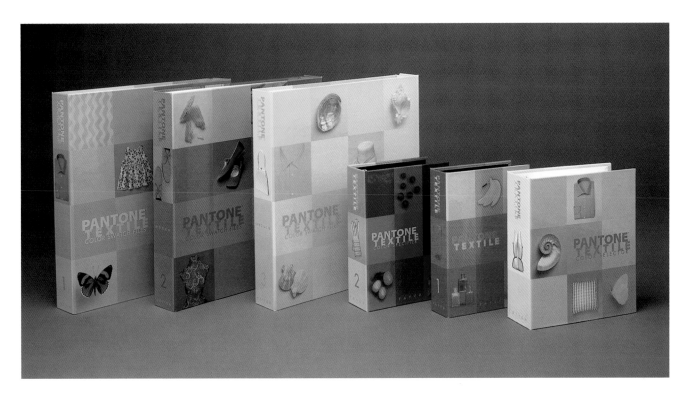

Merit
**PACKAGE DESIGN, GIFT/SPECIALTY PRODUCT,
SERIES**
Pantone Textile Color System Binders

ART DIRECTOR *Bridget de Socio*
DESIGNERS *Bridget de Socio, Ninja V. Oertzen*
PHOTOGRAPHER *Victor Schraeger*
STYLISTS *Lita Bosert, Annaliese Estrada, Leah Levin*
STUDIO *Socio X*
CLIENT *Pantone, Inc.*
COUNTRY *United States*

Merit

PACKAGE DESIGN, GIFT/SPECIALTY PRODUCT, SERIES

Lewis Carroll Photo Album • Borges Journal • Alphabet Book

ART DIRECTOR *Gretchen Scoble*
DESIGNER *Gretchen Scoble*
ILLUSTRATOR *Jeffrey Fisher*
PUBLISHER *Chronicle Books*
CLIENT *Chronicle Books*
COUNTRY *United States*

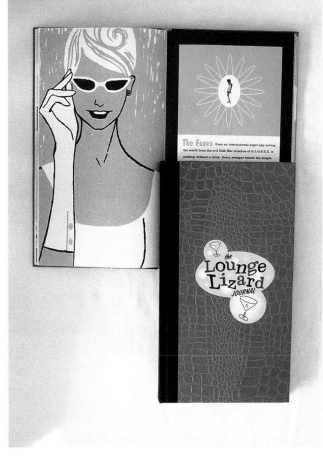

Merit
**PACKAGE DESIGN, GIFT/SPECIALTY PRODUCT,
SERIES**
Kahala

ART DIRECTOR *Akio Okumura*
DESIGNER *Akio Okumura*
STUDIO *Packaging Create Inc.*
CLIENT *Kahala*
COUNTRY *Japan*

Merit
PACKAGE DESIGN, GIFT/SPECIALTY PRODUCT
The Lounge Lizard Journal

COPYWRITER *Sam Wick*
DESIGN FIRM *Michael Mabry Design*
PUBLISHER *Chronicle Books*
CLIENT *Chronicle Books*
COUNTRY *United States*

Merit
PACKAGE DESIGN, RETAIL: HOUSE BRAND, SERIES
Winston Packaging

CREATIVE DIRECTOR *Joe Duffy*
DESIGNER *Kevin Flatt*
ILLUSTRATOR *Kevin Flatt*
STUDIO *Duffy Design*
CLIENT *RJ Reynolds*
COUNTRY *United States*

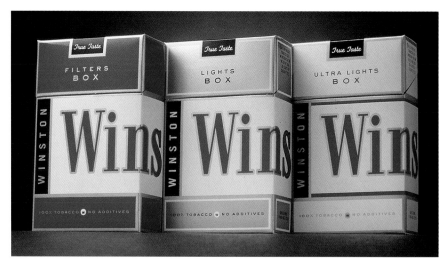

Merit
PACKAGE DESIGN, RETAIL: HOUSE BRAND, SERIES
Gift Package

ART DIRECTOR *Bill Martinez*
CREATIVE DIRECTOR *Flávio Marialva*
DESIGNER *Alexandre Gasparello*
ILLUSTRATOR *Sig Bergamin*
PRODUCER *Neide Bezerra*
AGENCY *Sell Comunicação*
STUDIO *By Design*
CLIENT *Sig & Joelle*
COUNTRY *Brazil*

Merit
PACKAGE DESIGN, MISCELLANEOUS
Creative Retreat Hat

ART DIRECTOR *Kobe*
CREATIVE DIRECTORS *Joe Duffy, Bill Westbrook*
DESIGNERS *Kobe, Craig Duffney*
ILLUSTRATOR *Craig Duffney*
STUDIO *Duffy Design*
CLIENT *Fallon McElligott/Duffy Design*
COUNTRY *United States*

Merit
**ENVIRONMENTAL DESIGN, DISPLAY OR
MERCHANDISING EXHIBIT**
Paper Show Takeo "Yawaragami"
(Handmade Japanese Paper)

ART DIRECTOR *Kotaro Hirano*
DESIGNER *Takashi Sumi*
PHOTOGRAPHER *Masayuki Hayashi*
PAPER SCULPTOR *Yoichi Fujimori*
STUDIO *Kotaro Hirano*
CLIENT *Takeo Co., Ltd.*
COUNTRY *Japan*

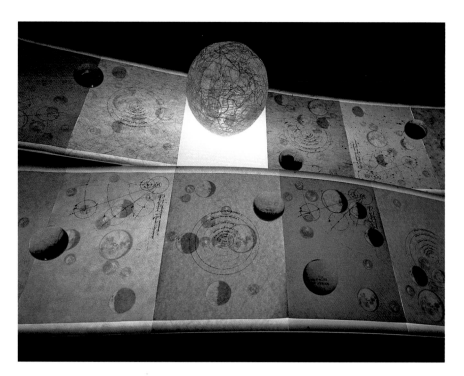

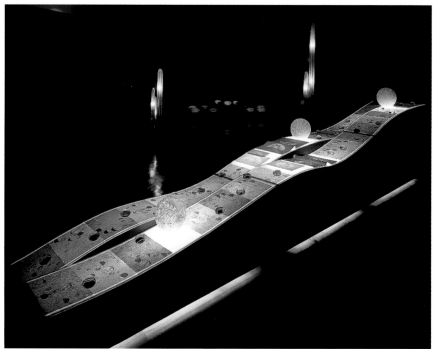

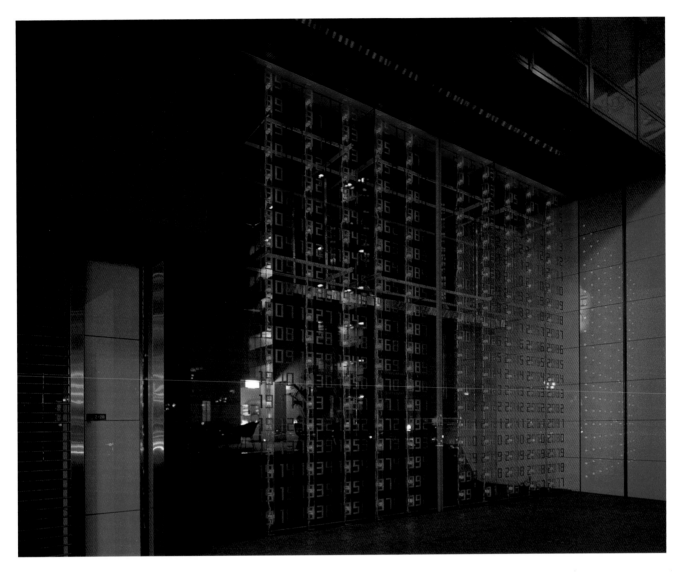

Merit
**ENVIRONMENTAL DESIGN, DISPLAY OR
MERCHANDISING EXHIBIT**
Shiseido Window Display, Osaka

ART DIRECTOR *Aoshi Kudo*
CREATIVE DIRECTOR *Masao Ohta*
DESIGNER *Aoshi Kudo*
AGENCY *Shiseido Creation Department*
CLIENT *Shiseido Co., Ltd.*
COUNTRY *Japan*

Merit

**ENVIRONMENTAL DESIGN, DISPLAY OR
MERCHANDISING EXHIBIT**
Shiseido Window Display, Tokyo

ART DIRECTOR *Aoshi Kudo*
CREATIVE DIRECTOR *Masao Ohta*
DESIGNER *Aoshi Kudo*
AGENCY *Shiseido Creation Department*
CLIENT *Shiseido Co., Ltd*
COUNTRY *Japan*

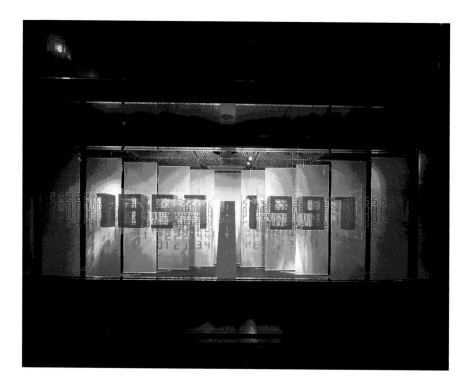

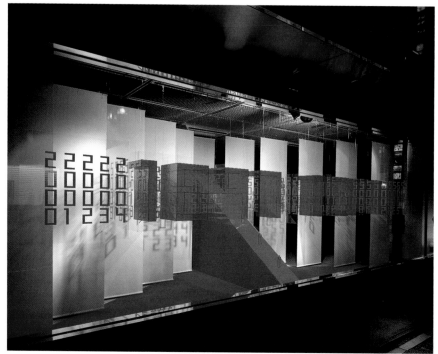

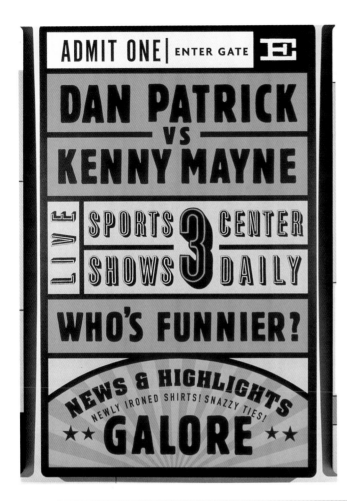

Merit
ENVIRONMENTAL DESIGN, INDOOR ENVIRONMENT
ESPN Trade Show Booth Exhibits & Posters

ART DIRECTORS *Sally Morrow, Jon Olsen*
CREATIVE DIRECTORS *Steve Sandstrom, Sally Morrow*
COPYWRITER *Matt Elhardt*
DESIGNERS *Jon Olsen, Sally Morrow, John Bohls*
EXHIBIT HOUSE *Display Works*
AGENCY *Sandstrom Design*
CLIENT *ESPN*
COUNTRY *United States*

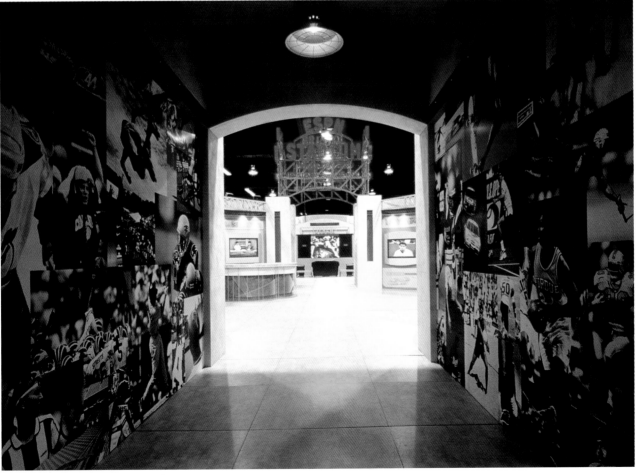

Merit
ENVIRONMENTAL DESIGN, INDOOR ENVIRONMENT
The Globe Restaurant

PRINCIPAL ARCHITECT *James Biber*
PRINCIPAL DESIGNER *Paula Scher*
ASSOCIATE ARCHITECT *Michael Zweck-Bronner*
DESIGNERS *James Cleary, Karen Moustafellos,
Tanya Van Cott (interior), Keith Daigle,
Jana Mella (graphics)*
PHOTOGRAPHERS *Peter Margonelli, Andrew Bord
(interior), Richard Bachmann (graphics)*
STUDIO *Pentagram Design*
CLIENTS *Jim Heckler, Nick Polsky (The Globe)*
COUNTRY *United States*

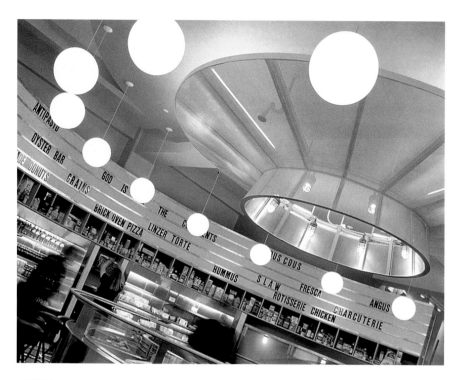

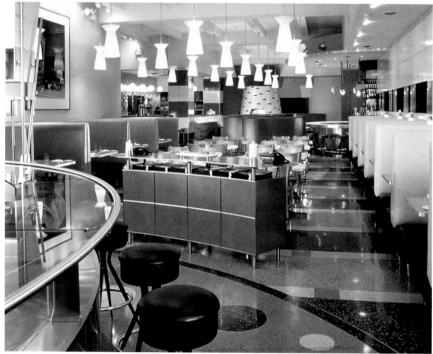

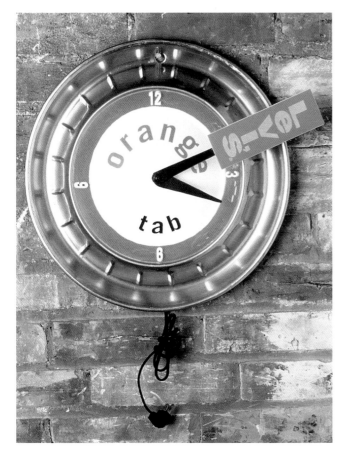

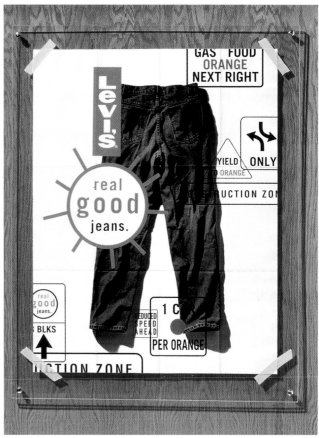

Merit
ENVIRONMENTAL DESIGN, INDOOR ENVIRONMENT
Levi's Orange Tab

CREATIVE DIRECTOR *Brian Collins*
(Foote Cone & Belding San Francisco)
COPYWRITER *Jeff Mueller*
DESIGNERS *Sharon Werner, Sarah Nelson*
PHOTOGRAPHERS *Eidur Snörri, Darrell Eager*
STUDIO *Werner Design Werks, Inc.*
CLIENT *Foote Cone & Belding San Francisco*
COUNTRY *United States*

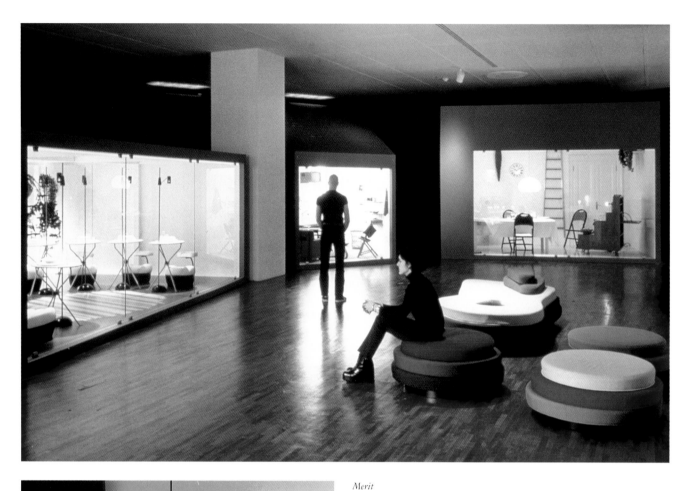

Merit
**ENVIRONMENTAL DESIGN, GALLERY/MUSEUM
EXHIBIT OR INSTALLATION, SERIES**
Achille Castiglioni: Design!

ART DIRECTORS *Paola Antonelli, Jerry Neuner,
Greg Van Alstyne*
CREATIVE DIRECTOR *Paola Antonelli*
COPYWRITER *Paola Antonelli*
DIRECTOR *Paola Antonelli*
DESIGNERS *Jerry Neuner, Greg Van Alstyne*
PHOTOGRAPHER *Michael Moran*
ILLUSTRATOR *Steven Guarnaccia*
STUDIO *The Museum of Modern Art*
CLIENT *The Museum of Modern Art*
COUNTRY *United States*

Merit

**TELEVISION, FILM AND VIDEO DESIGN,
TV BROADCAST GRAPHICS: IDENTITIES,
OPENINGS, TEASERS**
Microwave ID

ART DIRECTORS *Reuben Lee, Katherine Lynch*
CREATIVE DIRECTORS *Amy Nagasawa, Andy Hann*
DESIGNERS *Reuben Lee, Katherine Lynch*
PHOTOGRAPHER *Mike Bergstrom*
ILLUSTRATOR *Lisa Packel*
PRODUCERS *Jacki Pass, Eden Niederhauser*
STUDIO *E! Entertainment Television*
CLIENT *E! Entertainment Television*
COUNTRY *United States*

Merit
**TELEVISION, FILM AND VIDEO DESIGN,
TV BROADCAST GRAPHICS: IDENTITIES,
OPENINGS, TEASERS**
Monk ID

ART DIRECTOR *Carrie Hirsch*
CREATIVE DIRECTORS *Amy Nagasawa, Andy Hann*
DESIGNER *Carrie Hirsch*
PHOTOGRAPHER *Mike Bergstrom*
ILLUSTRATOR *Lisa Packel*
PRODUCERS *Jacki Pass, Eden Niederhauser*
STUDIO *E! Entertainment Television*
CLIENT *E! Entertainment Television*
COUNTRY *United States*

(facing page)
Merit
**TELEVISION, FILM AND VIDEO DESIGN,
TV BROADCAST GRAPHICS: IDENTITIES,
OPENINGS, TEASERS**
Behaviour's Identity

ART DIRECTOR *Orazio Fantini*
CREATIVE DIRECTOR *Orazio Fantini*
DIRECTOR *Orazio Fantini*
DESIGNER *Orazio Fantini*
COMPUTER GRAPHICS ARTIST *Guy Lampron*
FLAME ARTIST *Patrick Bergeron*
MAC PAINTING *René Morel*
PRODUCER *Hans van der Sluys*
MUSIC *Jane Tattersal*
AGENCY *Behaviour Design Inc.*
STUDIO *Behaviour Design Inc.*
CLIENT *Behaviour Communications Inc.*
COUNTRY *Canada*

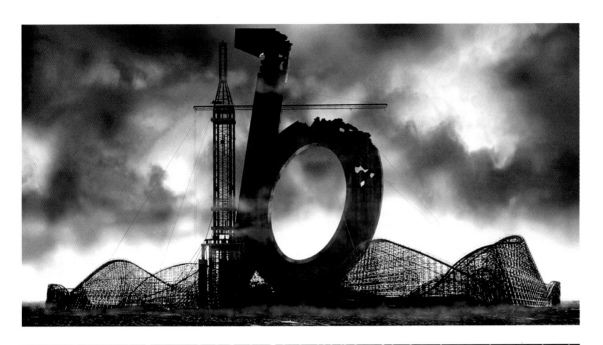

Merit
**TELEVISION, FILM AND VIDEO DESIGN,
TV BROADCAST GRAPHICS: IDENTITIES,
OPENINGS, TEASERS**
MTV House of Style

ART DIRECTOR *Romy Mann*
DESIGNER *Rodger Belknap*
HAL ARTIST *Betsy Brydon*
PRODUCER *Rodger Belknap*
STUDIO *MTV Networks*
CLIENT *MTV Networks*
COUNTRY *United States*

Merit
**TELEVISION, FILM AND VIDEO DESIGN,
OPENING TITLE SEQUENCE**
Fashion Emergency Open

ART DIRECTORS *Katherine Lynch, Carrie Hirsch*
CREATIVE DIRECTOR *Amy Nagasawa*
COPYWRITERS *Katherine Lynch, Carrie Hirsch,
Colleen Lehman, Stacey Batzer*
DESIGNERS *Katherine Lynch, Carrie Hirsch*
PHOTOGRAPHER *Andrew Turman*
ILLUSTRATOR *Georgia Deaver*
PRODUCERS *Jacki Pass, Colleen Lehman, Molly Lyda*
MUSIC *Elyse Schiller, Jim Watson*
STUDIO *E! Entertainment Television*
CLIENT *E! Entertainment Television*
COUNTRY *United States*

Merit
**TELEVISION, FILM AND VIDEO DESIGN,
OPENING TITLE SEQUENCE**
Baroque

ART DIRECTOR *Jessie Huang*
CREATIVE DIRECTOR *Chris Do*
ANIMATORS *Jessie Huang, Vanessa Marzaroli,
Chris Do*
PRODUCER *Jean Kim*
STUDIO *Blind Visual Propaganda, Inc.*
CLIENT *Inertia Pictures*
COUNTRY *United States*

Merit
**TELEVISION, FILM AND VIDEO DESIGN,
OPENING TITLE SEQUENCE**
Chocolate Titles

ART DIRECTOR *Geoff McFetridge*
CREATIVE DIRECTOR *Geoff McFetridge*
COPYWRITER *Geoff McFetridge*
DESIGNER *Geoff McFetridge*
ANIMATOR *Johannes Gamble*
PRODUCER *Ben Pjorn*
STUDIO *Champion Graphics*
CLIENT *Girl/Chocolate Skateboards*
COUNTRY *United States*

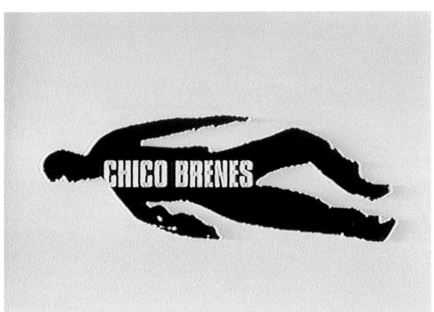

Merit
**TELEVISION, FILM AND VIDEO DESIGN,
OPENING TITLE SEQUENCE**
Underwear Stories

ILLUSTRATOR *Blair Thornley*
DIRECTOR *Wolfgang Hastert*
PRODUCER *Wolfgang Hastert*
MUSIC *Dimitri of Paris*
STUDIO *Wolfgang Hastert Productions*
CLIENT *ZDF/ARTE Television*
COUNTRY *United States*

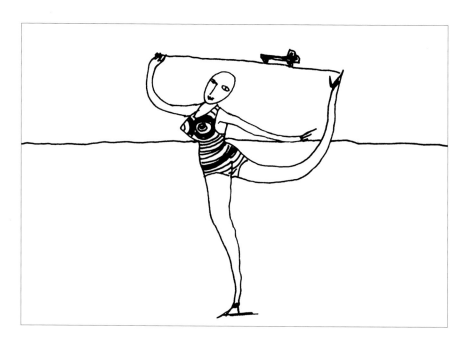

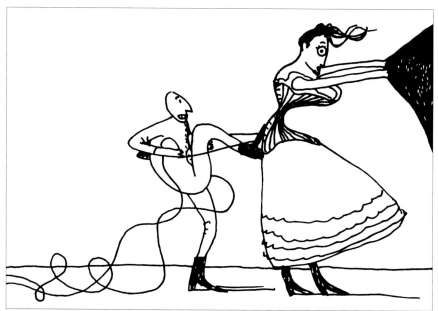

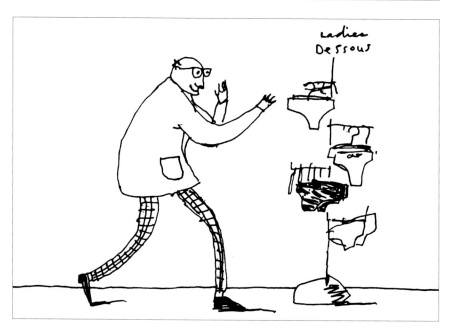

Merit
**TELEVISION, FILM AND VIDEO DESIGN,
OPENING TITLE SEQUENCE**
GUN

CREATIVE DIRECTOR *Jennifer Grey*
DESIGNER *Earl Jenshus*
CINEMATOGRAPHER *Tom Camarda*
DIRECTOR *Earl Jenshus*
EXECUTIVE PRODUCER *Billy Pittard*
PRODUCER *Sari Rosen*
MUSIC *U2*
STUDIO *Pittard Sullivan*
CLIENT *Kushner/Locke*
COUNTRY *United States*

Merit

**TELEVISION, FILM AND VIDEO DESIGN,
SELF-PROMOTION OR ART VIDEO**
Demo Reel Opener

ART DIRECTOR *Thomas Heinelt*
CREATIVE DIRECTOR *Mark Rowntree*
DESIGNER *Thomas Heinelt*
DIRECTOR *Thomas Heinelt*
PRODUCER *Jason Abdullah*
MUSIC *Perry Geyer (Cybersound),*
Roger Miller (Fun World Music)
STUDIO *Rowntree 3D*
CLIENT *Rowntree 3D*
COUNTRY *United States*

Merit
**BROADCAST DESIGN CRAFTS, ANIMATION,
CAMPAIGN**
Animate Your World: Bob • Can't • Percolate

ART DIRECTOR *Bee Murphy*
EXECUTIVE CREATIVE DIRECTOR *Michael Ouweleen*
DESIGNER *Denis Morella*
ANIMATORS *Philip Ames, Cathy Carlson, Leo Garza,
James Munro, Benjamin Goldman, Giles Mallory
(Giant Pictures)*
COPYWRITER *Meredith Fierman*
EXECUTIVE PRODUCERS *Anne Smith, David Starr*
PRODUCTION MANAGER *Craig Medrecky*
DIRECTORS *Denis Morella, John Robertson
(Flea Circus)*
ART FABRICATOR *Graham Maiden*
EDITOR *Greg Gilmore*
EDITORIAL HOUSE *Western Images*
AGENCY *Cartoon Network*
STUDIO *Curious Pictures*
CLIENT *Cartoon Network*
COUNTRY *United States*

Merit
BROADCAST DESIGN CRAFTS, ANIMATION
Christmas

ART DIRECTOR *Robert Smigel*
CREATIVE DIRECTOR *Robert Smigel*
COPYWRITERS *Robert Smigel,*
Michelle Saks Smigel, Louis C.K.
DESIGNER *David Wachtenheim*
ILLUSTRATOR *David Wachtenheim*
DIRECTOR *David Wachtenheim*
PRODUCER *J.J. Sedelmaier*
MUSIC *Existing Audio*
AGENCY *Saturday Night Live/NBC*
STUDIO *J.J. Sedelmaier Productions, Inc.*
CLIENT *NBC*
COUNTRY *United States*

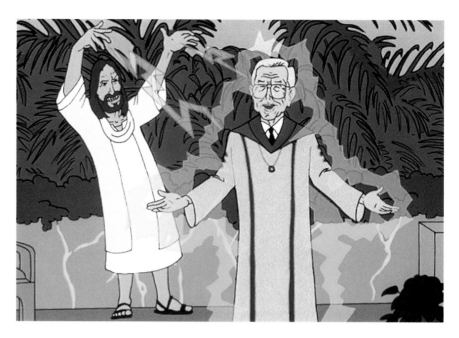

Merit
BROADCAST DESIGN CRAFTS, ANIMATION
Casablanca

ART DIRECTOR *Robert Smigel*
CREATIVE DIRECTOR *Robert Smigel*
COPYWRITER *Robert Smigel*
DESIGNERS *Brian Gaidry, Don McGrath*
ILLUSTRATORS *Brian Gaidry, Don McGrath*
DIRECTOR *J.J. Sedelmaier*
PRODUCER *J.J. Sedelmaier*
MUSIC *Existing Audio*
AGENCY *Saturday Night Live/NBC*
STUDIO *J.J. Sedelmaier Productions, Inc.*
CLIENT *NBC*
COUNTRY *United States*

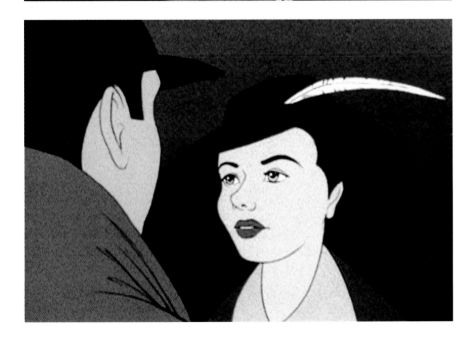

photography and illustration

Photography and Illustration entries were judged by the same group of judges who selected the Graphic Design winners. When forming the panel, I made a point of recruiting some judges with strong expertise and extensive experience in illustration, within their graphic design realm, specifically within editorial design.

Photographers and illustrators seem to be too often marginalized in the art direction process. This trend is exacerbated by the emergence of photo-manipulation computer programs.

Let's hope that the medals awarded this year to brilliant illustrations and compelling photo imaging projects will draw renewed attention to these two disciplines in the years to come.

—Mirko Ilić
Mirko Ilić Corporation
United States

photography and illustration
gold and silver

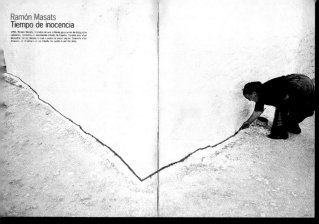

Ramón Masats
Tiempo de inocencia

1996. Ramón Masats, miembro de una brillante generación de fotógrafos catalanes, combina un apasionante retrato de España. Durante diez años Con su cámara cerca al centro a poetas de pasar pájaros. Cuarenta años después, es el clímax en un estado. Su suelto la escrita alto.

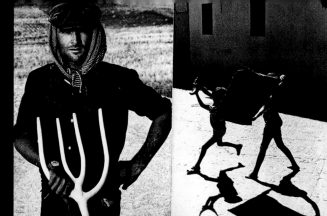

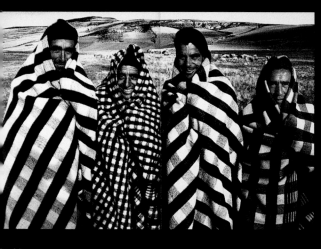

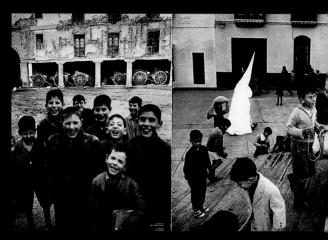

Gold

PHOTOGRAPHY, EDITORIAL OR COVER: NEWSPAPER/MAGAZINE, SERIES

Tiempo de Inocencia (The Time of Innocence)

ART DIRECTOR *Fernando Gutiérrez*
DESIGNERS *Fernando Gutiérrez, Pablo Martin, Emmanuel Ponty, Xavi Roca, María Ulecia*
PHOTOGRAPHER *Ramón Masats*
PHOTO EDITOR *Luis de las Alas*
ART WORK *María Ulecia*
PUBLISHER *La Fábrica*
EDITOR *Alberto Anaut*
PRINTER *TF, Artes Gráficas*
STUDIO *Grafica*
CLIENT *La Fábrica*

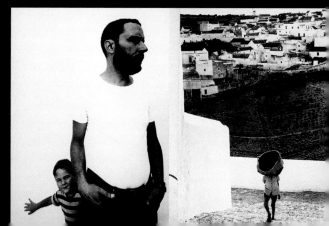

PAULO NOZOLINO
PAULO NOZOLINO, FOTÓGRAFO PORTUGUÊS INSTALADO EN PARÍS, RECORRE SU PAÍS DE LA MANO DE UNA GENERACIÓN QUE HA VIVIDO AL LÍMITE, EN EL FILO DE LA NAVAJA. SUS IMÁGENES SON UN RETRATO CARGADO DE EMOCIÓN, ANGUSTIA Y DESENCANTO. UNA HISTORIA DE PRÍNCIPES DESTRONADOS. **EL LARGO VIAJE**

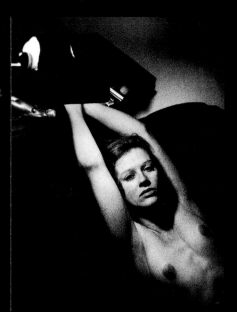

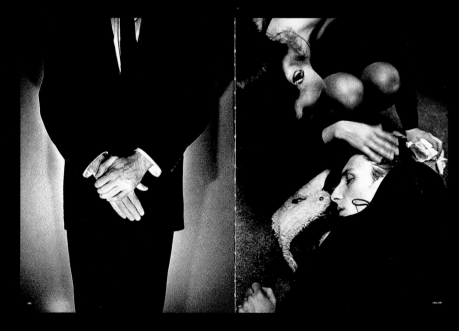

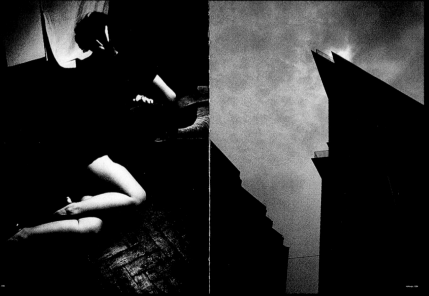

Silver
PHOTOGRAPHY, EDITORIAL OR COVER:
NEWSPAPER/MAGAZINE, SERIES
El Largo Viaje (The Long Journey)

ART DIRECTOR *Fernando Gutiérrez*
DESIGNERS *Fernando Gutiérrez, Pablo Martin,*
Emmanuel Ponty, Xavi Roca, María Ulecia
PHOTOGRAPHER *Paulo Nozolino*
PHOTO EDITOR *Luis de las Alas*
ART WORK *María Ulecia*
PUBLISHER *La Fábrica*
EDITOR *Alberto Anaut*
PRINTER *TF, Artes Gráficas*
STUDIO *Grafica*
CLIENT *La Fábrica*
COUNTRY *Spain*

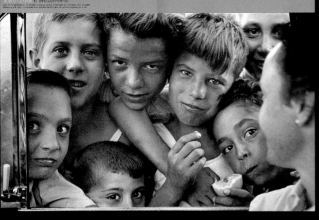

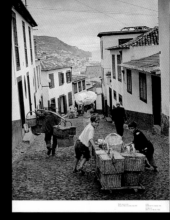

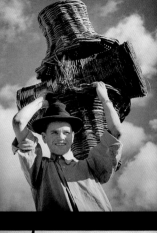

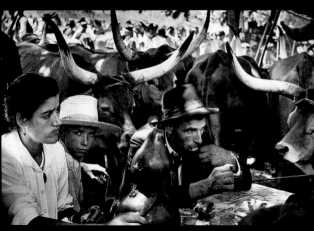

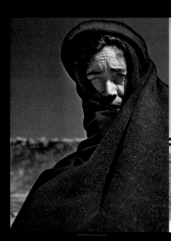

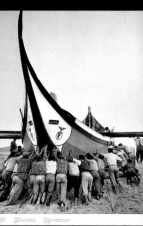

Jean Dieuzaide El descubrimiento

Silver

**PHOTOGRAPHY, EDITORIAL OR COVER:
NEWSPAPER/MAGAZINE, SERIES**

EL CIRCO

IT MAY NOT BE THE GREATEST SHOW ON EARTH, BUT THE MEXICAN CIRCUS IS THE REAL THING.

PHOTOGRAPHS BY MARY ELLEN MARK

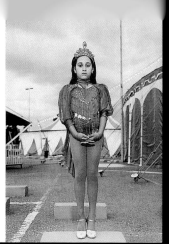

ARY ELLEN MARK doesn't shoot around when it comes to the circus. For nearly thirty years the five daily years the five York photographs, a certified complaint, has regarded the big top as left-entertainment and subject. "It's a universal love of theater," she says. But she elaborates, expresses three-ring extravaganzas of American culture don't punch her ticket, instead, Mark turns her lenses at the gritiest shows on earth—small-scale, hands-on operations in tumult and exotic locales, such as the Circus of Hanoi, the Godo Park Circus of Moscow, and numerous traveling troupes throughout India. Puma caging, Loos-leave productions are, she believes, the true latin to the circus tradition. (They are also similar in spirit to Texas' small-town rodeos, which Mark photographed for Texas Monthly in March 1982.)

This summer Texas Monthly sent Mark on her latest animal sojourn, a two-week tour of eight itinerant circuses in the interior of Mexico. The project entailed a bit of detective work—most outfits are commonly on the move—and inevitably some suspicion of the American stranger, which Mark's enthusiasm quickly diffused. "Circus people are wonderful," she says. "There they can get you appreciation, they are very open. Besides, they have strong American influences in their acts—Batman, Captain America, cowboys, Marilyn Monroe." After obtaining permission to shoot, Mark—whose subjects have also included hobos, teen circus kids, and social protests—always watched a performance before returning to photograph the artists and their animals.

Ladies and gentlemen, on these pages, thirteen photographs that run through the acts and occupy in the character of the center-tilt themselves. Step right up! ANNA TINSLEY

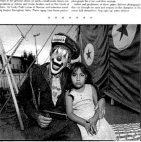

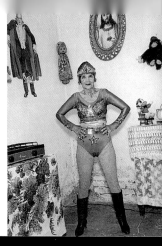

AMERICAN POP CULTURE HAS MARKED THE COSTUMES AND CUSTOMS OF CIRCO FRANZATTI'S PIPO THE CLOWN (ABOVE, WITH A FAN) AND KIMBERLY CROWN CIRCUS' MARINA CAMPA (OPPOSITE). A 78-YEAR-OLD DISCO DANCER WHO PORTRAYS BATMAN'S GRANDMOTHER. PREVIOUS PAGE: THE CROWN PRINCESS OF HER FATHER'S CIRCO ROLEX, ACROBAT MIRIAM STRIKES A REGAL POSE.

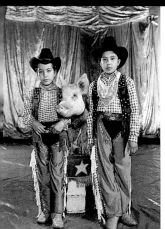

RICKS OF THE TRADE: IN MEXICO, EVEN FARM ANIMALS TAKE CENTER RING. OPPOSITE: SISTER COWGIRLS CLAUDIA (LEFT) AND MARITZA FLANK CIRCO BENNEVIESS' BABE, NAMED FOR THE MOVIE PIGLET. CLOCKWISE FROM TOP LEFT: LESLIE, A DOG TRAINER WITH CIRCO D'PORTUGAL, ASSEMBLES HER CHARGES NEAR THE PUP TENT; PANCHO THE MONKEY RIDES SHEEPISHLY INTO THE SPOTLIGHT WITH CIRCO BENNEVIESS HEADLINER PAUL SAFARI; CIRCO FRANZATTI'S TALL YANKO AND WEE MINA GUARANTEE MONKEYSHINES; AND GUAPA THE ELEPHANT, OF VASQUEZ BROTHERS CIRCUS, SNATCHES A COOKIE FROM GUILLERMO, HER PERSONAL TARZAN.

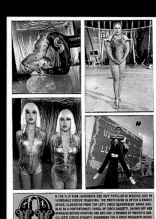

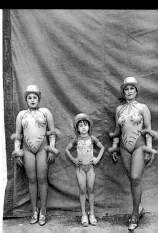

N THE FLIP SIDE: ACROBATS ARE MUY POPULAR IN MEXICO, AND IN VENERABLE CIRCUS TRADITION, THE PROFESSION IS OFTEN A FAMILY AFFAIR. CLOCKWISE FROM TOP LEFT: CIRCO BENNEVIESS' SONIA DOUBLES AS A CONTORTIONIST; YARED, OF CIRCO GARZETTI, SHOWS OFF HER SPANGLES BEFORE STARTING HER ACT; JAIR, A MEMBER OF MEXICO'S GARCIA VERTI CIRCUS DYNASTY, REHEARSES FOR A CIRCO FRANZATTI SHOW; AND PATRICIA (LEFT) AND SONIA OF CIRCO BENNEVIESS ADD MYSTIQUE WITH PLATINUM WIGS. OPPOSITE: CIRCO GARZETTI'S KILMA (CENTER) AND YARED WERE BORN TO THE BIG TOP, JUST LIKE THEIR MOTHER, ARELI.

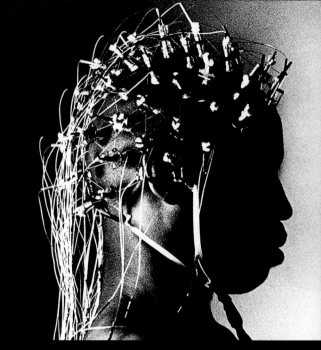

Silver
**PHOTOGRAPHY, CORPORATE/INSTITUTIONAL,
SERIES**
*Solving the Mysteries of the Mind—
Research Imaging Center Brochure*

ART DIRECTOR *Bradford Lawton*
COPYWRITER *Dr. Peter Fox*
DESIGNER *Bradford Lawton*
PHOTOGRAPHER *Arthur Meyerson*
AGENCY *Bradford Lawton Design Group*
CLIENT *University of Texas
Health Science Center*
COUNTRY *United States*

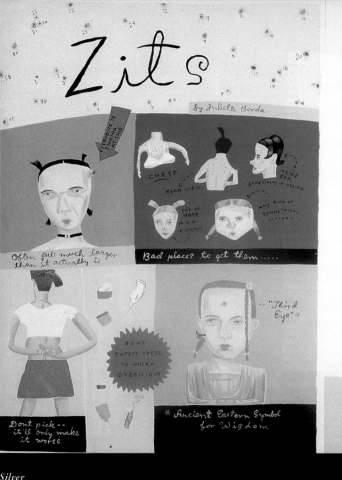

Zits

by Juliette Borda

EVERYONE IS STARING AT THIS

Often feels much larger than it actually is

CHEST

REAR VIEW

INSIDE EAR
ESPECIALLY IF BORING

END OF NOSE (A.K.A. RUDOLPH)

ANY KIND OF SYMMETRICAL PATTERN

Bad places to get them.....

DON'T EXPECT THESE TO WORK OVERNIGHT

-- "Third Eye" *

Don't pick -- it'll only make it worse

* Ancient Eastern Symbol for Wisdom

how to blitz your zits

Everything you ever wanted to know (and some stuff you wish you didn't) about those bum-out bumps and blemishes

By Maria Neuman

You're not the only one

who woke up with a zit today. According to a study from the National Center for Health Statistics, 86.4 percent of all 17-year-olds suffer from varying degrees of acne. "No matter what your skin type, at some point you're going to get acne. Nature just likes to set up shop on your face sometimes," says Dr. Dennis Gross, an NYC dermatologist. So quit trying to think of ways to stuff a paper bag over your head, because it *is* possible to get your skin under control (or to fake it with a little concealer). And contrary to how you feel, most people aren't gawking and pointing at that eruption on your nose as you walk down the street. We swear.

why do I have acne?

Unfortunately, it's genetic. "Acne is unavoidable if it's in your genes," says Dr. Richard Glogau, a San Francisco dermatologist. If your mom or dad didn't have a peaches-and-cream complexion in high school, chances are you won't either (only 27.7 percent of teens have flawless faces). Acne pops up out of nowhere starting at about age 14 because that's when your hormones start raging, stirring up the oil glands (mostly on your face, chest and back) to produce more sebum (oily stuff). Add PMS and stress breakouts, and it may seem like controlling acne is your new part-time job. No way.

Your monthly friend? Yeah, right. The week before your period your hormone levels drop, throwing your oil glands into overdrive, leaving you with a nice painful pink bump. You can't avoid it, but you can keep the zit at bay by dabbing the area with a mixture of cornstarch and alcohol (this is very drying, so just use it on the blemish). Also, if you're not already using a product that contains alpha-hydroxy acids (AHA), now is a good time to start. These acids help shed the dead skin cells that cause the little blockages, leading to acne. Your best bet would be to try an AHA cleanser or a light oil-free AHA moisturizer.

Silver
**ILLUSTRATION, CORPORATE/INSTITUTIONAL,
SERIES**
The Art Directors Club of Switzerland Annual

ART DIRECTORS *Roland Scotoni, Brad Holland*
DESIGNER *Roland Scotoni*
ILLUSTRATOR *Brad Holland*
STUDIO *Brad Holland*
CLIENT *The Art Directors Club of Switzerland*
COUNTRY *United States*

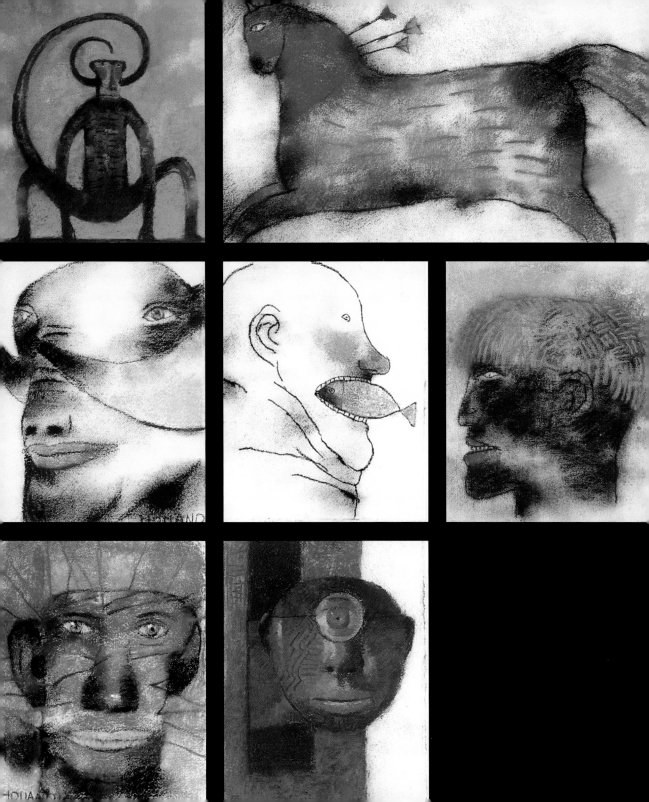

photography and illustration
distinctive merit

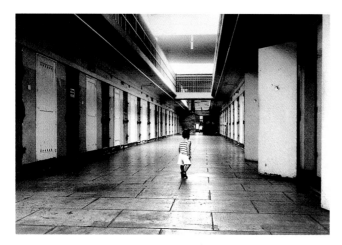

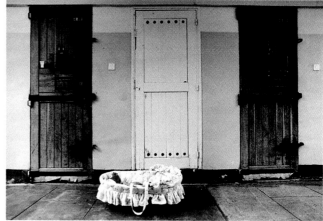

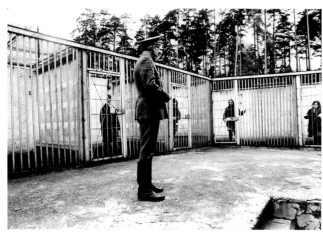

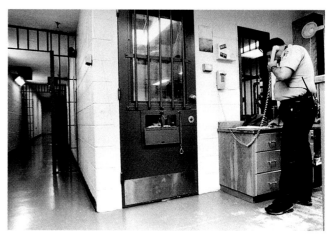

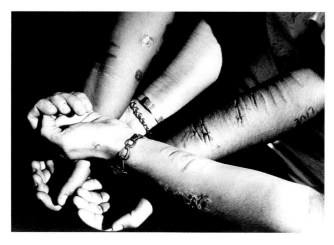

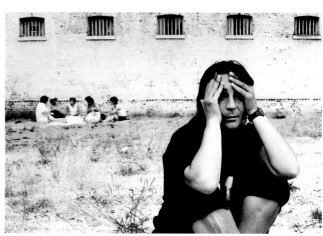

Distinctive Merit
**PHOTOGRAPHY, EDITORIAL OR COVER:
NEWSPAPER/MAGAZINE, SERIES**
Babies behind Bars

DESIGN DIRECTOR *Tom Bentkowski*
COPYWRITER *Claudia Glenn Dowling*
DESIGNER *Sam Serebin*
PHOTOGRAPHER *Jane Evelyn Atwood*
PHOTO EDITOR *David Friend*
CLIENT *LIFE Magazine*
COUNTRY *United States*

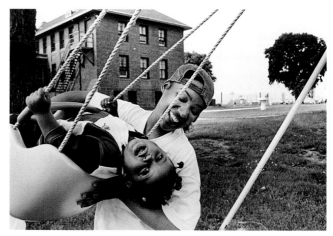

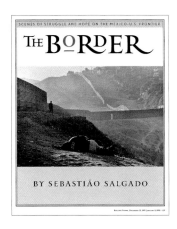

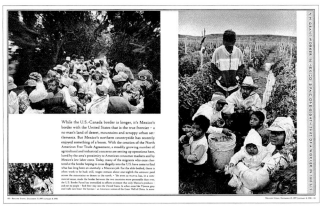

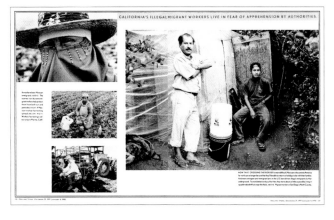

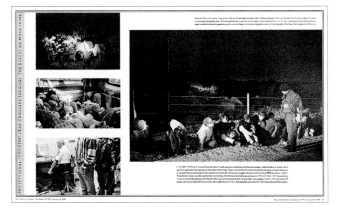

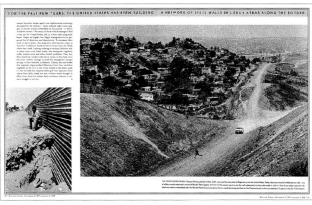

Distinctive Merit

**PHOTOGRAPHY, EDITORIAL OR COVER:
NEWSPAPER/MAGAZINE, SERIES**

The Border

ART DIRECTOR *Fred Woodward*
DESIGNERS *Fred Woodward, Gail Anderson*
PHOTOGRAPHER *Sebastião Salgado*
PHOTO EDITOR *Fiona McDonagh*
PUBLISHER *Wenner Media*
CLIENT *Rolling Stone*
COUNTRY *United States*

A
MOSQUITO
BITES BACK

Despite a decades-long effort to eliminate Aedes aegypti from the Western Hemisphere, this beautiful but deadly insect has recolonized 21 countries, and the diseases it transmits are taking wing, too. By Gary Taubes

IT BEGINS WITH THE BITE. SHE ALIGHTS on your skin, a small, elegant, grayish mosquito with a distinctive, silvery-white lyre-shaped pattern on her back. She has small wings and fernlike antennae. Her Latin name is Aedes aegypti. As with all mosquitoes, only the female bites you. Nothing personal: she simply requires protein to produce her eggs and has evolved the equipment to procure it from your blood. Males live exclusively on nectar.

Upon landing, she probes for a blood vessel, inserting her mouthparts into your skin a millimeter or two at a time, lubricating the motion with saliva, then pulling them back out. The motion is oddly reminiscent of fly-fishing, of dipping the rod in a cast and bringing it back. When she finds a blood vessel, she forces the tip of her proboscis through the skin and into the flow of the blood. She then simultaneously sucks out blood while continuing to dribble saliva. The walls of her proboscis are double-barreled, so saliva dribbles down one barrel while the blood is imbibed through the other. If she happens to be infected with a virus or a parasite, it will pass by way of the saliva to you.

Gary Taubes often writes about science and technology. This is his first story for the Magazine.

The bite is painless. If you are allergic to the saliva, the itching begins in about a minute, but the mosquito will probably be gone by then. If you are not allergic, you may never know you've been had. Aedes aegypti has evolved to bite you and get away alive.

It is precisely that bite, and its implications for human disease, that prompted Paul Reiter, an entomologist with the Centers for Disease Control and Prevention, to visit the central highlands of Puerto Rico several months ago. Reiter picked me up at my hotel at 6:30 on an already muggy morning to beat the rush-hour traffic out of San Juan, which we failed to do. We were headed for Florida, a small town about an hour's drive west of the capital.

The C.D.C. runs a laboratory in San Juan to keep track of Aedes aegypti and the diseases it causes, and there has been a lot to keep track of lately. The mosquito, long a bane in the Western Hemisphere, has made a stealthy and disturbing comeback. For 200 years this one species brought devastating epidemics of urban yellow fever to the Americas, including significant outbreaks in New York and Philadelphia. The mosquito is also responsible for infecting about 100 million people each year with dengue (pronounced DEN-gee) fever, a severe flulike illness whose common name —

Photographs by Tom Schierlitz

breakbone fever — adverts to its excruciating pain; it infects another 200,000 to 500,000 people with dengue hemorrhagic fever, a potentially fatal form of dengue. To epidemiologists, the presence of dengue and dengue hemorrhagic fever is a harbinger of urban yellow fever outbreaks to come.

Dengue fever is now a constant presence in Puerto Rico, with occasional epidemic flare-ups. A small dengue epidemic swept through the town of Florida in 1991. Among its 8,900 inhabitants, 400 had been sick enough to need medical attention. Four had hemorrhagic fever, and one of those died. Reiter was making a series of visits to the town as part of an experiment to see if it were possible to block the dangerous traffic among viruses, mosquitoes and humans.

As we drove out, Reiter, wearing a blue "C.D.C. at 50" T-shirt, his curly brown hair in disarray, explained the gist of the mosquito problem, which was not, as you might think, that the insect has become better adapted to the modern world, but rather that the world has become much more accommodating to the mosquito. Aedes aegypti is a mosquito that has evolved to live in proximity to humans and to breed almost exclusively in man-made containers capable of holding stagnant water. Thus the detritus of late-20th-century

WHILE MANKIND HAS DRIVEN thousands of species toward extinction by destroying their habitats, there are a few, like the mosquitoes that transmit malaria and yellow fever, for which we have done nothing but create new breeding grounds.

Splat: The life of mosquitoes is short and brutal. Previous page: An Aedes aegypti killed on a full stomach. This page: A day later.

civilization, all the junk and discards and certifiably nonbiodegradable material that have been liberally strewn throughout the world, now constitutes the ideal breeding site for the mosquito. While mankind has driven thousands of species on this planet toward extinction by destroying their habitats, there are a few, like Aedes aegypti and Anopheles gambiae, the primary carrier (or "vector") of malaria, for which we have done nothing but provide new habitats.

If anything, we may have created a severe public health crisis in the tropics. Despite a decades-long campaign to eradicate Aedes aegypti in this hemisphere, the mosquito has recolonized virtually every acre of its former breeding grounds. Of the 21 countries declared free of the mosquito in the 1960's, every last one has now become reinfested.

What makes this especially significant is what Reiter calls the Catch-22 of mosquito eradication: once you embark upon it, you can never stop, or the threat to public health actually gets worse. The reason is an unfortunate variable known to epidemiologists as "herd immunity" — the proportion of the population that has become immune to a virus like dengue. Not everyone infected by the virus gets dengue symptoms, but everyone who has been infected develops immunity to the virus, and when a mosquito bites one of those people, it wastes precious bites that could otherwise be spreading the disease. This dilutes the force of the epidemic and eventually kills it off, since most of the populace becomes immune. The higher the herd immunity, the more mosquitoes necessary to start an epidemic. The lower the immunity, the fewer mosquitoes.

Given the realities of herd immunity, you could argue that the worst possible public health situation would be to eradicate a mosquito like Aedes aegypti and then let it return. That is precisely what has happened in the Western Hemisphere, and among the people who know it best, this particular insect is a formidable foe.

"It's quite astonishing how resourceful the mosquito is," Reiter said, with a little wonder in his voice.

WONDERMENT IS NOT USUALLY THE FIRST sentiment that comes to mind when dealing with mosquitoes. From the human perspective, the insects (there are more than 3,000 species in the world) fall into two crude categories — mere pests and real menaces — and much of the distinction depends on where you live. Those of us who live in temperate climes deal with the mosquito as an annoyance, although the bother would be nearly unbearable were it not for prodigious amounts of mosquito control. Most of the state of Florida would be uninhabitable by modern standards without control measures, and so, for instance, would the South Shore of Long Island or much of New Jersey, which earlier in the century was known unaffectionately as the "Mosquito State."

In more tropical regions, the mosquito is considerably more than a nuisance; the danger is real and getting worse after several decades of ill-conceived eradication campaigns. While the diseases that make headlines these days are the freakish "emerging" viruses — the hantavirus outbreak that killed 27 people in the Southwest in 1993 or the rare Et Ebola that killed 245 in 1995 in one small corner of the former Zaire — mosquitoes transmit disease to at least 700 million people each year, about one-eighth of the world's population, and cause almost three million fatalities. In its World Health Report 1996, the World Health Organization labeled the mosquito the "greatest menace" of all disease-transmitting insects. Even that may understate the problem. Mosquitoes will kill, by W.H.O. tally, roughly 1 in every 17 people currently alive on this planet.

Perhaps 400 species of mosquito can transmit disease to humans. Malaria, for example, is carried by mosquitoes of the Anopheles family, of which some 60 species are reasonably competent vectors. One mosquito known colloquially as "quinks" (for Culex quinquefasciatus), which breeds in pit latrines, drainage ditches and any polluted water, spreads the filariasis worm that infects more than 100 million people, primarily in South Asia, the Pacific Islands and Africa. The parasite can cause either elephantiasis, in which the limbs become grossly swollen, or hydrocoele, in which the scrotum enlarges to gruesome proportions.

Several species common to North America, including Culex tarsalis, transmit encephalitis viruses in the United States. These viruses — in particular La Crosse encephalitis, St. Louis encephalitis and Western equine encephalitis — circulate unseen in forest settings, passed between sylvan mosquitoes and the local birds or rodents, but they occasionally cause serious disease in children. A few dozen cases are reported each year to the C.D.C., with outbreaks every decade or so. In 1990, 250 people in Florida were struck with St. Louis encephalitis and 25 died.

"The general perception is that mosquito-borne diseases ought to be eradicable," said Harold Varmus, director of the National Institutes of Health, "and they have not proven to be so. And not only have the mosquitoes not been eradicated, but some of these diseases they carry are resurgent. They have come back from a fairly low ebb." In response to this rebounding threat to public health, the National Institutes of Health and the World Health Organization are planning a long-range research effort, while the World Bank is seeking support for a 30-year plan to battle malaria, but the obstacles strike many as nearly insurmountable. An effective malaria vaccine, long a goal, seems years away, and no one talks about trying to eliminate malaria-carrying mosquitoes anymore. Like Aedes aegypti, the Anopheles mosquito rapidly developed resistance to insecticides like DDT. Eradication, as one World Bank official said, "has become a dirty word."

Aedes aegypti, meanwhile, has returned in a big way to this hemisphere, and brought disease back with it. Dengue is once again well-established throughout Latin America, and the number of cases of dengue hemorrhagic fever is creeping upward. The year 1995 was the worst on record for dengue fever in the Americas, and this summer there have already been epidemics in Mexico and Cuba. And while there haven't been epidemics of yellow fever in cities in this hemisphere in 50 years, tropical-disease experts are not so much warning of imminent outbreaks as wondering why they haven't yet occurred in places like Caracas or Cali.

"We now have in the American tropics several hundred million people who are susceptible to yellow fever," said Duane Gubler, who is the director of the division of the vector-borne infectious diseases of the C.D.C. "All these areas are infested with Aedes aegypti, and so we're at the highest risk in over 50 years for urban epidemics of yellow fever. Once urban transmission begins in the American region, it's probably going to spread very rapidly throughout the region to other urban centers and then from there to Asia and the Pacific." Yellow fever,

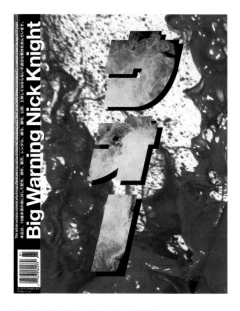

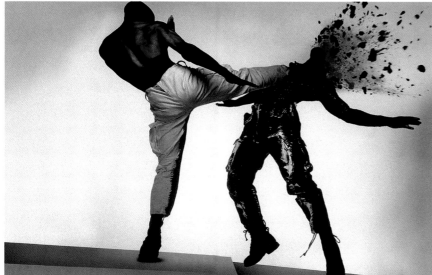

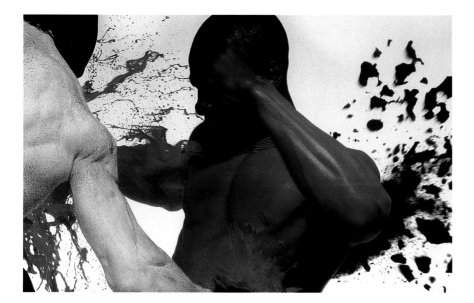

Distinctive Merit
**PHOTOGRAPHY, EDITORIAL OR COVER:
NEWSPAPER/MAGAZINE, SERIES**
Big Warning Nick Knight

CREATIVE DIRECTOR *Marcelo Jünemann*
DESIGNERS *Peter Saville, Howard Wakefield (cover),*
Chris Rehberger (interview)
PHOTOGRAPHER *Nick Knight*
CLIENT *Big Magazine*
COUNTRY *United States*

(facing page)
Distinctive Merit
**PHOTOGRAPHY, EDITORIAL OR COVER:
NEWSPAPER/MAGAZINE, SERIES**
Mosquitos

ART DIRECTOR *Janet Froelich*
PHOTOGRAPHER *Tom Schierlitz*
PHOTO EDITOR *Kathy Ryan*
STUDIO *Tom Schierlitz Photography*
CLIENT *The New York Times Magazine*
COUNTRY *United States*

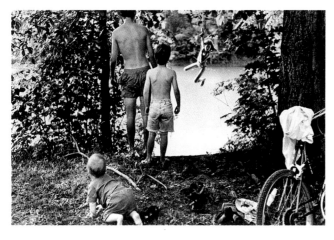

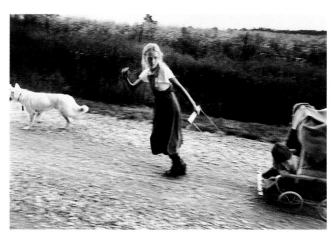

Distinctive Merit
**PHOTOGRAPHY, EDITORIAL OR COVER:
NEWSPAPER/MAGAZINE, SERIES**
The World from My Front Porch

DIRECTOR OF DESIGN *Tom Bentkowski*
COPYWRITER *Larry Towell*
DESIGNER *Tom Bentkowski*
PHOTOGRAPHER *Larry Towell*
PHOTO EDITOR *David Friend*
CLIENT *LIFE Magazine*
COUNTRY *United States*

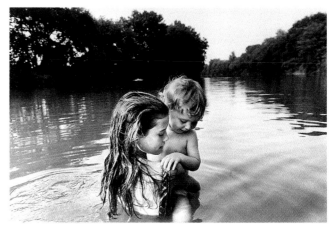

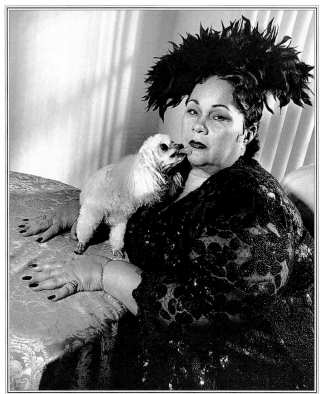

PHOTOGRAPH BY **Mary Ellen Mark**

Etta James

"I've had people say to me, 'Can't you be more feminine?' I would go, 'Feminine? Why do I have to be feminine?' Does that mean I have to put a little apron on and bake some cookies or something?'"

Distinctive Merit

PHOTOGRAPHY, EDITORIAL OR COVER: NEWSPAPER/MAGAZINE

Etta James

ART DIRECTOR *Fred Woodward*
DESIGNERS *Fred Woodward, Gail Anderson*
PHOTOGRAPHER *Mary Ellen Mark*
PHOTO EDITOR *Jodi Peckman*
PUBLISHER *Wenner Media*
CLIENT *Rolling Stone*
COUNTRY *United States*

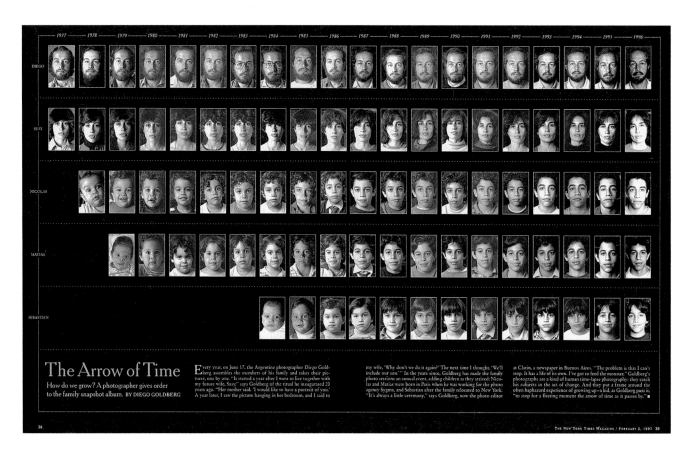

Distinctive Merit
PHOTOGRAPHY, PORTRAIT/FASHION
The Arrow of Time

ART DIRECTOR *Janet Froelich*
COPYWRITER *The New York Times*
PHOTOGRAPHER *Diego Goldberg*
PHOTO EDITOR *Kathy Ryan*
CLIENT *The New York Times Magazine*
COUNTRY *United States*

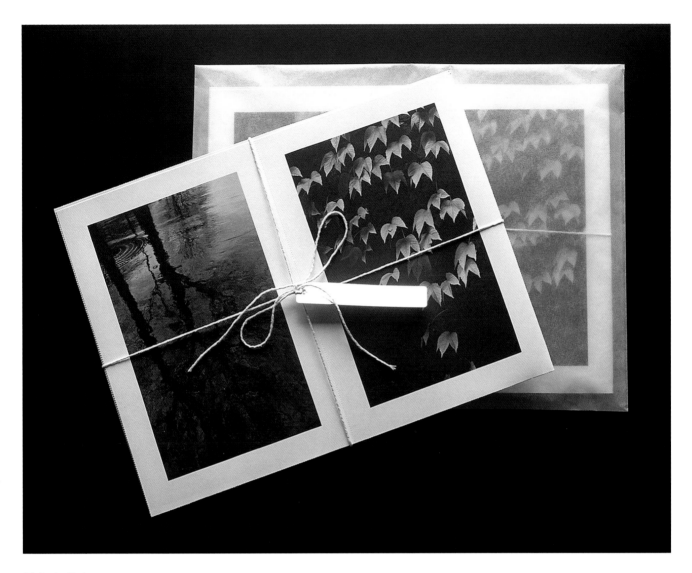

Distinctive Merit
PHOTOGRAPHY, SELF-PROMOTION
Paris Poster

ART DIRECTOR *Lana Rigsby*
DESIGNER *Trisha Rausch*
PHOTOGRAPHER *Terry Vine*
PRINTER *Bob Toudouze (IPP Printing)*
AGENCY *Rigsby Design*
CLIENT *Terry Vine Photography*
COUNTRY *United States*

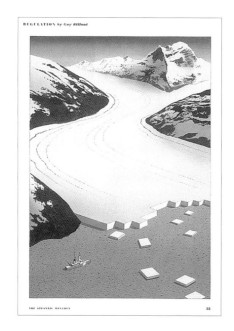

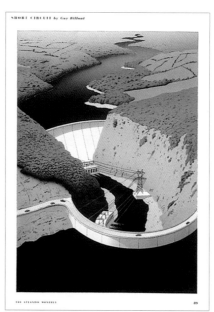

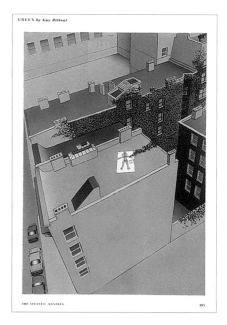

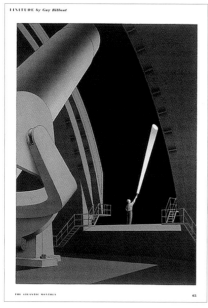

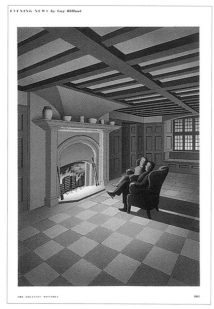

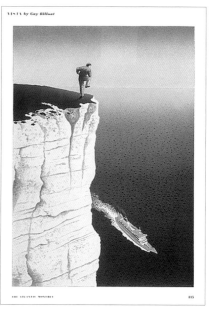

Distinctive Merit
**ILLUSTRATION, EDITORIAL OR COVER:
NEWSPAPER/MAGAZINE, SERIES**
*Regulation • Short Circuit • Green • Finitude •
Evening News • Vista*

ART DIRECTOR *Judy Garlan*
ILLUSTRATOR *Guy Billout*
CLIENT *The Atlantic Monthly*
COUNTRY *United States*

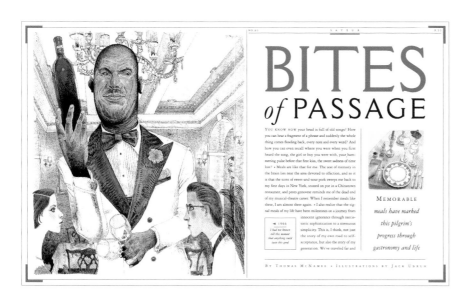

Distinctive Merit

**ILLUSTRATION, EDITORIAL OR COVER:
NEWSPAPER/MAGAZINE, SERIES**
Bites of Passage

ART DIRECTOR *Jill Armus*
CREATIVE DIRECTOR *Michael Grossman*
DESIGNER *Jill Armus*
ILLUSTRATOR *Jack Unruh*
CLIENT *Saveur Magazine*
COUNTRY *United States*

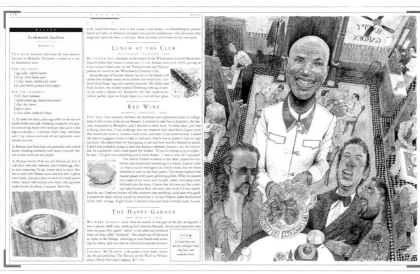

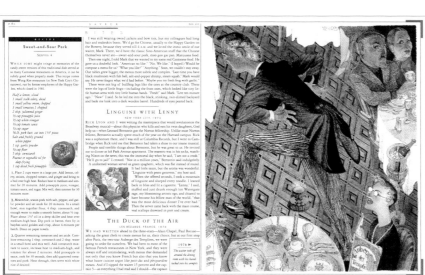

Distinctive Merit

ILLUSTRATION, EDITORIAL OR COVER:
NEWSPAPER/MAGAZINE, SERIES
The Capitalist Threat

ART DIRECTOR *Judy Garlan*
WRITER *George Soros*
DESIGNER *Judy Garlan*
ILLUSTRATOR *Brian Cronin*
CLIENT *The Atlantic Monthly*
COUNTRY *United States*

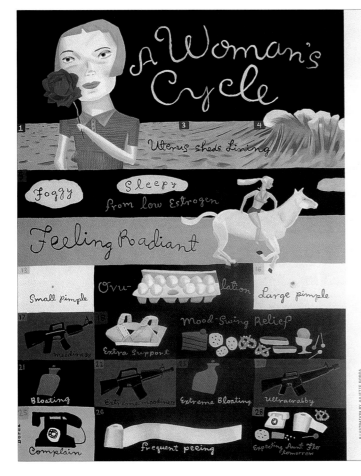

The illustration contains the following hand-lettered labels:

A Woman's Cycle

Uterus sheds lining

Foggy — Sleepy

From low Estrogen

Feeling Radiant

Small pimple — Ovu-lation — Large pimple

Moodiness — Extra support — Mood-Swing Relief

Bloating — Extreme moodiness — Extreme Bloating — Ultracrabby

Complain — Frequent peeing — Expecting Aunt Flo tomorrow

seeing RED, feeling BLUE?

cramps! bloating! breakouts!

Does your period have you singing the once-a-month blues? If so, check out this user-friendly guide and find out why being on the rag doesn't have to be such a drag.

IN THE BEGINNING, you just want it to start already. But once your period makes its debut, you suddenly realize why people call it The Curse. Just like Freddy from the *Nightmare on Elm Street* movies, it keeps coming back, whether you're in the middle of soccer play-offs or about to have your first real date with *him*. Of course, just because your body goes a little berserk every 28 days or so doesn't mean you can't, um, go with the flow. That is, if you know what to expect.

In case you slept through health class, here's the deal on menstruation: About once a month, your hormones kick into gear and your ovaries release an egg into one of your fallopian tubes. Meanwhile, your uterus starts prepping for the egg's arrival (which it does by growing a thicker lining). If, after arriving at its final destination, the egg isn't fertilized by sperm (here's hoping), your uterus reacts by shedding its lining in the form of blood, mucus and other body fluids through your vagina. Hence, you get your period.

By Wendy Marston

ILLUSTRATION BY JULIETTE BORDA

Hormones, your body's chemical messengers, orchestrate the whole menstrual thing. Fluctuations of the hormone levels in your bod can cause breakouts, munchies and mood swings, sometimes making you feel like your life is one big soap opera. Before you give in to all the drama, use this hormone chart to help you anticipate which days of the month you'll be happier, hungrier and even smarter. We based the chart on a 28-day cycle, because that's the average time between periods. To figure out how many days run in your cycle, count from the first day of your period to the first day of your next one. If your cycle is longer than 28 days, add those days to the end of the last week of this chart. If it's shorter, subtract them from the end. (Note: Since a lot of girls don't have regular monthly periods for the first two years or so, use this chart to guide you, not to rule your life.)

YOUR FLOW CHART

DAYS 1 THROUGH 4
your body: Let the countdown begin. As your body officially begins menstruating, the level of estrogen (that's the female hormone) in your body takes a major nosedive. This change can cause everything from headaches to breakouts. Got cramps? Blame it on prostaglandins, fatty acids that signal the ovary to release an egg. The good news: Your body stops hanging on to excess water, so you can kiss that bloated feeling good-bye!

your brain: With estrogen at its lowest level, bliss is right around the corner. You may now pass go, forgive your little brother, put your best friend back on speed dial, give your guy a second chance....

DAYS 5 THROUGH 8
your body: Bleeding should be tapering off, though don't be surprised if it lasts a few more days.
your brain: Because your estrogen level is still kind of low, you may feel a little groggy and out of it. Breakin' a sweat for more than 20 minutes at a time or taking a nap (no more than 60 minutes) is a great energy booster.

DAYS 9 THROUGH 12
your body: Your hormones start to balance out, which means your estrogen level rises and your androgen level (boy hormones that we all have) stays about the same. If you are sexually active, the risk of getting pregnant just got bigger. Be aware, especially if you're not using condoms (lame!). On a brighter note, your complexion is at its best. To keep it that way, cleanse with Neutrogena Multi-Vitamin Acne Treatment.

JUMP **107**

Distinctive Merit

ILLUSTRATION, EDITORIAL OR COVER: NEWSPAPER/MAGAZINE

Seeing Red, Feeling Blue?

ART DIRECTOR *Chrystal Falcioni*
CREATIVE DIRECTOR *Kathy Nenneker*
COPYWRITER *Wendy Marston*
DESIGNER *Chrystal Falcioni*
ILLUSTRATOR *Juliette Borda*
PUBLISHER *Weider Publications, Inc.*
CLIENT *Jump Magazine*
COUNTRY *United States*

Distinctive Merit
**ILLUSTRATION, EDITORIAL OR COVER:
NEWSPAPER/MAGAZINE**
Björk

ART DIRECTOR *Fred Woodward*
ILLUSTRATOR *Mark Ryden*
PUBLISHER *Wenner Media*
CLIENT *Rolling Stone*
COUNTRY *United States*

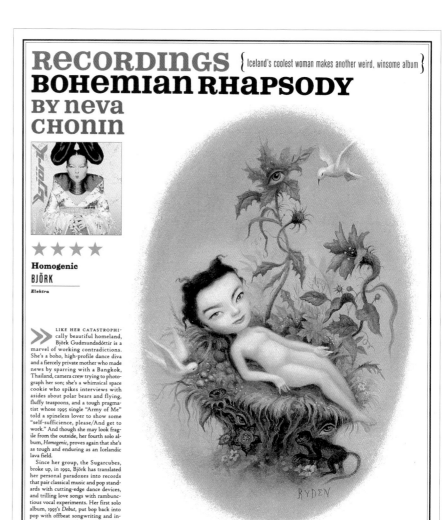

"I'M REALLY NOT A VERY OPINIONATED PERSON," SAID THE most controversial law professor in America. Swiveling his chair ninety degrees, Lino Graglia leaned back almost to horizontal, his gaze fixed on a splendid photograph of Delicate Arch in southeastern Utah that hung on the wall of his office at the University of Texas School of Law. "I pride myself on my humility," he said, invoking a word not normally associated with law professors (especially not this one). "I don't claim to have the answer on difficult policy issues like abortion, school prayer, and restriction of pornography, except that these issues should not be resolved by judges. I do have a strong opinion that anything that is done dishonestly ought not to be done."

What the 67-year-old constitutional law scholar thinks is especially dishonest is the use of racial preferences under the guise of helping the disadvantaged, who are seldom in fact the beneficiaries. "Race is not a proxy for disadvantage," he says. His conviction that affirmative action is a euphemism for racial discrimination led him to say, at a September student forum—in answer to a reporter's question with cameras rolling—that blacks and Hispanics "are not academically competitive with whites" and that they "have a culture that seems not to encourage achievement. Failure is not looked upon with disgrace." In another time or place, these remarks might have passed unnoticed. Sprinkle a little sympathy, stir in some hedging words, and they are not so different from what many authorities on race in America are saying today. (Glenn Loury, a prominent black economist, wrote in a recent issue of the *New Republic:* "Unless we candidly acknowledge that a pathological and debilitating subculture exists within our inner cities—a culture that robs its adherents of any chance to break away from their marginal status—we will be wasting our time.") But Graglia's comments came at the worst possible time for UT, the exact moment that the landmark 1996 case of *Hopwood v. Texas* took effect and the university became ground zero in the nationwide battle over affirmative action.

In that case, a three-judge panel of the U.S. Fifth Circuit Court of Appeals struck down the affirmative-action admissions policy at Graglia's own law school. It ruled that Cheryl Hopwood, a white woman who was denied a place in the school's entering class of 1992 despite having better grades and test scores than many minority students who were admitted, had been the victim of discrimination. Said the court: "The law school has presented no compelling justification . . . that allows it to continue to ele-

vate some races over others, even for the wholesome purpose of correcting perceived racial imbalance in the student body." The impact of *Hopwood* has been dramatic: This fall's entering class has only 4 black students and 26 Hispanics, down from 31 and 42, respectively, a year earlier. The law school has spent much of the year doing damage control, trying, without much success, to convince minority politicians, alumni, and students that there wasn't anything the school could do about it.

It turned out that there was one thing UT's leaders could do about it, and that was to vent their frustration upon Lino Graglia. The university's critics could do the same. In the days that followed Graglia's remarks, the Reverend Jesse Jackson flew in to address an anti-Graglia rally: "Isolate him as a moral and social pariah. . . . We are not the problem. He is the problem." UT leaders and faculty joined in a public shunning of the law professor. The chairman of the board of regents and the chancellor of the university called Graglia's comments "abhorrent," a Hispanic regent called for his suspension, both the main UT faculty and fifty members of the law school faculty adopted statements disavowing Graglia's views, his own dean publicly rebuked him, and still the furor would not subside. Students attended teach-ins. *The New Yorker* magazine even dispatched a writer to the provinces to see what all the fuss was about.

What all the fuss is really about is not Lino Graglia but *Hopwood* and the threat that it will result in the resegregation of America's elite universities. A similar lawsuit has been filed against the University of Michigan. California's Proposition 209, which eliminates affirmative action in that state by prohibiting any form of racial discrimination, recently survived a challenge in the U.S. Supreme Court. (There is one black student in the first-year class at the law school at Berkeley.) Other states, including Texas, will no doubt be debating a version of Proposition 209 in their next legislative sessions. Doors are closing all across the country, and if the enrollment statistics at the UT law school are any indication, black America stands to lose 87 percent of its gains.

For the University of Texas, the stakes are high. University officials fear that the number of blacks and Hispanics on campus will fall below the critical mass necessary for the school to be perceived as a hospitable environment by prospective minority students. This likelihood is greater for blacks than Hispanics; there is a history of hostility to blacks that UT has never quite overcome. The prospect of a law school without black students raises the specter of *Sweatt v. Painter,* [CONTINUED ON PAGE 142]

WHAT'S BLACK AND WHITE AND RED-FACED ALL OVER?

The University of Texas at Austin, embarrassed by law professor Lino Graglia's comments about race and bound by the *Hopwood* decision striking down its affirmative-action program. Is this the first step in the resegregation of American universities?

BY PAUL BURKA

ILLUSTRATION BY BRIAN CRONIN

Distinctive Merit

**ILLUSTRATION, EDITORIAL OR COVER:
NEWSPAPER/MAGAZINE**
What's Black & White

ART DIRECTOR *D.J. Stout*
CREATIVE DIRECTOR *D.J. Stout*
COPYWRITER *Paul Burka*
DESIGNERS *D.J. Stout, Nancy McMillen*
ILLUSTRATOR *Brian Cronin*
CLIENT *Texas Monthly*
COUNTRY *United States*

MULTIPLE AWARDS

Distinctive Merit
**ILLUSTRATION, BOOK OR BOOK JACKET,
SERIES AND SINGLE**

Distinctive Merit
GRAPHIC DESIGN, BOOK OR BOOK JACKET

and Merit
**GRAPHIC DESIGN, BOOK DESIGN,
GENERAL TRADE BOOKS**
American Illustration "Sweet 16"

CREATIVE DIRECTORS *Jeffrey Keyton,
Stacy Drummond, Tracy Boychuk*
DESIGNERS *Jeffrey Keyton, Stacy Drummond,
Tracy Boychuk*
ILLUSTRATORS *Geoffrey Grahn (cover),
Ed Fotheringham, Steve Wacksman, Mark Todd,
Calef Brown, Anthony Freda, Steve Byram,
Juliette Borda, Jordin Isip, Jonathon Rosen,
George Bates, Mark Gagnon, Ruth Marten,
Filip Pagowski, Esther Watson, Mark Ryden*
CLIENT *Amilus, Inc.*
COUNTRY *United States*

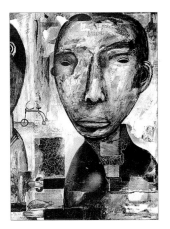

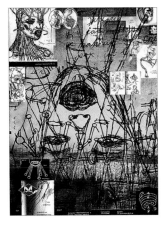
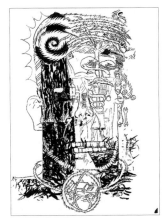
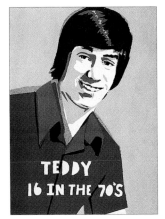

photography and illustration

merit

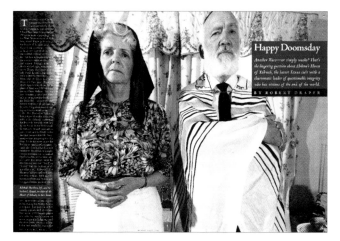

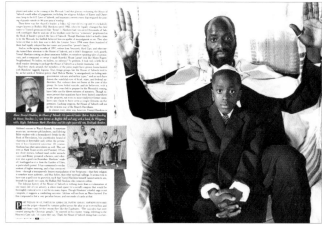

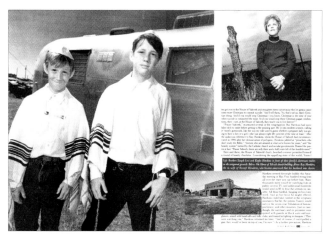

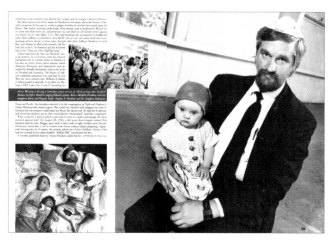

Merit

**PHOTOGRAPHY, EDITORIAL OR COVER:
NEWSPAPER/MAGAZINE, SERIES**

Happy Doomsday

ART DIRECTOR *D. J. Stout*
CREATIVE DIRECTOR *D. J. Stout*
COPYWRITER *Robert Draper*
DESIGNERS *D. J. Stout, Nancy McMillen*
PHOTOGRAPHER *Mary Ellen Mark*
CLIENT *Texas Monthly*
COUNTRY *United States*

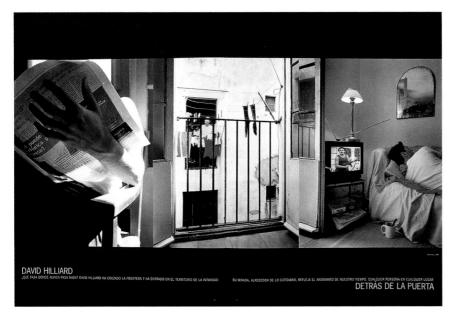

Merit
**PHOTOGRAPHY, EDITORIAL OR COVER:
NEWSPAPER/MAGAZINE, SERIES**
Detras de la Puerta (Behind the Door)

ART DIRECTOR *Fernando Gutiérrez*
EDITOR *Alberto Anaut*
DESIGNERS *Fernando Gutiérrez, Pablo Martin,
Emmanuel Ponty, Xavi Roca, María Ulecia*
PHOTOGRAPHER *David Hilliard*
PHOTO EDITOR *Luis de las Alas*
ART WORK *María Ulecia*
PUBLISHER *La Fábrica*
PRINTER *TF, Artes Gráficas*
STUDIO *GRAFICA*
CLIENT *La Fábrica*
COUNTRY *Spain*

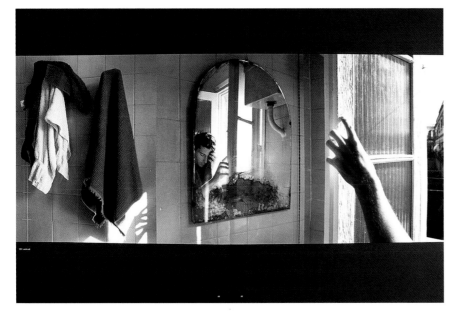

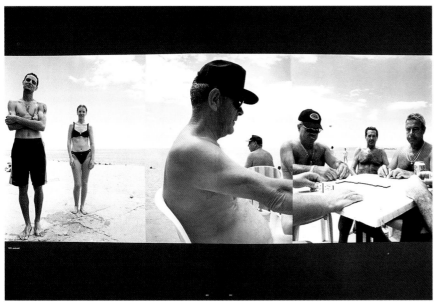

Merit

**PHOTOGRAPHY, EDITORIAL OR COVER:
NEWSPAPER/MAGAZINE, SERIES**
Exotiques

ART DIRECTOR *Christin Gangi*
CREATIVE DIRECTOR *Michael Grossman*
DESIGNER *Neal Boulton*
PHOTOGRAPHER *Linny Morris Cunningham*
AGENCY *Meigher Communications*
CLIENT *Garden Design Magazine*
COUNTRY *United States*

Courtney Love

"Somebody wrote.
'How can she rock in a Versace gown?' Well, easy—let me show you."

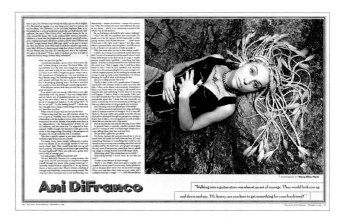

Ani DiFranco

"Walking into a guitar store was almost an act of courage. They would look you up and down and say, 'Hi, honey, are you here to get something for your boyfriend?'"

Sheryl Crow

"As long as this women-in-rock movement is treated as a novelty, we're still looking at it as something that's not here to stay."

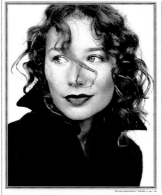

Tori Amos

"I remember being told, 'They're already playing one female on alternative radio, so they won't play you.'"

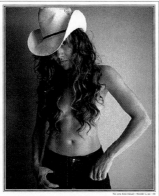

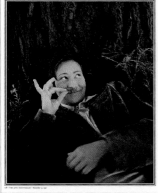

k.d. lang

"I was 16, living in Consort, Alberta, in the middle of nowhere, and by the magic of God, I heard Kate Bush on the radio and just about died."

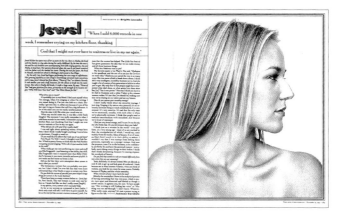

Jewel

"When I sold 8,000 records in one week, I remember crying on my kitchen floor, thanking God that I might not ever have to waitress or live in my car again."

Merit

PHOTOGRAPHY, EDITORIAL OR COVER:
NEWSPAPER/MAGAZINE, SERIES
Women in Rock

ART DIRECTOR *Fred Woodward*
DESIGNERS *Fred Woodward, Gail Anderson*
PHOTOGRAPHERS *Brigitte Lacombe, Peggy Sirota, Mary Ellen Mark*
PHOTO EDITOR *Jodi Peckman*
PUBLISHER *Wenner Media*
CLIENT *Rolling Stone*
COUNTRY *United States*

Natalie Merchant

"I think a lot of the material that I've written would have been ridiculed for its sensitivity had it been written by a man."

Kim Gordon

"The whole do-it-yourself thing took a lot of ideas from feminism."

481

ONE PICTURE

By Frans Lanting

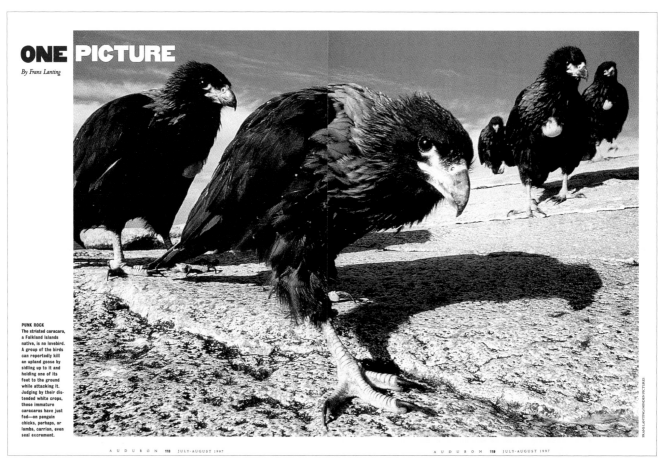

PUNK ROCK
The striated caracara, a Falkland Islands native, is no lovebird. A group of the birds can reportedly kill an upland goose by sidling up to it and holding one of its feet to the ground while attacking it. Judging by their distended white crops, these immature caracaras have just fed—on penguin chicks, perhaps, or lambs, carrion, even seal excrement.

FRANS LANTING/MINDEN PICTURES

ONE PICTURE

By Tony Arruza

SUSPENDED ANIMATION
A school of bluegill sunfish (plus a few hangers-on) in Alexander Springs, near Orlando, Florida. The 9- to 12-inch bluegill—which feeds on insects, minnows, and crustaceans—is often found in ponds and lakes, where it attends circular nests scooped from the bottom.

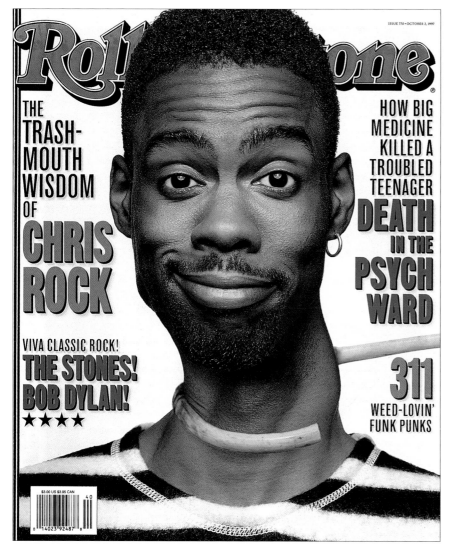

Merit

PHOTOGRAPHY, EDITORIAL OR COVER: NEWSPAPER/MAGAZINE

Chris Rock

ART DIRECTOR *Fred Woodward*
DESIGNER *Fred Woodward*
PHOTOGRAPHER *Mark Seliger*
PHOTO EDITOR *Jodi Peckman*
PUBLISHER *Wenner Media*
CLIENT *Rolling Stone*
COUNTRY *United States*

(facing page, top)
Merit

PHOTOGRAPHY, EDITORIAL OR COVER: NEWSPAPER/MAGAZINE

One Picture/Audubon Magazine, July–August 1997

ART DIRECTOR *Suzanne Morin*
PHOTOGRAPHERS *Frans Lanting, Minden Pictures*
PHOTO EDITOR *Peter Howe*
CLIENT *Audubon Magazine*
COUNTRY *United States*

(facing page, bottom)
Merit

PHOTOGRAPHY, EDITORIAL OR COVER: NEWSPAPER/MAGAZINE

One Picture/Audubon Magazine, November–December 1997

ART DIRECTOR *Suzanne Morin*
PHOTOGRAPHER *Tony Arruza*
PHOTO EDITOR *Peter Howe*
CLIENT *Audubon Magazine*
COUNTRY *United States*

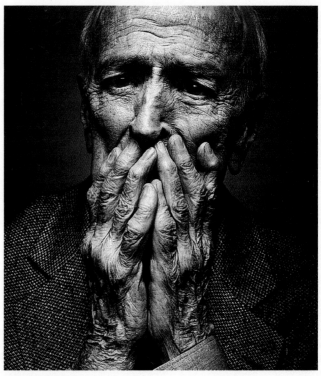

I have regrets but there
are not very many of them
and, fortunately,
I forget what they are.

Nearing 90
By William Maxwell

OUT OF THE CORNER OF MY EYE I SEE MY 90TH birthday approaching. It is one year and six months away. How long after that will I be the person I am now?

I don't yet need a cane but I have a feeling that my table manners have deteriorated. My posture is what you'd expect of someone addicted to sitting in front of a typewriter, but it was always that way. "Stand up straight," my father would say. "You're all bent over like an old man." It didn't bother me then and it doesn't now, though I agree that an erect carriage is a pleasure to see, in someone of any age.

I have regrets but there are not very many of them and, fortunately, I forget what they are. I forget names too, but it is not yet serious. What I am trying to remember and can't, quite often my wife will remember. And vice versa. She is in and out during the day but I know she will be home when evening comes, and so I am never lonely. Long ago, a neighbor in the country, looking at our flower garden, said, "Children and roses reflect their care." This is true of the very old as well.

I am not — I think I am not — afraid of dying. When I was 17 I worked on a farm in southern Wisconsin, near Portage. It was no ordinary farm and not much serious farming was done there, but it had the look of a place that had been lived in, and loved, for a good long time. The farm had come down in that family through several generations, to a woman who was so alive that everything and everybody seemed to revolve around her personality. She lived well into her 90's and then one day told her oldest daughter that she didn't want to live anymore, that she was tired. This remark reconciled me to my own inevitable extinction. I could believe that enough is enough.

Because I actively enjoy sleeping, dreams, the unexplainable dialogues that take place in my head as I am drifting off, all that, I tell myself that lying down to an afternoon nap that goes on and on through eternity is not something to be concerned about. What spoils this pleasant fancy is the recollection that when people are dead they don't read books. This I find unbearable. No Tolstoy, no Chekhov, no Elizabeth Bowen, no Keats, no Rilke. One might as well be —

Before I am ready to call it quits I would like to reread every book I have ever deeply enjoyed, beginning with Jane Austen and going through shelf after shelf of the bookcases, until I arrive at the "Autobiographies" of William Butler Yeats. As it is, I read a great deal of the time. I am harder to please, though. I see flaws in masterpieces. Conrad

William Maxwell is the author of 12 books, including six novels and a memoir. He was for 40 years a fiction editor at The New Yorker.

indulging in rhetoric when he would do better to get on with it. I would read all day long and well into the night if there were no other claims on my time. Appointments with doctors, with the dentist. The monthly bank statement. Income tax returns. And because I don't want to turn into a monster, people. Afternoon tea with X, dinner with the Y's. Our social life would be a good deal more active than it is if more than half of those I care about hadn't passed over to the other side.

I did not wholly escape the amnesia that overtakes children around the age of 6 but I carried along with me more of my childhood than, I think, most people do. Once, after dinner, my father hitched up the horse and took my mother and me for a sleigh ride. The winter stars were very bright. The sleigh bells made a lovely sound. I was bundled up to the nose, between my father and mother, where nothing, not even the cold, could get at me. The very perfection of happiness.

At something like the same age, I went for a ride, again with my father and mother, on a riverboat at Havana, Ill. It was a side-wheeler and the decks were screened, I suppose as protection against the mosquitoes. Across eight decades the name of the steamboat comes back to me — the Eastland — bringing with it the context of disaster. A year later, at the dock in Chicago, too many of the passengers crowded on one side, waving goodbye, and it rolled over and sank. Trapped by the screens everywhere, a great many people lost their lives. The fact that I had been on this very steamboat, that I had escaped from a watery grave, I continued to remember all through my childhood.

I have liked remembering almost as much as I have liked living. But now it is different, I have to be careful. I can ruin a night's sleep by suddenly, in the dark, thinking about some particular time in my life. Before I can stop myself it is as if I had driven a mine shaft down through layers and layers of the past and must explore, relive, remember, reconsider, until daylight delivers me.

I have not forgotten the pleasure, when our children were very young, of hoisting them onto my shoulders when their legs gave out. Of reading to them at bedtime. Of studying their beautiful faces. But that was more than 30 years ago. I admire the way that, as adults, they have taken hold of life, and I am glad that they are not materialistic, but there is little or nothing I can do for them at this point, except write a little fable to put in their Christmas stocking.

"Are you writing?" people ask — out of politeness, undoubtedly. And I say, "Nothing very much." The truth but not the whole truth — which is that I seem to have lost touch with the place that stories and novels come from. I have no idea why. I still like making sentences.

Every now and then, in my waking moments, and especially when I am in the country, I stand and look hard at everything. ∎

76

PHOTOGRAPH BY NIGEL PARRY/C.P.I., FOR THE NEW YORK TIMES

THE NEW YORK TIMES MAGAZINE / MARCH 9, 1997 77

Merit

PHOTOGRAPHY, PORTRAIT/FASHION

Nearing 90

ART DIRECTOR *Janet Froelich*
COPYWRITER *The New York Times*
DESIGNER *Joele Cuyler*
PHOTOGRAPHER *Nigel Parry*
PHOTO EDITOR *Kathy Ryan*
CLIENT *The New York Times Magazine*
COUNTRY *United States*

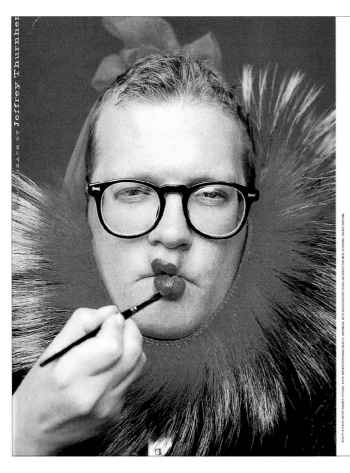

IT SEEMS JUST A LITTLE TOO PERFECT THAT Drew Carey asks to meet at Bob's Big Boy — exactly the kind of unassuming burger joint where you'd imagine running into the calorie-friendly 9-to-5-er he plays on his hit sitcom, *The Drew Carey Show.* But when the red-plaid-shirted Carey actually plops down at the counter and orders, it's with all the familiarity of a true greasy-spoon fixture. One Super Big Boy combo, no relish, no pickle, coming right up.

Then the cell phone rings.

"Excuse me, I forgot to shut my phone off," Carey effuses, reaching into his jeans pocket to take a call. It's a friend reporting that *The Drew Carey Show* is spoofed in the new issue of the juvenile humor rag *Cracked.* "Get outta here!" Carey responds with kidlike excitement.

OK, so maybe the real-life, famous Carey makes somewhat of an irregular Joe. But in many ways, the 39-year-old comedian's tastes are incredibly akin to those of his tube counterpart. Take Cleveland-mania, cheeseburgers, a good beer buzz, a few fart jokes and pals who know a little too much about you, and you have Drew Carey the man and his sitcom. After shaky first-season ratings in 1995, the unfailingly modest show has become a veritable powerhouse for ABC on Wednesday nights, thanks to its post-*Roseanne*, underdog wit, a perfect extension of the gently self-deprecating stand-up act that Carey, in his trademark horn rims and crew cut, has honed over the past 11 years.

Now the Cleveland native has a shot at further entrenching his status as America's working-stiff smartass of choice, with the September release of his first book, a slathering of raunchy laughs, personal anecdotes and riffs, unapologetically called *Dirty Jokes and Beer: Stories of the Unrefined.* Carey originally wanted to write a collection of short stories but backed off from that concept after showing a piece to his agent and publisher. "They were like, 'This is kind of dark. We want the funny, TV Drew!' " he says. "They were right." So Carey spent his summer hiatus churning out Drew-isms, without a ghostwriter. "I thought that was real important," he says. "Nobody can talk like you talk."

"He's very honest, and people trust him," says Bruce Helford, executive producer and co-creator of Carey's show. The two met in 1994 when the comedian was playing second banana on a short-lived 1994 sitcom called *The Good Life.* "He's a regular person, and he'll say what he thinks, and I think that comes across to the audience. There's no phoniness." Still, on road trips, when the pair scarf at places like Burger King, Helford reports,

"people will come up [to Carey] and go, 'You're not... Nah, you wouldn't be here.' And then he's got to prove it to them. He'll pull out his driver's license and say, 'Look, it's really me.' "

At the same time, it's obvious that for Carey — a one-time waiter at Denny's — this kind of recognition has become a glittering albatross. He has grown increasingly wary of the tabloids, which have variously reported on an alcohol-laden cast-and-crew excursion to Disney World ("I got drunk and had a blast. Big deal!") and a supposed secret engagement ("This was two weeks after I'd told this girl I wanted to date other people," says Carey, who is currently single). "Some guy came to Bob's Big Boy and was asking [the staff], 'Do you have anything bad to say about him?' " he says, suddenly incensed. "I think, well, f--- you, you know? That kind of stuff upsets me." Just then an eavesdropping waitress adds, "I read that you were on a potato diet." Carey, who at 5 feet 11 inches weighs in at 225, snickers. "Yeah, I lost 17 pounds. That was *The Star,*" he says, chomping into his burger.

Not that Carey isn't perfectly happy to share intimate details of his life. He candidly admits that it took a six-year Marine-reserves stint to overcome a dispiriting malaise that led to two suicide attempts with sleeping pills, one at 18 and one in his early 20s. The first time, he saved himself, but the second time was more serious. "I had called a girlfriend to give some teary goodbye, and she called an ambulance. They had to get the landlady to open the door, 'cause I was passed out." He has never seen a psychiatrist about either incident but says he could grasp at the time that they were "a cry for help."

For Carey, the help he got from the Marines, from 1980 to 1986, was initially just a shot at steady, paying work. "The discipline was a happy byproduct," he remarks. The trick to surviving boot camp? "My recruiter gave me great advice," he says. "Be either outstanding or anonymous; be really, really great or blend in. But don't be an a--hole, because once you're labeled an a--hole, you're done." Carey finished in the top 10 percent of his platoon.

Once out of the service, a rejuvenated Carey threw himself into stand-up, living out of his car on gigs and [*Continued on page 134*]

Drew Carey

HOT SQUARE

HE'S THE ULTIMATE EVERYGUY — AND, OH, YEAH, A TV STAR **BY ROBERT ABELE**

US OCTOBER 1997 **103**

Merit
PHOTOGRAPHY, PORTRAIT/FASHION
Drew Carey

ART DIRECTOR *Richard Baker*
DESIGNER *Rina Migliaccio*
PHOTOGRAPHER *Jeffrey Thurnher*
PHOTO EDITORS *Jennifer Crandall, Rachel Knepfer*
CLIENT *US Magazine*
COUNTRY *United States*

Merit
PHOTOGRAPHY, SELF-PROMOTION, SERIES
Photographer's Business Cards with
Transparencies Inlaid

DESIGNER *Bob Scott*
PHOTOGRAPHER *Bob Scott*
STUDIO *Bob Scott Photo*
CLIENT *Bob Scott Photo*
COUNTRY *United States*

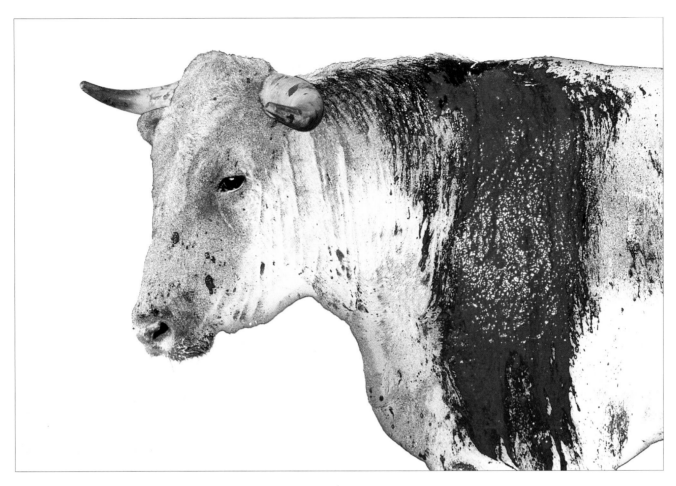

Merit
PHOTOGRAPHY, SELF-PROMOTION
Bull Fight, Mexico City—Stephen Wilkes

DESIGNER *Erik Cox (SamataMason)*
PHOTOGRAPHER *Stephen Wilkes*
STUDIO *Stephen Wilkes Photography*
CLIENT *Stephen Wilkes Photography*
COUNTRY *United States*

Merit

**ILLUSTRATION, EDITORIAL OR COVER:
NEWSPAPER/MAGAZINE, SERIES**
Notes on the Twentieth Century

ART DIRECTOR *Judy Garlan*
WRITER *Hans Koning*
DESIGNERS *Judy Garlan, Betsy Urrico*
ILLUSTRATOR *Kamil Vojnar*
CLIENT *The Atlantic Monthly*
COUNTRY *United States*

NOTES ON THE TWENTIETH CENTURY
by HANS KONING

*It was the bloodiest ever, but still
some surprising good has
come out of it*

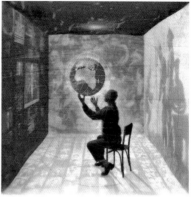

THE fate of the twentieth century was largely forged in the West. It may be the last century for which this will hold true. Inventions have changed our ways of doing most things, but the greatest changes have taken place in our way of looking at ourselves and at life. I want to focus on that, on the human condition, and on the Western world.

I have lived through most of this century and I have traveled to the four corners of the globe. I do not think I am stuck in a white U.S.-European viewpoint: I know how it feels to be an underdog. I have been in various jails as a political protester, and during those five medieval years when the Germans occupied the country of my youth, Holland, and most of Europe, I was a fugitive and a "terrorist."

In the Western world the century began with great expectations. The early years became known as La Belle Epoque, and if one focused on New York's Park Avenue and London's Mayfair and the 8th and 16th arrondissements of Paris, one found indeed a unique concentration of chic women and dashing men in private mansions and Delahaye convertibles, all in an atmosphere of total self-assurance. None of them doubted that they represented a progress that was to continue from strength to strength. The white race took it for granted then that it was meant to rule the earth; the rest of the world, Kipling's lesser breeds, largely took the whites at their own evaluation and timetable. In E. M. Forster's *A Passage to India* the Indian doctor Aziz tells his English friend, "If it's fifty-five hundred years we shall get rid of you." Twenty-five years after those words were written, the British Raj was gone.

It was a time in the West when violent death had become rare. Train wrecks and conflagrations and the sinking of the *Titanic* stood out shockingly and became engraved in national memories. It was a time filled with whispering about sex and about syphilis, which was the AIDS of those days but which few newspapers cared to mention. Eugenics was one of the century's prescriptions for progress: it worked well for horses and dogs, and professor Cesare Lombroso, of Turin, could already tell from a child's ears and skull whether he would turn out a criminal. A lessening of nationalism would end the wild military spending. "The coming nationality will be essentially a matter of education and economics," the famous eleventh edition of the *Encyclopaedia Britannica* announced in 1910.

Neither the earth nor even the sun was in the center of the universe anymore, but as Queen Victoria's chaplain, Charles Kingsley, had earlier written, "The railroad, Cunard's liners, and the electric telegraph are . . . signs that we are, on some points at least, in harmony with the universe; that there is a mighty spirit working among us . . . the ordering and creating God." Men and women, more than ever before or since, felt at home on earth and in control of their destiny. The natural demons of the past had been banished by reason and electricity, and the human demons of the new century were still hidden.

We do not need to be jealous of all this certainty. It masked another world, of exploitation, racism, colonialism, class arrogance. Coolies had to tap rubber for fifty centimes a day, miners had to breathe coal dust and gases until their lungs were used up, chimney sweeps died before they were eighteen, housemaids were fitting subjects for seduction jokes—all this injury and insult to maintain the civilized society that knew how to appreciate an entrechat royal, a new tenor, a new school of painting. And thus many people became enemies of

DER FRISCHFRÖHLICHE KRIEG

THE last white war: in 1895 Winston Churchill traveled to Cuba, where the Spanish were fighting the Cuban insurgents. He wrote that he just had to witness this, because it would be the last war ever in which whites fought whites. (The mistake of seeing contemporary events loom so large is a great stumbling block for futurists.) Churchill needn't have fretted himself. He got the greatest white-on-white war ever at his doorstep on the sunny Saturday of August 1, 1914, when the German infantry crossed the border of Luxembourg. That day we entered the modern age, and war became its expression.

Swedish suicide rate, which is regularly quoted to me as proof that people do not want all that security, has at times been close to the U.S. rate—which in this decade has floated around twelve per 100,000 (and Sweden is one dark country).

I realize that the European systems wouldn't work well here. We do not have the homogenous substructure, with a population counted and accounted for in great detail. We don't have the solidarity that Europe acquired only after the devastations of this century. We have had plenty of wars, but they were far away, and we did not go through any "stop-time." Perhaps 1932 came close to being just that, and thus made possible the New Deal, which was decried by big business as un-American and then saved the day for it. A transition from unenlightened self-interest to enlightened self-interest is not as painful as business once more seems to assume.

LONGER LIFE, MORE-ANXIOUS DEATH

WHEN I entered the British Army, in 1943, one could tell a private soldier and an officer apart even if they'd both appeared in regulation nightshirts. They were like different species: privates as a rule were shorter, looked older than their age, and had bad skin and terrible teeth. During the ensuing war years those differences became less and less, and the same held for civilians. War rations for the poor classes meant not less but more and healthier food. Now, after half a century of free medicine, that glaringly different look of people from different classes has vanished.

During this century the art of medicine has progressed at a fast clip. The famous British surgeon Joseph Lister announced around 1900 a "foreseeable end" to human disease. Unfortunately, he was wrong, and hosts of

viruses have taken a new lease on life (our life), helped along in their travels by our own frantic flying all over the globe. Wilhelm Roentgen's x-rays, which won the first Nobel Prize in physics, in 1901, got us off to a splendid start: the gap between the old and the new medicine can be measured by contemporary comments that it might become possible to photograph the human soul. It didn't, but by 1950 x-rays had saved the lives of some 30 million children, according to the estimate of a later Nobel-winning physicist, Arthur Compton. Sulfa drugs came around 1940, followed by penicillin and other antibiotics and the present armory of

Man in this century became far more brutish than any animal. Most of us would rather come upon a wild animal on a lonely road than upon a strange man.

electronic and chemical tools to fight afflictions that earlier could be mitigated but not cured. The increase in life expectancy tells it—from forty-nine years in 1900 to seventy-five years or more in the late 1990s. The effect on individual adults is less startling, because the drop in infant mortality in the West is the primary cause of the increase. (It has dropped from one in ten to less than one in a hundred during the first year of life.) But a man of forty will

Our century is ending in an abundance of new technology, but it is largely about sending, storing, and retrieving information at lightning speed, not about creating.

live about five years longer now than he would have in 1950, and he is healthier all along. The state of health of an eighty-year-old man now is comparable to the state of health of a seventy-year-old man twenty years ago.

What all this is doing to our perception of life is not yet clear. According to a 1995 French report, the increasing rarity of death among friends and colleagues "affects people's religion and their artistic and general look at life. It gives them a certain feeling of immortality." But, the report says, "they fear the idea of death the more, as it is less present in the collective imagination and seen as an abnormal and resistible phenomenon." Oddly enough, this is a sort of return to a pre-1914 mentality. I don't know if in the United States we feel this rarity of death, as we focus so much on criminal violence. And the re-

By 1914 the concept of warfare, in Europe as in the United States, was quite positive, perhaps more positive than it had been since the heyday of the Roman Empire. Jules Verne, the futurist writer, predicting a warless century ahead, had a twentieth-century man say, "Our bellicose notions are fading away, and with them our honorable ideas." Lack of fear and a peculiar idea of manly honor had become political qualifications, meant to prove that the ruling classes and the white race itself were willing to pay the price for their right to run the world. A handful of officers commanding native troops could keep vast colonial possessions in bondage because they were, supposedly, always ready to

As the truth became plain, that so many had been killed and maimed only because of the obtuseness of their officers, "pacifism" ceased to be a dirty word.

die, whereas the native populations weren't even ready to kill. In that 1910 *Encyclopaedia Britannica* a British officer wrote in the article "Egypt" that the Egyptian peasant would make an admirable soldier "if he only wished to kill someone." Professional soldiers held civilians in contempt, and to them the nonwhite races were civilians twice over. It never dawned on them that it isn't race but cause that makes people soldierly or not.

As for the United States, which had been a haven for thousands of draft dodgers from Europe, it had no military caste but its ideas of true manliness were not very different, and a successful general always had and still has a shortcut to the presidency.

Because of the positive concept of war, the generals running the show in 1914 were not appalled by the massacres caused by their tactics. On the contrary, when the planned and often already announced breakthroughs did not materialize, the massacres became the reason for their tactics. This was called attrition of the enemy. Newspapers, everywhere interfered with by governments, played along and continued describing trench warfare in the words of a cricket match. Life within the warring countries returned to near normalcy; it was just that there was a line between them along which young men were told to kill one another with every conceivable means, stopping at nothing. Twenty thousand British and Canadian soldiers were routinely killed on single mornings just by being sent out of their trenches at the Somme River. At Verdun on the first day of their attack the Germans fired one million shells on the French lines. Not until the war was almost over did the hopelessness, the criminal uselessness, of all this penetrate the populations at large. Then, finally, the truth began entering the despised civilians' minds that so many had been killed and gassed and maimed only through the self-satisfied obtuseness of their officers, and "pacifism" ceased to be a dirty word.

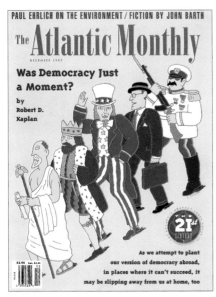

Merit

**ILLUSTRATION, EDITORIAL OR COVER:
NEWSPAPER/MAGAZINE, SERIES**
Was Democracy Just a Moment?

ART DIRECTOR *Judy Garlan*
WRITER *Robert D. Kaplan*
DESIGNER *Judy Garlan*
ILLUSTRATOR *Seymour Chwast*
CLIENT *The Atlantic Monthly*
COUNTRY *United States*

The Population Explosion Is Over

The prediction that spawned a generation of alarmists has now been turned on its head. But the prospect of an emptier planet is creating its own set of problems. **By Ben J. Wattenberg**

For 30 years, one notion has shaped much of modern social thought: that the human species is reproducing itself uncontrollably, and ominously. In his best-selling book of 1968, "The Population Bomb," Paul Ehrlich warned that "the cancer of population growth must be cut out" or "we will breed ourselves into oblivion." He appeared on the Johnny Carson show 25 times to sell this idea. Lester Brown's "29th Day" compared people to geometrically multiplying waterlilies; on the 30th day, the world would end. A study by the Club of Rome (which it later renounced) described how rapacious humans would soon "run out of resources."

Several generations of schoolchildren have been taught these lessons; the State Department endorses them. A 1992 documentary on Ted Turner's CNN described the impending global chaos "as the planet's population grows exponentially," and just a few days ago, Turner and his wife, Jane Fonda, were honored at a gala for Zero Population Growth, which preaches the mantra of out-of-control overpopulation. The issue of global warming, linked to soaring population growth deep into the next century, is front-page news.

Thirty years of persistent alarm. But now, mounting evidence, from rich nations and poor, strongly suggests that the population explosion is fizzling. Earlier this month, for the first time ever, the United Nations Population Division convened expert demographers to consider aspects of low and tumbling fertility rates. That discussion is a step toward a near-Copernican shift in the way our species looks at itself. Never before have birthrates fallen so far, so fast, so low, for so long all around the world. The potential implications — environmental, economic, geopolitical and personal — are both unclear and clearly monumental, for good and for ill.

The Plot Thins

The free fall in fertility can best be seen in "World Population Prospects: The 1996 Revision," an eye-opening reference book published by the United Nations, from which most data used here are drawn. From 1950 to 1955, the global "total fertility rate" (roughly speaking, the average number of children born per woman per lifetime) was five. That was explosively above the so-called replacement rate of 2.1 children, the level needed to keep a population

from falling over time, absent immigration. This scary growth continued for about 15 years until, by 1975 to 1980, fertility had fallen to four children per woman. Fifteen years after that, the rate had fallen to just below three. Today the total fertility rate is estimated at 2.8, and sinking.

Five children per woman. Then four. Then three. Then less than three. In estimating the population for the year 2050, demographers were caught with their projections up. Suddenly, worldwide, 650 million people were "missing." Many more will be missing soon. They will never be born.

But what about women in those teeming less-developed countries (L.D.C.'s) — those swarming places where the population bomb was allegedly ticking most loudly? Even there, the fuse is sputtering. The L.D.C. fertility rate in 1965 to 1970 was six children per woman. Now it's three, and falling more quickly than ever before in demographic history.

Those are broad numbers. Consider some specific nations. Italy, a Catholic country, has a fertility rate of 1.2 children per woman, the world's lowest rate — and the lowest national rate ever recorded (absent famines, plagues, wars or economic catastrophes). India's fertility is lower than American rates in the 1950's. The rate in Bangladesh has fallen from 6.2 to 3.4 — in just 10 years.

European birthrates of the 1980's, already at record-breaking lows, fell another 20 percent in the 90's, to about 1.4 children per woman. The demographer Antonio Golini says such rates are "unsustainable." Samuel Preston, director of the University of Pennsylvania's Population Studies Center, recently calculated what will happen if European fertility changes and moves back toward a rate of 2.1. Even then, by the year 2060, when its population levels off, Europe will have lost 24 percent of its people. Japanese and Russian rates are also at about 1.4 children.

In Muslim Tunisia, over three decades the rate has fallen from 7.2 to 2.9. Rates are higher, but way down, in Iran and Syria. Fertility rates are plunging in many (though not all) sub-Saharan African nations, including Kenya, once regarded as the premier demographic horror show. Mexico has moved 80 percent of the way toward replacement level.

In the United States, birthrates have been below replacement for

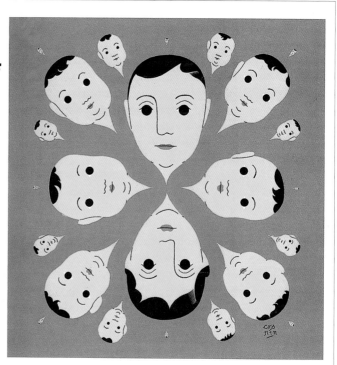

Illustrations by Brian Cronin

Why They Kill Their Newborns

A mother who murders her baby commits an immoral act, but not necessarily a pathological one. Neonaticide may be a product of maternal wiring.
By Steven Pinker
Illustration by Anita Kunz

Killing your baby. What could be more depraved? For a woman to destroy the fruit of her womb would seem like an ultimate violation of the natural order. But every year, hundreds of women commit neonaticide: they kill their newborns or let them die. Most neonaticides remain undiscovered, but every once in a while a janitor follows a trail of blood to a tiny body in a trash bin, or a woman faints and doctors find the remains of a placenta inside her.

Two cases have recently riveted the American public. Last November, Amy Grossberg and Brian Peterson, 18-year-old college sweethearts, delivered their baby in a motel room and, according to prosecutors, killed him and left his body in a Dumpster. They will go on trial for murder next year and, if convicted, could be sentenced to death. In June, another 18-year-old, Melissa Drexler, arrived at her high-school prom, locked herself in a bathroom stall, gave birth to a boy and left him dead in a garbage can. Everyone knows what happened next: she touched herself up and returned to the dance floor. In September, a grand jury indicted her for murder.

How could they do it? Nothing melts the heart like a helpless baby. Even a biologist's cold calculations tell us that nurturing an offspring that carries our genes is the whole point of our existence. Neonaticide, many think, could be only a product of pathology. The psychiatrists uncover childhood trauma. The defense lawyers argue temporary psychosis. The pundits blame a throwaway society, permissive sex education and, of course, rock lyrics.

But it's hard to maintain that neonaticide is an illness when we learn that it has been practiced and accepted in most cultures throughout history. And that neonaticidal women do not commonly show signs of psychopathology. In a classic 1970 study of statistics of child killing, a psychiatrist, Phillip Resnick, found that mothers who kill their *older* children are frequently psychotic, depressed or suicidal, but mothers who kill their newborns are usually not. (It was this difference that led Resnick to argue that the category infanticide be split into neonaticide, the killing of a baby on the day of its birth, and filicide, the killing of a child older than one day.)

Killing a baby is an immoral act, and we often express our outrage at the immoral by calling it a sickness. But normal human motives are not always moral, and neonaticide does not have to be a product of malfunctioning neural circuitry or a dysfunctional upbringing. We can try to understand what would lead a mother to kill her newborn, remembering that to understand is not necessarily to forgive.

Martin Daly and Margo Wilson, both psychologists, argue that a ca-

Steven Pinker is a professor of psychology at the Massachusetts Institute of Technology and the author of "How the Mind Works."

pacity for neonaticide is built into the biological design of our parental emotions. Mammals are extreme among animals in the amount of time, energy and food they invest in their young, and humans are extreme among mammals. Parental investment is a limited resource, and mammalian mothers must "decide" whether to allot it to their newborn or to their current and future offspring. If a newborn is sickly, or if its survival is not promising, they may cut their losses and favor the healthiest in the litter or try again later on.

In most cultures, neonaticide is a form of this triage. Until very recently in human evolutionary history, mothers nursed their children for two to four years before becoming fertile again. Many children died, especially in the perilous first year. Most women saw no more than two or three of their children survive to adulthood, and many did not see any survive. To become a grandmother, a woman had to make hard choices. In most societies documented by anthropologists, including those of hunter-gatherers (our best glimpse into our ancestors' way of life), a woman lets a newborn die when its prospects for survival to adulthood are poor. The forecast might be based on abnormal signs in the infant, or on bad circumstances for successful motherhood at the time — she might be burdened with older children, beset by war or famine or without a husband or social support. Moreover, she might be young enough to try again.

We are all descendants of women who made the difficult decisions that allowed them to become grandmothers in that unforgiving world, and we inherited that brain circuitry that led to those decisions. Daly and Wilson have shown that the statistics on neonaticide in contemporary North America parallel those in the anthropological literature. The women who sacrifice their offspring tend to be young, poor, unmarried and socially isolated.

Natural selection cannot push the buttons of our behavior directly; it affects our behavior by endowing us with emotions that coax us toward adaptive choices. New mothers have always faced a choice between a definite tragedy now and the possibility of an even greater tragedy months or years later, and that choice is not to be taken lightly. Even today, the typical rumination of a depressed new mother — how will I cope with this burden? — is a legitimate concern. The emotional response called bonding is also far more complex than the popular view, in which a woman is imprinted with a lifelong attachment to her baby if they interact in a critical period immediately following the baby's birth. A new mother will first coolly assess the infant and her current situation and only in the next few days begin to see it as a unique and wonderful individual. Her love will gradually deepen in ensuing years, in a trajectory that tracks the increasing biological value of a child (the chance that it will live to produce grandchildren) as the child proceeds through the mine field of early development.

Even when a mother in a hunter-gatherer society hardens her heart to sacrifice a newborn, her heart has not turned to stone. Anthropologists who interview these women (or their relatives) report that the event is often too painful for the woman to discuss) discover that the women see the death as an unavoidable tragedy, grieve at the time and remember the child with pain all their lives. Even the supposedly callous Melissa Drexler agonized over a name for her dead son and wept at his funeral. (Initial reports that, after giving birth, she requested a Metallica song

from the deejay and danced with her boyfriend turned out to be false.)

Many cultural practices are designed to distance people's emotions from a newborn until its survival seems probable. Full personhood is often not automatically granted at birth, as we see in our rituals of christening and the Jewish bris. And yet the recent neonaticides still seem puzzling. These are middle-class girls whose babies would have been kept far from starvation by the girls' parents or by any of thousands of eager adoptive couples. But our emotions, fashioned by the

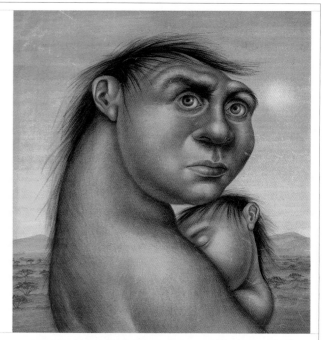

P.S.

A Road to Ruin

A human pipeline to the Arctic Ocean: Can the Alaskan tundra take it? BY KEVIN KRAJICK

As roads go, this one doesn't look like much: a 30-foot-wide gravel strip paralleling the Trans-Alaska Pipeline. The James Dalton Highway, also known as the Haul Road, runs 414 miles through scarcely inhabited boreal forest, among the glaciated spires of the Brooks Range, and on across the tundra to Prudhoe Bay, on the Arctic Coast. It passes within sight of both Gates of the Arctic National Park and the Arctic National Wildlife Refuge.

But two and a half years ago the Haul Road was opened to public travel, and now everyone—from Winnebago loads of retirees to rifle-packing caribou hunters—can wheel into this wild country. The pipeline was long ago predicted to be northern Alaska's downfall; now it seems the road alongside it may bring more problems than Evil Oil ever did.

Oil companies first conceived the Haul Road as a minimal, perhaps temporary, track for trucks headed to Prudhoe. When the pipe became operational in 1977, non-oil road traffic was barred. By 1978, though, lawmakers had declared the road a state highway and opened it to the Yukon River, 130 miles beyond Alaska's northernmost city, Fairbanks; in 1981 the line was moved up another 150 miles to Disaster Creek, in the southern Brooks Range. Here, at the insistence of the security-conscious oil consortium, the environmental community, and 10,000 or so insular northern natives, the state ran a checkpoint, admitting only oil trucks to the northern Brooks and the tundra.

But "there was never any will to enforce the law," says Ken Whitten, a research coordinator for the Alaska Department of Fish and Game. "People believed the road belonged to them." Highway authorities soon started issuing "business permits" to anyone with a phony excuse to pass Disaster Creek; it wasn't long before the checkpoint was left unmanned. (The main "business," it turns out, was a wealth of hunting and fishing, much of it illegal.) In 1991 Governor Wally Hickel decided to end the farce and officially opened the entire road. Native opposition won an injunction against public access, but by late 1994 it had been lifted. The next year, traffic leaped 40 percent.

Out on the Haul Road, it's still a rough day's drive between gas stations. You're out of AM-FM range, and musk oxen may outnumber people. But the effects of human travel are already easy to find (certainly easier than 20-pound trout, cleaned out of roadside lakes years ago). A 1987

study found that dust kicked up by vehicles coated the roadside inches deep in places, eradicating certain mosses and lichens—dominant tundra life-forms—as far as 100 yards out, and sickening spruces south of the Brooks Range. A follow-up this year shows that the "disturbed area" now reaches as far as 400 yards. There is also evidence that the Central Arctic caribou herd, whose territory the road bisects, has split in two.

The news isn't all bad for wildlife—or for videocam-armed tourists, who don't seem to mind the increasingly zoolike feeling. Snowy owls now perch on the tundra's metal mileposts, the highest vantages around. Since road dust melts the snow early, the permafrost is collapsing to form pools that attract masses of spring birds and, in turn, many wolves and bears. A university research station near the road has become a happy hunting ground for foxes, who pounce on garbage-fattened ground squirrels in full view of students.

Luckily for the fragile tundra, most visitors are afraid to stray into the mucky landscape, or even to roll down their car windows (too many mosquitoes). Still, officials expect traffic to grow steadily, and they are looking to upgrade the highway and to add outhouses, motels, gas stations, and convenience stores.

Most native villages are too far from the road to be accessible—yet. But many look to the highway's southern end for a preview. Randy Mayo, the first chief of Stevens Village, near the Yukon, says outsiders have decimated hunting and fishing and strewn trash around sacred grounds. Alcoholism and domestic violence are rampant. "We're dealing with the spiritual and economic degradation of our society," Mayo says. "We've become a colony of the road." He vows to resist more development "by any means necessary."

To those of us from much farther south, the ultimate preview is Prudhoe Bay itself. Here, on the rim of the Arctic Ocean, the visitor sees a vast, open coastal wetland—planted straight to the horizon with giant cranes, flashing radio towers, fuel tanks, and stacks spouting great jets of smoke and fire. The journey to the top of the earth seems to have brought us to a familiar place: the petrochemical sprawl of the New Jersey Turnpike. ❧

ILLUSTRATION, EDITORIAL OR COVER: NEWSPAPER/MAGAZINE
A Road to Ruin

ART DIRECTOR *Suzanne Morin*
DESIGNER *Suzanne Morin*
ILLUSTRATOR *Ferruccio Sardella*
CLIENT *Audubon Magazine*
COUNTRY *United States*

(facing page, top)
Merit

ILLUSTRATION, EDITORIAL OR COVER: NEWSPAPER/MAGAZINE
The Population Explosion Is Over

ART DIRECTOR *Janet Froelich*
COPYWRITER *The New York Times*
DESIGNER *Claude Martel*
ILLUSTRATOR *Brian Cronin*
CLIENT *The New York Times Magazine*
COUNTRY *United States*

(facing page, bottom)
Merit

ILLUSTRATION, EDITORIAL OR COVER: NEWSPAPER/MAGAZINE
Why They Kill Their Newborns

ART DIRECTOR *Janet Froelich*
COPYWRITER *The New York Times*
DESIGNER *Joele Cuyler*
ILLUSTRATOR *Anita Kunz*
CLIENT *The New York Times Magazine*
COUNTRY *United States*

Merit
ILLUSTRATION, EDITORIAL OR COVER:
NEWSPAPER/MAGAZINE
Discover

ART DIRECTOR *Richard Boddy*
CREATIVE DIRECTOR *Richard Boddy*
WRITER *Matt Cartmill*
ILLUSTRATOR *Brad Holland*
STUDIO *Brad Holland*
CLIENT *Discover Magazine*
COUNTRY *United States*

Merit
ILLUSTRATION, EDITORIAL OR COVER:
NEWSPAPER/MAGAZINE
STORY Magazine, Winter 1998

ART DIRECTOR *R.O. Blechman*
DESIGNER *R.O. Blechman*
ILLUSTRATOR *R.O. Blechman*
STUDIO *The Ink Tank*
CLIENT *STORY Magazine*
COUNTRY *United States*

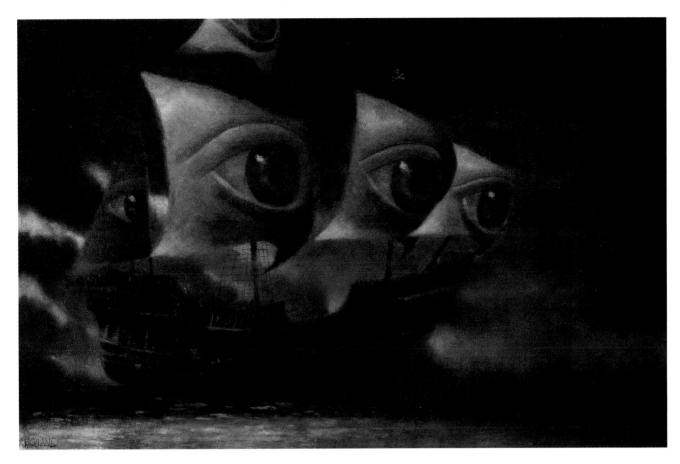

Merit
ILLUSTRATION, EDITORIAL OR COVER:
NEWSPAPER/MAGAZINE
The 21st Century Pirates

ART DIRECTORS *Frank DeVino, Mike McClellen*
CREATIVE DIRECTOR *Frank DeVino*
WRITERS *Ralf Blumenthal, Judith Miller*
ILLUSTRATOR *Brad Holland*
STUDIO *Brad Holland*
CLIENT *Penthouse Magazine*
COUNTRY *United States*

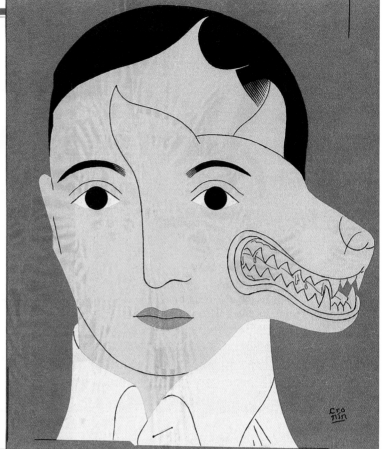

Lifestyle: The Mood Controller

A Little Help From Serotonin

Could a single brain chemical hold the key to happiness, high social status and a nice, flat stomach?

BY GEOFFREY COWLEY AND ANNE UNDERWOOD

OR RHESUS MONKEYS, LIFE IN THE WILD IS A little like high school. Some animals—call them losers—slouch around looking aggrieved. They're volatile and bellicose, slow to form alliances and loath to reconcile after a spat. One in five dies during the passage to adulthood. But while the losers scrap over bits of chow, other animals—call them winners—stay busy grooming each other. They maintain wide networks of allies. They deflect challenges without resorting to violence, and 49 out of 50 survive to produce offspring. Why do they fare so well? The answer is no doubt complicated, but the monkeys' spinal fluid provides an intriguing clue. In study after study, researchers at the National Institute on Alcohol Abuse and Alcoholism have found that the winners' nervous systems are loaded with serotonin.

As the 20th century winds down, we humans seem increasingly convinced that serotonin is the key to a good life—and it's easy to see why. This once obscure neurotransmitter is the secret behind Prozac, the drug that revolutionized the pursuit of happiness 10 years ago this winter. Prozac and its mood-altering cousins all work by boosting serotonin's activity in the brain. So do Redux and fenfluramine, the blockbuster diet drugs that were pulled off the market this fall due to safety concerns. Even Imitrex, the hot new migraine treatment, works its magic via serotonin. Somehow serotonin is implicated in just about everything that matters to us—from winning friends and wielding power to managing anxiety and controlling appetites and impulses. So what is serotonin? How does it work? And why is it in such short supply? Those issues are still murky, but science is yielding some clues.

Serotonin is so basic to life that even worms and sea slugs make it. The substance abounds in our bloodstreams, but our brains produce separate supplies via cells known as raphe nuclei. Rooted near the base of the skull, these specialized neurons extend like branching vines through the brain and spinal cord, each one maintaining links with a half-million target cells. When a nerve impulse reaches a branch ending, the neuron releases serotonin into a tiny space, or synapse. Serotonin molecules then lock into receptors on the target cell, transmitting a message that travels through the nervous system. Microseconds later, the neuron that released the chemical takes it back in—a process known as reuptake.

What does serotonin say during its moment in the synapse? It depends on the target. Our nervous systems harbor at least 14 classes of serotonin receptors, each tailored to a distinct piece of the molecule. Since different types of brain cells sport different receptors, their re-

ILLUSTRATIONS BY BRIAN CRONIN

Merit

ILLUSTRATION, PORTRAIT/FASHION

Serotonin Head

ART DIRECTOR *Janet Parker*
CREATIVE DIRECTOR *Lynn Staley*
DESIGNER *Janet Parker*
ILLUSTRATOR *Brian Cronin*
CLIENT *Newsweek*
COUNTRY *United States*

Merit
ILLUSTRATION, POSTER OR BILLBOARD, SERIES
To Be Young

ART DIRECTOR *Wakako Ishii*
CREATIVE DIRECTOR *Ikuo Amano*
DESIGNER *Wakako Ishii*
ILLUSTRATOR *Vivienne Flesher*
AGENCY *Shiseido*
STUDIO *Shiseido*
CLIENT *Shiseido*
COUNTRY *United States*

Merit
ILLUSTRATION, POSTER OR BILLBOARD, SERIES
Creatures from Mars

ART DIRECTORS *Steven Isakson, Julie Johnson*
ILLUSTRATOR *Steven Isakson*
AGENCY *Image Nation Design Group*
CLIENT *Portal Publications*
COUNTRY *United States*

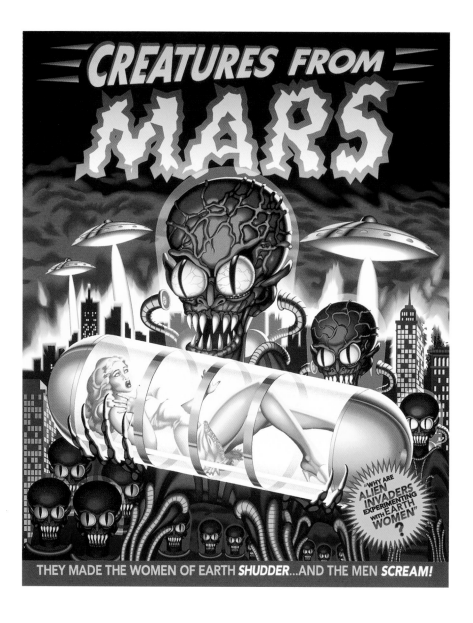

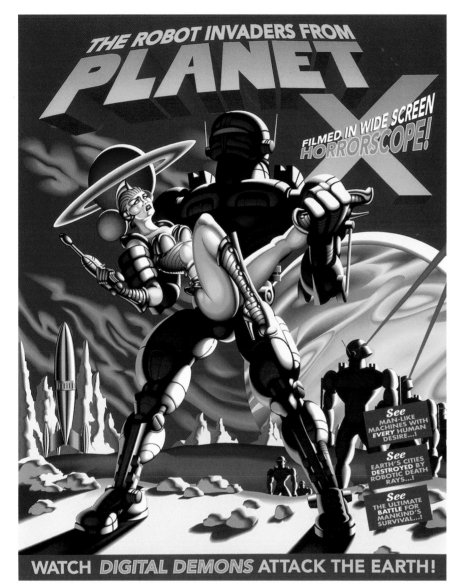

Merit
ILLUSTRATION, POSTER OR BILLBOARD
Planet X

ART DIRECTORS *Steven Isakson, Julie Johnson*
ILLUSTRATOR *Steven Isakson*
AGENCY *Image Nation Design Group*
CLIENT *Portal Publications*
COUNTRY *United States*

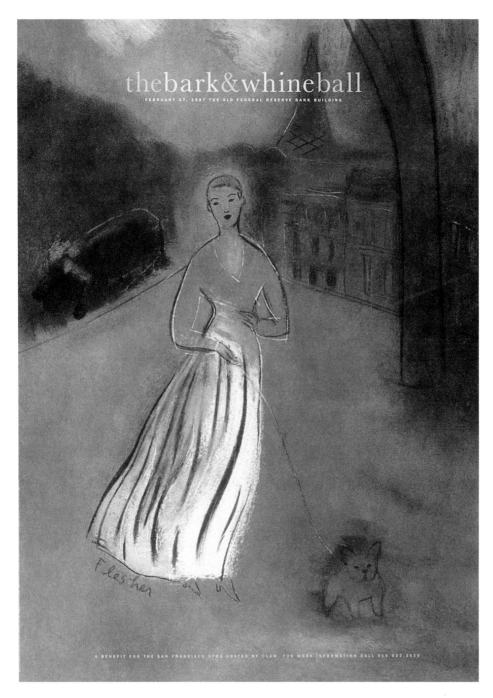

Merit
ILLUSTRATION, POSTER OR BILLBOARD
The Bark & Whine Ball

ART DIRECTOR *Keith Anderson*
DESIGNER *Keith Anderson*
ILLUSTRATOR *Vivienne Flesher*
AGENCY *Goodby Silverstein and Partners*
CLIENT *San Francisco Society for Prevention
of Cruelty to Animals*
COUNTRY *United States*

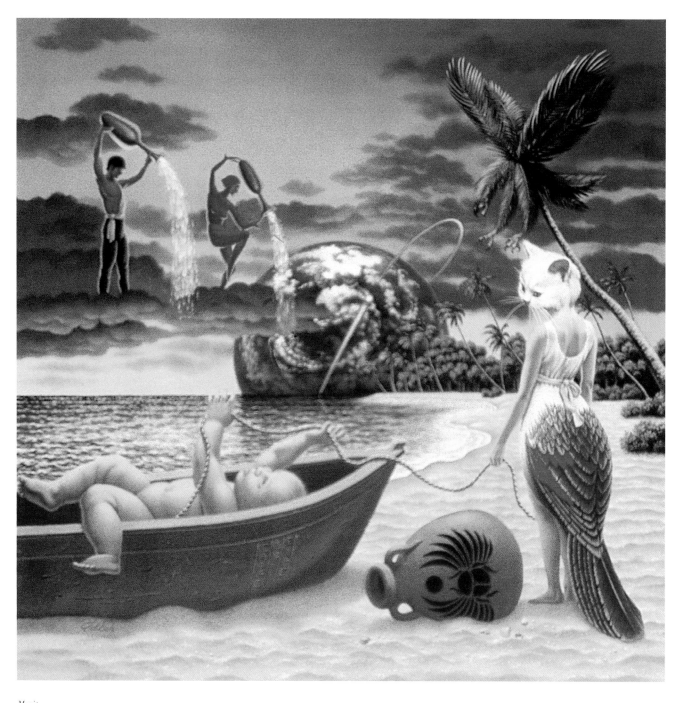

Merit
ILLUSTRATION, POSTER OR BILLBOARD
Journey, Trial by Fire

ART DIRECTOR *David Coleman*
DESIGNER *David Coleman*
ILLUSTRATOR *Steven Adler*
STUDIO *Sony Music/Santa Monica*
CLIENT *Columbia Records*
COUNTRY *United States*

Merit
ILLUSTRATION, POSTER OR BILLBOARD
Insects Collecting (Imaginary Insects)

ART DIRECTOR *Sadahito Mori*
DESIGNER *Sadahito Mori*
ILLUSTRATOR *Sadahito Mori*
STUDIO *Alfa Studio*
CLIENT *Graphic Trigger Association*
COUNTRY *Japan*

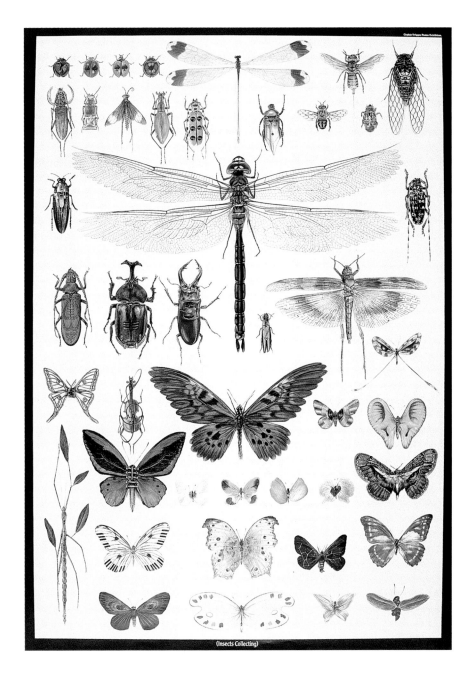

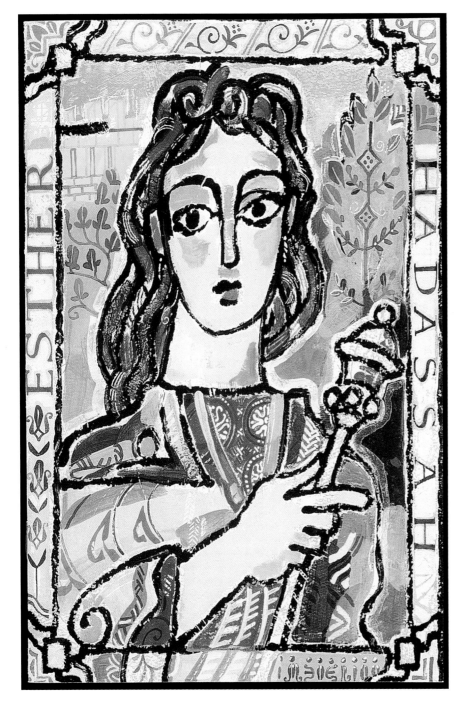

Merit
ILLUSTRATION, POSTER OR BILLBOARD
Esther's Gift

ART DIRECTOR *Michael Cohen*
CREATIVE DIRECTOR *Michael Cohen*
ILLUSTRATOR *David Scott Meier*
CLIENT *Hadassah*
COUNTRY *United States*

Merit
ILLUSTRATION, POSTER OR BILLBOARD
SNO Core

DESIGNER *Ward Sutton*
ILLUSTRATOR *Ward Sutton*
STUDIO *Ward Sutton Studio*
CLIENT *SNO Core/Art Rock*
COUNTRY *United States*

(facing page, top)
Merit
ILLUSTRATION, POSTER OR BILLBOARD
Pod

ART DIRECTOR *Maria Hipwell*
CREATIVE DIRECTOR *Graeme Norways*
COPYWRITER *Daniel Hume*
ILLUSTRATOR *James Marsh*
TYPOGRAPHER *Dave Jenner*
PRODUCER *Ben Catford*
AGENCY *Bean Andrews Norways Cramphorn*
CLIENT *The New Covent Garden Soup Company*
COUNTRY *England*

(facing page, bottom)
Merit
ILLUSTRATION, POSTER OR BILLBOARD
Playing in the Park!

ART DIRECTOR *David Bartels*
CREATIVE DIRECTOR *Bob Sanna*
COPYWRITER *David Bartels*
DESIGNERS *Bob Sanna, David Bartels*
ILLUSTRATOR *Gary Overacre*
PRODUCERS *JFB Lithographers & Sons, Dan Garcia*
AGENCY *Sanna Mattson MacLeod Advertising*
CLIENT *NY Philharmonic Free Concert Committee
of Long Island*
COUNTRY *United States*

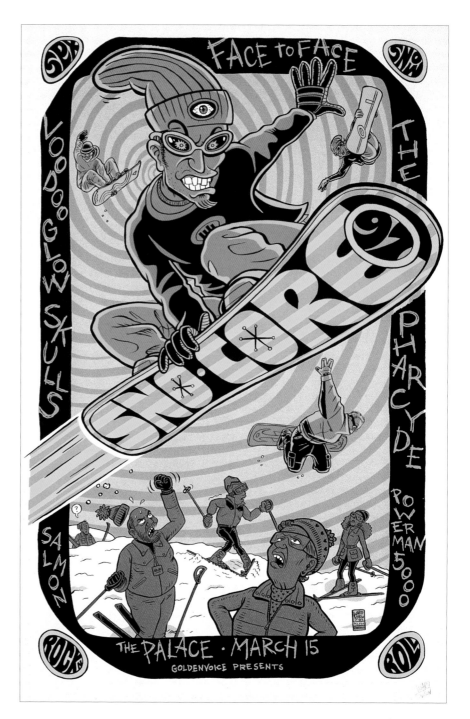

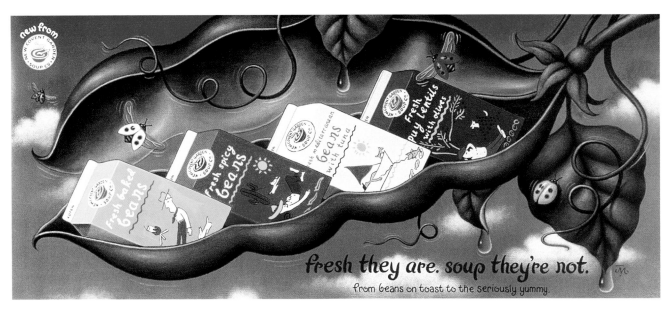

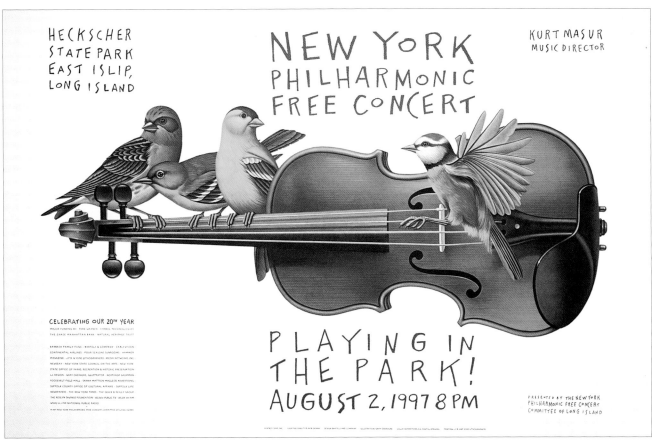

Merit
ILLUSTRATION, POSTER OR BILLBOARD
FREAK

ART DIRECTOR *Drew Hodges*
DESIGNER *Kevin Brainard*
ILLUSTRATOR *Ward Sutton*
STUDIO *SPOT Design*
CLIENT *FREAK, Broadway Show*
COUNTRY *United States*

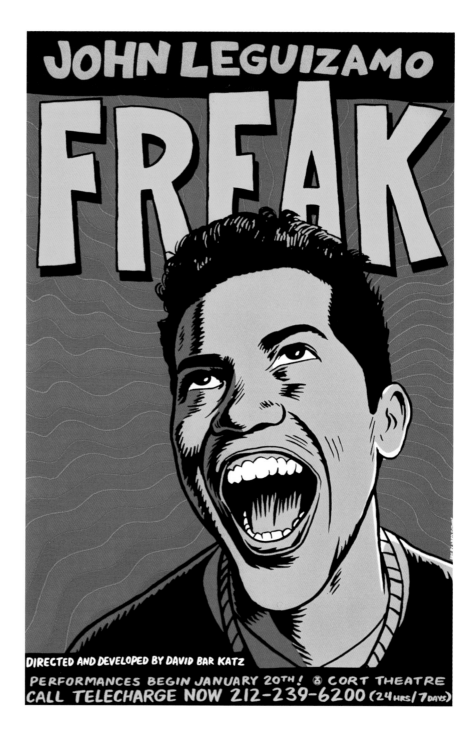

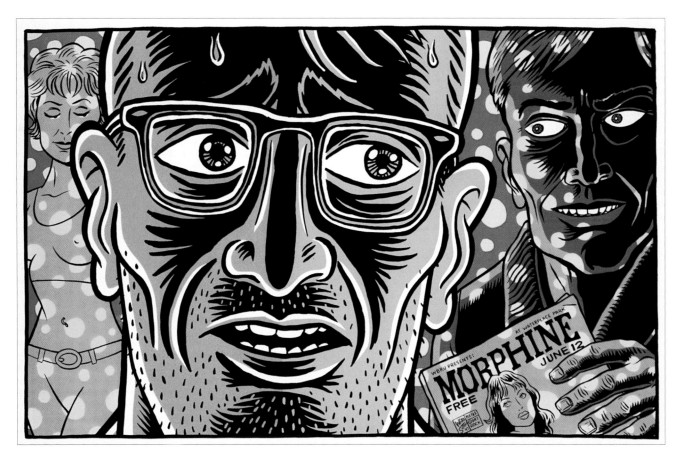

Merit
ILLUSTRATION, POSTER OR BILLBOARD
Morphine

DESIGNER *Ward Sutton*
ILLUSTRATOR *Ward Sutton*
STUDIO *Ward Sutton Studio*
CLIENT *Art Rock*
COUNTRY *United States*

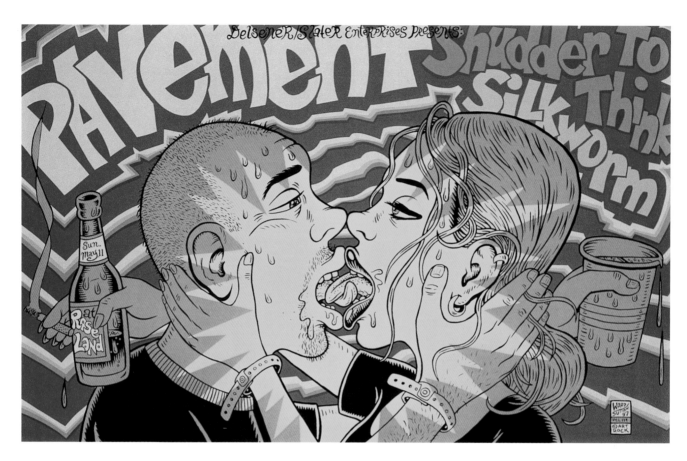

Merit
ILLUSTRATION, POSTER OR BILLBOARD
Pavement

DESIGNER *Ward Sutton*
ILLUSTRATOR *Ward Sutton*
STUDIO *Ward Sutton Studio*
CLIENT *Art Rock*
COUNTRY *United States*

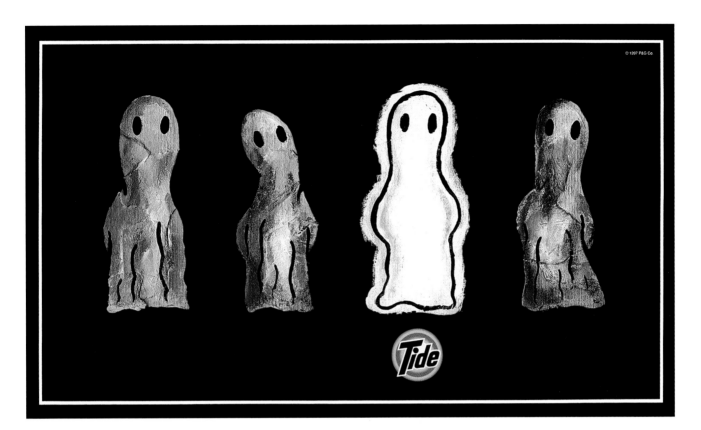

Merit
ILLUSTRATION, POSTER OR BILLBOARD
Ghosts

ART DIRECTORS *Adam Hunt, Tim Brown*
CREATIVE DIRECTORS *Stanley Becker, David Levine*
COPYWRITERS *Tim Brown, Adam Hunt*
DESIGNERS *Adam Hunt, Tim Brown*
ILLUSTRATOR *Gary Baseman*
AGENCY *Saatchi & Saatchi*
CLIENT *Procter & Gamble*
COUNTRY *United States*

Merit
ILLUSTRATION, POSTER OR BILLBOARD
Talk Trash

ART DIRECTORS *Eugene Hoffman, Dick Patrick*
CREATIVE DIRECTORS *Eugene Hoffman, Dick Patrick*
COPYWRITER *Paul Munsterman*
DESIGNER *Monster Design Inc.*
PHOTOGRAPHER *Joe Coca*
ILLUSTRATOR *Eugene Hoffman*
PRODUCER *Dallas Society of Visual Communications*
AGENCY *Direct (DSVC)*
STUDIO *Dick Patrick–Eugene Hoffman*
CLIENT *Dallas Society of Visual Communications*
COUNTRY *United States*

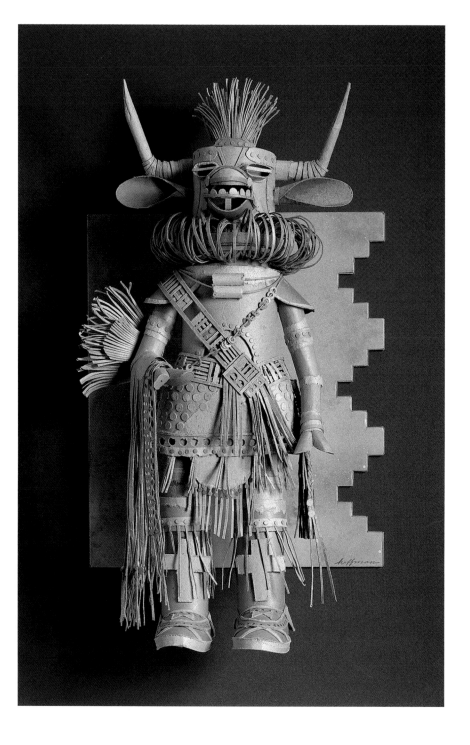

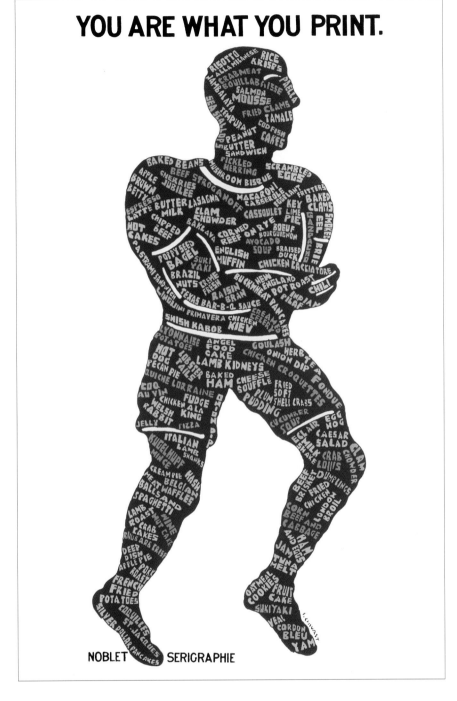

Merit
ILLUSTRATION, POSTER OR BILLBOARD
You Are What You Print

DESIGNER *Seymour Chwast*
ILLUSTRATOR *Seymour Chwast*
STUDIO *The Pushpin Group*
CLIENT *Noblet Serigraphie*
COUNTRY *United States*

Merit

ILLUSTRATION, POSTER OR BILLBOARD
Book Festival

ART DIRECTORS *John Sullivan, Dennis Gallagher*
COPYWRITER *Bob Martin*
DESIGNERS *John Sullivan, Dennis Gallagher*
ILLUSTRATOR *Vivienne Flesher*
STUDIO *Visual Strategies*
CLIENT *San Francisco Bay Area Book Council*
COUNTRY *United States*

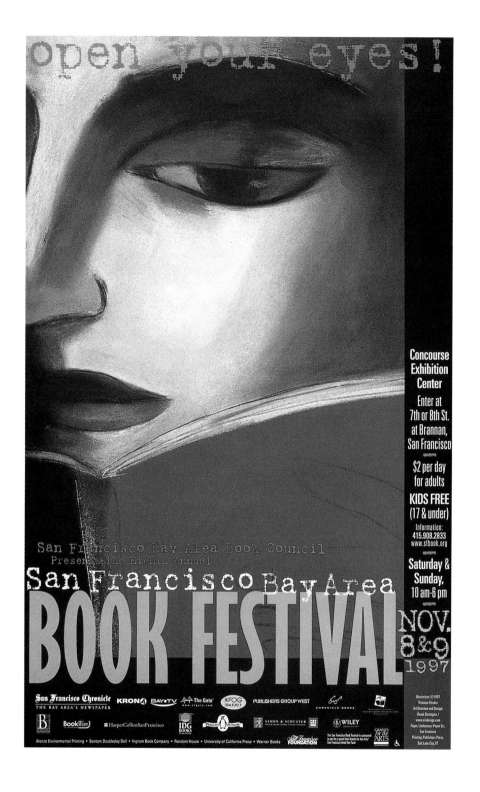

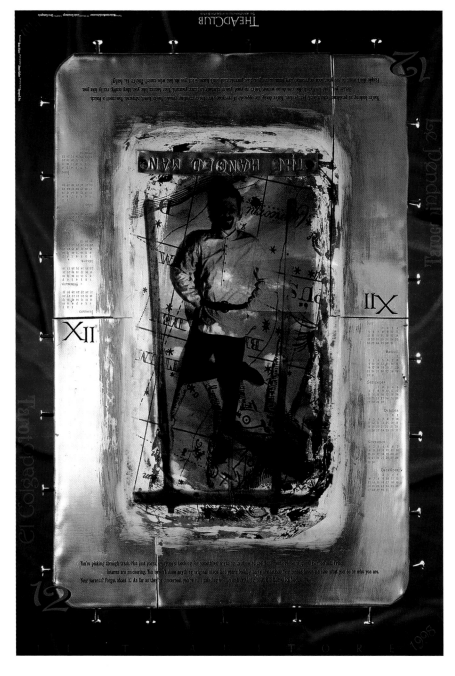

Merit
ILLUSTRATION, POSTER OR BILLBOARD
The Hanged Man

ART DIRECTOR *Linda Santomango*
CREATIVE DIRECTOR *Amy Hunt*
COPYWRITER *Chris Castagnola*
PHOTOGRAPHER *Jason Geller*
ILLUSTRATOR *Bina Altera*
AGENCY *Wickersham Hunt Schwantner*
CLIENT *The Advertising Club of Greater Boston*
COUNTRY *United States*

Merit
ILLUSTRATION, POSTER OR BILLBOARD
Working Class House Ad

ART DIRECTOR *Bill Atherton*
CREATIVE DIRECTOR *David Metcalf*
COPYWRITER *David Metcalf*
DESIGNER *Graham Clifford*
ILLUSTRATOR *Antar Dayal*
AGENCY *Working Class*
CLIENT *Working Class*
COUNTRY *United States*

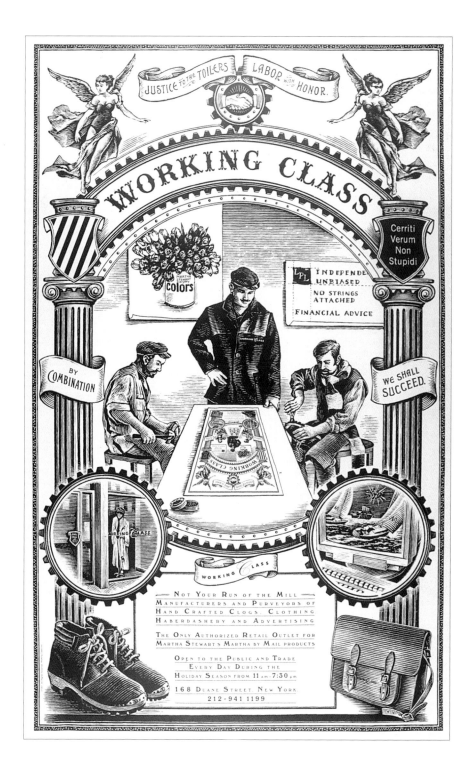

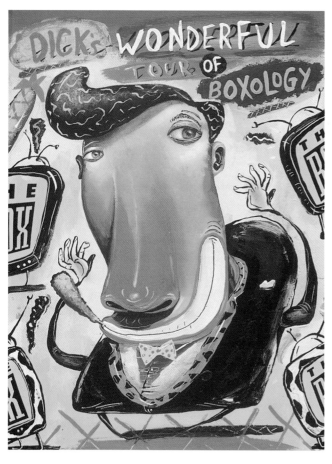

MULTIPLE AWARDS

Merit
ILLUSTRATION, BOOK OR BOOK JACKET

and Merit
GRAPHIC DESIGN, BOOK DESIGN,
PROMOTIONAL BOOKS
Dick's Wonderful Tour of Boxology

ART DIRECTOR *Jennifer Ann Segalini*
COPYWRITER *Libba Bray*
DESIGNER *Jennifer Ann Segalini*
ILLUSTRATOR *Rick Sealock*
STUDIO *THE BOX Worldwide, Inc.*
CLIENT *THE BOX Worldwide, Inc.*
COUNTRY *United States*

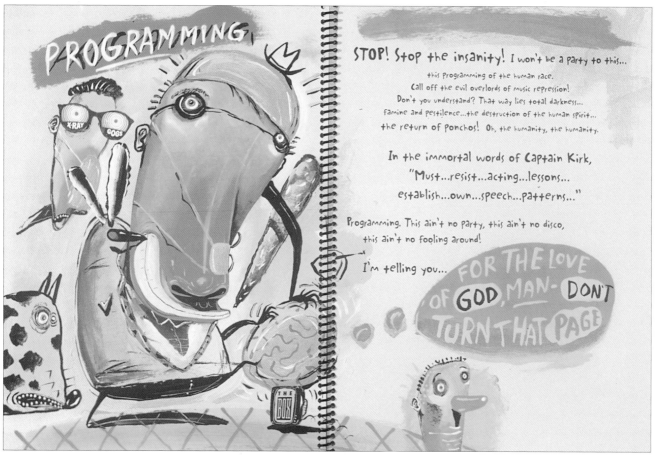

Merit
ILLUSTRATION, BOOK OR BOOK JACKET
Fax Art Tokyo-Helsinki

ART DIRECTOR *Takashi Akiyama*
DESIGNER *Takashi Akiyama*
ILLUSTRATOR *Takashi Akiyama*
PRODUCER *Takashi Akiyama*
STUDIO *Takashi Akiyama*
CLIENT *Multimedia YUMEKOUBOU*
COUNTRY *Japan*

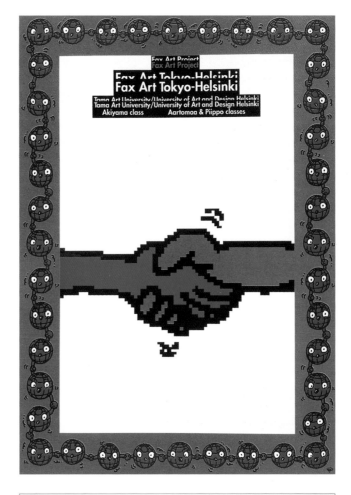

Merit
ILLUSTRATION, BOOK OR BOOK JACKET
Echoes of the Elders

ART DIRECTOR *Nicholas Callaway*
DESIGNER *Jennifer Wagner*
EDITOR *Andrea Danese*
ILLUSTRATOR *Chief Don Lelooska Smith*
PRODUCER *Callaway Editions, Inc.*
PRODUCTION DIRECTOR *True Sims*
FIRM *Callaway Editions, Inc.*
CLIENT *Dorling Kindersley*
COUNTRY *United States*

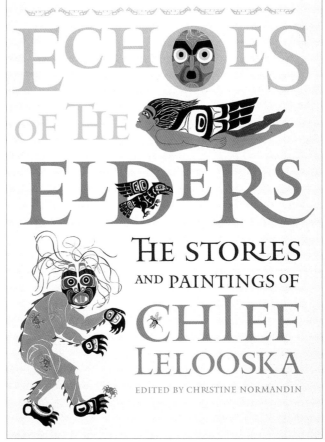

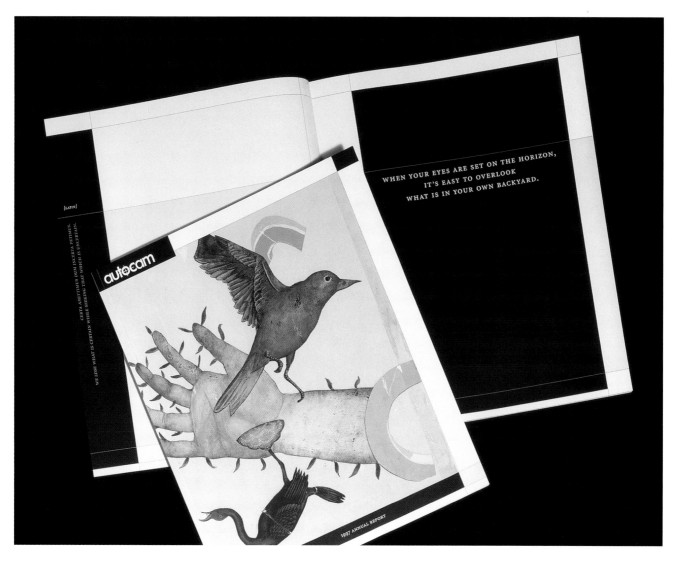

Merit
ILLUSTRATION, CORPORATE/INSTITUTIONAL
Autocam Annual Report, 1997

ART DIRECTOR *Leslie Black*
COPYWRITER *Polly Hewitt*
DESIGNERS *Leslie Black, Kevin Budelmann*
ILLUSTRATOR *Jason Holley*
STUDIO *Leslie Black Design*
CLIENT *Autocam*
COUNTRY *United States*

art directors club today

1998-99
Board of Directors

Bill Oberlander
Kirshenbaum Bond & Partners
President

Parry Merkley
Merkley Newman Harty
First Vice President

Peter Cohen
Lowe & Partners/SMS
Second Vice President

Jeffrey Keyton
MTV Music Television
Secretary

Richard Wilde
School Of Visual Arts
Treasurer

Ruth Lubell
Lubell Brodsky Inc.
Assistant Secretary/Treasurer

1998-99
Executive Committee

Stephen O. Frankfurt
Partners & Shevack Inc.

Jean Govoni
Jean Govoni & Partners

Jon Kamen
@radical.media

Peter Levine
Desgrippes Gobe & Associates

Jeffrey Metzner
Metzner Productions

Marty Weiss
Weiss, Whitten, Stagliano Inc.

Art Directors Club Staff

Administration

Myrna Davis
Executive Director

Olga Grisaitis
Associate Director

Autherine Allison
Melissa A. Hirsch
Membership

Jeff Newelt
Corporate Communications

Jennifer M. Synan
Development/Marketing

Tony Zisa
Financial Consultant

Ann Schirripa
Receptionist

Exhibitions

Laetitia Wolff
Annual Awards and
Exhibitions Coordinator

Glenn Kubota
Annual Awards and
Exhibitions Associate

Jennifer Galvelis
Annual Awards and
Exhibitions Assistant

Gwendolyn Leung
Annual Awards and
Exhibitions Assistant

Andre Lee
Design Intern

Camille Brett
Exhibitions Intern

Jin Lee
Exhibitions Intern

Facility

Romy Maldonado
Facilities Manager

Pierre Michel Hyppolite
Porter

Margaret Busweiler
Waitstaff

1998-99
Art Directors Club Committee Chairs

Carl Fischer
Advisory Board

Richard Wilde
Finance

Roy Anderson
New Media

Jean Govoni
Portfolio Review &
Student Competition

Susan Mayer
Saturday Career Workshop

Ruby Friedland
Speaker Events

Walter Kaprielian
Video Project

Jeffrey Keyton
1998 Young Guns Curatorial

The Art Directors Scholarship
Foundation, Inc. (ADSF)

1998-99 Board of Directors

Peter Adler
President

Meg Crane
First Vice President

David Davidian
Second Vice President

David MacInnes
Treasurer

Diane Moore
Assistant Treasurer

Gladys Barton
Secretary

Dorothy Wachtenheim
Secretary

Walter Kaprielian
Director

Shin Tora†
Director

Lee Epstein
Director

Nancy Stamatopoulos
Special Projects

77th Call for Entries

Gary Koepke
Wieden & Kennedy, New York
Design

Adrian Tomine
Artist

Champion
Paper

Sandy Alexander
Printer

77th Awards Invitation

Wieden & Kennedy, New York
Design

Monadnock Astrolite
Paper

Empire Graphics
Printer

77th Awards Presentation

Parry Merkley
Merkley Newman Harty
Chairperson

Olga Grisaitis
Maloney + Fox
Event Coordinators

77th Awards Animated Short Film

J.J. Sedelmaier
J.J. Sedelmaier Productions Inc.
Animation Producer/Director

Rick Adams
Bell Technology Group
Digital Ink & Paint

Tom Pomposello
Jeff Dickson
Ted Kuhn
Pomposello Productions
Music & Sound Design

Adrian Tomine
Artist

ADC Publications, Inc.

Jackie Merri Meyer
President

Joseph Montebello
Vice President

Nicholas Callaway
Secretary

Myrna Davis
Treasurer

Stefan Sagmeister
Board Member

The ADC International Review

Myrna Davis
Editorial Direction

Jeff Newelt
Editor

Steven Brower
Jonathan Tessler
Contributing Writers

Graphis Magazine
Publisher

Special thanks to:
B. Martin Pedersen

ADC Past Presidents

Richard J. Walsh, 1920-21
Joseph Chapin, 1921-22
Heyworth Campbell, 1922-23
Fred Suhr, 1923-24
Nathaniel Pousette-Dart, 1924-25
Walter Whitehead, 1925-26
Peirce Johnson, 1926-27
Arthur Munn, 1927-28
Stuart Campbell, 1929-30
Guy Gayler Clark, 1930-31
Edward F. Molyneux, 1931-33
Gordon C. Aymar, 1933-34
Mehemed Fehmy Agha, 1934-35
Joseph Platt, 1935-36
Deane Uptegrove, 1936-38
Walter B. Geoghegan, 1938-40
Lester Jay Loh, 1940-41
Loren B. Stone, 1941-42
William A. Adriance, 1942-43
William A. Irwin, 1943-45
Arthur Hawkins, Jr., 1945-46
Paul Smith, 1946-48
Lester Rondell, 1948-50
Harry O'Brien, 1950-51
Roy W. Tillotson, 1951-53
John Jamison, 1953-54
Julian Archer, 1954-55
Frank Baker, 1955-56
William H. Buckley, 1956-57
Walter R. Grotz, 1957-58
Garrett P. Orr, 1958-60
Robert H. Blattner, 1960-61
Edward B. Graham, 1961-62
Bert W. Littmann, 1962-64
Robert Sherrich Smith, 1964-65
John A. Skidmore, 1965-67
John Peter, 1967-69
William P. Brockmeier, 1969-71
George Lois, 1971-73
Herbert Lubalin, 1973-74
Louis Dorfsman, 1974-75
Eileen Hedy Schultz, 1975-77
David Davidian, 1977-79
William Taubin, 1979-81
Walter Kaprielian, 1981-83
Andrew Kner, 1983-85
Edward Brodsky, 1985-87
Karl Steinbrenner, 1987-89
Henry Wolf, 1989-91
Kurt Haiman, 1991-93
Allan Beaver, 1993-95
Carl Fischer, 1995-97

Corporate members
Abril South America
Interport Communications
McCall's Magazine
Nickelodeon On-Air Design
React Magazine
Rolling Stone Magazine
Takeo Company Limited
Union Camp Corporation

United States
Adamek, Tina
Adams, Cornelia
Adams, Gaylord
Adelman, Jim
Adler, Peter
Adorney, Charles
Ahlgrim, Dennis
Allen, Heidi Flynn
Altenpohl, Peggy
Altschul, Charles
Anderson, Jack
Anderson, Roy
Andreozzi, Gennaro
Angotti, Adriana Amanda
Ansaria, Kimia
Arias-Perez, Luis E.
Auman, Cynthia
Babitz, Jeff
Bach, Robert
Bacich, Jaqueline Anne
Bacsa, Ronald
Baer, Charles
Baer, Priscilla
Baker, Eric
Ballance, Georgette
Ballister, Ronald
Banasvk, Arkadiusz
Bank, Adam
Baron, Richard
Barron, Don
Barthelmes, Robert
Barton, Gladys
Baumann, Mary K.
Beaver, Allan
Bender, Lois
Bennett, Edward
Benshoff, Kirk
Berg, John
Berman, Matt
Bernard, Walter
Bertulis, Frank
Best, Robert
Bevington, William
Beylerian, George
Binzen, Barbara
Blank, Peter
Blechman, R.O.
Blend, Robert
Bonavita, Donna
Bourges, Jean
Bowman, Harold
Boyd, Doug
Braguin, Simeon
Brauer, Fred
Braverman, Al
Breslin, Lynn D.
Briggs, Kelley
Broadbent, Nadja
Brockmeier, Bill
Brodsky, Ed

Brody, Ruth
Brody, Sam
Brown, Beverly
Brown, George
Brown, Mark Delane
Bruce, Robert
Brugnatelli, Bruno
Bryant, Carol
Buckley, William H.
Burris, Sara
Cadge, Bill
Cafritz, Jodi
Callaway, Nicholas
Canniff, Bryan
Cardillo, James
Carey, Peter
Carnase, Thomas
Casado, Ralph
Castellano, Tony
Castelli, Angelo
Catherines, Diana
Cecere, Tina Marie
Ceradini, David
Chang, Andrew
Chaplinsky, Jr., Anthony
Chen, Jack
Chermayeff, Ivan
Chernik, Lazarus
Cherry, John
Chester, Laurie
Choy, Rene
Christie, Alan
Chung, Shelly
Church, Stanley
Churchill, Traci
Churchward, Charles
Chwast, Seymour
Clark, Herbert
Clarke, James
Clemente, Thomas
Cline, Mahlon
Cobban, Nicole
Cohen, Joel
Cohen, Peter
Cohen, Sally Ann
Cohn, Barrie
Coll, Michael
Colocho, Kevin
Compagnone, Ralph
Conner, Elaine
Connors, Catherine
Cook-Tench, Diane
Coon, Sean Patrick
Coron, Fabienne
Cory, Jeffrey
Cotler, Sheldon
Cotler-Block, Susan
Cox, Phyllis Richmond
Cox, Robert
Coxwell, Chris
Craig, James Edward
Crane, Meg
Crane, Susan
Crossley, Gregory
Crozier, Bob
Crumlish, Arthur
Curry, Alison Davis
Curry, Christine
Cutler, Ethel
D'Elia, Michelle
Davidian, David

Davis, Barbara Vaughn
Davis, Herman
Davis, J. Hamilton
Davis, Paul
Davis, Philip
Davis, Randi
DeHaan, Stuart
DeVito, Frank
Deegan, Faith
Del Sorbo, Joe
Demoney, Jerry
Deutsch, David
Devedjiev, Marilyn
Dignam, John
Divincenzo, Dennis
Dorfsman, Louis
Dorian, Marc
Dorr, Cheri
Doss, Davis
Douglas, Kay E.
Doyle, Stephen
Druiz, Fae
Drummond, Stacy
Dubiel, Ann
Duffy, Donald
Duggan, Laura
Duntemann, Matthew
Eckman Silverstein, Heidi
Eckstein, Bernard
Edgar, Peter
Edwards, William Page
Eibel, Barbara
Eisenman, Nina
Eisenman, Stanley
Eisner, Robert
Elder, Karen
Ellis, Judith
Endewelt, Jack
Epstein, David
Epstein, Lee
Ericson, Shirley
Ermoyan, Suren
Fable, Kathleen
Fajardo, Camilo
Fedele, Gene
Federico, Gene
Fenga, Michael
Ferrell, John
Ferrell, Megan
Finzi, Sylvia
Fiorenza, Blanche
Fischer, Carl
Fitzgerald, Robbie Meyn
Fitzpatrick, Bernadette
Fitzpatrick, Wayne
Flock, Donald
Fowler, Nichole
Fraioli, John
Frankfurt, Stephen
Fredy, Sherry
Freeland, Bill
Friedland, Ruby Miye
Friedson, Stephen
Frith, Michael
Fujita, Neil
Fury, Leonard
Gabrich, Michelle
Gadson, Tyme
Gage, Robert
Gagan, Maureen Tobin
Galicheva, Nina

Gallo, Danielle
Garlanda, Gino
Gavasci, Alberto Paolo
Geismar, Tom
Geissbuhler, Steff
George, Jeffrey
Geranmayeh, Vida
Germakian, Michael
Gibson, Kurt
Ginsberg, Frank
Giovanitti, Sara
Giraldi, Bob
Glaser, Milton
Glaser, Scott
Gleason, Maureen
Glicksman, Jon
Gliserman, Tom
Gluckman, Eric
Gobe, Marc
Goettel, Manfred
Gold, Bill
Goldfarb, Roz
Goodfellow, Joanne
Gorkin, Baruch
Gottlieb, Michael
Govoni, Jean
Grace, Roy
Graves, R. Vann
Gray, Gregory
Greenberg, Karen
Greiss, Abe
Gribben, Chip
Griffin, Jack
Groglio, Glen
Growick, Phillip
Grubshteyn, Raisa
Gruppo, Nelson
Guild, S. Rollins
Guzman, George
Hack, Robert
Hagel, Bob
Haiman, Kurt
Hall, Crystal
Halter, Lisa
Halvorsen, Everett
Hama, Sho
Hamilton, Edward
Hammar, Peter
Haney, David
Harmms, Daesung
Harris, Cabell
Harris, Tami
Heit, Amy
Heller, Steven
Hensley, Randall
Hill, Chris
Hillsman, William
Hirsch, Peter
Ho, Charles
Hoerchler, Kari
Hoffenberg, Harvey
Hoffmann, Nancy
Hoffner, Marilyn
Holden, Robert F.
Holland, Barry
Holtz, Jennifer
Horn, Steve
Houser, William David
Howard, Paul
Hunt, Lisa
Hutter, Brian

Igarashi, Takenobu
Ilic, Mirko
Inada, Manabu
Iocca-Fritzlo, Susanne
Ishii, Skip
Jacobs, Harry
Jaffee, Lee Ann
Jamilkowski, John
Jamison, John
Janerka, Andrzej
Jang, Kelly Y.
Jaycox, Jr., David
Jerina, Patricia
Jervis, Paul
Joiner, Erich
Jones, Jr., John
Jones, Karen
Jubert, Joanne
Kalayjian, Vasken
Kalish, Nicki
Kamen, Jonathan
Kaprielian, Walter
Kay, Woody
Kaye, Michael Ian
Keller, Ted
Kenny, Alice
Kent, Nancy
Kenzer, Myron
Kerwin, Chris
Keyton, Jeffrey
Kim, Cheolan
Kim, Anne Hyun Jin
Kim, Kate Hyun Joo
Kinch, Greg
Kirshenbaum, Susan
Klein, Hedy
Klein, Judith
Klueger, Peter
Klyde, Hilda Stanger
Kner, Andrew
Knoepfler, Henry
Koepke, Gary
Komai, Ray
Koranache, Benier
Korpijaakko, Kati
Kowaleszyn, Peter
Krauss, Agnes
Krivoy, Fanny
Kuntz, Thomas
Kurtz, Mara
Kurz, Anna
Kutsovskaya, Lina
Kwik, Sharon
Kwok, Alvin
La Barge, Robert
La Marca, Howard
La Petri, Anthony
La Rochelle, Lisa
Lacava, Vincent
Lachman, Brad
Lamarque, Abril
Lanotte, Michael
Laise, Beverly Schrager
Lazzarotti, Sal
LeVesque, Shawn
Lee, David
Lee, Mark
Leeds, Gregory
Leon, Maru
Levin, Jennifer
Levine, Peter

Levine, Rick
Lewi, Jennifer
Liberman, Alexander
Liska, Steven
Lloyd, Douglas
Locke Monda, Robin
Lois, George
Lott, George
Lubell, Ruth
Lucci, John
Lucci, Ralph
Luger, Diane
Lurin, Larry
Lyon, Karen Fencenko
Lyon, Jr., Robert
Lyons, Michael
Macagba, Jonathan
MacFarlane, Richard
MacInnes, David
Macrini, Carol Dietrich
Madigan, Molly
Magallanes, Fernando
Magdoff, Samuel
Maglionico, Linda
Magnani, Lou
Maisel, Jay
Mangan, Kate
Marcellino, Jean
Marcus, Eric
Marcus, Helen
Margolis, David
Margolis, Lee
Marino, III, Leo
Mariucci, Jack
Marquez, Andrea
Martzolff, David M.
Mason, Joel
Matson, Robert
Max. Eileen
Mayer, Susan
Mayhew, Marce
Mazzola, Michael
McCaffery, William
McGreevy, Nick
Mednick, Scott
Meher, Nancy
Melendez, Frances
Merkley, Parry
Merritt, Suzan
Messier, Nadine
Metzdorf, Lyle
Metzner, Jeffrey
Meyer, Jackie Merri
Mezyk, Jessica
Milbauer, Eugene
Milligan, John
Minor, Wendell
Miranda. Michael
Modenstein, Sam
Modu, Chi
Moen, Larry
Mok, Clement
Mongkolkasetarin, Sakol
Montebello, Joseph
Montone, Ken
Moore, Diane
Moore, Robert
Moran, Paul
Morita, Minoru
Morrison, William
Morton, Amy

Moses, Louie
Moshier, David
Moss, Tobias
Muench-Williams, Allison
Munoz, Antonio
Murphy, Colleen Sargent
Myrka, Mariaelena
Needham, Chris
Needleman, Robert
Neri, Emiliano
Nessim, Barbara
Newman, Robert
Newman, Susan
Ng, William
Nicholas, Maria
Nichols, Mary Ann
Nicosia, Davide
Nissen, Joseph
Noether, Evelyn
Norman, Barbara
Noszagh, George
November, David
O'Connor, Sandra
O'Donnell, Lisa
Oberlander, Bill
Oeth, Michael
Ogilvie, Andrew
Okudaira, Yukako
Oldenburg, Miguel
Olson, Stephen Scott
Ortiz, Jose Luis
Osius, Gary
Ossa, Claudia
Ovryn, Nina
Owett, Bernard
Paccione, Onofrio
Paganucci, Robert
Palecek, Jane
Pallas, Brad
Parada, Ernie
Pascoe Fischbein, Kathleen
Pastorelli, Suzanne
Pearson, Jason
Pedersen, B. Martin
Peduto, Patrick
Peeri, Ariel
Perine, Shawn
Perry, Harold
Peslak, Victoria
Petrocelli, Robert
Petrucelli, Daniel
Pettus, Theodore
Pfeifer, Robert
Pham-Phu, Oanh
Phelps, Steward
Philiba, Allan
Phipps, Alma
Pioppo, Ernest
Pliskin, Robert
Powell, Neil
Proctor, Grant
Quackenbush, Michael
Queener, Charles
Ragusa, Maria
Rambo, Michael
Raznick, Ronald
Reed, Samuel
Reinke, Herbert
Reitzfeld, Robert
Renaud, Joseph Leslie
Rhodes, David

Richards, Stan
Richardson, Lynne
Richer, Paul
Rigelhaupt, Gail
Riley, Elizabeth
Ritter, Arthur
Robbins, Nadine
Roberts, Joseph
Roberts, Renee
Robinson, Bennett
Robinson, William
Robison, Charles
Rockwell, Harlow
Rodin, Yana
Rodney, Drew Ann
Romano, Andy
Romano, Dianne
Romero, Javier
Rosenshein, Cindy
Rosenthal, Bobbi
Rosner, Charlie
Rosner, Eric
Ross, Andrew
Ross, Richard
Roston, Arnold
Rowe, Alan
Rubenstein, Mort
Rubes, Linda
Rubin, Randee
Rubinsky, Shelley
Ruis, Thomas
Russell, Henry
Russo, Deborah
Russo, John
Ruther, Don
Ruzicka, Thomas
Sabnis, Rahul
Sacklow, Stewart
Sagmeister, Stefan
Saido, Tatsuhiro
Saito, Moriyoshi
Saks, Robert
Sala, Loretta
Salkaln, Don
Salpeter, Robert
Salser, James
Salzburg, Diana
Samerjan, George
San Juan, Jose
Sauer, Hans
Sayles, John
Saylor, David
Scali, Sam
Scarfone, Ernest
Schaefer, Peter
Schenk, Roland
Scher, Paula
Scherrer, Randall
Scheuer, Glenn
Schick, Jennifer
Schmalz, Paul
Schmidt, Klaus
Schoeller, Geraldine
Schroeder, Jill
Schultz, Eileen Hedy
Sculco, Georgina
Seabrook, Alexis
Seabrook, III, William
Seabrook, IV, William
Seagram, Blair
Sedelmaier, J.J.

Segal, Ilene
Segal, Leslie
Seidler, Sheldon
Sellers, John
Seymour-Frazier, Vanessa
Shachnow, Audrey
Shadoan, Jesse
Silverstein, Louis
Simmons, Robert
Simon, Serge
Simpson, Milton
Singer, Leslie
Sirowitz, Leonard
Skoll, Steve
Slomski, Jamie
Smith, Bronson
Smith, Carol Lynn
Smith, Robert
Smith, Virginia
Sobel, Edward
Sodeoka, Yoshi
Soffel, Deborah
Solomon, Martin
Solomon, Russell
Sosnow, Harold
Souder, Kirk
Spears, Harvey
Spegman, Jim
Stamatopoulos, Nancy
Stansfield, Shelly Laroche
Stanton, Mindy Phelps
Steck, Lynn
Steele, Cecilia
Stefanides, Dean
Steigelman, Robert
Steinbrenner, Karl
Steiner, Vera
Stern, Barrie
Stessel, Francine
Stevenson, Monica
Stewart, Daniel
Stewart, Gerald
Stith, Steve
Stone, Bernard
Storch, Otto
Storrs, Lizabeth
Stout, D.J.
Strizver, Ilene
Strongwater, Peter
Strosahl, William
Stroud, Steve
Sudell, Mark
Sullivan, Pamela
Sutcliffe, Laura
Sutton, Ward
Szeto, Gong
Szeto, Nam
Tang, Khiem
Tansman, Jo Ann
Tashian, Melcon
Taubin, William
Tauss, Jack
Tekushan, Mark
Tessler, Jonathan
Tharp, Louis
Thayer, Alden
Thompson, Andrew
Thorhauer, Susanne
Todd, Robert
Toland, Toni
Tora, Shinichiro

Traina, Jean
Trasoff, Victor
Trombley, Michele
Trowbridge, Susan
Tsiavos, Staz
Tsukerman, Roman
Tully, Joseph
Twomey, John
Udell, Rochelle
Valon, Judy
Verdia, Haydee
Vipper, Johan
Vischio, Amy
Vitale, Frank
Vogler, David
Von Collande, Constance
Wachtenheim, Dorothy
Wade, Lee
Wajdowicz, Jurek
Waldron, Malene
Wallace, Joseph
Walsh, Brendan
Walsh, Linda
Warlick, Mary
Waxberg, Larry
Webb, Jonathan Andrew
Weber, Jessica
Weeeng, Joy
Weidema, Karin
Weinstein, Roy
Weisel, Mimi
Weiss, Marty
Weitenauer, Janine
Weithas, Art
Welsh, Michael
Wender, Max Adam
West, Robert Shaw
Wilde, Richard
Williams, Rodney
Windecker, Dora
Wittenberg, Ross
Wolf, Henry
Wolf, Jay Michael
Wong, Nelson
Woods, Laura
Woodson, Elizabeth
Woodward, Fred
Yates, Peter
Yeap, Min Ping
Yonkovig, Zen
Young, Frank
Zaino, Carmile
Zheng, Ron
Zhukov, Maxim
Zielinski, Mikael
Ziff, Lloyd
Zwiebel, Alan

Argentina
Stein, Guillermo
Verdino, Daniel
Vidal, Jorge

Australia
Dilanchian, Kathryn
James, Musson Alexander

Austria
Demner, Mariusz Jan
Klein, Helmut
Lammerhuber, Lois
Lammerhuber, Silvia
Merlicek, Franz
Reidinger, Roland

Brazil
Cipullo, Sergio
De Barros Lenora
Migliano, Ricardo
Stefhan, Elaine Margarete
Tsumori, Elza

Bulgaria
Tchakarov, Stefan

Canada
Lacroix, Jean-Piere
Lavoie, Paul
Power, Stephanie

Chile
Cavia, Manuel Segura

China
Yen, Shen-hua

Hong Kong
Chuen, Tommy Li Wing
Freyss, Christina

Finland
Bergqvist, Harald
Manty, Kirsikka
Virta, Marjaana

Germany
Ernsting, Thomas
Hebe, Reiner
Koch, Claus
Kohl, Chris
Leu, Olaf
Meier, Erwin
Mojen, Friederike
Mojen, Ingo
Nebl, Lothar
Pham-Phu, Oanh
Prommer, Helga
Ramm, H. Diddo
Schneider, Frank
Spiekerman, Erik
Todd, Samy
Van Meel, Johannes

India
Pereira, Brendan

Ireland
Helme, Donald

Israel
Reisinger, Dan

Italy
Anelli, Luigi Montaini
Baccari, Alberto
Barbella, Pasquale
Fabiani, Titti
Guidone, Silvano
Moretti, Gianfranco
Sala, Maurizio
Stoppini, Luca

Japan
Akiyama, Takashi
Baba, Yuji
Furumura, Osamu
Hirai, Akio
Ichihashi, Ken
Ito, Yasuyuki
Iwata, Toshio
Kaneko, Hideyuki
Kashimoto, Satoji
Katsui, Mitsuo
Kida, Yasuhiko
Kinoshita, Katsuhiro
Kisso, Hiromasa
Kitazawa, Takashi
Kiyomura, Kunio
Kobayashi, Pete
Kojima, Ryohei
Kotani, Mitsuhiko
Krakower, Pepie
Maeda, Kazuki
Matsumoto, Arata
Matsumoto, Takao
Matsunaga, Shin
Matsuura, Iwao
Mizutani, Koji
Morimoto, Junichi
Nagatomo, Keisuke
Nakahara, Michio
Nakazawa, Jun
Nishimura, Yoshimari
Nozue, Toshiaki
Oba, Yoshimi
Ohashi, Toshiyuki
Ohtaka, Takeshi
Okumura, Akio
Oseko, Nobumitsu
Saito, Toshiki
Sakamoto, Hiroki
Sakamoto, Ken
Suzuki, Zempaku
Takahama, Yutaka
Takanokura, Yoshinori
Takeo, Shegeru
Tanabe, Masakazu
Tanaka, Ikko
Tanaka, Soji George
Tomita, Ben
Usami, Michihiro
Watanabe, Yoshiko
Yamamoto, Akihiro
Yamamoto, Yoji
Yoshida, Masayuki

Korea
Ahn, Dan Dongrin
Chang, Don Ryun
Chung, Joon
Kim, Chul Han
Kim, Doo Hwang
Kim, Een Seok
Kim, Kwang Kyu

Malaysia
Lee, Yee Ser Angie
Wong, Peter

Mexico
Beltran, Felix
Flores, Luis Efren Ramirez

The Netherlands
Brattinga, Pieter
Dovianus, Joep

Philippines
Abrera, Emily
Pe, Roger

Portugal
Aires, Eduardo

Romania
Musteata, Silviu

Singapore
Aitchison, Jim
Eng, Chiet-Hsuen

Spain
Trias Folch, Jose

Sweden
Palmquist, Kari
Yngrodottir, Sigrun

Switzerland
Bundi, Stephan
Dallenbach, Bilal
Gaberthuel, Martin
Jaggi, Moritz
Mauner, Claudia
Netthoevel, Andreas
Oebel, Manfred
Schuetz, Dominique Anne
Syz, Hans
Welti, Philipp

United Kingdom
Blamire, Richard
Stothard, Celia

Exhibitions

Kirshenbaum Bond & Partners— "Can This Really Be Advertising?"

September 1997

A retrospective of "one of the industry's most dignified, understated agencies quietly celebrating a tear-filled exhibition of ten wonderful years of fabulous work and spectacular fame, envied by all, world-wide."

Levi Strauss & Co.

October 1997

The Winner of the Art Directors Club 1997 Management Award. Among items on display: the world's oldest pair of Levi's circa 1886.

Telling Stories

March 1998

The new redesign of Creativity Magazine *and other work by Holstein, Hereford, Guernsey & Shapiro, and founder Andy Jacobson were featured. Designer cow-print yarmulkes were distributed.*

5 Magazines: Independents To Watch

May 1998

This exhibition showcased five domestic independent magazines: Big, Black Book, Blind Spot, Icon, *and* Surface*.

The ADC 77th Annual Awards Exhibition

June-July 1998

The ADC Gallery presented the works of medalists and Distinctive Merit winners.

Brand Aid—A 14-year retrospective of Duffy Design

September 1998

Brand and corporate identity projects for companies including Coca-Cola, Nikon, Armani, BMW, and McDonald's.

Creative Oxygen— Bartle, Bogle, Hegarty

October 1998

The hot London Advertising agency comes to town with an exhibition and a new NYC office.

Young Guns • NYC II

December 1998

An exhibition showcasing some of the city's hottest young creatives.

Speaker Events

Eiko Ishioka "Collaboration"

October 1997

One of Japan's most famous designers, Ishioka won an Oscar for her brilliant costumes for Francis Ford Coppola's Dracula.

Neil Powell of Duffy Design

November 1997

As design director of Duffy's New York office, Powell's work includes brand and corporate identity for clients including Time Magazine, *Jim Beam Brands, and The Coca-Cola Company.*

"Creative Differences—Ads That Entertain vs. Ads That Sell"

January 1998

Andy Berlin, Chairman of Berlin, Cameron Partners; Bob Kuperman, President and CEO of TBWA Chiat/Day; and Jack Trout, President of Jack Trout & Partners. Moderated by Anthony Vagnoni, Editor at Large of Advertising Age.

J.J.Sedelmaier

January 1998

An acclaimed director and animation visionary. His studio has produced commercials for Volkswagen ("Speedracer"), Converse ("Psychotraining"), and vignettes for "Saturday Night Live" ("Fun with Real Audio" and "The Ambiguously Gay Duo").

Peter Frankfurt/Chip Houghton— Imaginary Forces

March 1998

Imaginary Forces produce identity packages, main title sequences and marketing campaigns for film and television including Men In Black, Seven, Braveheart, Twister, *and* Ally McBeal.

Chip Kidd/David Carson

April 1998

Chip Kidd's revolutionary book jacket designs for Knopf have been described as "surprisingly elegant" (A.S. Mehta). Carson was named "Art Director of the Era" by London's Creative Review, which called his design for Ray Gun Magazine *"the most important work coming out of America."*

ADC and the APNY present "The Future of Print Advertising"

April 1998

Participants included Bill Oberlander, Kirshenbaum, Bond, & Partners; David Angelo, Cliff Freeman & Partners; Paul Behmen, McCann-Erickson Inc.; Arnie Arlow, Margeotes, Fertitta & Partners Inc; Jack Trout, Trout & Partners; Stuart DeHaan, Tiffany & Company; and Bill Schwab, Fallon McElligot/Berlin.

Sheila Metzner

May 1998

Sheila Metzner's unique photographic style has been featured in Vogue, Interview *and* Vanity Fair. *She is a member of the Art Directors Club Hall of Fame.*

HOWARD BADEN

NYC High School Juniors Learn from Top Professionals in a Series of Hands-On Workshops at the Art Directors Club

Cooper Union. FIT. Parsons School Of Design. Pratt Institute. SVA. Over the past few years, these and other art schools have seen a marked decline in qualified applicants from New York City high schools. In response to this trend—the result of cutbacks in funding for arts programs—The School Arts League and the ADC have sponsored the Saturday Career Workshop, a program of five Spring and five Fall sessions.

Coordinated by ADC member Susan Mayer and the League's Naomi Lonergan, over 120 students from more than twenty schools city-wide have attended workshops led by graphic arts professionals including Rolling Stone associate art director Gail Anderson, artist and illustrator Marshall Arisman, art director Ben Cruz and photographer Matthew Klein. Students from Parsons assisted at each session.

The students leave the program with a renewed sense of their own potential, greater awareness of the myriad of opportunities which exist in the field, a certificate, and a complimentary ADC Annual. The program exposes students to viable careers in advertising, graphic design, and new media and helps them to develop competitive portfolios for art school admission. In addition to planning the Fall 1998 schedule, the ADC is planning a mentoring program to match motivated students with dedicated ADC members.

This past June, The School Art League presented a special recognition award to the ADC at their annual ceremony at the Metropolitan Museum's Grace Rainey Rogers Auditorium. Certificates were received by past ADC president Carl Fisher, who was a driving force behind the program, Susan Mayer, who implemented the workshops with great warmth and skill, and ADC executive director Myrna Davis.

THERESE KOPIN©

The Cooper Union School of Art
Robert Rindler, Dean

Kerry DeBruce
Otto Petersen
Sanchez Stanfield

Fashion Institute of Technology
Frank Csoka, Chair

Avigail Arafeli
Dana Von Bargen
Steven Giraldi

New York City Technical College
Joel Mason, Department Chair

Priska Diaz
Mitsuyo Niwa-Rawlinson
Noah Rodriguez

Parsons School of Design
William Bevington, Department Chair

Michael Helme
Jacqueline Hoi Yan Yue
Aruna Naimji

Pratt Institute
Joseph Roberts, Department Chair

Jim Menkiena
Eduardo Rosado
Evelyn Vaisman

Pratt Manhattan
Elliott Gordon, Director

Alexandra Chrobok
Wei-Te Li
Nicolle Merrit

School of Visual Arts
Richard Wilde, Department Chair

Frank Anselmo
Jayson Atienza
Jason B. Rogers

"I was one of the excited and nervous students waiting to receive my award, and to see my work in the slide presentation. I want to thank you so much for the scholarship, the Annual, and my complimentary year membership. I filled out my membership form the next day, and I'm very excited to begin attending your show openings and the Student Portfolio Review in the Spring! This award was such an encouraging boost in these hectic last few weeks of my junior year—a reminder that all this hard work does pay off! Thank you so much!" —AWARD RECIPIENT

Is there anything left to say? Yes, there certainly is! The Art Directors Scholarship Foundation and the 21 students who received awards this year want to say thank you...

...to the ADC members, corporations, and friends of the Club, who gave freely of their time, work, and money;

...to ADC President, Bill Oberlander, the ADC Board of Directors, and Executive Director, Myrna Davis, for their continuing support;

...to Autherine Allison for keeping us on track and to Ruth Lubell, our liaison from the ADC Board;

...to the members of the Board of the ADSF, for their care and dedication. As school expenses climb, let's help the talented, hard-working students along. So, in advance, thanks to all contributors who will make next year's student awards possible.

—Meg Crane
President, The Art Directors Scholarship Foundation, Inc.

index

GHIBERTI

BEATA

PIETRA

Esquisse

Stancia

LYRICA

PONTIF

Orbital

HATMAKER

CRESCI

Augustal

Plantagenet

AENEAS

Stancia

Creative Alliance

DONATELLO

CRESCI

PITCHFORK

ITC ABATON

MISSION

ITC BLAIR

ITC Týfa

ITC Roswell

ITC Coconino

KHAKI

INDUSTRIAL GOTHIC

Fiesta

MARTINI AT JOE'S

ITC Tremor

ITC GEMA

ITC Stoclet

ITC Scarborough

Goudy Handtooled

Siesta

itc simran

Briem

ITC Portago

Founded in 1899, Takeo Company Limited today is one of the leading paper wholesalers in its market not only in Japan but also in Asian countries. Especially in the field of Text & Cover papers, Takeo has been keep watching the customers' need now and then. With our flourished line up of paper products, we are celebrating our centenary in coming 1999.

TAKEO COMPANY LIMITED

3-12-6, Kanda Nishiki-cho Chiyoda-ku Tokyo Japan 101-0054 Tel:03-3292-3611 Fax:03-3295-3981

Branch : Osaka Nagoya Fukuoka Sendai Sapporo

<Hong Kong>
Tai Tak Takeo Fine Paper Co.,Ltd. Hong Kong
Unit B401 4TH Floor, Block B Sea
View Estate, Watson Rd.,
North Point, Hong Kong
Tel:852-2807-3096
Fax:852-2807-2516

<Singapore>
Takeo Co., Ltd. Singapore Branch
247 Victoria St., Bugis Village,
Singapore 0718
Tel:65-334-8681
Fax:65-334-8682

<Shanghai>
Takeo Paper Trading (Shanghai) Co.,Ltd.
No 337, Fu Zhou Rd.,
Shanghai, 200001 China
Tel:86-21-6373-8570
Fax:86-21-6320-2095

<Malaysia>
Fine Paper Takeo (Malaysia) Sdn. Bhd.
61, Jalan 10/91, Taman Shamelim Perkasa,
56100 Kuala Lumpur, Malaysia
Tel:60-3-986-1890
Fax:60-3-986-2301

TWO

TRIBUTES

TO

Grandest Master of Japanese Graphic Design (1915-1997)

In his later years Yusaku Kamekura made a powerful contribution to the chronicle of design with Creation magazine. He personally edited all 20 volumes in the series but, aiming for total objectivity, excluded his own works. Now, to commemorate his lifetime of artistic achievements, a special issue of Creation (No. 21) has been put together in his honor under the supervision of Ikko Tanaka, Kazumasa Nagai and Shigeo Fukuda. YUSAKU KAMEKURA 1915-1997 is a catalog of 43 works lovingly created by graphic designers, artists and illustrators from around the world in Mr.Kamekura's memory. It was compiled in conjunction with a joint exhibition of these and Mr. Kamekura's works simultaneously held at Creation Gallery G8 and Guardian Garden in spring 1998.

YUSAKU KAMEKURA

Creation No. 21: Special Issue in Memory of Yusaku Kamekura

The chronicle of Mr. Kamekura's design work is the very history of Japanese graphic design. In a career spanning 65 years he created works that consistently dazzled: from his geometrically innovative Nikon posters, through his powerful Tokyo Olympic posters, and on even into his posthumously released works. They are all here in this comprehensive tribute.

Publisher: Recruit Co., Ltd.
Editing & Production: Kamekura Design Office / Recruit Co., Ltd.
Printing: Toppan Printing Co., Ltd.

YUSAKU KAMEKURA 1915-1997 Pioneer of Graphic Design in Japan

Forty-three of Mr. Kamekura's fellow artists from around the world pay tribute to the late master with original works and short essays prepared in his memory.

Publisher & Distributor: Media Factory, Inc.
Editing & Production: Recruit Co., Ltd.
Printing: Toppan Printing Co., Ltd.

To order, contact the following companies:
Books Nippan/1123 Dominguez Street, #K
Carson, CA 90746 USA TEL: +1-310-604-9701 FAX: +1-310-604-1134
Nippon Shuppan Hanbai Deutschland GmbH/ Krefelder Str. 85 D-40549
Dusseldorf, Germany TEL: +49-211-504-8080 FAX: +49-211-504-9326
Recruit Co., Ltd./8-4-17, Ginza, Chuo-ku, Tokyo 104-8001, Japan
FAX: +81-3-3575-7077

Two Galleries Produced by Recruit Co., Ltd.

Creation Gallery G8 Creation Gallery G8 serves as a bridge between Tokyo and the world by exhibiting creative works of outstanding international artists, primarily graphic designers and illustrators. An introduction to *the Art Directors Annual Exhibition* is presented every year.
Guardian Garden Guardian Garden showcases works by young and upcoming Japanese artists. Entries are invited in genres such as graphic art, photography, theater, etc., for open judging. "Winning" artists are invited to exhibit at the gallery free of charge.

Creation Gallery G8

Creation Gallery G8
1F, Recruit Ginza 8 Bldg., 8-4-17, Ginza,
Chuo-ku, Tokyo 104-8001, Japan
TEL: +81-3-3575-6918 FAX: +81-3-3575-7077

Guardian Garden
Produced by RECRUIT

Guardian Garden
Ginza Guardian Garden Bldg., 8-8-18, Ginza,
Chuo-ku, Tokyo 104-0061, Japan
TEL: +81-3-5568-8818 FAX: +81-3-5568-0512

The 76th Art Directors Annual Exhibition

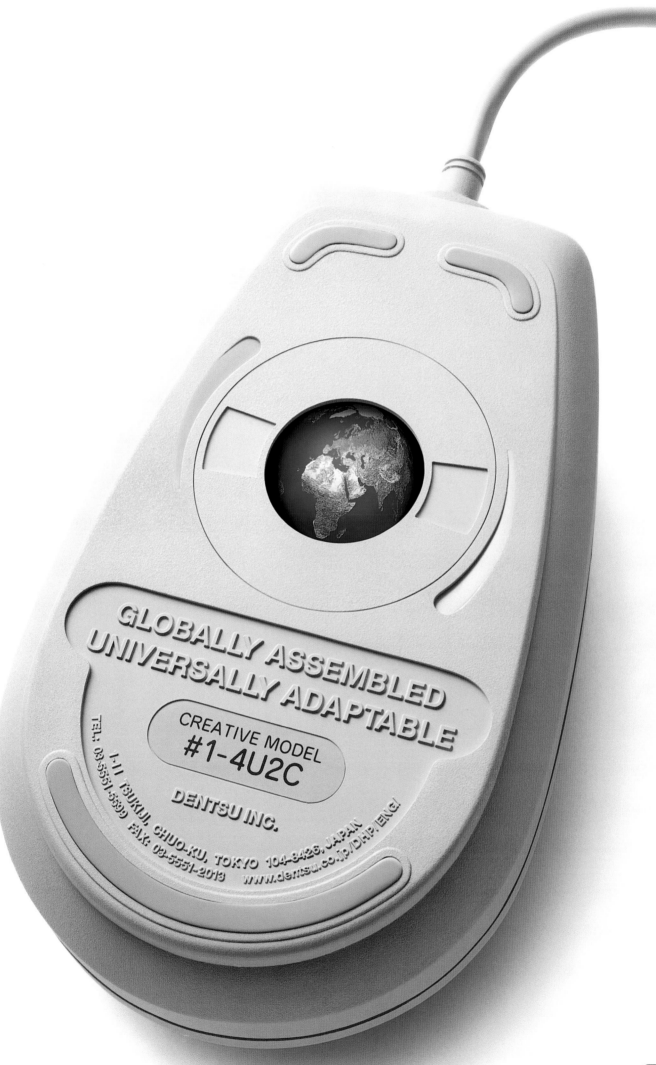

GLOBALLY ASSEMBLED
UNIVERSALLY ADAPTABLE

CREATIVE MODEL
#1-4U2C

DENTSU INC.

TEL: 03-5551-5399
1-11 TSUKIJI, CHUO-KU, TOKYO 104-8426, JAPAN
FAX: 03-5551-2013 www.dentsu.co.jp/DHP/ENG/

COMMUNICATIONS
EXCELLENCE
DENTSU

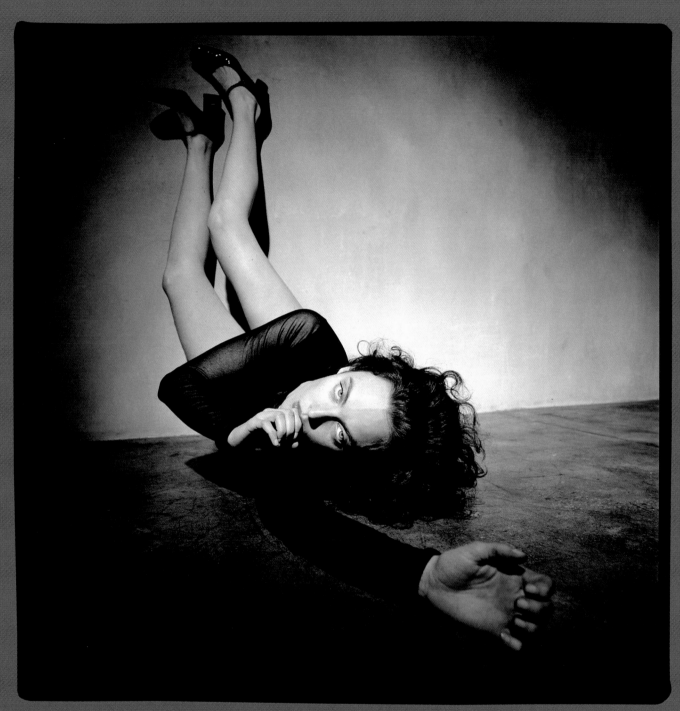

© 1998 Amy Arbus

Champion coated paper. The place to build your brand.™

Champion
Champion International Corporation

For samples or more information, call 1-800-442-3463

OVEN
SAY
RELAX

Integrated Strategic Consulting and Implementation guarantees Bulletproof Communications
Only a select few will find the proper balance of image and information. Call now for reservations; seating is limited. (www) oven.com

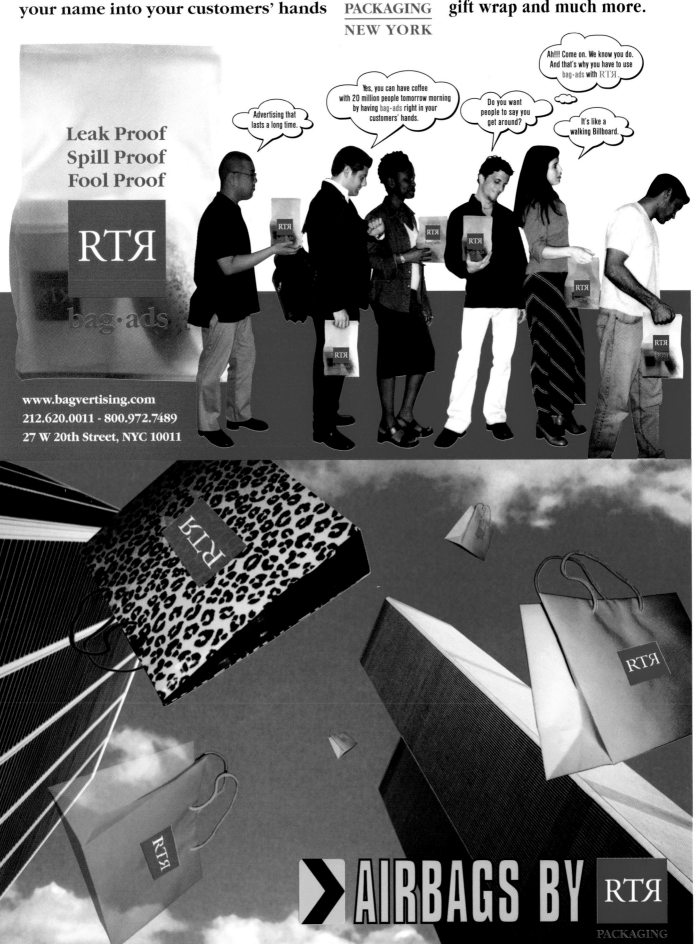

K/O→

CONCEPT

PROOF

COLOR CORRECT

DELIVERY

250 PARK AVENUE SOUTH SUITE 201 NEW YORK, NY 10003

TELEPHONE: 212.477.4300 FAX: 212.477.7170 EMAIL: ActualNY@aol.com

DATE DUE	
FEB 17 2009	